History and Catalog of the Portrait Collection
INDEPENDENCE NATIONAL HISTORICAL PARK

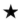

★

History of the Portrait Collection, Independence National Historical Park

by Doris Devine Fanelli

and

Catalog of the Collection

Karie Diethorn, *editor*

with

Introduction

by John C. Milley

★

American Philosophical Society
Independence Square · Philadelphia
2001

This catalog was supported in part by a grant from the National Endowment for the Arts, a Federal Agency, and by the Friends of Independence National Historical Park.

First published in the United States of America in 2002
by the American Philosophical Society, 104 S. 5th Street, Philadelphia, PA 19106-3387

Library of Congress Cataloging-in-Publication Data

Fanelli, Doris Devine
 History of the portrait collection, Independence National Historical Park / Doris Devine Fanelli; catalog of the collection, Karie Diethorn; with introduction by John C. Milley.
 p.cm.—(Memoirs of the American Philosophical Society; 242)
 Includes bibliographical references and index.
 ISBN 0-87169-242-2 (cloth)
 1. Portrait painting, American—Catalogs. 2. Portrait painting—18th century—United States—Catalogs. 3. Portrait painting—19th century—United States—Catalogs. 4. United States—Biography—Portraits—Catalogs. 5. Portrait painting—Pennsylvania—Philadelphia—Catalogs. 6. Independence National Historical Park (Philadelphia, Pa.) I. Diethorn, Karie. II. American Philosophical Society. III. Title. IV. Series.
ND1311.1.F37 2001
 00-053094

Design: Goldner Communications Design

Cover credits:
Photograph of Second Bank: Charles P. Mills
Individual portraits: Independence National Historical Park

Printed in the United States of America

History and Catalog of the Portrait Collection
Independence National Historical Park

Table of Contents

This book is dedicated to all the curators

who have worked to preserve the portrait collections

now in Independence National Historical Park.

Acknowledgments

Without the hospitality and support of many scholars, repositories, and institutions, this volume could never have reached publication. Chief among them is the American Philosophical Society, the repository of the Peale papers. Roy Goodman, reference librarian, and Beth Carroll-Horrocks, former manuscript librarian, were extraordinarily supportive during the data collection phase of this project. The Society's decision to publish this history and catalog as a volume of its *Memoirs* series acknowledges its long, collegial association with Independence National Historical Park. The patience and expertise of the editor, Carole LeFaivre-Rochester, have been indispensable.

The Historical Society of Pennsylvania and the Pennsylvania Genealogical Society were also repositories critical to this effort. The Historical Society houses many of the primary documentary records of the collections at Independence National Historical Park. During the years of my research in the manuscripts department, Linda M. Stanley's guidance and good nature contributed to the efficiency of my efforts. Her assistants followed her example, and I extend my gratitude to them as well. Without the minute records of the Genealogical Society, no curator of Pennsylvania collections could hope to sort out provenance.

The Library Company of Philadelphia and The Pennsylvania Academy of the Fine Arts also contain materials essential to comprehending the portraits at Independence National Historical Park. The Library Company's chief of research, Philip Lapsansky, and Cheryl Liebold, archivist at the Academy, deserve particular credit for their unerring direction.

Numerous other institutions shared our enthusiasm for this project. The Gallery, Williams Center for the Arts of Lafayette College and its director, Michiko Okaya; the Philadelphia Society for the Preservation of Landmarks; the Catalog of American Portraits, in particular Linda Thrift, Debra Sisum, and Ellen Collinson; the prints, pictures, and rare books sections of the Free Library of Philadelphia; the Frick Art Reference Library; Haverford College Library, the Quaker Collection; the Huntington Library, in particular Mary Robertson; The Independence Seaport Museum (formerly the Philadelphia Maritime Museum); The National Museum of American History, notably Marko Zlatich who deciphered the complex meanings of military medals; Ellen G. Miles of the National Portrait Gallery; and Saint Peter's Episcopal Church, Philadelphia, which allowed me to examine parish and burial records.

Three successive superintendents at Independence National Historical Park supported the curation and development of the portrait collection. Chester L. Brooks (1969–71); Hobart G. Cawood (1971–91); and Martha B. Aikens (1992–) affirmed their preservation responsibilities and recognized the necessity of sharing information about the portrait collection with a wider audience. Their endorsement of this project permitted its completion.

Research assistance for this catalog came in many forms. Chiefly, the Friends of Independence National Historical Park's former internship program provided a succession of young, eager researchers whose work is visible in a variety of areas of this project. Jane C. Busch, Margaret Harm Greene, John M. Bacon, Lori Fergusson, and Becky Breisacher, although acknowledged elsewhere in the text, deserve special mention here. Another fund of labor was summer employees. Long before the internship program, doctoral candidate Susanna Kothe Morikawa performed preliminary studies on the portraits. Nancy Lisewski and David Brigham also spent several months researching and updating catalog information. Former supervisory curator, David H. Wallace (1959–68) provided editorial advice and shared his remarkable memory of the collection.

Members of the Museum Branch at Independence National Historical Park devoted many hours of support to this work. Associate curator Robert L. Giannini, III performed photo research. Registrar Gloria Eddins maintained access to records. Anne M. Dadura and Barbara C. Davis used their personal computer skills to format text and convert data from one troublesome system to another.

The accuracy, detail, and completeness of this study was improved by conversations or correspondence with Herbert Bass, David Meschutt, Carol Soltis, Mark Miller, the late George Vaux, Mr. and Mrs. William Cramp Sheetz, Henry A. Boorse, Charles Dunlap of Paradise Valley, Arizona, and Alexander Koder, Old Masters, Ltd., London. All were generous with their personal records and knowledge. Stuart P. Feld's generosity enabled me to provide an extended discussion of Thomas Sully's creation of the Lafayette portrait.

The National Endowment for the Arts and the Friends of Independence National Historical Park provided financial support for this publication.

Doris Devine Fanelli
Independence National Historical Park

Preface

The purpose of this book is to provide a reference guide to the portrait collection at Independence National Historical Park. The Pennsylvania State House, or Independence Hall as it is called today, has always been a fitting site for the display of public portraiture. The portraits reinforced the power of the ruling government. Initially, they portrayed monarchs and figures in the proprietary government; after the onset of the Revolution, the portraits depicted men of republican virtue who overthrew the royal government and established a democracy. Although Charles Willson Peale did not intend to exhibit his portraits in the Pennsylvania State House when he began to create a gallery of "noted worthies," the Peale collection became linked with the building. Peale's portraits of officers of the American Revolution, founders of American government, jurists, scientists, and men of letters became the core of the collection and have defined the scope of its growth.

Visitors to Independence National Historical Park come to see Independence Hall, where the Declaration of Independence was signed and the United States Constitution was framed. Many are delighted to discover that the life portraits of the men responsible for those documents are also exhibited here in the Second Bank of the United States. These portraits have never before been published as a collection. Only a small group of scholars of American history and art is aware of their existence. Most of those scholars have contributed to this catalog through their work on the artists or subjects represented or through their correspondence with the curatorial staff at Independence Park.

The questions asked about this collection suggested the organizing structure of the catalog entries. The first category of question centers on physical description. Each entry, therefore, provides a physical description of the portrait, the appearance of the subject, and the design of the picture. Although financial limitations did not permit a color illustration of each portrait, there is at least a black-and-white image of each.

The circumstances of the portrait's creation, and of its artist form the second category of inquiry we receive. Closely related are inquiries about the circumstances of the portrait's acquisition and provenance, and degree of relationship or remove of the painting and its subject. This interest in whether a portrait is a life portrait, a replica, a facsimile, a copy or a complete reconstruction has been a recurrent theme in the history of this collection. Untangling these issues has offered insight into the Peale and Sharples families' methods of work. Notable, too, is the underlying question of authenticity. Originally never raised, questions of the difference between a life and a copy portrait as well as the degrees of distinction between those two extremes have occupied scholars of this century.

The majority of the subjects of these portraits are well-known. We sometimes receive requests for biographical information about the less prominent sitters. Biographical information about the sitter is given in an effort to illuminate his personality and thereby increase the viewer's appreciation of the portrayal. In order to avoid a tedious recitation of titles and dates, we determined to list only a few of the subject's notable accomplishments.

For nearly one hundred twenty-five years, the curators of these paintings have maintained a varied and rich correspondence about them. No question was ever unimportant because it opened doors to others or found answers. This inquiry has led to the reattribution of some works, the reidentification of sitters, and the identification of owners of replicas. This book is intended to broaden and deepen the dialogue within the community of scholars that has developed around these paintings. It is also hoped to encourage others to join the discussion.

The history that forms the first section of this book details the formation and curation of this collection until 1951, when the National Park Service assumed custody of it. But the contributions of several scholars since 1951 require mention here because their input went far beyond the level of involvement commonly noted in the Acknowledgments. Indeed, this book could not have been written without the benefit of their efforts and scholarship. Each brought the perspective of his or her particular academic discipline to the task of comprehending these paintings. The resultant data comprises a half century of inter-disciplinary studies.

Robert Stewart studied the paintings collection during his years as an historian at Independence. When he later worked at the National Portrait Gallery, his memory of the collection enabled him to use it comparatively in his subsequent endeavors.

Charles Coleman Sellers's work on Charles Willson Peale gave everyone access to the artist's oeuvre and enabled us to understand his museum. A Peale descendant, Sellers, along with other members of his family, was directly responsible for the preservation of the Independence Hall complex and its collections. His *Portraits and Miniatures* forms the keystone reference volume of the Peale canon. It furthered the production of this catalog by providing the documentary and comparative data necessary for the analysis of the portrait collection.

Edgar Richardson's devotion to American art scholarship is visible throughout the correspondence files relating to the paintings collection. His interest in the Peale family and his assessment of its work in a variety of media are valuable for situating our portraits within the Peales' larger practice of art. But this book has also benefited from his thoughts on other, non-Peale, paintings in the collection.

David Wallace took on the task of organizing the voluminous records and correspondence relating to the collections. Wallace made initial inquiries into specific paintings and developed a brief chronicle of the collections. Without his exceptional abilities as an historian and archivist, valuable documentary materials would have been lost through a lack of organizational structure. Wallace kindly edited an earlier version of Chapter II of the collections history and the majority of the catalog entries. This publication is indebted to his sharp memory. The collections at Independence continue to prosper by his enduring friendship.

Conservator Anne Clapp examined and treated many of the portraits. Hers were the first true records of their physical condition. These assessments contribute to the textual records of the portraits' histories. Her recent judgments about the Sharples pastels suggest that a later hand added the fanciful backgrounds in an effort to embellish the simple images.

An historian as well as an academically trained painter, John C. Milley evaluated the paintings as works of art. He used formidable connoisseurship skills to study the paintings on an artist's terms, and developed an understanding of the portraits in terms of technique, composition, structure, palette, and drawing. He easily identified several discernible stages of Charles Willson Peale's stylistic development, and the individual styles of members of the Sharples family. His judgments about individual portraits and his correspondence about them are found in their catalog folders. His greatest contribution to

the portrait collections was securing a permanent place of display for them in a fitting setting, the Second Bank of the United States.

Lillian Miller shared her curiosity about Charles Willson Peale and his endeavors, his family, and his times. It is chiefly through her foresight as editor of the Peale papers and as the author of numerous works about him that we are able to place Peale the artist within the greater context of Peale the artisan, the inventor, the museologist, and the progenitor of a large and inherently curious and productive family. I am particularly grateful for her many perceptive comments on the history of the collections and for her gentle corrections of my statements about the Peale Museum.

In preparing the history of the portrait collections, I have placed them in their socio-cultural context in order to understand them as historical artifacts, not as works of art. In the latter case, scholars may differ in their assessment of the creator's skill. However, Peale's portraits, as a body of work, are a powerful crucible that has heated a dialogue about public memory and history for nearly two hundred years. In my estimation, the portraits succeed through their ability to invest the past with immediacy. We cannot lightly dismiss the complexity of documentary information each painting carries for the viewer.

Karie Diethorn organized the information about the portraits by designing the structure of the catalog entries in this book. She unified the contributors' styles, checked documentation, and researched and wrote many of the entries. In the course of this project, she discovered new information and was able to revise some earlier assumptions about several of the portraits. She also learned a great deal about Charles Willson Peale's methods of work, which she shares in her brief note. The many writers who contributed entries to this effort are acknowledged in the list of contributors.

It is difficult to know whether Peale's paintings would have retained their collective significance had it not been for their association with Independence Hall. Their intermittent display in that building for one hundred fifty years solidified their linkages with the momentous events their subjects kindled. Whether by design or by serendipity, Peale's portraits of "noted worthies" have attained the immortality he sought for them.

Doris Devine Fanelli

Introduction

by John C. Milley

Portraiture:
Commemorative and Symbolic

1. Designed by William Strickland in 1818, and constructed between 1819 and 1824, the Second Bank of the United States, or its influence in regulating the nation's economy, became the election issue of 1832. For a discussion of the controversial issues involved see: Bray Hammond, *The Second Bank of the United States, Transactions of the American Philosophical Society,* 43, 1(1953). For an introduction to the architectural style of the Second Bank see: Talbot Faulkner Hamlin, *Greek Revival Architecture in America* (London: Oxford University Press, 1941).

A museum of portraits has a forbidding ring to the general public of today—a mausoleum perhaps better left to dust and mummies than entered for education and rational entertainment, two of its most important reasons for being. The principal purposes of a public portrait are commemoration and exemplification. The image preserves for present and future generations the likeness of an individual whose acts and deeds in life are deemed worthy of remembrance and emulation. A public portrait is, therefore, symbolic, a signpost to what people of a given time and place held to be a life honorably conducted. Displayed for public contemplation, portraiture further helps foster local affinity or national unity and conveys a sense of security through one's identification with a tradition or heritage.

There can be little doubt that these purposes and precedents were foremost in the mind of Charles Willson Peale (1741–1827)—the painter whose works constitute the nucleus of the portrait collections of Independence National Historical Park—when he first conceived a gallery of "celebrated personages" associated with the American Revolution. It was in the same context that architect William Strickland's Second Bank of the United States (1819–1824) was adapted in 1974 to serve as a portrait gallery dedicated to the founders of this country. The painting collections of the Park were consolidated in one building. The fortuitous marriage of one of the great examples of the Greek Revival style of architecture in America and a collection of portraits dating predominantly from the late eighteenth and early nineteenth centuries brought together two arts of similar ideological origin. Each in its own way was symbolic of the unification achieved through the American Revolution and of the country's need following that epochal time both to commemorate its accomplishments and to give visual expression to the stability of its government.[1]

Portraiture, like other art forms, tells us of a time. It is datable and attributable to a place of origin through stylistic and technological characteristics. The distinctiveness of the recorded image of an individual is, however, in the subject portrayed, for that lends itself to a personal association with, or a more intimate understanding of, a time past. While a chair, a teapot, a coverlet definitely tell us something about a culture, and may delight us in sensuous ways, they often leave us wanting to know more than mere vital statistics about the person or persons who created or used them. Everyday household things assume additional relevance when we are able to identify their makers and users. Portraiture, braced by interpretive biography, helps supply such depth of information.

Nevertheless, a portrait remains an abstraction of reality, and, aesthetic considerations aside, it can speak to us only in symbolic ways, provided, of course, that we are equipped with knowledge of the historical and ideological frames of reference in which the likeness was conceived. "In a historical point of view, this collection is unique … being composed of … men who were active and influential in the resistance of the British colonies to the domination of the mother country—the Sages and Soldiers of the Revolution,— the Members of Congress which declared Independence—the first Presidents and early Statesmen of the United States—the Military and Naval Heroes of the second war for

Independence, and many of the distinguished Statesmen of a later date." So wrote M. Thomas and Sons, the auctioneers who handled the sale of the portraits from the Philadelphia Museum of Charles Willson Peale in 1854. In the preface to the sale catalog, the Thomases continued with some truth that they doubted a comparable collection existed in any country, and that it was their hope that these portraits would become the basis for a national gallery. After all, this was the same year in which the National Portrait Gallery was founded in London. There were several institutions in the United States with impressive collections of portraits by this time, including Yale College, which had purchased John Trumbull's collection in 1831.[2]

Interest in the collection was overwhelmingly local. Failing, as Peale himself had failed years earlier to awaken a national consciousness to the educational potentials of the collection, the auctioneers hammered down the paintings piecemeal. Quite evident at the auction, however, were a few public-spirited citizens who represented the City of Philadelphia and who acquired a sizable number of the portraits for the express purpose of placing them in Independence Hall. The selection of paintings is significant for its emphasis on the portraits of persons who were in some way associated with the historical events that either took place in Philadelphia or made up the fabric of the city's history. Landscapes, still lifes, and more ambitious or personal forms of portraiture were sacrificed by the city to other buyers. Those who guided the city's purchases preferred history to art, and in that respect they may have been closer to an understanding of the traditional purposes of preserving an individual's likeness than later teachings of aesthetics might have us believe. This is not to say that aesthetic considerations were of no concern to the city's counselors in this matter, or to artists like Peale. Rather, it underscores a basic difference in the conception and perception of these paintings from one age to another.[3]

Conditioned as we are in the twentieth century to the candor and proliferation of the photographic image, we are insensitive to the significance the hand-crafted likeness held for its audience. Furthermore, viewing portraits through the lens of modern academic standards may place a greater emphasis upon their artistic virtuosity as opposed to their cultural value, occasionally yielding a distorted view. An aesthetician of today might conclude one thing about the portrait arts of Rome of the first century a.d., for instance, but Pliny the Elder tells us something different. Lodged in Pliny's compendious work on *Natural History* is his explicit condemnation of contemporary art as virtually unrecognizable in person. Moreover, he criticized harshly the collecting of portraits for no other purpose than the display of wealth. "Thus it is," he lamented, "that we possess the portraits of no living individuals (as his ancestors had) and leave behind us the picture of our wealth, not of our persons." Indolence had destroyed the arts.[4]

Pliny's words are not without their relevance to the portrait art of Charles Willson Peale. Pliny propounded a preference for verisimilitude in portrait art. He was disdainful of hedonism, and implied that there was a moral purpose to artistic endeavors. This argument that the portraitist's charge was fidelity to nature recurred over time and eventually found its way to colonial America through England. The phrase "to be like," however, meant something quite different from one end of the eighteenth century to the other. Where Roger de Piles in 1708 could concoct a formula of equal parts deportment, temperament, attitude, and costume, which rendered the subject's social station more recognizable, more "true" on canvas than it was in life, between 1767 and 1780, Sir Joshua Reynolds would lecture on a methodology for truth in portraiture that transmuted reality to idealization. The polarity of these extremes is exemplified in the contrast between the work of such American artists as Robert Feke and Thomas Sully.[5]

2. Several copies of the sale catalogue, M. Thomas & Sons, Auctioneers, *Peale's Museum Gallery of Oil Paintings* (Philadelphia: Wm. Y. Owen, Printer, 1854), are extant, including Rembrandt Peale's personally annotated copy in the Library of the American Philosophical Society. This essay quotes from the copy in Independence National Historical Park's collection.

3. Frank M. Etting's *An Historical Account of the Old State House of Pennsylvania* (Philadelphia: Porter & Coates, 1891), contains interesting accounts of the development of Independence Hall as a shrine, and it is especially useful with reference to the preparations made during the Centennial to establish the building as a national museum.

4. Quoted in part in John Pope-Hennessy, *The Portrait in the Renaissance,* Bolligen Series 35-12 (Princeton, N.J.: Princeton University Press, 1967), 72. For a more complete quotation see: C. Plinius Secundus, *Natural History*, compacted by Lloyd, (New York: 1957), 147–48.

5. This distillation of the thoughts contained in Roger de Piles, *Cours de Peinture par Principes* (Paris, 1708), is indebted to the analysis of Remy G. Saisselin, *Style, Truth and the Portrait* (Cleveland: The Cleveland Museum of Art, 1963), 5. The reference to Reynolds comes from my own reading of Sir Joshua Reynolds, *Discourses Delivered to the Students of the Royal Academy 1767–1780*, ed. Roger Fry (London: Seeley & Co. Ltd., 1905) in conjunction with my study: "Jacob Eicholtz 1776–1842, Pennsylvania Portraitist" (Thesis, University of Delaware, 1960).

6. Quoted by Samuel M. Green, "The English Origin of Seventeenth Century Painting in New England," *American Painting to 1776: A Reappraisal*, ed. Ian M.G. Quimby (Charlottesville: The University Press of Virginia, 1971), 31.

7. Saisselin, 1.

8. Quoted in Neil Harris, *The Artist in American Society: The Formative Years 1790–1860* (MXCLXVI; rpt. New York: Simon and Schuster, 1970), 9. Charles Coleman Sellers, *Portraits and Miniatures of Charles Willson Peale, Transactions of the American Philosophical Society* 42, 1 (Philadelphia: 1952), 9.

9. Charles Coleman Sellers, *Charles Willson Peale*, 1 (Philadelphia: The American Philosophical Society, 1947), 10. It is interesting that Barbara Novak, *American Painting of the Nineteenth Century* (New York: Praeger Publishers, 1969), concentrates upon West and Copley to the total exclusion of Peale in her prologue to the subject. By the omission she is one of the first to suggest that they not be considered as a triumvirate.

To advance the hypothesis that American artists of the first half of the eighteenth century possessed much more than a superficial acquaintance with the polemics of art theory, all of which was available in published form, may be to do both them and us an injustice. Rather, the assimilation of painterly conventions transmitted through the medium of prints and the perpetuation of artistic traditions placed the work of American artists within a unified community of British art.

For all the similarities that researchers have found between the works of artists in America and provincial England, there were the differences of time and place. If anything, American portraiture of the first half of the eighteenth century was more *retardataire* than the arts of silversmithing and cabinetmaking. The portrait style of Feke is comparable to that produced in England almost a century earlier. What we find in the work of someone like Feke is what Roy Strong, the director of the National Portrait Gallery in London, finds in earlier work of provincial England, "the transmission of the baroque vocabulary into a two-dimensional Jacobean icon." In other words, in areas removed from the style-setting centers, artists tended to cling tenaciously to older customs. The situation would reverse itself dramatically in America with the turn of the century (Sully's work, for example) as a result of more frequent and direct contact with the style centers of London, Rome, and Paris.[6]

Between the extremes of date and style of Feke and Sully were those who held that a person's character is revealed directly in the face and that to "be like" the portrait should approach a mirrored exactness. The eminent Dr. Samuel Johnson was of this thinking, adding that it was especially important in the portraits of ancestors that they be shown in the costume of their time, whereby the portrait became a historical document. It was this kind of thinking that suited best the pragmatic mind of Charles Willson Peale, and it synchronized or harmonized well with his craftsman-oriented training.[7]

As a young man, Peale was exposed to contemporary art theory on all sides, both in Philadelphia and in London where he trained in the atelier of Benjamin West during the very years that Reynolds initiated his annual discourses. These critiques were heady stuff for a saddler from far-off provincial Annapolis, Maryland. Try as he may, even to the point of executing a print laden with symbolism of classical origin, he could not quite digest thinking of a philosophical kind. Although Peale never shied from mouthing in all sincerity his master's stance on the respect due the professional artist or the premier position assigned to the painting of history, or from working tirelessly toward the establishment of an academy of art in Philadelphia, he had to confess that "my enthusiastic mind forms some idea of it, but I have not the execution … what little I do is by mear [*sic*] imitation." The idea that art is imitation, and more specifically, the "Imitation of Nature, and therefore, of God," was one of ancient derivation. According to Charles Coleman Sellers, Peale's biographer and descendant, such thinking "was probably sifted to Peale through West's teaching, or it would not have taken so well."[8]

Dr. Sellers, as well as other scholars, recognized the pragmatic nature of Peale's thought, although what that may mean in terms of his painting style needs further exploration. "He loved construction," Sellers revealingly writes of Peale, "the balancing of cause and effect, bringing together of elements into a harmonious whole, whether for sight or sound or practical service. Hammer and pliers filled his hand as readily as a brush, and the word 'engineer' not yet having currency, he was wont to speak of a skilled mechanic as 'artist,'" We tend to forget that Peale was an artisan and twenty-six years of age when he went to England, and that he lacked an educational background which might have influenced his receptivity to study substantively. Both West and Copley were considerably better prepared than Peale for study abroad, the former a precocious youth introduced quite early to art history and classical literature; the latter, equally astute and the stepson of a London-trained engraver.[9]

Peale's self-identification as an artisan and his place in society derived from the firmly-rooted classical idea of an art–craft equation. The Renaissance concept of an artist as something distinct from and superior to a craftsman in intellectual prowess and consequently deserving of a higher standing in social esteem, was again something relatively new to Peale and many of his contemporaries, hardly having had the time to filter down from the British upper class to the vernacular level much before the mid-eighteenth century. Artfulness was a desired component of a craftsman's work. Skilled craftsmen applied the same aesthetic ideal to their work, be it, for instance, the sine curve expressed as a Queen Anne chair or as the organizing design principal of a portrait.[10]

"In an age without machine industry," observes Harold Osborne, "people were keenly conscious of standards of workmanship." The question was not so much whether an object was "art" or not, but whether it was well executed and was "useful" to society. Peale's craftsmanlike approach to portrait painting, and his dependence upon classical precedents, becomes patent as one follows the development of his museum plans and critically examines the "museum portrait" in particular. What he absorbed in England was put to maximum advantage in ingenious ways.[11]

Charles Willson Peale, who epitomizes the American artist bent on useful purposes, is often misunderstood by many who have but a passing acquaintance with his name. We find the reasons for such misunderstanding in his portrayal by certain contemporaries, in our unfamiliarity with Peale's term "rational entertainment," as he applied it to his museums, and in the humorous misadventures of some of his well-meant endeavors. John Neal, for example, one of America's earliest but most caustic critics, branded Peale as "one of the best men that God ever made," albeit the hardness of the artist's portrait style caused Neal to demur that "he will paint portraits with a chisel, marry a fifth or sixth wife every few years, and outlive all the rest of the world." Peale's passion for life was infectious.[12]

Having little or no money, having absorbed as much as he cared to in England, Peale returned to America in 1769, determined to succeed at painting. The political strife that engulfed the colonies, Peale's move to Philadelphia in 1776, his roles as politician and soldier in the Revolutionary War including his encampment at Valley Forge illustrate how inextricably his life was bound up with the events and people he chronicled in paint. How, when, and why he came to the decision to develop a gallery of portraits of "eminent" men of the Revolutionary period are questions that may never be answered other than speculatively. That Philadelphia was a veritable gold mine for the head hunter may have been incentive enough. The important point, however, is that he did develop the idea, although it was far from original. Peale's incorporation into his museum of natural history, a branch of knowledge that eventually dominated his collections, was likewise not without precedent. What was new was the details of how he did these things.

To comprehend both the times and Peale's points of reference, it is of utmost importance to appreciate the eighteenth-century relationship of natural history to the portraits of man. My previous reference to Pliny suggests the classical origin of this association. This interplay found full flower, however, in the *Kunstkammern*, or "cabinets of curiosities," which sprang up all over Europe in the sixteenth and seventeenth centuries, the dawn of scientific enlightenment. Among the numerous examples of such "cabinets," one is of particular interest because its originator, Neickelius of Leipzig, produced a significant publication. In 1727, Neickelius published *Museographia*, a book in which he offered a kind of blueprint for a scholarly collection, with shelves placed along opposite walls of a gallery for the *naturalia* and *artificialia*, respectively, and with the space over the shelves reserved for the portraits of famous men. Neickelius was describing a fairly common practice—the establishment of cabinets as small encyclopedias of knowledge, following the sequential

10. For more on this idea see Harold Osborne, *Aesthetics and Art Theory* (New York: E.P. Dutton & Co., Inc., 1970), 17.

11. Osborne, 31.

12. Quoted in Sellers, *Charles Willson Peale*, 2: 392–93.

13. This and the following passages are paraphrased from Alma S. Wittlin, *Museums: In search of a Useable Future* (Cambridge, Mass.: MIT Press, 1970), 39–52, 60–74.

14. Wittlin, 42.

15. Ibid., fig. 14.

16. Some of the paintings have a number painted on one of the unfinished corners—e.g., "10" on that of Charles Thomson—possibly to designate the order in which they were painted for the gallery, but Peale was inconsistent in the practice. A close study of Titian Ramsay Peale's watercolor sketch of the museum in the Long Gallery of Independence Hall reveals a name plate attached to the frames. When the frames were restored in 1973, in preparation for the opening of the Portrait Gallery, two screw holes were found in the center of the bottom moldings of several frames underneath several layers of gilt, attesting to their originality.

arrangement of man–animals–plants–rocks in a rational order of descending importance. In the Galleria Palatine in Rome, for example, systemization was made aesthetic in form by placing all paintings in frames of a uniform style and size and hanging them according to the rules of symmetry.[13]

The keepers, caretakers, or curators, as they were variously called, who affiliated themselves with the curiosi, otiosi, and virtuosi, as the academicians and the collectors of the sixteenth and seventeenth centuries fashioned themselves, were learned men who seized upon every advance in science to better classify the world of *naturalia* and *artificialia*. Having shaken the fetters of theological superstition prevalent in medieval thought, men of the Renaissance and Enlightenment turned their attentions with increasing intensity to their own natural environment, human ingenuity, and artistic skills. Equally significant, as it runs through Peale's own works, is that there was a moral purpose attached to such an endeavor— it was useful. Peale was in perfect accord with Neickelius, who believed that "idleness creates wickedness" and that collecting was a good and proper preventive to laziness.[14]

When Peale tells us in his writings that his museum was to be "a world in miniature," he does not say that the idea originated with him. Where he tells us that he would follow a system of classification, he does not say that Linnaeus was the source of his museum plans. Knowledge of such things was widespread and certainly not lost upon the educated classes of either England or America. If Peale was not personally familiar with the *Museographia*, he most certainly was conversant with its contents. If he did not see first-hand the collections of the great Ashmolean Museum in Oxford, there certainly was no dearth of others in and about London. Members of Philadelphia's scientific and cultural communities, educated residents of the city as well as tourists, might be expected to have had intimate knowledge of well-worn ideas respecting "cabinets of curiosity." Finally, Peale gives us his own tangible documentation of indebtedness to predecessors like Neickelius in his monumental self-portrait entitled *The Artist in His Museum*. Here, in every particular, is a museum of European ancestry, and in every particular it bears a startling resemblance to the portrait of *Cardinal Mazarin in His Gallery*, a painting that was engraved for distribution in the seventeenth century.[15]

We are told in tracts like the *Museographia* that the portrait represented the genus man in the great scheme of things, the highest form of primate—which is why paintings were placed uppermost on the walls in early museums. This was the museum arrangement later adopted by Peale sometime after he opened his gallery of portraits of eminent men in his home on Lombard Street in 1784, and before the addition of specimens of natural history. Freeman's Journal of 1784, the first catalogue of the collection, lists no fewer than forty-four subjects. The form this portraiture took tells us that its purpose was not aesthetic enjoyment; nor did the portraits require formal education to be understood.

The majority of these paintings were executed in a more or less standard size and on rectangular canvases. They were bust portraits, with the subjects usually set against a neutral ground free of any accessory. And they were conceived to receive a gilded frame equipped with an oval spandrel. Evidence for the frames having been an integral part of Peale's creation of this, the characteristic "museum portrait," is contained on many of the canvases where the four corners are left unfinished.[16]

These portraits represent a radical departure from the majority of Peale's private commissions, in which he almost invariably included some personal accessory, attribute, or symbol that would help identify the subject. Allegory was also a convention for the life-size public portrait, such as that of Monsieur Alexandre Gerard, commissioned from Peale in 1779 by the Continental Congress to honor the services rendered by the first foreign minister to the United States. The illusion of statuary in the

upper right-hand corner of this painting, symbolic of the alliance formed between the two countries, has an obviously classical point of reference. More revealing, perhaps, with respect to Peale's thinking, is the portrait of Mary White Morris, painted in 1782, in which we find sculptured busts (among which is one of George Washington) placed upon pedestals in a formal garden setting. That the sculptured bust was the genesis of Peale's "museum portrait," either directly or indirectly, seems highly probable. He was thoroughly conversant with this form of portraiture, and no doubt knew its meaning. While in England he executed at least three plaster busts—one of Benjamin West, his teacher and master; one of Edmund Jennings, a patron of the arts and colonial sympathizer; and one of himself, the student—all three of which he later incorporated into the painting of his family.[17]

"Sculpture … in a sense," writes one scholar most tellingly, "is ever the portrait of immortals, for a bust portrait is often stripped to the essential to represent but the dominant trait which though particularly that of one man, yet is nevertheless of universal value; grandeur, nobility, courage, force of character, profundity of thought, esprit, genius, intelligence. …" Its potential realized during the Renaissance under the influence of humanist thinking, the sculptured bust was transposed to the painted surface. The reasons for this practice, John Pope-Hennessy finds in his researches on the subject, "is that initially the role of the Renaissance portrait was commemorative; it was consciously directed to the future. … the individual's reputation sprang from his character, and character as classical physiognomic treatises insisted, was directly mirrored in the face. It was in this way that he (the subject) should be commemorated." In the hands of a master like Botticelli, the portrait became a tour de force: "It stemmed from a tenuous web of Neoplatonic thinking whereby reality came to be accepted as a symbol and the depiction of reality took on symbolic overtones." Somewhat later, Giorgione was to give a sense of mysteriousness to the bust portrait by substituting a neutral background for the painted sky and giving less definition to the features.[18]

Thus we find ingeniously combined in the "museum portrait" by Peale almost all of the components that made for a new commemorative portrait style. It told of the virtues of the subject, it depicted one deserving of immortal fame. It was consciously directed to the future, it was realistically rendered (and in contemporary costume to make it a piece of history), and it had a foundation in the authority of antiquity. But to make the "museum portrait" resonate with Peale's own generation, more was needed. That ineffable link to the eighteenth century found expression in the frame.

A classical source of origin is once again suggested in the form the frames took, although the inspiration for them came via a more circuitous route of transmittal and with slightly different connotations. Where the commemorative portrait of the Renaissance is often found framed with a rondel, as are the busts of Ghiberti's Gates of Paradise in Florence, here Peale adopted an oval. Not that oval framing in itself was anything new with Peale, either as a separate entity or painted in grisaille upon the canvas. When the oval is combined with other elements of design in the Peale frames, however, then it is something more than a trite essay. The moldings to the outer rectangular frame are light in proportion, and are carved with delicate strings of husks. The lightness, the carving, the oval are all so characteristic of the work of Robert Adam as to constitute something of a hallmark.[19]

The revolution in design that the Adam brothers ushered into England upon their return from prolonged study abroad in 1758 was all-pervasive, profoundly effecting virtually every category of arts and crafts. It was in full sway in England, during Peale's sojourn there, and it washed America like a "nor'easter" with the cessation of armed conflict. Homogeneity of style in all its constituent parts of interior furnishings and design was yet another characteristic of this, the neoclassical style. Americans knew the meaning of the museum portrait; they understood the rational thinking that went into its

17. Charles Coleman Sellers, *Charles Willson Peale with Patron and Populace: A Supplement to Portraits and Miniatures by Charles Willson Peale*, 59, 3, *Transactions of the American Philosophical Society* (Philadelphia: 1969), 9.

18. Saisselin, 8. Pope-Hennessy, 8, 30, 64, 72, 132.

19. Jules David Prown, "Style in American Art 1750–1800," in *American Art, 1750–1800: Towards Independence* (Boston: New York Graphic Society, 1976), contains some interesting observations on the differences between pre- and post-Revolutionary picture frames.

20. See Katherine McCook Knox, *The Sharples: Their Portraits of George Washington and His Contemporaries* (New Haven: Yale University Press, 1930); and John C. Milley, "Thoughts on the Attribution of Sharples Pastels," in *University Hospital Antiques Show Catalogue* (Philadelphia: 1975).

composition, and although the subjects were of quite diverse national origins, religious persuasions, and social standings, they were as one in this uniform presentation. It made "common sense," didn't it?

Peale's portrait collection grew in number to eighty-seven by 1795, when Philadelphia was the nation's capital, and by this time he had broadened the set of those deserving of his particular stamp of recognition to include those whose lives were devoted to the humanities, jurisprudence, and the sciences. But by this time, too, any comparison of artist and craftsman was fast becoming an archaic kind of thinking, as Americans were told more and more what "art" was all about and what special gifts of talent the artist possessed from birth. That sort of thinking was something Peale could never swallow wholeheartedly, insisting that painting was a teachable art requiring but diligence and perseverance to be mastered—a simplistic, even idealistic, point of view to be sure. And he proceeded to make his point through his own example and by siring one of America's dynasties of painters.

The Peale "museum portrait" takes center stage in the Independence National Historical Park's Portrait Gallery, accompanied there by yet a second and complementary collection of commemorative portraiture. Much less is known about its originator, James Sharples, an English pastelist. Sharples was attracted to Philadelphia in 1796–97, during his first visit to the United States, by the promise of a lucrative and concentrated business. What he intended as the ultimate disposition of his collection of American worthies is unknown, but the immediate purpose it served was income through copy work. One suspects that Sharples entertained a more lofty opinion of art and artists than did Peale, but we cannot be sure of that since very little in the way of records has been found concerning his personal traits.[20]

His wife, Ellen, penned a few cryptic comments about her husband, which tell us that he lacked Peale's perseverance. Although no record of a communication between Peale and Sharples survives, they were competitors in a way for much the same clientele. Despite the differences between their media, and even the diminutive size of a Sharples portrait ($7'' \times 9''$), the work of these artists has much in common. Each concentrated on the portrait bust, each ignored background in a commemorative portrait, and each approached his subject as objectively as possible. Sharples also adopted a uniform framing for his pictures, but this was probably done more for convenience of conveyance than for anything else.

The medium of chalk and the small size of a Sharples pastel lends to his work a sense of intimacy, which in Peale's oils is developed more as a result of his personal acquaintance with his subjects than through the format and medium he favored. Both men were masters at capturing the salient features of their sitters, an art Sharples studied through a concentration upon the profile image, a portrait form he employed with some frequency. Also of classical derivation, the profile was effective in conveying a realistic vision. The oblique projection of the body, with both shoulders seen, gave solidity to the figure and strengthened its sense of being true-to-life.

Sharples left Philadelphia in 1797 to resume his vagabond life, taking baggage, family, and pastels with him. Except for its exhibit in Bath, England, in 1802, when a catalogue of the contents was printed, the Sharples collection received little public notice until it was advertised for sale better than fifty years later. Appreciation of the collection was left to another day, although its ultimate fate was identical to that of Peale's portrait grouping.

The orientalist Ananda Coomarswamy wrote that "nothing can properly be called a 'sign' that is not significant of something other than itself, and for the sake of which it exists." As time advances our perspectives change; the values of this generation

are not necessarily those of the next; what was one era's symbol becomes obscure to the next. The significance, then, of something like the "museum portrait," once lost, can impel the painting's total destruction, or its neglect for a period of time. If the painting's meaning is rediscovered, the work may be reevaluated within the cultural context of its rediscovery.[21]

This situation obtained in the early nineteenth century. The frustration Peale experienced in his attempt to gain the approbation and appreciation of Congress for his museum, the strident cries of artists against apparently unappreciative patronage, America's harkening back to Greece for an architectural style that might best express its own self-confidence, the flirtations with utopian experiments, and Emerson's outpouring of transcendental thinking—all these and much more, were signs of restlessness, change, and uncertainty in the young nation.

Reason, or what was believed by those of Peale's generation to be that which gave order to everything, was challenged as not entirely reasonable. That everything had a place in the order of things became questionable. Man's passion was unpredictable. Human emotions dictate man's actions with little or no reasonableness of thought. What to do about slavery? What to do about states' rights? About foreign intervention? The stream of questions that presented themselves as a new century dawned was seemingly endless. The dilemma such questions presented to thinking people could hardly have been expected to affect the body politic until it manifested itself in some material, pecuniary, or personal way.

The surge of nineteenth-century industrialization and territorial expansion reoriented populist values. Sensationalism supplanted rational entertainment, and Peale's museum portrait couldn't compete with the carnival atmospheres of the new popular pastimes. In the era of the common man, "museum" to the masses became synonymous with "sideshow," a collection of anomalies and distortions of nature, not nature rationally interpreted. No metaphysical need of national magnitude was felt to commemorate the lives of those but recently deceased or still alive. The portraits were old-fashioned but certainly not sufficiently old to be venerated; and they were neither art nor within the purview of a modern artist's concerns. To newly-minted industrialists, art in the "grand manner" was culture, and that must be acquired—quickly.[22]

As Peter Marzio has succinctly stated, "America's fascination with art, stemmed from her lack of art." The early nineteenth century saw the beginning of the idealization of art. This trend paralleled the propagation of art through newly developed reproductive media. The simultaneous elevation and popularization of art spawned our treasure-laden museums and fostered a faith in art as an entity unto itself.[23]

The American museum movement and the development of aesthetics as a branch of philosophy were in great measure responsible for the resurgence of interest in our material past. Different sentiments—in the form of a bombastic spurt of nationalism— urged the preservation of Peale's collection of portraits. Success in the bogus War of 1812, and the return visit of the Marquis de Lafayette in 1824, have been recognized as catalysts, if not the turning points, of America's awakening to historic preservation. One of its earliest manifestations was a stream of publications dealing with the lives of leaders in the Revolutionary War, many of them illustrated with engravings taken from the portraits of Peale, Trumbull, Stuart, and others. Two good examples are John Sanderson's nine-volume work, *Biographies of the Signers of the Declaration of Independence* (1820–27), and Longacre and Herring's *The National Portrait Gallery of Distinguished Americans* (1834). By 1854, and the auctioning off of Peale's portrait collection, however, one suspects that it was more than nationalism that goaded the City of Philadelphia into its purchases at the sale. The whole country was in desperate need of a rallying point of some kind, some unifying purpose, some reminder of what the American Revolution was supposed to have achieved.

21. Ananda K. Coomaraswamy, *Christian and Oriental Philosophy of Art* (New York: Dover Publications, Inc., 1956), 64–65.

22. Wayne Craven, "The Grand Manner in Early Nineteenth Century American Painting: Borrowings from Antiquity, the Renaissance, and the Baroque," *American Art Journal* 11.2 (1979).

23. Peter C. Marzio, "The Forms of a Democratic Art," in *Papers on American Art*, ed. John C. Milley (Philadelphia: The Friends of Independence National Historical Park, 1976), 24.

24. Susanna Koethe Morikawa, "History of Portrait Collection," TS. Independence National Historical Park Papers, (Philadelphia: 1975).

25. Ralph Waldo Emerson, "Uses of Great Men," in *Representative Men: Seven lectures* (Philadelphia: David McKay, Publisher, n.d.), 7, 9.

The questions posed at the turn of the century, now made manifest, affected everyone. America had nurtured its own holocaust. It was in the 1860s in the aftermath of war, more than at any other time perhaps, that the commemorative portrait fulfilled its purpose as a symbol. Its multifold presence in the Assembly Room of Independence Hall, where the body of Abraham Lincoln lay in state, could not have gone unnoticed by many of the thousands who queued for twenty-four hours dumbfounded, incensed, at a loss to explain how such a senseless thing could have happened.

On 11 April 1872, the Select and Common Councils of Philadelphia decreed that "Independence Hall is hereby set apart forever, and appropriated exclusively to receive such furniture and equipments of the room as it originally contained in July, 1776, together with the portraits of such men of the revolution as by their presence or action served to give the building its historic renown, and forever endear it to the hearts of patriots." The Centennial celebrations of 1876 helped a great deal in unifying Americans in a common cause of achievement and resulted in an intense interest in our national heritage. Again the portraits were paraded with all the patriotic oratory the occasion seemed to require.[24]

The city's decree was a license to collect for a good purpose if there ever was one. And collect they did—everything from a lock of Washington's hair to newly manufactured glass Liberty Bells. The accomplishments of the Centennial celebration, however, were considerable. One was the acquisition of forty-five of the portraits from the original collection of James Sharples. The collection had miraculously survived virtually intact. When it was offered for sale in Baltimore, a selection was purchased for Independence Hall.

The Councils' ordinance of 1872 had its negative effect, however, since it gave to city officials tremendous freedom in its acquisitions mandate. There were few guidelines placed upon the National Museum other than the charge to acquire images of great men, regardless of artistic or historic value. From the Centennial into the first quarter of the twentieth century this practice resulted in the admission of copies of portraits, and of some portraits of subjects having the most tenuous of historical associations with either the city or the Revolution. What matter if a painting was a life portrait or not? After all, it was the subject that counted most, and, as long as the figure was recognizable, what more could be wanted?

Our thinking on that score has been very much turned around, thanks to the coordinated contributions of scholars of several disciplines. Countless writers from antiquity to the present have attested to the efficacy of a life portrait, the truthfulness of which is sapped dry in copy work. One could not gain much insight into the character of "Old Hickory" from David Rent Etter's copied likeness. Andrew Jackson was a firespitting, headstrong, argumentative, stubborn, and crafty individual—one capable of beheading that "Hydra of corruption," the Second Bank of the United States. If he looked as we see him in the Etter portrait, however, we would have to conclude that he was a timid soul and quite the opposite in character. How insipid this portrait becomes when contrasted with that of Timothy Matlack, the last portrait that Peale painted and a tour de force in character study. Matlack, once a firebrand of a man, is now racked by old age, but his tenaciousness is revealed in the features and the way Peale has so understandingly preserved them for us.

In his essay "Uses of Great Men," Ralph Waldo Emerson wrote: "The world is upheld by the veracity of good men; they make the earth wholesome—We call our children and our lands by their names. Their names are wrought into the words of language, their works and effigies are in our houses, and every circumstance of the day recalls an anecdote of them … the great are near; we know them at sight."[25]

And so it is that the images, the character, the work of sacrifice and reward on behalf of human liberties by persons like Washington, Jefferson, and Adams—given faults of character each and every one may have had—have become graven in our minds through symbols of them in the form of portraiture. In the introduction to a catalog of an exhibition of portraits of these subjects, Mitchell Wilder writes "the years have added to their reputation as revolutionaries, yet is most unlikely that our heroic patriots saw themselves in any greater role than that of outraged citizens." If such was the case it brings them down to our level, and while we might protest the absence of portraits of the common man, we overlook the purposefulness that someone like Peale had in mind. And, if we choose to look at decorative objects—the chairs, the teapots, the coverlets, the portraits—as either "art" or artful, it could do no less than contribute to our rational entertainment.[26]

26. James Thomas Flexner, *The Faces of Liberty* (New York: Clarkson N. Potter, Inc., 1975), preface.

The History of
the Independence Hall
Portrait Collection

by Doris Devine Fanelli

Chapter I

Pre-1850:
Memory, History, and Portraiture

* I am grateful to Kenneth L. Ames and to Herbert Bass for their perceptive readings of this section.

1. By the term common history, I am referring to a consensual view of the past held by the populace. This view may or may not have a basis in fact. Thus, memory and oral tradition play a significant role in this form of history. For a discussion of the interplay of memory and history, see David Thelen, "Memory and American History," as well as David Lowenthal, "The Timeless Past: Some Anglo-American Historical Preconceptions," in *Journal of American History* 75 (March 1989):1117–29; 1263–79; Steven Knapp, "Collective Memory and the Actual Past,"; Pierre Nora, "Between Memory and History: *Les Lieux de Mémoire*," *Representations* 26 (Spring 1989):123–49; 7–25; and Michael Kammen, *Mystic Chords of Memory: The Transformation of Tradition in American Culture* (New York: Alfred A. Knopf, 1991).

Between 1800 and 1850, the City of Philadelphia acquired four portraits that became the roots from which Independence National Historical Park's paintings collection grew: *Lafayette*, by Thomas Sully; *William Penn*, by Henry Inman; *Stephen Decatur*, by Gilbert Stuart; and *George Washington*, by James Peale. Four paintings in fifty years is a modest acquisition rate by any standards. However, these paintings are merely the surviving records of a consistent effort by early-nineteenth-century Philadelphians to describe their past.*

During that time, Philadelphians were developing an awareness of their unique public memory and history. This was in part a reaction to the growing temporal distance from their city's establishment and its role in the American Revolution. The city's increasingly diversified population and its participation in larger political and industrial arenas also contributed to the needs of some Philadelphians to describe themselves in terms of their heritage. One mechanism for coping with this change was the development of a common history, one that combined factual knowledge with memory and oral tradition. This common or popular history was fostered by the establishment of historical societies, the orchestration of civic pageants and the publication of heroes' biographies and memoirs. Furthermore, a unified view of the past was reified by a growing collection of artifacts that included architecture, relics, monuments, and works of fine and decorative arts.[1]

This chapter describes how Philadelphians employed public portraiture to define their values and describe their past. While there is nothing unique about the commission of commemorative art, Philadelphians adapted this tradition to their situation. The four portraits listed above offer little documentary information about their subjects. Rather, the subjects chosen for commemoration, the images, and their manner of display disclose more about the patrons and their times. The men who commissioned and installed the paintings resolved social concerns by their manipulation of history through their designs of the portraits. In the process, the patrons developed criteria for portraiture in the new republic that were congruent with their notions of historical authenticity and that accommodated both memory and history. The se criteria became the standards for the admission of subsequent works to the Independence Hall collection.

The circumstances of the *Lafayette* and *William Penn* commissions are stressed because they were early private commissions for a public space. Their placement in the old Pennsylvania State House contributed to that structure's transition from a government office building to a public shrine called Independence Hall. Together, the paintings and the building promulgated a view of the past that became publicly accepted as Philadelphia's history. Although they were not created for display in Independence Hall, the acquisitions of *Stephen Decatur* and *George Washington* demonstrate the continued application of criteria for public portraiture.

In order to appreciate the paintings' perceived role as historical records, this chapter also describes some of the less permanent celebratory activities which contributed to the enshrinement of Independence Hall. As the structure transcended the

mundane and became a public shrine, paintings and other material guideposts that proclaimed the building's status through their explication of history became a necessity.

The Colonial Commissions

From its inception the Pennsylvania State House, today known as Independence Hall, was, through its materials, design, and siting, meant to express the power and wealth of the colonial government. Built between 1735 and 1752, the building was the meeting place of the Pennsylvania Supreme Court, the Governor's Council, and the Pennsylvania Assembly. Large and elegantly appointed, it was also an object of travelers' attention. The Swedish botanist Peter Kalm aptly described the structure as "the grandest ornament in town."[2]

The site of daily government routine, Independence Hall was also the focus of civic celebrations. On one such occasion, the provincial governor commemorated King George II's birthday with "a grand Entertainment to near 150 Gentlemen and Ladies, at the State House, which concluded with a Ball. The Day ended with Illuminations, bonfires, and other usual demonstrations of Joy."[3]

Activities outside and near Independence Hall also called it to public attention. Parades began or concluded at the building. In the rear yard, volunteer militia drilled, and political figures made speeches there. In 1784, Samuel Vaughan and William Bartram began collaboration on an elaborate landscaping of the grounds that would make Independence Hall even more a center of attraction. Ten years later, Charles Willson Peale moved his museum into the neighboring American Philosophical Society and quartered his menagerie behind the building.

In time, separate structures for county government and courts were erected, flanking Independence Hall. From 1790 to 1800, city, county, state, and federal governments all headquartered on the square. The people of Philadelphia came to regard the buildings as the formal seat of their government and the square as a civic center where their government was informally supported or challenged.[4]

Records of portraits in Independence Hall during the colonial era are scanty. A bound volume of drawings of the interiors at Stoke Park, the Penn family estate in Buckinghamshire, England, includes portraits of American subjects by American artists such as Gustavus Hesselius's portraits of Leni-Lenape chiefs Lapowinsa and Tishcohan. While these and portraits of the Penn family might once have hung in Independence Hall, there is no firm evidence that they ever did so. The Penns did commission portraits of William III, Queen Mary, Queen Anne and the Georges I, II, and III for display in the provincial capitol in 1761 or 1762. However, tensions between the colony and Great Britain so worsened during those years that the Penn family, to avoid untoward incidents, decided against sending the paintings to America.[5]

The American revolution occasioned the commissioning of the first republican portraits for Independence Hall. Aware of the

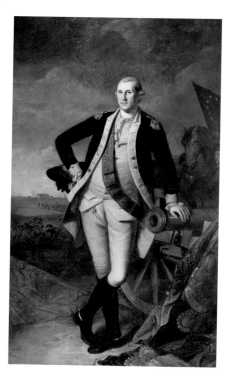

Illustration 1

2. Adolph B. Benson, ed., *Peter Kalm's Travels in North America* 1 (New York: Wilson-Crickson, 1937), 25.

3. *Pennsylvania Gazette*, 2 November 1738, 3, col. 1 (Microfilm, APS).

4. Staff, "Historic Grounds Report on State House Yard," (INHP, 1959, Mimeographed), 6. See also Charles Coleman Sellers, *Mr. Peale's Museum: Charles Willson Peale and The First Popular Museum of Natural Science and Art* (New York: Norton, 1980) for a description of Peale's life on the State House square.

5. Charles G. Dorman, "Furnishings Plan for the Second Floor of Independence Hall," Part D (INHP, 1971, Mimeographed), 27, 30. The volume of drawings, made in 1830, is now the property of HSP. Philadelphian George Harrison purchased the royal portraits at a London sale of Penn family effects and presented them to the city in 1873. They were displayed in the National Museum in Independence Hall during the Centennial. They are now the property of PAFA.

Illustration 1. *George Washington at Princeton* by Charles Willson Peale (1779). Oil on canvas, Courtesy of the Pennsylvania Academy of the Fine Arts, Philadelphia. Gift of Maria McKean Allen and Phoebe Warren Downes through the bequest of their mother, Elizabeth Wharton McKean.

6. *Minutes of the Supreme Executive Council of Pennsylvania From Its Organization to the Termination of the Revolution* (Harrisburg: published by the State, 1852; printed by Theo Fenn & Co.) 11:671–72.

7. Dorman, "Furnishings Plan," 87–88. For some reason, Peale regained custody of the Washington portrait. He displayed it in his museum and made many replicas of it. The portrait was sold in the 1854 Peale sale and today it is in the collection of PAFA. President of the Executive Council to Charles Willson Peale, 12 June 1780, Records of the Secretary to the Supreme Executive Council, Box 3036, Division of Public Records, Harrisburg (1780) and *Charles Willson Peale and His World*, p. 57. Peale also created a three-quarter-length mezzotint version of the painting that further disseminated the image. For a study of the growth of Washington's popularity, dating from his appointment as commander-in-chief, see Barry Schwartz, *George Washington: The Making of an American Symbol* (New York: The Free Press; London, Collier Macmillan, 1987).

Illustration 2. *Conrad Alexandre Gérard* by Charles Willson Peale (1779). Oil on canvas. Also illustrated in catalog. Independence National Historical Park.

inspirational and didactic function of public portraiture, the Supreme Executive Council of Pennsylvania commissioned Charles Willson Peale to paint a likeness of George Washington, commander-in-chief of the Continental Forces, to commemorate the victories at Trenton and Princeton *(Illustration 1)*. In the minutes for 18 January 1779, the council resolved:

> **Whereas** The wisest, freest *[sic]*, & bravest nations, in the most virtuous times have endeavored to perpetuate the memory of those who have rendered their Country distinguished services, by preserving their resemblances in Statues & Paintings; This Council, Deeply sensible how much the liberty, safety, & happiness of America in General, & Pennsylvania in particular, is owing to His Excell'y General Washington & the brave men under his Command, do resolve, That His Excell'y Gen'l Washington be requested to permit this Council to place his Portrait in the Council Chamber, not only as a mark of the great respect which they bear to His Excellency, but that the contemplation of it may excite others to tread in the same glorious & disinterested Steps which lead to public happiness and private honor, And that the President be desired to wait on his Excellency the General, with the above request, and if granted to inquire when & where it will be most agreeable to him for Mr. Peale to attend him.[6]

The above minute lays the foundation of a definition of republican portraiture that carried through to the formation of Independence Park's collection. It defines the appropriate object for public veneration as one who selflessly works for the common good, with no expectation of material gain. Contemplation of the painting should inspire the viewer to emulate its subject's character. In the actual painting, Peale helps the viewer identify with the remote Washington by clothing him in contemporary attire and picturing him in a relaxed posture, his direct gaze engaging the viewer.[7]

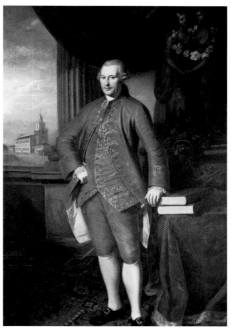

Illustration 2

The Peale painting of Washington, hung behind the Speaker's chair in Independence Hall's Assembly Room, helped set criteria of topic, quality, style, and mode of display of public art in Philadelphia. A second commission, eight months later, further verifies the importance of the Washington portrait. Having seen Peale's full-length *tour de force* of Washington, the Continental Congress commissioned the artist to paint a similar-sized portrait of Conrad Alexandre Gérard, minister of France. The portrait *(Illustration 2)* seems to have been intended as a conciliatory gesture to France after Gérard, following a summer of heated debate over the propriety of the alliance with France, announced his return to his country for "reasons of health." Composed in the grand manner, the painting contains, in the rear ground, a depiction of Independence Hall's steeple; and, in the mid-ground above the subject's left shoulder, allegorical figures of America and France, arms entwined and linked by a garland. Congress had presumably intended that the painting be exhibited in the Assembly Room along with the Washington portrait. However, while Congress authorized payment to Peale in 1780, the transaction was never completed. Peale kept the painting, later

putting it in the Peale Museum. It did not become public property until the City of Philadelphia purchased it in 1854.[8]

In size, subject, and composition, the *Gérard* prefigured the *Lafayette*, painted forty-seven years later. Both full length works featured French supporters of the American Revolution, with Independence Hall in the background. The paintings' similarities are not accidental. Thomas Sully, the creator of *Lafayette*, had access to the Peale collections in Independence Hall. The *Gérard*, however, celebrates the alliance of two powers against a mutual enemy; the *Lafayette*, depicting the Frenchman's return visit to America forty-nine years after the Revolution, exalts republican virtue.

Beginning in the last quarter of the eighteenth century, the Assembly Room was occasionally used for art exhibitions when government was not in session. These temporary exhibitions helped to establish the building as a site of genteel public recreation. From 1783 to 1785, the artist Robert Edge Pine exhibited his paintings, which included a portrait of General Washington and a history painting of the commander-in-chief resigning his commission to Congress. That depiction of an historic event hanging in the very room in which the event occurred may have been the first such evocative exhibit in America.[9]

Additional tenants sharpened public focus on Independence Hall as a site of "rational entertainment." The American Academy of Painting, Sculpture and Architecture held the first group art exhibit in America in the Assembly Room in 1795. Called "The Columbianum," the exhibit failed to garner support for academic art. Charles Willson Peale moved his museum to the second floor of Independence Hall in 1802 and in 1804, his son Rembrandt briefly kept his studio in the Assembly Room. Like Pine, the elder Peale used the building's history as a milieu for his paintings. Among the items displayed in the Peale museum were the portraits of "noted worthies," heroes of the Revolution and founders of American government. The museum remained in Independence Hall until 1828 and its visitors came to associate those portraits with the building.[10]

When the federal government removed to Washington and the state government moved to Lancaster in 1800, more space became available on Independence Square for municipal offices. On 13 March 1815, control and use of Independence Hall officially passed to the City and County of Philadelphia, though ownership remained with the state. Between 11 April 1816, when the city began negotiations for the purchase of the building, and 29 June 1818, when the negotiations were completed, much of the original paneling in the Assembly Room was removed as part of a "modernization" program, and pieces of it were sold as relics. Public outcry ensued when this practice was discovered. In 1816 the Democratic–Republican candidate for county commissioner, John Thompson, may have had the first preservationist plank in an American political campaign platform. Thompson promised to oppose defacement of Independence Hall if elected. Artist John Trumbull, whose *Signing of the Declaration of Independence* was considered the definitive painting on the topic, noted dolefully that "the spirit of innovation laid unhallowed hands upon [Independence Hall] and violated its venerable walls by 'modern improvement' as it is called."[11]

These expressions of outrage at the alteration of a material link to the past reveal the power of artifacts to evoke an awareness of history and to achieve a status that transcends ordinary usage. David Lowenthal has noted that "recognizing the historicity of artifacts transforms both their significance and their appearance." It was about the time of the paneling episode that people began calling the Assembly Room the Hall of Independence, a name they later applied to the entire building.[12]

The remodeling of the Assembly Room contributed to the growing fashion in the city to collect and document local history. Those seized by an interest in Philadelphia's past collected material bits of it as well as written records. Memory and long-established

8. *Pennsylvania Gazette*, 27 October 1779, 1, col. 2 quoted an extract from the Journal of Congress, 3 September 1779, which **"Resolved** That the Committee do request Mr. Gerard to sit for his picture before he leaves this city, and that the same be placed in the Council Chamber of the United States." MS note taken by David H. Wallace, 9 June 1958, in Painting folder S. N. 13.083, INHP. The Peale painting is an oil on canvas, 96″ × 60″. For a discussion of the circumstances of the painting, see Miller, *Papers*, 1:330–31; 634–35. See also Sellers, *Portraits and Miniatures*, 86; Richardson, *CWP and His World*, 58. The portraits of two past presidents of the Supreme Executive Council, Benjamin Franklin and Thomas Wharton, hung in the Executive Council Chamber on the second floor of Independence Hall. The Franklin bequest is discussed in Albert P. Brubaker, M. D., "The Martin Portraits of Franklin," *PMHB* 56 (1932): 254. According to Brubaker, the portrait Franklin gave was a replica of the original David Martin portrait, which was commissioned and owned by his friend, Robert Alexander. The replica is now the property of PAFA. The Wharton portrait by Peale also remained in the artist's possession. Eventually the Wharton family purchased it at the Peale sale in 1854. See Sellers, *Portraits and Miniatures*, 246–47.

9. Robert Hunter diary, 2, 10 October 1785, Huntington Library. William Dunlap, *A History of the Rise and Progress of The Arts of Design in the United States* (1834, reprint, New York: Dover Publications, 1969), 316–20.

10. Dunlap, *History*, 418–19. Carrie H. Scheflow, "Rembrandt Peale: A Chronology," PMHB 110 (1986): 138. Governor Thomas McKean, "Resolution Authorising Charles Willin [*sic*] Peale to remove his Museum into the east end of the State House in Philadelphia &tc." Wednesday, 17 March 1802 as published in *Pennsylvania Archives*, 9th ser., 3, (1817), n.p. C.W. Peale to Samuel Wetheral, 24 March 1802, CWP Letterbook 3: 138–39, published in *Peale Papers*, 2.1:418.

11. *Democratic Press*, October 1816, Platt, "Structures," 86. John Trumbull to his wife, 9 January 1819, Trumbull Papers, Library of Congress as quoted in Lee H. Nelson, "Restoration in Independence Hall: a Continuum of Historic Preservation," *The Magazine Antiques* 90 (July 1966):66.

12. David Lowenthal, "Age and Artifact: Dilemmas of Appreciation," D. W. Meinig, ed., *The Interpretation of Ordinary Landscapes: Geographical Essays* (New York and Oxford: Oxford University Press, 1979), 109. An equally provocative discussion of the development of popular history is Michael Kammen, *A Season of Youth: The American Revolution and the Historical Imagination* (New York: Alfred A. Knopf, 1978) in which the author describes the first quarter of the nineteenth century as a period of tentative selection of traditions and models.

13. Marc H. Miller, in "Lafayette's Farewell Tour and American Art," Stanley J. Idzerda et al., *Lafayette, Hero of two Worlds: The Art and Pageantry of His Farewell Tour of America, 1824–25* (Hanover and London: The Queens Museum, 1989), credits French pageantry as the inspiration for American celebrative art. Specifically, Miller cites Congress's commission of Charles Willson Peale to create a triumphal arch in honor of the birth of the dauphin in October 1782 (p. 96). This Franco-centric view ignores the long history of parades, celebrations, and monarchical pageantry in America prior to that date, as well as Peale's personal unfamiliarity with French culture. While the French minister, Luzerne, instituted the construction of the arch, Peale was no stranger to the idea, and the resultant work was probably a collaboration. The incident is more fully described in Charles Coleman Sellers, *Charles Willson Peale* (New York: Charles Scribner's Sons, 1969), 190. Sellers notes that one of the inscriptions on the arch was "Lud. XVI. Fr. and Nav. Rex defens Liberatis" ("Louis XVI, King of France and Navarre, defender of Liberty").

14. Extracts from the Minutes of the Select Council, Thomas Bradford, Jr., clerk, 8 July 1824; authorization to draw money from appropriation 21, 29 July 1824; resolution to invite Lafayette, 31 July 1824; in Select Council, 29 July 1824, HSP, Lafayette file AM 3651, folder 1. Minutes of the Committee of Arrangement, 18 August 1824, discuss and approve the offers by the three Peales; John M. Scott to Rembrandt Peale, 19 August 1824; John M. Scott to C. W. Peale, 19 August 1824. HSP, Lafayette file, AM3651, folder 2. The significance of the Union Canal Company reference will be discussed in the text below. For a discussion of the *Washington*, known as the *Patriae Pater* portrait, see Carol E. Hevner, "Rembrandt Peale's Life in Art," 6; Paul J. Staiti, "Rembrandt Peale on Art," 93 and Carrie H. Scheflow, "Rembrandt Peale: a Chronology," 129–80, *PMHB* 110.1 (January 1986).

15. HSP, Subscription list, 20 August 1824, Lafayette file AM3651.

traditions were important to this documentation process. The return visit of the Marquis de Lafayette in 1824 provided the opportunity to fuse these elements in the form of a commemorative portrait.

Lafayette, The First Private Subscription

Lafayette, the French hero of the American Revolution, the friend and favorite of Washington, and the personification of liberty, made a farewell tour of this country from 15 August 1824 to 6 September 1825. The journey of Lafayette, one of the last living links to the American Revolution, inspired tremendous outpourings of republican celebrations and commemorations.

Of all the cities on Lafayette's itinerary, Philadelphia orchestrated the most elaborate welcome. The city greeted Lafayette with sumptuous pageantry that included a parade, a reception in the Hall of Independence, and a ball. These festivities drew upon traditions of monarchical pageantry that had been practiced in America as well as in Europe and the British Isles. Philadelphians easily adapted the vast repertoire of artistic expressions in those traditions, including flags, banners, arches, tableaux, and transparencies, to a celebration of republican virtue. Titles such as "defender of Liberty," after all, could be applied as well to a revolutionary as to a king. But, while monarchical pageants, honoring a ruler, reminded subjects of their distance from the king, republican celebrations stressed the unity of citizen and leader. They elevated virtue rather than individuals; and if persons were featured, it was for their republican qualities. In stressing the virtues of Lafayette—his honor, fortitude, loyalty, and independence, the celebrations also pointed to the perfectibility of man and of human society. This identification of the populace with the honored individual distinguished republican festivities during Lafayette's visit. The preparation for the Lafayette celebration involved so many Philadelphians that their separate roles as performers and audience blurred.[13]

From the outset, the use of works of art was seen as essential to the celebration's success. Architect and engineer William Strickland was designated the reception's artistic coordinator. The Peale family enthusiastically offered to lend selected paintings for the decoration of the Assembly Room. Charles Willson offered a choice of the portraits in his museum, James his *Benjamin Franklin*, and Rembrandt his recently completed portrait of George Washington, which he believed to be the one authentic likeness of the first president. Regarding portraits of his revolutionary compatriots a fitting backdrop for the reception for Lafayette, the committee accepted the offers.[14]

Lafayette's return led directly to the first acquisition in the city of Philadelphia's portrait collection, when members of the Committee of Arrangement began a subscription for a portrait of the French general. The subscription list, dated 20 August 1824, states an intention to have "a correct resemblance of the excellent and early friend of their country … a Full length Portrait of His Excellency Major General La Fayette to be painted by Mr. [Thomas] Sully." The subscribers wanted the portrait completed before Lafayette's arrival and used "as circumstances may require during the visit of the General to the City of Philadelphia and afterwards to be deposited in the Building in which the Declaration of Independence [sic] was signed." Sully, however, did not even begin work on the painting until after Lafayette's departure from the city. Instead of providing an icon for the historic visit, Sully created a record of that visit by incorporating references to the parade and the reception into his painting.[15]

In this record Sully employed William Strickland's triumphal arch as a background for the figure of Lafayette. The Committee of Arrangement had instructed Strickland to design such a structure to stand in front of Independence Hall. What Strickland

developed was an elaborate and well-crafted stage prop, executed in the Chestnut Street Theater by scene painters. Based upon the arch erected for Septimus Severus in Rome, the finished structure was thirty feet high, forty-five feet wide, and twelve feet deep. Sully painted the city's coat of arms and allegorical figures of *Liberty, Victory, Independence,* and *Plenty* for it. Sculptor William Rush contributed to the commanding presence of the edifice by adding carvings of *Justice* and *Wisdom.* The arch stood west of Independence Hall in Chestnut Street.[16]

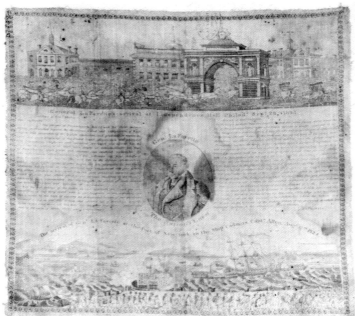

Illustration 3

Illustration 4

Several representations of the arch survive, the best being a printed linen handkerchief engraved by the Germantown Print Works *(Illustration 3).* This souvenir captures the emotional moment at a few minutes before 2 P.M. on Tuesday, 24 September 1824 when Lafayette arrived at the arch. The general's mounted military escort of several local militia units rides across the foreground of the view. A celebratory balloon is in ascent in the southern sky. Crowds throng the yard in front of Independence Hall and its flanking buildings, and one can almost hear them roar as Lafayette arrives in a white coach with six horses.

It was the instant immediately following, when Lafayette alighted from the coach and stood beneath the arch, that Thomas Sully intended to capture in his full-length portrait of Lafayette. Several surviving drawings show the development of the painting. Sully made a small pen-and-wash study in 1825, which depicts Lafayette standing beneath the arch *(Illustration 4).* This composition was an emblem in which the figures on the arch—a dog, an Indian princess, and an eagle—symbolized Lafayette's fidelity to America during the Revolution. Lafayette stands beneath the arch dressed in the traveling costume that he wore throughout the farewell tour, a dark suit with cape. He carries a top hat, gloves, and a walking stick. Through the arch in the rear ground are the cheering crowd and a mounted cavalryman before the much foreshortened northeast corner of Independence Hall. Groups of figures are in each of the three windows and also on the galleried roof of the building where a large flag flies from the parapet.[17]

16. HSP, Minutes of the Committee of Arrangement, 18 August 1824 and 20 August 1824, Lafayette file AM3651, folder 1. A full description of the arch is in Robert Waln, Jr., *Life of the Marquis de Lafayette,* 3rd ed. (Philadelphia: J.P. Ayres, 1826), 375. Waln was a subscriber to the painting. Rush's two figures, *Wisdom* and *Justice,* survive and are in the collections of the Philadelphia Museum of Art. The Sully *Coat of Arms* is now part of the INHP collection.

17. Marc H. Miller, "The Farewell Tour and American Art," dates the drawing to 1825; ibid., 150, 154. However, Monroe H. Fabian, *Mr. Sully, Portrait Painter: The Works of Thomas Sully (1783–1872),* an exhibition for the National Portrait Gallery (City of Washington: Smithsonian Institution Press, 1983), 78, number 36, dates it to 1824 or 1825. Since there is no evidence to the contrary, this essay employs Fabian's dating.

Illustration 3. Souvenir of Lafayette's visit by Germantown Print Works (1824). Ink on linen. Independence National Historical Park.

Illustration 4. *Lafayette* by Thomas Sully (1824–25). Pen and wash on paper. Courtesy of the collection of Miss Elizabeth Feld.

18. Sully noted the oil study in his register under 16 January 1826. The study descended in the Sully family and is presently in the collection of Lafayette College, Easton, Pennsylvania. The accuracy of Lafayette's costume is verified by the many depictions made of him during the farewell tour. Illustration 5 demonstrates Sully's practice of offering his patrons a choice of compositions (Fabian, 19). For some years, this drawing was misattributed to Samuel F. B. Morse.

19. J. S. Lewis et al. to General Lafayette, 2 October 1824, Lafayette file MSS, folder 8, HSP. Thomas Sully, "Recollections of an Old Painter," *Hours at Home*, 74, as quoted in Monroe Fabian, 78. The head study is signed and dated by Sully and is #1019 in Biddle and Fielding, 203–04. It is privately owned.

20. Miller, 150.

Illustration 5. *Lafayette*, double view by Thomas Sully (circa 1824–25). Pen and wash on paper. Courtesy of the National Gallery of Art, Washington, D.C. The John Davis Hatch Collection.

Illustration 6. *Lafayette* by Thomas Sully (1825). Oil on canvas. Courtesy of Hirschl & Adler Galleries, New York.

Illustration 7. *Lafayette* by Thomas Sully (1825–26). Oil on canvas. Courtesy of the Kirby Collection of Historical Paintings, Lafayette College, Easton, Pennsylvania.

Illustration 8. *Lafayette* by Thomas Sully (1826). Oil on canvas. Also illustrated in catalog. Independence National Historical Park.

Illustration 5

Illustration 6

In the final oil portrait, Sully eliminated the allegorical figures, and the pier of the arch is simply a mass in shadow behind the subject. As the composition progressed from sketches through a small oil study to the final portrait *(Illustrations 5, 6, 7, and 8)*, Sully changed the posture of his subject to increase his mass, allowing the other elements to recede further into the background. In the final painting, Lafayette is the topic, not an element in competition with allegorical figures and a busy street scene.[18]

Although some of his subjects made themselves available for many sittings, Sully appears to have had Lafayette for only one, and the artist had to travel to Washington, D.C. for that. On that visit, Sully sketched Lafayette's head from life *(Illustration 6)*. This sketch justified Sully's reputation for flattering portrayals. In the sketch, Lafayette is a man in his middle years but without the facial lines and graying hair associated with aging. Lafayette's dark toupee Sully depicts as close-cropped natural hair curling softly over his forehead in popular neo-classical fashion.[19]

Marc Miller comments on Sully's "classical idealization" of Lafayette, his deft correction of nature into a facial composition based upon academic standards. However, the artist's portrayal of Lafayette as a man much younger than his sixty-seven years was as much an accommodation of memory to fact as it was evidence of Sully's adaptation to neo-classicism. In the portrait, Philadelphians honored their memory of Lafayette as a young, vigorous man who fought for America's independence.[20]

Illustration 7 **Illustration 8**

In *Lafayette*, Thomas Sully incorporates the criteria for public portraiture in Independence Hall that were established by Charles Willson Peale's *Washington*: direct gaze, relaxed posture, and contemporary attire. The artist also observes the neo-classical emphasis upon youth and virility. Lafayette is made as ageless as the gods; he exists in a dimension where time and its limitations are transcended. Sully fashioned a version of the past from fact and fantasy. Through his artistry, he combined the memory of the young Revolutionary hero with a record of Lafayette's return fifty years after the war.[21]

Sully was interested in using his full-length portrait of Lafayette to promote his artistic skills before an audience of potential patrons. He periodically exhibited the painting in the Pennsylvania Academy of the Fine Arts' annual salons as well as in Independence Hall until about 1848. By then, the Assembly Room was taking on the appearance of a shrine. Sully's painting was an important unit of the display there.[22]

By the mid-nineteenth century, the awareness of Sully's artistic liberties taken with Lafayette's appearance had dimmed. The painting assumed authority for the historical event it portrayed. No records indicate that viewers of the painting were troubled by the disparity between the Frenchman's portrayal by Sully and his actual appearance in 1824. Thus memory was subsumed in the larger category of history and the portrait became regarded as a factual document.

The William Penn Society's Gift

In 1826, the Society for the Commemoration of the Landing of William Penn decided to commission a likeness of Pennsylvania's founder. Since many of the Society's members were also subscribers to the Lafayette painting and since they intended that the new painting would hang side-by-side with the *Lafayette* in the Assembly Room, their choice of Sully as the painter might have been expected. And, indeed, in 1826 Sully was negotiating with the Society. In the end, however, it was not Thomas Sully, but Henry Inman, a striving artist from New York, who won the Penn commission.

Inman's portrait of Penn is but one of many influenced by Benjamin West's portrayal of Penn a half century earlier in William *Penn's Treaty With The Indians When He Founded the Province of Pennsylvania in North America (Illustration 9)*. That famous painting depicts Penn and a group of men costumed as Quakers and merchants standing with a group of Native Americans. There is a large elm tree in the right midground; to the left is the Delaware River. The focus of attention of the assembled groups is a bolt of fabric that one of the Europeans has unrolled for the Native Americans to examine. From the actions of the figures, the barter item, and the painting's title, the viewer is to assume that negotiation of a treaty consenting to the conveyance of land for Penn's colony is underway.[23]

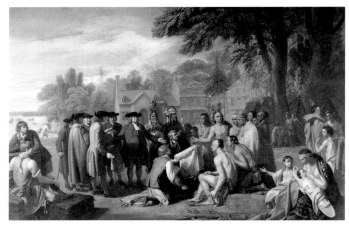

Illustration 9

The West painting was commissioned in 1770 or 1771 by William Penn's son, Thomas, quite possibly with the aim of using it to restore favor with the inhabitants of the colony. Thomas Penn's proprietorship had been marred by greed and treachery, the

21. For a discussion of the impact of an "awareness of history and decay" on objects, see David Lowenthal, "Age and Artifact," 108. See also David Lowenthal, *The Past Is A Foreign Country* (Cambridge: Cambridge University Press, 1985), 108 et seq.

22. There was subsequent confusion about the ownership of the Lafayette portrait due to its exhibition in both Independence Hall and the Pennsylvania Academy of the Fine Arts from the time of its purchase until 1848 when it returned permanently to the Assembly Room. However, the primary sources leave no doubt that Independence Hall was its intended repository. The threads of this issue are drawn together in "Notes on the Provenance," T.S. in Lafayette folder, INHP. No author is given. "Minutes of the Committee on City Property, 13 June 1836–23 January 1837; 25 July 1836," City Archives as transcribed to notecard file, INHP.

23. In 1851, Joseph Harrison purchased the painting from Granville Penn's estate and brought it to Philadelphia. The painting is presently in the PAFA collection.

24. Ann Uhry Abrams advances this interpretation of the painting in "Benjamin West's Documentation of Colonial History: *William Penn's Treaty With The Indians*," *Art Bulletin* 64 (March, 1982):61–68. See also Abrams, *The Valiant Hero: Benjamin West and Grand Style History Painting* (Washington D.C.: Smithsonian Institution Press, 1985), 192–95.

25. Abrams, 60. Ellen Starr Brinton, "Benjamin West's Painting of Penn's Treaty with the Indians," *Bulletin of the Friends Historical Association* 30 (Autumn 1941):99, provides a history of the painting's dissemination in other media. Brinton notes that she found no record of a treaty. Frederick B. Tolles, "The Culture of Early Pennsylvania," *PMHB* 81 (April 1957):119, also negates the single treaty theory. Likewise, Paul A. Wallace in *Pennsylvania, Seed of A Nation* (New York and Evanston: Harper and Row, 1962) discounts the treaty and the Euro-centric view of the incident, which ignores Native American concepts of property ownership and negotiation. William H. Treuttner furthers Wallace's ideas in "Reinterpreting Images of Westward Expansion, 1820–1920," *The Magazine Antiques* 139.3 (March 1991):542–55 and cites West's painting as an example of the use of art to glorify subjugation and colonization.

Illustration 9. *Penn's Treaty With the Indians* by Benjamin West (1771). Oil on canvas. Courtesy of the Pennsylvania Academy of the Fine Arts, Philadelphia. Gift of Mrs. Sarah Harrison (The Joseph Harrison, Jr. Collection).

26. HSP, Roberts Vaux Papers. Vaux was involved in many causes including the public school system, Eastern State Penitentiary, and the abolitionist movement. See also Nicholas B. Wainwright, in Russell F. Weigley, ed., *Philadelphia: A 300-Year History* (New York and London: W.W. Norton, 1982), 292, 297–98; John Fanning Watson, *Annals of Philadelphia and Pennsylvania in the Olden Time* (Philadelphia: 1830), 3:414; Roberts Vaux to Reuben Haines, Third month 15, 1818, Robert Haines Collection, Quaker Collection, Haverford College Library; HSP, Cadwalader Collection, Thomas Cadwalader to Roberts Vaux, 6 September 1820 and Roberts Vaux to Thomas Cadwalader, 10 September 1820, on same sheet.

27. Richard Peters to Roberts Vaux, 6 September 1825 cannot comprehend Vaux's doubt. Peters's uncle, Richard Peters, was secretary to the Penns. The younger Peters based his certainty of the treaty upon a childhood visit to Shackamaxon and his knowledge that Indian relics were recovered at the site. Peters again wrote to Vaux on 3 November 1825 and on 27 March 1826 with the corroboration of friends. HSP, Peters Papers, v. 12. Vaux's paper was published in *Memoirs of the Historical Society of Pennsylvania 1* (Philadelphia: M'Carty and Davis, 1826). He read his paper before the newly established society on 19 September 1825. In volume 3 of *Memoirs* (1834), J.F. Watson in "The Indian Treaty for the Lands Now the Site of Philadelphia and The Adjacent Country" offered the explanation that the treaty was not made by Penn but by his representative, Thomas Holme, in 1685. Watson reproduces a treaty by Holme that he found in the state archives in Harrisburg. P.S. DuPonceau and Joshua Francis Fisher rebut Watson in the same issue and support the original theory that Penn made the treaty at Schackamaxon in 1682.

Illustration 10. *The City and Port of Philadelphia on the River Delaware from Kensington* by William R. Birch (1800). Ink on paper, hand colored. Independence National Historical Park.

treaty at Fort Stanwix in 1768 being only the most recent of many deals designed to gain Penn more territory at the expense of indigenous peoples. As on previous occasions, Penn used his father's charter to substantiate his claims to the land. He commissioned the painting to enlist William Penn's popular image as a man of peace and to support his own actions. Thomas Penn was hoping that popular memory would mitigate historical record. After the painting was exhibited at the Royal Academy in 1772, it remained at Stoke Park.[24]

For the painting to achieve Thomas Penn's ends, it required popular dissemination. On the Penns' urging, John Boydell published an engraving of the painting in London in 1775 and exported it for sale in America. The print was an instant success and was copied in numerous forms. The very site of the supposed treaty, without Quakers and Native Americans, became a popular subject in American views. William R. Birch's *The City and Port of Philadelphia on the River Delaware from Kensington,* (Philadelphia, 1798)

Illustration 10

(Illustration 10) and George Cooke's engraving after Birch, *Philadelphia From the Great Tree, Kensington* (London, 1812), for instance, offer a southerly view of the Delaware as it flows towards distant Philadelphia while a large elm tree in full leaf dominates the right foreground. In West's painting, the tree is incidental to the composition; in the American scenes, the compositions are built around the elm. The tree, known as the "treaty elm," became a metonym for the legend of Penn's treaty at Shackamaxon (the Native American name for the place later called Kensington).

Anne Uhry Abrams asserts that even at the time of West's painting few believed that there had been such a treaty. Indeed, the painting was popularly regarded as an allegory for idealized cultural contact. Whether or not that is so, there is ample evidence that by 1800, a historical legend about the treaty, supported by the painting and related prints, existed. Indeed, the wide dissemination of this image of Penn and the Native Americans continues to make that legend the commonly accepted history of the founding of Pennsylvania.[25]

Roberts Vaux (1786–1836) was one who was attracted to the legend of the treaty elm. A birthright member of the Society of Friends, Vaux's interest in the treaty legend grew out of his concern for the welfare of Native Americans during an era of resettlement. When the purported treaty elm was blown down in a storm in 1810, Vaux had small boxes crafted from its wood and he distributed them to his friends. The relic wood boxes, like the Boydell engraving, reminded their owners of the legend of Penn's treaty.[26]

Despite the physical evidence of the tree and its relics, something about the legend troubled Roberts Vaux. Never challenging the story publicly, he raised questions about it in private correspondence. His correspondents regarded his questions as heresy. Eventually, Vaux allowed the existence of the elm tree to persuade him that the event had happened just as West painted it. His "Memoire on the Locality of the Great Treaty between William Penn and the Indian Natives in 1682" accepts the story of the single treaty and establishes its site at Shackamaxon.[27]

John Fanning Watson, an antiquarian whose collections of Philadelphia oral histories, traditions, and relics formed the basis of his *Annals of Philadelphia and*

Pennsylvania in the Olden Times, was one of Vaux's correspondents. Both men were members of the Committee of History, Moral Science, and General Literature of the American Philosophical Society. The committee's purpose was to collect documents relating to the histories of Pennsylvania and of the United States. Watson had amassed a large store of documents and relics as well as a knowledge of the locations of prime historical sites. He was well aware of the power of material objects to evoke the past. He frequently recombined relics into functional objects such as frames, chairs, and boxes, and he offered practical advice to Vaux on the improvement of the treaty elm relic boxes.[28]

Vaux and Watson capitalized on the enormous enthusiasm for the Lafayette reception to organize the Society for the Commemoration of the Landing of William Penn, more popularly known as the Penn Society. The Society's inaugural meeting was an exuberant banquet held at "the house in Letitia Court once the Founders [Penn's], now an Inn kept by John Doyle" on 4 November 1824. Twenty-two of the subscribers to the Lafayette portrait became members of the Penn Society. Its purpose was to commemorate "Penn's landing on the American shore" in 1682, and to honor "the memory of his virtue."[29]

The dinner became an annual event. In 1825, Charles Jared Ingersoll delivered a pre-dinner address to a company that included President John Quincy Adams. The president received a complimentary relic box—which he proceeded to use as a snuff box, much to the dismay of the assembly.[30]

The Penn Society intended to use the membership "funds to raise monuments to the fame and memory of their great Founder." Roberts Vaux proposed the placement of "a plain and substantial *obelisk of granite*, near where the tree formerly stood … with proper inscriptions." The members also decided that a painting would be another fitting monument to Penn, and began negotiation with Thomas Sully. By autumn 1826, Sully had begun to compose it.[31]

John F. Watson, however, had his own vision of the painting, and he shared it with Roberts Vaux in a series of characteristically perspicuous letters. Watson was a working man whose fascination with the past involved him with wealthy patrons of the arts and philanthropists. Watson collected visual art for its documentary value. The annalist proudly noted, "I have an original *perspective sketch* on Dennis [sic] paper, of what I think should represent the *locality* of Penn's landing at Guest's Tavern at Dock Creek Mouth. This might be usefully consulted by Mr. Sully, if he selects that site as the subject of his painting."[32]

Watson was interested in the creation of a work of art that would contribute to a commonly shared history of Penn's arrival in his colony. Watson also had ideas for the composition of the work based on the prints of West's *Treaty with the Indians*, which utilized a horizontal format and figure groups, and on popular panorama paintings then exhibited in local galleries. The painting he proposed, should be a

> *Landscape* or *perspective*, embracing such compass of the horizon as would show distinctly the meandering of Dock Creek, *Drinker's* hut at 2d st, The celebrated *Spring* vis a vis to Guests blue anchor, the River Delaware, & the *distant* Treaty Tree; The high land of Coaquannock, & the tall grove of Spruce-Pines; some caves & huts on the river bank of the first Settlers; Guests blue anchor house & the foundation of Budds adjoining "longrow;" In the foreground Penn & his company there landing from his boat from Chester;—and the previous Settlers & Indians making him welcome.[33]

The proposed landscape encompassed about three miles of shoreline from Budd's Row north to Shackamaxon. It would have required an unusually large scale for Penn and his associates to be discernible. Watson reasoned that it was best simply to suggest

28. HSP, Vaux Papers, John F. Watson to Roberts Vaux, 3 July 1824. HSP, Watson Papers, Vaux to Watson, 7mo 22 1824, 30163, 38–39 states his interest in preserving an elm at Schuylkill Seventh and Race Street, which he describes as "the Last tree of the [primeval] Forrest." To Watson, this tree was a living link with the past and therefore a conduit of history. For biographical information on Watson, see Deborah Dependahl Waters, "Philadelphia's Boswell: John Fanning Watson," *PMHB* 98.1 (1974):3–52.

29. William Thackara, "Constitution of the Society for the Commemoration of the Landing of William Penn" (1825), HSP. This hand-lettered volume has a vignette in grisaille of the treaty elm after Birch with the inscription "This Old Elm in Kensington As It Appeared in 1800—Under this Tree William Penn held his Treaty with the Indians in 1684—It was Blown Down 3d March 1810." The date of the banquet was chosen to conform to the old-style calendar date of October 24, when Penn's ship landed in Philadelphia. Roberts Vaux to John F. Watson, 2 November 1824, HSP, lists twelve toasts offered at the banquet by antiquarian Pierre S. duPonceau. Three of the toasts honored objects with a Penn association: the treaty elm, the Letitia House, and a chair loaned to Watson by Deborah Norris Logan for display at the dinner. The Letitia House is now located in Fairmount Park; the chair is in the INHP collections.

30. HSP, Watson Papers, John Bacon to John F. Watson, 22 October 1825. HSP, Vaux Papers, Richard Peters to Roberts Vaux, 21 November 1825. That year marked the inauguration of the Historical Society of Pennsylvania. The Penn Society membership thereby became the founding body of the new organization.

31. Membership in the Penn Society was open to "any person of good moral character" whom the board approved. The initiate became a "member of the society for life on paying the sum of ten dollars to the Treasurer." HSP, William Thackera, "Constitution of the Society for the Commemoration of the Landing of William Penn," Articles 5, 7 (1825), AM3146. Vaux, *Memoirs*, 98. Architect John Haviland designed the obelisk. John Sartain recorded that Roberts Vaux's son, Richard, showed him Haviland's model, but the monument proved too costly to execute. A simpler substitute was eventually installed. Sartain, *Reminiscences of a Very Old Man, 1807–1897* (New York: D. Appleton, 1899), 160.

32. HSP, Vaux Papers, John F. Watson to Roberts Vaux, 24 November 1826, Correspondence 1826– Oct., Nov.

33. Watson to Vaux, ibid.

34. HSP, Vaux Papers, John F. Watson to Roberts Vaux, 6 December 1826, Correspondence.

35. John Sartain, *Reminiscences*, 161.

36. For a discussion of contrivance and alteration of reality in the composition of history paintings, see Richard H. Saunders, "Genius and Glory: John Singleton Copley's *The Death of Major Pierson*," *American Art Journal* 22.3 (1990):5–39.

37. HSP, Vaux Papers, John F. Watson to Roberts Vaux, 6 December 1826, Correspondence. In *The Valiant Hero*, Anne Uhry Abrams demonstrates that history paintings provide enjoyment on both a literal level in terms of appreciation of the narrative and a symbolic level in terms of comprehension of the politics or deeper meanings portrayed. Watson's argument in favor of a literal composition seems to define class lines.

38. HSP, Watson Papers, Roberts Vaux to John F. Watson, 12 December 1826. HSP, Vaux Papers, John F. Watson to Roberts Vaux, 17 December 1826.

the Penn group because no likenesses of the persons were extant. His purpose in presenting the Founder in the context of an historic landscape was to contrast the past city with the present. That Arcadia Watson described, however, was not intended to evoke pastoral longings. Rather, the work of art should *"surprise"* the viewer with "truely primitive Scenery."

As early as December 1826, Watson was expressing misgivings about the tentative choice of Thomas Sully to paint this scene. "In thinking further upon the contemplated Pantg *[sic]* of *Penns' Landing*," Watson wrote to Vaux, "I feel a concern lest Mr. Sullys talent will not be the best adapted to make a popular display." Watson also had doubts about the artist's ability to submerge his artistic personality for the sake of the Penn painting. Further, Sully's very popularity as an established painter of the socially prominent made him suspect in Watson's eyes. He feared that Sully would feature Penn, not the event of his landing or the landscape. Finally, the penurious Watson believed the artist Thomas Doughty "would display a more *acceptable* talent than the other, & at a much more moderate price."[34]

While Watson had no personal acquaintance with Sully, his instincts about him were correct. Years later, John Sartain recorded that Sully had shown him his color study for the Penn painting. In the study, Penn held the charter for Pennsylvania. Behind Penn was an open door "disclosing the brilliant court circle he had just left."[35]

Watson proposed to create a work that, in its time, would have been received as a history painting. There is no evidence that Watson was motivated by Sir Joshua Reynolds's *Discourses*, which placed historical subjects at the pinnacle of the painting hierarchy. He was intent, rather, upon creating a work whose image and message would be clear to the unschooled. In academic history painting, the composition may be contrived but the event portrayed must actually have occurred. Watson was aware of the continuing debate about whether there ever was a treaty under the elm. Yet he saw his proposed work as documentation of the event.[36]

Watson also sought interpretive simplicity. The emotion he sought, "surprise," was to be elicited at a literal, not allegorical, level. He also believed the viewer should comprehend the painting without further written explanation. The poems and written description that accompanied Rembrandt Peale's *Court of Death* when that painting was exhibited in Philadelphia, for example, were not for Watson: "I am aware all this [lack of written interpretation] is in *bad taste*, with amateurs & cognoscenti," he wrote, "but what is it to please *them*, in comparison with a painting which may … delight forever, the whole mass of our Citizens!" Watson's populist argument ultimately obtained, and it remained a criterion in building the Independence Hall collection.[37]

Watson's ideas about Sully were not well received. Vaux replied that any painter other than Sully "is out of the question, he is engaged." Furthermore, Vaux reminded Watson that Penn first made land in New Castle, Delaware, not Philadelphia. This historical fact cast the project in a different light, as New Castle, to Vaux, "is now alien." For Watson, this was not a problem. New Castle may have been Penn's first landing, he reasoned, but the founder did land later at Guest's Blue Anchor. The view at Philadelphia with its pleasing landscape dotted with buildings was a far more appealing setting for Penn's landing than dull, uninteresting New Castle. He may have been no aesthete, but Watson demonstrated his affinity for the picturesque.[38]

Vaux and Watson were not the only two members of the Penn Society who had a say about the composition of the painting and about the painter. Cephas Childs, a subscriber to the Lafayette portrait and a member of the Penn Society, was responsible for shifting the commission from Sully. Childs had a growing engraving business and wanted to use the Penn commission to lure the New York artist Henry Inman to Philadelphia as a partner. Three years elapsed between Vaux's assurance that Sully had the commission and

its actual negotiation. In the interim, John F. Watson became the first curator of the Historical Society of Pennsylvania. At a meeting of the Society's Council on 23 September 1830, on the motion of Roberts Vaux, the Society resolved to have Childs engrave "a series of … views of public edifices in and near Philadelphia," each structure to be one that was "liable to decay or to be otherwise removed."[39]

Coincident with the engraving commission, the Society also transferred its commission from Sully to Inman for the Penn painting. Sully realized that the commission was slipping from his grasp. When he submitted his proposal, he anticipated the probability that he would not be chosen, graciously stating that "although I may not be the favored artist on this occasion, I shall be well pleased in the reflection that an order for a picture from so respectable a source is calculated greatly to forward the progress of art in our City." Inman received the commission. By the following July, Roberts Vaux wrote that the Inman painting "will probably be finished and exhibited on the next anniversary of the landing of the founder."[40]

The selection of a competent but less known and less expensive artist should have pleased Watson. Inman's composition, however, did not follow Watson's wishes at all. Henry Inman had come to Philadelphia to establish himself as a portrait painter. Watson's plan to have the figures of Penn and others made almost indistinguishable did not suit Inman's purposes. It may also be that the Penn Society itself preferred a composition very different from the one Watson championed. In any case, it appears that Inman discounted Watson's ideas from the very beginning. The only record of the development of the painting is a surviving color study that, excepting its size, is nearly identical to the final work (*Illustrations 11, 12,* and *13,* and in catalog).[41]

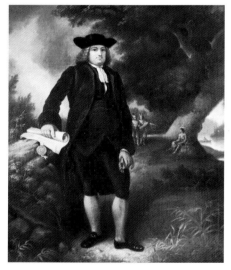

Illustration 11

The painting is vertical in format and prominently features Penn. Sully's proposed composition suggested that Penn's most important achievement was his rejection of wealth and court life in England. Inman's work speaks more to Americans by placing Penn in Pennsylvania in front of the legendary tree at Shackamaxon. Penn stands slightly left of the painting's center; his right hand holds a partially unrolled document that rests on top of a large boulder. From the document dangles the provincial seal, suggesting that it is the proprietary charter Penn received from the king.

The elm is behind and to the right of Penn; still further to its right is a glimpse of the river. The viewer is looking northward away from the City of Philadelphia. A canoe with a Native American paddling is visible on the river. Beneath the elm stand two Native Americans conversing, while a third sits holding a bow in front of its massive trunk. Penn and the tree dominate the scene. Through legend, both have transcended temporality.

The Inman *William Penn* depicts a very different relationship between Penn and the Native Americans from that in West's *Penn's Treaty*. West suggests, through the positioning of Penn and of the natives, the possibility of a harmonious coexistence. Inman's work does not. There is no interaction between Penn and the Native Americans. The former stares fixedly at the viewer and dominates the foreground of the painting. The latter observe Penn from beneath the elm's umbrage but remain distant from him. Penn does not negotiate with the natives. Inman compresses the elements of tree, subjects, and site that support the legend of Penn's single treaty without assuming a viewpoint about the event's

39. Sartain, *Reminiscences*, 161–62. Information about the endorsement is tipped into an 1827 edition of Childs's *Views of Philadelphia* in the American Philosophical Society Library.

40. HSP, Vaux Papers, Thomas Sully to Roberts Vaux and Thomas I. Wharton, 4 October 1830, Correspondence, August–October, 1830; cf. HSP, Vaux Papers, Henry Inman to Roberts Vaux, 3 October 1830, Correspondence, August–October, 1830. HSP, Vaux Papers, Roberts Vaux to Joshua Francis Fisher, 11 July 1831.

41. The color study is in the Kirby Collection of Lafayette College. I am grateful to Michio Okaya, director of the Lafayette College Art Gallery, for calling my attention to this work.

42. The composition may reflect Roberts Vaux's views on Native American mistreatment. See Joseph J. McCadden, "Roberts Vaux," *Bulletin of the Friends' Historical Association* (1936) 25:28. Vaux refused an appointment by Andrew Jackson to a commission to negotiate with the Native Americans in 1832. He stated that his religious convictions would be compromised by the military escort assigned to the commission. Abrams, *Art Bulletin.*

Illustration 11. *William Penn* by Henry Inman (1830–31). Oil on canvas. Courtesy of the Kirby Collection of Historical Paintings, Lafayette College, Easton, Pennsylvania.44. While Watson and Vaux corresponded about the painting, Philadelphia Friends held several heated meetings in which heterodoxy and orthodoxy clashed. On 15 February 1827, Vaux was shouted down by a standing-room-only crowd at Pine Street Meeting when he denounced the Hicksites (Ingle, 172–75).

veracity. It is left to the viewer to judge the result of the encounter. Displayed next to *Lafayette* in the Assembly Room, *William Penn* contributed to Philadelphia's view of the past.[42]

Like the West painting, Inman's portrait of Penn served a secondary purpose. This memorial portrait was commissioned at a time when intolerance and dissension threatened to rend Penn's Society of Friends. At the same time that Vaux was organizing the Penn Society and promoting the portrait, he was also active in opposition to the movement that led to the Hicksite schism of 1827, a rift that was to split the Society of Friends for more than 125 years.[43]

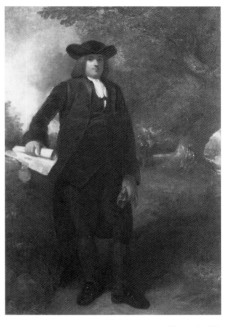

Illustration 12

It does not seem possible that Vaux and other Quaker members of the Penn Society could have put this controversy out of their minds as they considered a painting of America's most popular Friend. Had the painting come to represent to them more than a patriotic memorial to Pennsylvania's founder? In a religion that eschewed all outward forms of ritual and commemoration, a portrait of Penn was the closest thing to an icon that was permissible. In commissioning a painting of William Penn for public display, Vaux and his friends may have intended a subtle appeal to unity among their fellow Quakers.[44]

The Penn Society presented the painting to the City of Philadelphia in December 1832, shortly after the 150th anniversary of Penn's landing. The following April, the *National Gazette* recorded that "the historical portrait of the Founder of Pennsylvania, was yesterday deposited in the Hall of Independence. Thus is commenced a gallery of portraits which will adorn that chamber, and add to the veneration already entertained for it, by our citizens and by strangers visiting Philadelphia." *William Penn* was the last portrait commissioned for display in Independence Hall until the Centennial.[45]

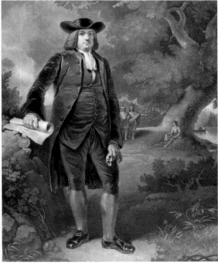

Illustration 13

The Assembly Room and Social Change

During the first half of the nineteenth century, the City of Philadelphia showed little interest in Independence Hall and its small portrait collection and took no advantage of opportunities to increase its art and relic collection. A single caretaker attended to custodial tasks. There was no permanent committee of oversight as there would be in later years. Without the attentions of such a group, decisions about acquiring patriotic paintings or using the hall were without plan, and dependent on political connections in city councils.

Financial considerations undoubtedly influenced the city's conservative acquisitions posture. Philadelphia had underwritten portions of the *Lafayette* and *William Penn* paintings because even her most public-spirited citizens were not willing to bear the cost of public portraiture executed on an appropriate scale. In 1840, city councils avoided the embarrassment of a private, insufficiently funded attempt to honor the late cleric, William

43. The social, not theological, issues of the Hicksite schism have bearing upon this essay. At the risk of oversimplification, one could say that the reformation was a conflict between the urban minority that dominated the governance of the Philadelphia Yearly Meeting of the Religious Society of Friends and the rural majority of its membership. Orthodox Friends tended to be city dwellers who were more exposed to a heterogeneous and industrially-progressive society. They accommodated their outward concessions to metropolitan life by an evangelical insistence upon the Bible as the source of personal revelation. The orthodox suppression of insularity and autonomous revelation angered rural Friends who called for a reformation, a return to the discipline of pre-industrial Quakers. For further explanation see H. Larry Ingle, *Quakers in Conflict: The Hicksite Reformation* (Knoxville: The University of Tennessee Press, 1986).

44. While Watson and Vaux corresponded about the painting, Philadelphia Friends held several heated meetings in which heterodoxy and orthodoxy clashed. On 15 February 1827, Vaux was shouted down by a standing-room-only crowd at Pine Street Meeting when he denounced the Hicksites (Ingle, 172–75).

45. Thomas Wharton to Roberts Vaux, 3 November 1832, HSP, indicates that the painting was completed. The city's acquisition of the portrait is recorded in Hazard's *Register*, 28. Evidently, the city had promised to partially recompense Vaux and the Penn Society for the painting. After his death in 1834, his executors received $200 and the Society received $50. See *Journal of Common Council*, 11 April 1837, 123. The Penn Society solicited subscriptions for an engraving of the painting but did not gain sufficient interest. John Sartain volunteered to "assume the risk" and made a preparative study and a plate for the engraving. There is no evidence that Sartain ever published the print. He sold the plate to James Earle, the co-proprietor with Thomas Sully of a gallery. Sartain, *Reminiscences*, 162. The one version of the print that has survived is marked "Painted by H. Inman, Engraved and printed by J. Sartain, Published by Jas. S. Earle, carver and gilder, 212 Chestnut Street."

Illustration 12. *William Penn* by Henry Inman (1831). Oil on canvas. Also illustrated in catalog. Independence National Historical Park.

Illustration 13. *William Penn* drawn and engraved by John Sartain after Henry Inman, printed by James S. Earle. Ink on paper. Courtesy of The Philadelphia Society for the Preservation of Landmarks.

White, by purchasing a simple engraving of the bishop by Wagstaff after his portrait by Henry Inman. The engraving was placed in the Assembly Room.[46]

While works of art decorated its space, the Assembly Room's use remained in question. As in the past, patriotic ceremonies and exhibits focused public attention on the room. The Assembly Room was a frequent site for funerary obsequies, so popular in the nineteenth century. The bodies of American heroes, or cenotaphs to them, were displayed in the Assembly Room, which was draped in mourning for the event. In 1841, for instance, obsequies for President William Henry Harrison were held there. John Quincy Adams, Henry Clay, Elisha Kent Kane, and Abraham Lincoln were but a few who were similarly honored.[47]

Gifts of art to the city were infrequent. Benjamin West's *Paul and Barnabas Rejecting the Jews and Receiving the Gentiles*, presented to the city by the painter's son in 1842, was displayed in the Assembly Room and later in other parts of Independence Hall until it was formally transferred to the Pennsylvania Academy of the Fine Arts.[48]

Many images of George Washington were loaned for exhibit in the Assembly Room. William Rush had used his influence as a member of City Council to place his heroic wood sculpture of Washington in the Assembly Room for Lafayette's reception. Rush eventually sold the statue to the city. In 1842, sculptor Ferdinand Pettrich (1798–1872) loaned his plaster model of the equestrian statue of Washington for display, and in 1847 N. Gevelot deposited a "large bronze bust of Washington" in the Hall of Independence "for the inspection of the public."[49]

The Assembly Room's ambiance gave visitors a taste of the sublime. The traveler W.L. Mactier described his visit to "that consecrated room in the State House" on 15 July 1843. To encourage contemplation of the sacred space and its paintings, "the room was furnished with easy chairs, and sofas, and carpeted like a drawing room." Mactier was describing a room that in many respects resembled a Victorian parlor. Yet his choice of the word "consecrated," suggests Independence Hall had by then begun to be regarded as a national shrine.[50]

Shrines, however, are not isolated from great social changes in the larger society. During the 1840s, the impact of widespread financial panic was felt locally in the form of business failures. Additionally, the tariff issue created an unfavorable balance of trade and forced the closure of many factories. To compound these economic problems, the population of Philadelphia and its surrounding area increased 58 percent, the direct result of immigration. By the end of the decade, 25 percent of the population of Philadelphia was foreign-born. The influx of immigrants led to intense job competition with native-born Americans and produced labor unrest and nativism.[51]

On 2 August 1842, thousands of workingmen rallied in the State House yard on behalf of the unemployed. City Council blocked the use of Independence Hall to promote nativism when it refused the Native American Party's request to hold a convention there in June 1845. Two years later, on Washington's birthday, the council allowed the use of the Assembly Room for the Irish Relief Collection. This use of the historic shrine to endorse ethnic diversity and civic unity is notable. Thirty years later, patriotic societies would use Independence Hall for a quite contrary purpose.[52]

Beginning with the Mexican War, City Council used Independence Hall to endorse the nation's military ventures. Shortly after President Polk proclaimed war with Mexico in 1846, Council transformed the Assembly Room from an intimate parlor into a patriotic public shrine. An official visit by Generals Houston and Rush and the United States Senators from Texas provided the occasion for the redecoration. The walls of the room were white, as before, but the ceiling was painted a celestial blue with thirteen gilt stars

46. *Journal of Select Council, 1839–40*, 8 October 1840, 127.

47. Harrison's father, Benjamin, had served as Virginia's representative to the Continental Congress and debated the Declaration of Independence in that same room. *National Gazette*, 12 April 1841.

48. *Journal of Councils*, 1841–42, Common Council 17 March 1842, 85 as cited in INHP notecard file.

49. The loan is mentioned in passing in "Attempt to Assassinate Mr. Petbrick [sic]," *Saturday Courier*, 4 June 1842, p. 2, col. 4 as cited in notecard file, INHP. According to Wayne Craven, *Sculpture in America* (New York: Thomas Y. Crowell, 1968), 68, the sculptor gave the model to the National Museum in Washington in 1842. Pettrich had sculpted a bust of John Vaughn, who had been a subscriber to the William Penn and Lafayette portraits and who may have induced the sculptor to exhibit the equestrian model.

50. W.L. Mactier, Journal, 1838–43, 25 July 1843 as cited in notecard file, INHP (no location given for source). Mactier also saw a head of Washington above the door, but no records survive to indicate the artist. *Public Ledger*, 20 July 1847, p. 2.

51. These population figures are taken from Elizabeth M. Geffen, "Industrial Development and Social Crisis, 1841–1854," in Weigley, ed., 309.

52. Although they were longheld to have been anti-Catholic, Michael Feldberg presents a convincing argument that nativist riots were aimed at the Irish, not at all Catholics. See *The Philadelphia Riots of 1844: A Study of Ethnic Conflict*, Contributions in American History, 43 (Westport, Connecticut and London: Greenwood Press, 1975). *Public Ledger*, 22 February 1847, vol. 22, No. 129, p. 21, and 23 February 1847. Independence Hall, two churches, and the Navy Yard were collection sites for the relief collection. The pro-Irish stance of the caretaker of Independence Hall, Jimmy Owens, was wellknown. Owens's obituary, "Death of a Well Known Citizen," 3 October 1857, Poulson scrapbooks, v. 2, p. 42, LC, stresses his long tenure as caretaker and implies he held the job in 1847. I am grateful to Phillip Lapsansky for his assistance in locating the Poulson scrapbooks.

53. Geffen notes the date the
 declaration of war reached
 Philadelphia, 351. *Public Ledger*,
 11 June 1846; 23 June 1846;
 7 July 1846. David Kimball in
 *Venerable Relic: The Story of the
 Liberty Bell* (Philadelphia:
 Eastern National Park and
 Monument Association, 1989),
 65, notes that the Bell was not
 brought down until 1852.

54. *Public Ledger*, 14 April 1847.
 That was the last candle-powered
 illumination in the building. Gas
 was introduced one year later and
 Public Ledger, 1 July 1848, p.2
 describes an anticipated Fourth
 of July gas-powered illumination
 with burners arranged in patriotic
 "tableaux of Peace."

55. For an account of Decatur see
 Irvin Anthony in *Decatur* (New
 York and London: Charles
 Scribner's Sons, 1931) or Charles
 Lee Lewis in *The Romantic
 Decatur* (1937 Freeport and New
 York: Books for Libraries Press,
 1971). *Public Ledger*, 22; no. 31,
 29 October 1846, p. 1 and 30
 October 1846, p. 2 describe the
 obsequies.

56. Stephen Decatur and his father
 had commanded vessels owned
 or managed by Francis Gurney
 Smith's father's partnership of
 Gurney and Smith. Francis
 Gurney Smith's brother, Daniel,
 was captain of the First City
 Troop and thereby able to
 organize the military escort for
 the reinterment. See Frank
 Willing Leach, "Old Philadelphia
 Families," 91, Smith (Daniel);
 North American, Philadelphia,
 Sunday, 28 July 1912, n.p.;
 Lewis, 85, 215. For his naval
 victories, the Smiths and others
 had presented Decatur with a
 ceremonial sword and a set of
 silver plate. See *Minutes of the
 Select Council*, February 1813
 and *American Daily Advertiser*,
 2 February 1813.

Illustration 14. *Stephen Decatur* by
 Gilbert Stuart (1806),
 overpainted by Alexander
 Simpson (1846–47). Oil on
 canvas. Also illustrated in catalog.
 Independence National
 Historical Park.

encircling the shaft of the chandelier. Curtains replaced the "miserable old green blinds that were formerly used to darken and disgrace the room." In addition to the paintings and sculpture, an engraved copy of the Declaration of Independence was now displayed in the Assembly Room. There was even a proposal to bring the Liberty Bell down from the tower and display it in the stair hall.[53]

In April 1847, Zachary Taylor's victories were celebrated with an illumination of Independence Hall that featured candles in every windowpane, transparencies, and Washington's image over the front door. This was the first such display since Lafayette's visit.[54]

First Private Donation

In that same year, 1847, Independence Hall received its first portrait through private donation. In December, the destitute widow of Commodore Stephen Decatur gave the city a portrait of her late husband *(Illustration 14)*. Decatur's naval heroism had earned him national honor. Subsequently, he was mortally wounded in a duel and was buried in Washington, D.C. When urban expansion threatened his gravesite, his widow, Susan Wheeler Decatur, appealed to friends to have his body exhumed and reinterred in Philadelphia, his native city.[55]

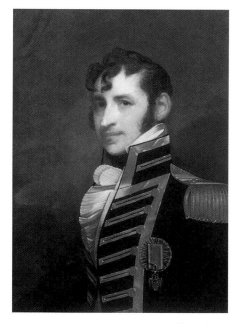

Illustration 14

Francis Gurney Smith, a Philadelphian whose family had a longstanding friendship with the Decaturs, facilitated the reinterment and its associated ceremonies. In gratitude for Decatur's reburial in the city of his birth, Susan Decatur gave her portrait of her husband for display in the Assembly Room. The gift may have been at Smith's suggestion. A subscriber to the Lafayette portrait, he knew well the need for portraits of American heroes in the Assembly Room. Perhaps it was even Smith who suggested that the widow employ an artist to update the portrait to Decatur's appearance in 1813, the year Philadelphia honored him with a parade and celebration for his capture of the British ship, *Macedonian*. Decatur was also inducted into the Order of the Society of Cincinnati that year.[56]

The artist Gilbert Stuart had painted Susan Wheeler's portrait in 1803, three years before her marriage to Stephen Decatur. Shortly after their wedding in 1806, Decatur had Stuart paint a companion to his wife's portrait. William Treuttner speculates that Susan Decatur influenced her husband to sit to Stuart in Boston while the commodore was on a tour of duty in Newport. In the painting that was hung in the Assembly Room, however, Decatur is wearing his Society of Cincinnati medal, a decoration he received at his 1813 induction.

In the 1960s, curators used modern technology to investigate the Decatur portrait in an effort to satisfy their curiosity about different painting styles on the same canvas. The X-radiography revealed that Independence Hall's painting is signed by Stuart and dated "1806." Furthermore, the subject is wearing another uniform beneath the visible one. This incongruity might be explained by Susan Decatur's desire to portray her husband as he appeared in 1813, the year Philadelphia honored him. In 1846–47, Susan

Decatur hired Washington artist James Alexander Simpson to overpaint the life portrait of her husband. No question of authenticity was raised in 1847, however, when the grateful city placed the painting in the Assembly Room.

Susan Decatur makes no mention of the overpainting in her correspondence with the Select Council. The adjustment to the 1806 portrait was necessary to immortalize Decatur. Simpson transformed the Decatur from a private painting that held sentimental significance for the subject's widow to a public portrait of a warrior at the height of his career.[57]

The City's First Purchase

In 1849, the City of Philadelphia made its first outright purchase of a portrait for the collection in the Assembly Room. This was James Peale's portrait of George Washington *(Illustration 15)*. The city acquired the painting from John Binns for $200 in February, just in time for Washington's birthday.[58]

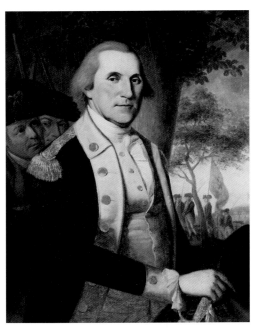

Illustration 15

John Binns was at least the second owner of the painting. A Dubliner, he was already a veteran newspaperman when he moved to Philadelphia in 1807. Binns published the *Democratic Press* until that newspaper's demise in 1829.[59]

John Binns seems to have had an interest in art for its commercial value. In 1808, after helping Simon Snyder win the state gubernatorial election, he commissioned Thomas Sully to paint the new governor's portrait. The following year, Binns had the artist David Edwin make an engraving after the Sully painting that bore the dedication, "To the People of Pennsylvania this portrait of the Man of their Choice Is respectfully dedicated by their Fellow-Citizen John Binns." Binns sold the engravings and again collaborated with Sully on an elaborate edition of the Declaration of Independence in 1819.[60]

When Binns offered the half-length Washington portrait to the city on 14 September 1848, he attested to the buyer that he had purchased the painting "at a sale of John Dunlap's furniture" about thirty years earlier. Dunlap was a fellow Hibernian and printer whose press produced the first printings of the Declaration of Independence and the United States Constitution, and the first daily newspaper in America. During the American War for Independence, he had served under Washington at the battle of Trenton in 1777. There is evidence that he purchased paintings for his personal enjoyment as well as for engraving ventures such as those of Binns.[61]

James Peale's half-length painting of George Washington depicts the commander-in-chief in his Continental Army uniform with his right hand on the hilt of his sword. Washington stands in three-quarter view, but he stares directly at the viewer. Behind him is a large tree. A group of soldiers carrying muskets march up a hill in the midground. One of the group carries the French colors. An encampment with wagons and tents is in the background and a flag flies on the hill of a distant fort. Two soldiers with tri-cornered, cockaded hats peer over Washington's right shoulder. The foremost soldier stares up at

57. Susan Decatur's economic plight is described in Lewes, 279, endnote 105. See also her obituary, undated newspaper clipping, Poulson scrapbooks, 4.129, LC. She died in 1860. William H. Treuettner, "Portraits of Stephen Decatur by or after Gilbert Stuart," *The Connoisseur* (August 1969):265. Simpson made several copies of the portrait for Mrs. Decatur.

58. *Public Ledger*, 10 January 1849 notes the resolution before Select Council to purchase the painting, which was to be "placed in Independence Hall." JCC, 18 Jan. 1849, pp. 196–97 notes the passage of the bill. Sellers, *Portraits*, #921.

59. For biographical information on Binns see *Dictionary of American Biography*, 282–83; also the entry, "Simon Snyder," *op cit.*, 389–90; also Binns's auto-biography, *Recollections on the Life of John Binns: Twenty-Nine Years in Europe and Fifty-Three in the United States* (Philadelphia: by the author, 1854). Before moving to Philadelphia, Binns owned the *Northumberland Gazette* and was instrumental in the three successful gubernatorial campaigns of Simon Snyder. See William N. Meigs, "Pennsylvania Politics Early in the Century," *PMHB* 17 (1893):462–90. Daniel Agnew, "Address to the Allegheny County Bar Association, December, 1888," as printed in *PMHB* 13 (1889):48 describes Binns' anti-Jacksonian activities.

60. The print was republished in 1812 after Snyder's reelection. Charles R. Hildburn, "A Contribution to the Catalogue of the Engraved Works of David Edwin," *PMHB* 18 (1894):228. William U. Hensel in, "Jacob Eichholtz, Painter," ibid. 37 (1913):51 quotes Sully's recollection of painting Snyder in Eichholtz's painting rooms in Lancaster.

61. John Binns to president of the Select Council as quoted in "Proceedings of Council: Select Council," *Public Ledger* 15 September 1848. *Dictionary of American Biography*, s.v. "John Dunlap." The Bureau of Wills, City of Philadelphia, could not locate Dunlap's will and inventory. Allowing for possible generalities in Binns's statement, the sale must have taken place between 1809, when Dunlap moved from High to Chestnut Street, and 1812 when he died. I am grateful to Henry A. Boorse whose article, "John Dunlap's House by James Barralett," *PMHB* 99 (1975) and whose correspondence on this topic have been invaluable.

Illustration 15. *George Washington* by James Peale (circa 1787–1806). Oil on canvas. Also illustrated in catalog. Independence National Historical Park.

62. Morgan and Fielding, *Portraits*. The INHP portrait is number 5 of their list of portraits of Washington by James Peale. The authors consider it the best and possibly the prototype for this group. John C. Milley, notes, painting file, INHP. On January 13, 1783, Charles Willson Peale wrote to a Mr. Dunlap requesting the "Balance for Genl Washingtons portrait." Peale required 9.15.10£ which Sellers speculates was half the price of a three-quarter length picture. Since Binns's painting is stylistically James Peale's work, it appears that Binns and Charles Willson Peale were discussing two different portraits.

63. Binns to President, 14 September 1848. Binns noted that George Washington Parke Custis believed the portrait was taken in 1776, that the flag was American, and that the two soldiers were Generals Knox and Mercer.

Washington; the latter soldier, represented only by a portion of his face and hat, looks at the viewer in imitation of Washington's gaze.

The painting's authorship and the scene it depicts have long been the subject of controversy. Because of a chance encounter with Charles Willson Peale, John Binns believed he was the artist. However, historians are certain that James Peale painted the portrait, and stylistic analysis bears them out. Early art historians John Hill Morgan and Mantle Fielding are definite neither about the date of the painting's execution nor about its setting. They speculate that James Peale copied Washington's head from the life portrait his brother, Charles Willson, made during the 1787 Constitutional Convention. John C. Milley concurs with Morgan and Fielding. He adds that the soldiers in the background of the composition were probably copied from those in the landscape of Charles Willson Peale's 1784 full-length portrait of Washington at Yorktown. The French colors lend further credence to the theory that the scene is the surrender at Yorktown in 1781.[62]

Some later viewers of the painting believed the men looking over Washington's shoulder were his generals or his aides. John Milley has convincingly argued that the soldiers are Charles Willson and James Peale, copied from their depictions in *The Peale Family*, a group portrait by Charles Willson Peale. By 1848, however, the identities of the men in the background were both forgotten and irrelevant, as was the actual location of the scene in the painting. No one who knew the Peales as young men came forward to identify them in the Washington portrait. All were subordinate to the image of commander-in-chief.[63]

The four portraits acquired by the City of Philadelphia between 1800 and 1850 became the standards for selecting all subsequent acquisitions. During those years, with no official body of overseers to set policy, interested citizens and elected officials together developed the parameters of acceptable commemorative portraiture in a republican society. The paintings they selected combined collective memory and oral traditions with documentable facts about their subjects. Lafayette's portrait reconciles the memory of his youth and strength with his actual appearance on his 1824 tour. The treaty elm legend is incorporated into the portrait of William Penn. The public portrait of Stephen Decatur is a posthumous refashioning of a life portrait originally created for private display. In the Washington portrait, the obscurity of the identities of the secondary figures and the location does not diminish the impact of the Washington icon.

As a group, these four paintings both identify and further Philadelphia's common history. They describe the city's origins, its role in the Revolution, and its military heroes, and they identify its patriarch. Because of the city's pivotal role in the formation of national government and policy, the portraits also transcend local history and assume national importance.

The paintings in the Assembly Room provided a patriotic environment for traditional civic functions. As a result, by the end of the period, the Assembly Room was coming to be regarded more as a national shrine than as merely a museum of curiosities or as an art gallery. When subsequent generations debated over including other portraits in the Assembly Room, the standard they applied was the one that had evolved during this first half-century of the collection's history.

Chapter II

The Collection Becomes a Shrine, 1850–1900

1. Lori Fergusson contributed research to this chapter. For more information on Peale's museum career, see Charles Coleman Sellers, *Mr. Peale's Museum: Charles Willson Peale and the First Popular Museum of Natural Science and Art* (New York: W. W. Norton & Co., 1980) and Sidney Hart and David C. Ward, "The Waning of an Enlightenment Ideal: Charles Willson Peale's Philadelphia Museum, 1790–1820," in Lillian B. Miller and David C. Ward, eds., *New Perspectives on Charles Willson Peale, A 250th Anniversary Celebration* (Pittsburgh: University of Pittsburgh Press for the Smithsonian Institution, 1991): 219–35. Gordon Wood discusses the republican obligation to create civil social institutions in an unpublished paper, "The Age of Federalism," presented at the Philadelphia Center for Early American Studies, January 1996.

Illustration 1. Charles Willson Peale, *The Artist in His Museum,* Oil on canvas. Courtesy of the Pennsylvania Academy of the Fine Arts, Philadelphia. Gift of Mrs. Sarah Harrison (The Joseph Harrison, Jr. Collection).

ainter, inventor, naturalist, and scientist, Charles Willson Peale saw unlimited opportunity for success when he opened the second museum in America in Philadelphia in 1784. For two years, in his sky-lit exhibition rooms on Lombard Street, Peale displayed his portraits of military heroes and founders of American government, all painted in a distinctive format. In time, the enterprising artist added noted scientists, explorers, jurists, and other men of accomplishment to the collection. Peale's acquisition of natural history specimens further broadened the scope of his museum. After an eight-year occupancy in the American Philosophical Society, Peale moved his growing museum to the second floor of Independence Hall in 1802. Peale saw his museum as an intellectual and educational pursuit serving both the general public and the scholarly community. The museum's programs combined scientific lectures and demonstrations with popular amusements such as silhouettes cut from a physiognotrace machine and magic lantern shows. The artist dreamed of state or even federal sponsorship for his museum, which, he believed, should be a republican, civic institution. But his interpretation of the provisions of the United States Constitution was at variance with the strict constructionists who formed the congressional majority and his goal was never realized *(Illustration 1).*[1]

In 1820, Charles Willson Peale incorporated the museum as The Philadelphia Museum Company. The new legal entity was to protect his life's work for himself and his heirs. However, the museum followed the unfortunate pattern of many small enterprises that, although capable of supporting their founder, are unable to yield livelihoods for several members of the next generation. After Charles Willson Peale's death in 1827, his family moved the museum from Independence Hall to more expensive quarters across the street. This move was overly ambitious. During the ensuing years, the composition of the Philadelphia Museum Company's board of trustees changed and the institution lost its scholarly supporters to new, exclusive learned societies. Popular taste also changed. The museum's educational

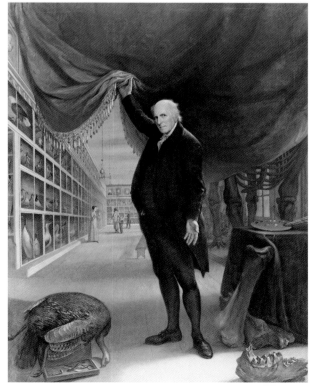

Illustration 1

entertainments were soon in competition for patrons with "museums" that traded in sensationalism. P. T. Barnum became the Philadelphia Museum's greatest nemesis.[2]

By 1835, a new board of trustees composed largely of bankers and businessmen entered the competition for an audience. The trustees determined to embark upon an ambitious course of expansion that included a new building. Because of personal friendships among the directors, the Bank of the United States (later rechartered as the United States Bank) gave the Philadelphia Museum Company a $200,000 loan secured by the paintings, and portions of the collections. To obtain the loan, the museum overvalued the paintings at $150,000 and exaggerated its receipts. Within two short years, the financial panic of 1837 and its subsequent depression destroyed the board's hopes of increased income.

During the 1840s, the Philadelphia Museum Company lost its building and portions of its natural history collections at sheriff's sales. Peale family members were using the museum's collections to pay down the museum's debts. In an effort to minimize its losses, the United States Bank seized the paintings and attempted to sell them. When an anticipated sale to the Smithsonian did not materialize, the desperate bank even allowed Charles Willson Peale's grandsons, Edmund Peale and George Escol Sellers, to use the collections to establish another Peale Museum in Cincinnati through another stock venture. That endeavor also collapsed. Finally, in July 1854, after refusing an offer of $6,000 for the entire collection from a group of Philadelphians seeking to purchase it for the city, the bank announced its intention to sell the Peale painting collection at auction.[3]

On 6 October 1854, the sale took place. At the outset, auctioneer Moses Thomas announced that the collection would be sold in its entirety if "an offer of sufficient liberality was made." D. B. Hinman, chairman of the Committee on City Property, responded with a bid of six thousand dollars for the lot. Thomas declined this offer and the auction proceeded under the rule that "the purchaser of the first choice should have the privilege of taking any number of pictures he wished at the price bid."[4]

The first purchase went to Mr. Edward Ingersoll, who acquired Peale's original portrait of Benjamin Franklin for $360 and also chose Peale's full-length portrait of Washington after the battle of Princeton at the same price. No subsequent bid exceeded $175. By the end of the auction, some works of art sold for as little as $2. John McAllister, a local antiquarian who observed the sale, noted that the entire collection brought "rather less than $12,000 and the paintings generally did not bring exorbitant prices." Shrewd Philadelphians bought such classics as *The Staircase Group, The Artist in His Museum, The Peale Family,* and portraits of Washington, Jefferson, and Joseph Priestly for bargain prices.[5]

One buyer was unknown to those attending the auction. With a high bid of $145, a Mr. P. C. Erben won the right to buy the portraits of Francis Hopkinson, Joseph Reed, Richard Henry Lee, Thomas McKean, Robert Morris, Charles Carroll, Thomas Jefferson, Samuel Huntington, R. R. Livingston and Dr. Witherspoon all at that price. Erben also purchased a portrait of John Hancock for $135. Altogether, Mr. Erben purchased 86 of the 271 paintings at a cost of $5,113. The portraits consisted largely of likenesses of the Signers of the Declaration of Independence and the Constitution, officers of the Revolutionary army and distinguished statesmen. Well-known scientists, explorers, physicians, and men of letters were also represented.

Local papers noted that Mr. Erben had purchased a "great number of pictures, principally portraits," but they offered no clues to his identity. Had reporters checked Erben's background, they would have discovered that he did not exist; the name, a play on the word, "urban," was a pseudonym concocted by agents of the City of

2. See Hart and Ward, ibid. Peale registered his corporation in 1820, it was signed into law nearly a year later in 1821. See *Selected Papers,* 3: 859–60n.

3. *Sheriff's Sale. Philadelphia Museum. Thomas & Sons, Auctioneers. Catalogue of the Extensive and Valuable Collection of National Portraits, Minerals, Birds, Shells, Fishes & Animals, and the North American Indian Collection, Known as Peale's Philadelphia Museum,* Thursday, June 8th, at ten o'clock a.m., and transcription of pamphlet prepared by the stock company, Peale Museum Gallery Sale file, APS. George Escol Sellers to Charles A. Stetson, 18 October 1848, Peale-Sellers Papers, APS. *Cincinnati Gazette,* 4 June 1851, *Cincinnati Daily Gazette,* 18 February 1852. *Catalogue of the National Portrait and Historical Gallery, Illustrative of American History, Formerly Belonging to Peale's Museum, Philadelphia. Now exhibiting at Independence Hall, in Fourth Street Between Walnut and Vine, Cincinnati* (Cincinnati: Gazette Company Print, 1852). George Ord to Charles Waterton, 7 December 1854, Ord-Waterton Papers, APS.

4. "Sale of the Peale Gallery of paintings," *North American and United States Gazette,* 7 October 1854.

5. John A. McAllister to Benson J. Lossing, 7 October 1854, Philadelphia. Peale-Sellers Papers, APS. In his copy of the sale catalogue, McAllister recorded the total proceeds from the sale as $11,700. *Peale's Museum Gallery Sale Catalogue,* John A. McAllister Collection, HSP. Another source lists the amount brought in by the auction as $11,672.06. Scharf and Wescott, *History of Philadelphia,* 1:711–12. "The Peale Gallery of Paintings," *Public Ledger,* 7 October 1854; "Sale of the Peale Gallery of Paintings," *North American and United States Gazette,* 7 October 1854; "Sale of the Peale Gallery of Paintings," *Evening Bulletin,* 6 October 1854. Information pertaining to the auction was also gleaned from annotated sale catalogs, one copy in the Etting Collection; one copy in the John McAllister Collection, HSP; one copy, INHP; one copy annotated by Rembrandt Peale and three other copies, APS. According to Rembrandt Peale, the printed catalog is incomplete and, in some cases, incorrect. John McAllister to Benson Lossing, 7 October 1854, Peale-Sellers Papers, APS.

6. Also referred to as "P.C. Urban,"
 McAllister to Lossing, 7 October
 1854, Peale-Sellers Papers, APS;
 and "P.E. Erben", *Peale Museum
 Gallery Sale Catalogue*, annotated
 by Rembrandt Peale, Peale
 Papers, HSP. Figures taken from
 sale catalog. McAllister informed
 Lossing, "You will please bear in
 mind that where ever *Urban* is
 written on the sheet enclosed you
 are to read 'City of Philadelphia'.
 For *Ward* read 'Historical
 Society.'" McAllister to Lossing,
 7 October 1854, Peale-Sellers
 Papers, APS.

7. Handwritten note by James S.
 Earle, 9 March 1857, Peale
 Museum Gallery Sale file, APS.
 Although this source states that
 Ward bought approximately
 twenty paintings in the Peale sale,
 the author has only found
 evidence in the annotated sale
 catalogs of his having purchased
 ten paintings. According to the
 annotated sale catalogs, Ward also
 purchased portraits of William
 Bartram, Chevalier de Cambray-
 Digny, Samuel Chase, Marquis de
 Chastellux, Louis Duportail,
 Gotthilf Muhlenberg, Arthur
 O'Connor, An Indian Chief (Red
 Jacket?) and Comte de Volney.
 *Controller's Reports,
 Appropriations 1854–1855,*
 Municipal Archives, INHP. The
 six additional portraits were of
 John Hanson, Steven Long,
 Compte Real, Lafayette, William
 Rush, and Martha Washington.
 I am grateful to Gary B. Nash for
 prompting me to reevaluate the
 number and sources of paintings
 in the 1855 exhibition.

8. *North American and United
 States Gazette,* 7 October 1854.
 The number of city purchases
 cited by McAllister is incorrect;
 as noted earlier, the city pur-
 chased eighty-four canvases at the
 auction. McAllister to Lossing,
 7 October 1854, Peale-Sellers
 Papers, APS.

Illustration 2. Max Rosenthal,
*Interior View of the Assembly
Room, Independence Hall.*
Lithograph on paper, 1856.
Independence National
Historical Park.

Philadelphia to allow the city to participate in the auction without revealing itself. Later, in revealing this subterfuge to Benson Lossing, John McAllister wryly noted, "As most of our Councilmen are of the K.N. [Know Nothing] fraternity the secrecy observed on this occasion was not altogether out of place."[6]

Some members of the community had also taken steps to assure that more of the collection was kept in the city. Townsend Ward, librarian of the Historical Society of Pennsylvania, for example, purchased ten paintings for the Society, including Peale's *Conrad Alexandre Gérard,* for a total of $175.75. Subsequently they were sold to the city at cost. The ten portraits purchased by Ward appear together with the eighty-four purchased by the city in the catalog of portraits in Independence Hall published in 1855. Four other private citizens—Lewis H. Newbold, Mr. Barton, Mr. Wayne, and Mrs. Dunton—individually purchased six paintings that they donated to the collection.[7]

Sentiment about the outcome of the sale was mixed. A reporter for the *North American and United States Gazette* lamented that Peale's collection had been dispersed. He criticized the city's conservative $6,000 bid and asserted that "there might have been a slight stretch to suit this occasion, and there would have been no grumbling among our citizens; for the purchase of the collection would have been a great gratification to them." John McAllister also deplored the city's failure to purchase the entire collection, but observed that, all in all, the sale had not come out too badly for the city of Philadelphia. He noted that the city government secured "some fifty or sixty of the most valuable paintings, the Historical Society purchased ten or twelve and the balance of the collection with few exceptions was knocked down to liberal minded Philadelphians."[8]

These acquisitions redirected the content and purpose of the city's portrait collection in Independence Hall toward national rather than local history. In February 1855, the newly renovated Assembly Room, now housing the city's national portrait collection, was opened to the public. The chromolithograph *Interior View of Independence Hall,* drawn by lithographer Max Rosenthal and published in 1856 *(Illustration 2),* only hints at the spectacular display that the new accessions made. The Peale portraits hung on every available inch of paneling. Because of their uniformity and spare, neo-classical design, the museum portraits complemented the interior architecture and presented a rhythmic, orderly appearance.

As the founder of the American museum movement, Peale approached the execution of his portraits of noted worthies as an exhibit design problem. The design of the portrait package—the frame, spandrel, and canvas support—was as critical to the painting's success as the image itself. Taking his key from the ovality of his miniature portraits, Peale placed a large, gilded wood spandrel over the surface of the canvas to soften its rectilinearity and create an oval picture plane. He out-lined his gilded frames with a carved husk and lozenge paterae that softened their edges, added a crisp rhythm, and aided the play of light across the burnished gilt and painted surfaces. In the Assembly Room, the portraits

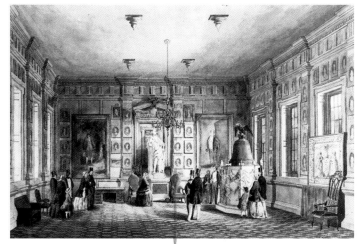

Illustration 2

became units of a modular design that guided the viewer around the exhibit walls. Seen in full sunlight or by flickering gaslight, the portraits must have presented a shimmering, fantastic world of faces.

Although they were painted by various hands over a thirty-five year span, the museum portraits have uniformity in their color range, tonality, and restrained design. All are bust portraits, and, while the sitter's direction varies, most are three-quarter views. In some portraits, such as *Samuel Smith* or *Nathaniel Greene,* the sitter stares defiantly at the viewer; in *Charles Thomson* and *John Hanson,* the sitter's direct gaze is softened by his facial attitude. But in many of the museum portraits, the subjects make no eye contact with their viewers. The honored sitter stares at a point beyond the viewer's shoulder, or, as in the examples of *Thomas Jefferson* or *John Adams,* the sitter fixes his gaze obliquely. In *Richard Henry Lee,* the subject, painted in profile, appears chiseled in stone.

This effect was intentional. With few exceptions, such as the portraits of Samuel Smith and John Hazelwood, whose naval exploits are depicted in rear ground scenes, the museum portraits have plain backgrounds of muted colors. This technique adds dimensionality to the sitter and focuses the viewer's attention on him. It also contributes to the conclusion that classical marble portrait busts were the inspiration for the design of Peale's museum portraits. Peale carried the ideals of American public portraiture in the new republic—identification with the sitter, public service, personal disinterest—a step further with his analogy in painterly form to the classical sculptural portraits of the Roman republic. But the effect of over one hundred portraits, all of uniform size and format with little variation of pose, displayed like a classical frieze around the museum's cornice would have been deadening had it not been for their one extravagance, the sitters' costumes.[9]

The sitters in the statesmen series all wear coats, waistcoats, and white shirts. While each sitter strove to portray himself as dignified and unpretentious in the best republican manner, no two chose the same attire. Jefferson's high-collared blue coat is set off by a yellow waistcoat; John Adams's dull, stolid olive-green suit and stiffly curled hair complement his restrained personality. Arthur Lee's figured mulberry jacket and lace neckerchief seem flamboyant by American standards, but the diplomat's long years abroad made Lee more cosmopolitan than some of his fellow sitters. Each statesman's hair or wig style lends individuality to his portrait; each man's neckerchief is uniquely knotted and gathered in folds or ruffles that cascade onto his waistcoat. The curvilinear ruffles are in sharp contrast with the sitters' stiff woolen coats.

The Revolutionary officers' portraits feature colorful uniforms individualized by their signs of rank and military decorations. *Henry Knox* contains the earliest depiction of the Order of the Cincinnati, the controversial society Knox helped found. The foreign officers' torsos gleam with braid, brass, silver, and jewels. Baron von Steuben's Star and Cross of the Baden Order of Fidelity is proportionally as large as his face.

The Peale portraits in the mid-nineteenth-century Assembly Room were not presented as the ultimate order of the Linnean hierarchy, as they had been in the museum on the second floor of Independence Hall thirty years earlier. Instead, the portraits were displayed as the enshrined images of the founders of the American republic. As seen in the Rosenthal drawing, explanatory labels were minimal. Visitors bore the responsibility of identifying each subject and of knowing his contributions to history. To facilitate the identification, the city published its collections for the first time in the *Catalogue of the National Portraits in Independence Hall, Comprising Many of the Signers of the Declaration of Independence, and other Distinguished Persons connected with the Early History of the Noble Efforts which resulted in the Glorious Liberty We Now Enjoy.* The booklet listed the one hundred and six paintings as "the only authentic Portraits of the celebrated persons

9. For a detailed discussion of Peale's inspiration and methods in the museum portraits, see John C. Milley's Introduction to this publication, in which he compares the portraits to Roman cameos. For a discussion of studied simplicity in portraiture of the early republic, see Richard Bushman, "Portraiture and Society in Late Eighteenth-Century Connecticut," in Elizabeth Mankin Kornhauser, *Ralph Earl: The Face of the Young Republic* (New Haven and Hartford: Yale University Press for Wadsworth Athenaeum, 1991), 69–84.

10. The official opening ceremonies were held on 22 February 1855, George Washington's birthday. *JSC*, 15 February 1855, 97. The Consolidation Act, 2 February 1854, which unified the city and county boundaries, occasioned gifts from the various incorporated bodies to the city. Etter was a commissioner of the Borough of Southwark. The original purpose of the paintings is unknown. The *Franklin* is copied from the David Martin original. The *Jackson* is copied after Longacre's 1833 engraving, which is based on Wood's 1824 life portrait. Both paintings are kit-kat size. *JSC*, 1857–58, pp. 194, 228, 235; 353, 363, 371. Scharf and Westcott, *History*, 1:715, 3:1703; Watson, *Annals*, 2:604–05. "The Hall of Independence," Unidentified newsclipping, 5 January 1855, cited in Ridgeway, *Philadelphia Scrapbooks;* "Independence Hall and Fairmount Park," LCP; *Public Ledger*, 8 January 1855; Catalog, 1856, INHP.

11. JSC, 1857–58, 194, 228, 235; 353, 363, 371. Donation record, Paine portrait, INHP specimen folder.

12. The exact circumstances of the Morris portraits are unknown. They are believed to have been commissioned for Morris's private residence. The city purchased the *Washington* with funds appropriated on 24 November 1862. *City Controller's Reports, Appropriations 1861–1862.* Municipal Archives, 159. For a view of the unpopularity of historical painting in the nineteenth century, see Mark Thistlethwaite, "Patronage Gone Awry: The 1883 Temple competition of Historical Paintings," *PMHB* 92.4 (October 1988) : 545–78. On Peale's *Washington,* see Hevner, *PMHB* 90.1 (January 1986):6.

whom they represent extant. …" This total included copy portraits of Benjamin Franklin and Andrew Jackson by David Rent Etter, which the city had received in March 1854 as gifts from the Borough of Southwark when the city consolidated its jurisdiction.[10]

Rosenthal's drawing shows that the exhibitions in the Assembly Room included not only portraits but also relics and objects with a historic association. No records survive to indicate who was the curator or organizer of this lavish display. Although there are arguable internal inconsistencies in the exhibit, the overriding theme seems to have been the founding of American government. The Liberty Bell was displayed on a special stand that had been designed by hydraulic engineer Frederich Graff. The stuffed bald eagle perched atop the Liberty Bell had belonged to Peale's menagerie and had once flown freely about his museum. Thomas Sully's painting of the coat of arms of the City of Philadelphia that had once graced William Strickland's triumphal arch in honor of Lafayette was now in the Assembly Room. In front of Sully's painting was a chair designed by John Fanning Watson, after the chair made in 1779 for the presiding officer of the Pennsylvania Assembly, and later used by George Washington as president of the Constitutional Convention. Watson christened his masterpiece the "Liberty and Equality Chair," because its prototype, then the property of the Commonwealth of Pennsylvania in Harrisburg, was popularly believed to have been used by John Hancock in 1776 when the Declaration of Independence was signed. Watson's chair was constructed entirely of relic wood. Several other furniture items in the 1855 Assembly Room, including the desk and the two large upholstered armchairs on the east wall in the Rosenthal drawing, were associated by legend with the Declaration of Independence.

The attention that the new shrine received inspired others to contribute portraits of American heroes to it. The artist Bass Otis donated a copy portrait of William Alexander in 1858, and a copy portrait of William Bradford, Jr., in 1859. That same year, a group of twenty-five admirers of Thomas Paine contributed a copy portrait of the patriot by Otis. The addition of a portrait of a political philosopher somewhat broadened the scope of the collections. More significant is the introduction of copy portraiture, which began during this decade and continued throughout the century. Many of these copies were given by descendants of the subjects. In 1860, for instance, a descendant of George Read, a signer of the Declaration of Independence, gave a copy portrait of his ancestor made by Thomas Sully after the original by Robert Edge Pine. The admission of copy works and their parameters in terms of their sources and degree of adaptation gave rise to some of the most venomous disagreements about the collections in the twentieth century.[11]

With the possible exceptions of Charles Willson Peale's *Robert Morris* and *Mary White Morris,* large domestic companion portraits purchased in the 1854 sale, the portraits in the city's collection adhered to established standards of public presentation. However, each portrait's authenticity, its fidelity to the sitters and its degree of remove from him, were never at issue among those who assembled the collection in the nineteenth century. Historical portraits were not regarded as works of art. The Peale collection contained life portraits, replica portraits, and copy portraits created according to the artists' expediency. By the mid-nineteenth century, there were few living who had personally known the subjects of the Revolutionary portraits. The public was acquainted with the images of historical figures through the popularity of published portrait prints. Visitors to the exhibit in Independence Hall relied upon comparison with published images of the subjects as tests of the paintings' correctness. Thus, when copy portraits, some of which had been made from print sources, were first admitted to the collection, their impact was not questioned. In 1862, when Rembrandt Peale's large equestrian portrait of Washington was purchased at the artist's estate sale, the painting was rightfully considered an important acquisition, although it was known that Peale had created an assembled image of the hero.[12]

Before and during the Civil War, the Assembly Room of Independence Hall achieved a growing recognition as a shrine to liberty. The building had become a popular spot for visitation, and the objects it housed had taken on increased significance as the material expressions of a growing civil religion. Writers wrote of the Hall in devotional terms, proclaiming it "a shrine at which millions of American hearts worship and beat with thrilling intensity; it is a Mecca where unrestricted homage is paid." Many regarded visits to the Hall as a pilgrimage, an act of fealty to the nation's forefathers. The tradition of holding funerary obsequies to national heroes in the Assembly Room furthered the public's reverential feeling toward the site. The body of Henry Clay, a symbol of national unity in the antebellum era, was honored in Independence Hall in 1852. In April 1865, more than eighty-five thousand people filed through Independence Hall to pay their last respects to President Lincoln, whose body lay in state in the Assembly Room for two days.[13]

After the Civil War, the City of Philadelphia maintained its commitment to the collections of portraits and relics. In January 1869, the city spent two thousand dollars to renovate the portraits and regild their frames. That same year, an updated catalog of paintings listed 125 images.[14]

The collections and their care would probably have remained at this level for some time, had it not been for the nation's impending centennial. In January 1870, the Select Council of the City of Philadelphia resolved to celebrate the anniversary with an international exposition, and to seek congressional support for it. Joseph Shoemaker was named chairman of a Committee of [City] Councils on the Centennial. This committee successfully lobbied Washington, and in March 1872, the United States Centennial Commission was organized. Although the celebration was ultimately financed by private donations, Congress established a Centennial Board of Finance to raise funds by a stock subscription.

To many, Independence Hall might have seemed a logical site around which to center a centennial celebration of the nation's birth; but by the 1870s Philadelphia's business and civic center had moved far to its west. Independence Square had become an island surrounded by heavily-developed city blocks full of small businesses and light industry. The site that was selected for the Centennial fairgrounds was a 450-acre plot in the city's recently created Fairmount Park, several miles west of Independence Hall. Eli K. Price, chairman of the Fairmount Park Commission, coordinated the city's Centennial efforts by hosting a meeting at his home on 2 March 1872, to decide how to include historic Independence Hall in the celebration.[15]

The group that met with Eli Price wanted to refurbish Independence Hall's appearance to a level in keeping with its stature as a national shrine. The entire first floor of the building would be devoted to commemorative displays of portraits and relics. Patriotic ceremonies would take place in Independence Square on 4 July 1876.

Eli Price's meeting solidified local support for the development of Independence Hall as a national shrine. On 20 April John L. Shoemaker successfully sponsored a bill that obligated the city to restore the building in time for the Centennial. The object of the ordinance, Shoemaker explained, was to provide for the restoration of the Hall to its original appearance. The Committee of Councils on the Centennial recommended that for the one-hundredth anniversary of the Declaration of Independence, the Assembly Room should appear as it did in 1776. They also suggested that portraits "of the actors in that great drama" be acquired by loan or by gift and placed in the room. In May, the mayor appointed the Committee on Restoration of Independence Hall to carry out the ordinance. This committee's membership included the presidents of City Councils, John L. Shoemaker, and former mayors. The chairman was Frank M. Etting *(Illustration 3)*.[16]

13. Belisle, *History of Independence Hall,* 29. On May 7, 1863, City Councils resolved to grant the use of Independence Hall for twenty-four-hour lyings in state of members of the armed forces. *JCC,* 7 May 1863, 274; *Young Reaper,* New Series, 2.4—Whole No. 172, 1857; Weigley, *Philadelphia,* 417. For thoughts on American civil religion, see Russel E. Richey and Donald G. Jones, eds., *American Civil Religion* (New York: 1974); James Mathiesen, "Twenty Years After Bellah," *Sociological Analysis* 50 (2:1989):129–49; and Eric Hobsbaum and Terrence Ranger, eds., *The Invention of Tradition* (New York: 1983).

14. The records do not reveal which portraits were restored, or what these restorations entailed. *Controller's Reports, Department of Surveys and Fire, Board of Revision, Markets, and City Property,* 28 March 1869, Municipal Archives, 122. *Catalogue* 1869, Horace Wells Sellers Collection, INHP.

15. Dorothy Gondos Beers, "The Centennial City, 1865–1876," in Weigley, ed., *History of Philadelphia,* 460 et seq. HSP, Notice and Minutes of initial meeting held to discuss restoration of Independence Hall, 2 March 1872, Etting Collection; HSP, "Philadelphia and Suburbs. Independence Square. A Plan for its Improvement, Monument of Memorials," unidentified newspaper clipping, n.d., Etting Collection.

16. *JSC* 4 April 1872, 273; 11 April 1872, 294–95, 312; and *JCC,* 11 April 1872, 371. *Digest of Laws and Ordinances Relating to the City of Philadelphia,* 20 April 1872, 243; HSP, Etting Collection, Scrapbook Relating to the Restoration of Independence Hall, Vol. I William Stokely, Mayor to Committee on Restoration, 3 May 1872.

17. Etting was a member of the Historical Society of Pennsylvania and the American Philosophical Society. He married Alice Taney Campbell of Baltimore on 27 October 1868. She died in 1882, and he died without issue in 1890. Frank Willing Leach, "Old Philadelphia Families, CLV, Etting," *The North American* (March 1913); Henry Samuel Morais, *The Jews of Philadelphia* (Phila: The Levytype Co., 1894), 434.

18. Etting received the chair from his relative, Mrs. William Meredith, the elder, a niece of Gouverneur Morris who obtained the chair when the furniture from the Hall was dispersed. Frank M. Etting, *An Historical Account of the Old State House now known as the Hall of Independence,* 2d ed. (Phila: Porter and Coates, 1891), 166. Subsequent scholarship proved the chair, one of a set, had been used in Congress Hall by the U.S. Congress from 1791 to 1800. For a detailed account of the chairs from Independence Hall, see Part D, Appendix 3 of the *Furnishing Plan for the Second Floor of Congress Hall* (Phila: Staff, Independence National Historical Park, 1963), 136–64; Etting, *An Historical Account,* 167; HSP, Etting Collection, "Independence Hall," *The American Historical Record,* October 1872.

19. HSP, Etting Collection, Scrapbook Relating to the Restoration of Independence Hall, I.7. Frank M. Etting to John L. Shoemaker, chairman of Committee of Councils on the Centennial, 29 April 1871. Etting was not above using others' ideas to achieve his ends. His ideas for the restoration were taken almost verbatim from Joseph Leeds, *One Hundreth Anniversary of the Declaration of Independence, and Independence Square in Philadelphia, as a Monument of memorials sacred and forever* (privately printed for the author, 1870) a copy of which is in the Etting Papers, HSP, annotated in Etting's own hand. Leeds presented his proposals at Price's home in 1872.

20. Mayor Stokely once referred to Etting as "the chief mainspring of this work of restoration on this Hall." *Philadelphia Press,* 8 June 1875; Etting, *An Historical Account,* 169. HSP, Etting Collection, Frank Etting to Unidentified Person [Jas. R. Osgood], circa September 1874. The chair, known today as the Rising Sun Chair, was constructed in 1779. The chair used in 1776 was destroyed or removed by the British during their 1777–78 occupation of Philadelphia. The table, however, was not original to the room; it was likely in the secretary's office or the Senate chamber of Congress Hall from 1791 to 1800. HSP, Etting Collection, Scrapbook Relating to the Restoration of Independece Hall, Vol. 1, "Independence Hall—Its Restoration by the City. All Miscellaneous Matter Removed," *Philadelphia Inquirer,* 22 July 1872; "Independence Hall," unidentified newsclipping, 22 July 1872.

More than any other member of the restoration committee, it was Frank Marx Etting who worked tirelessly to prepare Independence Hall for the Centennial. A member of Philadelphia's prominent Gratz family, he took his law degree at the University of Pennsylvania in 1854. When war broke out, Etting was commissioned a paymaster in the Union army, with the rank of major. Etting remained in the army after the war. Upon his discharge in 1870, he returned to Philadelphia and became involved in a variety of civic projects, serving as the director of Philadelphia's public schools and chief of the Historical Department of the Centennial Exposition.[17]

Photo by Wenderoth, Taylor & Brown.

FRANK M. ETTING

Illustration 3

According to his own account, Etting became interested in restoring the Assembly Room after inheriting a chair he believed had been used in Independence Hall during the signing of the Declaration of Independence. In 1865 Etting discovered two more such chairs at the state capitol in Harrisburg, and, shortly thereafter, a fourth at the American Philosophical Society. Finding these four chairs convinced Etting that the restoration of the Assembly Room to its appearance in 1776 was possible. "The very existence of these four chairs," Etting later stated, "afforded the wherewithal for the conviction that such 'restoration' as [I] then contemplated … was feasible, whenever permission could be obtained to undertake the work."[18] Etting coveted the position of chairman of the Committee on Restoration of Independence Hall. In April 1871, Etting wrote to John L. Shoemaker, and proposed the restoration of the room where the Declaration of Independence was formulated "to its original state, or at least, as near thereto as practicable." He also made specific suggestions for proceeding: first, to remove the assortment of portraits and relics in the Independence Chamber, which had no association with the struggle for independence, and to place them in a city museum; second, to reclaim the furniture that originally graced the chamber, and third, to obtain, "as far as practicable," portraits of those Signers that the city did not already possess. He observed that the approaching centennial of the nation's independence provided an ideal impetus for the project. Dismissing previous restoration efforts, Etting stated that the Assembly Room had become a mere depository for miscellaneous portraits and objects that "have no association therewith, but serve in many instances to deface it." Shoemaker was impressed with Etting's proposal; with his strong support, Etting was made chairman of the Committee on Restoration.[19]

Etting regarded the committee as his own, often making decisions in its name and speaking for it. He later claimed that "… the restoration of Independence Hall is absolutely the result of my individual researches and predicated exclusively upon them. …" Following his appointment, he immediately began to institute changes at Independence Hall. On 21 July 1872 he and a fellow committee member began removing those items not directly related to the Assembly Room as it appeared in July 1776. Portraits "relating to subsequent persons or events" were transferred to the offices of the Fidelity Safety, Trust and Deposit Company on Chestnut Street, to await later installation in a restored Court of Common Pleas room. The Liberty Bell was moved to the south entrance of the building. William Rush's statue of Washington, which had stood at the eastern end of the room, was moved to the northwest corner to make way for a table and chair believed to have been used by the president of the Continental Congress.[20]

By November 1872, the eighteen available portraits of the signers of the Declaration of Independence had been rehung. They were now placed on walls closest to where Etting believed the members had actually sat at the time the great Declaration was signed. Accordingly, President John Hancock's portrait occupied a place of prominence in the room. Likenesses of the presidents of the Congress of the Confederation and the officers of the Revolution were also placed around the paneled room, insuring, in the flowery language of Etting, that "not only the sponsors of the Republic [would] speak from the walls, but memorials of the Father of his country and of those who assisted to nurture and rear the young offspring, [would] be forever preserved in its birth chamber." Etting viewed the portraits as surrogates for the men who had struggled for America's independence. The images were to serve both an instructive and an inspirational function for viewers. In large part for that reason, only portraits that had been "absolutely authenticated" earned a place on the walls of the Assembly Room. For Etting, an authenticated portrait was either one taken from life or an accurate copy after an established life likeness.[21]

With the approaching Centennial, the demand for images of the signers increased, and several enterprising individuals fabricated portraits to meet it. To guard against counterfeits, the committee consulted descendants of the missing signers and other patriots as to "the most appropriate and satisfactory way to perpetuate their memory in the chamber" when a known likeness did not exist. A descendant of signer John Morton responded by sending an escutcheon in gray marble, inscribed with Morton's birth and death dates, to display in place of a portrait. Others—such as Nathaniel Heyward, who gladly sent a copy portrait of his ancestor Thomas Heyward, by Charles Fraser after Jeremiah Theus's original, and a descendant of Josiah Bartlett, who sent a copy portrait of the patriot by Caroline Weeks after John Trumbull—believed it their civic duty to supply the requested images.[22]

Etting's dogged pursuit of Revolutionary portraits and relics as supportive exhibitry in the Assembly Room was, in some ways, ironic. Richard Bushman notes that the subjects of Connecticut River Valley portraits in the late eighteenth century deliberately avoided the label of "aristocracy" in their self-presentations. These members of the new American republic attempted to create a class of "gentility" that was seemingly devoid of social discrimination and outward expressions of wealth. By the Centennial, there seems to have been a deliberate attempt on the part of Etting and others to create an aristocracy using the very portraits their forebears took pains to create. Now, the portraits became definitions of a hegemony that ruled by inheritance or descent and that consciously created social barriers to admission into it.[23]

Early in 1873, with restoration efforts in the Assembly Room progressing smoothly, the city's Select and Common Councils decided to expand the project to include all of Independence Hall and Square. At Etting's insistence, Common Council appropriated two thousand dollars to convert the Court of Common Pleas into a permanent National Museum. This museum would be an auxiliary of the Assembly Room across the hall. Portraits and relics not associated with the founding of American government were to be exhibited in this area.[24]

Meanwhile, Frank Etting, through the committee, began to acquire authentic copy portraits. He hired artist James Read Lambdin to copy the portraits of seven signers that had been discovered in Hartford and New Haven, and sent Philip Wharton to Lancaster to copy a portrait of Pennsylvania signer George Ross, and to Charleston to copy images of Arthur Middleton and Edward Rutledge. A Philadelphia relative presented a miniature of South Carolinian John Laurens, by Charles Willson Peale. The *Laurens* was a copy made posthumously. By the end of 1873, Etting had added seventeen copy portraits to broaden the spectrum of historic heroes.[25]

21. HSP, Etting Collection, Scrapbook Relating to the Restoration of Independence Hall, Vol. 1, "Independence Hall," *American Historical Record,* October 1872; "Philadelphia and Suburbs, Independence Hall. Its Restoration by the City—Some New Facts Connected with the Change—How It Was Brought About," unidentified newsclipping, circa November 1872. To showcase the newly-installed portrait collection, the city published an updated Catalogue with 131 entries, 7 more than the 1869 catalogue. *Catalogue,* 1872, Chew Collection, INHP; Frank Etting, "The National Museum. Independence Chamber," written originally for the *Penn Monthly,* 2d ed. (Philadelphia: W. W. Bates, Printer, 1873):3; *Preliminary Report of Committee,* 4, all INHP.

22. *Preliminary Report of Committee,* 5, INHP Archives; Paintings folders, *Thomas Heyward,* and *Josiah Bartlett,* INHP files.

23. Bushman, 80–82.

24. *JSC,* Appendix 128, 276. *JCC,* 22 May 1873, 453–54; Appendix 340, 716–17. On 12 June members of Common Council voted to pass the bill, and on 19 June Select Council notified Common Council that they supported the appropriation; *JCC,* 12 June 1873, 555; 19 June 1873, 613.

25. Full data on each portrait are listed within its entry in this catalog. HSP, Etting Collection, Scrapbook Relating to the Restoration of Independence Hall, Vol. 1, "Portraits," hand-written note by Frank Etting. William Henry Heyward to Frank Etting, 30 May 1872; "Philadelphia and Suburbs—City Government. An Addition to the Portraits of the Signers …," unidentified newsclipping, 24 April 1872; Philip Wharton to Frank Etting, 1 April 1872; Mrs. Olmsted to Frank Etting, 24 March 1873; unidentified newsclipping, 23 September 1872; *Evening Bulletin,* 13 January 1873; Joseph McClellan to Frank Etting, 22 February 1873; *JSC,* Appendices 191–92, 15 May 1873, 374–76. Frank M. Etting, *Memorials of 1776,* 2d. (Phila: W.W. Bates, Printer, 1873), 8, INHP.

26. *Minutes for Board,* 2 July 1873, INHP. Mary Johnson Chew (1839–1927) served on the board from 1873 until its termination in 1921. She was secretary from 1874 until 1899. Chew Collection, INHP.

27. Board of Lady Managers to Corresponding Secretaries, r.d. (rough draft). Mrs. William Mayo, Richmond, Va to Frank Etting, 8 March 1875, Chew Collection, INHP.

28. *Preliminary Report of Committee,* 6–7, INHP. HSP, Etting Collection, Scrapbook Relating to the Restoration of Independence Hall, Vol. 1. "The National Museum at Independence Hall. The Second Day of July to be Appropriately Commemorated," unidentified newsclipping, circa June 1873; "Strange Proceeding. The Representatives of the Daily Papers Excluded from Independence Hall," *The Age,* circa 5 July 1873; "Boss Etting, The Restorer," *Sunday Times,* 6 July 1873.

29. HSP, Etting Collection, Scrapbook Relating to the Restoration of Independence Hall, Vol. 1; "Too Much Local Leaven," *Philadelphia Inquirer,* 27 October 1873. Next to this article Etting noted, "More assistance ? from Penn Inquirer—and from the illiterate Publisher of this paper in Plain English." The "Publisher" was William H. Harding, who served as publisher of the *Philadelphia Inquirer* from 1860 to 1889; The Pennsylvania Historical Survey, Division of Community Service Programs, Work Projects Administration, comps., *A Checklist of Pennsylvania Newspapers, Vol. 1, Philadelphia County* (Harrisburg: Pennsylvania Historical Commission, 1944), 218.

30. *JCC,* 4 December 1873, 246; Appendix 218, 308–10; *JSC,* 11 December 1873, 237–38; *JCC,* 23 December, 1873 351–52; Appendix 299, 410; *JSC,* 23 December 1873, 291. See Chapter 1 for more on the Harrison paintings. Henderson, *The Pennsylvania Academy,* 332; Scharf and Westcott, *History of Philadelphia,* 3:1859, 2258–59. Frank Etting to Mme. Lily M. Berghmans and others, Board of Lady Managers of the National Museum, 25 October 1873, Chew Collection, INHP. A synopsis of Etting's letter may be found in *Public Ledger,* 27 October 1873.

The restoration committee also formed a new sub-committee of nine socially prominent Philadelphia women, the Board of Lady Managers of the National Museum. Etting hoped that this board would strengthen the restoration committee's influence nationally by enlisting female correspondents of similar social stature in each of the states of the Union. Led by its president, Lily Macalester Berghmans, the Board of Lady Managers pursued Etting's suggestion for a campaign to secure donations and loans to the collection. Through its efforts, Independence Hall acquired several hundred relics of the colonial and Revolutionary past, among them a British officer's sword, a written description of the battle at Concord, a Meschianza ticket, the canteen box and Indian axe of General Israel Putnam, and Daniel Webster's teapot.[26]

Obtaining relics from the newly Reconstructed South was extremely difficult. "I wish we could touch with a magic wand the ashes to which our souvenirs were reduced," wrote Virginian Mrs. William Mayo—whether with regret or bitter irony we cannot know—"and see them spring into their material forms like the fabled Phonix [*sic*] of old. We would send them to the centennial."[27]

For a time Etting and the committees were treated quite favorably by the local press. However, his high-handed leadership soon got him into trouble. When Etting excluded reporters from the organizational meeting of the Board of Lady Managers in July 1873, the press assailed him. "It is a question by what right this gentleman assumes such a prerogative," one reporter noted, "and another whether Independence Hall [chamber] and its auxiliary are to be used solely as the whims of any person may dictate, or for the benefits of the public, whose representatives the newspapers of Philadelphia are." The newspapers also questioned the qualifications of the society matrons of the Board of Lady Managers to manage a national museum.[28]

Etting's brusque treatment of the press was a serious mistake. By excluding them, he alienated valuable support early in the restoration campaign. In fact, the news articles were the start of a mounting press criticism that was to plague Etting and his committees for the next three years. During these years, the newspapers repeatedly charged Etting with abusing his position as chairman. Independence Hall, wrote one reporter, belonged to **all** the citizens of the United States, not just to Philadelphians, and its restoration was rightfully a national project. Instead, he complained, Etting and his groups proceeded "by virtue of their own self-assumption" as if they were "not only the bona-fide owners of Independence Hall but the original authors of the Declaration and the head and shoulders of the Centennial." Only when these gentlemen recognized the Centennial celebration as a national one, the reporter concluded, would the rest of the country so recognize it and take an interest in its success.[29]

Press criticism eventually helped undermine Etting's political support in the City Councils. Vocal members of the Councils soon publicly accused him of being stubborn and overbearing. Eventually this erosion of Etting's support in the Councils would lead to his removal as chairman of the restoration committee.

Despite the controversy, Etting and his committees moved forward with the project at Independence Hall. He prepared the Court of Common Pleas chamber for its new use as the National Museum. He also added to the collection with an important gift from Joseph Harrison: the paintings Harrison had purchased at the sale of the Penn family treasures in England in 1851. These were Benjamin West's *Penn's Treaty With The Indians,* Allan Ramsay's replica of his full-length life portrait of George III, and three-quarter length copy portraits of Charles I, William III, Mary II of England, Queen Anne, George I and George II. Thus, only the portraits of Charles I, Charles II, James I, and James II were needed to complete the series of British sovereigns of the colonial era.[30]

The Committee on Restoration of Independence Hall focused on the development of the portrait collection. The committee broadened its quest for portraits to include not only the signers of the Declaration of Independence, but also representations of all who took part in the debate and the vote on the document. In 1874, the State of Maryland donated portraits of Thomas Stone and William Paca by Francis Blackwell Mayer after Charles Willson Peale, and *Thomas Johnson* by Mayer after John Beale Bordley. At the same time, the Restoration Committee took an important step toward preserving the portraits already in the collection. An examination of the paintings had revealed that thirteen of the images purchased in the 1854 Peale sale, along with several older canvases in the collection (including Inman's portrait of William Penn), had been treated with copal varnish, a very hard resin that darkens with age and is difficult to remove. Warned that the varnish would eventually destroy the paintings, the committee had the paintings cleaned and the varnish removed.[31]

At Etting's insistence, items in the National Museum were so arranged that those associated with each other historically were grouped together. The charter of the incorporation of the City of Philadelphia, signed by William Penn, was displayed between a borrowed likeness of King Charles II and West's *Penn's Treaty with the Indians,* and a facsimile of the Non-Importation Resolutions of 25 October 1765 was placed near the portrait of King George III. Items relating to Pennsylvania's history now occupied an area of the installation.[32]

Meanwhile, Etting persuaded a Boston publishing firm to publish his *Historical Account of the Old State House of Pennsylvania now known as the Hall of Independence,* which appeared in 1876. He also invited "American Historians, Biographers and Literati" from across the United States to write biographies of every individual whose memory was associated with Independence Hall during the early days of the Republic, and to read their two-page sketches in a ceremony at Independence Hall on 2 July 1876. Following the presentation, the documents would be placed in the National Museum's archives.[33]

The most valuable addition to the collections of the National Museum in the pre-Centennial years was a selection of small pastel drawings known as the Sharples collection. This group of pastel portraits represents the work of the British artist James Sharples and his sons, James, Jr., and Felix, and his wife, Ellen. The pastels were executed during the family's two visits to the United States, the first from 1795 to 1801 and the second from 1809 to 1811.

In *The Sharples,* Katharine Knox suggests that the artist came to America with the idea of developing a semi-public portrait collection of "American notables" for England, like those Charles Willson Peale and John Trumbull were building in America. In England, Sharples had advertised himself as a "Portrait Painter in Oil and Crayons." In America, however, he worked exclusively in the latter medium. His decision to do so was a calculated one. In America, accomplished artists working in colored crayon were virtually nonexistent. Furthermore, because pastels were cheaper than oils, they could generate high-volume sales, and the necessary materials—crayons and paper—could easily be transported from place to place.[34]

Sharples's images are small, measuring approximately seven by nine inches, and minutely rendered, with careful attention given to the sitter's features and attire. The colors, laid down on slate colored paper with soft pastels, are velvety and delicate. The Sharples are bust-length portraits; but, unlike the Peale images of "noted worthies," which were created for a public display, the Sharples's subjects are more engaged with the viewer, frequently making direct eye contact. The sitters' postures demonstrate more variety and often include full-face as well as three-quarter and profile views. The present frames on the

31. *JSC,* 15 October 1874, 78; Appendix 28, 45–48; Appendix 29, 48; *JCC,* 30 November 1874, 323; HSP, Etting Collection, *General Assembly of Maryland, File of the Senate,* No. 181; Mr Stevens—Finance, 16 March 1874, and *Second Report,* 1–2. Tom Carter, National Park Service conservator, supplied information on copal varnish. The Department of Markets and City Property paid artists Charles F. Berger and his son $65 for "Restoring Thirteen Portraits of the Signers of the Declaration of Independence." *Controllers Reports, Department of Surveys and Fire, Board of Revision, Markets and City Property,* 27 March 1874, Municipal Archives, 190, and HSP, Etting Collection, voucher for same.

32. *List of Articles Received in the National Museum,* 29 November 1873, INHP. The portrait of Charles II was loaned to Independence Hall by Mr. William Thompson. Etting, *An Historical Account,* 188; 180.

33. HSP, Etting Collection, Frank M. Etting to Jas. R. Osgood, Esq., Boston, 9 September 1874. *Minutes of the Committee on Restoration of Independence Hall,* 4 June 1874, INHP; HSP, Etting Collection, Scrapbook Relating to the Restoration of Independence Hall, Vol., 1, "Restoration of Independence Hall," *Philadelphia Inquirer,* 3 January 1876; Frank Etting to American Historians, Biographers and Literati, rough draft of form letter, 25 October 1875; Frank Etting to Hon. Charles Francis Adams, n.d.; James H. Means to Frank Etting, 22 December 1875.

34. Ellen Wallace (1769–1849) was Sharples's third wife; they married around 1787. The maiden names of his first two wives are unknown. Felix (circa 1786–1830/5[?]) was the product of Sharples's second marriage; James, Jr. (circa 1788–1839) and Rolinda (who worked only in oil, 1793–1838) were products of the third marriage. Knox, *The Sharples,* 4–5; Richard Quick, comp., *Catalogue of the Sharples Collection of Pastel Portraits and Oil Paintings, etc.* (Bristol, England: J.W. Arrowsmith, Printer, n.d.) n.p.; Arnold Wilson, "The Sharples Family of Painters," *Antiques* 100 (November 1971):742; Karol A. Schmiegel, "Pastel Portraits in the Winterthur Museum," *Antiques* 2 (February 1975):330–31; Scharf and Westcott, *History of Philadelphia,* 2:1045; John C.Milley, "Thoughts on the Attribution of Sharples Pastels," *University Hospital Antiques Show Catalogue* (Phila., 1975), 60; Carolyn J. Weekley, "Artists Working in the South, 1750–1820," Antiques 10 (November 1976): 1046–55; Alice E.A. Hunt, "Notes on Felix Thomas Sharples," *The Virginia Magazine of History and Biography* 59 (April 1951): 214–19; Henderson, *Pennsylvania Academy,* 317–20; Knox, *The Sharples,* 8. The term "crayon" as used by Sharples and his contemporaries, referred to a pigment in a chalk medium, commonly called a "pastel" today, not to a pigment in a wax medium.

35. William Dunlap, *A History of the Rise and Progress of The Arts of Design in the United States* (1834; reprint, New York: Dover Publications, Inc., 1969), 2:70–71. Dunlap had his portrait taken by Sharples.

36. Knox, *The Sharples*, 13. Mrs. Ellen Sharples's Diary, 1803–1836, Bristol Academy for the Promotion of the Fine Arts (microfilm, reel 502, INHP).

37. An advertisement for the portraits ran in the *New York Public Advertiser* from 6 April 1811 to 10 July 1811. Knox, *The Sharples*, 45. Although Ellen Sharples mentions only her husband in the advertisement, it seems safe to assume that each member of the family, Rolinda excepted, had contributed a number of images to the collection. Ellen Sharples's diary, April 1811, Bristol Academy. Ellen Sharples also carried a number of the pastels back to England with her. She subsequently bequeathed these and other images (ninety-seven in all) to the city of Bristol, together with an endowment to found the Bristol Fine Arts Academy. Ellen Sharples died in Clifton, England, in 1849. Quick, comp., *Catalogue of the Sharples Collection*, 5.

38. Knox, *The Sharples*, 49. The estate is variously spelled as "Yeardley" and "Yardley." Professor R. B. Winder, M.D., D.D.S., of Baltimore in Clarence Winthrop Bowen, *Centennial Celebration of the Inauguration of Washington* (1892), 441 n. Reprinted in Knox, *The Sharples*, 47. F. P. O'Neill, reference librarian, The Maryland Historical Society provided biographical information on Winder, Harrison, and Tilghman.

39. Throughout the primary and secondary literature about the Sharples pastels, there is disagreement as to how many there were in the collections of various owners. Misidentification of the subjects further contributed to this problem. Regardless of how many pastels were originally offered, a careful review of INHP records indicates that the city purchased 10 pastels from Harrison in 1873, 11 from him in 1875, and 23 from him in 1876. HSP, Etting Collection, Scrapbook Relating to the Restoration of Independence Hall, Vol. 1, Tench Tilghman to G. W. Harris, 8 November 1873 (microfilm, reel 95, INHP).

40. HSP, Etting Collection, Scrapbook Relating to the Restoration of Independence Hall, Vol. 1, Tilghman to Etting, 12 November 1873; Etting to Tilghman, 26 December 1873; Harrison to Etting, 9 May 1874; Etting to James Claghorn, 25 July 1874; Shoemaker to Etting, 4 August 1874, and 14 August 1874 (microfilm reel 95, INHP); List of Articles Received in the National Museum, 7 January 1874, No. 51, INHP.

pastels are believed to have been designed by Frank Etting after information he had about a documented original. The frames complement those on the Peale portraits. Although the pastels were worked to the edges of the paper, the black enameled spandrel with carved and gilded bevel re-forms the image into an oval format.

Sharples found a ready market in the United States for his work, and he rapidly established a reputation as a skilled portraitist, capable of producing simple, yet authentic, likenesses for a modest fee. William Dunlap even included the pastelist in his two-volume *History of the Rise and Progress of Arts of Design in the United States.*[35]

As Sharples's reputation grew, so did the demand for his original portraits, and his copies after originals. His wife, Ellen, who had previously sketched only for her own amusement, began to assist in her husband's work. Sharples's sons, James, Jr., and Felix, also drew portraits in crayon, but they did not work professionally until the family's second trip to the United States in 1809.[36]

The story of how a selection of Sharples's pastels came into the collection of the National Museum is complex. On 26 February 1811, James Sharples, Sr., died in New York City. Ellen immediately began making preparations to return to London with her children, James, Jr., and Rolinda. After unsuccessfully attempting to sell "The Collection of Original Portraits of Distinguished American Characters painted by the late James Sharples," she gave most of the pastels to her stepson, Felix, who had elected to remain in America.[37]

Felix soon moved to Virginia, where he lived the life of an itinerant, traveling from one wealthy Virginia home to another sketching portraits. At some point he journeyed to "Yardley," the estate of the Winder family in Northampton County, bringing with him the family collection of pastels and his drawing materials. He obtained a loan from Levin Winder and left the pastels behind as collateral. Felix never returned for the pastels. Many years later, Winder sold some or all of them—exactly how many is not clear. A group of them eventually wound up in the hands of a Baltimore textile merchant named Murray Harrison.[38]

Finding himself in straitened financial circumstances in 1873, Harrison offered the portraits for sale through his friend, patent agent Tench Tilghman. Tilghman sent an offer of sale to various parties including Etting, describing the Harrison collection as "the most unique collection of Revolutionary portraits now extant. They are cabinet size," Tilghman stated, "and were taken from life about 1790–1800, by the celebrated artist 'Sharpless' [*sic*]. They contained originally 234 of which there is a complete list; 100 were lost during the war, and also the labels from 58 others, leaving 76 identified and 58 unidentified, total 134." Tilghman quoted a price of three thousand dollars for the collection.[39]

For nearly three years, Etting worked tirelessly to acquire the collection of Revolutionary noteworthies for the National Museum. Because of Etting's strong interest, Harrison sent the pastels to Philadelphia where they were exhibited in Independence Hall. The city showed characteristic reluctance to purchase art with public funds. Some Council members, as well as members of the Restoration Committee, questioned Etting's judgment of the collections' merit. Undeterred, Etting attempted to raise money from art collectors. He also encouraged the Pennsylvania Academy of the Fine Arts or individuals to buy those portraits unsuitable for Independence Hall, believing that their purchase would entice Harrison to give the city a favorable price.[40]

The owner of the pastels and his agent were difficult negotiators; Frank Etting, however, was tenacious. Between 1874 and 1876, he arranged for three large purchases of Sharples's drawings. Funds for the purchases came from private donations, from various city departments and committees including the Committee on Restoration,

and through the efforts of the Board of Lady Managers. By 1876, Etting had added forty-four pastels to the collection by purchase and two more by gift.[41]

In retrospect, the acquisition of the portraits, in particular the Sharples collection, was Etting's greatest contribution to Independence Hall. During the Centennial period, from 1870 through 1878, 99 portraits were added, nearly all under Frank Etting's direction. Etting nearly doubled the previous fifty years' 113 acquisitions in a mere eight years. Not every portrait was outstanding. Many were copies, and the quality of the Sharples pastels varies greatly. But such treasures as Robert Feke's portrait of Philadelphia mayor William Allen, done in the style of Feke's Dancing Assembly series, and Charles Willson Peale's posthumous miniature of John Laurens were notable additions.

By the close of the Centennial, the collections and the first floor of Independence Hall had assumed their identity as a national shrine. While he did not initiate this transition, Etting hastened the process through his selection, arrangement, and interpretation of the collections. Charles Willson Peale had integrated his portraits into a microcosm of the natural world. His objective was rational entertainment, imparting to the viewer a sense of unity and harmony within all of nature. Etting did not display the portraits according to Peale's intentions. He saw them and the other collections as didactic aids for instruction in American History and patriotism. Every item in the Etting exhibits was exploited for its symbolic importance. Control of the collections passed, ever so subtly, from the public servants of the city to a volunteer board or committee. Gradually, the distance that the exhibits, the rituals and ceremonies, and the volunteers established between the visitors and the collections contributed to their enshrinement.

Etting's accomplishments were not so well regarded at the time. Detractors in City Councils continued to question his expenditures and to criticize him for his arrogance in viewing Independence Hall as his personal fiefdom. Etting responded to the complaints of his critics in kind, decrying municipal cronyism and corruption, and, with breathtaking audacity, putting forward a proposal that the city government relinquish administrative control of the collection to the American Philosophical Society and the Historical Society of Pennsylvania. By 1875, a virtual state of war existed between Etting and City Councils. It was a war that Etting could not possibly win.[42]

During the Centennial celebration, Etting coordinated those commemorative ceremonies that took place at Independence Hall. Though he did not know it at the time, these were to be his last official acts as chairman of the Committee on Restoration. On 13 July, Select and Common Councils approved an ordinance to reorganize the government of Independence Hall and the National Museum, stripping Etting of his powers. In the Council deliberations Etting had a few defenders, notably John Shoemaker; but they were far too few. Council member C. T. Jones expressed the anger of most of his colleagues in asserting that Etting was "unfit to occupy the position from the rude manner in which he invariably dealt with citizens who [had] business relations with him." The Committee on Restoration of Independence Hall continued in existence, but with Etting gone and the Centennial celebration passed, it languished until its official end in 1878. The Board of Lady Managers, created by Etting, recognized that his removal left them powerless. Although some individual members remained active in other capacities at Independence Hall until 1921, Etting's removal was also the board's dissolution. It should be remembered, however, that it was Etting, not his successors some twenty years later, who created the precedent for permitting a volunteer board to direct the shrine's operations.[43]

Etting reacted with bitterness. He withdrew items from his personal collection that he had placed on loan to Independence Hall and encouraged others to do likewise. Having alienated the press years before, he had no public forum in which to

41. HSP, Etting Collection, Scrapbook Relating to the Restoration of Independence Hall, Vol. 1, Tilghman to Etting, 23 August 1874; Harrison to Etting, 4 September 1874; Harrison to Etting, 17 September 1874; A. E. Slent to Etting, 20 September, 1874; Etting to unidentified person, 4 November 1874; Harrison to Etting 13 February 1875, (microfilm reel 95, INHP). Etting, "Handwritten list," "Articles Received since October 31st," 1874, n.d.; "Nov. 27th—The return of the Sharpless Collection," Chew Collection, all INHP. HSP, Etting Collection, MS notes, TS explanations presented to Board of Lady Managers by Committee on Restoration, 24 October 1874; Department of Markets and City Property, City of Philadelphia to Harrison, 21 September 1874 (Etting's copy). Tilghman claimed that the pastels were exhibited by the New England Historic Genealogical Society, but no record of that exhibit exists. The unsold pastels were returned to Harrison on 26 December 1877. He eventually sold them to R. Garrett and Son of Baltimore. *List of Objects Returned By and Received Into National Museum, Beginning In January, 1877,* Superintendent, K. V. Wilson, INHP.

42. HSP, Etting Collection, Scrapbook Relating to the Restoration of Independence Hall, Vol., 1, Frank Etting to William Dixey, Commissioner of City Property, 28 December 1875. *JCC* 27 December, 1875, 517–18; "Common Council," *Philadelphia Press,* 28 December 1875; "Common Council," *Philadelphia Inquirer,* 28 December 1875; "Col. Etting Explains," *Philadelphia Press,* 29 December 1875.

43. *JSC,* Appendix 15, 10 July 1876, 30. Once Select Council had approved the measure, Common Council followed suit. *JSC,* 13 July 1876, 57–59, 77. The ordinance had been strongly endorsed several days prior by members of Select Council's Committee on Law. *JSC,* Appendix 15, 10 July 1876, 30. John L. Shoemaker to Agnes Irwin, 18 July 1876; Henry Wharton to Mary Johnson Chew, 19 July 1876; K. J. Wharton to Mary Johnson Chew, 19 July 1876, all in Chew Collection, INHP.

44. HSP, Etting Collection, Scrapbook Relating to the Restoration of Independence Hall, Vol., 1, "Independence Hall: The Work of Restoration Completed," *Evening Bulletin*, 4 August 1876; "Classical councilmen. Bad English, Hog Latin and Uneducated Sign Painters Objected To," unidentified newsclipping, circa May 1889; "Bad English and Worse Latin. War Against the Tablets Placed on the Old Courthouse," unidentified newsclipping, circa May 1889; "English and History Bad," *Philadelphia Press*, 18 May 1889; Frank M. Etting to Editor of the *Press*, 20 May 1889; Etting, Frank Marx. Will Book 155, 318, Register of Wills, Philadelphia, PA.

45. The Pine portrait was a bequest of the Honorable Benjamin Moran, who died in 1886. By tradition, Moran acquired it from George Washington Phillips. It was accepted by Select Council on 16 September 1886 and by Common Council on 7 October 1886. Specimen folder, INHP files. For a discussion of this and Pine's other portraits of Washington, see Robert G. Stewart, *Robert Edge Pine: A British Portrait Painter in America, 1784–1788* (City of Washington: Smithsonian Institution Press for the National Portrait Gallery, 1979), 92–97.

46. There is a reference in an 1809 edition of *Port Folio* that notes a full-length portrait of James Hamilton by Benjamin West at the Woodlands, the estate of James Hamilton's nephew, William. Beckett was the son-in-law of William Hamilton's niece, Anne Hamilton Lyle. Charles Henry Hart, "Matthew Pratt, Artist: discovery and Restoration to the City of His Portrait of Governor Hamilton," *Times*, Philadelphia, 6 November 1892. All in specimen folder, INHP.

respond to the Councils' castigations. In 1889, on the centennial of Washington's inauguration as president, Etting attempted to ingratiate himself with the city by placing a commemorative plaque on the facade of Congress Hall at Sixth and Chestnut streets. Instead of gratitude, his efforts were met with ridicule. In his will, Etting made a final effort to wrest control of his beloved Independence Hall away from the city by bequeathing an endowment for a curatorial chair to the Historical Society of Pennsylvania and the American Philosophical Society, who would jointly administer the position. After Etting's death in 1890, the bequest was refused.[44]

Frank Etting's legacy to America is the national focus he brought to Independence Hall. His lack of tact and political acumen stood in stark contrast to the well-oiled public personalities of the politicians he had to win over. But, that same singlemindedness stood him well in acquiring the Sharples collection and in preparing for the Centennial. He won over the descendants of patriots and many of America's leading intellectuals. In just three short years he organized the National Museum. Etting owed a great deal of his success to his hard-working and loyal assistants, the Board of Lady Managers, a group he seldom acknowledged. But in the end, it was his own leadership that made portraits the accepted vehicle for interpreting the historic events at Independence Hall.

In 1877, the city placed the daily operations of Independence Hall under the care of Katherine V. Wilson, its first superintendent. She was not an aggressive, flamboyant leader like Frank Etting. During Wilson's eighteen-year superintendency, however, twenty-one portraits were given to the shrine. The majority of those donations were contemporary copies, but several were notable works of American portraiture.

In 1886, for instance, Robert Edge Pine's half-length *George Washington* was bequeathed to the city. A century earlier, Washington had sat to Pine at Mount Vernon and in Philadelphia. The artist made several replica portraits after his original. Whether the city's portrait was taken from life or is a replica is still debated. However, it is considered one of Pine's best works.[45]

In 1892, amateur art historian Charles Henry Hart claimed responsibility for convincing the city to transfer Benjamin West's full-length portrait of James Hamilton from its place of display in the new Philadelphia City Hall to the Independence Hall collection. This intriguing grand manner painting is the largest West portrait in America, yet Hart believed its artist had been Philadelphia painter Matthew Pratt. James Hamilton (1710–1783), lieutenant governor of the province of Pennsylvania, had been a patron of Benjamin West before the artist relocated to England. West took Hamilton's portrait when the provincial aristocrat visited his London studio. In fact, the artist signed and dated the portrait in 1767, the year Hamilton returned to America. The portrait descended to Henry Beckett, the spouse of a collateral Hamilton relative. In 1872 Beckett bequeathed the painting to the Spring Garden Institute, a Philadelphia technical school. The school, however, had nowhere to exhibit the five by eight foot painting and offered it to the city for display in the Fairmount Park buildings, presumably around the time of the Centennial. After the grand celebration, the city found wall space in its new City Hall for the large work of art. There, Charles Henry Hart "discovered" the portrait and convinced the city to transfer it to Independence Hall.[46]

No one in the Anglophilic climate of the 1890s questioned the juxta-position of James Hamilton, once imprisoned for his Toryism, with the Revolutionary pantheon of the portrait collection. Garbed in lace, brocade and velvet, standing in a formal posture beside a table covered with a satin cloth trimmed in deep gold fringe, a pillar in the distance, Hamilton is every inch the prosperous colonial. There is little about him that might be construed as republican virtue; yet, to the Gilded Age visitors to Independence

Hall, Hamilton's appearance was congruent with their version of a past built as much upon tradition as upon documentable fact.

There is little evidence that superintendent Katherine Wilson played an active role in seeking or championing acquisitions. By the last quarter of the nineteenth century, Independence Hall's reputation as a national shrine attracted donations. There does survive a drawing by Wilson of the exhibit arrangement of the portraits, indicating her involvement in their display. At the *fin de siècle,* the portraits had come under the control of new special interest groups and Wilson, nearing her retirement in 1898, assumed the role of their functionary.

The decision of the city government to remove the last of its municipal offices from Independence Hall in the 1890s and the simultaneous rise of patriotic societies, led to new questions about both the future uses of, and control over, Independence Hall. By 1894, three of those societies—the Colonial Dames, the Pennsylvania Chapter of the National Society of the Daughters of the American Revolution, and the Pennsylvania Society of the Sons of the American Revolution—were competing intensely for the privilege of stewardship of Independence Hall.[47]

In 1895, City Councils approved an ordinance to restore Independence Square, including its buildings, "to its Revolutionary appearance." Mayor Warwick appointed a group of city officers to execute the project and another group of private citizens to advise on it. These groups merged and became informally known as the restoration committee. To carry out the plan, Councils authorized an appropriation of $3,000, two-thirds of which was to be spent on the restoration of the paintings and their frames. At the same time, the Daughters of the American Revolution came forward with a plan to restore the soon-to-be-vacated second floor of Independence Hall. As part of the plan, architect T. Mellon Rogers agreed to oversee the project at no fee. In March 1896, the city resolved to let the DAR and Rogers execute the project under the supervision and control of the Bureau of City Property.[48]

Perhaps the publicity surrounding the restoration of the building inspired Reverend Nalbro Frazier Robinson, who, in the course of giving away all of his worldly possessions to join the Order of St. John the Evangelist in 1896, presented the city with Charles Willson Peale's portrait of his grandfather, Thomas Robinson. Peale painted this half-length portrait in 1784 as a private commission. The portrait depicts Robinson, a lieutenant colonel in the First Pennsylvania Regiment who served at Ticonderoga and Brandywine, in military dress wearing the Order of the Cincinnati. The painting made a valuable addition to the collection.[49]

In less than one year, the restoration was complete. On the anniversary of Washington's birthday, 19 February 1897, the DAR symbolically returned control of Independence Hall to the city during a ceremony in which the chapter regent, Mrs. Charles Custis Harrison, presented the keys to the building to Mayor Warwick. Despite the sometimes faulty logic applied and unsupportable conclusions reached by the DAR and Rogers, this was the first architectural restoration to treat the building as a primary document and the first to be guided by other primary written evidence on it.[50]

During these years also, the City Councils, alerted by chief of the Bureau of City Property Alfred Eisenhower's warning that many portraits in the Assembly Room were in "advanced stages of decay," appropriated one thousand dollars for restoration work. According to the 30 October issue of the *Evening Telegraph,* Philadelphia artist John B. Wilkinson, who had also served as the restorer for the Pennsylvania Academy of the Fine Arts, performed the work. Previous to Wilkinson's assignment, another well-meaning artist had volunteered to conserve a portrait of George Washington after being allowed to execute a copy portrait. The volunteer had applied a varnish with no dryer in it,

47. "Independence Hall and the Colonial Dames," *Philadelphia Inquirer,* 16 September 1894. Throughout the decade, Eisenhower successfully campaigned for support from city council. *First Annual Message of Edwin S. Stuart, Mayor of Philadelphia,* Vol. 2, Public Safety: Annual Report of the Bureau of City Property, 1891 by Alfred S. Eisenhower, 675–76; and for 1893, 308; and for 1894, 336–37. *JCC* 20 December 1892, 272–73; *JCC* 29 December 1892, 336; Appendix 152, 250, 320; *JCC* 1 June 1893, 193–204; *JSC,* 21 June 1894, 169.

48. *JSC,* 16 December 1895; Appendix 80, 121; 9 January 1896, 201. Frank M. Riter, "Statement in Re: Restoration of Independence Hall," circa June 1898, Harrison Collection, APS; *JCC,* 27 January 1896, 369, 372; Appendix 123, 218; "Revolutionary Sons Beat a Retreat," *Evening Bulletin,* 17 March 1896; *JSC,* 19 March 1896, 302; Apendix 152, 286–87; "The Daughters Will Do It," *Evening Bulletin,* 19 March 1896; "City Councils and Independence Hall," *Evening Bulletin,* 20 March 1896; "The Old Banquet Hall; How the Daughters of the Revolution Propose to Restore It," *Public Ledger,* circa 24 March 1896, *Documents Relating to the Physical History of Independence Hall 1891–1899,* INHP.

49. Rosalie H. Campbell to Wilfred Jordan, 14 December 1919, Specimen folder, INHP.

50. Invitation to Presentation of the Newly-Restored Second Floor of Independence Hall to the City of Philadelphia, 19 February 1897, Ellen Waln Harrison Collection, INHP; "Historic Rooms Now Restored," *Evening Bulletin,* 19 February 1897; "Made As They Were In Colonial Days," *Philadelphia Inquirer,* 20 February 1897; "An Historic Hall Restored," *Times,* 20 February 1897; "As In the Olden Times," *Philadelphia Record,* 29 February 1897.

51. *First Annual Message of Edwin S. Stuart, Mayor of Philadelphia;* Vol. 2, Public Safety: Annual Report of the Bureau of City Property, 1891, by Alfred S. Eisenhower, 675–76; *JCC,* 1 June 1893, 193, 204; Appendix 57, 63–64; *Third Annual Message of Edwin S. Stuart,* Mayor of Philadelphia; Vol. 2, Public Safety: Annual Report of the Bureau of City Property, 1893, by Alfred S. Eisenhower, 308; "Portraits Saved," *Evening Telegraph,* 30 October 1896.

52. *Evening Telegraph,* ibid.

53. *Ibid.*

54. *Ibid.* Whether the Duffield is the original or a copy portrait is still debated. See Linda Crocker Simmons, *Charles Peale Polk, 1776–1822: A Limner and His Likenesses* (Washington, D.C.: Corcoran Gallery of Art, 1981), 24.

Illustration 4. The National Museum in Independence Hall, 1874–76. Independence National Historical Park.

causing the surface of the painting to remain tacky. Over time, the varnish darkened and the painting became covered with a layer of impregnable dust "thick enough to support a coal wagon." Other portraits had escaped the hands of "restorers" but had deteriorated due to neglect. The paint of many of these canvases had blistered, cracked, and finally peeled. By the end of 1893 Eisenhower could report that sixty-six of the historical portraits had been restored and were in "as good condition as when new." Each year, Eisenhower pressed the case for restoration, and each year, City Councils set a sum aside for the work. Near the end of the decade, the work of restoring the portrait paintings was complete.[51]

As part of the preparations to open the restored Independence Hall to the public, Hampton Carson, a noted jurist and a member of the mayor's restoration committee, directed the reinstallation of the portraits in Independence Hall. Historical portraits should have an instructive value, Carson maintained, and this instructive value could be realized only when the canvases were "properly arranged" in a chronological sequence the viewer could easily follow. Carson cited the galleries in the Palace of Versailles, where images were displayed so as to illustrate the history of France from the days of Charlemagne to Napoleon III. Albeit in exaggeration, Carson asserted that "by the time four or five hours of attentive study [had] been bestowed upon the work of the greatest artists of France, the student who started with but a fair knowledge of French history [left] the building with certain definite impressions upon his mind as to the great events … which characterize[d] each century."[52]

Carson created a series of historic tableaux in Independence Hall. He ordered the portraits in accordance with their subjects' roles in the struggle for independence. Thus portraits of only the Signers of the Declaration were displayed in the Assembly Room, while portraits of former chief justices were displayed in the old Court of Common Pleas chamber *(Illustration 4)*. Portraits along the staircase leading to the Long Gallery on the second floor proceeded from William Penn at the bottom to George Washington at the top, intending to suggest "the expansion of our government from the feebleness of Colonial days to the strength and dignity of national existence."[53]

The hallway leading to the Long Gallery held the first charter of the City of Philadelphia, a purported segment of the treaty elm, and portraits of miscellaneous distinguished men of colonial days. The Long Gallery was similarly organized with full-length portraits of the kings and queens of England during the colonial period, as well as of governors and other colonial leaders. The chamber once occupied by the Provincial Council housed the portraits of military and naval officers. Word of the restoration efforts spread and a patriotic descendant of Presbyterian minister George Duffield sent Charles Peale Polk's portrait of his ancestor.[54]

THE NATIONAL MUSEUM.
(EASTERN SIDE.)

Illustration 4

The acquisition of the portrait collection contributed to Independence Hall's nineteenth-century transformation from a white elephant of a building whose owners were disunited on its use and at times contemplated its demolition, to the key shrine in America's Colonial Revival movement. Recognizing that the City of Philadelphia's administration of the site was now under national scrutiny, the mayor, in 1899, created an official advisory board to oversee the collections. The Board to Take Charge of and Collect Relics for the Museum of

Independence Hall included private citizens with a record of involvement with the shrine and a member of City Councils. Independence Hall came under the direct care of the Bureau of City Property within the Department of Public Safety, and the director of that bureau was an *ex officio* member of the Board. For the next quarter century, this group's greatest impact was upon the portrait collection.[55]

The reinstallation of the portraits in Independence Hall marked the completion of an era for the collection. That era began with a small collection housed in one room, displayed with an exhibition technique that reflected Victorian eclecticism and excess *(Illustration 4)*. It ended with a more minimal display that the stewards of the 1890s regarded as having greater pedagogical value *(Illustration 5)*. Through two major acquisitions, the Peales and the Sharples, the collections gained focus and depth. The increased interest in the collections forced the city to acknowledge its responsibility for the paintings by establishing a system of governance for them during this era. While the board's names changed over time, this form of oversight remained in effect. By 1899, there was a regard for the paintings in Independence Hall that Charles Willson Peale himself would have approved. The National Museum was a misnomer in terms of its source of support; but the appellation was accurate in terms of its level of recognition.

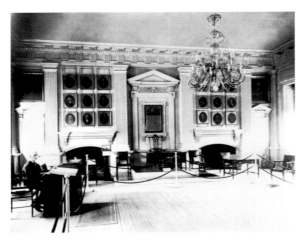

Illustration 5

55. For a discussion of the Colonial Revival see, for instance, Alan Axelrod, ed., *The Colonial Revival in America* (New York: Norton for The Henry Francis duPont Winterthur Museum, 1985; or, Karal Ann Marling, *George Washington Slept Here: Colonial Revivals and American Culture, 1876–1986* (Cambridge, Massachusetts and London, England: Harvard University Press, 1988). *Resolutions of Councils,* 1, 21 September, 1899, Appendix, 176; and 2, 21 December 1899, Appendix, 127 and 47.

Illustration 5. The Assembly Room in Independence Hall, circa 1899. Independence National Historical Park.

Chapter III
The Shrine Becomes a Museum, 1900–1951

1. Becky Briesacher contributed research to this chapter. For a different interpretation of this period, see her article, "Philadelphia's Gallery of Sacred Fakes," *PMHB* 95 (January 1991):89–114.

2. "Collecting Historical Portraits," *Item,* 9 February 1900. David Glassberg's *American Historical Pageantry: The Uses of Tradition in the Early Twentieth Century* (Chapel Hill and London: The University of North Carolina Press, 1990) describes the popular context of patriotism during this era and deals in some depth with other commemorative activities in Independence Hall.

As the new century began, the Board To Take Charge of and Collect Relics was determined to retain any ground the mayor's advisory committee had gained during the 1890s. The board consisted of a number of city officials and members of patriotic societies that had sought stewardship over parts of Independence Hall. These people included Hampton Carson, Mary Chew, Elizabeth Gillespie, Ellen Harrison, Charles Roberts, and William Staake. Although each was part of a social network that could have contributed money and even historic portraits to Independence Hall, during the nearly twenty years that the board held sway, they neither donated their own funds or paintings, nor sought the contributions of their social peers. This is less a comment upon the members' penuriousness than a statement of the regard in which they held their charge. To the members of the board, Independence Hall was a patriotic shrine, not an art museum.[1]

While the board did not materially support the collections, it wielded considerable power over them, in part because of the default of others. The chief of the Bureau of City Property, Alfred Eisenhower, sat on the board because he was responsible for the buildings and their contents, but Independence Hall was only one of his responsibilities. Independence Hall had a superintendent, Edward Crane, but his attentions were focused on overseeing the daily operations of the site.

Between 1900 and 1908, the board assumed an authority for the collections that may have exceeded the Councils' intentions when they created it. Chartered as merely an advisory group, the Board to Take Charge of and Collect Relics for the Museum of Independence Hall soon assumed control of the acquisition, placement, care, and even interpretation of the collection. To "prevent any cheap relics [from] being sent to the Hall and to insure the authenticity of those accepted," the board declared that it and no one else would determine the suitability of any loan or gift for inclusion in the museum.[2]

During this era, the board developed a close relationship with a Philadelphia artist and copyist named Albert Rosenthal, one that would have a major impact on the shaping of the Hall's collection of historical portraits. Rosenthal was the son of Max Rosenthal, a Polish émigré who had learned the crafts of engraving and lithography in Paris before he came to Philadelphia in 1849. According to his son, Albert, in 1870 Max received a commission from a group of print collectors to create lithographic portraits of American worthies for whom no engraved portrait existed. Among these print collectors were James T. Mitchell and Charles Roberts, who were later members of the advisory board of Independence Hall. In 1882, Max Rosenthal engraved on copper images of the First Continental Congress, the signers of the Declaration of Independence and the Constitution, and British officers who fought in the American Revolution. Albert worked with his father on this project. The elder Rosenthal gave the source of several engraved portraits as the Peale and Sharples collections in Independence Hall. As his 1854 engraving of the Assembly Room attests, Max Rosenthal had a long familiarity with the city's collections. An associate of Mitchell and Roberts, Hampton Carson had employed Max Rosenthal to

provide portrait illustrations for his history of the Constitutional Convention, which was published in honor of the event's centennial in 1887, and also for his history of the United States Supreme Court published in 1890. Carson praised the artist's skill and knowledge of source materials, saying, "There is no one in this country who knows where the rare portraits of our Revolutionary heroes can be found better than Mr. Rosenthal."[3]

Young Albert Rosenthal had some ability and boundless determination to follow his father's career path. In 1890, he journeyed to Paris where he studied at the École des Beaux-Arts. The artist returned to Philadelphia three years later, eager to begin his career. He won the confidence of his father's patrons. Young Rosenthal returned to Europe in 1896, carrying an order from James T. Mitchell for portrait copies. In 1898 Hampton Carson, while still a member of the mayor's restoration committee, had suggested that the young artist make a careful survey of the Hall's portrait collection *(Illustration 1)* and recommend the best measures for its care and preservation. Rosenthal eagerly undertook the task, and upon its completion let it be known to Frank M. Riter, the director of the Department of Public Safety (later the Department of Public Works), which claimed Independence Hall among its responsibilities, that he "would esteem it a favor to be of any assistance in doing my part looking to [the collection's] success."[4]

Rosenthal did not let the matter rest with this offer. For the next year he campaigned privately with city officials and members of the Board to Take Charge of and Collect Relics for the Museum of Independence Hall to carve out a role for himself in set-

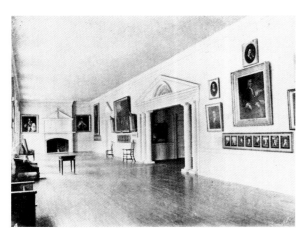

Illustration 1

ting the shrine's acquisitions policy. Early in 1900, perhaps on Rosenthal's urging, the board voted to "complete" the portrait collection with a number of additions, most of them copies. Although the board received proposals from several interested artists, it soon engaged Rosenthal to paint the first two copies, at a cost of $475 each. That was the beginning of a long, close relationship between the artist and the board. For the next seventeen years, Rosenthal was to be the only artist hired to paint copies of historical portraits for Independence Hall *(Illustration 2)*.[5]

Rosenthal worked with speed as well as skill, in some years producing as many as fifteen copies for the collection. While he enjoyed the income his paintings brought, and reveled in the notoriety that accompanied his working for Independence Hall, Rosenthal gave value in return. Once having received a commission for a copy, he researched and tracked down authentic originals. Undoubtedly, he used the documentary information that his father, with whom he shared a studio, had amassed; but he pursued further contacts of his own. He was skilled in authenticating provenance, and he kept scrupulous records of his search, which he urged the board to retain as historical documentation. Nonetheless, it remained true that in his travels he was forever coming upon other "important worthies" whose images were to his mind essential to the collection. Thus a trip to locate and copy one work often turned into a billing for two.[6]

Two members of the six-person board were Rosenthal's champions, Justices Hampton Carson and James T. Mitchell, who had joined the board in 1902. These men often acted as intermediaries between the board and the artist. Carson and Mitchell directed Rosenthal to make copy portraits and sometimes approved the work. Rosenthal, in

3. Albert Rosenthal, *List of Portraits, Lithographs, Etchings, Mezzotints by Albert and Max Rosenthal* (Philadelphia: privately printed, 1923). *Daily News,* (Philadelphia, 28 April 1891). See also Albert Rosenthal, *Max Rosenthal: Lithographer, Painter, Designer, Etcher, and Engraver in Mezzotint,* reprinted from *The Print Connoisseur* (New York: privately printed, 1921). Rosenthal Papers, Archives of American Art (hereafter cited as AAA), Roll D34, frame 941.

4. Albert Rosenthal to Frank M. Riter, 25 November 1898, INHP. Hampton Carson had edited a series on the Constitutional Convention in 1887 and then written a history of the Supreme Court in 1890, both of which were illustrated by Max and Albert Rosenthal. Rosenthal recalled his education and early consulting to Independence Hall in Albert Rosenthal to Jacques Gréber, undated—1920s, photocopy in INHP *Albert Rosenthal* file. Albert Rosenthal (Philadelphia: 1929) n.p., and "By the Way," *Daily News,* 28 April 1891.

5. Albert Rosenthal to Frank Riter, 25 November 1989 and 13 January 1899, INHP. Rosenthal recalled his education and early consulting to Independence Hall in Albert Rosenthal to Jacques Gréber, undated—1920s, photocopy in INHP Albert Rosenthal file. *Albert Rosenthal,* (Philadelphia: 1929) n.p., and "By the Way," *Daily News,* 28 April 1891. Also, Rosenthal Papers, AAA, Roll D-34, frame 980.

6. The entire allotment for the Hall's maintenance in 1901 was only $1,000. *Minutes,* Advisory Board of Independence Hall, 9 February 1900, INHP. One of Rosenthal's competitors wanted $1,000 for each portrait. Albert Rosenthal to Charles Roberts, 5 May 1900, INHP. Albert Rosenthal to William Staake, 3 March 1906, "Misc. Papers of the Advisory Board," INHP. Albert Rosenthal, "Letter to the Editor," *Public Ledger,* 6 July 1913.

Illustration 1. View of the Long Gallery, Independence Hall, circa 1904. The paintings and pastels displayed comprise a portion of the collection at the beginning of Albert Rosenthal's involvement. Independence National Historical Park.

7. Albert Rosenthal to Hampton Carson, 20 September 1916, INHP; William A. Staake to Hampton Carson, 25 February 1917, INHP; James T. Mitchell to Albert Rosenthal, 13 February 1909, Albert Rosenthal Folder, INHP.

8. The "committee" had dwindled to Carson, who apparently took no active part, and Rosenthal.

9. Rosenthal Papers, AAA, D34. See, for instance, frame 1060 on Hampton Carson.

10. Albert Rosenthal to William Staake, 1 February 1906, INHP; Albert Rosenthal to Commission of Independence Hall, circa 3 May 1906, INHP.

Illustration 2. View of the Long Gallery, 1914, showing the collection amended by Rosenthal's portraits. Independence National Historical Park.

turn, sent them his documentation for the copies. Mitchell even advised Rosenthal to send his required reports to the board to him first, so that he could polish them for presentation to the full board. Rosenthal never questioned the justices' authority. Even after Mitchell's death in 1915, the artist presented the city with a bill for a portrait series of colonial governors of Pennsylvania that Mitchell had ordered and approved without consultation or authorization. It was finally discovered that Carson and Mitchell had acted with such presumption that by 1917, only thirty-three of one hundred nineteen Rosenthal copies had been ordered by the full board.[7]

Rosenthal soon moved from contracted vendor to unofficial curator of the collection and overseer of Independence Hall. In 1902, when a committee of the full board was appointed to work with him in hanging the pictures, it was Rosenthal who determined where most of the new paintings were installed. For the next ten years, he regularly examined the condition of the paintings and estimated their value for insurance purposes. Rosenthal also loaned to the historic shrine his colonial print collection of Philadelphia views and the Charles Willson Peale portrait of Lafayette, which he offered to sell for $500 when an appropriation was available. He also took it upon himself to instruct the maintenance staff in matters such as screen doors, waxed floors, and label placement.[8]

Albert Rosenthal was a skilled opportunist. Self-assurance and charm were his best assets and he applied these liberally where he stood to gain. He did not confine his association with the members of the Independence Hall Advisory Board to copy com-

missions. He built a career as a corporate portraitist. He painted the portraits of several members of the advisory board as well as those of their associates in the legal and financial professions. Among Rosenthal's papers are sketches he wrote about his subjects. The artist fancied himself as their social equal, aspired to their lifestyles, and copied their affectations. Considering the highly constricted social structure of turn-of-the-century Philadelphia and the conservatism of the advisory board of Independence Hall, one may doubt that Rosenthal's patrons viewed him as their equal. He was proba-

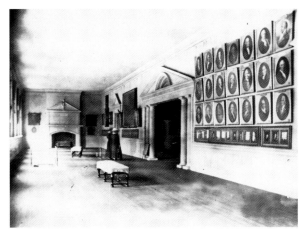

Illustration 2

bly aware of the limits his patrons placed upon his social mobility; he seems to have spent a lifetime repudiating their judgment.[9]

At Rosenthal's prompting, the board decided in 1905 to add portraits of Revolutionary officers from France to the Hall. The board and French Ambassador, Jean Jules Jusserand, encouraged Rosenthal, who was in London on personal business, to go to France, where he remained for seven months copying the desired pictures. On returning early in 1906 with his paintings and a bill for $7,500, Rosenthal was dismayed to learn that the city had cut the acquisitions fund to $1,500. He thereupon offered to "help the commission [i.e. the board] in the matter of appropriation … I feel sure that if the Mayors [*sic*] approval is got and then a direct appeal is made to the finance committee it will surely go through." He then wrote to the mayor, pressing upon him the importance of the paintings collection and offering to deposit the lot in Independence Hall "until such time as an appropriation would be available."[10]

While the city considered his offer, Rosenthal hung his portraits in the Hall and invited the newspaper staff from the *Public Ledger* to a private preview. Soon,

the mayor and board received accolades from the press for their foresight in sponsoring such an "indispensable addition" to the collections. Rosenthal's skillful manipulation worked: the city soon approved an unprecedented $7,500 for the acquisition.[11]

But Alfred Eisenhower was already suspicious. Early in 1906, he had ordered an inventory of the paintings collection. Eisenhower, as well, no doubt as others, was astonished and dismayed to learn from this inventory that the Hall owned no fewer than sixty-three Rosenthals, of which eleven were copy images of men already represented. Rosenthal blithely explained away the duplication with the observation that they made "our perception of the sitter even richer." As for the large number of his own works in the collection, Rosenthal asserted that they were "merely the logical result of a few a year and a number of years' work." The high quality of that work, he modestly added, "is a tribute entirely to my information acquired through some

Illustration 3

twenty or twenty-five years of special study." Rosenthal's assured response seems to have satisfied his critics, for little more was heard of this matter for many years.[12]

The portrait census caused a flurry of activity in the board. In addition to approving Rosenthal's numerous copies for display, the board reclaimed a number of paintings that had been hanging in City Hall since the restoration project of 1898. The board also moved the Peale portraits of George Duffield and Bishop William White, both of whom had served as chaplains to the Second Continental Congress, from the Assembly Room to the Long Gallery because "only the portraits of the signers and those officially connected with the Declaration" could hang in the Assembly Room. In their place, perhaps as an expression of the board's support for its copyist, they installed two Rosenthals.[13]

Once the portrait collection had representations of all the signers of the Declaration of Independence, Washington's aides-de-camp and assorted French patriots, Rosenthal won the board's approval to add images of noted Pennsylvanians. Typically, he reserved for himself the judgment as to which sitters were most worthy, located their portraits, obtained permission to make copies, and then decided where to hang them in the Long Room, all before formally offering the paintings to the board for approval. It was also part of Rosenthal's design to add copy portraits of Revolutionary artists, doctors, and surgeons, and colonial governors. The Rosenthal copy portraits were fast becoming the largest acquisition from a single source. In time, the copies exceeded the other two largest collections, the ninety-four portraits by members of the Peale family, and the forty-six Sharples pastels acquired during the 1870s. But while the proponents of the earlier acquisitions had great difficulty convincing the city to appropriate funds to purchase the historical portraits, Rosenthal succeeded in winning commissions for his copy work with comparatively little effort.[14]

During these years of growth, the Board to Take Charge of and Collect Relics for the Museum of Independence Hall made a decision that, although its members could not have foreseen it, would eventually lead to the greatest period of controversy in the history of the Hall's portrait collection. They determined to establish the position of curator, separate from the superintendent's duties. Mrs. Samuel Chew appears to have been the moving force behind the decision. Perhaps she and others on the board resented the way in which Carson, Mitchell, and Rosenthal arrogated to themselves virtually all decisions about the

11. "Independence Hall Group of French Worthies Is Complete," *Public Ledger,* 16 July 1906.

12. Albert Rosenthal to William Staake, 3 March 1906, INHP. The Rosenthal duplicates were as follows: *James Wilson, Thomas McKean, Benjamin Franklin, Thomas Jefferson* (2), *Marquis de Lafayette, Anthony Wayne, Charles Cotesworth Pinckney, John Langdon, James McHenry, William Few, William Penn,* and *William Richardson Davie.* Albert Rosenthal to the Independence Hall Commission, 2 March 1906, "Misc. Papers of the Advisory Board," INHP.

13. The list of returned portraits included portraits of *Zachary Taylor, John Armstrong, Andrew Jackson, General Charles Lee, Doctor Robert Hare, Governor Snyder, Governor Shulze, Albert Gallatin, Colonel Long, Governor Heister, Charles Thomson, Doctor Muhlenberg, Count Real,* and *William Findley.* Resolution, *JSC,* 1907 (2), 5 March 1908, INHP; William Staake to the Reverend Dr. Gibbons, 17 November 1908, INHP.

14. In 1911, Rosenthal presented the state government with sixteen completed portraits of associate judges at $800 each along with a proposal for forty more. When the chairman of the state Appropriations Committee found Rosenthal presumptuous, the artist replied, "What is the difference to you … to know where these will be placed when you know there will be a complete set of the Supreme Court Justices placed somewhere?", Statement of Albert Rosenthal of Philadelphia for the Sundry Civil Appropriation Bill, 1912, 2 February 1911, 898. The state purchased two paintings.

Illustration 3. Albert Rosenthal, self-portrait in his studio, 1903. Reprinted from a dinner invitation. Courtesy The Historical Society of Pennsylvania, Philadelphia.

15. Mrs. C. Harrison to William Staake, 21 February 1906, "Misc. Papers of the Advisory Board," INHP; James T. Mitchell and William Staake on behalf of the board to the Mayor of Philadelphia, 7 January 1907, INHP. In 1917, Mrs. Chew expressed her resentment openly. See below.

16. Before submitting the job proposal for city approval, Mitchell, Carson, and Staake had already interviewed and chosen Mr. Edward Robbins to be the first curator, but for some reason Robbins turned down the position. William Staake to John Reyburn, 25 April 1907, and Mrs. Mary Chew to William Staake, 24 April 1907, INHP. Wilfred Jordan never published the catalog in *PMHB*. Wilfred Jordan to the Chief of City Property, 13 February 1915, INHP. For more on John Jordan, Jr., see memorials to him in PMHB, 14 (1890). For John Woolf Jordan, see *DAB*.

17. William Staake to John Weaver, 7 January 1907, INHP.

18. Wilfred Jordan to George B. Hicks, Philadelphia Chamber of Commerce, 9 January 1918, INHP. Edward S. Rice, Acting Superintendent to Mr. Hardesty, 23 November 1912, "Curator, 1910–1924" folder, INHP.

19. Wilfred Jordan, "Improvements Recommended at Independence Hall," 11 March 1912, INHP. For more specific information on this topic see Warren Leon and Roy Rosenzweig's *History Museums in the United States* (Urbana and Chicago: University of Illinois Press, 1989). Jordan's full-time employment as a civil servant charged solely with nurturing a collection is evidence of a general movement in the United States toward museum professionalism.

Illustration 4. Horace T. Carpenter (facing), Wilfred Jordan, (right) and guard, Mr. Knox, standing at the rear door of Independence Hall, 1915. Independence National Historical Park.

collection and its expansion, and saw the brief controversy about the sixty-three Rosenthals as an opportunity to regain control.[15]

The person appointed to the position as curator was Wilfred Jordan *(Illustration 4)*, twenty-four-year-old son of John Woolf Jordan, who was librarian and editor at the Historical Society of Pennsylvania. The Jordans' cousin, John Jordan, Jr., had been an officer and benefactor of the Society until his death in 1890. It seems likely that Hampton Carson, who was also president of the Historical Society and who knew the Jordans well, arranged the appointment after the board's first choice declined. Jordan had no prior curatorial experience, and his formal education had not gone beyond the Moravian boarding school, Nazareth Academy, in Northampton County, Pennsylvania. Through his father's founding membership in the Sons of the American Revolution as well as through the Historical Society of Pennsylvania, Wilfred Jordan knew Independence Hall very well. Even before the curator's job was created, he had developed a thorough knowledge of the Hall's portrait collection, and had compiled a comprehensive list of the Hall's portrait holdings for intended publication in the *Pennsylvania Magazine of History and Biography*.[16]

The city funded the curatorial position, and the curator reported to the chief of the Bureau of City Property. The curator was to be "a man well informed and interested in his labors." The duties ranged from the registration, care, and display of the collections to the development of educational programs for the site's growing visitation. The incumbent's responsibilities also included the development of exhibit maintenance routines for the housekeeping staff. Such a job required tremendous versatility and conversance with a wide range of academic and technical subjects.[17]

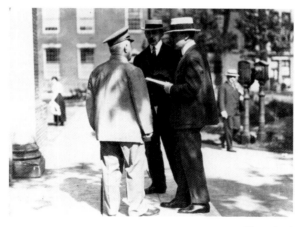

Illustration 4

Jordan was temperamentally well-suited to a position with such wide responsibilities. He was young and aggressive, and perhaps had social ambitions as well. Moreover, he had a natural flair for promotion. Some years later, for instance, when it was announced that airmail would be parachuted to building rooftops for greater efficiency, the curator immediately suggested the first experimental jump should take place over Independence Square. He curried favor with the press to the dismay of the chief of the Bureau of City Property. By 1912, the acting superintendent of Independence Hall was penning surreptitious critical messages to his superiors in City Hall about Jordan's friendliness with reporters.[18]

Unmindful of his critics, and with youthful optimism, Wilfred Jordan saw himself as a member of a growing breed in America, the museum professional. To compensate for his lack of experience, Jordan set out to school himself in curation. He visited the Pennsylvania Academy of the Fine Arts, the Metropolitan Museum of Art, the Essex Institute, Mount Vernon, and the Smithsonian Institution, all among the best museums in the country. On his return, Jordan prepared a list of necessary improvements for the city's collections. He recommended taking steps to meet fire and safety codes, expanding exhibit space, acquiring new display cases, restoring the paintings, publishing a collections catalog, and creating a storage area in the basement of Congress Hall. To accommodate the increasing numbers of visitors, the new curator recommended umbrella stands and guard rails. Jordan sought to treat Independence Hall as a modern museum according to the standards of his era and to make it "foremost among Historical Museums of their [*sic*] size in America. . . . "[19]

The board, however, did not warm to Jordan's ideas. In the board's view, Independence Hall was primarily a reliquary and only incidentally a museum. Aside from continuing its aggressive acquisitions policy, the board planned no significant changes at Independence Hall. When Jordan proposed that the board publish the catalog of Independence Hall's portrait holdings that he had earlier prepared, the board at first declined on the stated ground that such a publication would draw too much attention and invite possible theft. In 1915, the board published the catalog on the condition that Jordan's name be omitted as author.[20]

Jordan should have perceived the board's attitude. During the years of his smoldering discontent, the board supported the development of a series of special exhibitions in the other buildings on the Square. The titles of these exhibitions, which drew upon collections that were begun during the Centennial, "Philadelphia from Colonial Days to the Revolution," "Revolutionary Relics," "Colonial and Revolutionary Costumes and Related Textiles," demonstrate the board's involvement with the Colonial Revival Movement, which reconstructed and sometimes romanticized the past according to present ideas. The exhibitions were more romantic than didactic, and they must not have sat well with the young, tough-minded curator who fancied himself a member of the modern museum movement, capable of objective distance from his collections.

While Jordan was becoming disillusioned with the board's insistence upon control of the operations, Albert Rosenthal continued to receive commissions for copy portraits. He was able to add thirteen portraits to the collection in 1908, seven more in 1909, and another six in 1910. He made his presence known in Independence Hall, issuing orders and treating the building almost as his personal museum. Given the presumptuousness of Rosenthal and the ambition of Jordan, it was almost inevitable that the two would collide. The records offer a single but telling example of their rivalry: in 1910, Albert Rosenthal vigorously protested the board's acceptance of a portrait by William H. Jordan after Benjamin West's *William Henry*. Rosenthal mistakenly believed the portrait was of Wilfred Jordan's cousin, John Jordan, Jr. The board, in a demonstration of independence, voted to accept the painting.[21]

However, the board's rebuff of Rosenthal should not be mistaken as confidence in their curator. In 1912, the board accepted a copy portrait of George Taylor over Jordan's objections. Incensed, the curator turned to the Philadelphia Art Jury. In 1907, the Commonwealth of Pennsylvania had declared that all first-class cities must have an art jury that would determine the quality of public architecture and art. The art jury included practicing artists, businessmen, educators, and a director of the public parks. In the years following the mayor's appointment of its members in 1911, the Philadelphia Art Jury considered subjects as diverse as signage, bridges, and outdoor sculpture. Because Independence Hall's historical portraits were city property, the Art Jury could also oversee them. Jordan's seemingly innocent inquiry about the propriety of the acceptance procedure gave the newly-empowered Art Jury an opportunity to assert itself. Jury president Andrew W. Crawford responded that no title to a work of art could pass to the city without the Art Jury's approval.[22]

This was the answer Jordan wanted. If no works of art could become city property without first passing the scrutiny of the Art Jury, how did all of the Rosenthal copies created after 1907 get into the collection of Independence Hall? Jordan proposed in 1913 that the Bureau of City Property ask for three artists' or art critics' opinions on the Rosenthal works in the Hall before the board proceeded with any more purchases of the copyist's paintings. Frustrated and thwarted by the board at almost every turn, the curator had begun to inquire into the source of its power. His reading of the historical records led Jordan to conclude that the board had never actually been granted the authority to run

20. Paul Rea, secretary of the American Association of Museums, to Wilfred Jordan, 16 December 1915, INHP; Wilfred Jordan to the Chief of City Property, 13 February 1915, INHP.

21. Albert Rosenthal to William Staake, 13 June 1910, 1910 folder, Independence Hall box, 1899–1917, INHP. In fact, William Henry was an ancestor of John Jordan, Jr.

22. The portrait of George Taylor was by Laura Schneider. The Washington Camp of the SAR in Easton, Pennsylvania, gave the portrait to the city on 7 December 1912. Crawford to Jordan, 24 December 1912; Horace Carpenter to Chief, Bureau of City Property, 3 June 1926, details this case. Specimen folder, INHP.

23. Wilfred Jordan to "Committee on reception of portraits, etc. ... for Independence Hall," 6 September 1913, INHP.

24. 20 March 1917, Charles Henry Hart to Wilfred Jordan, states, "The James Peale portrait of Washington has always been somewhat of a Sphinx to me." Regarding the same painting, Jordan to Byron McCandless, 26 August 1920, writes "This portrait of ours has always been a Sphinx to me." Specimen folder, INHP.

Independence Hall, but merely to advise city officials who were empowered to do so. Jordan then began to publicly criticize the board's control.[23]

City officials grew weary of the constant discord between the board and the staff at Independence Hall. Seeking a buffer between the administration and the site, they gladly turned to the Philadelphia Art Jury. Beginning in 1914, the Art Jury ruled on new acquisitions as well as conservation of the collections. In effect, Jordan got his experts.

The focus of Jordan's campaign, the indiscriminate admission of copy portraits by a single artist, is curious in light of the collection's large holdings of copy portraits by individual artists, namely Charles Wilson Peale and the Sharpleses' pastels. As important as the Peale portraits are, not all of them were taken from life. There are twenty-two replicas and copies in the Peale collection. Moreover, the Sharples collection is even more problematic when one addresses the issue of life versus replica or copy portraits. But Jordan was a self-taught curator. His educational preparation for the Independence Hall position was limited, and he had no connoisseurship skills. Lacking the ability to examine an object in depth, that is to consider its validity in terms of its materials, its construction, its composition, its style, its maker, and its situation within a larger body of that artist's work, Jordan had to rely upon the opinions of others.

Often, those opinions were wrong. The correspondence files at Independence National Historical Park contain many examples of Jordan's exchanges with self-styled American art experts. In one instance, Jordan not only adopted one dilettante's opinion about James Peale's *George Washington,* but parroted the observation verbatim when he answered a subsequent inquiry about the portrait three years later. Before Wilfred Jordan assumed the position of curator, he had undoubtedly used the resources of the Historical Society of Pennsylvania to prepare his portrait catalog manuscript. Yet there is no evidence that Jordan ever used that rich repository to investigate the collections at Independence Hall. Jordan respectfully managed the collections, but he unquestioningly accepted the opinions of others about them.[24]

Furthermore, Jordan seems to have had no personal scheme that considered the degree of remove between an artist and his subject as a factor in the work's accuracy. During his curatorship, one of the longest-running exhibits was of the historical genre paintings of Jean Leon Gerome Ferris. For two months in 1913, Ferris and the artist Clyde O. De Land displayed forty-seven scenes that spanned American history from the landing of Columbus to the surrender at Appomattox. So successful were the genre paintings that a group of sixty works by Ferris alone was displayed in Congress Hall from 1916 to 1918 and then reinstalled in Old City Hall until 1931. Ferris's "Paintings of American History and Romance," like those of the best historical genre painters of his time, were expertly executed reconstructions of the past. The compositions reflect meticulous research of paintings, material culture, and historical accounts. The result is a work of art that confuses verity with verisimilitude. The historical paintings formed a bridge between fact and fiction over which the viewers—Jordan, the board, and the visitors—were willing travelers. The Ferris paintings tell more about the era in which they were produced than they reveal about the events they portray.

Jordan arrived at Independence Hall when the performance of large-scale historical pageants was at its zenith in America. In 1908, Philadelphia historian Ellis Paxson Oberholtzer organized Founder's Week, which commemorated the landing of William Penn and the founding of Pennsylvania with parades and events throughout the city. The celebration was repeated annually until about 1918. Oberholtzer drew heavily upon the paintings collection at Independence Hall as inspiration for the historical tableaux on parade floats. West's *Penn's Treaty With the Indians,* Inman's *William Penn,* as well as various portraits and scenes in the collection, were recreated with live actors. The members

of various women's patriotic societies met in Independence Hall and, wearing colonial costumes, sewed banners and regalia for the parade.[25]

Steeped so deeply in the romanticism of the Colonial Revival, the board of Independence Hall was unwilling to interrupt its contemplation of historical genre paintings and its assistance in the preparation of medievalesque pageantry to consider their curator's derision of the Rosenthal copy portraits. In fact, Wilfred Jordan's voice was the only discordant note in the otherwise harmonious operations of the historic shrine. The Art Jury, on the other hand, not only carried legal weight, but also was composed of modernists. The practicing artists on the jury not only evaluated the documentary evidence for each portrait, but they also judged the paintings' merits as works of art. This was the first time the collection had been subjected to such scrutiny. It was Jordan's insistence upon documentation, and perhaps his personal dislike of Albert Rosenthal, that eventually disrupted the portrayal of the past at Independence Hall.

Jordan's criticism was leveled at a time when American art was a relatively new field of inquiry. One amateur scholar, Charles Henry Hart, took a great interest in portraiture. Hart was quite familiar with the shrine and its collection. In 1876, he was one of many historians and literati whom Frank Etting invited to present biographies of the founding fathers at the Centennial festivities. He published an article in the *American Historical Review* in 1913 entitled "Frauds in Historical Portraiture or Spurious Portraits of Historical Personages." In the article, Hart denounced a number of Philadelphia's historic paintings, including Independence Hall's armor portrait of William Penn and its *George Washington* by Rembrandt Peale. The following year, 1914, the secretary of the Smithsonian Institution, in his report to Congress, cited several Independence Hall "fakes." Then in 1915, Hart charged in a *Public Ledger* newspaper article that at least four more frauds "have gained admission within the sacred portals of Independence Hall." As no known authentic portraits of Declaration signers William Whipple, George Taylor, John Hart, and Benjamin Harrison existed, how, Hart asked, could anyone make copies of them? Eager to escalate the controversy, Hart went on to cite seven more canvases of doubtful authenticity.[26]

Hart's use of language was extravagant. Traditionally, a work of art is considered a forgery if it was made with the intention to deceive. While there are instances of misrepresented subjects of paintings, the most common type of forgery is the deliberate misrepresentation of one artist's work as another's, usually for financial gain. None of Albert Rosenthal's copy work imitates the painting style of another artist. Rosenthal's copy style is quite uniform, and it differs markedly from the style of his original works. Considered as a body of evidence, the Rosenthal copies demonstrate a deliberate attempt to convey their distinctness from the original source.

Hart's definition of fraud also included works copied from insufficiently documented originals. This definition placed the burden of documentation not only on the copyist but also on the owner of the copied work. Even when portraits remain in the direct family line of their original owner, the oral traditions of successive generations often obscure the identities of the paintings' subjects.

There was no concerted response to Hart's initial charges, which were made in a scholarly journal. Members of the Historical Society of Pennsylvania made a half-hearted effort to investigate the authenticity of Independence Hall's portraits, but produced no conclusions. When Hart's ideas reached the popular press in 1915, however, the Board to Take Charge of and Collect Relics for the Museum of Independence Hall felt obliged to defend its actions. Seemingly unaware of the Art Jury's duties, Mrs. Chew, on behalf of the board, suggested that the city create a special Independence Hall paintings commission. She further pointed out that "[the board] is asked to decide whether relics or

25. For more on pageantry, see Glassberg, op.cit. For the use of some of the city's paintings as models for the Founder's Week parade floats, see Violet Oakley scrapbooks, Print Department, Philadelphia Museum of Art.

26. A lawyer, Charles Henry Hart became an art critic after a severe injury from a railroad accident in 1894. Frank M. Etting to Charles Henry Hart, Esq., 25 October 1875. AAA Charles Henry Hart Papers, Reel 931, frame 722; Charles Henry Hart, "Frauds in Historical Portraiture or Spurious Portraits of Historical Personages," *Annual Report of the American Historical Association* (1913). Charles D. Wolcott, secretary of the Smithsonian Institution, to the Congress of the United States, *Congressional Record* 21 September 1914, 87–99; Hart, "Priceless Paintings in Philadelphia Branded as Fakes by Experts," *Public Ledger*, 23 November 1915. For a discussion of authenticity in heritage preservation, see David Lowenthal, "Authenticity: Rock of Faith or Quicksand Quagmire?," *Conservation, The Getty Conservation Institute Newsletter* 14.3 (1999):5–8.

27. Dr. S. Weir Mitchell headed the investigative committee in 1913. After Mitchell's death in 1915, Hampton Carson assumed responsibilities, but the committee floundered. "Art Attack Revives Plan for Commission," *Philadelphia Inquirer,* 25 November 1915.

28. John Jordan to Charles Henry Hart, 4 April 1910. AAA Hart Papers, Reel 930, frame 210. Andrew Perate, assistant curator of the Versailles Museum to Wilfred Jordan, TS, Albert Rosenthal folder, INHP.

29. One of Rosenthal's chief supporters, James Mitchell, died in July 1915. Minutes of the Board, 19 October 1916, TS, INHP.

30. See, for example, Charles Henry Hart to Albert Rosenthal. 30 November 1909; 5 August 1909; 28 July 1910. Deposition, 10 December 1913. AAA Rosenthal Papers, Reel D-36.

31. Charles Henry Hart to Albert Rosenthal, 24 April 1916; 3 May 1916.

historical documents shall be allowed in the Hall but when it comes to paintings we are not consulted." In theory, the full board should have approved all acquisitions; in practice, only a few members did. Indeed, when a tally made a few years later revealed that of a total holding of 342 paintings, 118 were copies by Albert Rosenthal, Mrs. Chew's assertion was proved.[27]

Wilfred Jordan was not content to let the matter rest. Charles Henry Hart was an acquaintance of his father and the curator had an entrée to the antiquarian's counsel. Using Hart's definition of forgery, Jordan determined to unmask Albert Rosenthal. Although only one Rosenthal portrait, that of Carter Braxton, was among those about whose authenticity Hart or the Smithsonian expressed doubts, Rosenthal was quickly drawn into the controversy and soon found himself at its center. In May 1916, the curator reported verbally to the president and secretary of the board that he had written to Versailles for authentication of Rosenthal's French copy work and had found no documentation for it. Jordan submitted copies of his report to the Art Jury and to his supervisor, Acting Superintendent Robert Hicks, who brought it before the chief of the Bureau of City Property, Frank J. Cummiskey.[28]

Sensing the approaching end of a prosperous relationship, Rosenthal sent a letter to the board requesting payment for work completed under the late James Mitchell's direct orders. In the same letter, Rosenthal offered to sell his personal collection of historical views and his series of portraits of the chief justices of Pennsylvania to Independence Hall. The board signaled its wariness of Rosenthal when it granted payment for two works commissioned by Mitchell but rejected the other offers.[29]

Beginning in January 1917, a special committee of the Art Jury examined each portrait in the collection and made a written report on its authenticity. Wilfred Jordan was present at the committee's meetings. Not surprisingly, Jordan's forgery story reached the press in February. Individual board members disclaimed responsibility for the large number of copy portraits. "Art is not one of the things at which I claim to be proficient," said board secretary William Staake. Even Hampton Carson, Rosenthal's primary supporter, stated, "… I do not claim to be an authority on paintings." The board's position was that Independence Hall was a history museum, not an art museum, and the Art Jury, therefore, had no jurisdiction over the historical portrait collection. Even while the jury was culling Rosenthal's copies, the board unsuccessfully attempted to accept two more of his reproductions.

The disintegration of Albert Rosenthal's relationship with the Board to Take Charge of and Collect Relics of Independence Hall paralleled the unraveling of the artist's business ties with Charles Henry Hart. Correspondence in Rosenthal's papers reveals that, at least as early as 1909, Rosenthal and Hart had a prosperous partnership in the art market. They jointly purchased, restored, and sold portraits. Hart, like many "connoisseurs" of his day, also authenticated works of art. Both men used their polished charm to ingratiate themselves with private collectors and public institutions. By 1913, they saw fit to list their common holdings in a deposition stating their shares for estate purposes should either die.[30]

While Hart and Rosenthal could be devilishly charming when the occasion suited, they mistrusted each other. In 1915, the men turned against one another in a disagreement over the purported sale price of a jointly-owned painting. Hart concluded their relationship, once on a nick-name basis between himself and "Dear Rosey," in chilly prose by May 1916, with a financial settlement and a promise from "Mr. Rosenthal" to cease all communications with him. That was the same month that Wilfred Jordan reported his failed attempts to authenticate the French portraits.[31]

It would appear that Jordan was an unwary tool in the hands of Charles Henry Hart, who used the naive, poorly-educated curator to publicly discredit his business associate. Rosenthal was highly suspicious, carried a flexible definition of ethics and routinely offended and alienated everyone with whom he had business dealings. He was

not, however, a forger. His papers contain meticulous documentation of the sources of his portraits. Hart, on the other hand, made very wrong statements about the identities of subjects in the Peale portraits. That he sold and "authenticated" for personal profit so many Stuarts and portraits of Washington calls his major publications into question. It is possible that without Hart's animus, Rosenthal could have favorably settled the question of his integrity.[32]

Wilfred Jordan attempted to intensify public indignation over the board's inefficiency. Through his father, Jordan was able to goad the Society of Descendants of Signers of the Declaration of Independence into declaring its intention to launch its own investigation of the alleged misconduct. The city thereupon barred patriotic organizations from meeting in Independence Hall. Meanwhile, City Councils attempted to design an ordinance for a new commission of governance for all of the buildings on Independence Square and their collections. Finally, Mayor Thomas B. Smith ended all of these feeble efforts when he disapproved the ordinance and reminded councils that state law prevailed over municipal law and that the state-created Art Jury's decisions about the portrait collections would stand. By June, when the Art Jury had completed its examination of 342 paintings, it found 129 of them to be modern copies. Of those copies, 119 were by Albert Rosenthal. The jury ordered all of them removed from exhibit.[33]

Outraged, Albert Rosenthal quickly rallied a formidable defense. The sources for the French officers' portraits, he fumed, were not in Versailles but in French châteaux. Had Jordan's knowledge of French been adequate, he might have realized this. Although Rosenthal was unable to produce photographs of all his sources, the artist maintained that he had his preliminary sketches of them and lists of their locations. Rosenthal had never copied a portrait without the board's prior approval. Worse yet, he blustered, no one conducting the investigation of the portraits had ever approached him for information. In a final volley, the artist demanded an apology for the charges that "impugn my integrity and the intelligence of such worthy men as the late Justice Mitchell, the late Charles Roberts [the board member who, as a city official, authorized payments for the portraits], and others whose honor is above question."[34]

Jordan had underestimated the extent of Rosenthal's support. As a portrait painter, Rosenthal had many influential friends who stood by him during this controversy. Even the city comptroller wrote to the artist that "your staunch friends who know you are not shaken in their confidence in you … your ability, reputation and real work as an historical artist are well known to them." Jordan, however, appeared brash and self-serving. When Rosenthal discovered that Jordan had proposed a salary increase for himself as a reward for his diligence, the artist had his friends expose the curator's attempt in the press. Portrayed as a perpetrator of bureaucratic pettifoggery, Jordan lost his credibility. Displaying his usual self-confidence, and fearless of potential libel charges, Rosenthal described Jordan as an "ignorant, ambitious egoist."[35]

Perhaps the most significant outcome of the Rosenthal incident was that members of the art community gained the power to shape the paintings collections. Once it had completed its assessment of the portraits, the Art Jury retained control of the collection. Using the numerous examples of the board's mismanaged acquisitions, the Art Jury demonstrated the board's irrelevance. Realizing the implications of the Art Jury's collections survey, the board, in an attempt to preserve itself, wrote "that we would be happy to have the representatives [of the Art Jury] in consultation with us, so that there shall be no conflict." The jury remained aloof from the board's overtures. Always aware of its empowerment by the Commonwealth, the Art Jury communicated no more frequently with the board than with the rest of city government.[36]

32. See Rosenthal Papers, AAA, Reel D-34, frame 1205 et seq.

33. *JCC* 30 January 1917; "Fake Paintings In Independence Hall Surprise to Board," *North American,* 18 February 1917; "Independence Hall Fakes Barred by U. S. Envoy in France," *North American,* 19 February 1917; "Portraits in Independence Hall Under Suspicion," *New York Times Magazine,* 25 February 1917; Staake to Smith, 28 February 1917, INHP; "Special Committee on the Rehanging of Portraits in Independence Hall," TS of minutes, "Portrait Collection, Reports" file, INHP.

34. "Rosenthal Plans to Sift Charges," *Public (Evening) Ledger,* 20 February 1917. Some of these sketches are in the Rosenthal papers, AAA, Reel D-34.

35. Comptroller Walton to Albert Rosenthal, 2 February 1917, Rosenthal Papers, Archives of American Art; "Rosenthal Plans to Sift Charges," *Public (Evening) Ledger,* 20 February 1917; "Demands Denial of Fake Portrait Charge," *Public Ledger,* 23 February 1917; "Letters to the Bulletin," *Philadelphia Evening Bulletin,* 17 March 1917.

36. "Minutes from the Advisory Board," 26 February 1917, INHP. William H. Staake to Andrew Crawford, 1 March 1917, INHP.

37. TS "Special Committee on the Rehanging of Portraits in Independence Hall," January–June 1917, "Portrait Collection Reports" file, INHP.

38. Sallie Wistar, "Sallie Wistar Says," *Public Ledger,* 1915, clipping, INHP.

39. Wilfred Jordan to Art Jury, 3 May 1917, INHP.

40. "Rats Gnaw Pictures in Congress Hall's Historic Art Display," and "Notable Paintings Left as Food for Rats in Hall," *Public Ledger,* 4 December 1918; "Mayor Upholds City's Art Jury on Paintings," *Public Ledger,* 5 December 1918.

41. "Art Jury is Under Fire as Rats Ruin Pictures," *Philadelphia Record,* 5 December 1918, p. 4. Jordan and Arthur perversely insisted that the Art Jury's 1907 enabling legislation, which stated that "no existing work of art in the possession of the city shall be removed, relocated, or altered" without the jury's approval, prevented them from removing the paintings to safety.

The Art Jury intended to rid Independence Hall of all questionable paintings. This purge involved more than just the Rosenthal works; they disallowed any portrait whose fidelity to, or whose degree of remove from, its source was in doubt. A copy after a copy of an original painting was now liable to be rejected. Also, no Revolutionary character below the rank of major would be admitted to portrait immortality. The minutes demonstrate the careful examination of evidence for each painting. If the decision required more information, the committee dispatched Jordan to obtain it. While Jordan's instincts about copy portraits may have been correct, it was as the errand boy for the Art Jury that he learned the employment of historical evidence in the evaluation of works of art.[37]

For his campaign against Albert Rosenthal, Wilfred Jordan suffered professional death by the slow strangulation of his duties. As soon as the press aired the controversy, the Department of Public Works ordered the paintings catalog that Jordan had published in 1915 withdrawn from sale. Despite the ubiquitous copy portraits listed in it, each crediting Rosenthal, this catalog was the only complete list of the Hall's historical portraits.[38]

The episode of the so-called fraudulent portraits had an untoward and unfortunate sequel. The Art Jury, while conducting its painstaking evaluations, had ordered all paintings removed from display. Even after making its judgments, the jury left the paintings in basement storage. Since late 1917, Curator Jordan had been receiving complaints about the portraits' inaccessibility. He appealed to the jury to "designate the permanent locations in the buildings for the pictures ready to hang." When his requests were ignored, Jordan submitted the criticisms directly to the mayor's office. This tactic, plus his warnings to the chief of city property of possible negative news coverage, helped produce both the rejection list and a promise that the authenticated portraits would be rehung as quickly as possible.[39]

Four months later, the paintings were still in storage. In December 1918, newspaper headlines revealed one consequence of the Art Jury's dallying. "Rats Gnaw Pictures in Congress Hall's Historic Art Display" and "Notable Paintings Left as Food for Rats in Hall," reported Philadelphia's *Public Ledger*. Pressed for comment, Mayor Thomas B. Smith pleaded ignorance. "I know nothing at all about it. … I have directors and heads of bureaus to look after those things. All I have to say is that [those] rats have expensive taste."[40]

Eight paintings by Charles Willson Peale were among those that suffered damage. These works included the portraits of signer Thomas McKean and artillery officer Thomas Forrest. Apparently an art restorer hired thirty-five years earlier had relined the canvases using wheat-based paste, which attracted the rats and mice throughout the buildings. When the paintings had been hung high on walls, the wheat paste had not led to problems, but during the investigation they were stored on racks only inches from the floor and were easily accessible to vermin. The damage included displaced pigment and gnawed canvas.

The obvious answer was to rehang the undamaged works and fix the others. Curator Wilfred Jordan and chief of the Bureau of City Property John Arthur reached this conclusion; the Art Jury and other city officials did not.[41]

The Art Jury had in fact hired Pasquale Farina, an experienced and respected restorer of paintings, to work on the collection even before the revelation of rodent damage. In 1916, he examined selected portraits in the Independence Hall collection and presented the jury with reports on their condition and proposals for their restoration. The jury, however, insisted that before it would authorize treatment, Farina must first clean each painting and present it to them for inspection. Even then, members of the jury seldom approved Farina's entire treatment proposal, preferring to commission treatment of only selected areas of the portrait. "I was told to clean here," Farina later related, "to paint there, to varnish in another place, to fill cracks, and so on." Exasperated, and convinced that the Art Jury's indecision would prevent him from completing the project to their satisfaction

and receiving payment, Farina threatened a lawsuit in 1918. He even took his case to the public before finally settling his differences with the jury and parting with it.[42]

The Art Jury exercised its authority over loans as well as acquisitions, and adopted a policy even more restrictive than the one followed by the Board to Collect Relics. Fearful of compromising the collections, the jury refused nearly all loan requests. Predictably, because of the jury's composition, they acceded to the borrowing requests of fine arts museums. The jury also applied its hard-won standards of authenticity to proffered gifts. In 1917, the city had declined to purchase Albert Rosenthal's copy portrait of Dr. Bodo Otto from the artist. When the painting's subsequent owner, Mr. Otto Mallory, offered to give the copy portrait of his ancestor to the city in 1922, the Art Jury declined it.[43]

After its tempestuous relationship with Pasquale Farina, the Art Jury turned to "restorers" who were more tractable but less qualified to work on Independence Hall's paintings. Although Wilfred Jordan complained about the amateurs' treatment of the collections, his warnings went unheeded. The Art Jury obstinately insisted upon its sole prerogative to contract for restoration work. By 1920 Jordan, who was once in league with the Art Jury on the issue of copy portraits, had become the organization's opponent. He mustered support from city officials and disgruntled private citizens who had been sidelined by certain arrogant members of the Art Jury.[44]

With the approach of the sesquicentennial of the Declaration of Independence, various interest groups clamored for the right to include Independence Hall in their own plans for the celebration. One group, the American Institute of Architects, received permission to study and restore the building to its eighteenth-century appearance. Before undertaking their work, it was necessary once more to remove the paintings from Independence Hall. Restoration of the paintings not yet having been completed, Mayor J. Hampton Moore in 1921 appointed a new advisory board whose membership included representatives of the American Institute of Architects, society matrons, and city officials. The large number of the latter group on the new board seemed to prefigure a shift toward greater municipal control of Independence Hall.[45]

The Art Jury ignored the new advisory board and continued to contract for conservation work of varying quality. Wilfred Jordan thereupon persuaded the city that if the restoration project was to be completed on time for the Sesquicentennial, the city must employ a second restorer. Jordan's ploy worked. The city hired none other than Pasquale Farina to restore the last eight paintings in time for the celebration.

For one month in 1923, the Pennsylvania Academy of the Fine Arts mounted a major exhibition of the works of Charles Willson, James, and Rembrandt Peale. This venue featured 317 works by the portraitists and still ranks as one of the most comprehensive Peale shows ever mounted. Forty-seven portraits from the Independence Hall collection were included in the exhibition. For many, it marked the first time they were considered outside of Charles Willson Peale's scheme of noted worthies. The Independence Hall portraits were not isolated as a group, but were rather interspersed with the other public and domestic portraits in the display. Despite the brevity of the show, this public acknowledgment of the portraits as works of art as well as historical records did as much for their stature as the celebratory events that focused attention on Independence Hall. There was a partially illustrated catalog of the exhibit. While this publication has little informational value, it stands as a permanent record of the portraits situated within the larger context of the Peales' contemporaneous work.[46]

Back at Independence Hall, Jordan prepared for the Sesquicentennial by developing an exhibit plan for the newly restored building, grouping portraits according to the great events in which their subjects participated. Although the Sesquicentennial

42. "Department of the Art Jury: Seventh Annual Report," Philadelphia, 1917; William McGarry, "Neglect by Art Jury of Famed Paintings Brings $50,000 Suit," *North American*, 4 December 1918. "Paintings Stay Stored: Art Jury Will Not Act," *Philadelphia Inquirer*, 4 December 1918;4. "Art Jury Head orders Old Paintings Rehung," *Public Ledger*, 6 December 1918, 10; Raymond Pond to Joseph Wagner, 21 June 1920, INHP; Pasquale Farina, "The Philadelphia Art Scandal," *The Moment*, 7 December 1918, English Section.

43. Advisory Board, "Meeting Minutes," 14 March 1907, INHP. Charles Neeld to Wilfred Jordan, 6 March 1929, INHP. Jordan attempted to gain more storage space by suggesting that the city sell the banished Rosenthals. Despite the temptation to rid itself of a white elephant, the Art Jury would not test its power to deaccession collections. Jordan then suggested that the city's public schools might wish to display the Rosenthals. This idea received little attention. The copy portraits have remained consigned to storage. Charles Neeld to Theodore M. Dillaway, 4 November 1929, INHP; Wilfred Jordan to Chief of Bureau, 22 January 1929, INHP; Eli K. Price to Charles Neeld, 1 July 1929, INHP; Superintendent to the Chief of City Property, circa March 1930, INHP.

44. The Art Jury hired Gilbert Parker and Thomas E. Stevenson. Parker was a friend of Charles Henry Hart. Parker to Hart, 16, 20, and 22 February 1917, Charles Henry Hart papers, AAA. Wilfred Jordan to Acting Chief Raymond Pond, 24 May 1920, INHP. Harrison Morris, former director of the Pennsylvania Academy of the Fine Arts was one of Jordan's allies. Morris felt the Art Jury had favored the new Philadelphia Museum of Art over the Academy.

45. Wilfred Jordan to Harry Baxter, Chief of the Bureau of City Property, 7 October 1921, INHP; Andrew Crawford to Harry Baxter, 29 December 1921, INHP.

46. John Andrew Myers to Wilfred Jordan, 3 January 1923, INHP. *Catalogue of an Exhibition of Portraits by Charles Willson Peale and James Peale and Rembrandt Peale* (Philadelphia: The Pennsylvania Academy of the Fine Arts, 1923).

47. Andrew Crawford to Harry Baxter, 27 January 1922, INHP; Ernest Lee Parker to Chief of City Property, 5 December 1922, INHP; Wilfred Jordan to Chief of City Property, 27 February 1924, INHP; Curator, Independence Hall to Chief of Bureau, "Re-Hanging of Paintings— Independence Hall Collection," 6 February 1922, INHP.

48. Wilfred Jordan to Margaret G. Cowell, 11 August 1928, Specimen folder 13.394, INHP. Jordan never executed the refurnished room project. William Richardson Davie specimen folder 52.011, and accessions folder 938, INHP.

49. Edward P. Monck, a sixty-nine-year-old former teacher, replaced Jordan for a short time. Obituary, "Edward P. Monck," *New York Times,* 3 December 1940; *Twenty-Second Annual Report of the Art Jury,* Philadelphia, 1932.

50. Carpenter had studied at the Pennsylvania Academy of the Fine Arts (under Thomas Aikens), the Philadelphia School of Industrial Art, and the Art Students' League in New York. He had been an art editor of *Cosmopolitan Magazine* and a book illustrator. He painted his own historical paintings and displayed some of them in Independence Hall prior to 1929. Superintendent to the Chief of City Property regarding report *Re-Hanging of Portraits by the Art Jury,* 5 January 1933, INHP; *Twentieth Annual Report of the Art Jury,* Philadelphia, 1930, 27; H.W. Murphey to Horace Carpenter, regarding "Accession Record— Independence Hall," 23 August 1938, INHP; Laura Lee, "Curator Doubts Rodney Picture," *Philadelphia Evening Bulletin,* 30 March 1935, Temple University Photojournalism Archives.

festivities took place in South Philadelphia, the refurbished Independence Hall with its fresh display of historical portraits received a large number of visitors during the celebration.[47]

The renewed interest in Independence Hall led to two important paintings acquisitions. In 1928 the Art Jury accepted the donation of companion portraits of Martha and Rebecca Doz by James Claypoole, Jr. A descendant of the subjects donated the prize paintings. Influenced by the period rooms of the major museums he had visited twenty years earlier, and determined to rival the Philadelphia Museum of Art, which opened its new building on Fair Mount that year, Jordan was planning "to develop a colonial bedroom with all its appurtenances." He intended to place the Doz portraits in the furnished period room. Under those circumstances, the Art Jury had no problems accepting two fine portraits of young children who had no direct connection to the historical events that occurred in Independence Hall. That same year, Jordan was able to acquire a miniature of William Richardson Davie. That acquisition represented the culmination of nine years of effort by Jordan and by Independence Hall's superintendent, Horace T. Carpenter, to convince the portrait's owner to donate it. At a time when many owners of Americana were donating their treasures to the Philadelphia Museum of Art, Jordan must have been justifiably proud of those superb additions to the paintings collection.[48]

After twenty-one years as curator of Independence Hall, Wilfred Jordan resigned in September 1929, to become director of public relations for the Philadelphia Chamber of Commerce. Despite his sometimes tactless and confrontational ways, Jordan led the city to accept the responsibilities that go with the ownership of an important collection of historic portraits. Because of his badgering, the city defined a formal system of oversight for the paintings and set the limits of the overseers' power. Through Jordan's efforts, the Art Jury formulated an acquisitions policy that established the quality of the collections. While Jordan was less successful in expressing the need for consistent collections care, he introduced the notion that only the professionally qualified should treat the artworks. Jordan popularized the collections through his 1915 catalog, and later, through a series of educational bulletins written for school-age children. His work at Independence Hall had a lasting impact upon the operations of the historic site.

The economic depression of the 1930s was felt at Independence Hall as elsewhere. One effect was to eliminate Jordan's old position as curator in 1932 and to add its responsibilities to those of the superintendent.[49]

Horace Carpenter *(see Illustration 4)* was an academically trained painter who had a career as an art editor and illustrator to his credit. His longevity as a public employee owed much to his diplomatic ability. In 1930, when the Art Jury demanded the removal of forty-two portraits that had been hung before the Jury had completed its authentication process, Carpenter stalled the action for five years by reminding the city that, were this recommendation heeded, the resulting bare walls would require repainting. Finally, Carpenter removed one painting. Where Wilfred Jordan had confronted, Carpenter finessed. For example, a newly discovered watercolor image purported to be a Charles Willson Peale portrait of Caesar Rodney surfaced in 1935. Recognizing it as a copy, at best, but reluctant to disparage the portrait in print, Carpenter merely stated that "Rodney was too forthright and honest a person to allow a false likeness of himself." During his superintendency, however, Carpenter showed little interest in the collections. Without an energetic curator, the exhibits in Independence Hall remained unchanged.[50]

Although the Depression meant cuts in city funding for Independence Hall, it turned out to be a boon to historic preservation generally. The Historic Sites Act of 1935 declared a national policy "to preserve for public use historic sites, buildings, and objects. …" Furthermore, the act authorized the National Park Service to preserve and

maintain properties of "national historical and archeological significance." Private sentiment grew in Philadelphia for the creation of a national park to preserve Independence Hall. In June 1942, a group of citizens founded the Independence Hall Association. This group devoted itself to lobbying Congress to create Independence National Historical Park.[51]

After America entered World War II, Independence Hall and its collections received increased national attention as a symbol of patriotism. The several branches of the armed forces conducted enlistment ceremonies in the building, and the Hall's hours of operation were extended to accommodate visiting servicemen. The destruction of Great Britain's national treasures by bombing raids caused Philadelphians to consider how best to protect their own cultural collections. In the end, the city decided to keep the historical portraits in Independence Hall, where they could serve patriotic purposes, but Superintendent Carpenter and Fiske Kimball, director of the Philadelphia Museum of Art, also developed a disaster plan for off-site storage at the museum in the event of an emergency.[52]

In January, 1943, Congress named Independence Hall a National Historic Site. Realizing the public attention this honor brought to the collections, Carpenter ordered restoration work on Rembrandt Peale's *Washington, Armstrong*, and *Humphreys* portraits. The superintendent also initiated oral interviews with descendants of donors in an effort to validate some of the still unauthenticated portraits.

As part of the authentication effort, a number of museum professionals urged the application of scientific technology. This led to a decade-long confusion about the authenticity of one of the collection's best-known paintings. In March 1943, Fiske Kimball used X-radiography to examine Charles Willson Peale's portrait of Thomas Jefferson. Kimball subscribed to the popular belief that the brushwork revealed in an X-ray of a painting definitively determined its artist. After X-ray, Kimball pronounced Jefferson's portrait a copy. This conclusion was widely accepted, leading scholars to revise their assessments of the portrait and to question the whereabouts of its source. Not until the 1950s, when conservators employed a wide range of analytical techniques to the *Jefferson,* was Kimball's theory rejected and the *Jefferson* once again attributed to Peale.[53]

During the war, Superintendent Carpenter relaxed the policy against loaning paintings from the collection. In 1945, he loaned three Peale portraits, *Baron von Steuben, Nathanael Greene,* and *Joseph Brant,* to the Eastern Pennsylvania Women's Division of the War Finance Committee of the United States Treasury for a bond drive exhibition titled "Portraits of Warriors," which was held in a local department store. The use of the portraits for propaganda sustained public interest in their permanent preservation.[54]

Near the close of Carpenter's career, there was another portrait acquisition for which he deserves credit. In 1921, a descendant of Thomas Hartley had loaned Independence Hall a miniature of Hartley and one of his wife. Wilfred Jordan, seeking to convert the loan to a gift, offered to trade a Rosenthal copy portrait of Hartley for the miniatures. Surprisingly, the owner agreed. However, Jordan never followed through on the transaction, perhaps because of the Art Jury's defensive posture on deaccessions and on the Rosenthals. Twenty-five years later, at the owner's instigation, the negotiations were resumed. The Art Jury approved the exchange less than two months before Horace Carpenter's death.[55]

Because of the imminent transfer of Independence Hall from city to federal control, no superintendent was appointed in 1947 after Horace Carpenter's tenure. Instead, Warren McCullough, who had begun his career as a guard in the buildings, was appointed curator. McCullough rose to the occasion. For eight years Carpenter and other city officials had been corresponding with the potential donor of an important painting, Charles Willson Peale's *George Glentworth*. Glentworth had been a founder of the College

51. Historic Sites Act (P.L.74-292, 49 Stat. 666). For a detailed account of the founding of Independence National Historical Park, see Constance M. Grieff, *Independence: The Creation of a National Park* (Philadelphia: University of Pennsylvania Press, 1987).

52. Collas G. Harris, Executive Secretary of the Committee for the Conservation of Cultural Resources to Horace Carpenter, 18 December 1941, INHP; Horace Carpenter to Collas Harris, 26 December 1941, INHP; National Resources Planning Board, *The Protection of Cultural Resources Against the Hazards of War,* Washington, February 1942, 1. Fiske Kimball to Horace Carpenter, 25 February 1942, Philadelphia Museum of Art Archives.

53. The actual procedure was done in the engine room of the East Wing building of Independence Hall. Superintendent's "Daily Record," 5 April 1943, INHP. The Hall's Jefferson portrait remained a "copy" until 1962, when more sophisticated research tools refuted the validity of the 1943 X-ray determination. Corrected analysis based on findings of Anne F. Clapp, Intermuseum Laboratory, Oberlin, Ohio 28 January 1962, INHP.

54. The firm was Cecil & Presbrey, Inc., advertising for the Great American Group of Insurance Companies, New York. Memorandum from N. H. Rambo to H. T. Carpenter, 3 August 1942, INHP. Exhibition held in the Art Gallery of John Wanamaker Store in Philadelphia, 16–30 April 1945.

55. Charles H. Hall to Curator, Independence Hall, 28 September 1946; City Council Ordinance, 25 March 1947 (copy); N. H. Rambo to Charles H. Hall, 7 April 1947. Specimen folder 13.109, INHP.

56. Marguerite L. Glentworth to Howard W. Murphey, 30 September 1939; Howard W. Murphey to Marguerite L. Glentworth, 5 October 1939; Marguerite L. Glentworth to Howard W. Murphey, 26 February 1940; H. W. Murphey to Marguerite L. Glentworth, 28 February 1940; Horace T. Carpenter to Howard W. Murphey, 28 February 1940; Marguerite L. Glentworth to H. W. Murphey, 26 August 1947; Warren A. McCullough to Charles Coleman Sellers, 2 September 1947; Warren A. McCullough to N. H. Rambo, 2 September 1947; Charles Coleman Sellers to Warren A. McCullough, 9 September 1947; N. H. Rambo, Jr. to Grace G. Haupt, Art Jury, 7 November 1947; G. Haupt, Art Jury, to N. H. Rambo, 14 November 1947, Specimen folder, 13.086, INHP.

of Physicians of Philadelphia and an avid horticulturalist. The colorful, half-length portrait features medical books and flowers, attributes of those interests. He died in 1792. After the city's acquisition of the painting, investigation of an overpainted area revealed the date 1794, with Peale's signature indicating that the work was painted posthumously. The painting's owner, a direct descendant of Glentworth, wished to see it placed in Independence Hall because the physician had been director-general of hospitals for the Middle Division of the Continental army during the Revolution.

The tyro Warren McCullough pursued the Glentworth portrait with the tenacity and tact of a seasoned curator. He sought the consultation of the leading Peale scholar, Charles Coleman Sellers, to authenticate the painting. Meanwhile, he developed a cordial, trusting relationship with the donor. When the city's agents seemed to waver on its desire for the picture, McCullough urged them to act quickly as several "New York dealers" were also pursuing it with lucrative offers. After several years' assiduous curatorial work, the Art Jury finally approved the gift to the city in 1947, and, in consideration, gave the donor Albert Rosenthal's copy portrait of Glentworth, which the artist had sold to Independence Hall in 1910. Warren McCullough's quick thinking and professional conduct brought the city its last portrait acquisition for Independence Hall before the federal government assumed custody of the collections.[56]

After the war ended, the Independence Hall Association increased its lobbying efforts, and on 28 June 1948, Public Law 795 provided for the creation of Independence National Historical Park. From that time until the federal government assumed administrative control of the site and the paintings collection on 2 January 1951, there were no changes in the collection, as local officials contented themselves with diligent care of the art treasures until the arrival of federal authority.

Catalog of Portraits

Karie Diethorn, *editor*

"good and faithful paintings":
Charles Willson Peale's Philadelphia Museum Portraits

by Karie Diethorn

1. Standard sources for the study of Charles Willson Peale, his family, and their museums include a range of biographies and exhibition catalogs. Early works by Charles Coleman Sellers include: *Portraits and Miniatures by Charles Willson Peale* Transactions of the American Philosophical Society 42:1 (1952), *A Supplement to Portraits and Miniatures* Transactions 59:3 (1969), and *Mr. Peale's Museum: Charles Willson Peale and the First Popular Museum of Natural Science and Art* (New York: W.W. Norton & Company, Inc., 1980). Additional material may be found in Edgar P. Richardson, Brooke Hindle, and Lillian B. Miller, *Charles Willson Peale and His World* (New York: Harry N. Abrams, Inc., 1982). On the Philadelphia Museum specifically, David Rodney Brigham's "'A world in miniature': Charles Willson Peale's Philadelphia Museum and its audience, 1786–1827" (Ph.D. dissertation, University of Pennsylvania, 1992) and *Public Culture in the Early Republic: Peale's Museum and Its Audience* (Washington, D.C.: Smithsonian Institution Press, 1995) are extensive. On the Peale family, sources include Lillian B. Miller, ed., *The Peale Family: Creation of a Legacy, 1770–1870,* Smithsonian National Portrait Gallery exhibition catalog (New York: Abbeville Press, 1996); Carol Eaton Hevner, *Rembrandt Peale 1778–1860: A Life in the Arts,* exhibition catalog (Philadelphia: Historical Society of Pennsylvania, 1985); "Rembrandt Peale," special issue of *PMHB* 110 (January 1986); Lillian B. Miller, *In Pursuit of Fame: Rembrandt Peale, 1778–1860,* National Portrait Gallery exhibition catalog (Seattle: University of Washington Press, 1992), and Linda Crocker Simmons, *Charles Peale Polk, 1776–1822: A Limner and His Likenesses,* exhibition catalog (Washington, D.C.: Corcoran Gallery of Art, 1981). Primary source material is available through Lillian B. Miller, ed., *The Selected Papers of Charles Willson Peale and His Family* (New Haven: Yale University Press, 1988–1996), volumes 1 through 4. The original manuscripts are in the Peale-Sellers Papers, American Philosophical Society.

For forty-five years, Charles Willson Peale painted portraits of his distinguished contemporaries and gathered them for public display in his Philadelphia Museum. The museum was Peale's "world in miniature," open to those like himself who would indulge their own curiosity and quest for knowledge. Until his death in 1827 (except for the decade between 1810 and 1820, when his son Rubens managed it), Peale dedicated all of his resources to running the museum. Portrait painting provided both substance and subsistence in this effort.[1]

During the last years of the Revolution, Peale conceived the creation of his portrait gallery of "worthy Personages." By early 1784 he had transformed his Philadelphia home at Third and Lombard Streets, with the addition of a skylit room, from an artist's atelier into a public art gallery, which he called the Philadelphia Museum. Later that year he published his first museum catalog, a list of forty-four portraits depicting the men who had brought the late war to its successful conclusion. Within a decade the Philadelphia Museum collection, which now also contained natural history specimens as well as portraits, outgrew Peale's home. The artist then moved the museum and his household to the headquarters of the American Philosophical Society at Fifth and Chestnut streets. By 1802, the

Detail from "View of Several Public Buildings, in Philadelphia," 1790, courtesy of the American Philosophical Society

portrait collection had nearly doubled in size and the museum had moved to the second floor of the old Pennsylvania State House (now called Independence Hall). There Peale's collection eventually numbered nearly two hundred and fifty paintings, most of which were painted by him, with the addition of several score by his son Rembrandt and a few by Charles Willson's younger brother James.[2]

 Peale's prodigious rate of portrait production reflected his intense commitment to the museum's edifying mission "to instruct the mind and sow the seeds of Virtue." He intended his museum's visitors to view the portraits (and read the individual biographies associated with them in the accompanying catalogs) and reflect upon the illustrious deeds of the subjects portrayed in them. For Peale, the museum subjects were those whose lives represented the essential human qualities that had fueled the Revolution and would sustain the new American republic: public-spiritedness, self-sacrifice, and personal morality.[3]

 Peale shared this belief in the instructive power of portraiture with many of his contemporaries, artists and scientists alike. In fact, this concept was deeply ingrained in Western thought, beginning with the societies of Classical Greece and Rome, extending through the Renaissance and into the modern era. The late eighteenth century's own fascination with physiognomy, the study of how human facial features reflect characteristics of personality, represented the latest interpretation of this idea. Peale probably read the translated works of physiognomy's leading proponent, Johann Caspar Lavater (1741–1801), for the artist clearly supported the author's tenets: "The temper of man in a powerful degree fashions as I may say, the turns of the features." In a Peale museum portrait, the sitter's exemplary character was the artist's chief subject.[4]

 Peale's emphasis on the portrayal of subjects that personified society's highest moral achievements was well in keeping with the conventions of contemporary Anglo-American art. The exacting manner in which Peale painted his portraits, however, was not. Peale believed that nature portrayed in precise detail captured the essence of character. In fact, Peale wanted to paint pictures that equaled nature: "Let them have truth," he told his son, "so that every Eye may at a first glance exclaim how like the Man, make them believe it is the Man and see nothing of a picture."[5]

 Peale's "truthful" depiction of subjects contradicted the tenets of formal, or grand, portraiture as defined by the practice of painting in British art academies. Sir Joshua Reynolds, president of London's Royal Academy of Art and England's leading late-eighteenth-century portraitist, advocated an idealized type of portraiture because he considered it "very difficult to ennoble the character of a countenance but at the expense of the likeness." According to Reynolds, the painter improved an individual's physical appearance to the degree that it accurately communicated the sitter's admirable character. Slavish devotion to detail produced not art, in Reynolds' opinion, but mere copies.[6]

 Undoubtedly, Peale saw many idealized portraits and encountered the traditional elements of artistic training (extensive copying of master works, drawing studies from sculpture casts) during his two intermittent years as a student in Benjamin West's London studio in 1767, 1768, and 1769. As a result of this experience, his only period of formal art study, Peale readily accepted that skillful drawing was the foundation of competent painting. However, he always preferred live subjects to inanimate models (a practice he admired in Dutch painting, particularly that of Rembrandt van Rijn), because he considered works of nature to be themselves works of art. For Peale, a painting's purpose was to portray nature, not to display the painter's artifice.[7]

 The format that Peale chose for his museum portraits emphasized his intent to impress his audience with the realness of his sitters' appearance (and thus their character). The bust-length paintings are life-size, usually featuring a dark background

2. All transcriptions from Peale family manuscripts, unless otherwise stated, are from Miller, *Selected Papers*. For the first announcement of the gallery of "worthy Personages," see *Pennsylvania Packet* 14 November 1782. On the forty-four portraits, see *Freeman's Journal and Philadelphia Daily Advertiser* 14 October 1784; thirty-four of these portraits are now in the Independence Park collection. For the collection at "about 80 portraits," see Charles Willson Peale to John Isaac Hawkins, 28 March 1807 (Miller, *Selected Papers* 2:2, page 1010). On the size of the collection by the end of Peale's life, see Charles Willson Peale to Nicholas Brewer, 7 June 1823 (Miller, *Selected Papers* 4, page 281). In the Independence Park collection, there are eighty museum portraits by Charles Willson Peale, eleven by Rembrandt Peale, and three attributed to James Peale.

3. For "the seeds of Virtue," see Charles Willson Peale to the Representatives of the State of Massachusetts in Congress, 14 December 1795 (Miller, *Selected Papers* 2:1, page 136).

4. For a lengthy discussion of the ideology behind the theory of physiognomy and its influence on eighteenth-century thought, see Brandon Brame Fortune, "Portraits of Virtue and Genius: Pantheons of Worthies and Public Portraiture in the Early American Republic, 1780–1820" (Ph.D. dissertation, University of North Carolina, 1986, 189–197). For the "temper of man", see Charles Willson Peale, Diary 23, 2 December 1818 (Miller, *Selected Papers* 3, page 628).

5. For "how like the Man," see Charles Willson Peale to Rembrandt Peale, 16 June 1817, quoted in Lillian B. Miller, *In Pursuit of Fame*, 123.

6. For a discussion of idealization in British portrait of the eighteenth century, see Lauren Suber, "Rituals, Roots, and Rectangles: the Classical Tradition in Early American Portraiture" (M.A. thesis, College of William and Mary, 1992, 2–28). On Reynolds, see Robert R. Wark, ed., *Sir Joshua Reynolds, Discourses on Art*, 3rd edition (New Haven: Yale University Press, 1988), 72.

7. For Peale's use of "nature" studies rather than studio copies, see Charles Willson Peale to John Beale Bordley, November 1772 (Miller, *Selected Papers* 1, page 127). On Peale's admiration for Dutch painting, see Fortune, 179–180. Fortune also discusses (see 172–173) the influence on Peale of the theories of realistic painting by Roger de Piles (probably in translation for the 1778–1783 *Encyclopædia Britannica*) and Jonathan Richardson. On the lasting influence of Peale's London study, see Jules Prown, "Charles Willson Peale in London," in Lillian B. Miller and David C. Ward, eds., *New Perspectives on Charles Willson Peale* (Pittsburgh: University of Pittsburgh Press, 1991), 35.

8. On bust-length as life-size, see Charles Willson Peale to William Grayson, 7 March 1805 as quoted in Fortune, 202.

9. Because of the oval spandrels, Peale omitted painting the museum portraits to the edges of their rectangular canvases during the first thirty years of building the collection (an exception to this rule is the early 1780s portrait of Henry Knox, which is painted to the edges). After 1810, possibly due to a suggestion from Rubens Peale (the museum's manager at the time), all the museum portraits were painted to the edges of their rectangular frames and displayed without spandrels. An exception to this new program was the 1823 museum portrait of Charles Carroll (see catalog entry below). This is probably the case because Peale copied his son's Baltimore Museum portrait of the sitter, which was in an oval format. Charles Willson Peale reported that Rubens thought the museum portraits should be bigger, possibly as a concession to changing artistic tastes, in a letter to Rembrandt Peale on 26 June 1808 (Miller, *Selected Papers* 2:2, page 1093). Possibly the oval format was under review at this time as well.

On Peale's selection of "none to disgrace the Gallery," see Charles Willson Peale to John Isaac Hawkins, 28 March 1807 (Miller, *Selected Papers* 2:2, page 1010). A number of scholars have written on the symbolic nature of Peale's gallery. For an early analysis, see John C. Milley, "Portraiture: Commemorative and Symbolic," in *Treasures of Independence* (New York: Mayflower Books, Inc., 1980), 162–164. On Peale's placement of certain sitters in the gallery as a form of idealization, see Suber, 43, and Fortune, 203–207.

devoid of props. In them, the sitter is the one and only interest. In the prevailing republican fashion of the Revolution and its aftermath, few of Peale's sitters wear wigs or powdered hair. They also appear in their daily dress: coats and waistcoats with the appropriate addition of clerical robes, military uniforms, or diplomatic insignia.[8]

Some scholars have observed that Peale's emphasis on artistic realism did not prevent him from symbolically idealizing his sitters. Peale's method of displaying the portraits in rectangular frames with oval spandrels clearly associated the museum paintings with other commemorative portraiture, particularly Roman busts and coins, but also engraved frontispieces to biographies published in Great Britain. Peale selected his sitters carefully, intent upon including only those with unblemished records. As a result, Peale's museum subjects represent the artist's interpretation of the best men of that era. Although he specified that his portraits were to equal nature in their detail, Peale did compose his images with an eye to their visual effectiveness. Brandon Brame Fortune has suggested that Peale portrayed his museum subjects with a variety of similar physical attributes (a firm mouth suggesting stability, a faint smile as an expression of benevolence, a high forehead as the indicator of intelligence) in order to represent their shared character traits, rather than to stylize their physical appearance. She suggests that the museum portraits are, in their composition and format, physically emblematic of the civic ideal that Peale sought to include as part of his museum's educational message.[9]

Peale defined the didactic purpose of his museum portraits and established their format at the outset of his project; his artistic method, on the other hand, evolved slowly over the course of his career. An inveterate tinkerer, Peale worked in a variety of painting media and experimented constantly with new techniques. He used optical and mechanical devices, like the *camera obscura* and the physiognotrace, to augment his own natural abilities. And he collaborated on museum projects and public commissions with other artists, chiefly his brother James and his own children. Of these, Peale's second son Rembrandt was particularly significant in his father's development as a painter.

Rembrandt Peale began his professional artistic career in 1795 when he painted his first portrait of President George Washington. The younger Peale's first additions to the museum collection (these included those of David Ramsay, Christopher Gadsden, and Thomas Sumter [see catalog entries below]) stemmed from a painting trip to Charleston, South Carolina, in late 1795 and 1796. From then on through the 1820s, Rembrandt added several groups of portraits to the Philadelphia Museum (the paintings in the Peales' Baltimore Museum were Rembrandt's copies of the Philadelphia Museum collection made for his 1795–1796 trip to Charleston). The largest of Rembrandt's portrait contributions to his father's collection were made as a result of two study trips to Paris that Rembrandt took in 1808 and 1809–10 (among these was a portrait of America's ambassador to France John Armstrong [see catalog entry below]).

Rembrandt's Paris sojourns resulted in more than an increased museum collection; during these years, Rembrandt refined his own knowledge of painter's pigments and introduced his father to what the latter termed "a System of colouring ... so simple & easy in the immatation [*sic*] of Nature, of flesh &c. that I can play with the colours and produce any effect I choose. ... " Previously, the elder Peale had tried a variety of paints with limited satisfaction. His earliest museum portraits, like that of John Dickinson (see catalog entry below), have a distinct greenish cast that gives the sitters a pronounced pallor. In the late 1780s Peale changed his color palette, and the museum portraits from that time through the mid-1790s exhibit a silvery tone. Under the influence of Rembrandt's coloring system, adopted by Charles Willson around 1806, the senior artist substituted a red ground for the white one he had previously used on his canvases, with the result that his subjects'

skin tones became significantly warmer as well as more varied in color, as seen most effectively in the portrait of Zebulon Pike (see catalog entry below).[10]

The elder Peale exuded new-found confidence with the adoption of his son's color system. He considered the new palette the perfect complement to his strict adherence to realistic detail: "I am convinced that my knowledge of colouring has increased by my practice of late. If my Portraits where [*sic*] of value on account of the likeness being known at first sight, think how much More valuable my pictures will be when the tints give the effect of real life?" He continued to employ the system for the rest of his life, repeatedly testing its effectiveness in various situations. He pronounced it particularly successful in his portraits of aged sitters, like Timothy Matlack (see catalog entry below)—the artist's last museum portrait—during the 1820s. That he should be able to assimilate the new techniques seemed perfectly predictable to the senior artist. Describing his pleasure in Rembrandt's growth as an artist, Peale added that "it would be strange if I could not also improve, when it is an object with me to prove that acquirements is attainable at any period of life."[11]

Lifelong learning, Peale's personal and professional goal, was the inspiration for his Philadelphia Museum collection. Throughout its building, the museum provided Peale with a system by which to examine nature and reveal its infinite variety. Within that system, human beings performed an important role, one with weighty responsibilities and difficult tasks. Those who personified human achievement were the subjects of Peale's museum portraits. Their examples were to guide and inspire the present and future generations to further greatness. And for his ability to capture his illustrious sitters' presence and preserve it, Peale believed he "would be loved, would be admired, and would be honoured by the children and children's children, nay, by all who might see such of perfection of art for ages to come."[12]

10. For "the immatation [*sic*] of nature," see Charles Willson Peale to Thomas Jefferson, 15 January 1818 (Miller, *Selected Papers* 3, page 565). John C. Milley identified these three periods of Peale's work, recognized through their colorization, while serving as chief curator at Independence Park from 1972 until 1992.

11. For "how much More valuable my pictures," see Charles Willson Peale to Titian Ramsay Peale, 21 March 1820 (Miller, *Selected Papers* 3, page 797). Although Peale embraced Rembrandt's color system, he admonished his son that "truth is better than a high finish" (Charles Willson Peale to Rembrandt Peale, 5 August 1823, cited in Carol Eaton Hevner, "The Paintings of Rembrandt Peale: Character and Conventions," in Lillian B. Miller, *In Pursuit of Fame*, 270). For Rembrandt's emphasis on light and color, rather than realism, see Hevner, 263–264. For "acquirements is attainable," see Charles Willson Peale to Thomas Jefferson, 24 December 1806 (Miller, *Selected Papers* 2:2, page 993).

12. Charles Willson Peale, Autobiography, 1826. Peale-Sellers Papers, microfiche IIC 18 E6-7, American Philosophical Society.

Table of Bibliographic Abbreviations

Adams, Works	Adams, Charles F., The Works of John Adams. Boston: C. C. Little and J. Brown, 1850.
Freeman's Journal, 1784	"A List of Portraits," Freeman's Journal and Philadelphia Daily Advertiser, 13 October 1784.
Biddle and Fielding, Sully	Biddle, Edward and Mantle Fielding. The Life and Works of Thomas Sully. Philadelphia, 1921.
Burnett, Letters	Burnett, Edmund C., ed. Letters of Members of the Continental Congress. Washington, DC: Carnegie Institution of Washington, 1933.
Butterfield, Adams	Butterfield, L. H., ed. Diary and Autobiography of John Adams. Cambridge, MA: Belknap Press, 1961.
Catalogue, 1854	Peale's Museum Gallery of Oil Paintings. Thomas & Sons, Auctioneers. Catalogue of the National Portrait and Historical Gallery … October 6, 1854. Philadelphia, 1854.
Catalogue, 1855	Catalogue of the National Portraits in Independence Hall. Philadelphia: John Coates, 1855.
Catalogue, 1856	Catalogue of the National Portraits in Independence Hall. Philadelphia: 1856.
Catalogue, 1858	Catalogue of the National Portraits in Independence Hall. Philadelphia: 1858.
Catalogue, 1869	Catalogue of the National Portraits in Independence Hall. Philadelphia, 1869.
Catalogue, 1872	Catalogue of the National Portraits in Independence Hall. Philadelphia: 1872.
Catalogue, 1915	Catalogue of Portraits and Other Works of Art, Independence Hall. Philadelphia, 1915.
Corner, Rush	Corner, George W., ed. The Autobiography of Benjamin Rush. Westport, CT: Greenwood Press, 1948.
First Report	First Report of the Committee on Restoration of Independence Hall. Philadelphia, 21 June 1873.
Fitzpatrick, Writings	Fitzpartick, John C., ed. The Writings of George Washington. Washington, D.C.: U. S. Government Printing OYce, 1944.
Hart, Register	Hart, Charles Henry. A Register of Portraits Painted by Thomas Sully, 1801–1871. Philadelphia, 1908.

Hevner, Peale	Hevner, Carol Eaton. Rembrandt Peale, 1778–1860. A Life in the Arts. Exhibit catalog. Philadelphia: Historical Society of Pennsylvania, 1985.
Jackson and Twohig, Diaries	Jackson, Donald and Dorothy Twohig, eds. The Diaries of George Washington. Charlottesville: University Press of Virginia, 1979.
JCC	Journal of Common Council, Philadelphia.
JSC	Journal of Select Council, Philadelphia.
Knox, The Sharples	Knox, Katharine McCook. The Sharples, Their Portraits of George Washington and His Contemporaries. New York: Da Capo Press, 1972.
Lee, Memoirs	Lee, Henry. Memoirs of the War in the Southern Department of the United States. Philadelphia, 1812.
Miller, Papers	Miller, Lillian B., ed. The Selected Papers of Charles Willson Peale and His Family. New Haven, CT: Yale University Press, 1983 et seq.
Morgan, Trumbull	Morgan, John Hill. The Paintings of John Trumbull at Yale University of Historic Scenes and Personages Prominent in the American Revolution. New Haven, CT: Yale University Press, 1926.
Morgan and Fielding, Portraits	Morgan, John H. and Mantle Fielding, The Life Portraits of Washington and Their Replicas. Philadelphia: for the subscribers, 1931.
Peale, "Autobiography"	Peale, Charles Willson. "Autobiography," ts. Peale-Sellers Papers, American Philosophical Society.
Peale, Catalogue, 1795	Peale, Charles Willson. An Historical Catalogue of Peale's Collection of Paintings. Philadelphia, 1795.
Peale, Catalogue, 1813	Peale, Charles Willson. Historical Catalogue of the Paintings in the Peale Museum. Philadelphia, 1813.
Peale, "Diary"	Peale, Charles Willson. "Diary." Peale-Sellers Papers, American Philosophical Society.
Peale, "Memorandum Book"	Peale, Charles Willson. "Memorandum of the Philadelphia Museum, 1803–41." Peale Papers, Historical Society of Pennsylvania.
Peale-Sellers Papers	Peale-Sellers Papers, American Philosophical Society.
PMHB	Pennsylvania Magazine of History and Biography
Second Report	Second Report of the Committee on Restoration of Independence Hall. Philadelphia, 29 April 1874. Independence National Historical Park.
Sellers, Franklin	Sellers, Charles Coleman. Benjamin Franklin in Portraiture. New Haven, CT: Yale University Press, 1962.
Sellers, Portraits and Miniatures	Sellers, Charles Coleman. Portraits and Miniatures of Charles Willson Peale. Transactions of the American Philosophical Society, 42 (1952).

Smith, Letters	Smith, Paul H. et al., eds. Letters of Delegates to Congress, 1774–1789. Washington, DC: Library of Congress, 1976.
Smyth, Franklin	Smyth, Albert H., ed. The Writings of Benjamin Franklin Collated and Edited with a Life and Introduction. New York, 1905.
Stewart, Pine	Stewart, Robert G. Robert Edge Pine: A British Portrait Painter in America, 1784–1788. Washington, DC: Smithsonian Institution Press, 1979.
Sully, "Account"	Sully, Thomas. "Account of pictures painted." Sully Papers, Historical Society of Pennsylvania.
Third Report	Third Report of the Committee on Restoration of Independence Hall. Philadelphia, 1875. Independence National Historical Park.
Van Doren, Franklin	Van Doren, Carl. Benjamin Franklin's Autobiographical Writings. New York: Viking Press, 1945.

Abbreviations Used for Repositories

APS	American Philosophical Society
HSP	Historical Society of Pennsylvania
INHP	Independence National Historical Park
LC	Library of Congress
LCP	Library Company of Philadelphia
MHS	Massachusetts Historical Society
PAFA	Pennsylvania Academy of the Fine Arts

· 7 5 ·

Contributors to Catalog

John Bacon

Rebecca Briesacher

Karie Diethorn

David C. Dutcher

Doris D. Fanelli

Lori Ferguson

Robert L. Giannini III

Margaret Harm

David Kimball

Constance Kimmerle

Nancy Lisewski

JOHN ADAMS (1735–1826)
by Charles Willson Peale, from life, c. 1791–1794

Adams was born in Braintree (now Quincy), Massachusetts, on 19 October 1735 and graduated from Harvard twenty years later. Feeling himself unsuited for the clergy, he first taught school and then read law. He dabbled in politics and wrote on public issues for the Boston newspapers from the beginning of his legal career. He opposed the Stamp Act, and his version of Braintree's protest resolutions to the act put him among the leaders of the Massachusetts resistance to British rule. While he abhorred the mob violence associated with political protest, Adams hated British policy even more. A brilliant debater, Adams was a delegate to the First and Second Continental Congresses, where he led the movement to declare independence and signed the Declaration.

During the Revolution, Adams served in the American diplomatic corps, first as a commissioner to the country's new ally, France, and later as minister to the Netherlands. In the early 1780s, he played a key role in negotiating the peace between America and England, and he represented the United States as its first minister to Great Britain. Beginning in 1789, Adams served two terms as vice president, and then followed George Washington as president in 1796. Later, conflicts with his cabinet over the appointment of foreign ministers and of a peace commission to France left Adams in deep opposition to the political wishes of both Federalists and Antifederalists. His refusal to commit America to war with France led to his defeat in the presidential election of 1800. Grudgingly retired to private life, Adams died on 4 July 1826.

Though he professed a preference for the paintings of fellow Bostonian John Singleton Copley, Adams also admired Charles Willson Peale's "Variety of Portraits—very well done."[1] Peale's portrait of Adams was painted in the early 1790s when the sitter came to Philadelphia to serve as vice president.[2] Adams, nicknamed "His Rotundity" by his Senate colleagues, appears solid and three-dimensional in this portrait through the artist's fully developed sense of color (blush tints in the subject's face begin realistically below skin-level) and skilled draftsmanship.

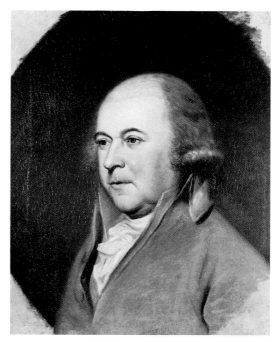

Catalog Number INDE11881
(SN 13.003)

⁕⊚⊚⊛⁕

Provenance:
Listed in the 1795 Peale Museum catalog. Purchased by the City of Philadelphia at the 1854 Peale Museum sale.

Physical Description:
Oil on canvas. Bust length, facing three quarters to the sitter's right. Gray hair rolled at ends below ear-level. Blue eyes. Green waistcoat and coat with green buttons. White stock and cravat. Olive brown background. 23 inches H × 19¾ inches W.

[1] John Adams to Abigail Smith Adams, 21 August 1776 (L.H. Butterfield, ed. *Adams Family Correspondence* [Cambridge, MA: The Belknap Press, 1963], 2, page 103).

[2] The completed portrait is first listed in the 1795 Peale Museum catalog.

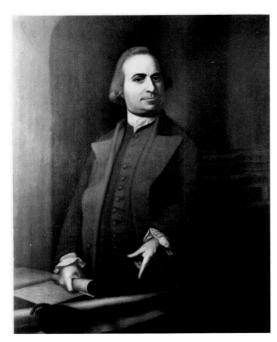

Catalog Number INDE14027

(SN 13.004)

[1] Jules David Prown, *John Singleton Copley in America, 1738–1774* (Cambridge, Mass.: Harvard University Press, 1966), 83.

SAMUEL ADAMS (1722–1803)
by Nahum Ball Onthank, after John Singleton Copley, c. 1873

Adams was born in Boston, Massachusetts, on 27 September 1722. In 1743, he received his Harvard degree with the thesis "Whether it is lawful to resist the Supreme Magistrate if the Commonwealth cannot be otherwise preserved." Following graduation, he worked in the counting house of Thomas Cushing and in his family's brewery (which he later inherited). He served as Boston's tax collector from 1756 until 1764, until his failure to account for several thousand pounds in tax receipts put him into severe debt.

Active in Boston's early political clubs, Adams became a leader in the faction opposed to royal colonial policy. In 1764, he used popular opposition to the taxes imposed by the Sugar and Stamp acts to denounce Massachusetts's royal governor. Joining the colonial legislature in 1765, Adams spent the next nine years openly advocating opposition to the British Crown. He drafted the circular letter describing Boston's non-importation policy in response to the Townshend Acts, led the creation of a committee to correspond with other colonies about common grievances against the Crown, and denounced the Tea Act.

In 1774, Adams prompted the Massachusetts legislature to dissolve itself and appoint delegates to a colonies-wide congress. He then organized a revolutionary assembly based on the Suffolk Resolves, which advocated aggressive resistance to the measures imposed by the Intolerable Acts. Afterward, he served in the First and Second Continental Congresses, where he promoted independence from England and signed the Declaration.

Following the adoption of the Declaration of Independence, Adams retreated from the forefront of American politics. He stayed in Congress until 1781 and attended Massachusetts's state constitutional convention and later its federal ratifying convention. He became Massachusetts's lieutenant governor in 1789 and then succeeded John Hancock in the governor's office four years later, where Adams remained until 1797. After a short retirement, he died on 2 October 1803.

Boston-area artist Nahum Ball Onthank (1823–1888) copied Copley's 1772 life portrait of Adams (now in the Museum of Fine Arts, Boston) as a private commission intended as a gift to Independence Hall. Here, Adams appears as Boston's spokesman, presenting the city's grievances to royal governor Thomas Hutchinson after the Boston Massacre in March of 1770. In the portrait, Adams grasps the citizens' statement of grievances in his right hand and points to the colony's royal charter and seal with his left.[1]

❦

Provenance:
Given to the City of Philadelphia by George A. Simmons in 1873.

Physical Description:
Oil on canvas. Three-quarter length, head slightly to the sitter's left, body turned three quarters to right. Gray-brown hair, blue eyes. Red-brown waistcoat and coat. White collar, neck cloth, and cuff. Document in right hand inscribed "Incorporation of/Town Boston," subject points to document with green seal inscribed "Massachusetts." Open book resting on table. Gray arch in background at left and columns on pedestal at right. 47¼ inches H × 37 inches W. Signed in red at bottom right corner of canvas, "Onthank/ after C."

PIERRE AUGUSTE ADET (1763–1832)
by James Sharples, Senior, from life, 1796–1797

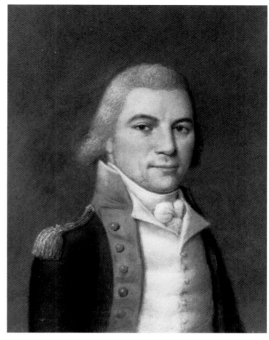

Catalog Number INDE11898
(SN 7.006)

Adet was born in Nevers, France, on 17 May 1763. After his initial training in the army's artillery, he studied with the renowned chemist Antoine Lavoisier. Adet then joined the administration of France's West Indian colonies as secretary to the royal commission in Santo Domingo. During the French Revolution, Adet returned to France, where he served as an advisor on marine affairs and on mines. Later, while living in Geneva, he received appointment as french minister to the United States.

Minister Adet arrived in America in mid-1795. At that time, Congress was debating the commercial-territorial treaty arranged by John Jay between the United States and Great Britain. To France, this proposed treaty represented a threat to open transatlantic trade. In late 1796, Adet wrote to Secretary of State Timothy Pickering that Jay's Treaty destroyed the friendly spirit of the 1778 French-American alliance. Adet also published this declaration in the *Philadelphia Aurora* in an attempt to influence the outcome of the upcoming presidential election in favor of Thomas Jefferson, a French supporter. As official relations between America and France deteriorated, France recalled Adet in protest and he left the United States in April of 1797. At home, Adet returned to administrative work. He served in the Tribunal, the Senate, and the Chamber of Deputies under Napoleon, and he was prefect of Nièvre for six years. Adet died in Paris on 19 March 1834.

In the fall of 1796 or early in 1797, Adet sat for a portrait by the British pastelist, James Sharples Senior (1751–1811). At the time, Sharples had just opened a portrait studio in Philadelphia (then the capital of the United States). When the artist returned to England, he published a catalog of his American work in which he listed "Adet, esq., Minister from France" among his sitters.

⁂

Provenance:
Listed in the 1802 Bath catalog of Sharples's work. Given by Ellen (Mrs. James) Sharples to Felix Sharples in 1811. Given by Felix Sharples to Levin Yardly Winder in the 1830s. Inherited by Nathaniel James Winder from Levin Yardly Winder. Inherited by Richard Bayly Winder from Nathaniel James Winder in 1844. Purchased by Murray Harrison from Richard Bayly Winder around 1865. Purchased by the City of Philadelphia from Murray Harrison in 1876.

Physical Description:
Pastel on paper. Half length, facing front with torso slightly to the sitter's left. In uniform of white waistcoat, blue coat with red standing collar and inside front borders, silver buttons and epaulettes, white stock and cravat. Gray hair. Blue variegated background. 9 inches H × 7 inches W.

WILLIAM ALEXANDER, LORD STIRLING (1726–1783)
by Bass Otis, possibly after the Joseph Napoleon Gimbrede engraving, c. 1858

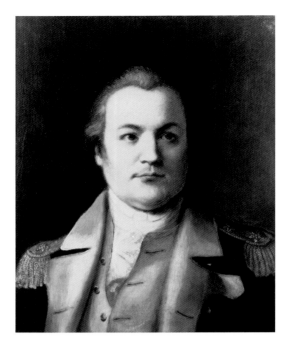

Catalog Number INDE
(SN 13.005)

[1] Duer was Alexander's grandson. Otis's "Notebook" (Manuscripts Department, American Antiquarian Society) includes lists of his work from 1815 to 1854. The Alexander portrait is not included.

[2] The Peale miniature appears not to be the one referenced in Miller, *Selected Papers* 1, page 345 n.6 as illustrated in Clarence Winthrop Bowen, *The History of the Centennial Celebration of the Inauguration of George Washington* (New York, 1892), 57. The Bowen image is derived from the Wollaston. A different miniature image purported to be of Alexander appears in Justin Winsor, ed. *The American Revolution, A Narrative, Critical and Bibliographic History* (1889, rpt. ed. 1972), 280, but the sitter is quite young and not in military uniform, unlike the Gimbrede.

Alexander was born in New York City in 1726. He received a private education, showing a great interest in mathematics and astronomy, and then engaged in a variety of commercial ventures. In 1755, he received a commission to provision the British army under Massachusetts's royal governor William Shirley. Alexander became Shirley's secretary and accompanied him to London in the following year. There, Alexander petitioned the Privy Council for what he claimed was his ancestral right to a peerage. He assumed the title "Lord Stirling" when he returned to America in 1761.

Upon his return, Alexander inherited from his father a substantial fortune and several political sinecures, including the surveyor generalship of New Jersey and membership in that colony's governor's council. He was also a governor of Kings College (now Columbia).

His politics became increasingly anti-British, and in late 1775, Alexander became a colonel in New Jersey's revolutionary militia. After he led the capture of a British transport ship, he received a brigadier general's commission in the Continental army and command of the defenses for New York City. He was captured during the battle of Long Island, and after his exchange, he was promoted to major general. He fought at the battles of Princeton, Trenton, Brandywine, Germantown, Monmouth, and Paulus Hook. During the winter of 1780 in Morristown, Stirling planned and led the unsuccessful invasion of Staten Island. At the end of the war, he was stationed in Albany where he died on 15 January 1783.

In early 1858, Massachusetts painter Bass Otis (1784–1861) donated his portrait of William Alexander to the city of Philadelphia. Otis worked intermittently in Philadelphia throughout the first half of the nineteenth century, and also donated a portrait of William Bradford Junior for display in Independence Hall (see below). Otis's portrait of Alexander was possibly based on that by New York engraver Joseph Napoleon Gimbrede, published in 1847 for William Alexander Duer's *Life of William Alexander*.[1] The source of Gimbrede's image is unknown. It is not the c. 1750 portrait of the sitter by John Wollaston (now at the New-York Historical Society). A 1778 miniature of Alexander by Charles Willson Peale (unlocated) may be the source, but no image of this miniature exists for comparison purposes.[2]

⸙

Provenance:
Given to the City of Philadelphia by the artist in 1858.

Physical Description:
Oil on canvas. Bust length, facing front. Blue and buff uniform with two stars on the left epaulette denoting the rank of brigadier general, white stock and shirt ruffle. Powdered brown hair, brown eyes. Graduated olive-brown background. 24 inches H × 20 inches W.

WILLIAM ALLEN (1704–1780)
by Robert Feke, from life, 1746

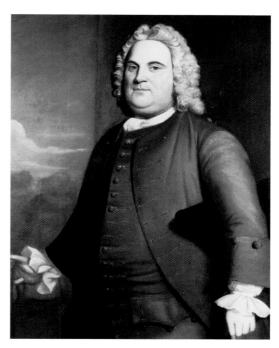

Catalog Number INDE11864
(SN 13.006)

Allen was born on 5 August 1704 in Philadelphia. After legal training at London's Middle Temple and at Clare College in Cambridge, he returned to Philadelphia in 1725 and succeeded his father in the family's successful mercantile firm. He joined Philadelphia's City Council in 1727 and organized its effort to petition the colonial assembly for permission to build Pennsylvania's State House (now called Independence Hall) in Philadelphia. He and his father-in-law, Assembly Speaker Andrew Hamilton, became the trustees of the funds allocated to erect the building, finished in 1735 (the year Allen became the city's mayor).

Allen also served in the colonial assembly for several terms and became recorder of the city. After many years on the bench of the local court, he became chief justice of Pennsylvania in 1750. He was also a founder of Philadelphia's first Masonic lodge, its academy, the Pennsylvania Hospital, and the city of Allentown. Although he supported colonial objections to British tax measures in the Sugar and Stamp acts, Allen (the head of Pennsylvania's proprietary party) rejected the idea of rebellion against the king. He resigned his judgeship in 1774 and then moved to England when the Revolution began. He died there on 6 September 1780.

As a prominent member of Philadelphia's political and economic elite and an important patron of the arts, Allen participated in the city's prestigious social scene. Chief among the city's elite groups was the Dancing Assembly, which gathered for dancing, card playing, and conversation. In the late 1740s several founding members of the Dancing Assembly, including William Allen, sat for the New York painter Robert Feke (died 1752). Feke visited Philadelphia in 1746 and again in late 1749 and early 1750.

Until recently, this portrait of Allen was attributed to Benjamin West. In 1973, Robert Stewart of the National Portrait Gallery, Smithsonian, discovered West's c. 1763 portrait of Allen in a private London collection and suggested that the Independence portrait was by Feke. After further study of the portrait, X-ray photography revealed strokes of white lead paint positioned in the same locations on Allen's face as on the face of Mrs. Charles Willing in a portrait signed and dated by Feke in 1746 (now at the Winterthur Museum). Laboratory examination of William Allen also revealed new tacking edges on all four sides; this indicates that the canvas was cut down, severing the outer edge of the sitter's left cuff, from its original size (probably 50 by 40 inches).[1]

Provenance:
Given to the City of Philadelphia by Mary Thomson Livingstone, the sitter's great-granddaughter, in 1876.

Physical Description:
Oil on canvas. Three-quarter length, turned slightly to the sitter's right. Brown great coat and waistcoat, white stock and cravat, white cuffs. White wig, blue eyes. Right hand holding a wooden cane, black tricorner hat tucked under left arm. Background of olive drab wall that opens at right to clouded blue sky and suggested landscape. 42⅛ H × 32⅜ inches W.

[1] R. Peter Mooz, "The founders of the Philadelphia School," *University Hospital 1975 Antiques Show Catalog*, 55.

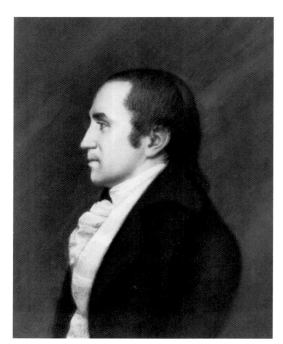

Catalog Number INDE11921

(SN 7.030)

FISHER AMES (1758–1808)
by James Sharples Senior, from life, 1796–1797

Ames was born on 9 April 1758 in Dedham, Massachusetts, where his father (a physician and astronomer) ran a tavern. A precocious boy, Ames entered Harvard in 1770 and spent four years there enjoying classical studies. He then taught school, and in late 1778 began his law study in Boston.

Early in his legal career, Ames's powerful intellect and skillful oratory earned him public notice. In 1781, he was elected to the Concord Convention (formed to bring order to the state's inflationary economy). Later, he published several newspaper essays in which he called for a firm governmental response to the turmoil of Shays' Rebellion. In 1787, he attended Massachusetts's ratifying convention; his outspoken support there for the proposed Constitution attracted the attention of prominent Federalists. He then served in his state legislature, and in 1789 was elected to the first federal Congress.

During his four terms in the United States House of Representatives, Ames was Federalism's leading spokesman. He promoted Treasury Secretary Alexander Hamilton's financial plan as the basis for a strong republic governed by knowledgeable and experienced men. As a New Englander, Ames also supported policies designed to foster maritime trade, particularly with England. In early 1796, Ames gave his most important speech, one that clinched a close vote in favor of House appropriations for Jay's Treaty. But, in perpetually bad health after a bout with pneumonia, Ames refused a fifth congressional term in 1797.

Although Ames returned to his Dedham legal practice, he remained politically active as part of the "Essex Junto," a small group of ardent New England Federalists. Writing for newspapers, Ames opposed President Thomas Jefferson and his Republican supporters, particularly in their support of France. Ames died at his home on 4 July 1808.

In early 1797, before he retired from Congress, Ames posed for British pastelist James Sharples Senior (1751–1811). The artist had been in Philadelphia about four months establishing himself as a portraitist in the federal capital. After Sharples returned to England, he listed the eloquent Federalist in his catalog of sitters as "Fisher Ames, esq., M[ember of] C[ongress]."

❧—⟨∞⟩—☙

Provenance:
Listed in the 1802 Bath catalog of Sharples's work. Given by Ellen (Mrs. James) Sharples to Felix Sharples in 1811. Given by Felix Sharples to Levin Yardly Winder in the 1830s. Inherited by Nathaniel James Winder from Levin Yardly Winder. Inherited by Richard Bayly Winder from Nathaniel James Winder in 1844. Purchased by Murray Harrison from Richard Bayly Winder around 1865. Purchased by the City of Philadelphia from Murray Harrison in 1874.

Physical Description:
Pastel on paper. Half length, left profile. Black coat, white waistcoat, white stock and shirt. Black hair in an unfastened queue. Gray-green variegated background. 9 inches H × 7 inches W.

JOHN ARMSTRONG (1758–1843)
by Rembrandt Peale, from life, c. 1808

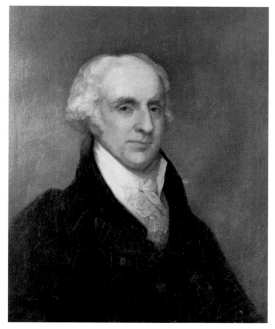

Catalog Number INDE14025
(SN 13.010)

Armstrong was born on 25 November 1758 in Carlisle, Pennsylvania. He attended the Reverend McKinley's school, and then enrolled in Princeton College just prior to the outbreak of the Revolution. In 1775, he volunteered for army service. He was first an aide to General Hugh Mercer and then to General Horatio Gates during the Saratoga campaign. While with Gates at Washington's Newburgh, New York, headquarters, Armstrong anonymously penned the mutinous Newburgh Resolves, which threatened a military insurrection if Congress continued to withhold the Continental Army's wages.

After the war, Armstrong served as secretary to Pennsylvania's Supreme Executive Council. The council sent him in command of the militia to mediate an armed dispute over land rights between settlers and speculators in the state's Wyoming Valley. He returned from the frontier as a delegate to Congress, where he supported ratification of the proposed federal Constitution. In late 1800, Armstrong entered the United States Senate, where he represented New York intermittently for four years. He became America's minister to France in 1804, and served the Jefferson and Madison administrations in negotiations for the Florida territory.

With the renewal of war between Britain and America in 1812, Brigadier General Armstrong took command of New York City's defenses. The following year, he became secretary of war. During his tenure, American forces were repeatedly defeated in the northwest territories and Canada, and the British captured the national capital in Washington. Armstrong resigned his secretariat in 1814,

and returned to his New York estate, where he devoted his time to writing history and biography. He died on 1 April 1843.

Rembrandt Peale (1778–1860) painted this portrait of Armstrong, then minister to France and an old family friend, in 1808 during his first trip to Paris. This European experience brought the young artist new techniques in color and the use of light. When he returned to Philadelphia with this portrait and others he had painted during his European tour, Rembrandt's father reported that the public praised the work as "equal if not superior to any in Europe."[1] Charles Willson Peale placed his son's portrait of Armstrong in his Philadelphia Museum in 1808.[2]

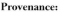

Provenance:
Listed in the 1813 Peale Museum catalog. Purchased by the City of Philadelphia at the 1854 Peale Museum sale.

Physical Description:
Oil on canvas. Half length, facing three quarters to the sitter's left. Black coat with brass buttons, white waistcoat, white stock and cravat. Gray hair, green eyes. Olive green background. 29 inches H × 24 inches W.

[1] Charles Willson Peale to Angelica Peale Robinson, 27 November 1808 in Miller, *Selected Papers* 2:2, page 1159.

[2] Portrait mentioned as finished in Charles Willson Peale to Angelica Peale Robinson, 6 October 1808 (Miller, *Selected Papers* 2:2, page 1145).

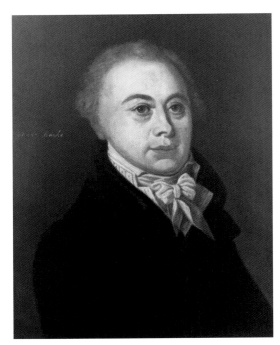

Catalog Number INDE10609

[1] See Carrie H. Scheflow, "Rembrandt Peale: A Chronology," *Pennsylvania Magazine of History and Biography* 110 (January 1986): 146.

RICHARD BACHE (1737–1811)
by an unknown artist, probably after John Hoppner, early-nineteenth century

Bache was born in Settle, Yorkshire, England, in 1737. He arrived in New York City in 1760, when he joined his brother's shipping business. Six years later, Richard moved to Philadelphia, where he acted as his brother's agent and opened his own dry goods store. There he met and married Sarah, the daughter of Benjamin and Deborah Franklin, in 1767.

Unsuccessful as an independent merchant and politically estranged from his pro-British brother, Bache served in his father-in-law's stead as postmaster general of the United States from 1776 until political opponents ousted him five years later. Later Bache also sat in the provincial congress and supervised the printing of congressional bills of credit. Having fled Philadelphia with his family during the British occupation of that city in 1777 and 1778, Bache was a member of Pennsylvania's Board of War.

After the war, Bache served as a director of the Bank of North America for nearly a decade. In 1792, he and his wife left Philadelphia for an extensive European tour. They returned to America after a few years and purchased a farm in Delaware. Bache died there on 29 July 1811.

The sole life portrait of Richard Bache (now privately owned) was painted by the London artist John Hoppner in 1797 (Hoppner's companion portrait of Sarah Franklin Bache is owned by the Metropolitan Museum of Art). Either Hoppner's work, or the 1813 copy of it by Rembrandt Peale,[1] provided the source for the unattributed portrait now in the Independence Park collection.

⸻⸺❧⸻

Provenance:
Given to Independence National Historical Park by Bache McEvers Whitlock, the sitter's brother's descendant, in 1975.

Physical Description:
Oil on canvas. Half length, facing the sitter's left. Black coat, white printed waistcoat, white stock. Gray and brown hair, brown eyes. Labeled "Richard Bache" in the left midground. 21¼ inches H × 17¾ inches W.

JOHN BARD (1716–1799)
by a member of the Sharples Family (possibly Ellen), after James Sharples Senior, c. 1805–1810

Bard was born in Burlington, New Jersey, on 1 February 1716. After a preliminary education in Philadelphia, he was apprenticed to John Kearsley, a local surgeon. Around 1740, Bard opened his own medical practice in the city, before moving to New York six years later. There, he participated in America's first systematic dissection of a cadaver for the purpose of medical instruction. Bard also instituted New York City's first quarantine procedures for communicable disease and became the city's health officer in 1759. During the Revolution, Bard served briefly as a surgeon for the British navy stationed in the port of New York. After the war, he returned to his private practice. In 1788, he became the first president of the New York Medical Society. Bard died in Hyde Park, New York on 30 March 1799.

Britain's Sharples family of pastelists twice visited the United States to collect portraits of important Americans. During his family's first visit to the United States, James Sharples Senior periodically plied his trade in New York City. There, in 1795 or late 1797–1798, he included Dr. Bard among his sitters. Later, Sharples listed the Bard portrait as "Dr. Bard" in the 1802 catalog of his work published on the family's return to England.

There are several known versions of Sharples's Bard portrait. The one given to Columbia University (Bard's son's alma mater) is probably the life portrait painted by James Senior. It exhibits the skillful facial modeling and costume details characteristic of his original work. Two other Bard portraits (one at the Smithsonian's National Gallery of Art and the other at the Museum of the City of New York)

appear to be copies, the first probably by James Senior and the other possibly by James Junior. Both of these portraits lack details in the costume (waistcoat buttons, the miter on the coat's collar trim) and some of the sensitivity in modeling (particularly in the Museum of the City of New York example) that appear in the Columbia University portrait.

The fourth version of the Bard portrait is also a copy, possibly by James Senior's wife Ellen (1769–1849). It has the costuming details of the Columbia University portrait, but the technique in painting the facial features and the hair is more minute. Ellen was trained as a miniaturist, and her technique in painting pastels seems to correspond with the miniaturist eye for precision and fine detail. This portrait of Bard in the Independence collection may be from the Sharples's second visit to the United States when Ellen produced several copies of her husband's work.[1]

Catalog Number INDE11932
(SN 7.041)

Provenance:
Given by Ellen (Mrs. James) Sharples to Felix Sharples in 1811. Given by Felix Sharples to Levin Yardly Winder in the 1830s. Inherited by Nathaniel James Winder from Levin Yardly Winder. Inherited by Richard Bayly Winder from Nathaniel James Winder in 1844. Purchased by Murray Harrison from Richard Bayly Winder around 1865. Purchased by the City of Philadelphia from Murray Harrison in 1876.

Physical Description:
Pastel on paper. Half length, left profile. Light gray coat with brown trim, white waistcoat, white stock and shirt. Gray hair in a queue. Gray-green variegated background. 9 inches H × 7 inches W.

[1] On Ellen's work, see Katharine McCook Knox, *The Sharples* (New York: Kennedy Graphics, Inc., 1972), 27–46.

Catalog Number INDE14026

(SN 13.016)

[1] Sellers, *Portraits and Miniatures*, 27. The portrait is first listed in the September 4, 1793 issue of the *National Gazette*. This portrait was not the model for Rembrandt Peale's 1819 portrait of the sitter for the city of Baltimore (now at the Maryland Historical Society); Rembrandt based his portrait on Joseph Wood's painting (Miller, *Selected Papers 3*, page 687).

JOSHUA BARNEY (1759–1818)
by Charles Willson Peale, from life, c. 1784–1793

Barney was born in Baltimore on 6 July 1759. Although his parents discouraged his early ambition to become a sailor, he went to sea at the age of thirteen aboard his brother-in-law's merchant ship and rose through harrowing experience to captain it by the age of sixteen. In 1775, Barney volunteered for Revolutionary service as a master's mate, and he served on several expeditions against British ports and vessels. Commissioned as a lieutenant in 1776, Barney served on the sloop *Sachem*, the brig *Andrea Doria*, the frigate *Virginia*, and the ship *Saratoga* (having been captured by the British three times) defending the American coast. He brought the first news of peace between Britain and America back from the treaty negotiations in Paris, and in 1784 was the last Continental navy officer discharged from active duty.

After the war, Barney captained his own vessels in America's merchant marine. He also served as a commodore in the French and American navies, as well as first clerk of the United States District Court for Maryland. In 1814, he commanded a gun boat flotilla at Bladensburg against a superior British force on its way to capture the capital in Washington. Honored after the war for his lengthy naval service, Barney died on 1 December 1818.

Near the end of his life, the veteran Barney recollected that Peale had painted his portrait at age twenty-two, dating this image to 1781. However, the portrait is not mentioned as among those in the Peale Museum collections in early 1784. Peale scholar Charles Coleman Sellers believed that Barney was mistaken in his remembrance, and dated the painting to late 1784 or early 1785.[1] However, this work is stylistically consistent with a still later date, as it shows signs of Peale's technical evolution (which would mature by 1791) toward the use of warmer flesh tones. Possibly, Peale painted Barney's portrait during a recorded encounter in 1788. Barney frequently visited Philadelphia during that year with his wife, a native of the city.

⁓⊛⁓

Provenance:
Listed in the 1795 Peale Museum catalog. Purchased by the City of Philadelphia at the 1854 Peale Museum sale.

Physical Description:
Oil on canvas. Bust length, nearly left profile. Dark blue uniform coat with red facings, brass buttons, and gold epaulettes, white stock and shirt ruffle. Powdered hair in a queue tied with a black ribbon, brown eyes. Dark brown background. 23 inches H × 20 inches W.

JOHN BARRY (1745–1803)
by Colin Campbell Cooper, after Gilbert Stuart, c. 1894

Catalog Number INDE14028

(SN 13.013)

Born in County Wexford, Ireland, in 1745, Barry went to sea as a youth. Later, he settled in Philadelphia where he prospered as a shipmaster and owner. He began his Revolutionary service when the Continental Congress appointed him to outfit four vessels of war and superintend the construction of a new ship. In 1776 his brig, the *Lexington*, seized an armed British supply ship—the first wartime capture made by America's navy.

Soon considered one of the navy's most talented commanders, Barry then captained the frigate *Effingham*, with which he defeated a blockade of the Delaware River to capture an armed British schooner and two transports using only four small boats. Later, he and his crew fought on shore in the Trenton campaign, making Barry one of the few officers in the Revolution to command on both sea and land. In late 1778, Barry commanded the frigates *Raleigh* and *Alliance*, with which he took many British ships. At the end of the Revolution, he captained the vessel that carried the Marquis de Lafayette and the Count de Neille back to France.

After the war, Barry returned to the merchant marine, voyaging as far as China. In 1794, Congress reorganized the navy and appointed him senior captain with the title of Commodore. He received a new frigate, the *United States*, and command of the American naval forces in the West Indies. Barry remained the navy's most senior officer until his death in Philadelphia on 13 September 1803.

In 1894, the Hibernian Society of Philadelphia commissioned Philadelphia artist Colin Campbell Cooper (1856–1937) for a portrait of Commodore Barry, in honor of the subject's Irish heritage. Cooper copied the 1801 life portrait of the sitter by Gilbert Stuart (now privately owned and on loan to the White House).

❧

Provenance:
Given to the City of Philadelphia by the Hibernian Society of Philadelphia in 1895.

Physical Description:
Oil on canvas. Bust length, facing three quarters to the sitter's left. Buff waistcoat and facings on dark blue coat with double row of brass buttons, gold epaulettes, and gold Society of the Cincinnati medal on light blue ribbon through buttonhole of facings at viewer's right. White hair in a queue with black ribbon. Blue eyes. White stock and jabot. Blue and brown background. 29⅛ inches H × 25⅛ inches W.

Catalog Number INDE14029

(SN 13.015)

JOSIAH BARTLETT (1729–1795)
by Caroline Weeks, after John Trumbull, c. 1871

Bartlett was born on 21 November 1729 in Amesbury, Massachusetts. After his preliminary schooling, he studied medicine. In 1750, Bartlett opened his own practice in Kingston, New Hampshire, where he gained renown for his successful, though unorthodox, treatments. The well-respected Bartlett entered public life with his election to the provincial assembly in 1765.

Appointed by the royal governor as a justice of the peace and colonel of the militia, Bartlett's Revolutionary politics became increasingly evident and soon caused his dismissal. He became a member of New Hampshire's committee of correspondence and its provincial congress. In 1774, he began his service in the Continental Congress. He was a member during the summer of 1776 and signed the Declaration of Independence.

In 1778, he was appointed chief justice of New Hampshire's court of common pleas. From there, he succeeded to the positions of associate and then chief justice in the state's supreme court. He also chaired his state's federal ratifying convention in 1788, securing for New Hampshire the distinction of being the ninth state to ratify the Constitution, thus making it law.

Bartlett declined a seat in the United States Senate, instead becoming governor of New Hampshire in 1790. That same year he received an honorary doctor of medicine degree from Dartmouth College. Later, he secured a charter for the New Hampshire Medical Society and served as its first president. Bartlett died in Kingston on 19 May 1795.

In 1871, Josiah Bartlett III commissioned artist Caroline Weeks (dates unknown) to paint a portrait of his grandfather for display in Independence Hall. Weeks copied Trumbull's 1824 replica of his original Bartlett portrait in *The Declaration of Independence* (now at the Yale University Art Gallery). At the time of Weeks's work, Bartlett had the Trumbull replica (now privately owned). Weeks may also have seen Trumbull's pencil sketch of Bartlett (now at the New Hampshire Historical Society), done as a study for *The Declaration* between 1789 and 1793.

❧

Provenance:
Given to the City of Philadelphia by Josiah Bartlett, the subject's grandson, in 1871.

Physical Description:
Oil on canvas. Half length, turned slightly to the sitter's left. Brown coat and waistcoat, white stock. Reddish-brown hair, hazel eyes. Dark brown background. 25 11/16 inches H × 21¾ inches W.

WILLIAM BARTRAM (1739–1823)
by Charles Willson Peale, from life, c. 1808

Bartram was born on 9 February 1739 at his Quaker family's farm near Philadelphia. He attended the Philadelphia Academy when not engaged with his father John (the king's botanist) on scientific expeditions. During their 1765 exploration and mapping of the St. John's River through Georgia and Florida, the Bartrams collected many botanical specimens. Among their discoveries was a flowering shrub that they named *Franklinia* in honor of their friend, Benjamin Franklin. William's drawings from the expedition caught the attention of several important British collectors, including the London physician John Fothergill (owner of the largest private botanical garden in England) who became William's sponsor.

For most of the 1770s, William Bartram traveled (often alone) throughout southeastern North America. He published an account of his trip, *Travels Through North and South Carolina, Georgia, East & West Florida*, in 1791. This book provided the first complete list of known North American birds. It also documented the respect shared by Bartram and the Native Americans he encountered (the Seminoles called him "Puc Puggy," or the Flower Hunter).

In 1782 the University of Pennsylvania offered Bartram its new professorship in botany, but he declined on the basis of poor health (probably due to recurrent fevers he had contracted while in Florida). Twenty years later, President Thomas Jefferson requested Bartram's participation in the expedition planned for Meriwether Lewis and William Clark, but the botanist again declined public service. At home, Bartram continued to observe and draw (he often provided illustrations for scientific journals and books) as well as to receive

visitors. Among the latter were Alexander Wilson, his successor as America's leading ornithologist, and Bartram's own grandnephew Thomas Say, later America's pre-eminent conchologist. While working in his garden, Bartram died on 22 July 1823.

Charles Willson Peale shared Bartram's dedication to scientific observation, and the two men became close friends. Bartram helped Peale to organize and develop his museum's botanical displays, and encouraged a passion for plants and gardening in Rubens Peale, one of the artist's sons. Charles Willson Peale signified Bartram's naturalist pursuits in his 1808 museum portrait of the sitter with the inclusion of a specimen of *Jasminium officinale* tucked into the sitter's coat.[1]

This portrait was an early product of the new coloring technique that Charles Willson Peale learned from his son, Rembrandt, after the latter returned from several months of art study in France. Exclaiming that "I never painted with so much ease,"[2] the elder Peale embraced the new technique in his quest to improve the skills he had established during nearly thirty years of painting. This new method involved the prominent use of red shades and tints. As used in this portrait, a red undercoating to the painting's entire surface imparts warm tones to the sitter's flesh.

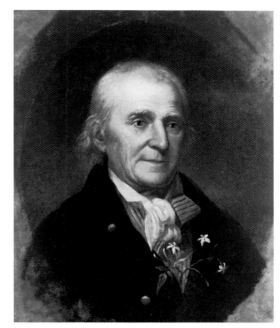

Catalog Number INDE11889
(SN 13.014)

[1] Completion of portrait mentioned in Charles Willson Peale to Rembrandt Peale, 26 June 1808 (Miller, *Selected Papers* 2:2, page 1093).

[2] Charles Willson Peale to Angelica Peale Robinson, 16 June 1808 (Miller, *Selected Papers* 2:2, page 1087.

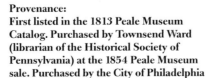

Provenance:
First listed in the 1813 Peale Museum Catalog. Purchased by Townsend Ward (librarian of the Historical Society of Pennsylvania) at the 1854 Peale Museum sale. Purchased by the City of Philadelphia from Townsend Ward in 1854.

Physical Description:
Oil on paper on canvas. Bust length, sitter slightly facing his left. Black coat, green and yellow striped waistcoat, white collar and cravat. Gray hair, blue eyes. 5-petal white flower on stem in buttonhole. Brown and russet background. 23⁷⁄₁₆ inches H × 19⁷⁄₁₆ inches W.

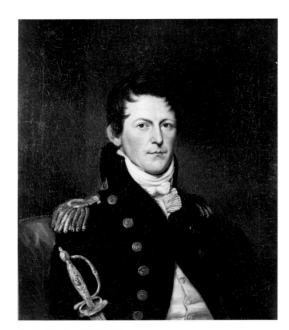

Catalog Number INDE14030

(SN 13.021)

JAMES BIDDLE (1783–1848)
by Charles Willson Peale, from life, c. 1816

Biddle was born in Philadelphia on 18 February 1783. He attended the University of Pennsylvania, and then followed his uncle Nicholas in a naval career. In 1800, Biddle and his brother Edward sailed the West Indies as midshipmen. After Edward's death, James served with the navy assigned to protect American merchant ships in the Mediterranean from pirates (who once imprisoned him in Tripoli). Later, he sailed a merchant ship to China and then enforced President Jefferson's trade embargo on British ships in the Atlantic.

During the War of 1812, Biddle led many successful campaigns against British naval forces as captain of the sloops-of-war *Wasp* and *Hornet*. After the war, Biddle commanded naval forces assigned to protect American merchant vessels off the coasts of South America and the West Indies, and in the Mediterranean. He also explored the Columbia River through the Oregon territory. Later, he served as governor of the Philadelphia Naval Asylum, and negotiated the first naval treaty between the United States and China. He last commanded American forces on the Pacific coast during the war with Mexico. He died in Philadelphia on 7 October 1848.

Charles Willson Peale, mindful of Biddle's popular acclaim as a daring naval commander, added the captain's portrait to the Philadelphia Museum in 1816.[1] By this time, Peale had returned to painting "more for amusement than profit" after a six-year retirement during which he decided that he had not yet "produced [art] pieces of great Excellence."[2] In this portrait, Biddle's high collar and stock hide the scar he received from a British musket ball that narrowly missed his chin. The sword pictured at his right was presented to him on 26 March 1814 by the Pennsylvania legislature in recognition of his dedicated service. The Biddle portrait's large scale and formal pose were suggested by Peale's children as a more contemporary format for the museum paintings (Peale later abandoned the practice in order to save money on frames and room in the galleries).[3]

───❦───

Provenance:
Purchased by the City of Philadelphia at the 1854 Peale Museum sale.

Physical Description:
Oil on canvas. Half length, facing front with torso turned slightly to sitter's left. Dark blue uniform coat with brass buttons and gold epaulettes, white waistcoat, white stock and jabot. Brown hair, gray eyes. Seated on red upholstered chair, gold sword at right side. 29⁷⁄₁₆ inches H × 24¼ inches W.

[1] Added in late December. Charles Willson Peale to Linnaeus Peale, 21 April 1816 (Miller, *Selected Papers 3*, page 402 n. 1).

[2] Charles Willson Peale to Angelica Peale Robinson, 5 May 1816. Letterbook 15, Peale–Sellers Papers, APS.

[3] Charles Willson Peale to Rubens Peale, 12 December 1818 (Miller, *Selected Papers 3*, page 666).

NICHOLAS BIDDLE (1750–1778)
by James Peale, probably after Charles Willson Peale, c. 1813

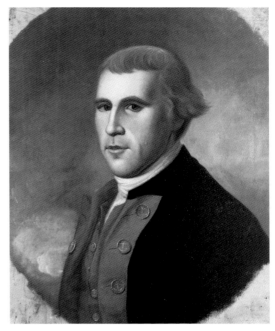

Catalog Number INDE14031
(SN 13.022)

Biddle was born in Philadelphia on 10 September 1750. He acquired little formal education and left home at age ten on a merchant ship bound for Quebec. A decade later, he secured an appointment as a midshipman in the British Navy and served with the future lord admiral Horatio Nelson as a coxswain on an Arctic expedition to northern Greenland.

At the start of the Revolution, Biddle commanded the Pennsylvania navy's galley *Franklin*. In late 1775, he received a commission as one of the Continental Navy's first four captains. His brig, the *Andrea Doria*, joined the American expedition to Canada and single-handedly captured numerous British vessels and sent their valuable arms and powder back to the ill-equipped American army.

Biddle captained his next ship, the frigate *Randolph*, through the West Indies, where he retained his reputation as a fearless fighter. After a visit to Charleston to deposit captured prizes, the *Randolph* and four small warships under Biddle's command encountered a large British force off the South Carolina coast. During a close battle, the *Randolph* exploded and Biddle was killed on 7 March 1778.

James Peale (1749–1831) was an accomplished miniaturist and portrait painter who often copied the work of his older brother, Charles Willson. An earlier likeness of Biddle by the elder Peale (probably a now-unlocated miniature) may have served as the source for this painting by James.[1]

The sitter's wooden features and flat flesh tones clearly mark this portrait as a posthumous one. James Peale's miniaturist style is evident in the tiny brushstrokes and soft pastel palette used in the painting.

❧

Provenance:
Listed in the 1813 Peale Museum catalog. Purchased by the City of Philadelphia at the 1854 Peale Museum sale.

Physical Description:
Oil on canvas. Bust length, facing slightly to the sitter's right. Dark blue uniform coat with red facings, brass buttons, red waistcoat, white stock. Powdered hair, brown eyes. Blue-gray top to blue-pink center background. 23⁷⁄₁₆ inches H × 19⁷⁄₁₆ inches W.

[1] The museum portrait is first recorded in the 1813 Peale Museum catalog. Its attribution to James Peale is based on annotations to that effect in several existing copies of the 1854 sale catalog, purportedly by Rembrandt Peale. A second James Peale portrait of Biddle is privately owned (Sellers, *Portraits and Miniatures*, 32–33).

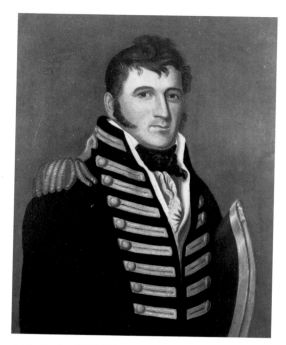

Catalog Number INDE14032

(SN 13.095)

¹ A different image of Blakely,
one with his face in profile,
was created in 1815 by
Moritz Furst for the con-
gressional medal honoring
Blakely's defeat of the
Reindeer.

JOHNSTON BLAKELY (1781–1814)
attributed to D. R. Fairfax, after a Thomas Gimbrede engraving, before 1829

Blakely was born in October of 1781 near Seaford, County Down, Ireland. Later, his family immigrated to Wilmington, North Carolina and he entered the university there. Lack of funds forced Blakely to suspend his education, and he became a midshipman in the United States navy, serving in the Mediterranean during America's 1801–1805 war with the Barbary pirates.

During the War of 1812, Blakely rose through the ranks to command the brig *Enterprise* and then the sloop-of-war *Wasp*, with which he captured the British brig *Reindeer* in the English Channel and received a congressional gold medal. On 9 October 1814, Blakely boarded a Swedish bark in order to pick up some American passengers for return to the United States. The *Wasp* was never heard from again; presumably, Blakely and his crew were lost at sea. He was posthumously promoted to captain and awarded the thanks of Congress.

This portrait belonged to Blakely's widow before she moved to St. Croix in 1829. Mrs. Blakely attributed the portrait to a D. R. Fairfax (dates unknown). Fairfax's portrait is possibly based on Thomas Gimbrede's popular stipple engraving of Blakely that appeared in an 1816 issue of the *Analectic Magazine.* The source of Gimbrede's image is unknown. Possibly it was the now unlocated miniature of Blakely purportedly made by an unknown artist in New York (prior to the commander's final voyage) for his former guardian Edward Jones of Rock Rest (near Chapel Hill, North Carolina). This miniature was apparently copied in 1840 for Jones and given to the Philanthropic Society of the University of North Carolina. Other known portraits of Blakely (including several in private collections and a twentieth-century one at the United States Naval Academy Museum) are all derivative of the Gimbrede or its source.¹

Provenance:
Given to the City of Philadelphia by Ephraim Clark (whose mother obtained it from the subject's widow) in 1873.

Physical Description:
Oil on canvas. Half length, facing front with torso turned to the sitter's left. Dark blue uniform coat with gold braid and gold epaulettes. White waistcoat, black stock and white frill. Black hat with gold trim under left arm. Brown hair and sideburns, dark brown eyes. Brown background. 28 inches H × 24 inches W.

WILLIAM BLOUNT (1749–1800)
by an unidentified artist, miniature from life, c. 1790

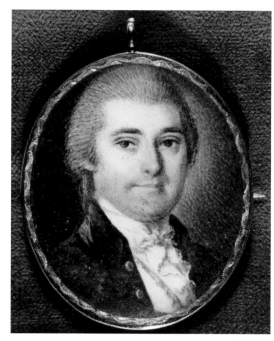

Catalog Number INDE57546

Blount was born on 26 March 1749 in North Carolina. After his schooling, he served the state as a paymaster in the Revolutionary militia, and as a member of the state legislature. He sat in Congress twice, represented North Carolina at the federal Convention of 1787, and signed the United States Constitution. After an unsuccessful campaign for the federal Senate, he represented his state in several western land speculation deals with local Native American tribes. In 1790, he was appointed territorial governor of North Carolina's western portion (recently ceded to the federal government) and served as an important force in guiding the territory to statehood as Tennessee.

With the creation of Tennessee in 1796, Blount was elected to the United States Senate, but he served only a year there before he was expelled from the legislature for allegedly conspiring to assist British land interests in an overthrow of the colonial governments in Spanish Florida and French Louisiana. Impeachment proceedings against Blount were later dismissed and he returned to North Carolina's state legislature in 1798. He died on 21 March 1800.

This presently unattributed miniature appears to be the source of all later portraits of Blount, including various nineteenth-century engravings and a c. 1857 oil on canvas by Washington B. Cooper (now at the Tennessee State Museum). An apparently related (in terms of painting style and frame) miniature of the sitter's brother, John Gray Blount (now unlocated), may be associated with a member of the Peale family.[1] Possibly, William Blount posed for his miniature in Charleston during the 1770s or 1780s or in Philadelphia during 1796–1797 (when his senatorial career placed him in the federal capital).

❦

Provenance:
Given to Independence National Historical Park by the sitter's great-great-great-great-granddaughter and her children in 1999.

Physical Description:
Watercolor on ivory. Bust length, facing forward, torso turned to the sitter's left. Blue coat with gold buttons, white waistcoat with gold trim, white stock and jabot. Brown hair tied in a queue, blue eyes. Sepia background. 2 inches H × 1½ inches W.

[1] Sellers, *Portraits and Miniatures*, 34.

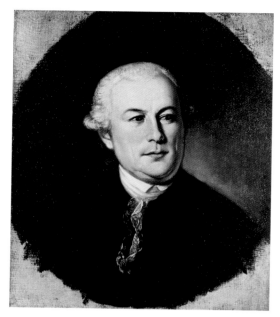

Catalog Number INDE14033

(SN 13.028)

ELIAS BOUDINOT (1740–1831)
by Charles Willson Peale, from life, 1782–1784

Descended from exiled French Huguenots, Boudinot was born in Philadelphia on 2 May 1740. He attended the Philadelphia Academy and then read law in Princeton with his future brother-in-law, Richard Stockton. Later, Boudinot practiced law with a growing interest in Revolutionary politics. Before the war, he founded the Essex County Committee of Correspondence, and served in New Jersey's assembly and in the provincial congress. In 1777, the Second Continental Congress appointed Boudinot as commissary general of all prisoners captured on both sides of the conflict. He conducted supply efforts, often with his own money, and arranged prisoner of war exchanges behind enemy lines. His unrestricted access to British officers and their camps allowed Boudinot secretly to collect valuable information for the American army's well-developed intelligence operation.

In 1778, Boudinot went to Congress, where he served for six years, for one year as that body's president. Later, he became the first lawyer admitted to practice before the United States Supreme Court. He was also a member of the House of Representatives from its first session in 1789 until he accepted the directorship of the United States Mint in 1795. A decade later, Boudinot retired to Burlington, New Jersey, and wrote biblical treatises. He died on 21 October 1831.

Charles Willson Peale's family became close friends of the Boudinots, and the artist's portrait of the president of Congress is possibly one of the first painted for the Philadelphia Museum.[1] The Boudinot portrait was first recorded as "President of Congress" in the 13 October 1784 issue of the *Freeman's Journal and Philadelphia Daily Advertiser.*

❦

Provenance:
Listed in the 1795 Peale Museum catalog. Purchased by the City of Philadelphia at the 1854 Peale Museum sale.

Physical Description:
Oil on canvas. Bust length, facing slightly to the sitter's left. Dark blue coat and waistcoat, White collar, stock, and lace jabot. Powdered hair, brown eyes. Dark brown background. 22¾ inches H × 18⅝ inches W.

[1] Sellers, *Portraits and Miniatures*, 39. Peale also painted half length portraits of Boudinot and his wife in 1784 (now at Princeton University).

JAMES BOWDOIN (1726–1790)
by Edgar Parker, after Christian Gullager, 1875–1876

Bowdoin was born in Boston on 7 August 1726. He later attended Harvard and then joined his family's mercantile business. In 1753, he entered the Massachusetts General Court, and four years later joined the Governor's Council, where he authored many of its declarations in opposition to British restrictions on colonial trade. He declined election to the Continental Congress in 1774, but served on Massachusetts's Executive in 1775. He later led his state's constitutional convention as president, also chairing the subcommittee appointed to draft the document.

Elected governor in 1785, Bowdoin's use of state militia to crush the frontier revolt led by Daniel Shays during the following year forced his early retirement in 1787. He was later elected to the Massachusetts ratifying convention where he supported the proposed federal Constitution. Bowdoin died on 6 November 1790 in Boston.

In the 1870s, Boston artist Edgar Parker (born 1840) made two bust length copies of Christian Gullager's c. 1791 full length portrait of Bowdoin (there are two Gullager portraits; both are now at Bowdoin College's Museum of Art).[1] One of Parker's copies was placed in Independence Hall and the other (now at the Massachusetts Historical Society) with the subject's family. Gullager's posthumous image may be based on an engraving by Samuel Hill for the January 1791 *Massachusetts Magazine*.[2]

—⁓⊙⁓—

Provenance:
Given to the City of Philadelphia by Robert C. Winthrop Senior, the subject's descendant, in 1876.

Physical Description:
Oil on canvas. Half length, right profile with torso facing forward. Brown coat and waistcoat, white stock. White wig tied in queue with black ribbon, blue eyes. 29 15/16 inches H × 25 1/8 inches W.

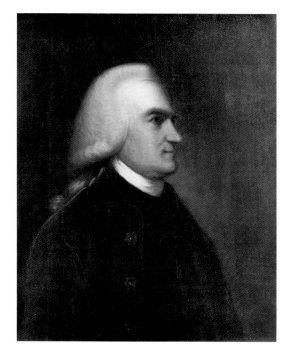

Catalog Number INDE14211

(SN 13.029)

[1] Bowdoin College also owns two other portraits of Bowdoin. Both depict him as a youth (one is by John Smibert, the other by Robert Feke).

[2] Marvin S. Sadik, *Colonial and Federal Portraits at Bowdoin College* (Bowdoin College Museum of Art, 1966), 99–100.

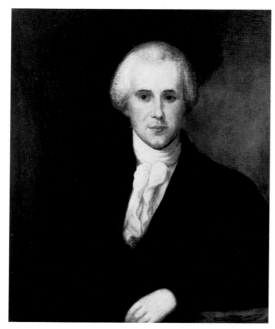

Catalog Number INDE14034

(SN 13.033)

WILLIAM BRADFORD JR. (1755–1795)
by Bass Otis, after Charles Willson Peale, 1859

Bradford was born on 14 September 1755 in Philadelphia. His father, the influential editor of the *Pennsylvania Journal*, sent him to Princeton College in 1769. After graduation, the younger Bradford studied law with Edward Shippen and then volunteered for the Pennsylvania militia in 1776. The following year, he became a Continental army colonel and deputy muster-master general.

In 1780, Bradford became Pennsylvania's attorney general, a position he retained for eleven years. After that, he sat on the state Supreme Court. During this time, he prepared a report on capital punishment in the state, which resulted in the elimination there of the death penalty for all crimes except first degree murder. In 1794, he succeeded Edmund Randolph as the United States attorney general. Attorney General Bradford headed the commission appointed to investigate frontier protests against the federal whiskey tax, which recommended the use of armed troops to enforce the law. During a yellow fever epidemic in Philadelphia, Bradford contracted the disease and died on 23 August 1795.

Massachusetts artist Bass Otis (1784–1861) copied Charles Willson Peale's 1783 half-length portrait of Bradford (now at the Redwood Library, Newport R.I.) specifically for display in Independence Hall. Otis also donated a portrait of William Alexander, Lord Stirling, to the City of Philadelphia around the same time (see above).

**Provenance:
Given to the City of Philadelphia by the artist in 1859.**

Description: Oil on canvas. Half length, facing front, body turned slightly to sitter's right. Dark brown coat, white stock and jabot. Powdered hair, brown eyes. Table draped in red. Brown drapery pulled back at right to reveal olive background. Inscription on reverse: "Bass Otis pinxt March 8, A.D. 1859." 36⅛ inches H × W 25⅛ inches W.

JOSEPH BRANT/THAYENDANEGEA (1742–1807)
by Charles Willson Peale, from life, 1797

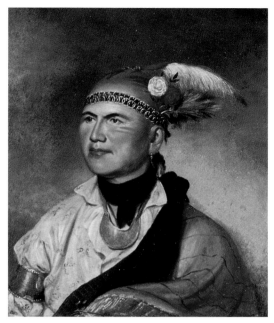

Catalog Number INDE11880

(SN 13.031)

Brant was born near the site of present day Cleveland, Ohio, in 1742. His Mohawk name meant "he [who] sets together two bets," a reference to the fastening together of valued articles for the purpose of wagering on the outcome of a contest. He served the British during the French and Indian War and then attended Moor's Charity School (later Dartmouth College). He was later a missionary's interpreter and helped to translate Anglican texts into the Mohawk language. During the Revolutionary War, British captain Brant and his mixed command of Native Americans and white Loyalists terrorized the colonists on the Pennsylvania–New York border. During this time, Brant earned a reputation as a ruthless commander for the swift and deadly attacks made by his men on frontier settlements, notably those at Oriskany and Cherry Valley.

After the war, Brant repeatedly tried to negotiate peace between the United States and the Indian Confederacy, then at war in the Ohio Valley. When the Indian Confederacy's defeat at the Battle of Fallen Timbers ended the tribes' threat in the Northwest, Brant turned his attention to the cause of Native American land rights. He lobbied Britain's foreign minister for his assistance in these negotiations. To focus attention on his cause, Brant capitalized on the British mistrust of France's rumored interest in Canada by aligning himself with pro-French factions in the American government. Brant's plan succeeded with the British, who established title for the Six Nations (Iroquois) to their ancestral lands in Canada. Brant spent the rest of his life there on the Grand River where he died on 24 November 1807.

In 1797, Brant and other representatives of several Native American nations toured Peale's Philadelphia Museum. Despite language barriers and historic hostilities, the encounter ended peacefully. Charles Willson Peale proudly recounted the story, stating that this "measure will afford unequivocal evidence of the advantages of a frequent intercourse with the Indian chiefs." He further recommended that his peers "promote the happiness of the savage state, by depriving it of some portion of its natural ferocity, and inspiring it with confidence in the purity of our motives."[1]

Peale's addition of Brant's portrait to the museum underscored the artist's interest in the complexity of Native American cultures (he also displayed tribal artifacts) and in comparing the qualities of their leaders to those of Anglo-American society. This portrayal of Brant probably dates to 1797 when Brant last visited Philadelphia.[2] In it, Peale emphasized the sitter's role as a negotiator, rather than as a warrior. Brant's trade silver armband (probably engraved with the seal of the United States) and his half-moon gorget (likely a gift from the British government) clearly represent his diplomatic alliances. As a man of peace, he wears a floral headdress and carries no weapons.

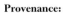

Provenance:
Listed in the 1813 Peale Museum catalog. Purchased by the City of Philadelphia at the 1854 Peale Museum sale.

Physical Description:
Oil on canvas. Bust length, slightly facing the sitter's right. Pink with brown patterned shirt, black neckcloth. Black headband with silver rings, red striped blanket with gold fringe over left shoulder. Brass gorget on blue ribbon, silver armband on right arm. Black hair in scalp lock decorated with feathers and flowers, brown eyes. Gray background. 27¾ inches H × 24¼ inches W.

[1] *Philadelphia Gazette,* 6 December 1796.

[2] Sellers, *Portraits and Miniatures,* 41.

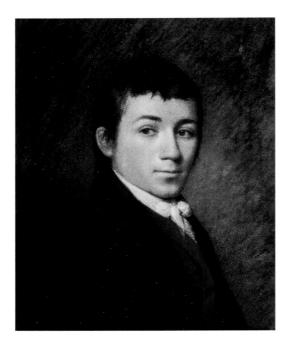

Catalog Number INDE11893

(SN 7.001)

[1] *Diary of William Dunlap (1766–1839)* (New York: New-York Historical Society, 1930), 1, page 305.

[2] Knox, *Sharples*, 120. Knox lists a third portrait of Brown among those in the collection at the City Art Gallery in Bristol England (Knox, 100). Ellen Sharples had donated her works to the Bristol Museum in 1849. This reference, however, is incorrect as the portrait in question depicts a different man and is labeled only "Mr. Brown." Knox probably based her identification on an erroneous listing in the *Bristol Art Gallery Catalogue of the Sharples Collection* (n.d.).

CHARLES BROCKDEN BROWN (1771–1810)
attributed to Ellen Sharples, after James Sharples Senior, c. 1810

Brown was born in Philadelphia on 17 January 1771. After his initial schooling, he was apprenticed in 1787 to a lawyer. Six years later, Brown left the legal profession in Philadelphia for literary pursuits in New York City.

During the next decade, Brown wrote several novels and many journal articles. His first essay, *Alcuin: A Dialogue* (1797), promoted equality for women and condemned the conservatism of the United States Constitution. In subsequent books, like *Wieland* (1798) and *Arthur Mervyn* (1799–1800), Brown combined his own observations of human events (like the horror and tragedy that accompanied Philadelphia's 1793 yellow fever epidemic) with his interest in moralistic fiction. He also served briefly as the editor of New York's shortlived *Monthly Magazine and American Review*. After his return to Philadelphia to join his brother's mercantile business, Brown founded *The Literary Magazine and American Register* in 1804.

Brown's last literary effort was a series of pamphlets that criticized the economic and diplomatic policies of the Jefferson administration. The author, always in delicate health, died of tuberculosis on 22 February 1810.

During his years in New York, Brown befriended several artists and literati with whom he formed a group called the Friendly Club. Among these was the painter William Dunlap. In early July of 1798, Brown and Dunlap shared lodgings and a visit to the British pastelist, James Sharples Senior, who resided in New York at that time, painting portraits of famous Americans.[1] Sharples later listed "C.B. Brown, esq., Author" in the 1802 catalog of portraits that he published after his return to England.

Two versions of the Sharples portrait of Brown are known. In 1874, a Brown descendant gave one to the City of Philadelphia for display in Independence Hall. A second example was purchased by the Worcester Art Museum in 1916 (this portrait's earlier history of ownership is unknown). Both of these pastels are proficiently executed. However, there are discernible differences between them. The direct gaze of the subject, the way in which the subject dominates the picture plane, and the sureness in application of the delicate gradations of flesh tones and modeling of the head in the Worcester example all suggest the hand of James Sharples, Sr. By contrast, the subject's gaze is turned away from the viewer in Independence's Brown portrait, possibly by an inadvertent placement of the highlight on the pupil of the left eye. In this example, the subject is smaller in scale and the modeling is tighter in execution.

Such comparison suggests that the Independence portrait of Brown is Ellen Sharples's copy of her husband's original likeness of the sitter. During her family's second visit to the United States, Ellen Sharples (1769–1849) noted in her diary that she copied her husband's portrait of "Mr. Charles Brown" in 1810.[2] Possibly, the author's death early in that year was the impetus for Mrs. Sharples's work.

❧❧❧

Provenance:
Listed in the 1802 Bath catalog of Sharples pastels. Given to the City of Philadelphia by Eugene A. B. Brown, the sitter's descendant, in 1874.

Physical Description:
Pastel on paper. Bust length, sitter facing front with torso half to the left. Dark brown coat, light brown waistcoat, white shirt and cravat. Black hair, brown eyes. Blue variegated background contains faint suggestion of possibly a tree behind the sitter's left shoulder. 9 inches H × 7 inches W.

LOUIS ANTOINE JEAN BAPTISTE, CHEVALIER DE CAMBRAY DIGNY (1751–1822)
by Charles Willson Peale, from life, 1783

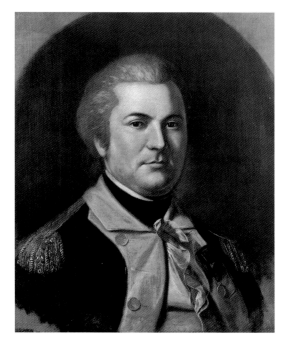

Catalog Number INDE14035

(SN 13.041)

Cambray Digny was born in Florence, Italy, on 7 June 1751. At nineteen, he entered the French Royal Artillery as an officer candidate. He later secured a letter of introduction to George Washington from Benjamin Franklin and sailed for America in 1777. While in the service of the American army's engineering corps, Cambray Digny oversaw the building of fortifications at North Carolina's Cape Lookout and at Pittsburgh's Fort McIntosh. Following the siege of Charleston and his release from prison by the British, he returned to France in 1783. There, he served as a major in the provincial army and died at his estate in the Somme in 1822.

Just prior to his departure from America, Colonel Cambray Digny sat for Charles Willson Peale in Philadelphia. The portrait appears on the first published list of the artist's museum portraits as printed in the 13 October 1784 issue of the *Freeman's Journal*. Peale was well respected for his detailed knowledge of military attire. Other artists often consulted him on uniform details and military medals, particularly since subtle regional variations in Continental army uniforms were common.[1] In this portrait, Cambray Digny wears an inscribed medal that is currently unidentified; it may be associated with the sieges of Savannah and Charleston, or it may represent some aspect of the sitter's French heritage. Technically, this painting resembles others from Peale's 1780s period. The sitter's silvery-green flesh tones are lit from an artificial source in the upper left corner that also reflects from the lower left. The Virginia Historical Society owns a replica of this portrait, possibly by Peale's son Rembrandt, who copied his father's museum portrait in 1795 for a patronage trip to Charleston and later for use in the Baltimore Peale Museum.[2]

❦

Provenance:
Listed in the 1795 Peale Museum catalog. Purchased by Townsend Ward (librarian of the Historical Society of Pennsylvania) at the 1854 Peale Museum sale. Purchased by the City of Philadelphia from Townsend Ward in 1854.

Physical Description:
Oil on canvas. Bust length, facing front with body turned slightly to the sitter's left. Blue uniform coat with red-edged buff facings, gold buttons, gold epaulettes. Gold medal (unidentified) on black ribbon through upper buttonhole on left facing. Buff waistcoat, white shirt and ruffle, black stock. Powdered hair, brown eyes. Dark brown background. 23⁷⁄₁₆ inches H × 19½ inches W.

[1] Benjamin West to Charles Willson Peale, 4 August 1783 (Miller, *Selected Papers* 1, page 393).

[2] A copy in the Musée Nationale, Versailles, appears not to be by a member of the Peale family.

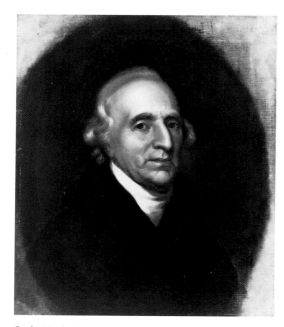

Catalog Number INDE14036

(SN 13.042)

CHARLES CARROLL (1737–1832)
by Charles Willson Peale, after Rembrandt Peale, c. 1823

Carroll was born in Annapolis on 19 September 1737. Extensively schooled in Europe and England, he studied law before returning to his Maryland estate, Carrollton, in 1765. He became a member of Annapolis's Revolutionary Committee of Correspondence, the Maryland Convention, and the provincial Committee of Safety. Fluent in French and strongly tied to the Jesuits, Carroll served on an unsuccessful American commission sent to gain Catholic Canada's backing for the Revolutionary cause. When he returned to Maryland, the provincial convention sent him to the Second Continental Congress in 1776 and he signed the Declaration of Independence.

Carroll served in the Continental Congress for two years and then periodically in his state senate. He declined a seat at the 1787 federal Constitutional Convention, in order to attend to his state's issue of inflationary paper money, although he supported the new federal Constitution. He then served in the first United States Senate until 1792. Thereafter he served on several companies, including the Baltimore and Ohio Railroad, with interests in developing inland transportation systems. The last surviving signer of the Declaration, he died at his estate on 14 November 1832.

Marylanders Charles Carroll and Charles Willson Peale enjoyed a long association. Carroll was an early and regular sponsor of Peale's, beginning with the latter's 1765 trip abroad to pursue formal art training. Throughout their friendship, the artist frequently visited Carroll at home, and the senator commissioned several family portraits from the artist.[1]

Peale overlooked his patron as a Philadelphia Museum subject until both men were in their eighties. Intent upon painting Carroll but unable to arrange a sitting with him, Peale copied an 1815–1820 portrait done by his son Rembrandt of the subject (now at the Baltimore Museum of Art).[2] Rembrandt's life portrait of Carroll was painted for the artist's use during a 1795 patronage trip to Charleston and was later used in the Baltimore Peale Museum.

⁂

Provenance:
Purchased by the City of Philadelphia at the 1854 Peale Museum sale.

Physical Description:
Oil on canvas. Bust length, facing front with torso slightly to the sitter's left. Brown coat with a dark brown fur collar. White stock. White hair, green eyes. Dark brown background. 23³⁄₁₆ inches H × 20 inches W.

[1] Peale's 1770 miniature and 1771 oil portrait of Charles Carroll are unlocated, as is an oil portrait of Carroll's daughter, and a family group portrait. The oil portrait of Carroll's wife is privately owned.

[2] Charles Willson Peale to Raphaelle Peale, 25 May 1823 (Miller, *Selected Papers* 4, page 276. Sellers, transcript of Peale autobiography, page 450. Peale–Sellers Papers, APS).

UNIDENTIFIED MAN of the Chambers family
by James Peale, from life, c. 1806–1809

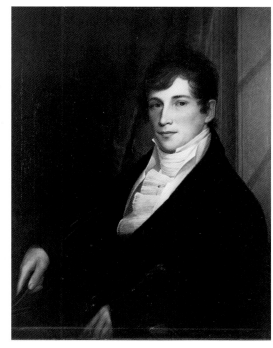

Catalog Number INDE12318

This subject has traditionally been identified as New York's Lieutenant James Chambers, who served in the Sixth Infantry, United States army. During his career, he was stationed in Pittsburgh and Bristol, Pennsylvania, and then on Bedlow's Island, New York. He became regimental paymaster early in 1809. After brief service in Albany, he died at Fort Columbus, New York, on 10 October 1809.

This sitter bears a strong family resemblance to Hugh Chambers (1783–1823) whose own portrait descended through his family until it was purchased by Massachusetts's Deerfield Academy. No record of whether Hugh Chambers had a brother or cousin named James is known. The Hugh Chambers portrait is signed "JP 1806," indicating that it was painted by Philadelphia artist James Peale (1749–1831), the younger brother of Charles Willson Peale. While early records of the Independence portrait state that it was signed "JP 1808," no initials or date inscription are now visible on the painting. Stylistically, however, the similarities (e.g., in the depiction of the hands and the lace ruffles) between the two portraits strongly suggest that they were painted by the same artist.

A privately owned panel portrait of a uniformed James Chambers signed by James Peale and dated 1809 was apparently extant in the early twentieth century, but is now unlocated.[1] While Lieutenant James Chambers was stationed in Bristol, he probably visited nearby Philadelphia, where Peale kept a painting studio. At present, no comparison between the Independence portrait and the panel portrait is possible. Whether these two paintings depict the same person and whether that person is the Lieutenant James Chambers who died at Fort Columbus remain unknown.

———

Provenance:
Given to the Washington Association of New Jersey by Katherine Chambers, Lieutenant James Chambers's grandniece, in 1910. Given to Morristown National Historical Park by the Washington Association in 1938. Given to Independence National Historical Park by Morristown National Historical Park in 1981.

Physical Description:
Oil on canvas. Three quarters length, facing left and looking forward. Brown coat, white waistcoat, white collar, stock, and jabot with gold stick pin. Brown hair, blue eyes. Seated in black armchair ornamented with brass tacks. Holding cane. Harp-shaped watch key on a black fob ribbon. Red drape and tan wall in background. 34 inches H × 26 inches W.

———

[1] It was listed as once part of the Frank Bulkeley Smith Collection in Frederic Fairchild Sherman, "Two Recently Discovered Portraits in Oils by James Peale," *Art in America* 21 (October 1933): 119–120.

(Unavailable
for reproduction)

Catalog Number INDE
(SN 13.044)

CHARLES II (1630–1685)
*by a "Miss" McDowell (either Susan Hannah or Elizabeth),
after Sir Peter Lely, c. 1883*

Charles was born on 29 May 1630 to King Charles I of England and Queen Henrietta Maria. He was educated by tutors until his teens, when political and religious strife split England. When the royal forces were defeated at Naseby, he joined his mother in France as an exile. After his father's execution in 1649, Charles exerted his claim to the throne by sailing to Scotland, where he was proclaimed king. However, his subsequent defeat by Oliver Cromwell's forces at the Battle of Worcester again drove Charles from England.

After Cromwell's death, Charles assumed the throne in 1660. He pardoned most of Cromwell's former troops, ordered Parliament into session, and issued a call for liberty of religious conscience. In the king's court, art and science flourished. He founded the Royal Society (a scientific organization) and the Royal Observatory at Greenwich, and financed architect Christopher Wren's rebuilding of fire-ravaged London. Charles II died on 6 February 1685.

During the 1880s, America's ambassador to Britain loaned a portrait of Charles II to the City of Philadelphia for an extended tour. This painting was reportedly one of the many portraits of the king painted during his reign by Sir Peter Lely. A Philadelphia artist, either Susan Hannah McDowell (1851–1938; married painter Thomas Eakins in 1884) or Elizabeth McDowell (1858–1953; married Louis Kenton), copied the portrait for the gallery of British monarchs then in Independence Hall.

⤜❦⤛

Provenance:
Given to the City of Philadelphia by the Committee of Lady Managers of the National Museum in 1883.

Physical Description:
Oil on canvas. Bust length, facing three quarters to the sitter's right. Dark coat, white shirt. Black wig, brown eyes. Brown background. 27¼ inches H × 23½ inches W.

SAMUEL CHASE (1741–1811)
by Charles Willson Peale, after Charles Willson Peale, c. 1819

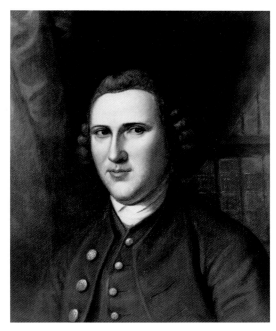

Catalog Number INDE14037

(SN 13.045)

Chase was born in Somerset County, Maryland, on 17 April 1741. Educated in the classics by his father, an Episcopal priest, Chase later read law and then joined the Maryland bar. In 1764, he was elected to the provincial assembly, where he served for the next twenty-four years. He joined Maryland's Committee of Correspondence, and represented his state in the First and Second Continental Congresses, where he became a strong advocate for independence (signing the Declaration) and a tireless committee worker. In 1778, Maryland removed him from its congressional delegation when his attempt to create a monopoly on flour (and thereby profit personally from his congressional knowledge) became public.

Chase quickly recovered from this public image problem. He served in his state's ratifying convention, where he opposed the new federal Constitution. He was also appointed chief judge of the Baltimore county and general courts. By this time, however, he had reversed his political beliefs and become a Federalist. President George Washington then appointed him to the United States Supreme Court in 1796. On the Court, Chase acted alternately as a prudent, insightful jurist and a vicious, anti-Jeffersonian partisan. The House of Representatives voted to impeach him in 1804, calling his performance as a judge undignified, but the Senate refused to convict him. Chase remained a member of the Court until he died on 19 June 1811.

Samuel Chase and the Maryland Sons of Liberty were the catalyst for young Charles Willson Peale's entry into Revolutionary politics. Peale contributed financially to

Chase's 1764 bid for the colonial assembly even though it forced the future artist to leave Annapolis in order to escape debtor's prison. Later, Chase's turbulent career diminished Peale's opinion of him. In 1807, the artist was relieved that he had not placed Chase's image in the Philadelphia Museum, where "amongst a collection of about 80 Portraits there is none to disgrace the Gallery."[1]

In 1819, however, a nostalgic Peale changed his mind about Chase and placed his portrait in the museum.[2] Peale copied his own 1773 portrait of the sitter (now at the Maryland Historical Society). In the later work, Peale replaced the silvery-green flesh tones of the earlier painting with the red-orange palette he had recently developed. Peale also reduced the earlier three-quarter length figure to a bust, straightened the sitter's cocked head, and drastically reduced the presence of background detail (retaining only a glimpse of the 1773 portrait's book-lined study walls) to make the 1819 image's format compatible with others in the museum.

Provenance:
Purchased by Townsend Ward (librarian of the Historical Society of Pennsylvania) at the 1854 Peale Museum sale. Purchased by the City of Philadelphia from Townsend Ward in 1854.

Physical Description:
Oil on canvas. Bust length, facing forward with torso slightly to the sitter's right. Blue coat and waistcoat with gold buttons. White collar and stock. Gray curled wig, hazel eyes. In background, brown drapery pulled back at right to reveal shelved books with green, brown and gilt bindings. 23⅜ inches H × 19⅝ inches W.

[1] Charles Willson Peale to John Isaac Hawkins, 28 March and 3 April 1807 (Miller, *Selected Papers* 2:2, page 1010).

[2] Charles Willson Peale to R. M. Johnson, 10 February 1819 (Miller, *Selected Papers* 3, page 691).

Catalog Number INDE14038

(SN 13.043)

FRANÇOIS JEAN DE BEAUVOIR, MARQUIS DE CHASTELLUX (1734–1788)
by Charles Willson Peale, from life, c. 1782

Chastellux was born in Paris on 5 May 1734. At the age of thirteen, he joined the army as a second lieutenant and rose through the ranks during the Seven Years' War. With military glory, he also gained literary fame. He was given membership in the French Academy after publishing a book of philosophy in 1772. When the French expeditionary forces assigned to the Revolutionary Continental army set sail for America in 1779, Chastellux was one of the three major generals sent with General Rochambeau. They arrived in America and took part in the victorious Yorktown campaign when Chastellux's fluency in English made him invaluable to the Continental army commanders.

After the Revolution, Chastellux returned to France and published his reminiscences, *Travels in North America*. He became military governor of Longwy, as well as an inspector general in the army. In 1784, he succeeded his brother as the Marquis de Chastellux. He died in Paris on 24 October 1788.

Charles Willson Peale was an ardent admirer of Chastellux and owned all of the Frenchman's published writings. The artist also shared Chastellux's interest in natural history and asked him for a portrait in 1782.[1] Peale's museum portrait of his fellow naturalist was among those listed in the 13 October 1784 issue of the *Freeman's Journal*, which contains the first advertisement for the collection.

―⊶⦿⦿⊷―

Provenance:
Listed in the 1795 Peale Museum catalog. Purchased by Townsend Ward (librarian of the Historical Society of Pennsylvania) at the 1854 Peale Museum sale. Purchased by the City of Philadelphia from Townsend Ward in 1854.

Physical Description:
Oil on canvas. Bust length, facing front with torso slightly to the sitter's right. Dark blue coat with gold braid trim and gold rosette buttons, red waistcoat, white stock and jabot. Powdered hair, hazel eyes. Dark brown background. 22 11/16 inches H × 20 inches W.

[1] Charles Willson Peale to the future Marquis de Chastellux, between 24 December 1782 and 13 January 1783 (Miller, *Selected Papers* 1, page 379).

BENJAMIN CHEW (1722–1810)
by James Read Lambdin, after a silhouette by Auguste Edouart, c. 1872

Catalog Number INDE
(SN 13.046)

Chew was born at his family's estate on Maryland's West River on 29 November 1722. Tutored at home, at fifteen he moved to Philadelphia to study law with Andrew Hamilton. Hamilton's death in 1741 sent Chew home to his father, the chief justice of the Lower Counties in Delaware, and then to London's Middle Temple. When the younger Chew returned to America in 1744, he quickly gained admittance to the bar of Pennsylvania's Supreme Court. In 1755, he became that colony's attorney general, serving nearly fifteen years. He was a member of the governor's council and speaker of the assembly. He also served in several administrative positions as recorder of Philadelphia and register-general of probates. In 1774, he became chief justice of the Pennsylvania Supreme Court.

Although he supported the colonial protest against British trade policies, Chew opposed independence. When the Revolution began, he was placed under house arrest by the American army and then exiled in 1777 to New Jersey along with Pennsylvania's former proprietary governor, John Penn. After a year, Chew was released and returned to his estate, "Cliveden," which had been the British army's headquarters during the Battle of Germantown.

After a decade in private law practice, Chew returned to public office in 1791 as judge and president of Pennsylvania's high court of errors and appeals. He remained there until the office was abolished seventeen years later. He died on 20 January 1810.

In the early 1870s, Philadelphia artist James Read Lambdin (1807–1889) painted two portraits of Benjamin Chew. Lambdin based his work on a silhouette by Auguste Edouart, a French artist who visited Philadelphia in the early 1840s. Edouart, in turn, had copied an earlier silhouette in which Chew wears a tricorner hat (reportedly done when Chew was seventy years old). It had been published in the literary magazine *Portfolio* in February of 1811.[1] Benjamin Chew's great-grandson donated one Lambdin portrait to Independence Hall and kept one at Cliveden.

—❧❧❧—

Provenance:
Given to the City of Philadelphia by Samuel Chew, the subject's great-grandson, in 1873.

Physical Description:
Oil on canvas. Bust length, right profile. Gray green coat, yellow waistcoat, white stock. Gray hair in a queue tied with a black ribbon, brown eyes with gold rimmed spectacles. Brown background. 23⅜ inches H × 19 inches W.

[1] Burton Alva Konkle, *Benjamin Chew 1722–1810* (Philadelphia: University of Pennsylvania Press, 1932), 230. Edouart generally cut two silhouettes of each sitter. One of the Chew silhouettes is at Cliveden; the other is unlocated. F. Nevill Jackson, *Ancestors in Silhouette Cut by Auguste Edouart* (New York: John Lane Co., 1921), 198.

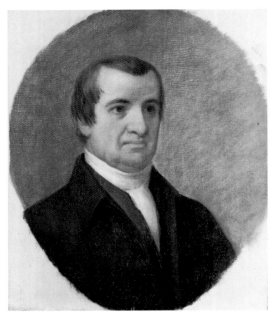

Catalog Number INDE

(SN 13.047)

ABRAHAM CLARK (1726–1794)
by James Read Lambdin, after John Trumbull, c. 1872

Clark was born in Elizabethtown, New Jersey, on 15 February 1726. He became a surveyor, and then studied law on his own and dispensed free legal advice to his neighbors. He gained further public recognition with several appointments to royal offices, including that of clerk in the colonial assembly. Clark switched his loyalty from the Crown to the colonial resistance when he joined New Jersey's Committee of Safety. He also sat in the provincial congress and helped to write the state's new constitution. In mid-1776, Clark attended the Second Continental Congress and signed the Declaration of Independence. He remained in Congress throughout the Revolution, except for one year.

After the war, Clark sat in his state legislature for several years and then returned to Congress in 1787. Illness prevented him from attending the Constitutional Convention, and he subsequently opposed the new Constitution. Reelected to Congress in 1791, he served there until his death on 15 September 1794.

The only known portrait of Clark was made by John Trumbull, probably in 1791 for the artist's rendering of the Declaration of Independence Congress (now at the Yale University Art Gallery). Trumbull's work provided the source for Philadelphia artist James Read Lambdin (1807–1889), whose portrait of Clark the City of Philadelphia commissioned for Independence Hall's collection of Declaration signers.

❧

Provenance:
Purchased by the City of Philadelphia from the artist in 1873.

Physical Description:
Oil on canvas. Bust length. Brown coat and waistcoat, white stock. Brown hair, brown eyes. Gray green background. 24 inches H × 20 inches W.

WILLIAM CLARK (1770–1838)
by Charles Willson Peale, from life, 1807–1808

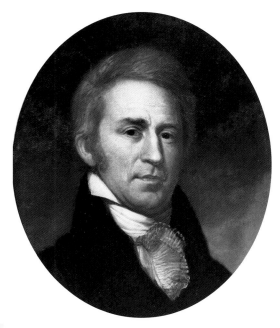

Catalog Number INDE11870

(SN 13.048)

Clark was born on 1 August 1770 in Caroline County, Virginia. After the Revolution, he followed his elder brother, George Rogers Clark, into the army. William served in the Indian wars on the Wabash and Ohio Rivers, and became a lieutenant under General Anthony Wayne. In 1796, he resigned his commission and passed the next few years as a merchant in the Mississippi River transport trade.

On a visit to the east coast, Clark renewed his friendship with Meriwether Lewis, with whom he had served in Wayne's regiment. Lewis invited Clark to accompany him on an expedition to find a navigable water passage from the Missouri River to the Pacific. President Thomas Jefferson sought the passage as a means by which to wrest control of the lucrative northwest fur trade from Great Britain. From mid-1804 until the fall of 1806, Lewis and Clark explored the area from Montana, over the Continental Divide, to the Yellowstone River. Throughout the expedition, Clark was responsible for navigation, geographical observations, drawings, and map-making.

Although Lewis and Clark discovered no continuous water route to the West Coast, they reported that the tribes in the upper Missouri River basin welcomed American trade and government-run trading posts. Jefferson seized this opportunity, and in 1807 appointed Clark as Indian agent for the new Louisiana Territory, as well as brigadier general of the Louisiana militia. Clark agreed with Jefferson that the United States could pacify the tribes by assimilating them into white society, rather than exterminating them. Clark later negotiated a treaty with the Osage Indians in which they relinquished large tracts of their hunting grounds to the United States in exchange for agricultural equipment and assistance.

Clark supported the government's removal of tribes to new lands, but he insisted that the process include furnishing them with some means of subsistence. As governor of the Missouri Territory in 1813, Clark attempted to balance the immediate needs of settlers living on the frontier with the government's long-range plan for Indian removal. Despite his success as a peace commissioner to the Indians following the War of 1812, Missouri voters rejected Clark's reelection bid in 1820. Congress made him superintendent of Indian affairs two years later, and he continued to report on Native American relations. Clark died in St. Louis on 1 September 1838.

A common interest in Native American culture, as well as in natural history, probably brought Clark and Charles Willson Peale together. Although publication of the Lewis and Clark journals was delayed until 1814, the expedition's discoveries were well known and Peale's Museum housed many of the specimens collected during the trip. The artist's 1807–1808[1] portrait of Clark is marked by a vibrant palette in which warm hues are mellowed by contrast to the black high-collared coat and white ruffled jabot. Peale's use of a new pigment, "Yellow Crome [*sic*]" in this portrait disappointed him when the color faded to a "common stone oker [*sic*]." As a result, he was "careful to cover with two coats the head of General Clark according to the mixture [Rembrandt] gave me of carnation tints."[2]

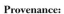

Provenance:
Listed in the 1813 Peale Museum catalog. Purchased by the City of Philadelphia at the 1854 Peale Museum sale.

Physical Description:
Oil on paper, mounted on canvas. Bust length, facing front, torso slightly to sitter's right. Dark coat, white collar and stock, lace jabot. Red hair, hazel eyes. Brown background. 23³⁄₁₆ inches H × 19¼ inches W.

[1] This is an earlier date for the portrait than that proposed in Sellers, *Portraits and Miniatures*, 54. It is based on a reference to the painting in John Conrad to William Clark, 29 January 1809 (Clark Papers, Box 3, Missouri Historical Society). Conrad was Clark's publisher.

[2] On early dissatisfaction with pigments, see Edmund Jenings to Charles Willson Peale, 10 August 1771 (Miller, *Selected Papers* 1, page 103). Charles Willson Peale to Rembrandt Peale, 3 February 1810 (Miller, *Selected Papers* 3, page 3).

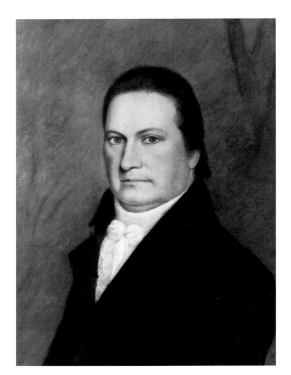

Catalog Number INDE11913

(SN 7.021)

[1] John C. Milley, "Thoughts on the Attribution of Sharples Pastels," *University of Pennsylvania Hospital 1975 Antiques Show Catalog*, 62.

DEWITT CLINTON (1769–1828)
Attributed to James Sharples Junior, from life, c. 1806–1809

Clinton was born on 2 March 1769 in Orange County, New York. He attended Kingston Academy and then graduated from Columbia College. After studying law for three years, he became private secretary to his uncle, George Clinton, New York's governor. Strongly Antifederalist, DeWitt Clinton entered his state's legislature in 1797. After several years on the governor's council, during which he clashed openly with Federalist governor John Jay, Clinton entered the United States Senate. He resigned the seat soon afterward in order to accept the mayorship of New York City, serving for ten nonconsecutive years until 1815. During most of those years, he was also a state senator and then lieutenant governor.

After a failed presidential bid in 1812, Clinton briefly turned his interests away from politics toward transportation improvements. He successfully led the effort to obtain state funding for the Erie and Champlain canals begun in 1816. The following year, a resurgence of political popularity put Clinton in the governor's office. He remained there (except for one term) until his death on 11 February 1828.

During the time that Clinton served as a mayor and as state senator, British pastelist James Sharples Junior (1789–1839) worked in New York City and in the state capital of Albany.

The artist and his half-brother Felix had accompanied their parents to America during the family's first painting visit from 1795 through 1801, and had returned to America in 1806. After their father died, the family (except for Felix) returned to England in 1811. This pastel, probably a life portrait of Clinton, presents the sitter's features as stiff and flat, with little modeling. This tightness distinguishes James Junior's amateurish work from that of his more accomplished father.[1]

Provenance:
Given by Ellen (Mrs. James) Sharples to Felix Sharples in 1811. Given by Felix Sharples to Levin Yardly Winder in the 1830s. Inherited by Nathaniel James Winder from Levin Yardly Winder. Inherited by Richard Bayly Winder from Nathaniel James Winder in 1844. Purchased by Murray Harrison from Richard Bayly Winder around 1865. Purchased by the City of Philadelphia from Murray Harrison in 1876.

Physical Description:
Pastel on paper. Half length, facing front, torso facing one half to the sitter's right. Gray-black coat, white shirt and stock with ruffled jabot. Black hair, blue eyes. Blue-green background with a suggestion of tree trunks on both left and right of sitter. 9 inches H × 7 inches W.

GEORGE CLINTON (1739–1812)
by James Sharples Senior, from life, 1795–1797

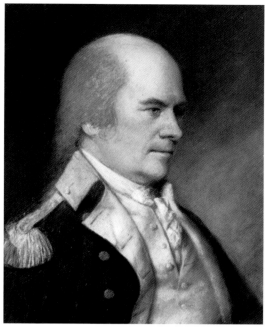

Catalog Number INDE11902
(SN 7.010)

Clinton was born in Ulster County, New York, on 26 July 1739. He served in his father's regiment during the 1750s and then read law in New York City. His political career began with his election to the provincial assembly in 1768 as a member of the colony's radical minority. He served briefly in the Second Continental Congress, attending the debates of summer 1776 but missing the Declaration signing. During the Revolution, Clinton served in the militia, commanding failed defenses of the Hudson River and Fort Montgomery. In 1777, he was elected both lieutenant governor and governor, accepting the latter office, in which he served for six successive terms.

Over the next eighteen years as governor, Clinton built a powerful state political machine with which he ultimately led his state's unsuccessful opposition to the proposed federal Constitution. Briefly retired from politics during the Federalist administration of John Adams, Clinton was again elected governor in 1800. Later, he was elected vice president under Thomas Jefferson's second administration and then again under James Madison. Clinton died in office on 20 April 1812.

During his first visit to the United States in the late 1790s, British pastelist James Sharples Senior (1751–1811) painted a portrait of a "General Clinton" (as recorded in the 1802 catalog that the artist published in Bath, England). This portrait appears to be one of George Clinton when compared to documented life portraits of the sitter by John Ramage c. 1785 (now at the Metropolitan Museum of Art), John Trumbull in 1791 (now at the New York City Hall),

Saint-Mémin in 1797 (now at the Munson–Williams–Proctor Institute Museum of Art), and Ezra Ames in 1814 (now at the New-York Historical Society). Previously, Sharples's portrait had been identified as the sitter's older brother, James (also a general in the Revolution). However, the subject in the Sharples portrait looks quite unlike the 1797 engraving of James Clinton by Saint-Mémin (now at the Smithsonian's National Portrait Gallery and at the Corcoran Gallery of Art), particularly in the shape of the nose and the set of the mouth.

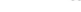

Provenance:
Given by Ellen (Mrs. James) Sharples to Felix Sharples in 1811. Given by Felix Sharples to Levin Yardly Winder in the 1830s. Inherited by Nathaniel James Winder from Levin Yardly Winder. Inherited by Richard Bayly Winder from Nathaniel James Winder in 1844. Purchased by Murray Harrison from Richard Bayly Winder around 1865. Purchased by the City of Philadelphia from Murray Harrison in 1874.

Physical Description: Pastel on paper. Half length, nearly left profile. Blue uniform coat with white facings, silver buttons and silver epaulettes, white waistcoat. White stock and jabot. Gray hair tied in a queue, brown eyes. Blue-green variegated background with the suggestion of a tree trunk to the sitter's left.

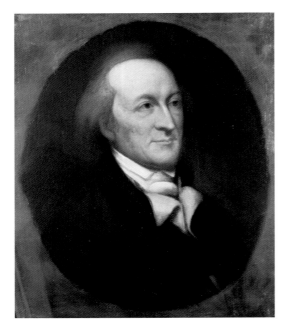

Catalog Number INDE14039

(SN 13.049)

GEORGE CLYMER (1739–1813)
by Edward Dalton Marchant, after Charles Willson Peale, c. 1872

Clymer was born in Philadelphia on 16 March 1739. Raised by his uncle, a book collector, successful merchant, and financier, Clymer read widely and eventually inherited his uncle's business. By 1773, Clymer was an active opponent of Great Britain's colonial policy. He chaired the committee that forced the local consignees of East India Company tea to refuse its unloading in Philadelphia. He was a militia captain, a delegate to the provincial conference, and a member of the Committee of Safety directing Philadelphia's war effort.

Clymer entered national politics in 1775 with his appointment as one of the first two Continental treasurers. He participated in the drafting of Pennsylvania's radical state constitution, and then accepted election to the Continental Congress, where he signed the Declaration of Independence. In late 1776, when Congress fled Philadelphia for Baltimore, he was one of three remaining members who conducted the daily business of the war. He later served on the Boards of War and Treasury, as well as on a committee to supervise the defense of Philadelphia. He returned to Congress in 1780, the year he and Robert Morris began plans for the Bank of North America.

Elected to the Pennsylvania legislature in 1785, Clymer was later one of the state's delegates to the 1787 Constitutional Convention. He then participated in the new government as a member of the first United States House of Representatives. An organizer of the Pennsylvania Academy of the Fine Arts, he served as its first president in 1805. Clymer died at his son's home in Morrisville, Pennsylvania on 23 January 1813.

Commissioned by the Clymer family, New York/Philadelphia painter Edward Dalton Marchant (1806–1887) copied Charles Willson Peale's replica of his 1807 life portrait of the signer (the replica is privately owned, the life portrait is now at the Pennsylvania Academy of the Fine Arts) for the collection in Independence Hall.[1] Marchant was particularly reverential in his communication with the Hall's custodians about the Clymer commission. He noted that, through the display of historical portraits there, "this Hall may be made an instrument, to foster in all breasts at the same time, feelings both of National pride and of National Brotherhood."[2]

⁓◦∘◦⁓

Provenance:
Given to the City of Philadelphia by George Clymer, the subject's grandson, in 1872.

Physical Description:
Oil on canvas. Bust portrait, facing three quarters right. Brown coat, buff waistcoat, white collar and stock. Brown hair, blue eyes. Dark-brown background. 24⅛ inches H × 20⅛ inches W.

[1] In Peale's replica of his 1807 portrait, the subject sits in an upholstered chair (not the Windsor of the life portrait), the subject's gaze is angled upward (whereas in the life portrait the subject looks away from the viewer but directly ahead), and his collar is devoid of creases (Sellers, *Portraits and Miniatures,* 56). These latter two characteristics are shared by the Marchant copy, which was painted when the family owned the Peale replica.

[2] Edward Dalton Marchant to Frank M. Etting, 10 June 1871. Etting Papers, 56. Historical Society of Pennsylvania.

HERNANDO CORTEZ (1485–1547)
by Charles Willson Peale, from a copy after Christofano dell'Altissimo, c. 1816

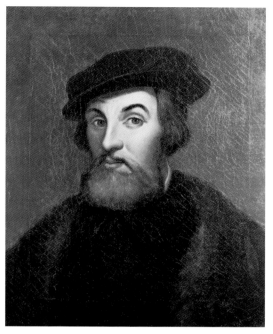

Catalog Number INDE15035

(SN 13.051)

Cortez was born in Medellin, Spain, in 1485. Trained as a lawyer, he preferred adventure in the New World, sailing to Santo Domingo in 1504 and then to Cuba, where he was made Santiago's chief magistrate. In 1519, the Spanish Crown dispatched Cortez to the newly discovered territory of Mexico, where he imposed military rule on the Indian populations there in order to establish Spain's control of the region. In the process, Cortez captured the Aztec stronghold of Mexico City, taking its emperor Montezuma hostage. Further warfare cemented Spain's empire in Mexico, and Cortez was rewarded with the governorship of the region (which included present-day Vera Cruz and Baja). After his return to Spain in 1541, Cortez volunteered for military service but failed to obtain royal favor. He then retired to his estate near Seville, where he died on 2 December 1547.

In 1816 Charles Willson Peale painted Cortez's portrait for the Philadelphia Museum, perhaps as context for the existing museum portraits of contemporary explorers (e.g. Meriwether Lewis and William Clark, Zebulon Pike). Peale copied the portrait of Cortez (now unlocated) that belonged to Mrs. Joel Barlow, widow of America's former minister to France. The Barlows had commissioned their Cortez portrait (and those of three other New World explorers) from works by sixteenth-century artist Christofano dell'Altissimo hanging in Florence's Uffizi Gallery.[1]

Peale's decision to include Cortez and his contemporaries in the museum may have been influenced by the same sentiment that motivated Thomas Jefferson to commission his own copies of the Uffizi paintings twenty-seven years earlier: "our country," Jefferson wrote, "should not be without the portraits of its first discoverers."[2]

⸙

Provenance:
Purchased by the City of Philadelphia at the 1854 Peale Museum sale.

Physical Description:
Oil on canvas. Bust length, facing front. Dark fur-trimmed overcoat, black coat, white shirt collar. Gray hair and short beard with mustache, brown eyes. Black soft crown hat. Green-brown background. 24 inches H × 20 inches W.

[1] Charles Willson Peale to Mrs. Joel Barlow, 26 January 1816 (Miller, *Selected Papers* 3, page 382). Peale's other Barlow copies depicted Amerigo Vespucci (now at the Historical Society of Pennsylvania), Christopher Columbus (unlocated), and Ferdinand Magellan (unlocated). A second set of unattributed copies from the four Barlow portraits was presented to the New-York Historical Society by Mrs. Gouverneur Morris in 1817.

[2] Quoted in Julian P. Boyd, ed., *The Papers of Thomas Jefferson* (Princeton: Princeton University Press, 1958), 15: xxxv. Only the Columbus portrait (now at the Massachusetts Historical Society) from Jefferson's explorer collection has been located.

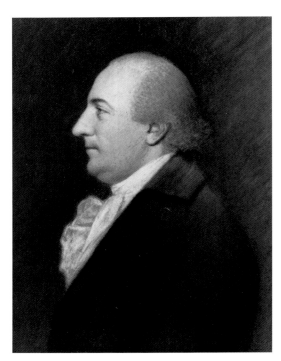

Catalog Number INDE11908

(SN 7.016)

HENRY CRUGER (1743–1826)
James Sharples Senior, from life, c. 1797–1800

Cruger was born in New York City on 22 November 1739. He later enrolled in King's College (now Columbia), but left school early to join his family's mercantile firm in their Bristol, England, office. He established himself in that city, and successfully stood for election to Parliament in 1774 as a member of the Whig party. Cruger's American sympathies during the Revolution made him a target of other members of Parliament, and he lost his reelection bid. He then became the mayor of Bristol, England's second largest city. After a second term in the House of Commons, Cruger returned to America in 1792. There, he served one term in the New York state senate. He died on 24 April 1827.

In this portrait, the skillful modeling of the sitter's facial features, the distinct line marking the profile, and the velvet blue-gray hues of the background represent the work of British pastelist James Sharples Senior (1751–1811).

Sharples probably executed this particular work between 1797 and 1800, when he lived in New York City. When the artist returned to England, he published a catalog of his American work in which he listed "Henry Cruger, esq." among his sitters.

———

Provenance:
Listed in the 1802 Bath catalog of Sharples's work. Given by Ellen (Mrs. James) Sharples to Felix Sharples in 1811. Given by Felix Sharples to Levin Yardly Winder in the 1830s. Inherited by Nathaniel James Winder from Levin Yardly Winder. Inherited by Richard Bayly Winder from Nathaniel James Winder in 1844. Purchased by Murray Harrison from Richard Bayly Winder around 1865. Purchased by the City of Philadelphia from Murray Harrison in 1876.

Physical Description:
Pastel on paper. Half length, left profile. Black coat, white stock and jabot. Powdered hair, gray eyes. Blue-green variegated background. 9 inches H × 7 inches W.

HANNAH PHILLIPS (MRS. WILLIAM) CUSHING (1754–1834)

by James Sharples Senior, from life, 1797

Catalog Number INDE11915

(SN 7.023)

In 1754, Hannah Phillips was born in Middletown, Connecticut. At the age of twenty, she married her distant cousin, William Cushing (a judge of the Massachusetts Superior Court) and moved to his home in Scituate, Massachusetts. After her husband was appointed to the United States Supreme Court in 1789, she accompanied him on his judicial circuit, riding in a specially outfitted carriage and reading to him as they traveled. Cushing cared for her husband through his final illness in 1810. She remained in their Scituate house until her death in 1834.

In early 1797, the Cushings shared lodgings with the British pastelist James Sharples Senior (1751–1811) and his family in Philadelphia. William Cushing wryly wrote to his niece that Sharples "took [a likeness of] your aunt, and whether you will believe it or not, has given her a prodigious handsome face, and yet, through the embellishments, one may see some of the original lineaments."[1] Later, Sharples listed "Mrs. Cushing" (and her husband William) in the 1802 catalog he published in Bath, England.

─◦◦◦◦◦─

Provenance:
Listed in the 1802 Bath catalog of Sharples's work. Given by Ellen (Mrs. James) Sharples to Felix Sharples in 1811. Given by Felix Sharples to Levin Yardly Winder in the 1830s. Inherited by Nathaniel James Winder from Levin Yardly Winder. Inherited by Richard Bayly Winder from Nathaniel James Winder in 1844. Purchased by Murray Harrison from Richard Bayly Winder around 1865. Purchased by the City of Philadelphia from Murray Harrison in 1876.

Physical Description:
Pastel on paper. Half-length, right profile. Grey dress of fitted satin top with long sleeves, deep v-neck with lace at bodice and around neck. Grey skirt with fullness at back. Grey fichu tucked into bodice. Powdered hair tied with gray ribbons, brown eyes. Deep matte blue background. 9 inches H × 7 inches W.

[1] William Cushing to Esther Parsons, 19 January 1797 (Knox, *Sharples*, 15).

Catalog Number INDE

(SN 13.053)

THOMAS CUSHING (1694–1746)
by John Wimbush, after Joseph Badger, c. 1876

Cushing was born in Boston, Massachusetts, in 1694. Although he studied law at Harvard, he pursued a mercantile career. His early public service ranged from moderator of the Boston Town Meeting to treasurer of the province of New England. In 1731, he entered the Massachusetts General Court's House of Representatives where he became speaker eleven years later. He died in 1746.

When the Cushing family donated a portrait of their ancestor to Independence Hall at the time of the Centennial, they believed that the painting depicted Continental congressman and lieutenant governor of Massachusetts Thomas Cushing (1725–1788). However, the copy portrait's source, a 1740s work by Boston artist Joseph Badger (now at the Essex Institute in Salem) had been misidentified at the time the copy was made.

Early twentieth-century research revealed that the work was actually the lieutenant governor's father of the same name.[1]

⟡

Provenance:
Given to the City of Philadelphia by Thomas Cushing Ladd, the subject's descendant, in 1876.

Physical Description:
Oil on canvas. Three-quarter length seated, torso facing slightly to the sitter's left. Olive green coat with black buttons, dark waistcoat, white stock and ruffled cuffs. Powdered wig, brown eyes. High backed upholstered armchair, red-covered table with book and document. Column behind chair. Dark gray sky and landscape scene to sitter's left. 54½ inches H × 46½ inches W.

[1] Lawrence Park, *Joseph Badger (1708–1765) and a Descriptive List of Some of His Works* (Boston: The University Press, 1918), 13.

WILLIAM CUSHING (1732–1810)
by James Sharples Senior, from life, 1797

Catalog Number INDE2033

Cushing was born on 1 March 1723 in Scituate, Massachusetts. Later, he attended Harvard College, taught school, and then read law. Appointed registrar of deeds and judge of probate in the new county of Lincoln (now in Maine), Cushing opened his own law practice. In 1771, he was appointed to succeed his father as judge of the superior court of Massachusetts. He later drafted Scituate's instructions to its congressional representatives in favor of independence. When the Revolution began, Cushing presided over the state's new supreme court. He maintained the court's regular operation throughout the war, even during Shays's Rebellion when he defied an armed mob that threatened to close the Springfield court house. Later, Cushing helped to write his state's new constitution and he attended Massachusetts's federal Constitution ratifying convention in 1787.

In 1789, Cushing became the first associate justice appointed to the United States Supreme Court, where he served for twenty-one years. He administered the oath of office to President George Washington during his second inauguration. Appointed chief justice in 1794, Cushing resigned the position after one week because he preferred to remain an associate justice. A tireless circuit riding judge, Cushing remained in office until his death in Scituate on 13 September 1810.

British pastelist James Sharples Senior (1751–1811) drew this portrait of Cushing in early 1797. When the Cushings arrived in Philadelphia for the beginning of the Supreme Court term, they took rooms in the same lodging house as the artist and his family. Sharples's first portrait of the associate justice (now unlocated) failed to please its subject. Cushing declared a second attempt "much better, though he does not incline to abate much, if anything, in the nose."[1] The artist later listed "Judge Cushing" in the 1802 catalog he published in Bath, England.

❧

Provenance:
Listed in the 1802 Bath catalog of Sharples's work. Given by Ellen (Mrs. James) Sharples to Felix Sharples in 1811. Given by Felix Sharples to Levin Yardly Winder in the 1830s. Inherited by Nathaniel James Winder from Levin Yardly Winder. Inherited by Richard Bayly Winder from Nathaniel James Winder in 1844. Purchased by Murray Harrison from Richard Bayly Winder around 1865. Purchased by Horace Gray from Murray Harrison in 1874. Inherited by Roland Gray in 1902. Purchased by the Vose Galleries in 1961. Purchased by Robert Carlen from the Vose Galleries in 1961. Purchased for Independence National Historical Park by Eastern National Park and Monument Association from Robert Carlen in 1961.

Physical Description:
Pastel on paper. Half length, left profile. Black coat, white stock and jabot. Powdered wig with a queue tied in a black ribbon. Deep blue background. 9 inches H × 7 inches W.

[1] William Cushing to Esther Parsons, 19 January 1797 (Knox, *Sharples*, 15).

Catalog Number INDE11924

(SN 7.033)

WILLIAM RICHARDSON DAVIE (1756–1820)
1. by James Sharples Senior, from life, 1798–1799

Davie was born in Cumberlandshire, England, on 20 June 1756. As a child, he immigrated to America and was raised by his uncle in the Waxhaw settlement on South Carolina's Catawba River. Davie later graduated from Princeton, and then alternated his study of law with volunteer service in the Revolutionary Army. Following his recovery from wounds sustained in the 1779 battle at Charleston's Stono Ferry, Davie served with distinction, particularly at Camden. In 1781, he became commissary general in the Continental Army's southern campaign.

After the war, Davie moved to North Carolina and served in the state legislature for twelve years, during which he helped to establish the state's university. In 1787, he attended the federal Constitutional Convention, and then worked in his state for two years to ratify the document. He became North Carolina's governor in 1798, but immediately resigned in order to accept an appointment as a brigadier general in the United States Army during the war with France. The following year, he joined a peace commission sent by President John Adams to Paris. After an unsuccessful bid for Congress in 1803, Davie returned to South Carolina. He died there on 29 November 1820.

1. British pastelist James Sharples Senior (1751–1811) listed "Governor Davis [*sic*], late Ambassador to France" among the subjects in his 1802 catalog of portraits, and probably painted his portrait of Davie just prior to the ambassador's departure from either Philadelphia or New York for Europe.[1] Although heavily abraded on its surface, this pastel exhibits the characteristic soft, fluid colors and strong, smooth lines in the sitter's profile that are usually identified with the senior Sharples's work. Another Sharples version of this Davie portrait existed in a private collection early in the twentieth century, but the pastel's present location is now unknown.

─◦◦◦─

Provenance:
Listed in the 1802 Bath catalog of Sharples's work. Given by Ellen (Mrs. James) Sharples to Felix Sharples in 1811. Given by Felix Sharples to Levin Yardly Winder in the 1830s. Inherited by Nathaniel James Winder from Levin Yardly Winder. Inherited by Richard Bayly Winder from Nathaniel James Winder in 1844. Purchased by Murray Harrison from Richard Bayly Winder around 1865. Purchased by the City of Philadelphia from Murray Harrison in 1875.

Physical Description:
Pastel on paper. Half length, left profile. Dark blue uniform coat with light collar facing, white waistcoat, white stock and jabot. Powdered hair tied in an elaborate queue, brown eyes. Dark blue background. 9 inches H × 7 inches W.

[1] This portrait was recognized as Davie in the early twentieth century. Previously, it had been called "Aaron Burr." James Sharples's portrait of Burr (along with Ellen Sharples's pencil copy of it) is now located at the City Art Gallery of Bristol, England. Knox, *The Sharples*, 101.

WILLIAM RICHARDSON DAVIE (1756–1820)
2. by "Eliza M.," miniature from life, 1800

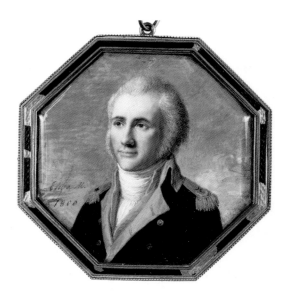

2. While in Paris with the diplomatic corps, Davie sat for the miniaturist, "Eliza M," in 1800. Previous identification of the artist focused on Lizinska Aimée Zoé Mirbel, court miniaturist to Louis XVIII. However, Mirbel's life dates, 1796 to 1849, preclude her from consideration as the Davie portraitist. Instead, the artist may have been Elisabeth Melanie Moitte (working as late as 1828), a daughter of French painter Pierre Etienne Moitte (1722–1780), or Elizabeth Manners (working eighteenth century), a British painter.

Catalog Number INDE14040
(SN 52.011)

⸺◦◦⊙◦◦⸺

Provenance:
Given to the City of Philadelphia by Mrs. William Richardson Davie Crockett in memory of her husband, the sitter's great-great-grandson, in 1928.

Physical Description:
Watercolor on ivory. Bust length, facing slightly to the sitter's right. Blue uniform coat with buff facings, gold buttons and gold epaulettes, buff waistcoat, white stock. Powdered hair, blue eyes. Sky blue background with clouds in lower right. Signed in lower left "Eliza M. 1800." Octagonal gold frame with blue enamel. 3 inches H × 3 inches W.

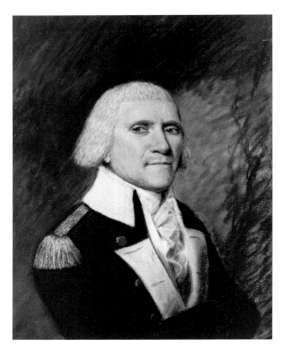

Catalog Number INDE11923

(SN 7.032)

ELIAS DAYTON (1737–1807)
by a member of the Sharples family, after James Sharples Senior, c. 1795–1810

Dayton was born in Elizabethtown, New Jersey, on 1 May 1737. He later chose service in his colony's militia during the French and Indian War, fighting in the attack on Quebec and near Fort Detroit during Pontiac's Rebellion. Afterward, he returned to New Jersey and opened a general store. When the Revolution began, Dayton commanded the Third New Jersey Regiment. He oversaw the building of Forts Schuyler and Dayton in western New York. His regiment saw heavy fighting during the battles of Brandywine, Germantown, and Monmouth, and served under grueling winter conditions at Valley Forge and Morristown. In 1781, Dayton led two New Jersey regiments and one Rhode Island regiment in the American victory at Yorktown. After the war, Dayton served as president of the New Jersey Society of the Cincinnati and commanded his state's militia. He also served for a year in Congress and spent two terms in his state's legislature. He died on 22 October 1807.

During two visits to the United States, in the late 1790s and again from 1808 to 1811, England's Sharples family painted pastel portraits of many American sitters. Those subjects painted during the first visit, including "General Dayton," were listed by James Sharples Senior (1751–1811) in an 1802 catalog of his work published in England. There are two versions of the Dayton pastel presently known. The life portrait by James Senior is at the Detroit Institute of Arts. A copy, possibly by sons Felix (1778?–1835?) or James Junior (1789–1839), is in the Independence collection. The copyist's technique is awkward (the subject's face lacks modeling and the coloring is indelicate) and missing details (e.g. coat buttons) when compared to that used for the life portrait. In addition, the copy was poorly restored in the nineteenth century, resulting in its rather coarse appearance (particularly in the background and along the subject's lower jaw).

⟡

Provenance:
Given by Ellen (Mrs. James) Sharples to Felix Sharples in 1811. Given by Felix Sharples to Levin Yardly Winder in the 1830s. Inherited by Nathaniel James Winder from Levin Yardly Winder. Inherited by Richard Bayly Winder from Nathaniel James Winder in 1844. Purchased by Murray Harrison from Richard Bayly Winder around 1865. Purchased by the City of Philadelphia from Murray Harrison in 1875.

Physical Description:
Pastel on paper. Half length, facing front, torso slightly to the sitter's left. Blue uniform coat with buff facings, gold epaulettes. White stock and jabot. Gray hair, brown eyes. Blue-gray background. 9 inches H × 7 inches W.

HENRY DEARBORN (1751–1829)
Charles Willson Peale, from life, 1796–1797

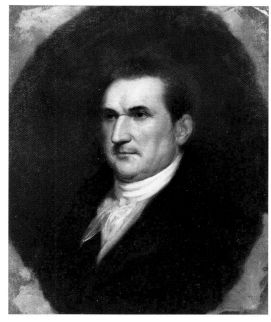

Catalog Number INDE14041

(SN 13.056)

Dearborn was born in Hampton, New Hampshire, on 23 February 1751. He later studied medicine, and opened his own medical practice in 1771. When Revolutionary fighting began, he led a local militia troop to Boston and fought at Bunker Hill. He then served under Benedict Arnold during the American expedition to Quebec, where he was captured and imprisoned for a year. Dearborn later fought at Ticonderoga, Monmouth, and in the Genesee Valley; he also served on George Washington's staff at Yorktown. After the war, he worked as United States marshal for the District of Maine. In 1793, he represented Massachusetts in Congress for two terms. In 1801, President Thomas Jefferson appointed him secretary of war, a post he held for eight years.

During the War of 1812, Dearborn commanded the army's northeast sector, but lost Detroit and several other forts in the Great Lakes to the British while sustaining heavy casualties in the capture of Toronto. As a result, he was reassigned to an administrative command in New York City. In 1815, President James Madison recommended Dearborn's reappointment as secretary of war, but the Senate rejected the nomination. Dearborn later served two years as United States minister to Portugal. He died on 6 June 1829.

Charles Willson Peale's museum portrait of Dearborn reflects the silvery tones common to the artist's work of the 1790s, but the painting is absent from the 1795 museum catalog. Peale probably painted it when Dearborn was in Philadelphia serving in Congress through 1796 and 1797.[1] The portrait first appears in the 1813 Peale Museum catalog.

⁓❦⁓

Provenance:
Listed in the 1813 Peale Museum catalog. Purchased by the City of Philadelphia at the 1854 Peale Museum sale.

Physical Description:
Oil on canvas. Bust length, facing slightly to the sitter's right. Dark green coat, yellow waistcoat, white stock and jabot. Reddish brown hair, brown eyes. Dark brown background. 23¾ inches H × 19⅞ inches W.

[1] Sellers, *Portraits and Miniatures*, 63.

STEPHEN DECATUR (1779–1820)
by Gilbert Stuart (uniform by James Alexander Simpson), from life, 1806

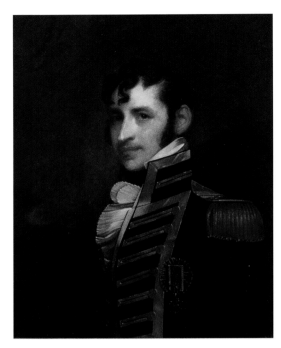

Catalog Number INDE14044

(SN 13.057)

[1] William H. Truettner, "portraits of Stephen Decatur by or after Gilbert Stuart," *The Connoisseur* (August 1969): 268–269.

Decatur was born on Maryland's Eastern Shore on 5 January 1779. He grew up in Philadelphia and later attended the University of Pennsylvania. In early 1798, he joined the United States navy during the war with France and served in the West Indies. By 1803, he had achieved public acclaim for his bold exploits in the Mediterranean during actions against Tripoli. Two years later, after negotiating the peace at Tunis, he received a congressional commendation and was appointed head of the Norfolk Navy Yard and commander of naval forces in the Chesapeake.

When the War of 1812 began, Decatur's much-celebrated capture of the British frigate *Macedonian* earned him the medal of the Society of the Cincinnati and command of the American naval defenses at New York City. Though wounded and captured off Long Island early in 1815, Decatur finished the war with a return to service in the Mediterranean. After the war, Decatur served on the Board of Navy Commissioners in Washington. In this administrative capacity, he opposed the reinstatement of James Barron, who had been court-martialed several years earlier. As a result, Barron challenged Decatur to a duel. The two met outside of Washington, and Decatur was killed on 22 March 1820.

Commodore Decatur's dashing figure and valiant exploits made him an attractive subject for portrait painters (including John Wesley Jarvis, Thomas Sully, and Rembrandt Peale). The first artist to capture Decatur's image was Boston artist Gilbert Stuart (1755–1828), who depicted the commodore in 1806 while he was serving in Newport, Rhode Island. Stuart's portrait of Decatur was extremely popular; several other artists copied it (including David Edwin, whose engraved version appeared in the May 1813 issue of *Analectic Magazine*). In the mid-1820s, Stuart himself painted another version of the portrait (now on long-term loan to the Virginia Museum of Fine Arts). It shows Decatur in civilian clothes, and it was commissioned by Decatur's widow as a gift for her husband's friend Senator John Randolph.

During the 1830s or 1840s, Decatur's widow commissioned Georgetown artist James Alexander Simpson to paint several copies of the 1806 Stuart portrait for her acquaintances (one copy survives in the art collections of Georgetown University). Apparently, she also asked Simpson to repaint parts of the uniform in the Stuart life portrait. The medal of the Society of the Cincinnati was probably added to the portrait at that time. A pentimento of Stuart's original uniform lapel, which crossed the epaulette on Decatur's shoulder, is visible on the painting today.[1] Following the removal of Decatur's remains from Washington to Philadelphia's St. Peter's Church cemetery in late 1846, Mrs. Decatur donated the Stuart life portrait of her husband to the City of Philadelphia for placement in Independence Hall.

———⚬⚬⚬———

Provenance:
Given to the City of Philadelphia by Susan Wheeler (Mrs. Stephen) Decatur in 1847.

Physical Description:
Oil on canvas. Half length, facing slightly to the sitter's right. Dark blue naval uniform coat with gold lace and epaulette, brass buttons. Light blue ribbon with gold medal of the Order of the Cincinnati. White shirt with ruffled jabot, black stock. Brown hair, brown eyes. Dark background. Signed in lower left corner: "G. Stuart Pinx./1806."
29⅛ inches H × 24¼ inches W.

JOHN DICKINSON (1732–1808)
Charles Willson Peale, from life, 1782–1783

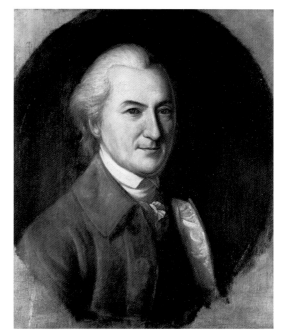

Catalog Number INDE14042
(SN 13.059)

Dickinson was born in Talbot County, Maryland, on 8 November 1732. After his Quaker family moved to Delaware, Dickinson studied law in Philadelphia and at London's Middle Temple before opening his own practice in 1757. After service in the Assembly of the Lower Counties (i.e. Delaware), he entered the Pennsylvania legislature, but his continued support for the colony's proprietary government alienated his constituents, and he lost his seat in 1764. Though he attended the Stamp Act Congress, he wrote that its protest should be in formal communications with the royal government, not in rioting or the refusal to pay taxes. In 1767, Dickinson began to publish his series *Letters from a Farmer in Pennsylvania to the Inhabitants of the British Colonies*, in which he discussed the legal basis of personal liberties and how incursions on those liberties should be met with boycotts, rather than violence.

As a member of the First and Second Continental Congresses, Dickinson drafted many of the formal statements that outlined colonial grievances and lobbied for their redress. Throughout his writing, Dickinson advocated a peaceful resolution to the conflict between Britain and its American colonies. He attended the debates that led to the drafting of the Declaration of Independence, but he voted against the document. Despite his rejection of independence, Dickinson served in uniform when Revolutionary fighting began. He returned to Congress in 1779, and then accepted election first as president of Delaware's Supreme Executive Council and then as that of Pennsylvania.

In 1787, Dickinson attended the federal Constitutional Convention and worked for ratification of the document by Delaware, the first state to do so. Later, he participated in his state's own constitutional convention and published several volumes of political treatises. He died on 14 February 1808.

Although Charles Willson Peale differed with Dickinson politically, the artist considered the president of the Supreme Executive Council to be a fitting subject for the Philadelphia Museum.[1] This portrait appears as "President of this state [Pennsylvania]" on the first list of the museum's contents published in the 13 October 1784 issue of the *Freeman's Journal and Philadelphia Daily Advertiser*. The portrait is representative of the artist's early palette, in which the flesh tones took on a greenish pallor soon after the paintings' completion.

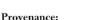

Provenance:
Listed in the 1795 Peale Museum catalog. Purchased by the City of Philadelphia at the 1854 Peale Museum sale.

Physical Description:
Oil on canvas. Bust length, torso turned slightly to the sitter's left. Brown coat with white lining, brown waistcoat, white collar, stock, and jabot. Gray hair, blue eyes. Dark brown background. 23⁷⁄₁₆ inches H × 19⅜ inches W.

[1] As part of his introduction to Philadelphia society, Peale had painted Dickinson previously, in 1770. There were three versions of this painting: the life portrait (now at the Historical Society of Pennsylvania) and two replicas (now unlocated). Charles Willson Peale to Edmund Jenings, 20 April 1771 (Miller, *Selected Papers* 1, page 96–97.

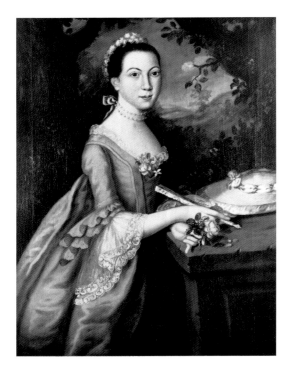

Catalog Number INDE14043

(SN 13.394)

MARTHA DOZ (1750–1808)
attributed to James Claypoole Junior, from life, c. 1766–1769

Doz was born in 1750 in Philadelphia. In the mid-1770s, she married Benjamin Flower, who became a colonel in the Continental army's Artillery Artificer Regiment and commissary general of military stores during the Revolution. The Colonel died in 1781, and Mrs. Flower remained a widow until the early 1790s. Her second husband, Samuel Magaw, was the rector of Philadelphia's Christ Church. He was a graduate of the College of Philadelphia, vice provost and professor of moral philosophy at the University of Pennsylvania. He resigned his ministry in 1804 due to the infirmities of age. Mrs. Magaw died childless on 22 November 1808.

This portrait of the teenaged Martha Doz was attributed to Philadelphia artist James Claypoole Junior (born c. 1743), initially on the basis of family tradition. In addition, elements in the portrait are similar to those in documented Claypoole portraits, e.g. the roughhewn plinth is identical to that in his 1769 portrait of Anne Galloway Pemberton (now at the Pennsylvania Academy of the Fine Arts), and the rounded eyes and eyebrows are like those in the 1769 portrait of Lydia Irons (now at the Corbit–Sharp House in Odessa, Delaware).

Compositionally, Claypoole was probably influenced by the work of Philadelphia artists whom he knew personally. Preeminent among these was William Williams. Similarities between Williams's 1766 portrait of Deborah Hall (now at the Brooklyn Museum) and Claypoole's Martha Doz, are evident. Both were completed around the same time for families who were acquainted (Hall was the daughter of Benjamin Franklin's

business partner, and Doz was Mrs. Franklin's third cousin). Claypoole depicted Doz in a pink watteau-back gown very similar to that worn by Williams's Hall.[1] Both subjects wear floral coronets and bodice corsages. The rose held by each may represent the bloom and purity of youth.[2]

In the colonies, where art academies were non-existent and professional portraitists were often itinerant, imported English mezzotints frequently provided artists with accessible sources for composition study. The influence of mezzotints on Claypoole's work may be seen in the way in which he posed Martha Doz. Her pose is quite similar to that used by Sir Godfrey Kneller, court painter for the Stuart and Hanover houses, in his portrait of Princess Anne. This Kneller portrait was later published as a mezzotint by John Simon in 1720.[3]

—◦◦◦◦—

Provenance:
Given to the City of Philadelphia by Margaret G. Cowell, the sitter's great-grandniece, in 1928.

Physical Description:
Oil on canvas. Three-quarter length, facing front with torso in right profile. Pink gown with white lace at bodice and sleeves. Pearl necklace tied with pink ribbon, red and white flowers in hair, pink and orange corsage on bodice, pink rose in left hand and pink fan in right. Brown hair, brown eyes. Stone plinth in right foreground, hands and straw hat having band of pink flowers resting on plinth. Background of landscape with trees and hills beneath blue sky. 39⁹⁄₁₆ inches H × 30¼ inches W.

[1] Richard Saunders and Ellen G. Miles, *American Colonial Portraits, 1700–1776*, exhibition catalog, National Portrait Gallery (Washington: Smithsonian Institution Press, 1987), 313.

[2] Roland E. Fleischer, "Emblems and Colonial American Painting," *American Art Journal* 20:3 (1988), 3–9.

[3] Simon mezzotint illustrated in Waldron Phoenix Belknap, Jr., *American Colonial Painting, Materials for a History* (Cambridge, Mass.: The Belknap Press, 1959), plate XXI, number 31.

REBECCA DOZ (1760–1775)
attributed to James Claypoole Junior, from life, c. 1766–1769

Catalog Number INDE11878
(SN 13.395)

Doz was born on 3 February 1760 in Philadelphia. Her parents, Andrew and Rebecca Cash Doz, were prominent members of St. Paul's Episcopal Church. Young Rebecca died in early January 1775.

Like its companion portrait of her older sister Martha (also in this collection), that of Rebecca Doz shares style and compositional characteristics with the known work by Philadelphia artist James Claypoole Junior (born c. 1743). In particular, the influence of the artist's contemporary, William Williams, through his 1766 portrait of Deborah Hall (now at the Brooklyn Museum) appears evident. Both Williams and Claypoole arranged their sitters' hands in graceful gestures with their separated fingers extended at similar angles. Claypoole portrays Rebecca holding a toy cup and ball on a string and standing in the same position as Hall, who plucks a rose with her right hand and holds the leash to a small squirrel with the other. The presence of toys in children's portraits was somewhat rare before 1770, particularly for girls. When shown, quiet or solitary toys (like a ball and cup) were generally the props given to girls.[1]

Like the stylistic link between the Doz and Hall portrait subjects, the Doz portraits and their creator represent a close familial association. The Doz and Claypoole patriarchs served together in the 1760s as founding vestrymen at St. Paul's Episcopal Church, which may have occasioned the portrait commissions for the younger Claypoole.

❧⊷⊶☙

Provenance:
Given to the City of Philadelphia by Margaret G. Cowell, the sitter's great-grandniece, in 1928.

Physical Description:
Oil on canvas. Nearly full length, facing front with torso slightly to the sitter's right. Blue gown with white lace at bodice and sleeves. Red and gold necklace tied with blue ribbon, flower garland in hair, holding ball and cup toy in two hands. Brown hair, brown eyes. Background of landscape with trees and hills beneath blue sky. 39¾ inches H × 30⁵⁄₁₆ inches W.

[1] Karin Calvert, "Children in American Family Portraiture, 1670–1810," *William and Mary Quarterly* 39 (January 1982), 111.

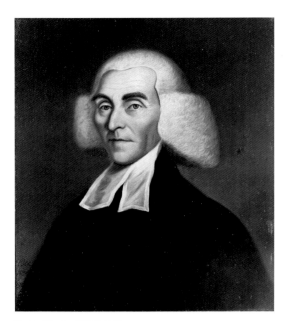

Catalog Number INDE14045

(SN 13.231)

GEORGE DUFFIELD (1732–1790)
by Charles Peale Polk, possibly from life, c. 1790

On 7 October 1732, Duffield was born in Lancaster County, Pennsylvania. Later, he attended the College of New Jersey (now Princeton) and then studied theology. While a tutor at the College of New Jersey, he was ordained in the Presbyterian church. In 1772, he accepted the pastorate of Philadelphia's Third (Old Pine) Street Presbyterian Church. Long a vocal critic of the Crown, he served as a commissioned chaplain in the Revolutionary Pennsylvania militia. Briefly, he also ministered to the Continental Congress during its sojourn at York, Pennsylvania. After the war, Duffield helped to organize the American Presbyterian Church, and became its first executive officer in 1789. He also served as a trustee of the College of New Jersey. He remained pastor of the Third Street Presbyterian Church until his death in Philadelphia on 2 February 1790.

Baltimorean Charles Peale Polk (1767–1822) grew up in the home of his uncle Charles Willson Peale and first advertised as a painter in Philadelphia in 1787. His Duffield portrait is signed and dated 1790; Polk may have painted it shortly before the subject's death, or it may be a posthumous portrait. Possibly, Polk copied an earlier work (now unlocated) by another artist.[1]

‒‒❧❧❧‒‒

Provenance:
Given to the City of Philadelphia by Dr. George Duffield, the subject's descendant, in 1896.

Physical Description:
Oil on canvas. Bust length, facing three quarters to the sitter's right. Black clerical robe with white tailed clerical collar. Powdered wig, light blue eyes. Graduated olive green-gray background. Signed and dated lower left: "Polk/pinx/1790." 23½ inches H × 20¼ inches W.

[1] Linda Crocker Simmons, *Charles Peale Polk 1776–1822, A Limner and His Likenesses*, exhibit catalog, Corcoran Gallery of Art (Washington: Corcoran Gallery, 1981), 24.

LOUIS LE BEGUE DE PRESLE, DUPORTAIL (1743–1802)
by Charles Willson Peale, probably from life, c. 1781–1784

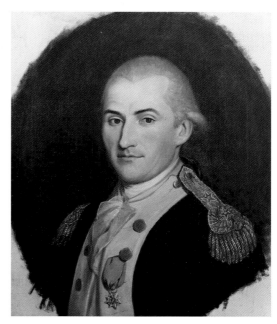

Catalog Number INDE14046
(SN 13.063)

Duportail was born in 1743 near Orleans, France. After graduation from the prestigious military academy in Mézières, he joined the French government's program of covert aid to the American war effort. In 1777, he was appointed the Continental army's chief of engineers, and began by rebuilding the forts on the Delaware River and organizing the encampment at Valley Forge. Subsequently, he fought at Monmouth and on the Hudson, and improved the defenses at Philadelphia and West Point. In 1779, he became commandant of the Corps of Engineers and Sappers (underground fortifications). He was captured during the siege of Charleston, and later fought at Yorktown. After a leave of absence in France, Duportail resumed his American command, not resigning until the end of the war in 1783. His return to French military service was cut short by the French Revolution, during which he spent two years in hiding, before returning to America. He settled near Philadelphia for a few years, but died in 1802 during a voyage back to France.

Charles Willson Peale may have painted Duportail's portrait for the Philadelphia Museum in late 1781, just after the subject received his promotion to major general and just before he left for France.

Or the portrait may date to the period between Duportail's American return in late 1782 and his resignation from the Continental army in late 1783. The portrait is listed among those in the museum as advertised in the 13 October 1784 issue of the *Freeman's Journal and Philadelphia Daily Advertiser*. Although this painting has the flat appearance (caused by the rather vague facial modeling) usually associated with copy portraits, no other Peale portrait of Duportail is known.

❧❧❧

Provenance:
Listed in the 1795 Peale Museum catalog. Purchased by Townsend Ward (librarian of the Historical Society of Pennsylvania) at the 1854 Peale Museum sale. Purchased by the City of Philadelphia from Townsend Ward in 1854.

Physical Description:
Oil on canvas. Bust length, turned slightly to the sitter's right. Blue uniform coat with buff facings, gold buttons and epaulettes, buff waistcoat, white stock and jabot. Silver and gold medal on salmon pink ribbon is the French Order of Merité Militaire. Powdered hair tied in a queue with a black ribbon, brown eyes. 23⅜ inches H × 19⁷⁄₁₆ inches W.

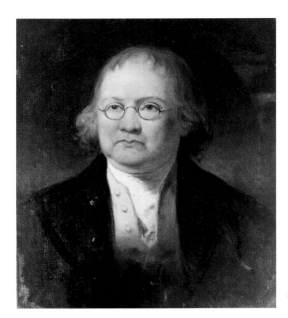

Catalog Number INDE14047

(SN 13.065)

WILLIAM ELLERY (1727–1820)
1. by James Read Lambdin, after John Trumbull, 1872

William Ellery was born on 22 December 1727 in Newport, Rhode Island. After graduation from Harvard, he worked as a merchant, a naval commander, and clerk of the Court of Common Pleas before he opened a law practice in 1770. He was elected to the Second Continental Congress in mid-1776, and he signed the Declaration of Independence. During the war, he served on the administrative Board of Admiralty. He retired from Congress in 1786, after which he spent three years as Rhode Island's continental loan officer. His last public service was as Newport's collector of customs, the position he held until his death on 15 February 1820.

1. A few years prior to the United States Centennial, the City of Philadelphia commissioned local artist James Read Lambdin (1807–1889) for a portrait of Ellery to hang in Independence Hall. Lambdin copied John Trumbull's late eighteenth-century depiction of Ellery in *The Declaration of Independence* (now at Yale University Art Gallery).[1]

❧

Provenance:
Purchased by the City of Philadelphia from the artist in 1873.

Physical Description:
Oil on canvas. Bust length, facing slightly toward sitter's right. Gray-green coat and waistcoat with green buttons, white stock. Gray hair, hazel eyes. Silver-rimmed spectacles. Reddish brown background. 23½ inches H × 19⅝ inches W.

[1] Trumbull's 1791 study sketch of Ellery was lost after the 1896 sale of the artist's drawings. Theodore Sizer, ed., *The Autobiography of Colonel John Trumbull* (New Haven: Yale University Press, 1952), 171. Trumbull's other depiction of Ellery in *General George Washington Resigning His Commission, Annapolis, 23 December 1783* (1824–1828) is also in the Yale collection.

WILLIAM ELLERY (1727–1820)
2. by Samuel Bell Waugh, after John Trumbull, 1876

2. The Lambdin copy, however, failed to satisfy the committee charged with furnishing the Independence Hall museum. In 1876, a second copy of Trumbull's Ellery image was purchased from another Philadelphia artist, Samuel Bell Waugh (1814–1885).

<center>—◦⊙◦—</center>

Provenance:
Purchased by the City of Philadelphia from the artist in 1876.

Physical Description:
Oil on canvas. Bust length, facing slightly to the sitter's right. Blue coat and yellow waistcoat, white stock. Gray hair, hazel eyes. Silver-rimmed spectacles. 24 inches H × 20 inches W.

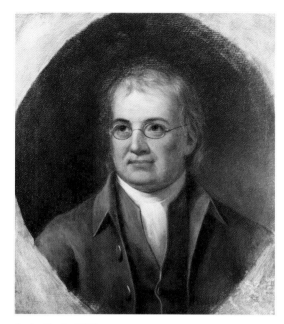

Catalog Number INDE
(SN 13.064)

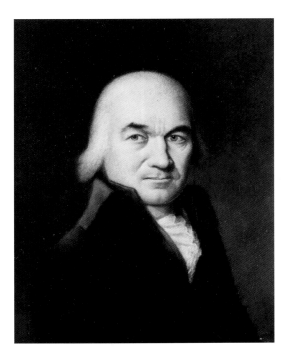

Catalog Number INDE2764

OLIVER ELLSWORTH (1745–1807)
by James Sharples Senior, from life, 1796–1797

Ellsworth was born on 29 April 1745 in Windsor, Connecticut. He graduated from Princeton and then began theological studies. However, he soon turned to the law and passed the bar in 1771. He then served in his colony's legislature and as state's attorney for Hartford County. A delegate to the Continental Congress from 1778 to 1783, he also served on his state's Governor's Council until he became a member of the state superior court. At the 1787 federal Constitutional Convention, he and his two Connecticut colleagues outlined the principle of representation by state in the Senate and by population in the House.

Ellsworth worked hard for ratification of the federal Constitution, and he served under it in the United States Senate, where his legal expertise informed the bill that organized the federal judiciary. He left the Senate when he was appointed chief justice of the United States Supreme Court in 1796. His last public office was as a member of the problem-plagued American peace commission to France in 1799–1800. The stress of negotiations and the hardships of the transatlantic crossing permanently damaged Ellsworth's health. He died at his home in Windsor, Connecticut, on 26 November 1807.

British pastelist James Sharples Senior (1751–1811) probably painted Ellsworth's portrait when the artist and the chief justice both lived in Philadelphia. This portrait conveys a strong sense of the sitter's character in the determined jaw and unflinching gaze. The artist's expert handling of the sitter's facial features includes astute attention to detail, such as the crow's feet around the left eye, the lines around the mouth, and the delicate fabric of the jabot. The richly colored background has subtle gradations of tone that also indicate the artist's thorough understanding of his medium. Sharples later listed this portrait in his 1802 catalog as "Chief Justice Ellsworth, late Ambassador to France." Another version of this pastel, also attributed to the elder Sharples, currently exists at the Ellsworth Homestead in Windsor, Connecticut.

⁓◦≪◦⁓

Provenance:
Listed in the 1802 Bath catalog of Sharples's work. Given by Ellen (Mrs. James) Sharples to Felix Sharples in 1811. Given by Felix Sharples to Levin Yardly Winder in the 1830s. Inherited by Nathaniel James Winder from Levin Yardly Winder. Inherited by Richard Bayly Winder from Nathaniel James Winder in 1844. Purchased by Murray Harrison from Richard Bayly Winder around 1865. Purchased by Horace Gray from Murray Harrison in 1874. Inherited by Roland Gray in 1902. Purchased by the Vose Galleries in 1961. Purchased by Robert Carlen from the Vose Galleries in 1961. Purchased for Independence National Historical Park by Eastern National Park and Monument Association from Robert Carlen in 1961.

Physical Description:
Pastel on paper. Bust length, torso turned slightly toward sitter's left. Black coat and waistcoat. White stock and jabot. Gray hair, blue eyes. Dark blue variegated background. 9 inches H × 7 inches W.

WILLIAM FINDLEY (1741–1821)
by Rembrandt Peale, from life, 1805

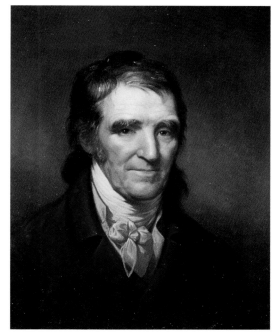

Catalog Number INDE14048

(SN 13.071)

Findley was born in Northern Ireland in 1741. As a young man, he immigrated to Waynesboro, Pennsylvania. He served as a militia captain during the Revolution, after which he moved to Pennsylvania's frontier and served in several state offices, including that assigned to review the new state constitution. He declined to represent Pennsylvania at the federal Constitutional Convention, however, and vigorously opposed ratification of the new document because it lacked a bill of rights.

In 1791, Findley entered the House of Representatives, where he served for twenty-two years as an expert on frontier issues. As such, he initially opposed the Washington administration's 1794 tax on whiskey and supported the farmers' armed insurrection against the federal government. Later, he urged moderation and led the effort to diffuse tensions over the tax. In Congress, he also initiated the creation of permanent committees to address major legislative issues before they reached cabinet departments. After his retirement, Findley pursued historical studies. He died on 5 April 1821.

In 1804, Charles Willson Peale organized a trip to the new capitol in Washington with the hope that "Painting the likenesses of some of the Public officials for my Museum … may excite the desire of some of the members of Congress to employ [my son Rembrandt]."[1] The strategy proved very successful, and Rembrandt (1778–1860) obtained sittings from several prominent citizens, including William Findley. When Rembrandt finished Findley's likeness, his father appraised it as "a charming portrait."[2]

In the painting, the sitter's rugged face exhibits a vivid interplay of colors that suggests varied skin tones and textures. Findley's distinctive eyebrows also received careful attention from the artist. The 1854 Peale Museum auction catalog misidentified this portrait as one of Pennsylvania's former governor William Findlay (1768–1846), but Senator Findley's great-great-granddaughter corrected the portrait's identification early in the twentieth century.

Provenance:
Listed in the 1813 Peale Museum catalog. Purchased by the City of Philadelphia at the 1854 Peale Museum sale.

Physical Description:
Oil on canvas. Bust length, facing front. Brown coat, yellow waistcoat, white stock and cravat. Dark brown graying hair, brown eyes. Green background. 23¹⁵⁄₁₆ inches H × 19¹⁵⁄₁₆ inches W.

[1] Charles Willson Peale, "Diary," 27 December 1804 (Miller, *Selected Papers* 2:2, page 183).

[2] Charles Willson Peale to Rubens and Sophonisba Peale, 19 January 1805 (Miller, *Selected Papers* 2:2, page 793).

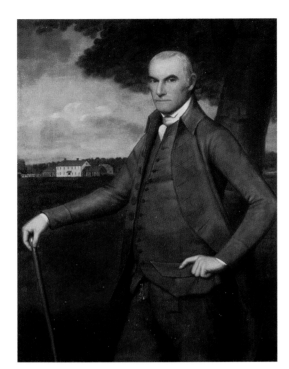

Catalog Number INDE10167

WILLIAM FLOYD (1734–1821)
1. by Ralph Earl, from life, c. 1793

Floyd was born on Long Island in New York on 17 December 1734. A prominent landowner, he was elected in 1774 to the Continental Congress, where he later signed the Declaration of Independence. He remained in Congress through most of the war, and also served in his state's senate. From 1789 to 1791, he sat in the United States House of Representatives. He attended his state's constitutional convention in 1801 and served again in the state legislature. Floyd died in Westernville, New York, on 4 August 1821.

1. As an artist's subject, the wealthy and politically prominent Floyd was an important client to the New England painter Ralph Earl (1751–1801). For this reason, scholars consider the Floyd portrait to be Earl's "most important commission on Long Island." The painting shows Floyd standing on the grounds of his family estate, Brookhaven. Early in the twentieth century, the portrait underwent restoration and the lower right corner of the work (which contained the artist-inscribed date) was lost. During a pre-restoration examination of the painting, however, historians fortuitously recorded the presence of the now-missing 1793 date.[1]

Provenance:
Given to Independence National Historical Park by Mrs. David Weld, the sitter's great-great-great-granddaughter, in 1973.

Physical Description:
Oil on canvas. Three-quarter length, turned slightly to the sitter's right. Olive green coat, waistcoat, and breeches; white shirt and stock. Gray hair tied with a brown ribbon, blue eyes. Gold seals hanging from waistcoat pocket. Gold-tipped walking stick in right hand. Left background shows landscape including Floyd estate in present day Mastic, Long Island, New York. Signed in lower left: "R. Earl 17[93]." 47⅛ inches H × 35½ inches W.

[1] Elizabeth Mankin Kornhauser, *Ralph Earl, the Face of the Young Republic*, exhibit catalog, Yale University Art Gallery (New Haven: Yale University Press, 1991), 192.

WILLIAM FLOYD (1734–1821)
2. by Edward Lamson Henry, after Ralph Earl, c. 1870

2. Prior to the United States
Centennial, Floyd's descendants
gave New York artist Edward
Lamson Henry (1841–1919) access
to the Earl portrait (then still at
the family estate) in order to
copy it for the portrait gallery in
Independence Hall.[2]

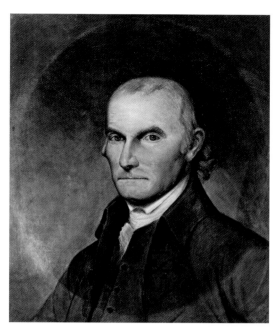

Catalog Number INDE

(SN 13.072)

Provenance:
**Given to the City of Philadelphia by David
Floyd, the subject's grandson(?), in 1874.**

Physical Description:
*Oil on canvas. Bust length, body turned toward
subject's right. Drab green coat and waistcoat,
white shirt and stock. Gray hair, blue eyes.
Dark background. 23 inches H × 19 inches W.*

[2] The precise date that the
portrait was painted is
unclear. The Henry
Collection at the New York
State Museum Cultural
Educational Center in
Albany contains a photo-
graph of the artist's Floyd
copy with the notation
"Original copied by E.L.
Henry for Independence
Hall, Philadelphia, No. 1874,
presented by David Floyd,
Greenport, L.I. Nov. 1874."
Accession records for the
City of Philadelphia are
incomplete on this matter,
saying only that the acquisi-
tion was a gift recorded on
3 July 1873. A 12 March
1917 letter from the artist to
the *American Art News* (cited
in Elizabeth McCausland,
"The Life and Work of
Edward Lamson Henry
1841–1919," *New York State
Museum Bulletin* Number
339 [1945], 171–172) states
that Henry received the
Floyd commission in 1876.

THOMAS FORREST (1747–1825)

1. by Charles Willson Peale, from life, c. 1820

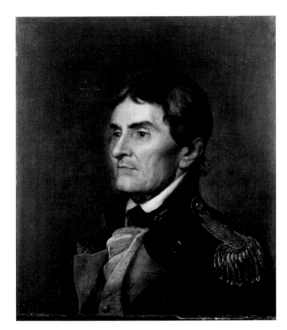

Catalog Number INDE14057

(SN 13.326)

Forrest was born in Philadelphia on 12 July 1747. As a youth, he wrote a satire, *The Disappointment, or the Force of Credulity*, in which he ridiculed several prominent local citizens. Had the work been produced, he would have been the first American playwright to present his work on a public stage. Later, Forrest served as an artillery officer in the Revolution, at first commanding a troop of marines disguised as Native Americans, then serving at Trenton, Brandywine, and Valley Forge. In 1781, he resigned from the Continental army and took a commission with the Pennsylvania militia. After the war, Forrest served in the Pennsylvania legislature and as a captain in the Philadelphia County Troop of Horse. In 1819, he entered the United States House of Representatives, where he served for two terms. Forrest died in Germantown, Pennsylvania, on 20 March 1825.

Early scholarship suggests that Charles Willson Peale included Forrest's portrait among his museum subjects as a means of fostering political support for the museum's public funding.[1] Although this motive is certainly plausible, it is unclear whether Peale conceived this museum addition independently or whether he was influenced by a private commission for Forrest's portrait. Clearly, the artist painted two portraits of Forrest, apparently around the same time. But the works differ significantly in appearance and quality. One possibility is that Peale painted a privately commissioned portrait first and then copied it for the museum. Another possibility is that Peale painted the museum portrait first and then gave or sold it to the sitter, generating another portrait later for his own use.

1. In the portrait owned by the Forrest family, the sitter wears a nineteenth-century military uniform and is portrayed in the bust-length Museum format without any background attributes. The manner in which the sitter's face is modeled through shading and highlighting appears to be based on a life sitting. If this portrait was originally intended for the museum, it would present Forrest's Revolutionary War (as opposed to his governmental civilian) service as his significant contribution to society.

—⁓⧃⁓—

Provenance:
Given to the City of Philadelphia by Samuel Betton, the subject's grandson, in 1916.

Physical Description:
Oil on canvas. Bust length, facing the sitter's right. Dark blue uniform coat with red facings, gold braid on collar, gold epaulette, gold buttons; buff waistcoat, black stock, white jabot. Graying black hair, brown eyes. Olive green background. 24³⁄₁₆ inches H × 20³⁄₁₆ inches W.

[1] Sellers, *Portraits and Miniatures*, 79.

THOMAS FORREST (1747–1825)
2. by Charles Willson Peale, after Charles Willson Peale, c. 1820

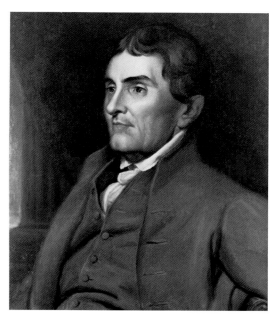

Catalog Number INDE14049
(SN 13.073)

2. In contrast to the portrait of a uniformed Forrest, the museum portrait depicts the subject in civilian dress, seated in a chair with a classical column and drape in the background. The flat and stilted appearance of this painting strongly suggest that it was copied from another source, possibly the privately owned portrait of Forrest in military uniform. Very few museum portraits contain background attributes, and those that do are specific to the subject's career (see the portrait of Samuel Smith below). As a result, the generic composition of the Forrest museum portrait (as well as the possibility that Peale initially planned a military portrait for the museum but changed his mind) is unexplained.

—◦◦◦◦—

Provenance:
Purchased by the City of Philadelphia at the 1854 Peale Museum sale.

Physical Description:
Oil on canvas. Nearly half length, facing subject's right. Olive green coat and waistcoat, white stock and cravat. Graying black hair, brown eyes. Left arm draped over a curved chair back, classical column and maroon drape in background. 24½ inches H × 20⅝ inches W.

BENJAMIN FRANKLIN (1706–1790)

Franklin was born on 17 January 1706 in Boston, Massachusetts. He attended the Boston Grammar School, worked briefly in his father's tallow chandlery, and then apprenticed as a printer with his elder half-brother. In late 1723, the young Franklin moved to Philadelphia, where he worked as a printer, purchasing his own business (which included the *Pennsylvania Gazette*) in 1730. A voracious reader with multifaceted interests, Franklin incorporated a wide range of subjects into his publishing, which included books of aphorisms (*Poor Richard's Almanac*), essays on science, religion and politics, and newspaper editorials.

Franklin also plunged into civic improvement projects including street paving, fire protection, a circulating library, an insurance company, a hospital, and various local educational institutions. He was clerk of the Pennsylvania Assembly from 1736 until 1751 and then a member until 1764. In 1754, he represented Pennsylvania at the Albany Congress and drafted its unsuccessful plan for a united colonial response to the French and Indian War. He also traveled widely as deputy post master general for the American colonies.

In the late 1750s, Franklin began the first of his appointments as a colonial agent in England and France. While abroad, he met numerous intellectuals, artists, and scientists with whom he associated throughout his life as a member of learned societies and cosmopolitan salons. His personal and professional popularity was immediate, and he received a number of honorary university degrees while becoming the recognized representative of colonial America at large. His most influential remarks came during the parliamentary debates on the Stamp Act, when he was called to report on the colonial position.

Up until early 1775, Franklin remained a supporter of moderate British policy, but he returned to America convinced that reconciliation between England and the colonies was next to impossible. In 1776, he was elected to the Second Continental Congress and signed the Declaration of Independence before sailing for Europe as a member of the delegation sent to secure French assistance for the Revolution. In little over a year, he and his fellow commissioners succeeded with a formal alliance declared between America and France. Intrigue at the French court and internal disagreements between Franklin and the other commissioners plagued his stay in France until 1781, when he was reassigned to England as one of the peace commissioners sent to negotiate the end of the war.

BENJAMIN FRANKLIN (1706–1790)

1. by an unidentified French artist, after Joseph Siffred Duplessis, possibly late-eighteenth or early-nineteenth century

Catalog Number INDE1334

When Franklin returned to America in 1784, he was elected president of Pennsylvania's executive council, where he served for three years. He then attended the federal Constitutional Convention and, though disliking the final plan, supported the new government. In his retirement, he returned to scientific pursuits and writing before he died in Philadelphia on 17 April 1790.

Though he sought public attention throughout his professional life, even Franklin tired of fame's demands and noted, "I have at the request of friends sat so much and so often to painters and statuaries that I am perfectly sick of it."[1] Among the most widely circulated of the Franklin images was that painted in 1778 by Joseph Siffred Duplessis for Franklin's Passy landlord. This painting (now at the Metropolitan Museum of Art) is frequently called the "fur collar portrait" in reference to the subject's distinctive coat collar. Duplessis's work (both the fur collar portrait and one of the sitter in a gray silk coat) was copied many times by his contemporaries and students, and by subsequent artists in a variety of media.[2]

1. The Duplessis-type fur collar portrait at Independence has a reported association with Franklin in its descent through the family of Madame Helvétius, Franklin's long-time Paris correspondent. Although this association has also linked the painting to Duplessis or his studio, elements of the portrait suggest that it is not an original work. The form, oil on paper mounted on canvas, was popular among eighteenth-century French artists. But, the scumbling application of paint is quite loose and not reminiscent of Duplessis' style. There are, however, similarities between the Independence portrait and one of Franklin owned by the Boston Athenaeum that has been associated with Duplessis' contemporary and copyist, Jean Valade.[3]

Recent conservation studies of the Independence painting, however, reveal that significant changes have been made in the portrait over time. The stretchers have circular saw marks and modern wood stain, and a large repair to the lower left corner of the painting clearly shows pigments different from those used in the rest of the painting. This apparent remounting and surface reworking have obscured the portrait's origin, making specific attribution difficult.

Provenance:
Given to Independence National Historical Park by former President Harry S. Truman in 1954. Presented to president Truman by General Charles de Gaulle in 1945. Purchased in 1935 by de Gaulle from Paris art dealer Jean Cailleux, who obtained it from the Marquise de Mun (wife of Madame Helvétius's great-grandson).

Physical Description:
Oil on paper on canvas. Bust length, facing forward, turned slightly to the subject's left. Reddish brown coat with brown fur collar, white stock and jabot. Brown hair, brown eyes. Olive background. 21 inches H × 15¾ inches W.

[1] Benjamin Franklin to Thomas Digges, 25 June 1780 (Carl Van Doren, ed., *Benjamin Franklin's Autobiographical Writings*, [New York: Viking Press, 1945], 480.

[2] Charles Coleman Sellers, *Benjamin Franklin in Portraiture* (New Haven: Yale University Press, 1962), 246–264.

[3] Ibid., 253–254.

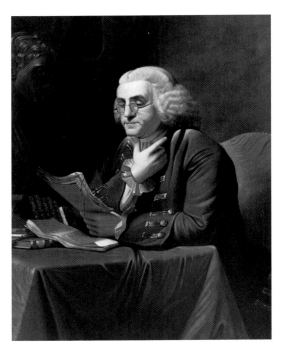

Catalog Number INDE14050

(SN 13.074)

BENJAMIN FRANKLIN (1706–1790)
2. by David Rent Etter, after Charles Willson Peale after David Martin, 1835

2. To commemorate the 1854 consolidation of Philadelphia and its neighbors into one municipality, the Southwark district gave a portrait of Franklin (eighteenth-century Philadelphia's leading civic booster) to Independence Hall (see also the Andrew Jackson portrait below). The portrait was painted by David Rent Etter (1807–1880), a Philadelphia sign painter who was also a member of the Southwark Board of Commissioners. Etter based his work on Charles Willson Peale's 1772 copy (now at the American Philosophical Society) of David Martin's 1767 replica portrait (originally owned by Franklin and now at the Pennsylvania Academy of the Fine Arts) of his life portrait (now at the White House).

Provenance:
Given to the City of Philadelphia by the Commissioners of the District of Southwark in 1854.

Physical Description:
Oil on canvas. Half length, seated. Subject facing to his right. Blue coat with gold trim and gold buttons; white stock, jabot, and cuffs. Powdered wig, silver rimmed spectacles. Holding sheaf of papers in left hand, chin resting in right hand. Red table cover, leather bound books on table, red upholstered chair, red draperies in upper left. Sculpted bust of Sir Isaac Newton in the left midground. Dark brown background. Signed at base of Newton bust "D.Etter/1835." 48 inches H × 39 inches W.

BENJAMIN FRANKLIN (1706–1790)
3. by Thomas B. Welch, after Joseph Siffred Duplessis, 1855

3. Philadelphia artist Thomas B. Welch (1814–1874) probably based his 1855 portrait of Franklin on earlier engravings of both Duplessis's 1778 fur collar portrait and Joseph Wright's 1782 copy of Duplessis's gray coat portrait (Welch's image is reversed from the life portraits).[4] It is not known why the City of Philadelphia acquired the Welch portrait for Independence Hall. The city already owned Etter's version of Martin's 1767 portrait. Possibly, the Etter Franklin hung somewhere other than in Independence Hall's historical museum, and the Welch Franklin was intended to fill the museum's gap.

—⁂—

Provenance:
Purchased by the City of Philadelphia from Albert Rosenthal in 1902.

Physical Description:
Oil on canvas. Bust length, facing front, torso turned slightly to the subject's left. Dark brown coat with reddish brown fur collar, dark brown waistcoat, white stock and jabot. Brown hair, brown eyes. Dark brown background with lightning bolt behind sitter's right shoulder. Inscribed on back of lining canvas: "TB Welch Pa 1855." 27¼ inches H × 22¼ inches W.

Catalog Number INDE15567
(SN 13.075)

[4] Early in the twentieth century, the Welch portrait was described as copied from a painting by Benjamin West, but no West portrait is known. Ibid., 403–404.

Catalog Number INDE6613

(SN 52.001)

BENJAMIN FRANKLIN (1706–1790)
4. by an unidentified European artist, miniature after Joseph Siffred Duplessis, late-nineteenth century

4. A Franklin miniature donated to the Independence Hall museum late in the nineteenth century appears to be another interpretation of Duplessis's 1778 fur collar portrait. While the technique of oil painting on mother of pearl was practiced in Europe during Franklin's lifetime, this portrait's rococo revival housing strongly suggests that it represents a late-nineteenth century interpretation of the older form.

─◦◦◦◦─

Provenance:
Given to the City of Philadelphia by John Heyl Raser in 1896.

Physical Description:
Oil on mother of pearl. Bust length, facing front, torso turned slightly to subject's right. Green coat with reddish fur collar, black waist coat, white stock and cravat. Gray hair, brown eyes. Dark brown background. Octagonal gilt frame with oval opening.
¹⁵⁄₁₆ inches H × ¹¹⁄₁₆ inches W.

CIPRIANO RIBEIRO FREIRE (1749–1825)
by James Sharples Senior, 1797–1798

Catalog Number INDE11920

(SN 7.029)

Freire was born in 1749 in Portugal's central Coimbra region. After studying finance, he entered diplomatic service. In 1774, he served as secretary of the Portuguese legation to England. In London, he eventually rose to the position of Portuguese chargé d'affaires and directed Portugal's negotiations with the United States for a post-Revolutionary trade treaty.

In 1790, Freire was appointed Portugal's first resident minister in the United States. Although matters of administrative protocol delayed his arrival in the United States for four years, he continued as minister plenipotentiary until 1799. Upon his return to Europe, Freire served consecutively as Portugal's minister of finance, secretary of state for foreign affairs, and minister of commerce. He died in 1825.

During his family's first visit to America's federal capital in Philadelphia, British pastelist James Sharples Senior (1751–1811) painted Freire's portrait, probably in 1797 or 1798. The 1802 catalog of Sharples's pastels lists this portrait as "Chevalier Le Frere, Portugese [*sic*] Minister."

In the portrait, the heavily eyebrowed minister wears his Star of the Order of Christ (awarded to Portuguese Catholic nobles) and his medal of the Order of Saint James of the Sword (a Spanish and Portuguese military award).

───❦───

Provenance:
Listed in the 1802 Bath catalog of Sharples's work. Given by Ellen (Mrs. James) Sharples to Felix Sharples in 1811. Given by Felix Sharples to Levin Yardly Winder in the 1830s. Inherited by Nathaniel James Winder from Levin Yardly Winder. Inherited by Richard Bayly Winder from Nathaniel James Winder in 1844. Purchased by Murray Harrison from Richard Bayly Winder around 1865. Purchased by the City of Philadelphia from Murray Harrison in 1876.

Physical Description:
Pastel on paper. Half length, facing forward, turned slightly to the sitter's right. Blue coat, white waistcoat, white cravat. Powdered hair, brown eyes. Large, star-shaped gold medal with central cross; smaller oval medal with central decorated cross and jeweled edge, worn on red ribbon threaded through button hole. Blue-green variegated background.
9 inches H × 7 inches W.

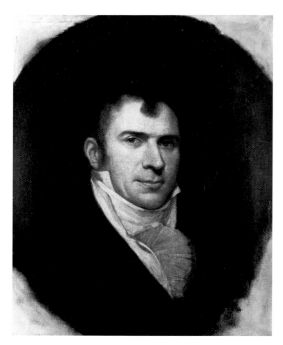

Catalog Number INDE14051

(SN 13.076)

ROBERT FULTON (1765–1815)
by Charles Willson Peale, from life, 1807

Fulton was born in Lancaster County, Pennsylvania, on 14 November 1765. His early interest in drawing and mechanics led him to gunsmithing, and he also began painting professionally. In 1786 he traveled to London and studied with expatriate American artist Benjamin West, and then spent several years exhibiting his paintings in England. Later, working as an engineer, Fulton published *A Treatise on the Improvement of Canal Navigation*, which gained him considerable notice in England and America. In Europe, he also designed cast-iron aqueducts and bridges, boats of varying type, torpedoes, and underwater mines. After interest in his newly invented submarine failed to materialize, Fulton returned to America in late 1806.

Steamboat technology had attracted Fulton during his years abroad, when he built and tested prototypes with the financial assistance of America's minister to France, Robert R. Livingston. In mid-1807, Fulton's *Clermont* steamed the Hudson River from New York to Albany and back in an unprecedented sixty-two hours. This success brought Fulton many commercial and military commissions. Among them was the design for a huge, steam-powered war vessel that Congress later built and named *Fulton the First* during the War of 1812. Fulton died in New York on 24 February 1815.

When he returned to America in 1806, Fulton brought with him a large art collection, including paintings by his teacher (and that of Charles Willson Peale), Benjamin West. Fulton immediately contacted Peale, co-founder of the Pennsylvania Academy of the Fine Arts, with an offer to display the paintings there.[1] Peale, also a mechanic-turned-painter, called Fulton "an Ingenous [*sic*] Man"[2] and asked him to sit for a museum portrait. Peale had just returned to painting after several years away from his easel, and used his renewed creative enthusiasm to produce a fine character study of Fulton. This painting was entered in Peale's Museum accession book on 8 April 1807.

❧❧❧

Provenance:
Listed in the 1813 Peale Museum catalog. Purchased by the City of Philadelphia at the 1854 Peale Museum sale.

Physical Description:
Oil on canvas. Bust length, facing forward turned slightly to the sitter's left. Black coat, white waistcoat, white stock and lace jabot. Brown hair, brown eyes. Dark brown background. 23⅝ inches H × 19¹⁵⁄₁₆ inches W.

[1] Carrie Rebora, "Robert Fulton's Art Collection," *The American Art Journal* 22:3 (1990), 47.

[2] Charles Willson Peale to John Isaac Hawkins, 25 October 1807 (Miller, *Selected Papers* 2:2, page 1038).

CHRISTOPHER GADSDEN (1724–1805)
by Rembrandt Peale, from life, 1795–1796

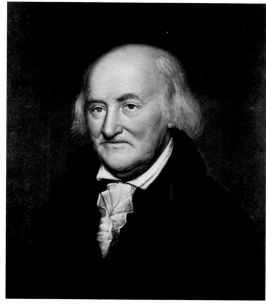

Catalog Number INDE14052
(SN 13.077)

Gadsden was born on 16 February 1724 in Charleston, South Carolina. He attended an English classical school and apprenticed with a Philadelphia merchant before he served three years as a purser in the British navy. After returning to Charleston, he joined the colonial assembly and then led his colony's delegation to the Stamp Act Congress in 1764. He later represented his state at the First and Second Continental Congresses and served in his provincial legislature.

When the Revolution began, Gadsden commanded Fort Johnson during the first British attack on Charleston. Later, while serving as South Carolina's vice president, he was captured during the siege of Charleston and spent a year in Florida's Fort St. Augustine prison. After his release, he refused election to the governorship and returned to his state's assembly. After the war, Gadsden attended his state's ratifying convention in support of the new federal Constitution. Gadsden died on 28 August 1805.

During his first professional trip to South Carolina in 1795 and 1796, Rembrandt Peale (1778–1860) took along copies of his father's paintings to illustrate his own artistic skill and to attract patrons. While in Charleston with his brother Raphaelle, Rembrandt painted a portrait of Gadsden to take back to the Philadelphia Museum. The museum portrait pleased Gadsden, who commissioned a copy (now owned by the City of Charleston) for himself. It differs only slightly from the museum portrait, specifically in the configuration of the subject's jabot.[1]

<hr />

Provenance:
Listed in the 1813 Peale Museum catalog. Purchased by the City of Philadelphia at the 1854 Peale Museum sale.

Physical Description:
Oil on canvas. Bust length, facing front, torso slightly to the sitter's right. Blue coat and waistcoat, white shirt and jabot. Gray hair, brown eyes. Dark red background. 22 11/16 inches H × 18¾ inches W.

[1] Earlier, Charles Willson Peale had painted a miniature of Gadsden, now unlocated (Miller, *Selected Papers* 1, page 422).

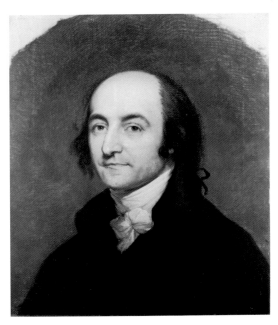

Catalog Number INDE11875

(SN 13.078)

ALBERT GALLATIN (1761–1849)
by Rembrandt Peale, from life, 1805

Gallatin was born on 29 January 1761 in Switzerland. He graduated from the Geneva Academy and, in 1780, emigrated to America. After the Revolution, he moved to the western Pennsylvania frontier where he soon entered the state legislature and became a tireless committeeman. An Antifederalist, he entered the United States Senate in 1793, but political opponents engineered his ouster, claiming he lacked American citizenship. After a few months (during which Gallatin mediated between factions in western Pennsylvania warring over the federal excise tax on whiskey), he returned to Congress as a member of the House of Representatives.

Gallatin's expertise in congressional financial matters gained him political acclaim. In 1801, President Thomas Jefferson appointed him secretary of the treasury, a position that he continued to hold for thirteen years (the longest tenure by anyone in that office). When growing hostilities between America and England over maritime rights thwarted his efforts to reduce the national debt, he abandoned his plans and turned to diplomatic concerns. A patient negotiator, Gallatin achieved an equitable compromise that ended the War of 1812. Following this success, he served as minister to France for nine years and then as minister to England for another year.

At the end of his life, Gallatin devoted himself to scholarly pursuits. He published an important treatise on currency (as president of New York's National Bank), and he pursued a lifelong interest in Native American culture, founding the American Ethnological Society in 1842. Gallatin died on 12 August 1849.

During the early years of his tenure as secretary of the treasury, Gallatin gained the admiration of painter Charles Willson Peale, who praised "the superior abilities of that man, superior to I may safely say to any other in the United States without one exception." Peale also recognized that Gallatin's political influence might assist the artist in obtaining public support for his museum.[1] Although Peale tried to arrange a museum portrait sitting with Gallatin while both were in Washington (he asked President Jefferson for an introduction to the secretary),[2] the artist was unsuccessful until early in 1805. At that time Peale's son Rembrandt (1778–1860), who had accompanied his father to the federal capital, arranged his own sitting with Gallatin. The session proved fruitful, and its result completely satisfied the elder artist, who announced that "My Son Rembrandt's improvement in his art, overpays me for any trouble I went through. He has brought me a charming Portrait of Mr. Galatine [*sic*]."[3] This quickly, though capably, done portrait of Gallatin represents Rembrandt's growing skill in the use of the painting techniques taught to him by his father. Gallatin's thinning hair and prominent nose are finely rendered, as is the luminous paleness of his skin.

Provenance:
Listed in the 1813 Peale Museum catalog. Purchased by the City of Philadelphia at the 1854 Peale Museum sale.

Physical Description:
Oil on canvas. Bust length, facing forward, torso slightly to the sitter's right. Black coat and waistcoat, white stock and jabot. Dark brown hair tied in a queue with a black ribbon, brown eyes. Olive green background. 23 inches H × 19 inches W.

[1] Charles Willson Peale, "Diary," 5(?) July 1804 (Miller, *Selected Papers* 2:2, page 731). Lillian B. Miller, ed., *In Pursuit of Fame, Rembrandt Peale, 1778–1860*, exhibit catalog, National Portrait Gallery (Washington D.C.: Smithsonian Institution, 1992), 76.

[2] Charles Willson Peale to Thomas Jefferson, 19 August 1804 (Miller, *Selected Papers* 2:2, page 748).

[3] Charles Willson Peale to Angelica Peale Robinson, 15 February 1805 (Miller, *Selected Papers* 2:2, page 809).

HORATIO GATES (1728/9–1806)
1. by Charles Willson Peale, from life, 1782

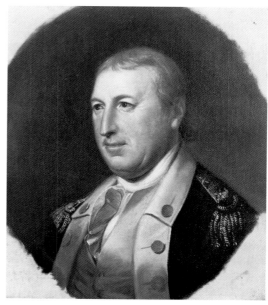

Catalog Number INDE14053

(SN 13.079)

Born in Essex, England, in 1728 or 1729, Gates later became a professional soldier in the British army. He served during the French and Indian War, including Braddock's campaign to Fort Duquesne, and the Monckton expedition against French Martinique. In 1772, he purchased an estate in western Virginia. Three years later, he joined General Washington's staff and provided the Continental army's first disciplinary code, supply procedures, and camp sanitation regulations. In 1777, Gates triumphed over the British at Saratoga, earning a congressional gold medal and a public day of thanksgiving. Later, despite strained relations with Washington over an alleged coup in Gates's favor, Congress elected him president of the War Board. In 1780, as commander of the army's southern campaign, Gates misjudged the South Carolina terrain and his troops' level of readiness, abandoning the battlefield to Cornwallis near Camden.

After the Revolution, Gates served as vice president of the national Order of the Cincinnati (the organization of former Continental army officers) and president of its Virginia chapter. In 1790, he moved to New York, and later served in the state legislature. Gates died on 10 April 1806.

1. Charles Willson Peale probably painted his museum portrait of Gates in 1782, when the subject visited Philadelphia in order to petition Congress for an investigation into his conduct at Camden.[1] The portrait was first publicized in the 13 October 1784 issue of the *Freeman's Journal and Philadelphia Daily Advertiser*.

❧

Provenance:
Listed in the 1795 Peale Museum catalog. Purchased by the City of Philadelphia at the 1854 Peale Museum sale.

Physical Description:
Oil on canvas. Bust length, facing slightly to the sitter's right. Dark blue uniform coat with buff facings, gold buttons and gold epaulettes with silver stars, buff waistcoat, white stock and jabot. Gray hair, brown eyes. Dark brown background. 21⅞ inches H × 19⁹⁄₁₆ inches W.

[1] Sellers, *Portraits and Miniatures*, 85.

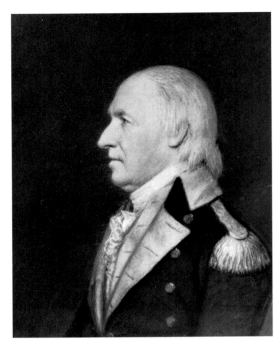

Catalog Number INDE11901

(SN 7.009)

HORATIO GATES (1728/9–1806)
2. by James Sharples Senior, from life, c. 1795–1798

2. While living near New York City, Gates sat for a portrait by British pastelist James Sharples Senior (1751–1811). Sharples and his family first visited in New York in 1795 and returned repeatedly through 1798. After returning to England, Sharples published a catalog in which he listed "General Gates" among the sitters in his collection.

───◦◦◦◦◦───

Provenance:
Listed in the 1802 Bath catalog of Sharples's works. Given by Ellen (Mrs. James) Sharples to Felix Sharples in 1811. Given by Felix Sharples to Levin Yardly Winder in the 1830s. Inherited by Nathaniel James Winder from Levin Yardly Winder. Inherited by Richard Bayly Winder from Nathaniel James Winder in 1844. Purchased by Murray Harrison from Richard Bayly Winder around 1865. Purchased by the City of Philadelphia from Murray Harrison in 1874.

Physical Description:
Pastel on paper. Half length, left profile. Dark blue uniform coat with buff facings, gold epaulettes, buff waistcoat, white stock and jabot. Gray hair, brown eyes. Blue background. 9 inches H × 7 inches W.

CONRAD ALEXANDRE GÉRARD (1729–1790)
by Charles Willson Peale, from life, 1779

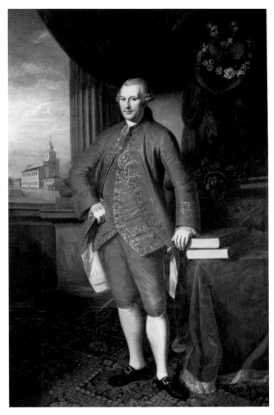

Catalog Number INDE11866

(SN 13.083)

Gérard was born in the Alsace region of France on 12 December 1729. He attended a Jesuit college, and then received a law degree from the University of Strasbourg. Later, he entered France's diplomatic service and served in Germany and Austria before becoming first counsel of the French Foreign Office and secretary of the Council of State. In 1777, Gérard represented the French secretary of state for foreign affairs, the Comte de Vergennes, during the negotiations that led to the Treaty of Amity and Commerce with America in early 1778. As a reward for his work, Gérard received a noble title and the appointment as France's first minister plenipotentiary to the United States.

In mid-1778, Gérard began his American assignment to monitor the progress of the Continental army and to represent French interests in the expansion of settlement and trade beyond the Mississippi and into Canada and Spanish Florida. However, plagued by poor health that he attributed to the American climate, Gérard left for France in the fall of 1779. Upon his European return, he became France's royal councilor. Later, he served as *prêteur royal* of Strasbourg and as a member of the Assembly of Notables at Versailles. He died in Strasbourg on 16 April 1790.

When Gérard announced his impending return to France, Congress ordered a full-length portrait of the minister from Charles Willson Peale. This was Peale's first congressional commission, and he was determined to do his "best to give satisfaction to the Honorable Gentlemen of Congress at whose request you have granted me the honor and opportunity of transmitting to posterity my name as an Artist." Peale portrayed the French minister in his own study with a view across Philadelphia's Chestnut Street to the Pennsylvania State House (now Independence Hall).[1] Behind him stand two female statues, their shoulders draped with a floral garland and their hands clasped. The larger figure represents France, who protectively embraces her younger companion, America, who wears a quiver of arrows to symbolize her status at war. Although Congress paid Peale for this work, the portrait was apparently never delivered to the Council Chamber of the State House.[2] The painting remained with Peale, who listed it in the 1795 catalog of the museum. By 1813, however, the painting was apparently no longer in the museum as it is absent from the catalog of that year. By this time, Peale had moved Gérard's portrait to his own home where John Quincy Adams reported seeing it in the fall of 1825.[3] Around 1795, Peale's son Rembrandt painted a bust-length copy of the Gérard portrait (now at the Virginia Historical Society) for use during a patronage trip to Charleston and later for exhibit in the Baltimore Peale Museum opened by Rembrandt in 1814.

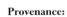

Provenance:
Listed in the 1795 Peale Museum catalog. Purchased by Townsend Ward (librarian of the Historical Society of Pennsylvania) at the 1854 Peale Museum sale. Purchased by the City of Philadelphia from Townsend Ward in 1854.

Physical Description:
Oil on canvas. Full length, facing front, right hand on hip, left hand resting on books piled on table. Red coat and waistcoat with white silk lining, silver floral embroidery, silver braid. White stock and lace jabot, white silk stockings, black shoes with silver buckles. Powdered wig. Silver sword with gold grip at left hip. Red draped table cover with gold fringe, multicolored patterned carpet. Green drapery and the top of the image with Independence Hall in the left background, statue of two female figures draped with a floral garland in the right background.
95 inches H × 59⅛ inches W.

[1] James Trenchard published an engraved version of this image of the State House in the 1787 issue of the *Columbian Magazine.*

[2] Charles Willson Peale to Conrad Alexandre Gérard, 18 September 1779 (Miller, *Selected Papers* 1, page 330–331).

[3] Adams, Charles Francis, ed., *Memoirs of John Quincy Adams* (Philadelphia: J.B. Lippincott & Co., 1875), 7, page 50.

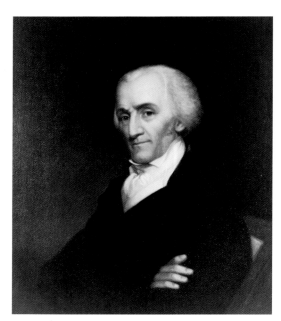

Catalog Number INDE14054

(SN 13.084)

ELBRIDGE GERRY (1744–1814)
by James Bogle, after John Vanderlyn, 1861

Gerry was born in Marblehead, Massachusetts, on 17 July 1744. He graduated from Harvard and then joined his family's mercantile firm. In 1772, he became a member of the Massachusetts General Court and later chaired the Essex County Convention. He joined his colony's Committee of Safety and provincial congress, and early in 1776 began a series of terms in the Continental Congress. There, he signed the Declaration of Independence and the Articles of Confederation, serving almost continuously until the end of the war. Though he represented his state at the federal Constitutional Convention, he opposed ratification of the document. Later, with election to the House of Representatives, he reversed his politics and supported the Federalists, including their Hamiltonian economic program.

As a reward for his support of John Adams's presidency, Gerry joined the American diplomatic mission sent to France. Intrigue in France's revolutionary government entangled the American ministers, resulting in their public censure at home. Gerry became Massachusetts's governor in 1810, but cast a shadow over his office when he sponsored a plan to reapportion congressional districts in Massachusetts to give advantage to a specific political faction. This process is now known as "gerrymandering," in honor of him. Despite this dubious distinction, Gerry remained in public service and became vice president of the United States under James Madison. Gerry died in office on 23 November 1814.

Prior to the Civil War, Gerry's son commissioned a portrait of his father for Philadelphia's gallery of Declaration signers in Independence Hall. New York artist James Bogle (c. 1817–1873) copied John Vanderlyn's 1798 pencil sketch of Gerry (now at the Fogg Art Museum of Harvard University).

⸺◦⟨∞⟩◦⸺

Provenance:
Given to the City of Philadelphia by Elbridge Gerry, the subject's son, in 1861.

Physical Description:
Oil on canvas. Half length, facing front, torso slightly to the left. Dark brown coat, white waistcoat, white stock and jabot. Powdered wig, brown eyes. Figure crosses arms at waist and sits on red upholstered chair. Dark olive-gray background. 30½ inches H × 25¾ inches W.

GEORGE GLENTWORTH (1735–1792)
by Charles Willson Peale, posthumous, 1794

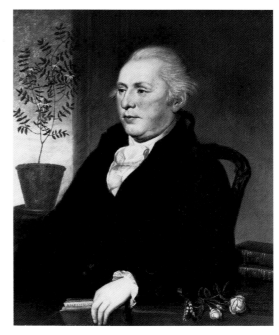

Catalog Number INDE11865
(SN 13.086)

Glentworth was born in Philadelphia on 22 July 1735. He later studied medicine at the University of Edinburgh in Scotland, and then started a medical practice in Philadelphia. He began his medical military service during the French and Indian War as a British army surgeon. In 1777 he joined the Continental army, becoming first senior surgeon and then general director of the Army's Middle Department General Hospital, concluding his service in 1780. Professionally, he helped to found the Philadelphia Medical Society and the Philadelphia College of Physicians. Glentworth died in Philadelphia on 4 November 1792.

During removal of modern over-paint from this painting's left midground, conservation work uncovered the depiction of a potted plant on a windowsill. Inscribed on the pot's base is Charles Willson Peale's signature and the year 1794. Apparently, the Glentworth family commissioned the artist for a posthumous portrait of the doctor, possibly based on sittings by the doctor's son.[1] Peale portrayed Glentworth with some standard medical books of his era: volume four of Benjamin Bell's *System of Surgery* (Edinburgh, 1785) and volume six of *Medical and Philosophical Commentaries* (London, 1786). Peale also included several botanical specimens, possibly in reference to both the doctor's medical practice (the cabbage rose was used as a purgative and the lily-of-the-valley as an emetic) and his horticultural interests (the potted plant appears to be of the *Jasminium* family).

⁓ ❧ ⁓

Provenance:
Given to the City of Philadelphia by Marguerite L. and Henry R. Glentworth, the subject's great-great-grandchildren, in 1947.

Physical Description:
Oil on canvas. Half length, seated in Chippendale chair facing slightly to the subject's right. Dark green coat and waistcoat, white stock and jabot. Gray hair tied in a queue with a green ribbon, blue eyes. Left arm resting on an uncovered table with two leather-bound books and two floral specimens. Left hand holding book. Behind subject's right is a plant in a terra cotta pot before an open window. Signed "C. W Peale/1794" on the pot's base. 32¾ inches H × 26⅝ inches W.

[1] Sellers, *Portraits and Miniatures*, 89.

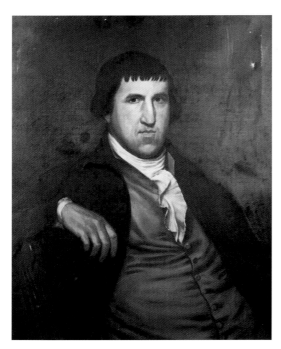

Catalog Number INDE
(SN 13.087)

BENJAMIN GOODHUE (1748–1814)
attributed to George Southward, after Joseph Wright, c. 1850–1870

Benjamin Goodhue was born in Salem, Massachusetts, on 20 September 1748. He graduated from Harvard, and then entered a Philadelphia mercantile firm. Later, he returned to Salem, where during the Revolution he volunteered for the Rhode Island campaign of 1778. The following year, he served in his state's constitutional convention and then in its general court. Elected to the first Congress in 1789, the staunchly Federalist Goodhue was a representative and then a senator until 1800, when he returned to Salem. He died there on 28 July 1814.

In 1895, the City of Philadelphia received a portrait of Goodhue now attributed to Salem, Massachusetts artist George Southward (1803–1876).

Southward copied Joseph Wright's 1790 portrait of Goodhue (now owned by the New York Society Library)[1] twice for the subject's family. In 1895, one copy went to Independence Hall and the other to Salem's Essex Institute.

❧

Provenance:
Given to the City of Philadelphia by Mrs. D. Clarkson in 1895.

Physical Description:
Oil on canvas. Half length, seated in a Windsor chair, facing front. Brown coat, green waistcoat, white stock and jabot. Brown hair, brown eyes. Right arm draped over back of chair. Brown background. 30 inches H × 25 inches W.

[1] Monroe H. Fabian, *Joseph Wright, American Artist, 1756–1793*, exhibit catalog, Smithsonian (Washington D.C., Smithsonian Institution Press, 1985), 125.

ASHBEL GREEN (1762–1848)
by James Sharples Senior, from life, 1799

Catalog Number INDE11925
(SN 7.034)

Green was born on 6 July 1762 in Hanover, New Jersey. He served intermittently in his state's militia during the Revolution, and then entered the College of New Jersey (now Princeton). He became first a tutor there and then professor of mathematics and natural philosophy. His study with Princeton's president, John Witherspoon, influenced Green to join the ministry. In 1792, he became principal minister of Philadelphia's Second Presbyterian Church. At the time, he was also a co-chaplain (with Bishop William White) of Congress. When Congress moved to Washington, Green returned to Princeton's faculty and became its president in 1812, creating the college's theological seminary. Following a decade at Princeton, Green assumed the editorship of the *Christian Advocate* and became a spokesman for the theologically conservative branch of Presbyterianism during its debate and 1837 split from the more liberal Connecticut membership. Green died on 19 May 1848.

Traveling through America during the late 1790s, British pastelist James Sharples Senior (1751–1811) attracted prospective clients by exhibiting to visitors his portraits of well-known people. Always looking for new subjects, Sharples asked Bishop William White in late 1798 for an introduction to his colleague and fellow chaplain, Ashbel Green. During January of 1799, Green noted that he visited with Sharples in Philadelphia "some time for the limner to perfect a copy of my portrait."[1] When Sharples returned to England, he published a catalog of his American portraits, listing the "Rev. Dr. Green" among them.

⁂

Provenance:
Listed in the 1802 Bath catalog of Sharples's work. Given by Ellen (Mrs. James) Sharples to Felix Sharples in 1811. Given by Felix Sharples to Levin Yardly Winder in the 1830s. Inherited by Nathaniel James Winder from Levin Yardly Winder. Inherited by Richard Bayly Winder from Nathaniel James Winder in 1844. Purchased by Murray Harrison from Richard Bayly Winder around 1865. Purchased by the City of Philadelphia from Murray Harrison in 1876.

Physical Description:
Pastel on paper. Half length, facing slightly to the sitter's right. Black clerical robes, white banded collar. Gray hair, brown eyes. Variegated blue background. 9 inches H × 7 inches W.

[1] Ashbel Green Diary, 25 January 1799. Special Collections, Firestone Library, Princeton University.

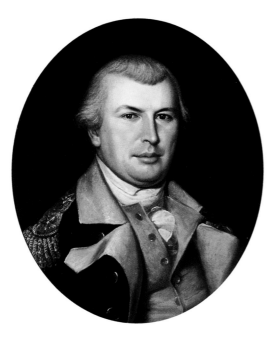

Catalog Number INDE14055

(SN 13.092)

NATHANAEL GREENE (1742–1786)
by Charles Willson Peale, from life, 1783

Greene was born in Potowomut, Rhode Island on 27 July 1742. Self-educated, he assumed the management of his family's iron forge in 1770. Soon afterward, he was elected to the General Assembly and he helped to organize a militia unit, the Kentish Guards. By 1776, he had joined General Washington's staff and, within two years, became the army's quartermaster general. Succeeding Horatio Gates at the head of the army's final southern campaign, Greene engineered successes at Cowpens and Guilford Court House. His strategy pushed the British out of the Carolinas and Georgia, thereby saving Charleston and Savannah. After the war, Greene faced financial ruin when an army contractor whom he had underwritten defaulted on payments to the American government. His battlefield acclaim, however, prompted the state of Georgia to reward him with a landed estate, Mulberry Grove, where he died on 19 June 1786.

Charles Willson Peale recognized the public interest in Greene's military success and decided early on "to have his portrait in my collection of Great men."[1] Previously, the artist had painted both Greene's and his wife's miniature portraits (both now unlocated). Stylistically, the museum portrait is typical of the artist's early 1780s work. Greene's hair is painted in wispy lines, his flesh tones are highlighted in Naples yellow, and his upper eyelids are incised with heavy lines. After finishing the portrait, Peale painted a replica (now at New Jersey's Montclair Art Museum) and sent it to London to serve as the basis for a mezzotint engraving.[2] Eventually, the portrait was engraved by American James Trenchard and published in the September 1786 issue of the *Columbian Magazine*. Peale included the Greene portrait in his 13 October 1784 *Freeman's Journal and Daily Advertiser* announcement of the museum's contents. Later, Peale's son Rembrandt copied the portrait twice, possibly for display in the family's Baltimore and New York museums (the portraits are at the Maryland and Rhode Island historical societies, respectively). Peale's son Rembrandt painted a copy of the Green portrait (now owned by the Maryland Historical Society) around 1795 for use during a patronage trip to Charleston and later for use in the Baltimore Peale Museum.

⚬◦⊚◦⚬

Provenance:
Listed in the 1795 Peale Museum catalog. Purchased by the City of Philadelphia at the 1854 Peale Museum sale.

Physical Description:
Oil on canvas. Bust length, facing slightly to the sitter's left. Dark blue uniform with buff facings, gold epaulettes with two silver stars on each shoulder. White collar, stock and jabot. Powdered hair in a queue, dark gray eyes. Dark brown background. 22⅞ inches H × 18½ inches W.

[1] Charles Willson Peale to John Mathews, 23 January 1783 (Miller, *Selected Papers* 1, page 384).

[2] Charles Willson Peale to Benjamin West, 10 December 1783 (Miller, *Selected Papers* 1, page 404–5). Peale's engraving series (which included Washington and Franklin) failed to sell sufficiently, and he abandoned the project.

CYRUS GRIFFIN (1748–1810)
by David S. Pope, after Lawrence Sully, c. 1885

Catalog Number INDE
(SN 13.093)

Griffin was born on 16 July 1748 in Richmond County, Virginia. After his preliminary schooling, he studied law at Scotland's Edinburgh University and London's Middle Temple. He returned to Virginia in 1774 to open his own legal practice. At the beginning of the Revolution, he served one year in his state's legislature before being elected to several terms in the Continental Congress. In 1780, he accepted an appointment to the Court of Appeals in Cases of Capture. He was reelected to Congress in 1786, and became its president two years later, the last before that body's dissolution in 1789. Under the new federal Constitution, Griffin served as a commissioner in the treaty negotiations between the Creek Indians and the state of Georgia and as the judge for the District Court of Virginia (in this latter capacity, he assisted in the treason trial of Aaron Burr). Griffin died in Yorktown on 14 December 1810.

Late in 1886, the City of Philadelphia received a portrait of Griffin for its historical collection in Independence Hall. Baltimore artist David S. Pope (working 1877–1895), copied Lawrence Sully's 1799 miniature of Griffin (now at the Historical Society of Pennsylvania). Although the donor of the Pope copy is unknown, the 1886 date of the gift (being one year prior to the gift of the Sully miniature to the Historical Society by Griffin's granddaughter in 1887) suggests that she may have been the source of the Independence Hall donation as well.

❧

Provenance:
Unknown. Possibly given to the City of Philadelphia by Louisa Stewart Mercer Leyburn, the subject's granddaughter, in 1886.

Physical Description:
Oil on canvas. Bust length, slightly to the sitter's left. Blue coat, white stock and jabot. Gray hair, blue eyes. Dark background. 23 inches H × 18 inches W.

Catalog Number INDE14060

(SN 13.096)

[1] There is a copy of the Kollock engraving at the Georgia Historical Society. A later copy of the Douglass portrait by Richard W. Habersham is now owned by the Georgia Historical Society.

[2] Robert G. Stewart, *A Nineteenth Century Gallery of Distinguished Americans*, exhibit catalog (Washington D.C.: Smithsonian Institution Press, 1969), p. 36. At the time he copied the Douglass portrait of Habersham for Longacre, Conarroe also painted a portrait of the subject's grandson (Robert Habersham Junior) that is now privately owned.

JOSEPH HABERSHAM (1751–1815)
by George Washington Conarroe, after an unidentified Georgia artist named Douglass, c. 1837

Habersham was born in Savannah, Georgia, on 28 July 1751. After his early education, he worked in a London mercantile firm. When he returned to America in 1771, he joined his family's commercial house, one of Savannah's most prominent. He was later a member of the city's Council of Safety and a delegate to the provincial congress, and then saw Revolutionary field service. He returned to his state's legislature after the war, and became its speaker for two terms. He sat for a term in Congress, and he was a member of his state's convention to ratify the Constitution in 1788. From 1795 to 1801, he served as postmaster general of the United States. He then refused an appointment as treasurer of the United States and returned to his mercantile interests in Savannah. There, he became president of the city's branch bank of the United States where he served until his death on 17 November 1815.

The portrait of Habersham donated to the museum in Independence Hall late in the nineteenth century is by Philadelphia artist George Washington Conarroe (1803–1882). Conarroe copied an original portrait (now on loan to the Georgia Society of the Cincinnati) by an artist known as "Douglass." Douglass may have been an African American painter who also painted a portrait of Savannah's Reverend Henry Kollock prior to 1821.[1]

Conarroe had painted the Habersham portrait for James Barton Longacre, who included an engraving of the portrait in volume four of his National Portrait Gallery of Distinguished Americans published in 1839.[2] Longacre's estate was sold in 1870, and the donor of the Conarroe copy possibly purchased it at this sale.

❧

Provenance:
Given to the City of Philadelphia by William Neyle Habersham, the subject's great-grandson, 1898–1899.

Physical Description:
Oil on canvas. Half length, turned slightly to the sitter's left. Dark coat, gold waistcoat, white stock and jabot. Graying brown hair, brown eyes. Variegated brown background. 22 inches H × 26⅞ inches W.

ALEXANDER HAMILTON (1755–1804)
by Charles Willson Peale, from life, c. 1790–1795

Hamilton was born 11 January 1755 or 1757 in Nevis, British West Indies. He immigrated to America as a child after his mother died, and he later graduated from King's College (now Columbia). A precocious intellect, Hamilton contributed extensively to the anti-parliamentary pamphlet war in New York. At the beginning of the Revolution, he was commissioned a captain, fighting on Long Island and at Trenton and Princeton. He gained Washington's attention and progressed swiftly from a staff secretary to the general's aide-de-camp, efficiently organizing the administrative work of the commander's office. In 1781, he left Washington's staff for a regimental command and led a successful attack on the British at Yorktown.

After the war, Hamilton studied law and served a year in the Continental Congress. In 1786, he was elected to the New York legislature and to the Annapolis Convention (whose report of recommendations he wrote). He proposed the idea of a constitutional congress and attended the federal Constitutional Convention in Philadelphia. A vocal supporter of the new government, he wrote the majority of essays in *The Federalist Papers*, an erudite explanation of the principles of a federal, representative government.

In 1789, Hamilton was appointed United States secretary of the treasury and implemented an extensive plan to organize the new nation's economic system. His plan for the assumption and funding of the wartime debt converted nearly worthless paper money into viable capital, his *Report on Manufactures* described an extensive system to guide America into the industrial era

beginning with a strong tariff for imported goods, and he designed the first national bank. The growing political rift between Hamilton and Secretary of State Thomas Jefferson, particularly over the conduct of foreign affairs, led to the resignation of both from office (Hamilton's in 1795). Although no longer in office, he remained a viable political force nationally, particularly in blocking the election of Aaron Burr to the presidency in 1800. Long-simmering hostilities between Hamilton and Vice President Burr led to a duel between them, Hamilton was mortally wounded, and died on 12 July 1804.

Hamilton was at the height of his career when Charles Willson Peale painted his portrait for the Philadelphia Museum.[1] The portrait appears to be a hastily done sketch re-worked sometime after the initial sitting. Only the face is painted in detail, and the hair and body do not exhibit the same degree of completion as Peale's other works from the same period. The ruddy palette used for the flesh tones is typical of the artist's work produced in the early 1790s. Peale first listed this portrait in his 1795 museum catalog.[2]

Catalog Number INDE11877

(SN 13.097)

[1] Peale's 1777 miniature of the sitter is now privately owned. A c. 1784 miniature is unlocated (Sellers, *Portraits and Miniatures*, 97).

[2] A replica of the subject in uniform, possibly by a member of the Peale family, is now in the collection of the New-York Historical Society.

❧

Provenance:
Listed in the 1795 Peale Museum catalog. Purchased by the City of Philadelphia at the 1854 Peale Museum sale.

Physical Description:
Oil on canvas. Bust length, facing slightly to the sitter's left. Blue coat, yellow waistcoat, white stock. Powdered light brown hair, hazel eyes. Brown background. 23⅝ inches H × 19⅝ inches W.

ANDREW HAMILTON (c. 1676–1741)
by William F. Cogswell, after Adolph Ulrik Wertmüller, 1852

Catalog Number INDE14061

(SN 13.097)

[1] Nicholas B. Wainwright, *Paintings and Miniatures at the Historical Society of Pennsylvania* (Philadelphia, 1974), 89.

Hamilton was born in Scotland around 1676. In the late 1690s, he immigrated to Virginia where he taught school and practiced law. In 1713, he visited London as the legal representative of the Penn family, Pennsylvania's proprietors. After his return to Pennsylvania, he served as the colony's attorney general and as a member of the provincial assembly. Then followed his appointment as recorder of Philadelphia, prothonotary of the colonial supreme court, and vice-admiralty court judge. Beginning in 1727, he sat in the colonial assembly; two years later, he became its speaker, serving in that capacity until the end of his life. Under his speakership, the Pennsylvania State House (now called Independence Hall) was built. In 1735, he successfully defended New York publisher John Peter Zenger against a libel charge, a case that established the legal basis for freedom of the press in America. Hamilton died in Philadelphia on 4 August 1741.

Just prior to the United States Centennial, the City of Philadelphia received for Independence Hall a portrait of Hamilton by New York artist William F. Cogswell (1819–1903). Cogswell had copied Adolf Ulrik Wertmüller's 1808 copy of an earlier Hamilton portrait (artist unknown, destroyed in the nineteenth century). The Historical Society of Pennsylvania had owned Cogswell's copy since its creation in 1852 and, by 1874, acquired Wertmüller's copy. Apparently, this 1874 acquisition prompted the Society to divest itself of the twice-derivative Cogswell portrait.[1]

❦

Provenance:
Given to the Historical Society of Pennsylvania by some of its members in 1852. Given to the City of Philadelphia by John Jordan Junior, vice president of the Historical Society of Pennsylvania, in 1874.

Physical Description:
Oil on canvas. Half length, facing slightly to the subject's left. Black judicial robes, brown coat with gold embroidered buttonholes, white shirt and banded collar. Powdered gray wig, brown eyes. Brown background. Signed in upper right "W Cogswell 1852/from Wertmüller 1808." 29¼ inches H × 24⅝ inches W.

JAMES HAMILTON (c. 1710–1783)
by Benjamin West, from life, 1767

Hamilton was born around 1710 in Virginia. After his family moved to Philadelphia, he received his early education there and then studied law in London. In 1733, he succeeded his father (see above) as notary of Pennsylvania's supreme court. The younger Hamilton then became a member of the colonial assembly, followed by a term as Philadelphia's mayor, and by membership in the provincial council. In 1748, he became lieutenant governor of the colony, representing the Penn family proprietors for a term. A Penn favorite, he returned to the governor's office several times in the next twenty-two years. With the coming of the Revolution, Hamilton was arrested for Loyalism and paroled to Northampton. He escaped behind British lines and remained in exile from Philadelphia until his death in New City on 14 August 1783.

Hamilton, an avid art collector, was an early patron of Pennsylvania-born artist Benjamin West (1738–1820) and partially financed West's study trip to Italy in 1760. After that, West never returned to America, instead establishing himself in London by 1763. In 1765 Hamilton began a two-year stay in London, in order to undergo medical treatment, and he sat for West in 1767.[1] At this same time, Charles Willson Peale was studying with West and posed for the hands in the Hamilton portrait. West's composition for this grand manner portrait reflects a standard vocabulary of late eighteenth-century painting in which elements of the antique (e.g. the column) are combined with contemporary symbols of authority (e.g. the sword) to represent the sitter's importance.

The portrait's descent through the sitter's family also documents the West-Hamilton relationship. Hamilton's nephew William, whose fashionable estate the Woodlands was renowned, shared his uncle's interest in art, and displayed the West portrait prominently in his home.[2] While the association of this portrait with West has never been challenged, subsequent restorations to the painting have altered the canvas in the area that held the original inscription. Specifically, the present inscription contains later watercolor overpaint in the form of "B West" that overlaps the older (and perhaps original) lettering of "pinxit Londini/1767."

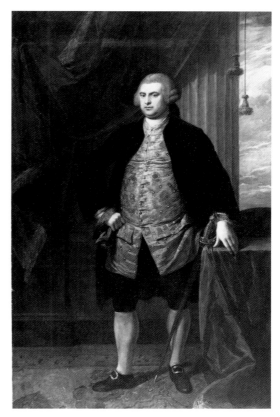

Catalog Number INDE14062
(SN 13.099)

Provenance:
Owned by William Hamilton (died 1813), the sitter's nephew, from 1783 until 1813. Owned by Henry Beckett (died 1871), the sitter's great-grand-nephew by marriage, from at least 1852 until 1871. Given to the Spring Garden Institute by Henry Beckett around 1871. Given to the City of Philadelphia by the Spring Garden Institute before 1892.

Physical Description:
Oil on canvas. Full length, turned slightly toward the sitter's right. Black coat, red and silver patterned yellow waistcoat, white stock, black breeches, white stockings, black shoes with silver buckles. Powdered wig, brown eyes. Right hand grasping gloves at hip, left hand on table covered by red and gold fringed cloth. Gold-handled sword on left hip. Dark paneled interior with patterned carpet. In upper left background a dark red curtain pulled up. In upper right background fluted column and cloudy sky. Inscribed in lower left "B West [a later addition] pinxit Londini/1767." 95 inches H × 61 inches W.

[1] Philadelphia Museum of Art, "Benjamin West in Pennsylvania Collections," exhibit catalog (1986), 16.

[2] "American Scenery for the *Port Folio*, the Woodlands," Port Folio 6 (December 1809), 505–506.

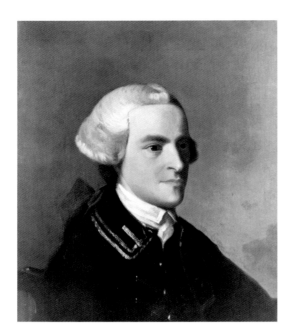

Catalog Number INDE14063

(SN 13.100)

JOHN HANCOCK (1737–1793)
by Samuel Finley Breese Morse, after John Singleton Copley, c. 1816

Hancock was born in Braintree, Massachusetts on 12 January 1737. He attended the Boston Latin School and then Harvard College. In 1754, he joined his uncle's mercantile firm. After inheriting the firm, Hancock became a prominent proponent of the growing protest against British colonial economic policy. When his sloop *Liberty* was confiscated by the royal navy for smuggling, he became a public symbol of the colonial resistance. He joined the Massachusetts General Court in 1769, and was elected its president when that body was reorganized as the provincial congress five years later.

His political partnership with the popular spokesman Samuel Adams helped to increase Hancock's influence and he entered the Continental Congress in 1775. As its president, he signed the Declaration of Independence. The following year, however, he resigned his office in protest after losing the appointment as commander-in-chief of the Continental army to George Washington. Hancock then returned to Massachusetts and became its first governor in 1780. He retained the office, except for the period 1785–1787, until the end of his life. In 1788, he also served as president of his state's federal Constitution ratifying convention. Hancock died in office on 8 October 1793.

When Philadelphia publisher Joseph Delaplaine compiled his *Repository of the Lives and Portraits of Distinguished Americans*, he commissioned several artists for paintings of his intended biographical subjects. In 1816, Boston artist-inventor Samuel F.B. Morse (1791–1872) copied for Delaplaine John Singleton Copley's 1765 full-length portrait of Hancock (now on loan to the Museum of Fine Arts, Boston).[1] Although Delaplaine eventually omitted Hancock from the *Repository*, he

retained the Morse portrait for the public gallery that he opened in early 1819. Four years later, financial failure forced Delaplaine to sell his portrait collection. In 1825, Delaplaine's collection of portraits (including the Hancock) was purchased by Charles Willson Peale's son Rubens for use in the New York Peale Museum.[2]

Charles Willson Peale had always intended to add a portrait of Hancock to the Philadelphia Museum collection. As early as 1784, the artist had tried to borrow the miniature he had painted of Hancock in 1776 (now unlocated) so that a copy could be made of it.[3] The loan never materialized, and Hancock's early death prevented Peale from obtaining a new sitting. Ironically, Morse's Hancock portrait eventually wound up in Philadelphia. Rubens owned the Morse Hancock portrait until he sold the New York Museum's contents in 1842. By 1843, Phineas T. Barnum had purchased Ruben's former collection. Sometime after that, Barnum apparently moved the Hancock portrait to his Philadelphia museum. In late 1851, Barnum's Philadelphia museum burned, but some of the collection (including the Hancock) was saved. Following the fire, the Hancock portrait returned to the Peale family (either by sale or gift) in time to be sold at the 1854 Peale Museum auction.[4]

❧

Provenance:
Purchased by Joseph Reed (recorder of the City of Philadelphia) from Joseph Delaplaine in 1823. Purchased by Rubens Peale from Joseph Reed in 1825. Sold by Rubens Peale in 1842. Purchased by Phineas T. Barnum in 1843. Obtained by Peale family in 1852 or 1853? Purchased by the City of Philadelphia at the 1854 Peale Museum sale.

Physical Description:
Oil on canvas. Bust length, facing to the subject's left. Dark blue coat with gold trim, dark blue waistcoat, white shirt and stock. Powdered hair tied in a queue with a gray ribbon, blue eyes. Corner of Chippendale chair visible in lower left. Light gray-blue and pink background. 24¼ inches H × 20¼ inches W.

[1] Paul J. Staiti, *Samuel F.B. Morse*, Grey Art Gallery and Study Center (New York University; 1982), 25–27.

[2] Wendy Wick Reaves, ed., *American Portrait Prints: Proceedings of the Tenth Annual American Print Conference*, National Portrait Gallery (Charlottesville Va.: University Press of Virginia, 1984), 45.

[3] Sellers, *Portraits and Miniatures*, 98.

[4] On Barnum's New York and Philadelphia museums, see Charles Coleman Sellers, *Mr. Peale's Museum* (New York: W.W. Norton & Company, Inc., 1980), 305 and 313.

EDWARD HAND (1744–1802)
by an unidentified artist, possibly after John Trumbull or Jacob Eichholtz, prior to 1875

Hand was born on 31 December 1744 in Leinster, Ireland. After medical studies at Dublin's Trinity College, he enlisted in the Royal Irish Regiment of Foot as a surgeon's mate. In 1774, he resigned from the royal army and opened a medical practice in Lancaster, Pennsylvania. Early in the Revolution, he commanded several militia companies at the siege of Boston, Long Island, White Plains, Trenton, and Princeton. In 1777, he was assigned to patrol the Pennsylvania and New York frontiers. He was appointed adjutant general in early 1781, and fought at Yorktown. After the war, he served in Congress and in the Pennsylvania legislature; he was also president of the state's chapter of the Society of the Cincinnati. President George Washington appointed him an inspector of revenue in 1791, and Hand served in that office until his death on 3 September 1802.

The portrait of Hand acquired by the City of Philadelphia was copied by a presently unidentified artist prior to the Centennial. Possibly, this copy is based on John Trumbull's profile of the subject that is included in the artist's 1787–1828 work *Surrender of Lord Cornwallis at Yorktown, October 18, 1791* (now at the Yale University Art Gallery).

Trumbull's work may have influenced Jacob Eichholtz, with whom several profile portraits of Hand are associated, but not firmly attributed (now owned by the Rockford Foundation, the Historical Society of Pennsylvania, and a private collection).[1] One of these so-called Eichholtz portraits (or a print thereof) may then have provided the source for the copy hung in Independence Hall.

<center>⤙⦁⤚</center>

Provenance:
Given to the City of Philadelphia by Mrs. Anna M. Hand, the subject's grand-daughter by marriage, in 1875.

Physical Description:
Oil on canvas. Half length, head turned to subject's right. Dark blue uniform coat with buff facings, gold epaulettes, buff waistcoat, white stock and jabot. White hair tied in a queue with a black ribbon, blue eyes. Brown background. 24 inches H × 20 inches W.

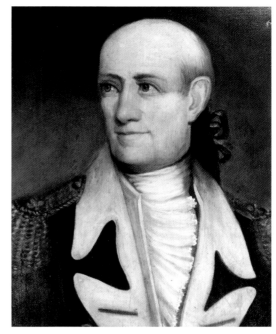

Catalog Number INDE
(SN 13.101)

[1] Rebecca J. Beal, *Jacob Eichholtz, 1776–1842, Portrait Painter of Pennsylvania* (Philadelphia: Historical Society of Pennsylvania, 1969), 102. The proliferation of Hand profile portraits is traditionally explained as a disguise for his blinded right eye suffered during the battle of Princeton.

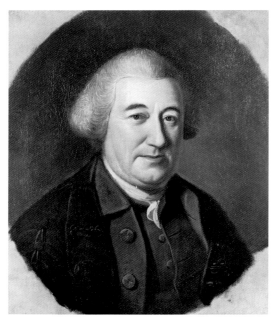

Catalog Number INDE11888

(SN 13.103)

JOHN HANSON (1721–1783)
by Charles Willson Peale, from life, 1781–1782

Hanson was born in Charles County, Maryland, on 3 April 1715. His grandfather was one of four officers sent to America by Sweden's Queen Christina in 1642. After a local education, Hanson became a farmer and planter. He entered provincial politics in 1757 with election to the General Assembly, later sitting on the legislative committee that wrote the instructions for Maryland's delegation to the Stamp Act Congress. An early local supporter of American independence, he entered the Continental Congress in 1779. He led Maryland's effort to ratify the Articles of Confederation, and in late 1781 was elected the first president of Congress under the new government. Hanson died on 22 November 1783.

Hanson's portrait was one of the earliest painted by Charles Willson Peale for his Philadelphia Museum. Through the development of this and other early likenesses, Peale arrived at his formula for the museum portraits as bust length with a neutral background, unfinished at the corners in order to receive a gold leafed spandrel, which, laid over the painting, created the oval picture format. Hanson's portrait,

showing the sitter in his winter cloak, is listed as "President of Congress" in Peale's first advertisement of the museum collection published in the 13 October 1784 issue of the *Freeman's Journal and Daily Advertiser.*

—⊷⊶—

Provenance:
Listed in the 1795 Peale Museum catalog. Purchased by "Mr. Barton" at the 1854 Peale Museum sale. Given to the City of Philadelphia by "Mr. Barton" in 1854 or 1855.

Physical Description:
Oil on canvas. Bust length, slightly turned to sitter's left. Gray cloak, brown coat and waistcoat, white stock and jabot. Powdered gray wig, green eyes. Brown background. 23 11/16 inches H × 19 3/4 inches W.

ROBERT HARE (1781–1858)
by Rembrandt Peale, from life, 1830–1832

Catalog Number INDE14064

(SN 13.104)

Hare was born in Philadelphia on 17 January 1781. After an education at home, he managed his father's brewery. His early interest in chemistry grew from his studies with Dr. James Woodhouse of the University of Pennsylvania. In 1801, Hare built an apparatus that combined oxygen and hydrogen under pressure and produced the most intense heat then known to science. As he devoted more time to scientific experimentation, he began a teaching career at the College of William and Mary, and then followed his former mentor as the professor of chemistry at the University of Pennsylvania in 1818.

For the next thirty years Hare wrote, lectured, and invented a range of scientific instruments, including the calorimeter. In 1827, he published his basic course of lectures in a textbook form that continued through three editions. The American Academy of Arts and Sciences honored his achievements with the Rumford Medal in 1839. When he retired eight years later, he gave his instrument collection to the Smithsonian Institution. During the last years of his life, he published a novel and a manual on communication with the spirit world. Hare died on 15 May 1858.

Charles Willson Peale and his sons were among the many enthusiastic students of Hare's experiments. As a result, chemical demonstrations (occasionally conducted by Hare himself) formed a popular part of the public evening programs at the Peale Museum in the 1820s. In late 1822, Peale finished his portrait of Hare (now unlocated) for the museum collection. Sometime later, the artist's son Rembrandt (1778–1860) also painted a portrait of the chemist, which he displayed at the Pennsylvania Academy of the Fine Arts in 1832.[1] The portrait is reminiscent of Rembrandt's work during the period following his two-year stay in Italy. At this time, his work featured a "subdued and simplified palette" that imparts an antique patina reminiscent of the Old Masters that Rembrandt had studied while abroad.[2]

Provenance:
Purchased by the City of Philadelphia at the 1854 Peale Museum sale.

Physical Description:
Oil on canvas. Half length, facing slightly to the sitter's left. Dark brown overcoat, white waistcoat, white shirt and stock. Brown hair, brown eyes. Olive background. 28⅝ inches H × 23⁹⁄₁₆ inches W.

[1] Anna Wells Rutledge, ed., *Cumulative Record of Exhibition Catalogues, the Pennsylvania Academy of the Fine Arts, 1807–1870* (Philadelphia: American Philosophical Society, 1955), 167.

[2] Lillian B. Miller, ed., *In Pursuit of Fame, Rembrandt Peale 1778–1860*, exhibit catalog, National Portrait Gallery (Seattle: University of Washington Press, 1992), 194.

Catalog Number INDE

(SN 13.106)

BENJAMIN HARRISON (c. 1726–1791)
by James Read Lambdin, after John Trumbull, 1873

Harrison was born around 1726 in Charles County, Virginia. His father's death in 1745 brought his early departure from the College of William and Mary and his assumption of managerial duties at the family estate. Three years later, he entered the House of Burgesses, where he served, frequently as speaker, until that body was dissolved by the royal governor in 1774. In that year, long a vocal opponent of British colonial policy, he joined his fellow Virginians in their call for a general colonial congress and was elected to the Continental Congress. In 1776, he was chairman of Congress's committee of the whole during the debates over the Declaration of Independence, and he signed the document later that summer. At the end of 1777, he left Congress for a seat in his state's legislature, where he remained for the rest of his life, except for three years spent as Virginia's governor. Harrison died on 24 April 1791.

In 1873, the City of Philadelphia commissioned local artist James Read Lambdin (1807–1889) for a portrait of Harrison to hang in Independence Hall. Lambdin copied John Trumbull's portrait of Harrison included in his 1787–1820 *Declaration of Independence* (now at the Yale University Art Gallery). Most of the *Declaration* portraits were based upon sittings from life or life portraits of the individual subjects. Harrison, however, died before Trumbull began his work on the *Declaration*. In 1817, the artist added to the group portrait an image of Harrison composed from memory and probably aided by descriptions from the sitter's son.[1]

A late eighteenth-century miniature of Harrison by an unidentified artist (now owned by the Virginia Historical Society) was apparently unknown to Trumbull as a possible source for his work.

―∞∞∞―

Provenance:
Purchased by the City of Philadelphia from the artist in 1873.

Physical Description:
Oil on canvas. Bust length, facing front. Reddish-brown coat with brass buttons, buff waistcoat, white stock and jabot. Powdered hair with brown eyes. Brown background. 24 inches H × 20 inches W.

[1] John Trumbull to General William Henry Harrison, 10 February 1815, quoted in John Hill Morgan, *The Paintings of John Trumbull of Yale* (New Haven: Yale University Press, 1926), 42. Irma B. Jaffe, *Trumbull: The Declaration of Independence* (New Haven: Yale University Press, 1976), 81–82. Trumbull had consulted with Charles Willson Peale about whether he had a portrait of Harrison, but the latter artist was unable to help. Charles Willson Peale to John Trumbull, 14 February 1818 (Miller, *Selected Papers 3*, page 571).

"JOHN HART"[1] (1713–1779)
by Herman F. Deigendisch, after Henry Bryan Hall, 1895

Hart was born in Hunterdon County, New Jersey, during the autumn of 1713. He became a prosperous farmer and began his public service in 1755 as a county justice of the peace. Six years later, he took a seat in the colonial assembly, where he served until that body's dissolution in 1771. Later a justice in the court of common pleas, he earned election to the provincial congress and then served as its vice-president. A supporter of colonial resistance to British tax measures, he joined the Jersey Committees of Correspondence and Safety. In mid-1776, he was elected to the Continental Congress where he signed the Declaration of Independence. Elected to New Jersey's first state legislature, he became its speaker in late 1776. He served there until his death on 11 May 1779.

At the end of the nineteenth century, the City of Philadelphia accepted for display in Independence Hall a portrait labeled "John Hart." This portrait was painted by Philadelphia artist Herman F. Deigendisch (1858–1921) in 1895 from a photograph provided by a Hart descendant.[2] The source was a watercolor portrait of Hart (now at the New York Public Library) by Henry Bryan Hall. Hall was employed in 1869 by Dr. Thomas Addis Emmet to portray all the signers of the Declaration. Hall also published engravings of the Emmet watercolors, including the Hart. In the early twentieth century, extensive critical debate began over the source of Hall's Hart watercolor, ending with the conclusion that no accurate portrait of Hart existed.[3]

Nevertheless, several copies of the Hall image (including a miniature signed by Deigendisch and dated "1894" that is now at the Historical Society of Pennsylvania) were made by various artists for Hart descendants.

❧

Provenance:
Given to the City of Philadelphia by Miss Frances Sarah Magee, the subject's great-great-granddaughter(?), in 1895.

Physical Description:
Oil on canvas. Bust length, torso slightly to subject's left. Brown coat and waistcoat, white stock and jabot. Brown hair, blue eyes. Dark background. 24 inches H × 20 inches W.

Catalog Number INDE
(SN 13.108)

[1] No authentic likeness of this subject is known.

[2] Herman F. Deigendisch to Wilfred Jordan (curator of Independence Hall), 2 February 1916. Independence Hall Papers, Independence National Historical Park.

[3] Charles Henry Hart, "Frauds in Historical Portraiture," *American Historical Association Report* 19 (1913), 93. For a complete summary of the Hart portrait debate, see Cleon E. Hammond, "John Hart, Signer: Falsely Portrayed Patriot," *New Jersey History* (Autumn 1974): 133–146.

Catalog Number INDE14059

(SN 52.007)

THOMAS HARTLEY (1748–1800)
attributed to Edward Green Malbone, miniature from life, 1798

Hartley was born in Berks County, Pennsylvania, on 7 September 1748. He later read law and joined the Philadelphia bar in 1769. He led the local protest to British colonial economic policy, representing the county in the provincial legislature of 1774 and 1775. At the beginning of the Revolution, he joined the militia and quickly rose to command a battalion in the Continental army. He fought at Brandywine, Paoli, and Germantown before traveling to the interior to defend the western frontier. In 1779, he left the army for service in the state legislature. He was part of the state's Council of Censors which oversaw implementation of Pennsylvania's new state constitution, and he supported the new federal Constitution at his state's ratifying convention. He was a member of the Society of the Cincinnati, and was admitted to practice law before the federal Supreme Court. In 1788, he entered the United States House of Representatives, where he served until just before his death on 21 December 1800.

Rhode Island-born miniaturist Edward Greene Malbone (1777–1807) visited Philadelphia in 1798 (while Hartley was in Congress) and may have painted this miniature portrait of Hartley at that time.[1] Although water-damaged, the Hartley miniature reflects a delicate use of color with the planes of the sitter's face expertly delineated. The sitter's distinctive red inner vest is very similar to that in Malbone's 1801–1802 miniature of Thomas Pinckney (now at the Carolina Art Association).

❦

Provenance:
Given to the City of Philadelphia by Charles H. Hall, the sitter's great-great-grandson, in 1947.[2]

Physical Description:
Watercolor on ivory. Bust length, turned slightly to the sitter's left. Blue coat, white waistcoat with red inner vest, white stock and jabot. Powdered hair, blue eyes. Off-white background. 2⅝ inches H × 2⅛ inches W. Oval gold frame with plain bezel later inscription on housing reverse "Thomas Hartley/York/PA/Col in the/Rev War."

[1] Hartley is not listed among Malbone's sitters in the catalogue raisonné by Ruel P. Tolman, *The Life and Works of Edward G. Malbone 1777–1807* (New York Historical Society, 1958).

[2] A portrait of Catherine Holtzinger (Mrs. Thomas) Hartley from the same donor but by a different artist was stolen from Independence National Historical Park in 1978 and has not been recovered.

JOHN HAZELWOOD (c. 1726–1800)
by Charles Willson Peale, from life, c. 1785

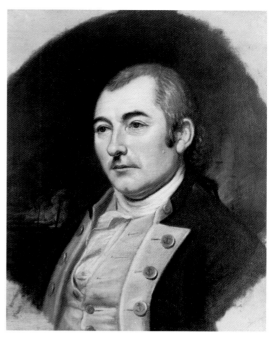

Catalog Number INDE14065
(SN 13.110)

Hazelwood was born near Cambridge, England, around 1726. He immigrated to America in his early twenties and captained various merchant vessels in the transatlantic trade. In 1775, he assisted with the building of and commanded the harbor defenses for Philadelphia. After that, he rose rapidly in rank to command the entire Pennsylvania navy in late 1777. During the British naval assault on Philadelphia after the battles of Brandywine and Germantown, Hazelwood blocked the enemy's progress through the Delaware River. He destroyed several British vessels, for which Congress honored him with a presentation sword. Eventually, the British royal navy forced its way to Philadelphia and, although Hazelwood evacuated the American fleet, he was forced to burn it to prevent its capture. After that, he served in several administrative wartime capacities and raised funds for the American army. Following the war, he served briefly as port warden for Philadelphia. Hazelwood died in Philadelphia on 1 or 2 March 1800.

Charles Willson Peale probably added Hazelwood's portrait to the Philadelphia Museum during the late 1780s. Unlike most of the museum portraits, Hazelwood's contains background attributes that represent events in the sitter's life (see also Peale's portrait of Samuel Smith below). The background scene in this portrait probably refers to the 1777 defense of Philadelphia, with shadowy cannon flashes to the right and advancing ships surrounded by smoke to the left. Stylistically, this painting resembles the artist's works during the first half of the 1780s: coarse highlights dot the eyes and mouth areas; strong contours outline the nose, neck, and ears; and the palette shows a subtle shift from silvery green tones to red. However, Hazelwood's portrait is not listed in Peale's 13 October 1784 *Freeman's Journal and Daily Advertiser* advertisement for the museum.

⁂

Provenance:
Listed in the 1795 Peale Museum catalog. Purchased by the City of Philadelphia at the 1854 Peale Museum sale.

Physical Description:
Oil on canvas. Bust length, facing toward the sitter's right. Blue uniform coat with buff facings and brass buttons ornamented with anchors, buff waistcoat, white stock and jabot. Graying hair tied in a queue with a black ribbon, hazel eyes. Dark background containing a naval battle scene in both the left and right midground. 22⅞ inches H × 19¼ inches W.

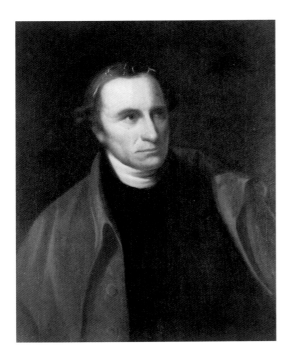

Catalog Number INDE14066
(SN 13.111)

PATRICK HENRY (1736–1799)
by an unidentified artist, after Thomas Sully, before 1878

Henry was born on 29 May 1736 in Hanover County, Virginia. He studied law on his own and then gained wide acclaim for his successful representation of the colony's freeholders in their case to determine the salaries paid to their Church of England clergy. Soon thereafter, he entered the House of Burgesses, dominating debate with his anti-parliamentary rhetoric. His seven resolutions opposing the 1765 Stamp Act demanded complete legislative independence for Virginia and circulated throughout the colonies. As a member of Virginia's committee of correspondence, he led the colonies-wide convention that called for a Continental Congress. Before that body in early 1775, Henry proposed that Virginia arm herself against Britain in his memorable "give me Liberty, or give me death" speech. He left Congress later that year and returned to command Virginia's militia. Following his military service, he helped to write the state's constitution and then entered the governor's office, where he served five nonconsecutive terms.

After the Revolution, Henry returned to the state legislature several times. He was elected to represent Virginia at the Constitutional Convention in 1787, but he opposed the convention's purpose and refused to attend. At Virginia's subsequent ratifying convention he boycotted the federal plan and later rejected presidential appointments as secretary of state and chief justice. He then resumed his profitable law practice. In his last years, Henry changed his political views and supported the Federalists until his death on 6 June 1799.

During the Centennial years, the City of Philadelphia added a portrait of Henry to the historical museum in Independence Hall. An unidentified artist based this copy on Thomas Sully's 1815 portrayal of Henry (now at the Colonial Williamsburg Foundation). Henry biographer William Wirt had commissioned Thomas Sully for the portrait to be engraved in his 1817 *Sketches of the Life and Character of Patrick Henry.*[1] Sully's 1815 portrait is a copy based on a 1795 miniature (now at Amherst College's Mead Art Museum) by Sully's brother, Lawrence. In 1876, Sully's copy was owned by William Wirt Henry (the grandson of William Wirt and Patrick Henry); he may be the source of the unattributed copy in the Independence collection.

❧

Provenance:
Unknown. Acquired by the City of Philadelphia between late 1876 and early 1878.

Physical Description:
Oil on canvas. Bust length, facing front with body turned slightly toward the subject's left. Reddish orange cloak, dark brown coat and waistcoat, white stock. Brown hair, blue-gray eyes. Round, metal-framed glasses resting on head. Dark olive background. 29⅝ inches H × 24⅞ inches W.

[1] In 1851, Sully painted another copy for the Virginia Historical Society (Virginius Cornick Hall, Jr., *Portraits in the Collection of the Virginia Historical Society* [Charlottesville: University of Virginia Press, 1981], 115).

JOSEPH HEWES (1730–1779)
by Georges D'Almaine, after Charles Willson Peale, 1875

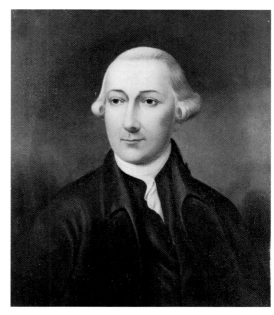

Catalog Number INDE14068
(SN 13.114)

Hewes was born on 23 January 1730 in Kingston, New Jersey. His parents apprenticed him to a Philadelphia merchant; later Hewes established his own commercial business in the city. In the late 1750s, Hewes moved to Edenton, North Carolina, where he built a successful shipping company. As a prominent businessman, he served in his colony's assembly for nearly ten years. A member of North Carolina's Committee of Correspondence and of his provincial congress, he was also elected to the Continental Congress in 1774 and signed the Declaration of Independence. During the next three years, he worked on numerous committees, including that formed to design a plan for the new confederation of states. He chaired the first committee of the navy and, as such, brought the abilities of John Paul Jones to the attention of Congress. After another year in the North Carolina legislature, he returned to the Continental Congress in 1779. Hewes died on 10 November 1779.

The City of Philadelphia added Hewes's portrait to the Independence Hall museum in 1875. English-born Baltimore artist Georges d'Almaine (died 1884) copied Charles Willson Peale's 1776 miniature of Hewes (now at the United States Naval Academy Museum) for presentation to Independence Hall.

❦

Provenance:
Purchased by the City of Philadelphia from the artist in 1875.

Physical Description:
Oil on canvas. Bust length, head turned slightly toward subject's right. Maroon coat and waistcoat, white stock and jabot. Powdered wig tied in a queue with a dark blue ribbon, brown eyes. Dark olive background. 24⅛ inches H × 19¹⁵⁄₁₆ inches W.

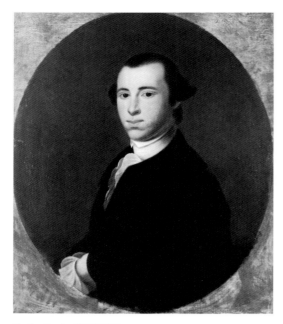

Catalog Number INDE14069

(SN 13.115)

THOMAS HEYWARD JUNIOR (1746–1809)
by Charles Fraser, after Jeremiah Theus, c. 1825–1850

Heyward was born near Charleston, South Carolina, on 18 July 1746. The son of one of Carolina's wealthiest planters, he studied law at London's Middle Temple and was admitted to the South Carolina bar in 1771. He entered the colonial legislature the following year, and served in several of the provincial congresses during the last years before the Revolution. A member of the Carolina Council of Safety, he also served on the committee that drafted the state's first constitution in 1776. He was elected to the Continental Congress in that year and signed the Declaration of Independence. In 1778, he left Congress for a militia command and was wounded at Port Royal Island the following year. During the siege of Charleston, he was captured and sent to St. Augustine, Florida, until his exchange in mid-1781. At that time, he joined the state legislature, where he served for two years. Following the Revolution, he left politics and became a circuit judge, serving until 1789. Heyward died on 6 March 1809.

Among the City of Philadelphia's earliest acquisitions for Independence Hall in preparation for the Centennial celebration was this copy portrait of Heyward. Attributed to Charleston artist Charles Fraser (1782–1860), the painting is a copy of Jeremiah Theus's c. 1770 portrait of Heyward (now in a private collection).[1]

Provenance:
Given to the City of Philadelphia by Nathaniel Heyward, the subject's half-brother, in 1870.

Physical Description:
Oil on canvas. Half length, torso turned to the subject's right. Blue coat and waistcoat, white stock and jabot, white cuff. Brown hair, blue eyes. Brownish red background.
27⅜ inches H × 22¼ inches W.

[1] Several entries in Fraser's account book show entries for copies painted for "Mr. Heyward" during the years 1827 through 1829 ("Account Book of Charles Fraser, 1819–1846," in Martha R. Severens, ed., *Charles Fraser of Charleston* [Charleston S.C.: Carolina Art Association, 1983], 127–129).

JOSEPH HIESTER (1752–1832)
by Charles Willson Peale, from life, 1821

Hiester was born on 18 November 1752 in Berks County, Pennsylvania. After a local education, he joined a mercantile firm and then began his public career with service in the provincial assembly. In mid-1776, he raised and captained a county militia troop that fought at the battles of Long Island (where Hiester was captured and imprisoned on the British prison ship *Jersey*) and Germantown. In 1779, he left field duty for administrative tasks. He then retired from the military a year later in order to take his seat in the state legislature, where he served for fourteen years. During these years, he opposed the new federal Constitution at his state's ratifying convention and participated in his state's own constitutional convention. He entered Congress in 1797 and sat there for eight years and again from 1815 to 1820. In the latter year, he was elected Pennsylvania's governor and served one term. Hiester died on 10 June 1832.

In his efforts to acquire financial support for the Philadelphia Museum, Charles Willson Peale relentlessly petitioned government authorities with his plans. As a personal inducement, he offered representation in the museum's portrait collection to important legislators. With this in mind, he developed a collection of Pennsylvania governors, successfully acquiring sittings from Thomas Mifflin, Thomas McKean, Simon Snyder, and Joseph Hiester (Hiester's predecessor, William Findlay, apparently ignored the artist's request).[1] Peale extended his first invitation to Governor Hiester in April of 1821, and the portrait was in the museum by year's end.[2]

Catalog Number INDE14067

(SN 13.113)

~❦~

Provenance:
Purchased by the City of Philadelphia at the 1854 Peale Museum sale.

Physical Description:
Oil on canvas. Bust length, facing the sitter's right. Black coat, gray waistcoat, white stock and jabot. Brown hair, brown eyes. Red drapery in upper left, brown background. 24 inches H × 20 inches W.

[1] Sellers, *Portraits and Miniatures*, 103.

[2] Charles Willson Peale to Rembrandt Peale, 18 April 1821 (Miller, *Selected Papers* 4, page 48).

Catalog Number INDE11930

(SN 7.039)

[1] Ellen Sharples's pencil sketch
copy of her husband's
Hillhouse portrait is now in
the collection of the West of
England Art Gallery, Bristol.

JAMES HILLHOUSE (1754–1832)
*by a member of the Sharples family, after James Sharples Senior,
c. 1797–1800*

Hillhouse was born in Montville, Connecticut, on 20 October 1754. At nineteen, he graduated from Yale and then began his legal studies, inheriting his uncle's New Haven law practice two years later. In late 1776, Hillhouse joined his state's militia, later serving in the defense of New Haven. In 1780 he entered Connecticut's assembly, where he remained for nearly a decade, and then spent two years in the state senate.

In 1791, Hillhouse entered the United States House of Representatives. Five years later, he succeeded his colleague Oliver Ellsworth in the Senate (serving briefly as president pro tempore). An ardent Federalist, Hillhouse vocally opposed the foreign policy of presidents Jefferson and Madison, resigning in protest of it in 1810. Afterward, he returned to Connecticut and served in several fiscal administration positions including treasurer of Yale College and overseer of the Farmington and Hampshire Canal. He continued his political opposition to the Madison administration, attending the Hartford Convention in 1814. Hillhouse died in New Haven on 29 December 1832.

During his family's first visit to the United States, British pastelist James Sharples Senior painted portraits of many American politicians. Hillhouse probably sat for the artist in early 1797 when the Sharples family visited Philadelphia. The portrait is listed as "James Hilhouse, esq., Senator" in the catalog Sharples published after he returned to England. This life portrait is now owned by the Smithsonian's National Museum of American Art. A copy, either by Sharples or a member of his family (possibly his wife Ellen), is in the Independence collection.[1] This copy lacks the life portrait's delicate coloration and expert modeling, and details like the ribbon wrapping on the subject's queue are missing from it. Previously, the Independence copy was wrongly identified as Sharples's portrait of Alexander Hamilton.

Provenance:
Listed in the 1802 Bath catalog of Sharples's work. Given by Ellen (Mrs. James) Sharples to Felix Sharples in 1811. Given by Felix Sharples to Levin Yardly Winder in the 1830s. Inherited by Nathaniel James Winder from Levin Yardly Winder. Inherited by Richard Bayly Winder from Nathaniel James Winder in 1844. Purchased by Murray Harrison from Richard Bayly Winder around 1865. Purchased by the City of Philadelphia from Murray Harrison in 1875.

Physical Description:
Pastel on paper. Half length, left profile. Black coat and waistcoat, white jabot. Powdered hair tied in a queue, blue eyes. Gray background. 9 inches H × 7 inches W.

JOHN SLOSS HOBART (1738–1805)

attributed to a member of the Sharples family,
after James Sharples Senior, c. 1795–1810

Hobart was born in Fairfield, Connecticut, on 6 May 1738. Later, he graduated from Yale and moved to Long Island, New York. He served as a member of the local Committee of Correspondence and Council of Safety, and represented his county in four provincial congresses. In 1777, he accepted an appointment to the state supreme court, where he served for twenty-one years. His extensive legal experience took him to his state's Constitutional ratifying convention, where he supported the new federal government. In 1798, he entered the United States Senate but resigned within a few months in order to become judge of New York's federal district court. He served there until his death on 4 February 1805.

British pastelist James Sharples Senior and his family visited America for the first time from 1795 to 1800. Traveling regularly, they visited New York City several times and Philadelphia once. In one of these cities, Sharples painted a portrait that he listed in a later catalog as "Judge Hobart."

The Independence pastel appears to be a copy of this life portrait; the subject's features are sketchily drawn with less of the subtle modeling usually characteristic of Sharples's original work. Possibly, the Independence pastel (which is competently composed, the subject filling most of the picture plane) is a later copy by Sharples himself of the now unlocated Hobart life portrait.

───※───

Provenance:
Listed in the 1802 Bath catalog of Sharples's work. Given by Ellen (Mrs. James) Sharples to Felix Sharples in 1811. Given by Felix Sharples to Levin Yardly Winder in the 1830s. Inherited by Nathaniel James Winder from Levin Yardly Winder. Inherited by Richard Bayly Winder from Nathaniel James Winder in 1844. Purchased by Murray Harrison from Richard Bayly Winder around 1865. Purchased by the City of Philadelphia from Murray Harrison in 1876.

Physical Description:
Pastel on paper. Half length, torso facing slightly toward the subject's left. Dark gray coat and waistcoat, white stock. Gray wig, brown eyes. Blue variegated background. 9 inches H × 7 inches W.

Catalog Number INDE11937

(SN 7.046)

Catalog Number INDE
(SN 13.117)

WILLIAM HOOPER (1742–1790)
by James Read Lambdin, after John Trumbull, 1873

Hooper was born in Boston, Massachusetts, on 17 June 1742. He attended Boston Latin School and Harvard College, then becoming a clerk in the law office of James Otis. Later, Hooper set up his own practice in Wilmington, North Carolina. There, he served as the colony's deputy attorney general in the late 1760s, during which time he prosecuted many of the anti-royal faction known as the Regulators. In 1773, he entered the colonial assembly and later the provincial congress as a leading proponent of colonial legislative independence. A member of North Carolina's Committee of Correspondence, he served in the First and Second Continental Congresses, where he signed the Declaration of Independence. In 1777, he returned to his North Carolina law practice and to the state legislature, where he served until the end of the war. Hooper died on 14 October 1790.

In preparation for the nation's Centennial, the City of Philadelphia commissioned local artist James Read Lambdin (1807–89) for the portraits of several Declaration signers, including Hooper, to hang in Independence Hall. Lambdin copied John Trumbull's depiction of Hooper in the 1787–1820 *Declaration of Independence* (now at the Yale University Art Gallery).

Trumbull's portrait may be based on a life sitting with Hooper; in April 1790, the artist visited Charleston, South Carolina, where he took a number of portraits in preparation for painting the *Declaration*.[1]

————

Provenance:
Purchased by the City of Philadelphia from the artist in 1873.

Physical Description:
Oil on canvas. Bust length, facing front, torso turned slightly toward subject's left. Green coat, buff waistcoat, white stock and jabot. Powdered hair with brown eyes. Reddish-brown background. 24 inches H × 19 inches W.

————

[1] Theodore Sizer, *The Autobiography of Colonel John Trumbull* (New Haven: Yale University Press, 1953), 167–168.

UNIDENTIFIED MAN formerly known as "Stephen Hopkins"
by George Cochran Lambdin, after John Trumbull, 1873

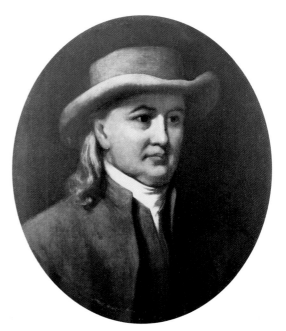

Catalog Number INDE

(SN 13.118)

During its preparation for the United States Centennial, the City of Philadelphia added a number of portraits to the historical collection displayed in Independence Hall. Many of these portraits depict signers of the Declaration of Independence and were based on original portraits from public and private collections located throughout the United States. In early 1873, Philadelphia painter James Read Lambdin received a substantial commission for signers' portraits (including William Ellery, Abraham Clark, Benjamin Harrison, Stephen Hopkins, William Hooper, and Oliver Wolcott). Lambdin traveled to Connecticut, where his principal source of information was John Trumbull's 1787–1820 painting entitled *Declaration of Independence* (now at the Yale University Art Gallery). Lambdin's son, George (1830–1896), accompanied his father and contributed to the commission by copying Trumbull's depiction identified as that of Rhode Island signer Stephen Hopkins.[1]

Trumull scholar Irma Jaffe has suggested that the portrait in the *Declaration* traditionally known as Hopkins—that of a man standing in the center background and wearing a wide brimmed hat—had been traditionally misidentified. The 1823 pictorial key to the painting was published as an accompaniment to Asher B. Durand's engraving of Trumbull's work and lists the portrait that way. According to Jaffe, Trumbull had actually depicted Hopkins in the *Declaration*'s left foreground, and Durand's key wrongly labeled this figure as New York signer George Clinton. Jaffe theorizes that this "Clinton" is Trumbull's portrait of Hopkins based on the artist's 1791

pencil sketch of Hopkins's son Rufus (now at Fordham University), created as a substitute for the deceased signer.[2]

With the proposed re-identification of Hopkins's portrait in Trumbull's *Declaration*, the identity of George Cochran Lambdin's subject becomes a mystery. Jaffe noted that Trumbull himself forgot who the man in the hat represented (and so did not correct Durand) because the artist composed the *Declaration* over an extended period of time during which he made many adjustments and compositional changes. At one time, however, Trumbull specifically referred to the hat in this individual portrait as "Quaker." Therefore, Jaffe suggests, the man wearing it must have been a Quaker member of the Declaration Congress. Jaffe then concludes, through a process of elimination, that Trumbull intended the man in the hat to portray Delawarean John Dickinson. Jaffe proposes that Trumbull's source for Dickinson's portrait, since the sitter (a non-signer) declined to pose for the artist, was James Smither's engraving of Charles Willson Peale's 1770 portrait of the Delawarean.[3]

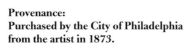

Provenance:
Purchased by the City of Philadelphia from the artist in 1873.

Physical Description:
Oil on canvas. Bust length, facing front with body turned toward subject's left. Gray coat and waistcoat, white stock. Brown eyes, gray hair. Gray hat. Dark-brown background. 24 inches H × 20 inches W.

[1] George Cochran Lambdin to Frank M. Etting, 2 June 1873 (Etting Papers, Historical Society of Pennsylvania, 45).

[2] Irma Jaffe, "Trumbull's 'The Declaration of Independence,'" *American Art Journal* (Fall 1971): 41–49 and Jaffe, *Trumbull: The Declaration of Independence* (New York: Viking Press, 1976), 78–81.

[3] Jaffe, *Trumbull*, 81–87.

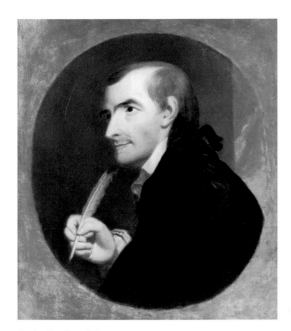

Catalog Number INDE14070

(SN 13.119)

FRANCIS HOPKINSON (1737–1791)
by an unidentified artist, possibly Charles Willson Peale or Samuel F. DuBois, after Robert Edge Pine, before 1854

Hopkinson was born in Philadelphia on 2 October 1737. He was the first student and, in 1757, graduate of the Academy of Philadelphia (today the University of Pennsylvania). He then read law under provincial attorney general Benjamin Chew and worked as a conveyancer and as a collector of customs for Salem, New Jersey. In 1766, Hopkinson went to England to lobby for a crown appointment through his mother's cousins, the bishop of Worcester and Lord North. While there, he lived for a time with Benjamin West's family, and may have studied art with his old friend. When Hopkinson returned to Philadelphia, he opened a dry goods store. After a brief stint as customs collector for New Castle, Delaware, he moved back to New Jersey, practiced law, and sat on the Governor's Council.

In 1776, New Jersey sent Hopkinson to the Continental Congress. He arrived in time to vote for and sign the Declaration of Independence. During his two-year congressional service, he chaired the Navy Board and served as treasurer of loans. Later, he was appointed Pennsylvania's admiralty judge. In 1789, President Washington named him the first United States district judge for Pennsylvania's Eastern District. In addition to his professional duties, he also wrote (political propaganda, essays, and poetry), indulged an interest in science, and also helped to design the United States flag as well as seals for the Navy Board, the Treasury Board, and the University of Pennsylvania. Hopkinson died on 9 May 1791.

At the 1854 Peale Museum sale, the City of Philadelphia purchased a portrait of Hopkinson copied from Robert Edge Pine's 1785 portrayal of the sitter (now at the Historical Society of Pennsylvania). In the city's 1856 catalog of its portrait collection, the Hopkinson portrait is attributed to "Dubois." By the Centennial, however, this attribution had changed to Charles Willson Peale.[1] The senior Peale had painted a life portrait of Anne Borden (Mrs. Francis) Hopkinson, but a life portrait of her husband is not documented in Peale's papers or in his catalogs and accession book for the museum. The Peale–DuBois connection may stem from a possible association between Rembrandt Peale and Philadelphia artist Samuel F. DuBois (1805–1889) when the two exhibited concurrently at the Pennsylvania Academy of the Fine Arts. Dubois had studied with Thomas Sully and worked as a portraitist and copyist from the 1830s through the 1850s. The Hopkinson copy's oval format suggests that it was painted to hang in the Peale Museum, but the source of the portrait is still unclear.

❧⚬❧

Provenance:
Purchased by the City of Philadelphia at the 1854 Peale Museum sale.

Physical Description:
Oil on canvas. Bust length, left profile. Black coat, white collar, jabot and cuff. Gray hair tied in a queue with a black ribbon, brown eyes. Subject holds a quill pen in his right hand. Dark background with a window showing blue sky and clouds in the upper right. 20⁵⁄₁₆ inches H × 16½ inches W.

[1] *Catalogue of the National Portraits in Independence Hall* (Philadelphia, 1856), 7. Charles Coleman Sellers reported that some copies of the 1854 Peale Sale catalog contain the later annotation "C.W.P." next to the Hopkinson entry (Sellers, *Portraits and Miniatures*, 104).

JOHN EAGER HOWARD (1752–1827)
by Charles Willson Peale, from life, c. 1781–1784

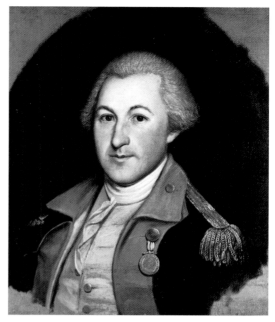

Catalog Number INDE14071

(SN 13.121)

Howard was born 4 June 1752 in Baltimore, Maryland. At the beginning of the Revolution, he joined the Continental army as an officer and fought at White Plains and in the Monmouth campaign. In 1779, he transferred to the war's southern theatre and the disastrous American defeat at Camden, South Carolina. Later, he led his troops at the battle of Cowpens (for which Congress awarded him a silver medal), Guilford Courthouse, Hobkirk's Hill, Eutaw Springs, and Charleston. After retiring from the army, he served in the last session of the Continental Congress. Following that, he was Maryland's governor for a term and then a state senator. He spent one term in the United States Senate, but declined an appointment as secretary of war. During the War of 1812, he commanded the defense of Baltimore. An outspoken Federalist, he was their unsuccessful candidate for vice president in 1816. Howard died in Baltimore on 12 October 1827.

Howard sat for Charles Willson Peale sometime during the early 1780s. The portrait was completed by 1784 when it was listed in the advertisement for the museum printed in the 13 October *Freeman's Journal and Philadelphia Daily Advertiser*. Although the sitter wears a medal, it is not the one awarded him by Congress in early 1781 to commemorate his heroism at the battle of Cowpens.[1] Completion of that medal was delayed until late 1789; in that year, its creator, Benjamin Duvivier, displayed it at the French Royal Academy's annual salon.[2] The medal in the Peale portrait bears a different Latin motto from that made by Duvivier, and may represent recognition of Howard's Cowpens valor by one of the southern state legislatures. Peale painted a replica of the Howard portrait (now at the Hampton National Historical Site) for the subject's family around 1787.[3]

⁜

Provenance:
Listed in the 1795 Peale Museum catalog. Purchased by the City of Philadelphia at the 1854 Peale Museum sale.

Physical Description:
Oil on canvas. Bust length, torso turned slightly to the sitter's right. Dark blue uniform coat with red facings and silver epaulettes, off-white waistcoat, white stock and jabot. Powdered hair tied in a queue with a black ribbon, blue eyes. Round silver medal (inscribed "VIRTUTE ET JUSTITIA VALET") on a blue ribbon hanging from top coat button. Dark brown background. 23⅛ inches H × 19½ inches W.

[1] Sellers, in *Portraits and Miniatures* (p. 105), asserts that it was the congressional medal.

[2] Vladimir and Elvira Clain-Stefanelli, *Medals Commemorating Battles of the American Revolution* (Washington D.C.: Smithsonian Institution Press, 1973), 31.

[3] In 1824, Peale painted another portrait of Howard (now at the Maryland State Archives), a copy of his son Rembrandt's recent work, for the Annapolis Corporation's collection of Maryland governors (Miller, *Selected Papers* 4, page 317).

Catalog Number INDE11911

(SN 7.019)

WILLIAM HULL (1753–1825)
by James Sharples Senior, from life, c. 1795–1801

Hull was born on 24 June 1753 in Derby, Connecticut. After graduating from Yale, he studied law and, in 1775, joined his local militia. During the Revolution, he served at White Plains, Trenton, Princeton, Saratoga, Monmouth, and Stony Point, and commanded the winter defensive lines north of New York City. In 1779, he left the military and opened a law practice in Newton, Massachusetts. After the war, he commanded troops in western Massachusetts sent to suppress Daniel Shays's frontier revolt. Later, he accompanied two United States diplomatic missions to Canada. He also served as a judge in his state's court of common pleas and sat in his state's senate. In 1805, President Thomas Jefferson appointed him governor of the new Michigan Territory. At the beginning of the War of 1812, Hull accepted a brigadier general's commission and led a failed invasion of Canada that resulted in the loss of Detroit to British forces. Though courtmartialed and sentenced to death, Hull received a reprieve from President James Madison. Hull died in Newton on 29 November 1825.

During his family's first visit to the United States, British pastelist James Sharples Senior (1751–1811) painted a portrait of Hull. Sharples worked in New England, New York, and Philadelphia from 1795 to 1801. After the family's return to England, Sharples published a catalog of pastels including one of "General Hull." Until recently, Sharples's Hull portrait was wrongly identified as that of General Anthony Wayne.[1]

A second version of this portrait (now owned by the Worcester Art Museum) shows Hull in civilian dress. This pastel is a copy of the Independence portrait, possibly by Sharples or his wife Ellen, and was painted for the subject's family.

❦

Provenance:
Listed in the 1801 Bath catalog of Sharples's works. Given by Ellen (Mrs. James) Sharples to Felix Sharples in 1811. Given by Felix Sharples to Levin Yardly Winder in the 1830s. Inherited by Nathaniel James Winder from Levin Yardly Winder. Inherited by Richard Bayly Winder from Nathaniel James Winder in 1844. Purchased by Murray Harrison from Richard Bayly Winder around 1865. Purchased by the City of Philadelphia from Murray Harrison in 1875.

Physical Description:
Pastel on paper. Half length, left profile. Dark blue uniform coat with buff facings and gold epaulette, buff waistcoat, white stock. Powdered hair tied in a queue, blue eyes. Variegated brown background. 9 inches H × 7 inches W.

[1] David Meschutt, "Re-identification of a portrait by James Sharples," *American Art Journal* 16 (Autumn 1984), 93–94.

DAVID HUMPHREYS (1752–1818)
by Rembrandt Peale, from life, 1808

Catalog Number INDE14073

(SN 13.124)

Humphreys was born in Derby, Connecticut, on 10 July 1752. He later graduated from Yale College, and briefly taught school. In 1776, he volunteered for his state's militia. Near the end of the war, he became an aide-de-camp to General Washington. In 1781, he received a dress sword from Congress for his service at Yorktown. At the end of the war, he accompanied Washington to his home, Mount Vernon. Humphreys remained there until his 1784 appointment as secretary of the American delegation sent to Paris to negotiate post-Revolution commercial treaties with the European nations. After his return to the United States two years later, he entered the Connecticut legislature. At that time, he also co-wrote a series of satirical poems later published as the "Anarchiad."

In 1790, President Washington appointed Humphreys the first American minister to Portugal. There, he collected intelligence information for Secretary of State Thomas Jefferson on the long-standing feud between Spain and England. Humphreys also became America's representative on the Barbary Coast and, in 1796, minister plenipotentiary to Spain. On his return to America in 1802, Humphreys employed himself raising Spanish Merino sheep and manufacturing fine woolen cloth for which the Massachusetts Society for Promoting Agriculture awarded him a gold medal. He returned to military service briefly during the War of 1812 as commander of his state's veteran volunteers. Humphreys died in Boston on 21 February 1818.

In 1808, Humphreys sat for his Peale Museum portrait, which was entered in the museum's accession book on 30 December 1808.[1] Rembrandt Peale (1778–1860) completed the Humphreys portrait just prior to the artist's first visit to France. There, Peale absorbed the painting techniques and color palette use of Jacques-Louis David and his circle.

‹―⦾›―

Provenance:
Listed in the 1813 Peale Museum catalog. Purchased at the 1854 Peale Museum sale.

Physical Description:
Oil on canvas. Half length, facing slightly to the sitter's right. Black coat, white waistcoat and shirt with stock. Gray hair, hazel eyes. Chair back in lower right corner. Dark brown background. 28½ inches H × 23⅛ inches W.

[1] Miller, *Selected Papers* 2:2, page 1157. Rembrandt Peale identified the painting as his in a copy of the 1854 Peale Museum sale catalog. *Peale's Museum Gallery of Oil Paintings. Thomas & Sons, Auctioneers. Catalogue of the National Portrait & Historical Gallery 6th October, 1854*, entry number 210. Collections of Independence National Historical Park.

Catalog Number INDE14072

(SN 13.123)

[1] Charles Willson Peale to
Samuel Huntington, 9 March
1781 (Miller, *Selected Papers*
1, pages 360–351).

SAMUEL HUNTINGTON (1731–1796)
by Charles Willson Peale, from life, 1783

H untington was born on
3 July 1731 in Windham,
Connecticut. He attended
the local school, and was then
apprenticed to a cooper. He taught
himself Latin and law, and was
admitted to the bar in 1758 when
he opened a practice in Norwich.
Later, he was elected to the state
legislature, and he served in other
public offices including king's
attorney, representative to the
upper house of the state legisla-
ture, judge, and chief justice of the
state Superior Court. In 1776, he
represented Connecticut in the
Continental Congress and signed
the Declaration of Independence.
He returned to Congress and was
elected its president in 1779,
serving through 1781. As such, he
was the first president of the United
States in Congress Assembled
to serve under the Articles of
Confederation, which took effect
early in that year. He was elected
lieutenant governor of Connecticut
in 1785 and the next year he
became governor. He held that
post until his death on 5 July 1796.

Huntington's brief return to
Congress in Philadelphia in July
1783 would have been the first
opportunity that Charles Willson
Peale had to take his portrait for
the museum. Peale had begun
courting Huntington's favor as a
potentially influential patron in
1781, when he sent the president of
Congress an engraving of George
Washington.[1] The Huntingdon

portrait was listed as "President of
Congress" in the first advertise-
ment of the contents in Peale's
Museum in the 13 October 1784
issue of the *Freeman's Journal and
Philadelphia Daily Advertiser.*

Provenance:
Listed in the 1795 Peale Museum catalog.
**Purchased by the City of Philadelphia at
the 1854 Peale Museum sale.**

Physical Description:
*Oil on canvas. Bust length, facing forward.
Black coat and waistcoat, white stock and
jabot. Gray hair tied in a queue, brown eyes.
Olive green background. 20⅞ inches H ×
17 inches W.*

CHARLES JARED INGERSOLL (1782–1862)
by Thomas Sully, from life, 1839

Catalog Number INDE12565

Ingersoll was born on 3 October 1782 in Philadelphia. After attending Princeton, he studied law and then joined the Pennsylvania bar as had his father and grandfather (see below for both). In 1812, he entered the United States House of Representatives, where he chaired the judiciary committee. Later, he became United States district attorney for Philadelphia and retained the position for fourteen years. Later, he spent one term in the state assembly, attended his state's constitutional convention, and served briefly as secretary to the United States diplomatic legation to Prussia.

Ingersoll returned to the House of Representatives in 1840. He served as chairman of the committee on foreign affairs during the annexation of Texas, and advocated compromise in the increasingly heated debates between pro- and anti-slavery factions in Congress. During this time, he filed charges of fiscal mismanagement against former secretary of state Daniel Webster, who retaliated by leading the Senate in its rejection of Ingersoll's 1847 appointment as United States minister to France. Thereafter he followed a literary career, writing on law and history and publishing his memoirs. Ingersoll died in Philadelphia on 14 May 1862.

Philadelphia artist Thomas Sully (1783–1872) painted a portrait of Ingersoll in 1839 at the request of the sitter's son, Henry. The artist had just returned from a year in London, where he painted the portrait of Britain's new queen, Victoria.[1] There was a long association between Sully and the Ingersoll family. Earlier, the artist had painted Ingersoll's brother Joseph Reed and his wife Ann (née Wilcocks), Ann's brother Benjamin Chew Wilcocks and sister Mary (who later married Charles Jared), and another sister-in-law, Catherine Ann (née Brinton); after painting Charles Jared's portrait, he portrayed his son Charles Junior and daughter-in-law Susan (née Brown), another daughter-in-law, Sarah (née Roberts), and his niece Mary.[2]

❧

Provenance:
Given to Independence National Historical Park by Anna Warren Ingersoll, the sitter's great-granddaughter, in 1986.

Physical Description:
Oil on canvas. Half length, facing slightly toward the sitter's right. Black coat, yellow waistcoat, white shirt, black stock. Brown hair, blue eyes. Green background. Inscribed on reverse "TS 1839." 30 inches H × 25 inches W.

[1] Monroe H. Fabian, *Mr. Sully, Portrait Painter*, exhibition catalog (Washington D.C.: Smithsonian Institution Press, 1983), 16, 96–99.

[2] Charles Henry Hart, "Thomas Sully's Register of Portraits, 1801–1871," *Pennsylvania Magazine of History and Biography* 33 (1909): 53 and 212; Edward Biddle and Mantle Fielding, *The Life and Works of Thomas Sully* (Philadelphia: Wickersham Press, 1921), 183. Both of these catalogs erroneously list a second Charles Jared Ingersoll portrait dated 1838.

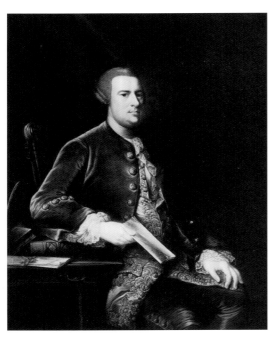

Catalog Number INDE12236

JARED INGERSOLL SENIOR (1722–1781)
by an unknown (possibly English) artist, from life, 1764–1765

Ingersoll was born in Milford, Connecticut, in 1722. Later, he graduated from Yale and opened his own legal practice. In 1751, he was appointed king's attorney for New Haven County. During the 1750s and 1760s, he was his colony's agent sent to London on fiscal matters, including opposition to the 1764 Stamp Act. He became a supporter of the act and returned to Connecticut as its stampmaster. Public condemnation of the measure forced him to resign his post, and he retired to an appointment as justice of the peace. He continued his legal practice (defending Benedict Arnold on an assault charge), and in 1771 moved to Philadelphia as judge of the new vice admiralty court there. During the Revolution, he lived in seclusion, returning to New Haven in 1778. Ingersoll died on 25 August 1781.

This portrait of Ingersoll was probably completed during his last visit to London in 1764–1765. The sitter's rich and formal attire suggests court dress, and the elaborately carved chair he sits in resembles those produced by premier London cabinetmakers of this era. Previously, descendants of the sitter had associated this portrait with Boston painter John Singleton Copley, but this picture is not reminiscent of Copley's 1760s work (this tradition was probably suggested by a marriage between the Ingersoll and Copley families in the early nineteenth century).[1] Ingersoll's residence in Philadelphia also suggested that the portrait might be by locally born artist Henry Benbridge, who worked there in 1770 and 1771.

But none of Benbridge's Philadelphia work survives for comparison,[2] and the earlier English style elements (clothing, furniture) in the painting are not generally associated with Benbridge's work.

❦

Provenance:
Given to Independence National Historical Park by C. Jared Ingersoll, the sitter's great-great-great-grandson, in 1981.

Physical Description:
Oil on canvas. Three-quarter length, seated, facing slightly to the sitter's left. Dark red coat with gold buttons, gold embroidered waistcoat, white stock and jabot, lace cuffs, dark red breeches. Brown hair, blue eyes. Chippendale chair back visible, right elbow on leather-bound books resting on mahogany table with center drawer, right hand holding folded document. Left hand on knee. Dark background. 56 inches H × 46½ inches W.

[1] Jules David Prown does not mention the Ingersoll in *John Singleton Copley*, (Cambridge, Mass.: Harvard University Press, 1966).

[2] Robert G. Stewart, *Henry Benbridge (1743–1812), American Portrait Painter*, exhibit catalog, National Portrait Gallery (Washington, D.C.: Smithsonian Institution Press, 1971), 19.

JARED INGERSOLL JUNIOR (1749–1822)

1. by Charles Willson Peale, from life, 1820

Catalog Number INDE11096

Ingersoll was born in New Haven, Connecticut, on 27 October 1749. As did his father (see above), he graduated from Yale and practiced law in New Haven. He then studied law further at London's Middle Temple, and moved in 1776 to France, where he lived for two years before returning to Philadelphia. In 1780, he served a year in the Continental Congress. He was later appointed to the federal Constitutional Convention, but attended only sporadically due to business demands. He represented Senator William Blount during his 1797 impeachment proceedings, and the State of Georgia in *Chisolm v. Georgia* before the United States Supreme Court (the initial verdict against Ingersoll's client was overturned by the Eleventh Amendment to the Constitution). In 1800, he served briefly as United States attorney for the Eastern District of Pennsylvania, and from 1811 until 1817 he was Pennsylvania's attorney general. He was the unsuccessful Federalist candidate for the vice presidency in the election of 1812, and then presided over the Philadelphia District Court. Ingersoll died in Philadelphia on 31 October 1822.

1. One of Ingersoll's clients was artist Charles Willson Peale. The lawyer oversaw Peale's 1805 patent violation suit for the rights to his physiognotrace (a mechanical device used to trace profiles), and he defended the artist's thwarted 1817 attempt to make the Peale Museum a municipal institution. Perhaps most important to Peale was Ingersoll's assistance in obtaining for the artist's son Franklin an 1820 annulment of his disastrous marriage. Peale's portrait of Ingersoll, completed in early 1820, was not intended for Peale's Philadelphia Museum, but rather was a gift to the sitter's family. The final portrait pleased Peale and his contemporaries; he noted that observers of the painting at the Pennsylvania Academy of the Fine Arts had "spoken off [*sic*] [it] in the highest terms of admiration."[1] A year later, Peale retouched the portrait so that "the coloring [was] not so hard."[2] This painting illustrates how Peale's use of color had developed during his late career; the complementary colors red and green are harmoniously applied with compatible values in the background. Also, the sitter's skin tones are well-modeled with warm hues, while its highlights are uniformly lightened without adding white pigment.

Provenance:
Given to Independence National Historical Park by Anna Warren Ingersoll, the sitter's great-great-granddaughter, in 1986.

Physical Description:
Oil on canvas. Three-quarter length, seated, facing slightly to the sitter's right. Black coat and waistcoat, white stock and jabot. Gray hair, brown eyes. Chair back visible, sitter's left elbow resting on a document on a table, holding a book in left hand. Red drapery in upper left. Green background. 28⅝ inches H × 23³⁄₁₆ inches W.

[1] Charles Willson Peale to Angelica Kauffman Peale Ramsey, 22 February 1820 (Miller, *Selected Papers 3*, page 805).

[2] Charles Willson Peale to Raphaelle Peale, 14 January 1821 (Miller, *Selected Papers 4*, page 7).

Catalog Number INDE

(SN 13.126)

JARED INGERSOLL JUNIOR (1749–1822)
2. by George Cochran Lambdin, after Charles Willson Peale, 1874

2. During preparations for the Centennial celebration, the City of Philadelphia commissioned a portrait of Ingersoll (a Constitution signer) from local artist George Cochran Lambdin (1830–1896). Lambdin copied Peale's 1820 life portrait (now in the Independence collection).

⸻❧⸻

Provenance:
Purchased by the City of Philadelphia from the artist in 1874.

Physical Description:
Oil on canvas. Bust length, slightly facing subject's left. Black coat and waistcoat, white stock and jabot. Gray hair, brown eyes. Dark background. 24 inches H × 20 inches W.

MARY WILCOCKS (MRS. CHARLES JARED) INGERSOLL (1784–1862)
by Thomas Sully, after Thomas Sully, 1808

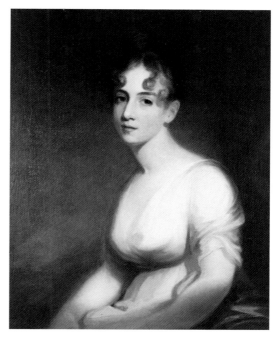

Catalog Number INDE12564

The granddaughter of colonial Pennsylvania's Chief Justice Benjamin Chew, Mary Wilcocks was born on 2 January 1784. At the age of twenty, she married Philadelphia attorney Charles Jared Ingersoll (see above). The Ingersolls made their home on Girard Street in Philadelphia and at their rural estate, Fern Hill. They had nine children, two of whom followed their father into the legal profession. After a debilitating illness in the last five years of her life, Mrs. Ingersoll died on 28 August 1862.

During his long artistic career, Philadelphia artist Thomas Sully (1783–1872) cultivated patrons among the families of his city's economic and political elite. He formed an early association with Benjamin Chew Wilcocks, Mrs. Ingersoll's brother, who made his fortune in the China trade. Wilcocks commissioned portraits of himself and his sisters, Ann and Mary, in late 1807 and early 1808.

Sully actually painted two portraits of Mary (Mrs. Ingersoll) during February of 1808; the life portrait (now unlocated) was for Wilcocks, and the replica (now in the Independence collection) was probably for Mary's husband Charles Jared, whom she had married in 1804.[1]

❧

Provenance:
Given to Independence National Historical Park by Anna Warren Ingersoll, the subject's great-granddaughter, in 1986.

Physical Description:
Oil on canvas. Half length, facing the sitter's right. White Empire-style dress, yellow shawl draped over left arm. Brown hair, brown eyes. Green background. Inscribed on reverse "Sully/1808." 29 inches H × 24 inches W.

[1] Sully painted a second replica (now unlocated) of Mary Wilcocks Ingersoll's portrait in 1843, possibly for her daughter, Anne Wilcocks Meigs. Charles Henry Hart, "Thomas Sully's Register of Portraits, 1801–1871," *Pennsylvania Magazine of History and Biography* 33 (1909): 53, 207–208; Edward Biddle and Mantle Fielding, *The Life and Works of Thomas Sully* (Philadelphia: Wickersham Press, 1921), 183, 319–320.

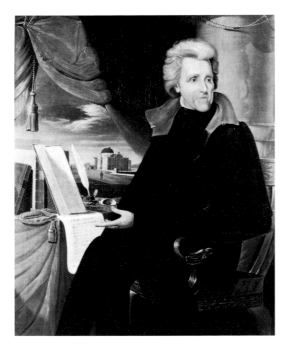

Catalog Number INDE11873

(SN 13.128)

ANDREW JACKSON (1767–1845)
by David Rent Etter, after the James Barton Longacre engraving from a painting by Joseph Wood, 1835

Jackson was born on the South Carolina frontier on 15 March 1767. Orphaned at fourteen, he moved to North Carolina, where he read law. In 1788, he moved to the state's frontier settlement of Nashville and became its prosecuting attorney. When the frontier territory achieved statehood as Tennessee eight years later, Jackson attended its constitutional convention and represented the new state in the United States House of Representatives. The following year, he served briefly in the Senate. In 1798, Jackson returned to Tennessee as a circuit court judge and major general of the state militia.

Jackson's subsequent military career established his popular reputation beyond his state, and provided the basis for his future success in politics. During the War of 1812, his troops defeated Native American tribes in the Mississippi Territory, and British regulars at the battle of New Orleans. In 1818, Jackson's zeal in pursuing warring Seminole tribes into Spanish Florida nearly caused a diplomatic crisis for President James Monroe's administration. After the United States purchased Florida from Spain in 1821, Jackson resigned his army commission and served briefly as the new territory's governor.

Jackson and his political supporters made his status as a military hero the focus of his 1828 presidential campaign. His re-election in 1832 established the Democratic party as paramount in American politics. During his presidency, Jackson prevented the rechartering of the Bank of the United States and then dispersed federal deposits to state banks, a policy that contributed to the subsequent fiscal crisis. He favored territorial expansion, particularly into Texas, and opposed states' rights, forcing South Carolina to adopt the nation's high protective tariff. After his second term, Jackson retired to his estate, The Hermitage, where he died on 8 June 1845.

Jackson's tremendous popular appeal promised artists a ready market for their portraits of "Old Hickory." Philadelphia artist David Rent Etter (1807–1880) based his 1835 portrait of the president on an engraving, probably that made by James Barton Longacre in 1824 after Joseph Wood's life portrait (now privately owned) of the same year.[1] Etter depicted Jackson seated in the White House. The president points to a copy of his 1832 proclamation instructing the people of South Carolina to accept the national tariff. Upon the proclamation rests a dress sword and a bound copy of the Constitution, which leans against biographies of Thomas Jefferson and William Penn. Through the window, the northern end and eastern facade of the United States Capitol are visible. Here, the artist misunderstood the orientation of the White House, which is northwest of the Capitol. Etter probably painted this portrait (along with one of Benjamin Franklin, see above) for his fellow commissioners of Southwark, an independent municipality that merged with the City of Philadelphia in 1854. The Commissioners gave the Jackson portrait to the City of Philadelphia to commemorate this merger.

———❧———

Provenance:
Given to the City of Philadelphia by the Commissioners of the District of Southwark c. 1854.

Physical Description:
Oil on canvas. Full length, seated, head facing the subject's left, torso turned toward the subject's right. Dark blue cloak with red collar. Black coat, black stock, white shirt, black trousers. Gray hair, blue eyes. Red upholstered Empire style armchair, red covered table with leather bound volumes, documents, silver inkwell and quill. Left arm on chair pointing to document. Red drapery pulled back in upper left to reveal architectural view with cloudy sky. Smooth column in upper right. Signed "D. Etter/Pinx/1835" in lower left. 50 3/16 inches H × 40 1/2 inches W.

———

[1] James G. Barber, *Andrew Jackson: A Portrait Study* (Seattle: University of Washington Press, 1991), 125. A portrait of Jackson attributed to Wood was offered at Sotheby's sale number 6373 in December 1992, but was unsold.

WILLIAM JACKSON (1759–1828)
by an unidentified artist, miniature from life
(later retouched by John Henry Brown), c. 1795

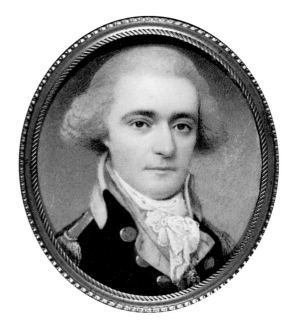

Catalog Number INDE14074
(SN 52.003)

Jackson was born in Cumberland, England, on 9 March 1759. An orphan, he immigrated to Charleston, South Carolina. In 1775, he accepted a lieutenant's commission in the Continental army. He fought at Stono Ferry, Savannah, and the siege of Charleston (where he was briefly imprisoned by the British). In 1781, he served as secretary to John Laurens during a trip to seek war aid from France and Holland. Jackson returned to America in the following year and became assistant secretary of the War Department under his former commander, Benjamin Lincoln.

After the war, Jackson briefly pursued commercial projects in Europe. In 1787, he served as secretary to the federal Constitutional Convention. After a failed effort to secure appointment as secretary to the United States Senate, he joined the Philadelphia bar and spent two years as one of President George Washington's personal secretaries. In 1791, Jackson refused an appointment as adjutant general of the army and returned to his mercantile interests abroad. He then worked as Philadelphia's surveyor of customs from 1796 until 1802. Subsequently, he edited one of the city's Federalist newspapers, the *Political and Commercial Register*, and served as secretary of the Pennsylvania chapter of the Society of the Cincinnati. He died on 17 December 1828.

This miniature shows Jackson uniformed as a major (the rank by which he was addressed both during and after the Revolution) and wearing the badge of the Society of the Cincinnati. The portrait was probably painted during the 1790s, possibly for Miss Elizabeth Willing, whom Jackson married in late 1795. At this time, the preeminent miniaturist in Philadelphia was James Peale (1749–1831), the younger brother of Charles Willson Peale. However, during the first half of the nineteenth century, Jackson's family commissioned Philadelphia artist John Henry Brown (1818–1891) to repair the miniature by inpainting it.[1] Brown's work has obscured the original surface of the miniature, making attribution to the initial artist difficult.

~⚬⚬~

Provenance:
Given to the City of Philadelphia by Ann Willing Jackson, the sitter's daughter, in 1876.

Physical Description:
Watercolor on ivory. Bust length oval miniature. Dark blue uniform coat with buff facings, gold epaulettes. White stock and jabot. Powdered hair, blue eyes. Society of the Cincinnati medal suspended from blue ribbon in left lapel. Variegated blue background. Framed in gadrooned edge inner bezel with reddish-brown velvet outer lining and pearl beading around outermost rim. 1⅞ inches H × 1½ inches W.

[1] In 1876, the same donor gave a slightly larger copy of the Jackson miniature to the Historical Society of Pennsylvania. This copy has not been studied for the possibility of its association with Brown's work on the original miniature. The copy was referred to in the nineteenth century as a work by John Trumbull.

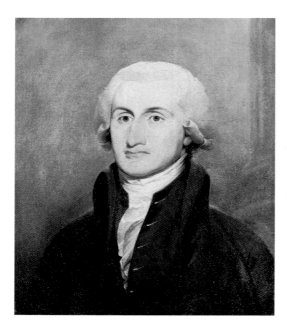

Catalog Number INDE14086

(SN 13.130)

JOHN JAY (1745–1829)
by an unidentified artist, after John Trumbull, c. 1875

Jay was born in New York City on 12 December 1745. After he graduated from King's College (now Columbia) in 1764, he studied law and gained admittance to the New York bar. In 1774, he joined New York's Revolutionary committee of correspondence and had a seat in the First and Second Continental Congresses. After a two-year hiatus, during which he helped to draft New York's first constitution, he returned to Congress in late 1778. He was then elected its president and served for several months until he accepted an appointment as America's minister plenipotentiary to Spain. For nearly two years, Jay tried unsuccessfully to gain formal Spanish recognition of America's independent status. In early 1782, he left Madrid for Paris as one of the commissioners appointed to negotiate the peace between America and England.

Back in America, Jay served as secretary of foreign affairs and negotiated several trade treaties with European nations. In 1789, President George Washington appointed him the first chief justice of the United States Supreme Court. During his tenure, Jay also negotiated the 1794–1795 treaty between America and England that established procedures for evacuating British outposts in the Northwest Territory, settled boundary and war reparation disputes between the two nations, and gave England free navigation of the Mississippi River. Jay resigned his judicial and diplomatic appointments in 1795, and became governor of New York, serving until 1800. He died on 17 May 1829.

During the Centennial decade, the City of Philadelphia collected portraits for Independence Hall's historical museum. The city obtained a portrait of Jay copied by an unidentified artist from John Trumbull's 1805 full-length portrait of the sitter (owned by the City of New York) wearing his formal wig. The date of Philadelphia's acquisition is uncertain; the portrait is not mentioned in the Independence Hall collection inventory of 1878 but it is listed in that of 1884.

Provenance:
Unknown. Acquired by the City of Philadelphia between 1878 and 1884.

Physical Description:
Oil on canvas. Bust length, facing forward. Dark gray coat and waistcoat. White stock and jabot. White wig, blue eyes. Fluted column in upper right. Light brown background. 24⅛ inches H × 20½ inches W.

THOMAS JEFFERSON (1743–1826)

Jefferson was born in Goochland (now Albemarle) County on the Virginia frontier on 2 April 1743. Educated at home by tutors, he was an avid classical scholar who later graduated from the College of William and Mary, and then studied law with George Wythe. He inherited a significant land holding and in 1769 became a member of the House of Burgesses, where he remained (except for 1772) until its dissolution in 1775. He was an early advocate for the creation of Virginia's committee of correspondence, and wrote publicly on the concept of natural rights. He entered the Second Continental Congress and, during that service, drafted the Declaration of Independence using many concepts from his previous work in writing Virginia's new constitution.

In late 1776, Jefferson returned to the Virginia legislature, where he promoted the separation of church and state, and changes in land inheritance, prosecution of criminal cases, and the state's educational system. He became governor in 1779, but was forced to abdicate when the British occupied Richmond in 1781. He then resumed his private studies, penning *Notes on the State of Virginia*. He returned to Congress in 1783 for a short but active term, in which he submitted reports on financial programs and westward expansion. In 1785, he succeeded Benjamin Franklin as America's foreign minister to France. There, Jefferson secured some commercial and diplomatic successes while immersing himself in art and scientific study.

After returning to America, Jefferson became secretary of state in 1790. During the next three years, he clashed openly with Secretary of the Treasury Alexander Hamilton over the concept of republicanism, the direction of American economic policy, and American foreign relations. He resigned his secretariat in late 1793, not returning to politics until his 1796 election as America's vice president. As such, his responsibility focused on presiding over the United States Senate (for which he prepared a manual of procedures). During this time, he also drafted the Kentucky Resolutions on the constitutional issue of limits to the federal government's power.

In 1800, Jefferson succeeded John Adams as president of the United States in a close race decided by vote in the House of Representatives (a circumstance that led to the adoption of the Twelfth Amendment to the Constitution). During his first administration, Jefferson secured for the United States all the Louisiana Purchase, extending the nation's frontier to the Pacific Ocean. During his second administration, he experienced growing hostilities between the United States and Great Britain over territorial rights on America's northern border and on the Atlantic Ocean. His 1807 embargo on British trade failed due to congressional pressure, and he left the presidency the following year.

During his last retirement, Jefferson pursued the classics, architecture, and agriculture. He founded the University of Virginia in 1819, and continued his voluminous personal correspondence. Jefferson died at Monticello on 4 July 1826.

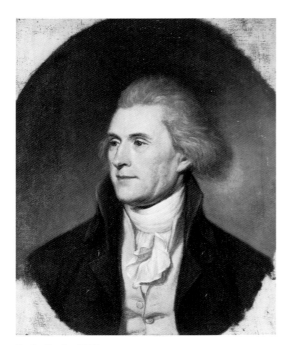

Catalog Number INDE11883

(SN 13.131)

[1] Charles Willson Peale, "my design in forming this Museum," broadside, Philadelphia, 1792 (Miller, *Selected Papers* 2:1, pages 12–19.

[2] In 1944, Fiske Kimball of the Philadelphia Museum of Art examined the museum portrait under X-ray and declared the painting a copy. Subsequent restoration of the portrait removed past revarnishing and inpainting to reveal Peale's original work (Sellers, *Supplement*, 67–68). There are three copies of the Jefferson museum portrait at: the Huntington Library and Art Gallery, the U.S. Department of State, and unlocated (currently known through photographs only); these pictures, by apparently unidentified artists, appear to date from the 19th century (David Meschutt, independent scholar, to Karie Diethorn, Chief of Museum Branch, Independence NHP, 29 May 2001).

[3] Alfred L. Bush, *The Life Portraits of Thomas Jefferson*, exhibit catalog, University of Virginia Museum of Fine Arts (Charlottesville, Va.: The Thomas Jefferson Memorial Foundation, 1962), 32–33. Rembrandt Peale's 1799–1800 portrait of Jefferson (now owned by the White House) soon overtook the museum portrait in popularity (Miller, *Selected Papers* 2:1, page 298 n.1). In 1805, Rembrandt painted another Jefferson portrait (now owned by the New York Historical Society).

THOMAS JEFFERSON (1743–1826)
1. by Charles Willson Peale, from life, 1791–1792

1. Charles Willson Peale shared many of Jefferson's scientific and artistic interests, and saw in Jefferson an important potential ally for the Philadelphia Museum. In late 1791, the artist requested a portrait sitting from the secretary of state. Less than a month later, Jefferson subscribed to the Peale Museum as one of its leading supporters.[1] Jefferson and Peale exchanged ideas on everything from polygraphs, eyeglasses, and milk carts to the removal of skunk odor. Later, as president, Jefferson donated many gifts, most notably specimens from the Lewis and Clark expedition, to Peale's Museum.

Among Peale's most outstanding museum portraits, the Jefferson portrait demonstrates the artist's virtuosity in its easy transition between light and shadow, its definition of features with minimal outline, and its successful illusion of three-dimensional space.[2] Unique to this work are details such as the delicate veining around Jefferson's eye, the subtle highlights on his lips and nose and the complementing shades of blue in the background, eyes, and coat.

This is the only portrait of Jefferson that shows his natural auburn hair. This portrait also was the first likeness of Jefferson disseminated through prints. Copied as early as 1795, when William Birch displayed his artist's proof in the Columbianum exhibition, the print gave Americans a glimpse of their future President.[3]

❦

Provenance:
Listed in the 1795 Peale Museum catalog. Purchased by the City of Philadelphia at the 1854 Peale Museum sale.

Physical Description:
Oil on canvas. Bust length, facing the subject's right. Dark blue coat, yellow waistcoat, white stock and jabot. Auburn hair, blue eyes. Gray background. 23¼ inches H × 19 inches W.

THOMAS JEFFERSON (1743–1826)
2. by James Sharples Senior, from life, 1796–1797

2. During his first visit to the United States, British pastelist James Sharples Senior (1751–1811) lived in Philadelphia during 1796 and 1797. At that time, he painted a portrait of Jefferson. The artist's catalog, published upon his return to England in 1802, lists this portrait as "Thomas Jefferson, esq., President of the United States of America." A pencil copy of the portrait by Sharples's wife Ellen is in the West of England Art Gallery in Bristol.

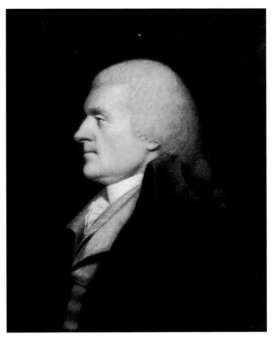

Catalog Number INDE11905

(SN 7.013)

—⚬⚬⚬—

Provenance:
Listed in the 1802 Bath catalog of Sharples's works. Given by Ellen (Mrs. James) Sharples to Felix Sharples in 1811. Given by Felix Sharples to Levin Yardly Winder in the 1830s. Inherited by Nathaniel James Winder from Levin Yardly Winder. Inherited by Richard Bayly Winder from Nathaniel James Winder in 1844. Purchased by Murray Harrison from Richard Bayly Winder around 1865. Purchased by the City of Philadelphia from Murray Harrison in 1874.

Physical Description:
Pastel on paper. Half length, left profile. Blue coat, buff waistcoat with light blue lining, white stock and cravat. Powdered hair, blue eyes. Blue-gray background. 9 inches H × 7 inches W.

Catalog Number INDE14085

(SN 13.135)

THOMAS JOHNSON (1732–1819)
by Francis Blackwell Mayer, after Charles Willson Peale, c. 1874

Johnson was born on 4 November 1732 in Calvert County, Maryland. He received his early education at home and was later employed as a clerk in Annapolis's land office. At that time, he also studied law with Stephen Bordley and then opened his own legal practice. In 1762, Johnson represented his county in the provincial assembly and served for several years. He was elected to the Continental Congress in 1774, later presenting the formal nomination of George Washington as commander-in-chief of the Continental army. Although Johnson left Congress before the Declaration of Independence was formally adopted, Johnson supported Maryland's approval of the break with England. He helped to draft Maryland's first constitution in 1776, served in his state's militia, and then spent two years as Maryland's governor.

After the war, Johnson returned to Maryland's legislative service, where he supported the adoption of the Articles of Confederation and, later, of the federal Constitution. He spent several months as chief justice of Maryland's General Court before, in mid-1791, President George Washington appointed him as an associate justice of the United States Supreme Court. Johnson was also a member of the board of commissioners for the new federal capital on the Potomac that he and his colleagues decided to call Washington. In 1794 Johnson left public office, refusing an appointment as secretary of state. He died in Frederick on 26 October 1819.

In 1874, the state of Maryland donated three portraits of Revolutionary-era statesmen (Johnson, William Paca and Thomas Stone—see below) to the historical collection at Independence Hall. Baltimore artist Francis Blackwell Mayer (1827–1899) copied Charles Willson Peale's 1824 posthumous portrait of Johnson (now located at the Maryland State House) that had been commissioned by the Corporation of Annapolis from Peale's 1772 portrait of Johnson and his family (now privately owned).

~⚬⚬⚬~

Provenance:
Given to the City of Philadelphia by the state of Maryland in 1874.

Physical Description:
Oil on canvas. Bust length, turned to the subject's left, head down. Black coat and waistcoat, white stock and jabot. Brown hair, gray eyes. Subject's left hand on left cheek. Dark green background. 24⅛ inches H × 20³⁄₁₆ inches W.

UNIDENTIFIED MAN of the Johnson family
by James Sharples Senior, from life, c. 1795–1801

At the time of the Centennial, the City of Philadelphia purchased this portrait in the belief that it depicted William Samuel Johnson, a member of the 1787 Constitutional Convention and a president of Columbia University. British pastelist James Sharples Senior (1751–1811) did include "Dr. Johnson, President of the College of New York" among the subjects in his 1802 catalog of portraits. However, the Independence portrait is not like the one by Ellen Sharples (the artist's wife) that was copied from her husband's work and labeled "Dr. Johnson" in her sketchbook.[1] Nor does the Independence pastel resemble Sharples's portrait (now owned by the Colonial Dames of Ohio and on loan to the Cincinnati Art Museum) of New York legal writer William Johnson (1769–1848). Sharples listed the writer as "Wm. Johnson, esq. Author" in his catalog, and Ellen Sharples also copied him in her sketchbook as "William Johnson, Esq."[2]

The Independence pastel is possibly a son of William Samuel Johnson, the Constitution signer.[3] There are no known portraits of the Constitution signer's sons with which to compare the Independence pastel. There is, however, a resemblance (which may be considered familial) between the Independence pastel and portraits of the signer by Robert Edge Pine (Columbia University), Gilbert Stuart (privately owned), and John Wesley Jarvis (National Portrait Gallery, Smithsonian Institution).

Johnson's sons, Samuel William (1761–1846) and Robert Charles (1766–1806), both graduated from Yale and practiced law in Stratford, Connecticut. In Sharples's 1802 catalog, the artist lists "[illegible] Johnson, esq.," which may refer to this portrait.

———

Provenance:
Given by Ellen (Mrs. James) Sharples to Felix Sharples in 1811. Given by Felix Sharples to Levin Yardly Winder in the 1830s. Inherited by Nathaniel James Winder from Levin Yardly Winder. Inherited by Richard Bayly Winder from Nathaniel James Winder in 1844. Purchased by Murray Harrison from Richard Bayly Winder around 1865. Purchased by the City of Philadelphia from Murray Harrison in 1874.

Physical Description:
Pastel on paper. Half length, left profile. Blue coat, white stock and cravat. Powdered hair tied in a queue, gray eyes. Blue-green variegated background. 9 inches H × 7 inches W.

Catalog Number INDE11933
(SN 7.042)

[1] Knox, *Sharples*, 101, illustration 76. The sketchbook is in the City of Bristol Art Gallery.

[2] The Ohio Dames portrait is mistakenly identified as William Johnson of Charleston (1771–1834), who was not portrayed by Sharples. Ellen Sharples's pencil sketch of William Johnson the author is shown in Knox, page 101, illustration 60. In *Diary of William Dunlap (1766–1839)* (New York: New-York Historical Society, 1930), 1, page 201, James Sharples's portrait of Johnson the author is mentioned. John Wesley Jarvis painted a portrait of Johnson the author in 1816 (now at the New-York Historical Society).

[3] The identity of the Independence pastel as that of Samuel William Johnson was suggested in George C. Groce, Jr., *William Samuel Johnson, A Maker of the Constitution* (New York: AMS Press, Inc., 1967), 196.

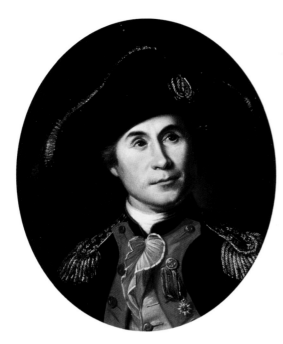

Catalog Number INDE11886

(SN 13.137)

JOHN PAUL JONES (1741–1792)
by Charles Willson Peale, from life, c. 1781–1784

John Paul (he added "Jones" later) was born on 6 July 1747 in Kirkbean, Scotland. He attended the parish school and then went to sea as an apprentice. Within four years, he captained his own trading ship, sailing between English ports and the West Indies. During the early 1770s, he was involved in a series of controversial command decisions that resulted in the deaths of two crew members, and he fled to America. In 1775, he moved to Philadelphia under the name of John Paul Jones. There, he obtained a Continental navy appointment and captained several ships in raids against the British. In 1776, he commanded a worn-out French merchant ship, which he renamed the *Bonhomme Richard* (after Benjamin Franklin's nom de plume "Poor Richard"), against the British frigate *Serapis*. Jones's refusal to accept defeat in this battle, even as his ship sunk with nearly all her guns disabled, was one of the American navy's most celebrated victories during the Revolution.

After the Revolution, Jones lived in France, where his naval exploits gained him the reputation of a romantic, swashbuckling privateer. Despite his appointment as commander of the Russian fleet against the Turks in 1788, he continued to consider himself an American citizen. Jones died in Paris on 18 July 1792. In 1913, his remains were reinterred in the United States Naval Academy chapel in Annapolis.

Charles Willson Peale may have painted his Museum portrait of Jones as early as 1781. In this portrait, the sitter wears the French Cross of the Institution of Military Merit, which Louis XVI presented to him in 1780. Early in the following year, Jones returned to Philadelphia, where Congress confirmed his acceptance of the French decoration. Peale knew of the congressional honor and he may have taken Jones's portrait during the six-month period in 1781 when the captain was in America to receive it. On the other hand, Jones returned to Philadelphia in 1783; that may have been the occasion of this portrait. The portrait is listed in Peale's 13 October 1784 *Freeman's Journal and Pennsylvania Daily Advertiser* announcement of the museum. Jones and his exploits provided Peale with material for an additional museum endeavor; in 1786, the artist made the "Gallant action of Paul Jones in taking the Serapis" the topic of a painting for his moving picture exhibition.[1]

Provenance:
Listed in the 1795 Peale Museum catalog. Purchased by the City of Philadelphia at the 1854 Peale Museum sale.

Physical Description:
Oil on canvas. Bust length, facing the sitter's left with head cocked. Dark blue uniform coat with red facings, gold epaulettes with silver stars, brass buttons with anchor motif, off-white waistcoat, white stock and jabot. Black tricorner hat with silver lace edging; red, white, and blue cockade. Powdered hair tied in a queue with a black ribbon, gray eyes. Gold medal (French Cross of the Institution of Military Merit) hanging from blue ribbon through top left buttonhole. Brown background. 22¼ inches H × 19¹⁵⁄₁₆ inches W.

[1] Sellers, *Portraits and Miniatures*, 114. Charles Willson Peale to George Weedon, 21 February 1786 (Miller, *Selected Papers* 1, page 441).

JOHANN, BARON DE KALB (1721–1780)
by Charles Willson Peale, from life, 1781–1782

De Kalb was born in Huettendorf, Bavaria, on 19 June 1721. This peasants' son later learned French, English, and sufficient social skills to obtain a substantial military commission in the Lowendal Regiment of the French army, with which he served throughout the War of Austrian Succession. In 1763, at the battle of Wilhelmstahl, he won the Order of Military Merit that gave him his baronic title. Five years later, he traveled to America on a secret mission for France to determine the extent of colonial discontent there. Later, he and his protégé, the Marquis de Lafayette, went to America in 1777 and joined the Continental army, which De Kalb served in an administrative capacity. During the spring of 1780, he received his first field command, leading the American army to relieve besieged Charleston, South Carolina. At the battle of Camden later that summer, he was mortally wounded and captured by the British. De Kalb died on 18 August 1780.

In 1780, before De Kalb left for South Carolina, he commissioned Charles Willson Peale for two half-length portraits. Peale completed the works (one is now privately owned, the other unlocated; a modern half-length copy is located at Versailles) and shipped them to the sitter's family in Europe.

Within a year following De Kalb's death, Peale had painted another portrait of him for the Philadelphia Museum. The museum portrait may represent Peale's response to De Kalb's posthumous congressional honor—a monument in Annapolis—with the idea to start a portrait gallery to commemorate Revolutionary heroes.[1] The portrait is listed in Peale's 13 October 1784 advertisement for the museum in the *Freeman's Journal and Philadelphia Advertiser*.

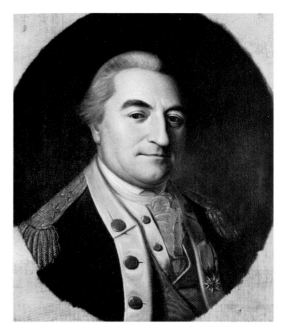

Catalog Number INDE14084
(SN 13.139)

Provenance:
Listed in the 1795 Peale Museum catalog. Purchased by the City of Philadelphia at the 1854 Peale Museum sale.

Physical Description:
Oil on canvas. Bust length, facing slightly to the sitter's left. Dark blue coat with buff facings and gold epaulettes with two silver stars, buff waistcoat, white stock and jabot. Powdered hair, brown eyes. Wearing light blue sash with gold medal (Knight's Cross, third class, of the order of Military Merit created in 1759 for Swiss and German Protestant officers in the French service). Dark brown background. 23⅜ inches H × 18¼ inches W.

[1] Sellers, *Portraits and Miniatures*, 115. Peale may have painted a fourth De Kalb portrait, later purchased by James Read Lambdin in 1826. In Lambdin's 1834 Louisville Museum catalog, he lists a "Portrait of Baron de Kalb, an Original" by C.W. Peale. The portrait is now unlocated (Sellers, 212).

Catalog Number INDE11900

(SN 7.008)

JAMES KENT (1763–1847)
attributed to a member of the Sharples family (possibly Ellen),
after James Sharples Senior, c. 1798–1810

Kent was born in Fredericksburgh (now Southeast), New York, on 31 July 1763. He later graduated from Yale, where he founded the Phi Beta Kappa society, and read law in the Poughkeepsie office of New York's attorney general. He later served three nonconsecutive terms in his state's assembly and ran unsuccessfully for Congress in 1793. He then moved to New York City as Columbia College's first professor of law and the city's recorder. In early 1798, he accepted a seat on the state supreme court, becoming chief justice six years later. During his judgeship, he instituted the practice of submitting written opinions in New York's state supreme court. After retiring from the bench in 1824, he published *Commentaries on American Law*, which went through six editions during his lifetime and eight after his death. Kent died in New York City on 12 December 1847.

During his first visit to America, British pastelist James Sharples Senior (1751–1811) resided for a time in New York City. After returning to England, Sharples recorded the portrait as that of "Judge Kent" in the 1802 catalog of his work. There are two versions of the Sharples Kent portrait; the one at Independence and one in the collections of Columbia University's Low Memorial Library. The Columbia pastel is apparently Sharples's life portrait of Kent. Even though the hair in it has been repainted a shaggy gray, the subtle modeling of the sitter's features and the details in his waistcoat and jabot strongly suggest the senior artist's work.

The Independence pastel may be a later copy by Ellen Sharples (1769–1849). The subject in this pastel is painted in minute detail (particularly in the ear and eye), possibly reflecting Ellen's training as a miniaturist. The subject's appearance also differs substantively from that in the Columbia pastel. The Independence portrait shows Kent with short, brown hair. However, he wears a dark coat with an awkwardly notched lapel, an undetailed dark waistcoat, and a crudely painted jabot. The Columbia portrait shows him in a high collared dark coat, light patterned waistcoat, and finely detailed shirt linen.

Provenance:
Given by Ellen (Mrs. James) Sharples to Felix Sharples in 1811. Given by Felix Sharples to Levin Yardly Winder in the 1830s. Inherited by Nathaniel James Winder from Levin Yardly Winder. Inherited by Richard Bayly Winder from Nathaniel James Winder in 1844. Purchased by Murray Harrison from Richard Bayly Winder around 1865. Purchased by the City of Philadelphia from Murray Harrison in 1875.

Physical Description:
Pastel on paper. Half length, right profile. Black coat, black waistcoat, white stock and jabot. Dark brown hair, brown eyes. Gray background. 9 inches H × 7 inches W.

RUFUS KING (1755–1827)
by Charles Willson Peale, from life, 1818

King was born in Scarborough, Massachusetts (now Maine), on 24 March 1755. He later attended Harvard College before studying law and serving as a volunteer aide to General John Sullivan during the Revolutionary Rhode Island campaign of 1777. After the war, he entered the Massachusetts legislature and the Continental Congress. He attended the federal Constitutional Convention of 1787 (serving on the committee that prepared the document's final draft) and supported the new government in his state's ratifying convention. He served briefly in the United States Senate before becoming United States minister to Great Britain in 1796. He later left that office to run unsuccessfully as the Federalist candidate for vice president. He then returned to the Senate in 1813 and briefly to diplomatic service in 1825. King died on Long Island on 29 April 1827.

Charles Willson Peale, on a trip to Washington to gather additional museum portraits, painted his portrait of King in late 1818. When King, pressured by the demands of his office, hesitated to grant the sitting, Peale assured the senator that he was an "expeditious" painter, and completed most of the portrait in one two-hour session.[1] Known for his robust, athletic appearance, King appears much younger than his sixty years in this painting. His dark hair is only lightly flecked with gray and his flesh tones are ruddy and vital. The sitter holds his spectacles in his right hand, a touch that contributes both informality and a sense of activity to King's manner. While waiting for King to arrive for his second and final sitting, Peale wrote to his son that "Mr. Rufus King tells me that he has had several Portraits taken of him but none was in his oppinion [*sic*] so like as this I have on hand … Perhaps I have never made a better portrait."[2]

⁓◦⊙◦⁓

Provenance:
Purchased by the City of Philadelphia at the 1854 Peale Museum sale.

Physical Description:
Oil on canvas. Bust length, facing slightly to the sitter's right, torso turned toward the right. Black coat and waistcoat, white stock and jabot. Graying brown hair, hazel eyes. Right hand holds gold spectacles. Painted wooden chair back in lower right corner. Olive green background. 24¼ inches H × 20¹⁄₁₆ inches W.

Catalog Number INDE14083
(SN 13.142)

[1] Charles Willson Peale, Diary, 15 December 1818 (Miller, *Selected Papers* 3, page 635).

[2] Charles Willson Peale to Rubens Peale, 18 December 1818. Letterbook 16, Peale–Sellers Papers, American Philosophical Society.

Catalog Number INDE14081

(SN 13.143)

¹ Peale's first portrait of Knox was a miniature (now unlocated) painted in 1778 (Sellers, *Portraits and Miniatures*, 116–117).

HENRY KNOX (1750–1806)
by Charles Willson Peale, from life, c. 1784

Knox was born in Boston on 25 July 1750. He attended the Boston Latin School but left to work in a bookstore. He later enlisted in the British army, with which he served during the Boston Massacre (in which his left hand was permanently disabled by a musket failure). At the start of the Revolution, he quickly became a close advisor to General George Washington, who sent him to retrieve the British artillery captured at Fort Ticonderoga. Later, he marched with Washington in the retreat up Manhattan Island, at Trenton, Princeton, Brandywine, Germantown, Monmouth, Yorktown, Valley Forge, and Morristown. Knox briefly succeeded Washington as commander-in-chief, following the latter's retirement in 1783, and he initiated the creation of the Society of the Cincinnati, a fraternity of American and French officers of the Revolution.

Knox was the first secretary of war, entering the office in 1785 and remaining there for a decade. He supported the proposal for a federal Constitutional Convention, persuading the reluctant Washington to attend it. Later, he initiated the construction of the first ships built for the United States navy. Knox retired from public office in 1796 and died at his estate near Thomaston, Maine, on 25 October 1806.

Apparently, Charles Willson Peale painted Knox's museum portrait in the spring of 1784, when the sitter came to Philadelphia for the first national meeting of the Society of the Cincinnati.¹ At that time, Major Pierre L'Enfant brought the Society members their newly cast medals from Paris; Knox wears his in the museum portrait. Although the Knox portrait appears on Peale's 13 October 1784 *Freeman's Journal and Philadelphia Daily*

Advertiser announcement of the museum's contents, the painting has a format different from that of other contemporary Peale Museum examples. Prior to the early nineteenth century, Peale left the museum portraits unpainted at the corners because those areas were covered by oval spandrels within each frame. As a result, the Cincinnati medal on Knox's left lapel was obscured when the portrait hung in the museum. Another inconsistency in the Knox portrait is that the right epaulette has been substantively over-painted, as if to reflect the addition of a star to it. But Knox had received his promotion to brigadier general in the spring of 1782, and would have used two stars on each epaulette from that time onward.

❦

Provenance:
Listed in the 1795 Peale Museum catalog. Purchased by the City of Philadelphia at the 1854 Peale Museum sale.

Physical Description:
Oil on canvas. Bust length, facing slightly to the sitter's right. Dark blue uniform coat with buff facings and gold epaulettes with two stars each, buff waistcoat, white stock and jabot. Powdered hair, blue eyes. Sitter wears gold Society of the Cincinnati medal on blue and white ribbon in upper left buttonhole. Dark brown background. 23³⁄₁₆ inches H × 19½ inches W.

THADDEUS KOSCIUSZKO (1746–1817)
by Julian Rys, after an unidentified source, 1897

Catalog Number INDE14082

(SN 13.144)

Kosciuszko was born on 5 February 1746 in the Palatinate of Brzesc, Grand Duchy of Lithuania (now Poland). He later entered the local Jesuit College, the Royal School in Warsaw, and then the engineering and artillery academy in Mézières, France. In 1776, he arrived in Philadelphia to join the Continental army. His engineering expertise was invaluable to the American Revolutionary cause in the form of defenses for the Delaware River, Ticonderoga, Saratoga, and West Point. In late 1780, he directed troop transportations during General Nathanael Greene's retreat through South Carolina and rode with the cavalry when the British evacuated Charleston in 1782. During the last months of the war, he served at George Washington's headquarters in Newburgh, New York, where the Society of the Cincinnati was founded.

Kosciuszko returned to Europe in 1784, and resumed his military career as major general in the Polish army. During his command, he led his troops and, later, the Polish peasants in rebellion against the Russian tsar. In 1794, he was severely wounded at the battle of Maciejowice and imprisoned by the Russians for two years. Exiled from Poland, he returned briefly to America in late 1797. There, Congress awarded him his back pay and the land he earned during his Revolutionary service. He went to France in 1798, where he recorded his observations of Napoleon's government for America's vice president, Thomas Jefferson. Kosciuszko died in Switzerland on 15 October 1817.

In early 1897, the Polish National Alliance offered the City of Philadelphia portraits of Kosciuszko and Casimir Pulaski (see below) for the gallery of Revolutionary War heroes in Independence Hall. The portraits were painted by Polish expatriate Julian Rys (born 1856). Rys probably copied one of the many engraved images of Kosciuszko produced in Europe and America throughout the nineteenth century. These engravings were based on Josef Grassi's 1792 portrait of Kosciuszko.

⌘

Provenance:
Given to the City of Philadelphia by the Polish National Alliance in 1897.

Physical Description:
Oil on canvas. Bust length, head turned to the subject's left. Black coat with red facings and gold epaulettes. White cravat with lace ruffle. Brown hair, brown eyes. Red, white, and blue sword belt with silver buckle. Gold Society of the Cincinnati medal on blue and white ribbon, gold Polish Cross for Military Valor medal on a blue and white ribbon. Olive-brown background. 24 inches H × 20 inches W.

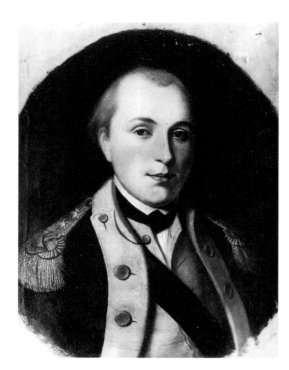

Catalog Number INDE14080

(SN 13.148)

MARIE JOSEPH PAUL YVES ROCH GILBERT MOTIER, MARQUIS DE LAFAYETTE (1757–1834)

1. by Charles Willson Peale, after Charles Willson Peale, 1779–1780

Lafayette was born on 6 September 1757 in Auvergne, France. He attended the Collège du Plessis and a military academy, in keeping with his aristocratic heritage. Seeking adventure, he joined the Continental army in 1777, funding his own ship for the transatlantic passage. In America, he served without pay and provided for his troops out of his own pocket. He fought at Brandywine and Gloucester, wintered at Valley Forge, and accompanied the Monmouth and then the southern campaigns, fighting at Yorktown, where the British surrendered.

After the Revolution, Lafayette encouraged the tenets of republicanism in his home country. He wrote the "Declaration of the Rights of Men" (which he equated with the Declaration of Independence) and presented it to the National Assembly. However, the combination of his aristocratic heritage and his republican politics made him suspect both to the growing revolutionary faction in France and to traditional monarchists. In 1792, he and his family were imprisoned (which probably saved them from the guillotine); they spent the next five years outside of France. When Napoleon assumed power, Lafayette secured his family's release in 1799 and retired to his home near Paris, where he continued to write in support of countries engaged in political reform.

Lafayette returned to America in 1824 on the eve of the Revolution's fiftieth anniversary. He toured the United States for several months, hailed as the triumphant hero of the Revolution and the fond companion of Washington. In gratitude for his support during the Revolution, the United States government gave him $200,000

and a large tract of land in Florida. Returning to France, he spent the next decade speaking publicly about liberty. He died near Paris on 20 May 1834 and was buried under a mound of earth that he had brought to France from Bunker Hill.

1. As tokens of their mutual admiration, George Washington and Lafayette simultaneously commissioned portraits of each other from artist Charles Willson Peale in 1778 or 1779. Peale left the three-quarter length Lafayette portrait (now at Washington and Lee University) unfinished for almost a year, apparently reluctant to part with such an important subject. Before he sent the portrait to Mount Vernon, Peale painted a bust-length replica of it for the museum.[1] The replica is included in the 13 October 1784 list of the museum's contents printed in the *Freeman's Journal and Philadelphia Daily Advertiser*.

Provenance:
Listed in the 1795 Peale Museum catalog. Purchased by Captain William Wayne at the 1854 Peale Museum sale. Purchased by Albert Rosenthal for the City of Philadelphia from Wayne's granddaughter in 1903.

Physical Description:
Oil on canvas. Bust length, facing forward. Dark blue uniform coat with buff facings, gold epaulettes with two stars each. Buff waistcoat, white shirt, black stock. Black sword belt across chest. Red hair, brown eyes. Dark brown background. 23¹⁄₁₆ inches H × 18⅛ inches W.

[1] Peale painted two other replicas, one (now at the Winterthur Museum) for Lafayette's friend James Duane of New York and one (now at Stratford Hall) for Henry Lee of Virginia.

MARIE JOSEPH PAUL YVES ROCH GILBERT MOTIER, MARQUIS DE LAFAYETTE (1757–1834)

2. by Thomas Sully, from life, 1825–1826

2. To commemorate Lafayette's visit to Philadelphia in late September 1824, a group of private citizens commissioned his portrait for Independence Hall from Philadelphia artist Thomas Sully (1783–1872). Sully developed the portrait from a series of small sketches (including one study of Lafayette's head made during a later sitting with the subject in Washington, D.C.) and one study painting made for review by his patrons.[2] Known for his flattering society portraits, Sully idealistically depicted Lafayette as much younger than his sixty-seven years. The subject wore a toupee during his visit, and that manifestation of vanity argues that Lafayette willingly accepted an image of youth and vigor in his portrait projects.[3] In the finished portrait, Lafayette stands in front of the triumphal arch designed by the architect William Strickland for the hero's reception at Independence Hall. Philadelphia's Washington Grays, Lafayette's military escort through the city, are visible in the midground. In the background is Independence Hall, filled with a cheering crowd and topped by the flourishing American flag.

Catalog Number INDE11879
(SN 13.146)

※

Provenance:
Purchased by the City of Philadelphia from the subscribers in 1826.

Physical Description:
Oil on canvas. Full length, facing slightly to the sitter's left. Red-lined black cape, black coat, black trousers, white shirt and stock. Holds a black top hat and walking stick in right hand, left hand is gloved holding mate. Stands beneath arch and next to classical statue of Diana. In right background is Independence Hall and a parade of equestrian figures with spectators. 94⅜ inches H × 59¼ inches W.

[2] Sully's oil sketch of Lafayette's head was offered at the December 1991 Sotheby's auction. Sully's watercolor sketch of the full-length composition is privately owned. Sully's oil study of the full-length composition is in the Lafayette College Art Collection.

[3] Marc H. Miller, "The Farewell Tour and American Art," in *Lafayette, Hero of Two Worlds: the Art and Pageantry of His Farewell Tour of America, 1824–1825*, exhibit catalog, The Queens Museum (Hanover: University Press of New England, 1989), 150.

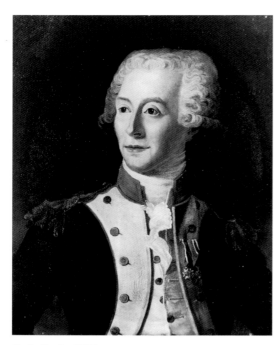

Catalog Number INDE

(SN 13.147)

MARIE JOSEPH PAUL YVES ROCH GILBERT MOTIER, MARQUIS DE LAFAYETTE (1757–1834)
3. by an unidentified artist, after Joseph Boze, nineteenth century

3. During the late nineteenth century, the City of Philadelphia acquired for Independence Hall a copy by an unidentified artist of Joseph Boze's 1790 portrait of Lafayette (now at the Massachusetts Historical Society). The original Boze portrait was commissioned for Thomas Jefferson, possibly on the occasion of his return to America after serving as minister to France.[4] In it, the subject wears his Garde Nationale uniform and three medals of honor (Croix du Saint Louis, Medal des Vanquers de la Bastille, and the Society of the Cincinnati eagle).[5] It is unclear why the city would acquire this portrait when two others of the subject were already in the Independence Hall museum collection.

—◦⊙◦—

Provenance:
Unknown. Acquired by the City of Philadelphia prior to 1893.

Physical Description:
Oil on canvas. Bust length, head turned toward the subject's right. Dark blue uniform coat with red-trimmed buff facings and red collar, gold epaulettes; buff waistcoat, white stock and lace jabot. Wearing three gold medals on red, white, and blue ribbons (Cross of Saint Louis, Medal of the Vainqueurs de la Bastille, and Eagle of the Society of the Cincinnati). White wig, brown eyes. Dark background. 24 inches H × 20 inches W.

[4] A contemporary copy, probably not by Boze, was painted for Ebenezer Stevens (Lafayette's artillery officer) and is now owned by the New-York Historical Society.

[5] Miller, 105.

JOHN LANGDON (1741–1819)
by James Sharples Senior, after James Sharples Senior, c. 1796–1810

Catalog Number INDE11910

(SN 7.018)

Langdon was born in Portsmouth, New Hampshire, on 26 June 1741. As a young man, he served aboard a merchant vessel, and then returned to a political career in America. He was speaker of the provincial legislature and then a member of the Continental Congress in 1775. After several administrative posts managing his state's wartime naval concerns, he returned to the speakership of his state legislature. Later, he fought at Bennington and Saratoga.

After the war, he served several terms in Congress, in New Hampshire's senate, and in its chief executive's office. He also attended the federal Constitutional Convention and his own state's ratifying convention. In 1789, he took a seat in the new United States Senate. He served for nearly a decade (and was the president *pro tempore* for nearly two terms). When he left the Senate in 1801, he declined an appointment as secretary of the navy. Instead, he served as New Hampshire's governor from 1805 to 1811. He then declined the Jeffersonian Republican nomination for vice president in 1812. Langdon died on 18 September 1819.

During 1796 and 1797, British pastelist James Sharples Senior (1751–1811) visited Philadelphia and included Langdon among his sitters. The artist later listed Langdon in an 1802 catalog of portraits as "Governor Langdon, Senator." There are two versions of the Langdon pastel, both apparently by Sharples Senior. The life portrait is probably the one now at the Smith College Museum of Art (donated by a descendant of the sitter), and a replica by Sharples Senior is in the Independence collection. Both pastels show Sharples's effective modeling of facial features through subtle use of light and color, and the proportions of the subject's body are well-balanced in the picture plane of both.

The major differences between the two pastels are in the color of the subject's coat, and the appearance of the subject's hair. In the Smith College pastel, Langdon's coat is a lighter blue, his hair has been carefully curled over the ears, and he wears a wrapped queue. The Independence portrait shows Langdon in a dark blue coat, and neither curl nor queue is visible. In addition, the Independence pastel shows evidence of early restoration with heavy outlines drawn along the sitter's hairline, left eyebrow, nose, and mouth.

Provenance:
Given by Ellen (Mrs. James) Sharples to Felix Sharples in 1811. Given by Felix Sharples to Levin Yardly Winder in the 1830s. Inherited by Nathaniel James Winder from Levin Yardly Winder. Inherited by Richard Bayly Winder from Nathaniel James Winder in 1844. Purchased by Murray Harrison from Richard Bayly Winder around 1865. Purchased by the City of Philadelphia from Murray Harrison in 1874.

Physical Description:
Pastel on paper. Bust length, facing slightly to the sitter's right. Dark blue coat, white waistcoat, white stock and jabot. Gray hair, brown eyes. Variegated blue background. 9 inches H × 7 inches W.

HENRY LAURENS (1724–1792)
by Charles Willson Peale, from life, c. 1784

Catalog Number INDE14079

(SN 13.151)

Laurens was born in Charleston, South Carolina, on 6 March 1724. He apprenticed in a London mercantile office and then inherited his father's estate, which he developed extensively as an import and export business. In 1757, he entered the colonial legislature for a year and then returned to England for more than a decade. Despite his strong ties with England, he later returned to Charleston and accepted several local offices including membership in the provincial congress and the council of safety, and his state's vice presidency. In 1777, he was elected to Congress, later becoming its president. In mid-1780, he left America for his diplomatic assignment as newly-appointed minister to Holland, but was captured by the British before reaching his new post, and was imprisoned in the Tower of London until late 1781 (when he was exchanged for British general Lord Cornwallis). Laurens was then appointed to the American commission sent to England in order to offer terms of peace. After his return to Charleston in 1784, he retired from public office and died on 8 December 1792.

Before he embarked on his ill-fated voyage to Holland, Laurens had promised to send Charles Willson Peale Dutch art supplies.[1] The diplomat's capture and imprisonment made that promise impossible to fulfill. During his journey back to South Carolina, Laurens passed through Philadelphia between 4 and 23 September 1784 and visited Peale's home. Peale probably painted this portrait at that time.

In mid-October of that year, the artist listed this portrait as "President of Congress" in the announcement of his museum's collection in the *Freeman's Journal and Philadelphia Daily Advertiser*. Later, Peale planned to include Laurens in a series of engravings from his portraits, but the project failed to materialize.[2]

—◦◦◦—

Provenance:
Listed in the 1795 Peale Museum catalog. Purchased by the City of Philadelphia at the 1854 Peale Museum sale.

Physical Description:
Oil on canvas. Bust length, facing three quarters to the sitter's right. Black collarless coat, black waistcoat. White stock and jabot. Powdered hair, blue eyes. Greenish brown background. 21⁵⁄₁₆ inches H × 17⅜ inches W.

[1] Charles Willson Peale to Henry Laurens, 6 March 1780 (Miller, *Selected Papers* 1, page 340).

[2] Charles Willson Peale to David Ramsay, 22 February 1787 (Miller, *Selected Papers* 1, page 471, n. 6).

JOHN LAURENS (1754–1782)
by Charles Willson Peale, from a miniature after
Charles Willson Peale, c. 1784

Catalog Number INDE14075
(SN 52.002)

aurens was born in Charleston, South Carolina, on 28 October 1754. He went with his father (see above) to England for his education, attending the University of Geneva for two years, and then London's Middle Temple for legal studies. Early in the war, he returned home to America, becoming General George Washington's aide-de-camp in the fall of 1777. Laurens fought at Brandywine and Germantown, wintered at Valley Forge, and was injured in the Monmouth campaign. In 1779 he returned to South Carolina for service in the state legislature. He was captured during the British siege of Charleston and, after his release, went to France in order to assist Benjamin Franklin with the task of raising funds for the Continental army. Returning to the war a few months later, Laurens fought at Yorktown and was killed on 27 August 1782 at Combahee Ferry in South Carolina.

Prior to his last visit abroad, Laurens commissioned a miniature portrait (now privately owned) from Charles Willson Peale.

Laurens probably took the miniature with him in the fall of 1780 as a gift for his wife, who was living in France. Later, Peale copied the miniature for one of Laurens's comrades, Major William Jackson, apparently as a postwar memento of their joint service during the siege of Charleston.[1] The copy miniature bears the Latin motto, "Dulce et decorum est pro patria mori" ("It is a sweet and honorable thing to die for one's country").

Provenance:
Given to the City of Philadelphia by Ann Willing Jackson, daughter of Major William Jackson, in 1876.

Physical Description:
Watercolor on ivory miniature. Facing slightly to subject's left. Dark blue uniform coat with buff facings, gold epaulette, buff waistcoat, white stock and jabot. Powdered hair tied in a queue with a black ribbon, blue eyes. Variegated blue background. Oval bezel frame in white enamel with Latin motto on inner bezel, green, purple and gold flowers in middle bezel, garnet-studded outer bezel. 1¾ inches H × 1½ inches W.

[1] Possibly, the subject's father actually commissioned the copy miniature and then gave it to Jackson (Sellers, *Portraits and Miniatures*, 123). Peale may also have painted a museum portrait based upon the original miniature, as one was listed in the 1795 museum catalog. This picture (now unlocated) was probably taken by Peale's sons to Charleston for exhibition in 1795–1796 and not returned to Philadelphia (Sellers, Ibid).

Catalog Number INDE14077

(SN 13.156)

[1] Sellers, *Portraits and Miniatures*, 124. There is a replica of the museum portrait at the Virginia Historical Society, probably painted by Charles Willson Peale.

ARTHUR LEE (1740–1792)
by Charles Willson Peale, from life, c. 1785

L ee was born in Westmoreland County, Virginia, on 21 December 1740. Orphaned at ten, he became the ward of his oldest brother, Richard Henry Lee (see below). In 1751, Arthur entered Eton College, following that with medical degrees at the University of Edinburgh in Scotland and the University of Leyden in Amsterdam, and a law degree at London's Middle Temple. In 1769, while in England, he published a series of letters attacking the British Parliament. As a result of his political writings, he caught the attention of Samuel Adams, who arranged for Lee's appointment as colonial agent for Massachusetts.

In late 1775, Lee served as Congress's confidential correspondent in London to report on France's potential interest in the American cause. A year later, he joined the American commission sent to France to negotiate a treaty between the two countries. From Paris, he went to Spain, where he procured substantial financial aid for America. In 1780, after twenty-seven years abroad, he returned to America and served in the Continental Congress. After a term as an Indian commissioner, he joined the national treasury board, on which he served until 1789. Lee died at his home, Lansdowne, on 12 December 1792.

Lee's role as a negotiator, with both European nations and Native American tribes, may have led Charles Willson Peale to add the diplomat's portrait to his Philadelphia Museum. That the painting is not one of the forty-four listed in the 13 October 1784 issue of the *Freeman's Journal and Philadelphia Daily Advertiser*, and the number "49" is painted in the upper-right corner of the picture, might support a post-1784 date.[1]

⸺◦◦◦⸺

Provenance:
Listed in the 1795 Peale Museum catalog. Purchased by the City of Philadelphia at the 1854 Peale Museum sale.

Physical Description:
Oil on canvas. Bust length, facing the sitter's right. Brown coat with braided closures, blue embroidered waistcoat, white stock and lace jabot. Powdered hair tied in a queue with black ribbon, blue eyes. Brown background. 23⅜ inches H × 19⅜ inches W.

HENRY LEE (1756–1818)
by Charles Willson Peale, from life, c. 1782

Catalog Number INDE14076

(SN 13.158)

Lee was born near Dumfries, Virginia, on 29 January 1756. He graduated from the College of New Jersey (now Princeton), and then chose a military career in his state's militia, followed by one in the Continental army. In 1779, Lee captured the British fort at Paulus Hook, New York, and earned the nickname "Light Horse Harry." Later, during the southern campaign, he and his men protected the Continentals during their retreat from superior British forces, and fought in the Carolinas and Georgia at the battles of Guilford Courthouse and Eutaw Springs.

After the Revolution, Lee entered his state's legislature and then Congress. In 1792, he became Virginia's governor for a term. During that time, he commanded a militia troop sent to western Pennsylvania to quell the popular revolt there against the federal whiskey tax. Later, he returned to Congress for one term, during which he delivered the official funeral eulogy for George Washington, proclaiming his late friend as "first in war, first in peace and first in the hearts of his countrymen." Lee was also a member of the United States House of Representatives from 1799 to 1801.

Although Lee's retirement was plagued by imprisonment for debt, he managed to successfully publish his wartime memoirs in 1812. An ill-advised public statement of support for a Baltimore critic of the impending war with England led to a jail turn for Lee and a severe beating by irate citizens. Afterward, he secluded himself on the Georgia plantation of his former Revolutionary commander, Nathanael Greene. Lee died there on 25 March 1818.

As one of the Revolution's most celebrated commanders, Lee was a natural subject for Peale's Museum. The portrait is listed in the 13 October 1784 issue of the *Freeman's Journal and Philadelphia Daily Advertiser*. The artist may have painted this portrait as early as 1782 when Lee came to Philadelphia to receive his congressional commendation for the victory at Paulus Hook and to resign his military commission.[1] Sometime in 1785, "Light Horse Harry" sat for Peale a second time when the artist painted a miniature of him (now in a private collection) that remained in the museum collection until Peale's death.

Provenance:
Listed in the 1795 Peale Museum catalog. Purchased by the City of Philadelphia at the 1854 Peale Museum sale.

Physical Description:
Oil on canvas. Bust length, torso turned slightly toward the sitter's right. Buff field uniform coat with green facings and gold epaulette on right shoulder, white shirt and jabot, black stock, black sword belt. Powdered hair, gray eyes. Brown background.
23⅛ inches H × 19 inches W.

[1] Sellers, *Portraits and Miniatures*, 124. The question has arisen of when Lee wore the particular field uniform (created for the Virginia dragoons in January 1778) with one epaulette designating a captain's rank (Lee was promoted to major in April 1778 and had the option of two epaulettes) as shown in the museum portrait. In late 1780, Lee was further promoted to lieutenant colonel. It has been suggested that he would not have continued to wear his older uniform at that time. If the Lee portrait was painted prior to 1780, it would be the earliest in Peale's museum format.

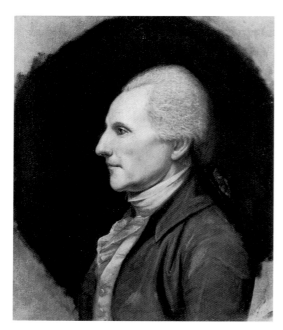

Catalog Number INDE11882

(SN 13.159)

RICHARD HENRY LEE (1732–1794)
by Charles Willson Peale, from life, c. 1785

Lee was born on 31 January 1732 in Westmoreland County, Virginia. He was tutored at home and then sent to school in England. By 1758, he had returned home and entered Virginia's House of Burgesses. In 1774, he attended the First Continental Congress and later the Second Continental Congress, where he made the motion that led to independence and signed the Declaration. He supported the Articles of Confederation, and urged Virginia to give up its claims to the Northwest Territory in order to settle its boundary disputes and ratify the Articles. He resigned from Congress in 1779, but returned to it five years later and was then elected its president. Later, he opposed the new federal Constitution during the Virginia ratifying convention, and maintained his Antifederalist opinions when he entered the United States Senate in 1789. He served until 1792, supporting the creation of Constitutional amendments, the most important of which are now part of the Bill of Rights. Lee died on 19 June 1794.

Charles Willson Peale's museum portrait of Lee probably dates to the summer of 1785 when the subject left Congress in New York in order to visit the recuperative waters of a mineral spring near Philadelphia. Peale's respect for Lee, whom he portrayed in profile (an unusual pose for a museum subject), led him to praise the President of Congress as the man who "kindle[d] the flame of liberty throughout the continent."[1] After Lee's death, Peale copied the museum portrait for the Lee family (the painting is now at the Smithsonian's National Portrait Gallery).

⁓◦◦◦⁓

Provenance:
Listed in the 1795 Peale Museum catalog. Purchased by the City of Philadelphia at the 1854 Peale Museum sale.

Physical Description:
Oil on canvas. Bust length, left profile. Blue coat, tan waistcoat, white stock and jabot. Gray hair tied in a queue, blue eyes. Dark brown background. 23 3/16 inches H × 19 9/16 inches W.

[1] Charles Willson Peale, *An Historical Catalogue of Paintings Attached to the Philadelphia Museum* (Philadelphia, 1813).

MERIWETHER LEWIS (1774–1809)
by Charles Willson Peale, from life, 1807

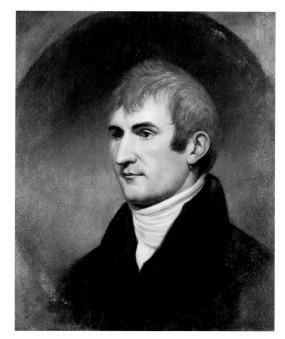

Catalog Number INDE14096
(SN 13.161)

Lewis was born on 18 August 1774 in Albemarle County, Virginia. Tutored in the classics, he bypassed college in order to manage his mother's Virginia estate. In 1794, he joined the state militia during a call for troops to quell the Whiskey Rebellion, and made the decision to pursue a military career. He served at various posts throughout the Northwest Territory, among them Fort Pickering in Tennessee, where he mastered the Chickasaw tribe's language and customs. In 1801, President Thomas Jefferson asked Lewis to join his personal staff as secretary. Together, they planned a mission to secure trade relations with Native American tribes in the Northwest. Jefferson's keen interest in natural history gave the expedition a scientific purpose as well, and its leader Lewis studied mathematics, astronomy, and surveying before he departed for the west in mid-1803. As his fellow officer on the expedition, Lewis chose William Clark (see above), his former commander in the Northwest Territory.

Lewis and Clark began their journey in the spring of 1804 at the mouth of the Missouri and followed the river into North Dakota where they spent the winter. Guided by the Shoshone woman Sacajawea and her French Canadian husband, the expedition reached the end of the river in August of 1805. There they crossed the Continental Divide and navigated the Columbia River to the shore of the Pacific. The group then retraced its route and ended the journey in St. Louis in September of 1806. After reporting on the expedition to the president in Washington, Lewis accepted an appointment as governor of the new Louisiana Territory. Headquartered at St. Louis in 1807, he organized the territory's militia and instituted a code of civil laws. During an administrative trip to Washington, Lewis committed suicide in the Tennessee back-country on 11 October 1809.

Charles Willson Peale eagerly accepted President Jefferson's donation to the Philadelphia Museum of many natural history specimens and ethnographic objects collected by Lewis and Clark during their exploration of the great Northwest. Peale's own fascination with discovery extended to its practitioners, including Lewis, who the artist said was "richly entitled to a place amongst the Portraits in the museum." At that time, Peale was in the midst of a creative resurgence, spurred by his son Rembrandt's experiments with new pigments. The senior Peale, exhilarated by the experience, acknowledged "It can scarcely be believed that I should now paint much better than when I was much younger & in constant practice, but my judgement is ripened."[1] Peale painted Lewis' portrait in the spring of 1807, just before the new territorial governor's departure for St. Louis.

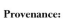

Provenance:
Listed in the 1813 Peale Museum catalog. Purchased by the City of Philadelphia at the 1854 Peale Museum sale.

Physical Description:
Oil on wood panel. Bust length, facing sitter's right. Black coat, dark gray waistcoat, white stock. Graying brown hair, gray-blue eyes. Olive green background. 23 inches H × 18¾ inches W.

[1] Charles Willson Peale to Thomas Jefferson, 24 December 1806 (Miller, *Selected Papers* 2:2, page 993). Charles Willson Peale to John Isaac Hawkins, 5 May 1807. Letterbook 8, Peale–Sellers Papers, American Philosophical Society.

Catalog Number INDE14097

(SN 13.162)

BENJAMIN LINCOLN (1733–1810)
by Charles Willson Peale, from life, c. 1781–1783

Lincoln was born on 24 January 1733 in Hingham, Massachusetts. He attended local schools, and then established his own farm. Elected town clerk in 1757, he gradually became prominent in the colony's militia and politics. By 1772, he had achieved the rank of lieutenant colonel and had been elected to the colonial legislature. He later served as the secretary of the provincial assembly that replaced the colonial legislature in defiance of the Boston Port Bill. In 1776, he received a militia command in the defense of New York, and although Lincoln held no congressional commission, Washington gave him the command of a Continental division. In early 1777, he went to Morristown and then assumed command of the entire New England militia. With these troops, he disrupted British supply lines and participated in the Continental victory at Saratoga, where he was badly wounded. He rejoined the army as commander of the southern campaign in September 1778. Following a year of minor skirmishes, the British defeated Lincoln, captured him and his army, and conquered Charleston. Exchanged in late 1780, he commanded a division during the Continental victory at Yorktown.

Lincoln left active field duty after Yorktown. He served as secretary of war from late 1781 until late 1783. After a brief and financially disastrous period, he commanded the Massachusetts troops sent to end Shays's Rebellion. Later, he worked for the ratification of the Constitution in his state, and served for one year as its lieutenant governor. Later, he was appointed collector of the port of Boston. Lincoln died on 9 May 1810.

Charles Willson Peale probably painted this museum portrait during Lincoln's term as secretary of war. It is first recorded as "secretary of war" in the 13 October 1784 issue of the *Freeman's Journal and Philadelphia Daily Advertiser*. The epaulettes worn by Lincoln in this painting may be those presented to him early in the war by General Washington as a token of appreciation for his service.

Provenance:
Listed in the 1795 Peale Museum catalog. Purchased by the City of Philadelphia at the 1854 Peale Museum sale.

Physical Description:
Oil on canvas. Bust length, facing fully front. Dark blue uniform coat with buff facings and gold epaulettes with two silver stars each. White stock. Gray hair, blue eyes. Dark brown background. 22 3/16 inches H × 18 7/16 inches W.

SAMUEL LIVERMORE (1732–1803)
by a member of the Sharples family (possibly Ellen),
after James Sharples Senior, c. 1796–1810

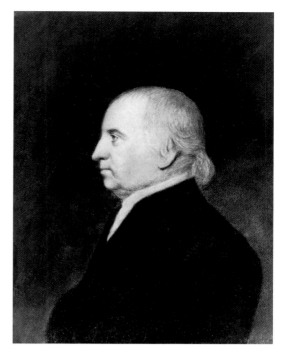

Catalog Number INDE11935
(SN 7.044)

Livermore was born in Waltham, Massachusetts, on 25 May 1732. He graduated from the College of New Jersey (now Princeton), and then taught school while he studied law. In 1757, he opened a practice in Portsmouth, New Hampshire. Later, he sat in that colony's assembly for two terms, served as judge advocate of its admiralty court, and was appointed the king's provincial attorney general. Despite his earlier ties to the Crown, he retained his attorney generalship during the Revolution and served four terms in the Continental Congress. At the same time, he was chief justice of his state's superior court. He also attended his state's convention to ratify the new federal Constitution, and his support ensured the document's acceptance. In 1793, he entered the United States Senate and served for eight years, two as president *pro tempore*. Livermore died on 18 May 1803.

Livermore was among the many members of Congress who sat for British pastelist James Sharples Senior during the artist's visit to Philadelphia from late 1796 through most of 1797.[1] Sharples later listed this sitter as "Judge Livirmore [*sic*], M[ember of] C[ongress]" in his 1802 catalog published in Bath, England. The Independence pastel of Livermore is possibly a copy by a member of the Sharples family after the life portrait by James Sharples Senior. This copy may be the work of the artist's wife Ellen (1769–1849) who was trained as a miniaturist. The tightly controlled lines and minute rendering of facial details, like the sitter's hair and eyebrows, are reminiscent of Mrs. Sharples's work. The rather poorly rendered contours of the subject's torso also suggest that this is not the work of the more experienced James Sharples Senior. A second version of the Sharples Livermore pastel was known in 1930, but it is now unlocated.[2]

⁓⦿⁓

Provenance:
Given by Ellen (Mrs. James) Sharples to Felix Sharples in 1811. Given by Felix Sharples to Levin Yardly Winder in the 1830s. Inherited by Nathaniel James Winder from Levin Yardly Winder. Inherited by Richard Bayly Winder from Nathaniel James Winder in 1844. Purchased by Murray Harrison from Richard Bayly Winder around 1865. Purchased by the City of Philadelphia from Murray Harrison in 1876.

Physical Description:
Pastel on paper. Half length, left profile. Brown coat with black lining, white stock and jabot. Gray hair, gray eyes. Charcoal gray background. 9 inches H × 7 inches W.

[1] The Independence pastel of Livermore was previously identified as that of Henry Laurens, former president of Congress. However, Laurens died in 1792 (before the Sharples family arrived in America). And the Independence pastel is clearly the same sitter painted in miniature by John Trumbull as Livermore in 1791 (now at the Yale University Art Gallery).

[2] Knox, *The Sharples*, 96.

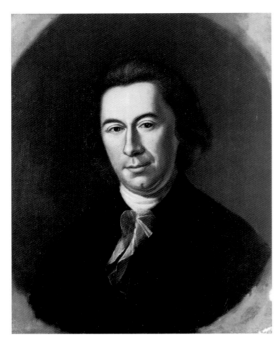

Catalog Number INDE14098

(SN 13.163)

ROBERT R. LIVINGSTON (1746–1813)
1. by Charles Willson Peale, from life, 1782–1783

Livingston was born on 19 November 1746 in New York City. He attended King's College (now Columbia) and then studied law. He began his legal practice with John Jay and in 1773 became recorder of the City of New York. His support for the Revolutionary movement gained him a seat in the Continental Congress in 1775. A member of the committee appointed in June of 1776 to draft a letter of grievances to the king, Livingston left Congress before the Declaration of Independence was signed. Back in New York, he co-authored the state's first constitution and became its legal chancellor, a position he held for twenty-four years. When he returned to Congress in 1779, he sat on numerous committees for funding and administering the war. In early 1781, Congress appointed him secretary of foreign affairs and he organized the new department's system of consulates and established its procedures for reporting to Congress and the army. In mid-1783, he resigned his diplomatic post and returned to New York.

In 1801, President Thomas Jefferson appointed Livingston as Minister to France, a position he had previously refused during George Washington's administration. At Napoleon's court, Livingston and James Monroe managed the complex negotiations that led to America's purchase of the Louisiana Territory in 1803. The following year, Livingston retired to his estate on the Hudson River. Interested in agriculture and animal husbandry, he brought some of the first merino sheep to the United States from Spain and co-founded the Society for the Promotion of Useful Arts, of which he served as president. A devoted art collector, he was also the first president of the American Academy of Fine Arts. Based on their earlier acquaintance in France, Livingston provided Robert Fulton with technical and financial support for his steamboat, the *Clermont*, which secured a monopoly on steam navigation in New York waters. Livingston died on 26 February 1813.

1. Charles Willson Peale included Livingston, the secretary of foreign affairs, in his first collection of portraits painted for the new Philadelphia Museum. This portrait was first recorded as "secretary of foreign affairs" in the 13 October 1784 issue of the *Freeman's Journal and Philadelphia Daily Advertiser*.

Provenance:
Listed in the 1795 Peale Museum catalog. Purchased by the City of Philadelphia at the 1854 Peale Museum sale.

Physical Description:
Oil on canvas. Bust length, facing forward. Black coat, white stock and lace jabot. Brown hair tied in a queue, green eyes. Brown background. 21 5/16 inches H × 17 3/8 inches W.

ROBERT R. LIVINGSTON (1746–1813)
2. attributed to Ellen Sharples, after James Sharples Senior, c. 1795–1810

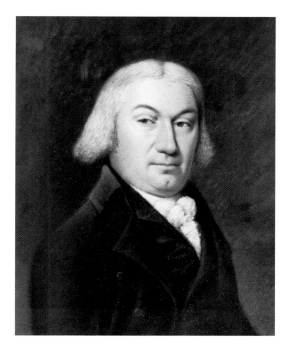

Catalog Number INDE11896
(SN 7.004)

2. During his intermittent residence in New York City from 1797 through 1800, British pastelist James Sharples Senior painted Livingston's portrait for his collection of prominent Americans. The portrait was later listed in the artist's 1802 catalog as that of "Chancellor Livingston." There are two versions of the Sharples portrait of Livingston. The life portrait by James Sharples Senior is probably the one now owned by Amherst College's Mead Art Museum. Although it shows some evidence of inpainting along the sitter's hairline, the expert facial modeling and the successfully painted contours of the sitter's torso indicate the senior Sharples's expertise. The Independence pastel is possibly by Ellen Sharples (1769–1849), the senior Sharples's wife. The pastel portrait, while competently painted, exhibits a tightly controlled quality that may reflect Ellen Sharples's training as a miniaturist.

❦

Provenance:
Given by Ellen (Mrs. James) Sharples to Felix Sharples in 1811. Given by Felix Sharples to Levin Yardly Winder in the 1830s. Inherited by Nathaniel James Winder from Levin Yardly Winder. Inherited by Richard Bayly Winder from Nathaniel James Winder in 1844. Purchased by Murray Harrison from Richard Bayly Winder around 1865. Purchased by the City of Philadelphia from Murray Harrison in 1875.

Physical Description:
Pastel on paper. Bust length, torso turned to the subject's left. Gray coat and waistcoat, white stock and jabot. Gray hair, brown eyes. Variegated blue-green background.
9 inches H × 7 inches W.

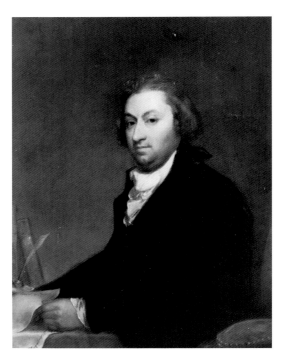

Catalog Number INDE

(SN 13.164)

ROBERT R. LIVINGSTON (1746–1813)
3. by Robert M. Pratt, after Gilbert Stuart, c. 1870

3. For the museum in Independence Hall, the City of Philadelphia purchased Charles Willson Peale's 1782 portrait of Robert R. Livingston (see above) in 1854 with the impression that the portrait depicted the sitter's cousin, Philip Livingston (1716–1778), a signer of the Declaration of Independence. This unrealized mistake led the city to include Foreign Secretary Robert R. Livingston among those listed as desirable subjects for the Independence Hall museum. In response, the subject's family offered New York artist Robert M. Pratt's (1811–1880) copy of Gilbert Stuart's c. 1794 portrait of Livingston (now owned by the New-York Historical Society). Apparently, the Livingston family gift was already in production when the city purchased the Sharples pastel of the subject (see above), leaving the city with several portrayals of Livingston by late 1873.

⁂

Provenance:
Given to the City of Philadelphia by Clermont Livingston, Eugene A. Livingston, Robert E. Livingston, Margaret Clarkson, Elizabeth Ludlow, Mary Clarkson, and Adelaide Clarkson (grandchildren of the subject) in 1873.

Physical Description:
Oil on canvas. Half length, seated, facing the subject's right. Black coat and waistcoat, white stock, jabot and cuffs. Brown hair tied in a queue with a black ribbon, blue eyes. Red upholstered armchair in right corner, left hand holds a document and rests on a second document on a red covered table. Quill in inkstand with leather-bound volumes visible at left. Dark green background. 36 inches H × 28 inches W.

STEPHEN HARRIMAN LONG (1784–1864)
by Charles Willson Peale, from life, c. 1819

Long was born on 30 December 1784 in Hopkinton, New Hampshire. After graduating from Dartmouth College, he taught school and then joined the army's Corps of Engineers in 1814. He served two years at West Point as assistant professor of mathematics, and then commanded three army topograpical missions to the portages of the Fox and Wisconsin rivers and the upper Mississippi, an expedition to the Rocky Mountains, and one to the source of the Minnesota River and along the northwestern boundary of the United States.

In the 1820s, Long was the War Department's consulting engineer to the Baltimore & Ohio Railroad Company. During that time, he published several treatises on mathematical applications for computing bed grades and track curves and for building wooden bridges. He also surveyed areas of Georgia and Tennessee for possible rail routes, and in 1837 he was appointed chief engineer of the Atlantic & Great Western Railroad. After 1840, he alternated military service with consulting for railroad companies. At the beginning of the Civil War, he was promoted to colonel and made chief of the Topographical Engineers, working in Washington. Long died on 4 September 1864.

Charles Willson Peale and his youngest son, Titian Ramsay, regarded Long's pending 1819 expedition to the Rockies as a unique opportunity for Titian to pursue his natural history studies.

The Peales traveled to Washington and obtained an appointment for Titian as assistant naturalist to the party. Before the expedition's embarkation in April, the senior Peale painted portraits of several members, including Long, for his Philadelphia Museum.[1] Later in life, Peale described his intent in portraying the expedition as a means of both rewarding their bravery and reassuring those they left at home: "if they did honour to themselves in that hazardous expedition that they might have the honour of being placed in the museum and if they lost their skuls [*sic*], their friends would be glad to have their portraits."[2]

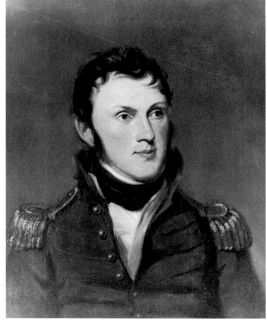

Catalog Number INDE14094

(SN 13.167)

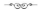

Provenance:
Purchased by "Mr. Barton" at the 1854 Peale Museum sale. Given to the City of Philadelphia by "Mr. Barton" in 1854 or 1855.

Physical Description:
Oil on canvas. Bust length, facing slightly to the sitter's left. Dark blue uniform coat with gold epaulettes, buff waistcoat, black stock, white jabot. Black hair, brown eyes. Olive green background. 24 3/16 inches H × 20 3/16 inches W.

[1] The others were Titian (portrait now privately owned), Thomas Say as zoologist (portrait now owned by the Academy of Natural Sciences, Philadelphia), Dr. William Baldwin as botanist (portrait now privately owned), and Augustus Edward Jessup as geologist (portrait unlocated). Charles Willson Peale to Angelica Peale Robinson, 4 April 1819 (Miller, *Selected Papers 3*, page 707).

[2] Charles Willson Peale, "Autobiography," 1826, typescript by Charles Coleman Sellers, 427. Peale–Sellers Papers, American Philosophical Society.

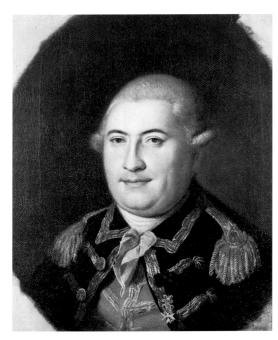

Catalog Number INDE14095

(SN 13.169)

ANNE CÉSAR, CHEVALIER DE LA LUZERNE (1741–1791)
by Charles Willson Peale, from life, 1781–1782

Luzerne was born in Paris in 1741. During his youth, he prepared for a military career at the city's riding academy and then served as an aide to the Duc de Broglie. At the age of twenty-one, Luzerne became a major general in the cavalry and then a colonel in the French grenadiers. He began his diplomatic career in 1776 as French envoy to the elector of Bavaria. His distinguished service there earned him the appointment of minister to America, and he arrived in Philadelphia to replace the ailing Conrad Alexandre Gérard in September 1779.

Luzerne's previous military experience served him well in his mission to report on the status of General George Washington's Revolutionary army for the French king Louis XVI. The minister toured the army's camps and discussed supply needs with American officers and civil administrators. The first news of the official peace between England and America after the battle of Yorktown came to Luzerne, who then dispatched it by messenger throughout Philadelphia and beyond. He returned to France in 1783, and later served as French Minister to England. Luzerne died in London on 14 September 1791.

For his genuine commitment to the American cause and his valuable assistance in sustaining the Revolutionary effort, Luzerne received an early place in Charles Willson Peale's Philadelphia Museum. The artist completed this painting of the minister, who wears a combination of military and diplomatic dress, before the latter's return to France in early 1783. Later, Luzerne became a member of the Society of the Cincinnati, but in Peale's portrait he wears only the commander's cross of a Maltese magisterial knight of grace. The portrait was first listed in the 13 October 1784 issue of the *Freeman's Journal and Philadelphia Daily Advertiser*. Ten years later, Peale's son Rembrandt copied Luzerne's portrait for use on a patronage trip to Charleston and then in his own short-lived Baltimore museum (the copy is now at the Virginia Historical Society).

⁓

Provenance:
Listed in the 1795 Peale Museum catalog. Purchased by the City of Philadelphia at the 1854 Peale Museum sale.

Physical Description:
Oil on canvas. Bust length, facing front. Dark blue coat with gold braid trim and gold epaulettes with one silver star each, red waistcoat with gold braid trim. White stock and jabot. Powdered wig, blue eyes. Wears silver medal (Maltese magisterial knight of grace commander's cross) on a black ribbon through upper left lapel. Brown background. 22¹⁄₁₆ inches H × 19¼ inches W.

THOMAS LYNCH JUNIOR (1749–1779)
by Anna Lea Merritt, after the James Barton Longacre engraving from an unknown miniature, 1875

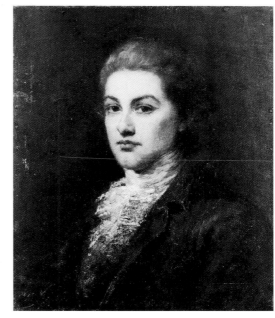

Catalog Number INDE
(SN 13.170)

Lynch was born on 5 August 1749 in Prince George's Parish, Winyaw, South Carolina. In 1764, he went to England, where he attended Eton and Cambridge before studying law at London's Middle Temple. After his return to America in 1772, he served in several public bodies, including the provincial congress, South Carolina's constitutional committee, and its first state assembly. In 1776, Lynch succeeded his father as a member of his state's delegation to the Second Continental Congress, where he signed the Declaration of Independence. Poor health forced his retirement from public life in the following year. Seeking relief, Lynch and his wife sailed for the West Indies in late 1779 and were lost at sea.

During the Centennial era, the City of Philadelphia received for display in Independence Hall a copy portrait of Lynch by Philadelphia artist Anna Lea Merritt (1844–1930). Merritt copied James Barton Longacre's 1824 engraving of Lynch created for John Sanderson's *Biography of the Signers to the Declaration of Independence*.[1] Longacre's source (probably the same one used by John Trumbull for his posthumous sketch of Lynch, now at the Yale University Art Gallery) was a miniature (allegedly destroyed in the nineteenth century) owned by the subject's sister.[2]

Provenance:
Given to the City of Philadelphia by Thomas Balch Senior in 1875.

Physical Description:
Oil on canvas. Bust length, torso facing slightly to the subject's right. Brown coat, white stock and lace jabot. Brown hair, brown eyes. Tan background. 24 inches H × 20 inches W.

[1] Anna Lea Merritt to Frank M. Etting, 17 December 1874. Etting Papers, p. 51. Historical Society of Pennyslvania.

[2] Charles F. Jenkins, "An Account of a New Portrait of Thomas Lynch, Jr.," *The South Carolina Historical and Genealogical Magazine* 28 (January 1927): 3. Two miniatures purported to be of Lynch are known (now owned by the Bruce Gimelson Gallery in New York and the R.W. Norton Gallery in Shreveport), but neither resembles the Longacre engraving or the Merritt painting.

JAMES McHENRY (1773–1816)
by James Sharples Senior, from life, c. 1796–1800

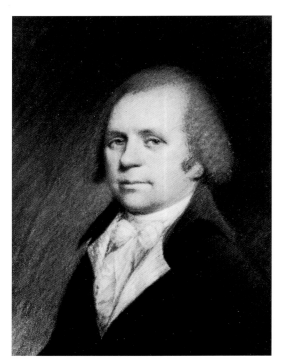

Catalog Number INDE11904

(SN 7.012)

Born in Ireland on 16 November 1753, McHenry immigrated to Baltimore, Maryland, in 1771. After a year of study at Delaware's Newark Academy, he studied medicine with Philadelphia's illustrious physician Benjamin Rush. In early 1776, McHenry volunteered for wartime service and was assigned to the Cambridge, Massachusetts, military hospital as a surgeon. Captured by the British at Fort Washington, he was soon exchanged and then joined General George Washington's staff as an assistant secretary. He was later transferred to the Marquis de Lafayette's staff and promoted to major in 1781. In this capacity, he served in the Yorktown campaign.

McHenry resigned from the army in late 1781 to accept a seat in Maryland's senate. He remained there for five years, simultaneously serving in the Continental Congress from 1783 to 1786. In 1787, he was appointed to the federal Constitutional Convention, although his brother's serious illness kept him in Baltimore for two months during the convention. Later, as a member of his state's Constitutional ratifying convention, he supported the proposed new government. In early 1796, he was appointed secretary of war and served through the administration of President John Adams. At Adams's request, McHenry resigned in the spring of 1800 after his failure to adequately prepare the American navy for hostile actions by the French. He then lived in retirement at his Maryland estate until his death on 3 May 1816.

British pastelist James Sharples Senior (1751–1811) painted this portrait of McHenry in 1797 or 1798–1800 when the artist lived in and then revisited Philadelphia. Sharples listed the portrait as "Mac Henry, esq., Secretary of War" in the catalog he published upon his return to England in 1802. The artist's skill is well represented in this portrait by details of the sitter's appearance (e.g., McHenry's deeply set eyes and his fancy silk coat lining) that show the use of subtly shaded pigments and highlights that suggest surface contours.

⟶∘❦∘⟵

Provenance:
Listed in the 1802 Bath catalog of Sharples's works. Given by Ellen (Mrs. James) Sharples to Felix Sharples in 1811. Given by Felix Sharples to Levin Yardly Winder in the 1830s. Inherited by Nathaniel James Winder from Levin Yardly Winder. Inherited by Richard Bayly Winder from Nathaniel James Winder in 1844. Purchased by Murray Harrison from Richard Bayly Winder around 1865. Purchased by the City of Philadelphia from Murray Harrison in 1874.

Physical Description:
Pastel on paper. Bust length, torso turned slightly to the sitter's right. Blue coat with striped lining, white stock and jabot. Graying black hair, brown eyes. Blue variegated background. 9 inches H × 7 inches W.

LACHLAN McINTOSH (1725–1806)
by Charles Willson Peale, from life, c. 1783–1793

McIntosh was born in Badenoch, Scotland, on 17 March 1725. When he was eleven, his family immigrated to Georgia with other Highlanders and settled near the mouth of the Altamaha River. In 1748, he moved to Charleston, South Carolina, and entered the shipping trade. He returned to Georgia in 1775 as a member of the provincial congress, and was later given command, a militia battalion. In the fall of 1776, his militia force joined the Continental army. Subsequent administrative and personal disagreements between him and Georgia's governor Button Gwinnett led to a duel between the two in May 1777 in which Gwinnett was killed.

After his recovery from injuries sustained in the duel, McIntosh transferred to the Northern Army. Headquartered at Pennsylvania's Fort Pitt, he was criticized heavily by his subordinates for inactivity, and he was reassigned to the southern campaign in early 1779. The army's failures at Savannah and Charleston (where McIntosh and others were captured by the British) provided his political enemies in Georgia with the opportunity to secure his suspension from active duty, although he was later restored to his rank by Congress. After the war, he retired to modest financial circumstances and no active political role (he was elected to Congress in 1784, but did not attend). He later founded and served as the first president of the Georgia Society of the Cincinnati. McIntosh died in Savannah on 20 February 1806.

Charles Willson Peale's museum portrait of McIntosh was apparently not exhibited during the artist's lifetime. Mention of it is absent from the museum catalogs and from Peale's letters and autobiography. Perhaps, although the canvas was prepared with the unfinished corners that are typical of the museum portraits, the artist was reluctant to display the portrait of a man who participated in duels (a practice that Peale abhorred).[1] Peale may have painted this portrait as early as 1783, when Congress revoked McIntosh's suspension for the capture of Charleston, just before promoting him to major general (entitling him to two stars on each epaulette). McIntosh may have been in Philadelphia at the time to present his case to Congress. The pale flesh tones used also suggest that the artist painted this portrait prior to the mid-1790s, when he began using a redder palette.

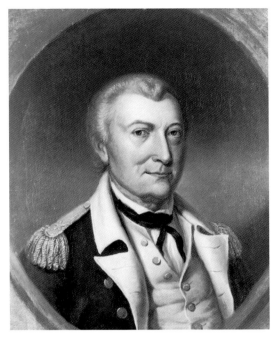

Catalog Number INDE14092
(SN 13.174)

Provenance:
Purchased by the City of Philadelphia at the 1854 Peale Museum sale.

Physical Description:
Oil on canvas. Bust length, torso turned slightly to the sitter's left. Dark blue uniform with buff facings and gold epaulettes with one silver star, buff waistcoat, black stock, white shirt. Gray hair, blue eyes. Brown background. 24⅜ inches H × 20½ inches W.

[1] Sellers, *Portraits and Miniatures*, 135.

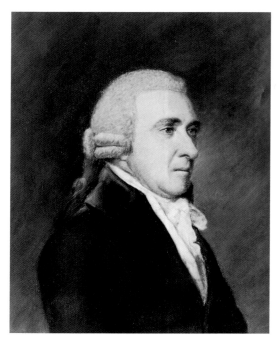

Catalog Number INDE11931

(SN 7.040)

¹ Knox, *The Sharples*, 96.

THOMAS McKEAN (1734–1817)
*1. by a member of the Sharples family (possibly James Senior),
after James Sharples Senior, c. 1796–1810*

McKean was born on 19 March 1734 in Chester County, Pennsylvania. He attended the New London Academy and then read law with his cousin in New Castle, Delaware. At that time, he worked in the county prothonotary and probate offices until he gained admission to the Delaware bar. In 1756, he served as the colony's deputy attorney general and, later, as clerk of the assembly. Elected to the provincial legislature in 1762, he served there for seventeen years, during which he helped to write Delaware's legal code and its constitution, and served a term as assembly speaker. He strongly opposed the 1765 Stamp Act, both as a delegate to the congress convened to address it and as justice of the court of common pleas, in which capacity he ordered that local commerce proceed without the stamps.

In 1774, McKean urged Delaware to support the call for a colonies-wide assembly and then attended the new Continental Congress. An early advocate of reconciliation with England, he later signed the Declaration of Independence. In 1777, he left Congress briefly to begin his appointment as chief justice of the Pennsylvania supreme court, a position he retained after he returned to Congress and for the next twenty-two years. For several months in 1781, he was president of Congress.

A strong supporter of the new federal Constitution, McKean later became a Jeffersonian Republican when he rejected the Washington administration's foreign policy. As such, he won election to the Pennsylvania governor's office in 1799 and served there during a period of turmoil in which he was accused of nepotism and libel.

Impeachment proceedings against him failed, and he concluded his service in 1809. McKean died in Philadelphia on 24 June 1817.

1. British pastelist James Sharples Senior (1751–1811) received a variety of clients during late 1796 and 1797 while the artist visited Philadelphia. McKean was among Sharples's sitters during that time, listed in the artist's 1802 catalog as "Governor Macklane." The Independence pastel appears to be a later copy, possibly by James Sharples Senior, of the life portrait. While the likeness is competently done, vagueness in certain aspects of it (e.g., the subject's queue and his jabot) suggest that it is not a life portrait. A second version of this pastel was once known, but is now unlocated.¹

Provenance:
Given by Ellen (Mrs. James) Sharples to Felix Sharples in 1811. Given by Felix Sharples to Levin Yardly Winder in the 1830s. Inherited by Nathaniel James Winder from Levin Yardly Winder. Inherited by Richard Bayly Winder from Nathaniel James Winder in 1844. Purchased by Murray Harrison from Richard Bayly Winder around 1865. Purchased by the City of Philadelphia from Murray Harrison in 1876.

Physical Description:
Pastel on paper. Half length, nearly right profile. Black coat, white waistcoat, white stock and jabot. Gray wig tied in a queue, brown eyes. Blue-green variegated background. 9 inches H × 7 inches W.

THOMAS McKEAN (1734–1817)
2. by Charles Willson Peale, from life, 1797

2. Charles Willson Peale painted
several portraits of McKean
during the men's long personal
acquaintance. After his initial
commission for portraits (now
unlocated) of McKean and his wife
in 1776, Peale painted his first
museum portrait of the chief justice
in 1781 or 1782. During the next ten
years, the artist also painted the
McKeans individually with their son
and daughter (both portraits are
privately owned) and made another
portrait of Mr. McKean (now owned
by the Westmoreland County
Museum of Art). In 1797, he obliged
the wishes of McKean's daughters
with a second museum portrait,
giving the first one (now at the Fogg
Museum of Art) to the sitter's family.
Peale referred to this second
museum portrait as "nearly the last I
shall perform in that line," referring
to his decision to give up painting
for the museum in order to focus
on its organization and expansion.[2]

Catalog Number INDE14093
(SN 13.175)

Provenance:
Listed in the 1813 Peale Museum catalog.
Purchased by the City of Philadelphia at
the 1854 Peale Museum sale.

Physical Description:
*Oil on canvas. Bust length, torso turned
slightly to the sitter's left. Black coat and
waistcoat, white stock and lace jabot. White
wig, blue eyes. Olive background.
21½ inches H × 17⅜ inches W.*

[2] Charles Willson Peale to
Thomas McKean, 8 February
1797 (Miller, *Selected Papers*
2:1, page 168).

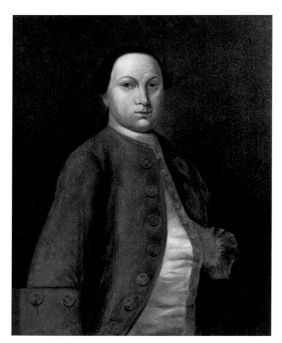

Catalog Number INDE
(SN 13.171)

UNIDENTIFIED MAN possibly Andrew McMyer(s) (died 1777)
by an unidentified artist, after an unknown source, before 1874

This portrait appears to be based upon a mid eighteenth–century work, given the style of the subject's coat. The pose of a hand tucked into the waistcoat with a hat under the arm was quite common to English and American portraits of this era. This nineteenth-century copy, however, is rather flat and awkward, suggesting that its painter either lacked extensive training or was working from an undistinguished source, possibly a woodcut.

According to the city's records of accession for Independence Hall, this portrait depicts Captain Andrew McMyer(s)of Newark, who joined the First New Jersey Regiment of the Continental army in late 1775. He was killed at the battle of Germantown on 4 October 1777.

No other portraits of McMyer(s) are known and only incomplete biographical information for him is available. As a result, no confirmation is currently available as to whether this is a likeness of McMyer(s) or whether a mid eighteenth-century life portrait of him was plausible based on his death date.

❦

Provenance:
Given to the City of Philadelphia by Albert James Myer in 1874.

Physical Description:
Oil on canvas. Three-quarter length, standing, torso turned slightly toward the subject's left. Tan coat, orange-trimmed white waistcoat, white stock and lace cuff. Brown wig tied in a queue, brown eyes. Left hand tucked into waistcoat, black tricorner hat held under left arm. Brown background. 30 inches H × 25 inches W.

DOLLEY PAYNE TODD (MRS. JAMES) MADISON (1768–1849)
by James Sharples Senior, from life, 1796–1797

Catalog Number INDE10052

Payne was born on 20 May 1768 in Guilford County, North Carolina. The following year, her Quaker family returned to their original Virginia home, where they lived until they moved to Philadelphia in 1783. There, in early 1790, Miss Payne married attorney John Todd with whom she had two sons. Three years later, her husband and younger son died during the city's devastating yellow fever epidemic.

Soon afterward, Mrs. Todd moved to her mother's nearby Philadelphia home where several members of the new federal Congress boarded. Among them was Senator Aaron Burr, who later introduced her to Representative James Madison, the man she married on 15 September 1794. The couple remained in Philadelphia for two more years while Madison completed his congressional term. After that, he returned to state politics and the Madisons lived at their Virginia plantation, Montpelier.

In 1801, Mrs. Madison moved to Washington as the wife of the new secretary of state. There she acted as widowed president Thomas Jefferson's official hostess during White House social affairs. This experience proved invaluable when her husband succeeded Jefferson as president in 1809. A popular first lady, Mrs. Madison was also intensely patriotic; when the British burned the White House in 1814, she rescued a large collection of state documents and Gilbert Stuart's full length portrait of President Washington from the building.

Mrs. Madison returned to Montpelier at the end of her husband's presidency in 1817. Widowed twenty years later, she again graced the capital's social scene and remained the toast of the town. In 1844, the House of Representatives honored her with her own seat on its chamber floor. A few years later, she assisted in laying the cornerstone of the Washington Monument. Mrs. Madison died on 12 July 1849.

Just before the Madisons left Philadelphia for Virginia in early 1797, they sat for visiting British portraitist James Sharples Senior (1751–1811). The artist later listed her as "Mrs. Madison" in the 1802 catalog of his work. Mrs. Madison's portrait is among the senior Sharples's best, showing the young Philadelphia matron in beautiful detail from her curly hair and sheer lace cap to her delicately blushed cheek. Later, Ellen Sharples, the artist's wife, drew a pencil copy of Mrs. Madison's portrait in her sketchbook.[1]

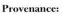

Provenance:
Listed in the 1802 Bath catalog of Sharples's work. Given to the Royal West of England Academy by Ellen Sharples in 1849. Purchased by the City Art Gallery of Bristol from the Royal West of England Academy in 1931. Purchased by the Friends of Independence National Historical Park from the City Art Gallery of Bristol and given to Independence Park in 1973.

Physical Description:
Pastel on paper. Half length, left profile. Olive green long sleeved dress with lace empire waist, white lace fichu and bonnet. Brown hair, blue eyes. Variegated blue-gray background. 9 inches H × 7 inches W.

[1] Knox, *The Sharples*, 105.

JAMES MADISON (1751–1836)

Madison was born on 16 March 1751 at Port Conway, Virginia. He later entered the College of New Jersey (now Princeton) where he studied philosophy, history, and ethics (the latter with the college president, John Witherspoon). Drawn to the growing debate over the deteriorating relationship between the American colonies and England, Madison joined his county's council of safety in 1775. The following year, he attended Virginia's convention, where he sat on the committee that drafted the state's first constitution and its declaration of rights. He then served one year in the Virginia House of Delegates and two in the Governor's Council before he was elected to the Continental Congress in 1780. The youngest delegate, he served there for three years.

In 1784 Madison returned to Virginia's legislature, where he led the opposition to conservative Patrick Henry and his group, particularly on the issue of religious toleration, which Madison strongly supported. An advocate of a national commercial policy (to better regulate America's inter-national trade), Madison also helped to organize and attended the Annapolis Convention, where he favored amending the Articles of Confederation and strengthening the central government.

At the following Constitutional Convention in 1787, Madison exerted a powerful influence on the direction of the proceedings. Among his proposals were those for legislative representation based on population, creation of a national judiciary, a popularly elected bicameral legislature with differing terms of office, and a single executive. Afterward, he promoted the new Constitution at Virginia's ratification convention and also contributed to the newspaper essays written by John Jay and Alexander Hamilton and collectively published as *The Federalist Papers*.

Elected to the first House of Representatives in 1789, Madison became a leading Antifederalist. After two terms, he returned to state politics. There, he and Thomas Jefferson co-authored the Virginia and Kentucky Resolutions, which asserted the rights of states to oppose any act of Congress they deemed unconstitutional. In 1801, President Jefferson appointed Madison his secretary of state. Together, they attempted to insulate American commercial ships and crews from the ongoing naval war between Britain and France with an American embargo.

When he succeeded Jefferson as president in 1809, Madison inherited America's involvement in European hostilities. Plagued by poor military preparation and rumors of secession in some New England states, the president suffered harsh criticism for his conduct of the War of 1812. After a disastrous Canadian campaign and the British capture of the capital in Washington, Andrew Jackson's victory at New Orleans and a successful peace treaty in 1814 turned the popular tide in Madison's favor. Three years later, he left Washington for retirement at his estate, Montpelier. Later, he succeeded Jefferson as rector of the University of Virginia and prepared his notes of the 1787 Convention for publication. Madison died on 28 June 1836.

JAMES MADISON (1751–1836)
1. by James Sharples Senior, from life, 1796–1797

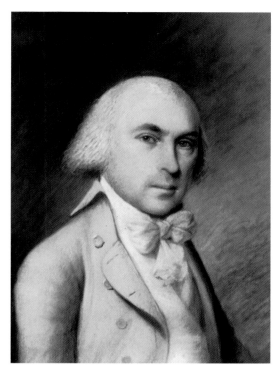

Catalog Number INDE10053

1. During his last few months in Congress, Madison and his wife posed for British pastelist James Sharples Senior (1751–1811) at his studio in Philadelphia. The artist recorded the Congressman's portrait as "James Madison, esq., M[ember of] C[ongress]" in his 1802 catalog published on his return to England. In Madison's portrait, his softly modeled features and delicate pink flesh tones characterize some of Sharples's best work.[1] A second version of Sharples's Madison portrait (attributed to James Sharples Senior but probably a copy by the artist's wife Ellen Sharples) is now in Amherst College's Mead Art Museum collection.[2]

⁓◦⟨⟩◦⁓

Provenance:
Listed in the 1802 Bath catalog of Sharples's work. Given to the Royal West of England Academy by Ellen Sharples in 1849. Purchased by the City Art Gallery of Bristol from the Royal West of England Academy in 1931. Purchased by the Friends of Independence National Historical Park from the City Art Gallery of Bristol and given to Independence Park in 1973.

Physical Description:
Pastel on paper. Half length, torso turned slightly to the sitter's right. Tan coat, white waistcoat, white stock and jabot. Powdered hair, blue eyes. Variegated blue and orange background. 9 inches H × 7 inches W.

[1] John C. Milley, "Thoughts on the Attribution of Sharples Pastels," *1975 University of Pennsylvania Hospital Antiques Show,* exhibit catalog, 62.

[2] The Mead pastel was donated by Herbert L. Pratt, who purchased it at the 1916 sale of Frank M. Etting's Philadelphia estate. Etting had organized the City of Philadelphia's Centennial-era purchase of nearly fifty pastels from a large collection that had once belonged to Sharples's son Felix. The Madison portrait in Felix Sharples's former collection was not among those purchased by the city, but rather became part of Etting's own collection.

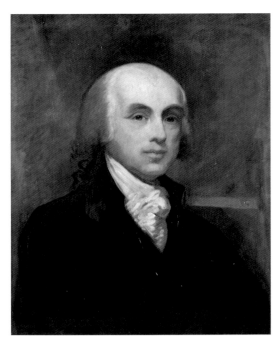

Catalog Number INDE14091

(SN 13.177)

JAMES MADISON (1751–1836)
2. by Catherine A. Drinker, after Gilbert Stuart, 1875

2. For its historical museum in Independence Hall, the City of Philadelphia commissioned a portrait of Madison from Philadelphia artist Catherine A. Drinker (1844–1922). Drinker copied Gilbert Stuart's 1804 portrait of Madison (now owned by the Colonial Williamsburg Foundation) for the city.

—⁂—

Provenance:
Purchased by the City of Philadelphia from the artist in 1875.

Physical Description:
Oil on canvas. Half length, seated torso turned slightly to the subject's left. Black coat and waistcoat, white stock and cravat. Powdered hair tied in a queue with a black ribbon, hazel eyes. Red drapery in left background pulled back to show leather-bound books. 24¼ inches H × 20 inches W.

JOHN MARSHALL (1755–1835)
by George Kasson Knapp, after Henry Inman, c. 1899

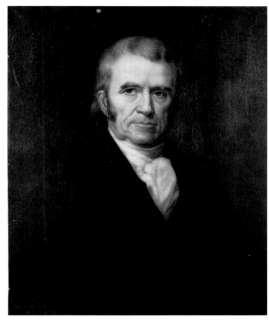

Catalog Number INDE14087

(SN 13.178)

Marshall was born on 24 September 1755 in Prince William (now Fauquier) County on the Virginia frontier. In 1775, he joined Virginia's Revolutionary militia; the following year he entered the Continental army, with which he served at Brandywine, Germantown, Monmouth, Valley Forge, and Stony Point before his enlistment term ended in 1779. He then studied law with George Wythe at the College of William and Mary. With his election to the Virginia Assembly in 1782, Marshall moved to Richmond and opened a legal practice. He attended his state's federal Constitution ratifying convention in 1787, and became a leader among Virginia's Federalists. Later, he declined presidential appointments as attorney general, minister to France, associate Supreme Court justice, and secretary of war. In 1799, he entered Congress where he remained for a year until he served briefly as President John Adams's secretary of state.

In early 1801, Marshall became chief justice of the United States Supreme Court, opening the court's first session in the new Washington capital. During the next thirty-four years, he ruled the Court absolutely, personally composing nearly half of the twelve hundred decisions made by the court during this time. In them, he committed himself to the principle of the Court's ultimate authority in interpreting the Constitution (confirmed in the 1803 case *Marbury vs. Madison*). Throughout his career, he viewed the Constitution and the Court as the protectors of both national integrity and private interest, not of states' rights. Marshall died in office on 6 July 1835.

In 1899, the City of Philadelphia added a portrait of Marshall to Independence Hall's museum. New York artist George Kasson Knapp (1833–1910) copied Henry Inman's 1831–1832 portrait of Marshall (commissioned for and still owned by the Philadelphia Bar Association).[1]

❦

Provenance:
Given to the City of Philadelphia by the artist in 1899.

Physical Description:
Oil on canvas. Half length, facing front. Black coat, white stock and jabot. Graying brown hair, brown eyes. Dark olive background. Signed in lower left "G.K. Knapp. 1899/After H. Inman 1833." 26⅜ inches H × 21½ inches W.

[1] Inman's own copies of his Marshall portrait are owned by the Virginia State Library and the Pennsylvania Academy of the Fine Arts.

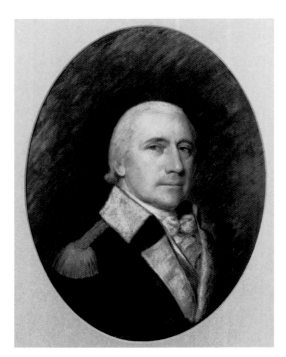

Catalog Number INDE12606

ALEXANDER MARTIN (1740–1807)
by James Sharples Senior, probably from life, 1797

Martin was born in 1740 in Hunterdon County, New Jersey. After graduating from the College of New Jersey (now Princeton), he spent a year in Virginia as a tutor. He then moved to North Carolina and became a merchant while reading law. By 1766, he was appointed deputy king's attorney for Rowan County. The county was the center for the North Carolina Regulators, poor farmers who rose in protest against lawyers, taxes, and the colony's eastern residents. In 1770, the Regulators attacked the colonial court at Hillsborough and beat many of its lawyers, including Martin. Six months later, he helped prevent a similar attack on the Rowan County court by negotiating an agreement to cut court fees.

When the Revolutionary War began, Martin fought against Loyalist forces in the Carolinas, then against the British at Charleston, Brandywine, and Germantown. After the American defeat at Germantown, Martin was courtmartialed for cowardice. He was acquitted, but resigned and returned to North Carolina to serve as governor for most of the period between 1782 and 1792. He also served in the Continental Congress and, in 1787, attended the federal Constitutional Convention (although he left early in order to attend North Carolina's lucrative court sessions and did not sign the completed Constitution). In 1792, he entered the United States Senate for a term and then retired. He continued to participate in state affairs, notably as a trustee of the University of North Carolina. Martin died on 2 November 1807.

While serving in the United States Senate, Martin sat for his portrait by British pastelist James Sharples Senior (1751–1811) in 1797. Sharples later listed this portrait as "Governor Martin" in the catalog he published on his return to England. Sharples's decision to depict Martin in uniform is interesting, given the sitter's clouded military record. The opacity of Martin's coat and of the background in this pastel may be the result of later retouching. There is a second version of the Martin pastel, also by James Sharples Senior, at the museum of Early Southern Decorative Arts in Winston-Salem, North Carolina. This and the Independence pastel are virtually indistinguishable from one another, making it unclear which is the life portrait.

‑‑‑⬭‑‑‑

Provenance:
Listed in the 1802 Bath catalog of Sharples's work. Given to Independence National Historical Park by Thomas T. Upshur, great-great-great-grandson of the sitter, in 1982.

Physical Description:
Pastel on paper. Half length, torso facing the sitter's left. Dark blue uniform coat with white lapels and gold epaulettes. White stock and jabot. Light blue sash. Gray hair, brown eyes. Dark brown and blue background. 9 inches H × 7 inches W.

LUTHER MARTIN (1748–1826)
by William Shaw Tiffany, after Cephas Thompson, 1875

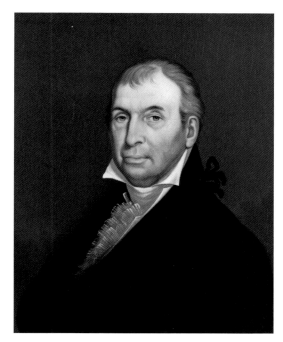

Martin was born on 20 February 1748 near Piscataway, New Jersey. Later, he attended the College of New Jersey (now Princeton), and then taught school on Maryland's Eastern Shore. Afterward, he read law and opened a Maryland practice. He joined his county's Revolutionary Committee of Observation (which enforced Maryland's boycott of British imports) and sat in the provincial convention. In 1778, he became his state's first attorney general. He held the office for the next twenty-seven years.

Martin declined election to Congress, but did attend the 1787 federal Constitutional Convention. His states' rights views prevented him from supporting the new federal plan and he led the failed opposition effort to it in his state. At the same time, he maintained his legal practice, defending Associate Supreme Court Justice Samuel Chase during his impeachment and former vice president Aaron Burr during his treason trial. After service as Baltimore's chief judge of the court of oyer and terminer, Martin returned to the state's attorney general's office in 1818. Following a debilitating stroke, he moved into the New York home of his former client, Aaron Burr, and received from the state of Maryland a stipend raised through a tax on all attorneys in the state. Martin died on 10 July 1826.

During its preparations for the Centennial, the City of Philadelphia commissioned Baltimore artist William Shaw Tiffany (1824–1907) for a portrait of Martin. Tiffany copied Cephas Thompson's c. 1804 portrait of Martin (now owned by the Baltimore Bar Association, Baltimore Court House).[1]

Provenance:
Purchased by the City of Philadelphia from the artist in 1875.

Physical Description:
Oil on canvas. Bust length, torso turned to subject's right. Black coat, white waistcoat, white stock and lace jabot. Light brown hair tied in a queue with a black ribbon, hazel eyes. Reddish brown background. 24¼ inches H × 20⅗₆ inches W.

Catalog Number INDE14089
(SN 13.180)

[1] Thompson's work was identified in Stiles Tuttle Colwill, "A Chronicle of Artists in Joshua Johnson's Baltimore," in Carolyn J. Weekley et al., *Joshua Johnson, Freeman and Early American Portrait Painter* (Williamsburg, Va.: The Abby Aldrich Rockefeller Folk Art Center, The Colonial Williamsburg Foundation, 1987), 83.

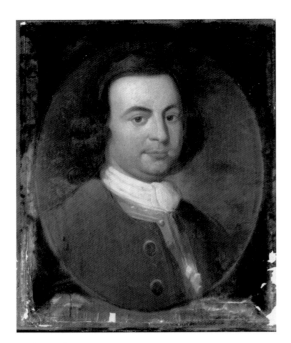

Catalog Number INDE14088
(SN 13.181)

GEORGE MASON (1725–1792)
by an unidentified artist (possibly Herbert B. Welsh),
after Dominic W. Boudet from a painting by John Hesselius, c. 1850–1874

Mason was born in Fairfax County, Virginia, in 1725. After his father's early death, George grew up under the guardianship of his uncle, attorney John Mercer. Mercer's enormous library provided Mason with a broad and deep education, particularly in the law. Although he never entered his uncle's profession, Mason earned an extensive reputation for his knowledge in matters of law. Most of Mason's time was spent in the management of his substantial estate, Gunston Hall, but he also served as a county court justice, a member of the House of Burgesses, and treasurer of the Ohio Company.

After 1765, when he defied the Stamp Act by purchasing goods without paying the tax, Mason established himself as a leading theorist for the growing colonial protest against English rule. For Virginia, he drafted the non-importation resolutions in response to the Townshend Acts, and the Fairfax Resolves in reaction to the Boston Port Bill, both of which were later adopted by the Continental Congress. In 1776, he composed Virginia's first state constitution and framed its Declaration of Rights. The latter served Thomas Jefferson in his creation of the Declaration of Independence and also provided the basis for the Constitutional amendments that form the federal Bill of Rights.

Mason's growing concern with the weakness of the Articles of Confederation government brought him back to public service after a self-imposed retirement during the 1780s. At the 1787 Constitutional Convention, he spoke frequently and influentially on various components of the proposed federal plan, but rejected the final plan because it lacked a bill of rights and because it permitted slavery. Later, he maintained his opposition to the Constitution at Virginia's ratifying convention and in a pamphlet campaign. Declining election to the first United States Senate, Mason died on 7 October 1792.

In early 1875, the City of Philadelphia acquired a portrait of Mason for its historical collection in Independence Hall. This painting was based on the 1811 work by French artist Dominic W. Boudet. According to family tradition, Boudet copied John Hesselius's 1750 life portrait of Mason (presumed destroyed) for each of the sitter's three surviving children. One of these Boudet copies apparently served as the source for the later Independence portrait of Mason by an unidentified artist.[1] The Independence portrait was donated by Mrs. Samuel Chew, whose husband was the nephew of Mason's granddaughter-in-law and the owner of the Boudet copy that is now at the Virginia Museum of Fine Art (the second Boudet is now privately owned, and the third is unlocated).

⸻

Provenance:
Given to the City of Philadelphia by Mary Johnson Brown (Mrs. Samuel) Chew, member of the mayor's Committee for the Restoration of Independence Hall, in 1875.

Physical Description:
Oil on canvas. Bust length, torso slightly toward subject's left. Brown coat, blue waistcoat with gold trim and gold buttons, white stock and cravat. Brown hair, dark brown eyes. Brownish-red background. 22⅜ inches H × 18⅜ inches W.

[1] A tag attached to the Independence painting reads in part "artist Herbert Welsh." Herbert B. Welsh was working in Philadelphia in 1851 (a signed and dated portrait of Charles Willing was owned by the Philadelphia Contributionship, and a dated landscape is privately owned).

TIMOTHY MATLACK (about 1735–1829)
by Charles Willson Peale, from life, 1826

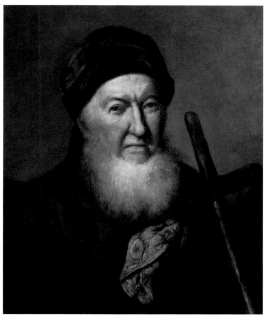

Catalog Number INDE11869
(SN 13.183)

Matlack was born in Haddonfield, New Jersey, sometime between 1734 and 1736. His family moved to Philadelphia in the 1740s as members of the Society of Friends. In the spring of 1775, he became clerk to the Continental Congress (reportedly penning the formal copy of the Declaration of Independence). Early in 1776, he joined the state militia and fought in the Trenton campaign. He was also elected to Pennsylvania's state constitutional convention and served on the committee that drafted this most radical and controversial of the new state constitutions. In 1777, he was elected secretary to Pennsylvania's Supreme Executive Council, where he served until his removal in 1782.

During this period Matlack was also chosen a trustee of the University of Pennsylvania, a director of the Bank of North America, a member and secretary of the American Philosophical Society, and a delegate to the Continental Congress he had once served as a clerk. In 1781, he was among the founders of the Society of Free Quakers, which accepted Quakers ejected from their own meetings because of their Revolutionary military service. He later served as secretary to the state senate in Lancaster and prothonotary of the federal district court in Philadelphia. Matlack died in that city on 14 April 1829.

Still painting at the age of eighty-five, Charles Willson Peale traveled over ten miles for a portrait sitting with his old political friend Matlack, who was in his nineties.[1] The resulting work is a fine portrayal of dignified old age.

In 1826, Peale wrote to his son Rubens that he had finished this museum portrait and "as far as I have yet heard [it] is much admired, his long white beard and Brown velvet cap makes it a singular picture."[2] Peale also mentioned that he had signed and dated the back of the canvas, a practice he wished he had begun during the Revolutionary War. The Matlack portrait is a remarkably cohesive work, especially considering the artist's advanced age and impaired eyesight. Peale died on 22 February 1827; Matlack's museum portrait was the last he ever painted.

⁂

Provenance:
Purchased by the City of Philadelphia at the 1854 Peale Museum sale.

Physical Description:
Oil on canvas. Half length, seated facing nearly fully to the front. Dark gray coat with red bandanna scarf tucked into the left lapel. Brown velvet cap, gray beard, green eyes. Holds wooden staff in crook of his left arm. Wooden chair back in right midground. Olive-brown background. Signed on back of canvas "Portrait Timothy Matlack Esq./ aged 90/by C.W. Peale at age of 85." 24⅜ inches H × 20⅛ inches W.

[1] An earlier portrait of Matlack (now owned by the National Gallery of Art), once attributed to the senior Peale, was painted by the artist's son Rembrandt in 1805.

[2] Charles Willson Peale to Rubens Peale, 27 June 1826 (Miller, *Selected Papers* 4, page 545).

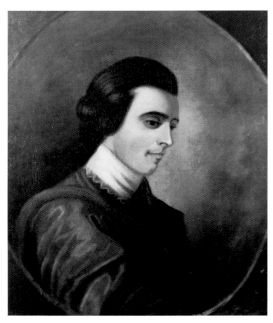

Catalog Number INDE14090

(SN 13.185)

ARTHUR MIDDLETON (1742–1787)
by Philip Fisbourne Wharton, after Benjamin West, c. 1872

Middleton was born near Charleston, South Carolina, on 26 June 1742. As a youth, he received most of his education in England, including legal studies at London's Middle Temple. After his return to South Carolina six years later, he took a seat in the colonial assembly, where he served for five years. Following an extensive tour of Europe with his wife and family, he returned to South Carolina's assembly, and later joined the provincial congress formed to debate South Carolina's continued colonial status.

In 1775, Middleton joined South Carolina's council of safety (the state's Revolutionary government), and assisted with the preparation of the state's first constitution. After the new government's installation, he went to the Continental Congress in late spring and there signed the Declaration of Independence. Despite his repeated reelection to Congress, he remained in South Carolina until the British captured Charleston in 1780. After his parole from prison in Florida the following summer, he returned to Charleston and then to Congress in 1782. Middleton died on 1 January 1787.

In 1872, as Philadelphia began its preparations for the approaching national Centennial, local artist Philip Fisbourne Wharton (1841–1880) offered a portrait of Middleton for the museum in Independence Hall. Wharton based this copy on Benjamin West's 1772 three-quarter length portrait of Middleton and his family while they were in England (now privately owned, on loan to the Middleton Place Foundation).

⤜✥⤛

Provenance:
Given to the City of Philadelphia by the artist in 1872.

Physical Description:
Oil on canvas. Bust portrait, nearly profile to the subject's right. Dark red cloak, gray coat with white Vandyke collar. Brown hair tied in a queue with dark ribbon, brown eyes. Olive-green background. 24¼ inches H × 20⅛ inches W.

THOMAS MIFFLIN (1744–1800)
by Charles Willson Peale, from life, 1783–1784

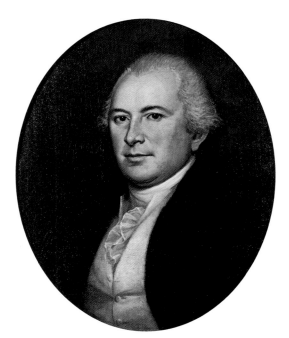

Catalog Number INDE14105
(SN 13.186)

Mifflin was born in Philadelphia on 10 January 1744. He was educated at a Quaker school and at the College of Philadelphia (now the University of Pennsylvania). After graduation, he spent four years in the office of William Coleman, one of Philadelphia's most successful merchants. In 1764, Mifflin toured England and France, then returned to Philadelphia and joined his brother in a prosperous mercantile partnership. After serving as a Philadelphia municipal warden in 1772, Mifflin entered the colonial legislature. Two years later, he helped to organize and then attended the First and Second Continental Congresses.

Mifflin joined Pennsylvania's militia and in 1775 was appointed quarter-master general. He served two years. At that time, he was appointed to the Board of War, where he was implicated in the purported scheme to replace commander-in-chief Washington with General Horatio Gates. Mifflin denied any involvement, but resigned from military service. In 1782, he returned to Congress as its president. Later, he attended the federal Constitutional Convention and presided over his state's ratifying convention. He was speaker of the state legislature and served three terms as governor, during which he suppressed the 1794 Whiskey Rebellion on the state's western frontier. Bankrupted by a lifetime of lavish spending, Mifflin died on 20 January 1800, and was buried at the state's expense.

During the Revolution, Charles Willson Peale (who was in a neighboring military camp painting portraits) recorded one of Mifflin's recruitment rallies: "the Battalion went out to be Review'd by General Mifflin, who haranged [*sic*] them for the purpose to turning out to join Genl. Washington, the Battalion was small but unaminous [*sic*] in going to stop the Progress of the Enemy."[1] The artist found himself equally swayed by the "harangue" and so he too joined in the march. Following the war, Peale selected Mifflin as a portrait subject for the Philadelphia Museum. Peale first recorded this painting as "president of Congress" in the 13 October 1784 issue of the *Freeman's Journal and Philadelphia Daily Advertiser*. Peale's son Rembrandt copied the Mifflin museum portrait (now at the Maryland Historical Society) around 1795 for use during a patronage trip to Charleston and later in the Baltimore Peale Museum.

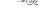

Provenance:
Listed in the 1795 Peale Museum catalog. Purchased by the City of Philadelphia at the 1854 Peale Museum sale.

Physical Description:
Oil on canvas. Bust length, torso turned slightly to sitter's right. Dark blue coat, yellow waistcoat, white stock and jabot. Powdered hair, brown eyes. Olive-brown background. 23³⁄₁₆ inches H × 20¼ inches W.

[1] Charles Willson Peale, Diary, 29 November 1776. Peale–Sellers Papers, American Philosophical Society.

JAMES MONROE (1758–1831)

Monroe was born on 28 April 1758 in Westmoreland County, Virginia. During his youth, he attended a private school and then the College of William and Mary. In 1776, he enlisted as a lieutenant in the Continental army. He fought at Harlem, White Plains, and Trenton (where he was wounded). Promoted to major, he served as aide to William Alexander, Lord Stirling, at Brandywine, Germantown, and Monmouth. In 1780, Monroe began his legal studies with Thomas Jefferson, then the governor of Virginia. Monroe began his political career with election to the Virginia legislature in 1782. Then, after a term in Congress and attendance at the Annapolis Convention, he returned to his state's legislature. Afterward, he sat in his state's federal Constitution ratifying convention, where he opposed the new federal plan.

In 1790, Monroe was appointed to fill a sudden vacancy in the United States Senate. Despite his Antifederalist politics, he received an appointment as minister to France in 1794. He remained in Paris for two years and attempted to ease French concerns over American concessions to England in the recent Jay's Treaty. Like his French ministry, his subsequent diplomatic career involved several difficult assignments. He made a second trip to France in 1803 to assist his successor, Robert R. Livingston, with the negotiations that led to the Louisiana Purchase. In the following year, Monroe served an unsuccessful posting to Spain to assist Minister Charles Pinckney in clarifying American claims to Florida. In 1805, Monroe went as minister to England where he and William Pinckney attempted to formalize British and American compromises on commercial neutrality.

When he returned to America, Monroe served a brief term in the Virginia legislature and in the governor's office (he had previously served there before his second trip to France) before he accepted an appointment as President James Madison's secretary of state in 1811. During the diplomatic crisis that led to America's declaration of war on England in 1812, Monroe favored reconciliation between the two nations. Afterward, he supported the president's war policy in the foreign office as well as serving two years as secretary of war.

In 1816, Monroe began the first of his two presidential terms. During the second, his administration successfully concluded negotiations with Spain for possession of Florida. European reaction to this event propelled Monroe, aided by his secretary of state John Quincy Adams, formally to declare American opposition to European colonialism. This 1823 "doctrine" formed the foundation of American foreign policy for the next century. After his retirement, Monroe returned once to public service as the president of Virginia's 1829 constitutional convention. He died in New York on 4 July 1831.

JAMES MONROE (1758–1831)
1. attributed to Felix Sharples, probably from life, c. 1807–1811

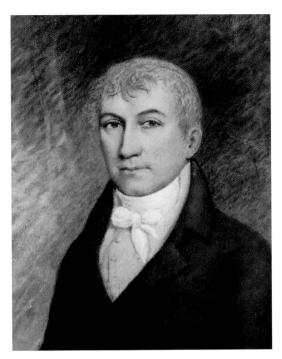

Catalog Number INDE11916
(SN 7.024)

1. During their second visit to the United States, the Sharples family of British pastelists resumed their travels (begun during the 1790s), painting portraits of prestigious Americans. James Sharples Senior is not known to have visited south of Philadelphia during this time; therefore, a pastel portrait of Monroe in the Sharples style is attributed to his son Felix (1778?–1835?) who traveled extensively in Virginia.[1] Felix Sharples preceded his parents and sister in their return to America, arriving in 1806 (he also remained after they left in 1811, when James Senior died). Felix may have arranged the sitting after Monroe returned from England in 1807 and before he moved to Washington in early 1811. The portrait is competently done with able technique in depicting form, but without James Sharples Senior's skill in modeling through the use of delicate shading. A second version (now in a private collection) of the Sharples's Monroe pastel appears to be the work of Felix's mother, Ellen. This pastel exhibits a tightly controlled painting technique that may reflect Ellen Sharples's training as a miniaturist.

⟶◦◉◦⟵

Provenance:
Given by Ellen (Mrs. James) Sharples to Felix Sharples in 1811. Given by Felix Sharples to Levin Yardly Winder in the 1830s. Inherited by Nathaniel James Winder from Levin Yardly Winder. Inherited by Richard Bayly Winder from Nathaniel James Winder in 1844. Purchased by Murray Harrison from Richard Bayly Winder around 1865. Purchased by the City of Philadelphia from Murray Harrison in 1874.

Physical Description:
Pastel on paper. Half length, torso slightly to the sitter's right. Black coat, tan waistcoat, white stock and jabot. Gray hair, brown eyes. Gray and rust hatched background.
9 inches H × 7 inches W.

[1] Lee A. Langston–Harrison, ed., David Meschutt and John N. Pearce, assoc. eds., *Images of a President: Portraits of James Monroe,* exhibit catalog, James Monroe Museum (Fredericksburg, Va., 1992), 9. The museum of Early Southern Decorative Arts in Winston–Salem, North Carolina, has a substantial collection of pastels attributed to Felix Sharples.

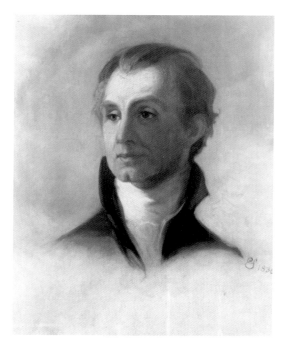

Catalog Number INDE15054

(SN 13.190)

JAMES MONROE (1758–1831)
2. by Ellen Oldmixon Sully, after Thomas Sully, 1836

2. During the first half of the twentieth century, the City of Philadelphia continued to acquire portraits for the historical museum in Independence Hall. Around 1923, the Pennsylvania Colonization Society donated to the city a portrait of Monroe by Philadelphia artist Ellen Oldmixon Sully (1816–1896).[2] In 1836, the Society had commissioned Miss Sully for a copy of her father's 1829 bust portrait of Monroe (now in the United States Department of State collection). Miss Sully's portrait honored President Monroe's 1822 assistance in establishing the free colony of Liberia on the West African coast.

❧

Provenance:
Given to the City of Philadelphia by the Pennsylvania Colonization Society around 1923.

Physical Description:
Oil on artist's board. Head and neck, facing slightly to the subject's right. Gray jacket, white stock. Brown hair, blue eyes. Light, unfinished background. Signed in lower right "ES 1836." 24 inches H × 20 inches W.

[2]This 1923 date is based on the Society's documented donation of forty-two paintings (including two portraits by Ellen Sully, one of Charles Carroll and one of Bishop William White) to the Historical Society of Pennsylvania. Nicholas B. Wainwright, *Paintings and Miniatures at the Historical Society of Pennsylvania* (Philadelphia: Historical Society of Pennsylvania, 1974), 48, 281. The Colonization Society apparently disbanded in the early 1920s.

RICHARD MONTGOMERY (1738–1775)
by Charles Willson Peale, possibly after an engraving, 1784–1786

Catalog Number INDE14116

(SN 13.189)

Montgomery was born on 2 December 1738 in County Dublin, Ireland. He later graduated from St. Andrews and Trinity College before he accepted an ensign's commission in the British army in 1756. During the French and Indian War, he served at the siege of Louisbourg, the Lake Champlain campaign, and the captures of Martinique and Havana. After a brief return to Great Britain, he resigned his captain's commission and settled in New York in 1772. His move to the colonies involved him in the growing protest against British rule, and he joined New York's Provincial Congress in 1775. A few months later, he accepted a brigadier general's appointment from the Continental Congress and led the American campaign into Canada. There, his troops captured the British forts at Chambly and St. Johns, and the city of Montreal. Later, Montgomery was killed during the American attack on Quebec on 31 December 1775.

The dramatic circumstances of Montgomery's early death elevated him to heroic status among Americans during the Revolution. Intending to capitalize on this interest, Charles Willson Peale added a portrait of Montgomery to his Philadelphia Museum. Possibly, Peale based his posthumous portrait (indicated by the convention of blue sky in the background) on the one engraved by John Norman for volume one of *An Impartial History of the War in America*, published in 1781.[1] Or the museum portrait may be based on a miniature (now in the Manney collection of the Metropolitan Museum of Art) purportedly copied by Peale from an earlier portrait brought by the subject from Ireland.[2] The Peale Montgomery portrait has the number "51" in its lower right corner, suggesting its one-time position in Peale's gallery. Since the announcement of Peale's Museum published in the 13 October 1784 *Freeman's Journal and Philadelphia Advertiser* lists forty-four paintings (the Montgomery is not included), it suggests that the Montgomery portrait was finished a short time after that.[3]

Provenance:
Listed in the 1795 Peale Museum catalog. Purchased by the City of Philadelphia at the 1854 Peale Museum sale.

Physical Description:
Oil on canvas. Bust length, left profile. Dark blue uniform with buff facings, gold epaulette. Black stock, white lace jabot. Brown hair tied in a queue, blue eyes. Light blue sky and clouds in background. 23⅛ inches H × 19½ inches W.

[1] Mary Jane Peale, the artist's granddaughter, noted in her copy of the 1854 Peale Museum sale catalog (in the collections of Independence National Historical Park) that the Montgomery was a "copy from a print CWP."

[2] Sellers, *Portraits and Miniatures*, 144.

[3] The British traveler Henry Wansey mentions the Montgomery portrait in his 1794 account of a visit to Philadelphia. David John Jeremy, ed., *Henry Wansey and His American Journal, 1794* (Philadelphia: American Philosophical Society, 1970), 105.

Catalog Number INDE14115

(SN 13.191)

WILLIAM MOORE (around 1735–1793)
by Charles Willson Peale, from life, 1781–1782

Moore was born in Philadelphia around 1735. Later, he entered his family's mercantile business, and he received an appointment to the city's Revolutionary council of safety in 1776. He also became a member of the Pennsylvania Board of War and joined his state's Supreme Executive Council as its vice president. In 1781, he became the council's president and the judge of Pennsylvania's high court of errors and appeals. After the Revolution, he served in the state assembly and as director of the Bank of Pennsylvania. Moore died on 24 July 1793.

Charles Willson Peale included Moore, a popular politician, in his first collection of portraits painted for the Philadelphia Museum. The portrait was possibly painted during the year that Moore was president of the Pennsylvania Supreme Executive Council.[1]

Moore's was among the portraits listed in Peale's advertisement for the museum (as "President of this state [Pennsylvania]") in the 13 October 1784 issue of the *Freeman's Journal and Philadelphia Daily Advertiser*.

❧

Provenance:
Listed in the 1795 Peale Museum catalog. Purchased by the City of Philadelphia at the 1854 Peale Museum sale.

Physical Description:
Oil on canvas. Bust length, torso turned slightly to the sitter's left. Gray green coat, white waistcoat, white stock and jabot. Powdered wig, brown eyes. Brown background. 23⁵⁄₁₆ inches H × 19⅝ inches W.

[1] Sellers, *Portraits and Miniatures*, 145.

DANIEL MORGAN (1736–1802)
by Charles Willson Peale, from life, c. 1794

Catalog Number INDE11884
(SN 13.192)

Morgan was born in 1736, probably in Hunterdon County, New Jersey. As a teenager, he moved near Winchester, Virginia, to work as a farm hand and teamster. Around 1755, he contracted with the British army under General Braddock, and, when the French and Indian War began, he volunteered for frontier defense. In 1758 his unit was caught in an ambush, and he was severely wounded in the upper jaw. Early in the Revolutionary War, Morgan commanded a rifle company in the Continental army's abortive assault on Quebec during the winter of 1776 (in which he was captured). After his exchange, he joined the Northern Army and fought at the battle of Saratoga. Following a short retirement, he returned to active service in 1779. Now attached to the Southern Army, he commanded a militia force with light infantry and cavalry. In early 1781, he won a celebrated victory over the British at the battle of Cowpens. Afterward, injuries forced him home to Virginia. In 1794, he commanded the Virginia militia assigned to combat the Whiskey Rebellion in western Pennsylvania. Morgan entered Congress for a term in 1797 and died on 6 July 1802.

Charles Willson Peale probably painted his museum portrait of Morgan when the hero of Cowpens passed through Philadelphia in 1794 on his way to the western frontier at the time of the Whiskey Rebellion. Previously, this painting was considered a copy until recent conservation removed earlier overpaint, uncovering the distinctive scar on Morgan's upper lip.[1] Another Peale portrait of the subject (in uniform, but posed differently, and possibly by the artist's son Rembrandt) is now owned by the Virginia Historical Society.[2]

Provenance:
Listed (incorrectly as "Jacob Morgan") in the 1795 Peale Museum catalog. Purchased by the City of Philadelphia at the 1854 Peale Museum sale.

Physical Description:
Oil on canvas. Bust length, torso turned slightly toward the sitter's right. Dark blue uniform coat with buff facings, gold epaulettes with one silver star each. Black stock, white lace jabot. Gray hair, blue eyes. Gray background. 23 1/16 inches H × 19 3/16 inches W.

[1] Sellers, *Portraits and Miniatures*, 146.

[2] Sellers, *Supplement*, 72–73.

Catalog Number INDE11362

ANTHONY MORRIS (1766–1860)
by Charles Willson Peale, from life, 1795–1796

Morris was born in Philadelphia on 10 February 1766. After private study, he graduated from the University of Pennsylvania and then read law. Although he was admitted to the bar, he pursued a mercantile career in the East India trade. In 1793, he entered the state senate and was elected its speaker for two terms. Later, he served as a director of the Bank of North America and a trustee of his alma mater. In mid-1813, President James Madison appointed Morris as one of America's envoys to the Spanish court. For two years, he conducted negotiations there that eventually resulted in the sale of Florida to the United States. After his return to America in 1817, he lived in Georgetown outside the national capital. In 1830, he founded a short-lived agricultural school at Bolton Farm in Pennsylvania. Morris died in Georgetown on 3 November 1860.

Morris owned several properties in Philadelphia. In 1796, builders finished his new summer estate, "The Highlands," near Fort Washington, Pennsylvania.

Early in that same year, he recorded the completion of another symbol of his wealth, a portrait painted by Charles Willson Peale.[1] The portrait depicts Morris seated casually in his library, the epitome of a learned country gentleman.

⎯⎯◦⟨∞⟩◦⎯⎯

Provenance:
Given to Independence National Historical Park by Eleanor Morris Thacher, the sitter's great-great-great-grandniece, in 1976.

Physical Description:
Oil on canvas. Half length, seated, body turned slightly to the sitter's right. Medium brown coat, gray waistcoat, white stock and jabot, medium brown breeches. Powdered wig, blue eyes. Left arm draped over chair back. Background of wooden shelves with leather bound books. 34¼ inches H × 26¾ inches W.

[1] Anthony Morris Daybook, 11 February 1796. Joseph Downs Manuscript Collection, Winterthur Museum and Library. In 1789, Peale's younger brother James painted miniature portraits (now privately owned) of Morris and his fiancée, Mary Pemberton. Sellers, *Supplement*, 73.

GOUVERNEUR MORRIS (1752–1816)
by Edward Dalton Marchant, after Thomas Sully, 1873–1874

Morris was born at his parents' Hudson River estate, Morrisania, on 31 January 1752. He attended school in New Rochelle, New York, and then entered Kings College (now Columbia University) in 1765. Following that, he studied the law and then opened his own practice. In the early 1770s, he entered New York's provincial assembly, and helped to draft the state's first constitution (in which he supported the abolition of slavery). A member of New York's Council of Safety, in 1778 he won election to the Continental Congress. There he frequently composed official policy reports, including Congress's instructions to Benjamin Franklin, which were later used in negotiating peace with England.

In 1779, Morris moved to Philadelphia, where he resumed his legal practice. His political and economic acumen caught the attention of Robert Morris (no relation) who hired him in 1781 as his United States assistant minister of finance. In 1787, Gouverneur Morris represented Pennsylvania at the federal Constitutional Convention, where he advocated a strong central government managed by a political elite. During the Convention's debates, he spoke more frequently than any other delegate, and he composed the final draft of the Constitution.

In 1789, Morris went to Paris as Robert Morris's financial representative and there gained an extensive knowledge of French politics, in addition to trade. As a result, President Washington appointed Gouverneur Morris as America's minister to France in 1792. He served there for two anxious years (secretly supporting the deposed king Louis XVI) until France's Jacobin government

severed diplomatic relations with the United States and demanded Morris's ouster. After he returned to America in 1798, he retired to his estate on the Hudson. Although he spent a brief period in the United States Senate, most of his attention was directed toward the planning and building of the Erie Canal. Morris died on 16 November 1816.

In preparation for the Centennial celebration, the City of Philadelphia commissioned a portrait of Morris for the museum in Independence Hall. Philadelphia artist Edward Dalton Marchant (1806–1887) copied Thomas Sully's 1808 portrait of the subject (now owned by the Historical Society of Pennsylvania)[1] for the city's use.

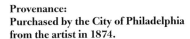

Provenance:
Purchased by the City of Philadelphia from the artist in 1874.

Physical Description:
Oil on canvas. Bust length, facing the subject's right. Black coat and waistcoat, white cravat. Powdered hair tied in a queue with a black ribbon, gray eyes. Deep-red background. Signed in lower left "E. D. Marchant./After/Mr. Sully." 24⅛ inches H × 20 inches W.

[1] Sully's own copy of the Morris portrait is now at Columbia University.

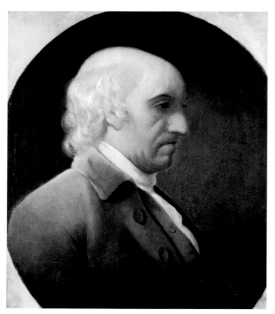

Catalog Number INDE14114

(SN 13.195)

LEWIS MORRIS (1726–1798)
by Charles Noel Flagg, after John Trumbull, c. 1873

Morris was born on 8 April 1726 at his family's estate, Morrisania, on the Hudson River in New York. After graduating from Yale, he served one term in the provincial assembly, and chaired his county's delegation to the 1775 provincial convention formed to elect representatives to the Second Continental Congress. He also served in that body, where he signed the Declaration of Independence. In addition, he accepted a commission in New York's militia and entered his state's legislature. After the war, he served on the Board of Regents for New York University. In 1788, he (like his half-brother Gouverneur, see above) supported the new federal Constitution at his state's ratifying convention. Morris died at Morrisania on 22 January 1798.

The City of Philadelphia added a portrait of Morris to the museum in Independence Hall at the time of the Centennial. For the subject's family, Connecticut artist Charles Noel Flagg (1848–1916) copied John Trumbull's portrait of Morris in the 1786–1820 *Declaration of Independence* (now at the Yale University Art Gallery).

❧

Provenance:
Given to the City of Philadelphia by Henry Manigault Morris, the subject's great-grandson, in 1874.

Physical Description:
Oil on canvas. Bust length, right profile. White hair, brown eyes. Light brown coat and waistcoat, white shirt. Gray hair, brown eyes. Dark background. 23 ¹³⁄₁₆ inches H × 20⅛ inches W.

MARTHA MORRIS (1751–1792)
by an unidentified artist, from life, c. 1755

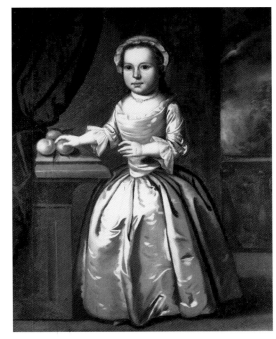

Catalog Number INDE10360

Morris was born in Philadelphia in 1751. At the time, her father, Joseph, was participating in the founding of the Pennsylvania Hospital. On 15 October 1772, she married Philadelphia merchant George Mifflin. The Mifflins subsequently had three children (their only daughter later married the eminent Philadelphia physician Dr. Caspar Wistar) before Mr. Mifflin's death in mid-1785. Mrs. Mifflin died on 9 January 1792.

This portrait of Morris presents its young sitter in the formal, adult manner common in American art prior to the third quarter of the eighteenth century. Her clothing and hair style, as well as her rigid pose, echo those of grown women. Only the pudginess of her forearms and cheeks, and the smooth front of her gown's bodice (indicating that the garment laced up the back at the hands of an adult) suggest her early youth.[1] The unidentified artist's awkward depiction of Morris's head (which seems to float above her neck, rather than resting upon it) suggests that this painting is not an original composition but a copy of some other work, possibly a British mezzotint.[2] The artist may also have been influenced by the style of one or more of the professional painters (like William Williams, John Wollaston, or John Hesselius) who worked in Philadelphia during the 1750s.

The setting portrayed in this painting contains a variety of generic elements, many of which are quite common in works of the same era. The subject stands in a formal but stark interior with a balcony at one end that overlooks an indistinct outdoor scene. In the foreground, a dark drapery folds back to reveal a plinth next to which the subject stands. Morris rests her right hand on one of three peaches on top of the plinth. Symbolically, the fruit may represent the freshness of youth and its potential for ripeness with age.

⁓◦⊚◦⁓

Provenance:
Given to Independence National Historical Park by Elliston Perot Morris, the sitter's great-great-great-grand nephew, in 1974.

Physical Description:
Oil on canvas. Full length, figure facing forward. Gray silk dress trimmed with white lace. Dark hair and dark eyes. White cap, coral bead necklace with locket. Brown shoes. Right hand resting on one of three peaches atop a stone plinth. Dark drapery swag over plinth in left foreground. Stone balustrade in right background, stormy sky. 37 ½ inches H × 31 inches W.

[1] Karin Calvert, "Children in American Family Portraiture, 1670 to 1810," *William and Mary Quarterly* 39 (January 1982): 101–103.

[2] The angle of Morris's arms and the placement of her fingers is quite similar to John Faber's 1727 mezzotint of Britain's Queen Caroline engraved after an earlier portrait by Highmore. See Waldron Phoenix Belknap, Jr., *American Colonial Painting* (Cambridge, Mass.: The Belknap Press, 1959), plate xxix.

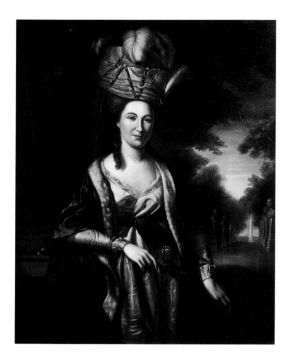

Catalog Number INDE11868

(SN 13.197)

MARY WHITE (MRS. ROBERT) MORRIS (1749–1827)
by Charles Willson Peale, from life, c. 1782

Mary, the daughter of Colonel Thomas White, was born in Philadelphia on 13 April 1749. She married entrepreneur Robert Morris on 2 March 1769, just before her brother William (later America's first Episcopal bishop) left for divinity school in London. The Morrises had seven children. With her husband's growing importance to the Revolution's political and financial success, Mrs. Morris became a leader in Philadelphia society as well as a hostess renowned for her expert domestic management.

After the unscrupulous actions of a business associate forced her husband into debtors' prison in early 1798, Morris lost her prestigious lifestyle. For three years, she dined with her imprisoned spouse every day. After his death in 1806, she remained a close friend to his former colleagues, including the Marquis de Lafayette, who made her home his first stop in Philadelphia on his return to America in 1824. Mrs. Morris died on 16 January 1827.

Charles Willson Peale painted companion portraits of Mrs. Morris and her husband (see below) around 1782.[1] Peale depicted the woman who "ruled the world of fashion with unrivaled sway" in a sumptuous costume and opulent headdress that reflect the current taste for exotic fancy dress.[2] She also wears chain bracelets embellished with miniature portraits (of her husband and, possibly, her father), a recent fashion in America.[3] The artist portrayed Morris in a pose identical to that of Baltimore's Margaret Tilghman Carroll (wife of Charles Carroll the barrister), whom he had painted in 1770. Like her Baltimore contemporary, Morris holds a leafy branch from an orange tree.[4] Mrs. Morris stands in a verdant garden, possibly at her country estate, "The Hills," on Philadelphia's Schuylkill River. The sculpture-lined allée in the right midground, led by a bust of George Washington, is reminiscent of one described by Abigail Adams during her stay in Philadelphia.[5] At Morris's right elbow stands a pedestal topped by an allegorical figure, possibly Euterpe, the muse of lyric poetry, adorned with a fresh floral garland and holding an attenuated trumpet. Both the garden and its sculptural elements probably refer to the sitter's education and refinement and to her traditional feminine role as a nurturing, civilizing force.

Sometime before 1854, this portrait of Mrs. Morris (as well as the companion portrait of her husband— see below) returned to the Peale family. Possibly, Charles Willson Peale acquired the paintings when the Morrises liquidated their estate during bankruptcy proceedings or after Mrs. Morris died.

— ·◦◦◦◦◦◦◦· —

Provenance:
Acquired by the Peale family possibly between 1798 and 1827. Purchased by the City of Philadelphia at the 1854 Peale Museum sale.

Physical Description:
Oil on canvas. Three-quarter length, standing, facing front. Fur-trimmed dark gray robe, gray wrap dress with blue sash and lace at neck and cuffs. Multi-chain bracelet with miniature portrait mounted on each wrist. Gray turban decorated with plumes, beaded cord twisted with ribbon, and diamond star and crescent moon pins. Right elbow resting on stone plinth topped with a sculpted bust (probably Euterpe, the muse of lyric poetry), right hand holding an orange tree branch. Sculpture-topped pedestals in right midground with an allée of trees open to the sky. 50⁷⁄₁₆ inches H × 40¾ inches W.

[1] The artist also painted miniatures (now privately owned) of the couple at this time. Sellers, *Portraits and Miniatures*, 149.

[2] Harrison Gray Otis to Mrs. Harrison Gray Otis, 16 February 1798. Otis Papers, Massachusetts Historical Society.

[3] John Adams noted that such bracelet miniatures were first seen by him in 1777. L.H. Butterfield, ed., *Diary and Autobiography of John Adams* (Cambridge, Mass.: Belknap Press, 1961), 2:260.

[4] On the Morris's greenhouse, see Kenneth and Anna M. Roberts, trans., *Moreau de St. Méry's American Journey, 1793–1798* (Garden City, N.Y.: Doubleday & Company, 1947), 231.

[5] Abigail Adams to Mrs. Shaw, 20 March 1791 in Charles Francis Adams, ed., *Letters of Mrs. Adams* (Boston: Charles C. Little, 1850), 420.

ROBERT MORRIS (1734–1806)

Morris was born on 31 January 1734 near Liverpool, England. During his early teens, he immigrated to Maryland, where his father worked as a tobacco exporter. He briefly attended school in Philadelphia, and then joined a local shipping firm. He rose quickly to a partnership in Willing, Morris & Company and entered the public arena as warden of the port of Philadelphia. In 1775, Morris expanded his political career to include Pennsylvania's Council of Safety, its Assembly, and the Continental Congress (where he signed the Declaration of Independence and, later, the Articles of Confederation). His congressional work, much of it through the secret Committee of Correspondence, included importing munitions for the army and conducting financial affairs for the Revolutionary government. In early 1781, he accepted a congressional appointment as superintendent of finance and organized a credit program to refit and refinance the Continental armed forces. He remained in the office for three years, during which time he founded the Bank of North America as the financial agency for Congress.

After the Revolution, Morris attended the Annapolis Convention (which met to create a comprehensive commercial policy for the United States) and the 1787 federal Constitutional Convention. A strong Federalist, he supported the new national government, and served in the United States Senate from 1789 until 1795. Throughout his professional career, Morris also managed a vast array of private investments. During the late 1790s, he acted upon some poor financial advice and overextended his credit in several land speculation deals. In 1798, he was arrested and sent to Philadelphia's debtors' prison. He remained there until 1801, when a new federal law that prohibited the long-term incarceration of debtors took effect. He died in Philadelphia on 8 May 1806.

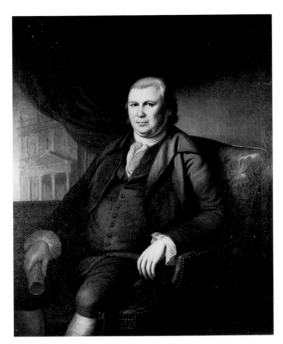

Catalog Number INDE14113

(SN 13.196)

[1] Sellers, *Portraits and Miniatures*, 148. In reality, the Bank of North America remained in modest quarters (a three-story brick town house) from its founding until 1847. It is possible that the edifice in Morris's three-quarter length portrait was designed by Peale as a reference to the Bank of England (built 1732–4, enlarged 1764–1774). Peale certainly knew the Bank during the 1760s when he worked in Benjamin West's London studio. For a discussion of the Bank's architecture, see Kenneth Hafertepe, "Banking Houses in the United States, The First Generation, 1781–1811," *Winterthur Portfolio* 35 (Spring 2000): 2–5.

[2] See Lillian B. Miller, "Charles Willson Peale: A Life of Harmony and Purpose," in Edgar P. Richardson et al., *Charles Willson Peale and His World* (New York: Harry N. Abrams, 1982), 213, in regard to architecture as symbolic of a subject's life's work in Peale's 1788 portrait of William Smith and his grandson. See also Robert J.H. Janson–LaPalme, "Generous Marylanders: Paying for Peale's Study in England," in Lillian B. Miller and David C. Ward, eds., *New Perspectives on Charles Willson Peale* (Pittsburgh, Pa.: University of Pittsburgh Press, 1991), 17.

ROBERT MORRIS (1734–1806)
1. by Charles Willson Peale, from life, c. 1782

1. Charles Willson Peale and Robert Morris began their respective political careers as opponents, the former a supporter of the popularly based government initiated under Pennsylvania's 1776 constitution and the latter a political conservative. After the two men (and their factions) alternately ousted each other from the state legislature during the 1779 and 1780 elections, however, the pair apparently became more cordial. Subsequently, Morris commissioned Peale for a series of portraits that celebrated the financier's public and private successes. During 1782 and 1783, Peale painted for Morris and his wife their miniatures (now privately owned) and a pair of pendant three-quarter length portraits (now at Independence National Historical Park). At the same time, he painted for Morris a double portrait (now at the Pennsylvania Academy of the Fine Arts) of him with his assistant superintendent of finance Gouverneur Morris.

Peale depicted Robert Morris in a three-quarter length portrait that shows him seated in his office holding a rolled document, possibly the charter for the newly created Bank of North America. Outside the window, there stands a neoclassical building with a portico topped by statuary. This structure bears no resemblance to any public buildings in America at that time nor to any of Morris's own properties.[1] It may be Peale's conjectural view of a proposed bank building, or it may be a symbolic edifice representing Morris's building of the new nation's economy through his fiscal planning.[2] Later, Morris commissioned a copy of this portrait (now owned by the New Orleans Museum of Art) for the Schuylkill Navigation Company.

Sometime before 1854, the three-quarter length portrait of Morris (as well as the companion portrait of his wife) returned to the Peale family. Possibly, Charles Willson Peale acquired the paintings when the Morrises liquidated their estate during bankruptcy proceedings or after Mrs. Morris died in 1827.

❦

Provenance:
Acquired by the Peale family possibly between 1798 and 1827. Purchased by the City of Philadelphia at the 1854 Peale Museum sale.

Physical Description:
Oil on canvas. Three-quarter length, seated, turned slightly toward the sitter's right. Blue coat and waistcoat, white stock, jabot and cuffs. White stockings. Gray hair, blue eyes. Red upholstered armchair with ornamental brass nail ornamentation. Holding rolled document in right hand, left elbow on chair arm. In left background, red drapery pulled back to show neoclassical building topped by statuary. 50½ inches H × 40 1/16 inches W.

ROBERT MORRIS (1734–1806)
2. by Charles Willson Peale, after Charles Willson Peale, c. 1782

2. The three-quarter length
portrait of Morris (and that of his
wife) returned to the Peale family,
possibly through Mrs. Morris or
her estate, sometime before 1854,
when they were sold at auction.
These portraits were probably not
part of the Philadelphia Museum
collection, as Peale had placed a
bust-length replica of Mr. Morris
as superintendent of finance in the
museum. This portrait was in the
13 October 1784 issue of the
*Freeman's Journal and
Philadelphia Daily Advertiser*
advertisement for the museum as
"superintendent of finance."

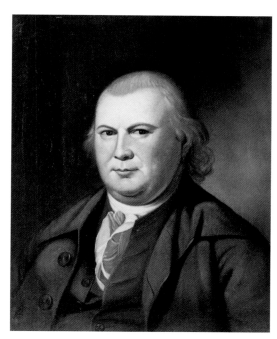

Catalog Number INDE14112
(SN 13.195)

—⚬⚬⚬—

Provenance:
Listed in the 1795 Peale Museum catalog.
**Purchased by the City of Philadelphia at
the 1854 Peale Museum sale.**

Physical Description:
*Oil on canvas. Bust length, facing front. Blue
coat and waistcoat, white stock and jabot.
Gray hair, blue eyes. Brown background.
23⅜ inches H × 19 5/16 inches W.*

Catalog Number INDE10414

SAMUEL BUCKLEY MORRIS (1791–1859)
by Rembrandt Peale, from life, 1795

Morris was born in Philadelphia on 27 December 1791. After his schooling, he joined his family's successful mercantile partnership. Around 1831, he resigned from the family business in order to pursue philanthropic interests. This included helping to found the Philadelphia Savings Fund Society, the Germantown Savings Fund, the Pennsylvania Asylum for the Deaf and Dumb, the Society of Friends Asylum for the Insane, Germantown Friends School, and Haverford College. Morris died in Germantown on 23 January 1859.

Philadelphia artist Rembrandt Peale (1778–1860) painted the three-year-old Morris in 1795, a year in which the young artist progressed from painting family portraits and copy works to a portrait of President George Washington. Peale's father had previously painted a portrait of Morris's uncle, Anthony (see above), and this connection may well have served Rembrandt in his own commission from the family. Rembrandt's portrayal of his young subject is both engaging and precise. The boy's dress and hair style reflect the contemporary custom of identically attiring children of both sexes until about the age of four or five.[1] The puppy in Morris's arms (a common masculine prop in boys' portraits of this era) and the farm in the portrait's background (probably the Morrises' Solitude Farm south of Philadelphia) provide references to the subject's life as a child of a successful Quaker family.[2] Upon finishing this portrait, Rembrandt exhibited it as *Portrait of Child and Lap-Dog* at the short-lived Columbianum, an art academy founded by Charles Willson Peale and other Philadelphia artists.

❧

Provenance:
Given to Independence National Historical Park by Marriot Canby Morris, great-grandson of the sitter, in 1974.

Physical Description:
Oil on canvas. Three-quarter length, standing, body facing slightly to the sitter's left. White dress, gold necklace with pendant locket. Brown hair, blue eyes. Holding a brown and white puppy in both arms. Large tree in left background, farm landscape with buildings, team and wagon in right background. Signed in lower left "Rembrandt Peale/Pinxit 1795." 26 inches H × 22 inches W.

[1] Karin Calvert, "Children in American Family Portraiture, 1670–1810," *The William and Mary Quarterly* 39:1 (January 1982), 94–5.

[2] Lillian B. Miller, *In Pursuit of Fame: Rembrandt Peale, 1778–1860*, exhibit catalog, National Portrait Gallery (Washington, D.C.: Smithsonian Institution, 1992), 30.

GOTTHILF HENRY ERNEST MUHLENBERG (1750–1801)
by Charles Willson Peale, from life, 1810

Catalog Number INDE14109

(SN 13.201)

Muhlenberg was born in New Providence, Pennsylvania, on 17 November 1753. His father, the eminent theologian Henry Melchior Muhlenberg, sent him and his two brothers to the prestigious academy and then the university in Halle, Germany. In 1770, the three brothers returned to America in order to assist their father in the ministry. Early in his career, Gotthilf Muhlenberg worked for the Lutheran United Congregations in Philadelphia, Barren Hill, and New Jersey's Raritan Valley. He often rode the circuit for his father and his brother Frederick Augustus (later Speaker of the United States House of Representatives) to the smaller churches in their care.

In 1774, Muhlenberg was elected third pastor of the United Congregations and he returned to the church in Philadelphia. Subsequently, he began a lifelong pursuit of botanical studies. In 1813 he published a *Catalog of the ... Plants of North America*, an annotated list of plant names based on the Linnean classification system. He also contributed to the work of other American botanists, and they credited him by giving his name to several new discoveries. In 1787, he received his doctor of divinity degree from Princeton and became the first president of Franklin College (now Franklin and Marshall). He had moved to Lancaster, Pennsylvania seven years before when he became the pastor of that city's Trinity Lutheran Church. Muhlenberg remained there until his death on 23 May 1815.

Charles Willson Peale visited Pennsylvania's capital of Lancaster in 1810, seeking support for his museum from the governor. At that time, Muhlenberg became one of the artist's strongest supporters, promising that he would "do all in his power with many of the members [of the state legislature] that he is acquainted with, and ... that he knows that he can materially aide [*sic*] me."[1] Peale then returned to Philadelphia with Muhlenberg's portrait (one of only three clerics honored in the museum), which he entered in the museum's accession book on 12 March 1810.[2]

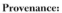

Provenance:
Listed in the 1813 Peale Museum catalog. Purchased by Townsend Ward (librarian of the Historical Society of Pennsylvania) at the 1854 Peale Museum sale. Purchased by the City of Philadelphia from Townsend Ward in 1854.

Physical Description:
Oil on canvas. Bust length, torso turned slightly to the sitter's right. Black coat, dark brown waistcoat, white clerical bands. Gray hair, green eyes. Dark brown background. 23⁷⁄₁₆ inches H × 19¹³⁄₁₆ inches W.

[1] Charles Willson Peale to Rubens Peale, 25 February 1810 (Miller, *Selected Papers* 3, page 16).

[2] Charles Willson Peale, "Memorandum of the Philadelphia Museum, 1803–1841," 49. Peale Papers, Historical Society of Pennsylvania. Sellers, *Portraits and Miniatures*, 150.

Catalog Number INDE14110

(SN 13.202)

JOHN PETER GABRIEL MUHLENBERG (1746–1807)
by Gustavus Adolphus Behne, after John Trumbull, c. 1875

Muhlenberg was born on 1 October 1746 in Trappe, Pennsylvania. After a few years at the Philadelphia Academy, he and his brothers were sent by their father (the theologian Henry Melchior Muhlenberg) to school in Halle, Germany. There, John began an apprenticeship to a shopkeeper and then joined the German army. After he and his brothers returned to America, Muhlenberg studied for the ministry and soon directed the Lutheran churches in Bedminister and New Germantown, New Jersey. Later, Muhlenberg moved to Virginia and became an Anglican priest. He then went to the colony's House of Burgesses and joined his county's Committee of Safety. In 1776, he led a militia unit in the Eighth Virginia "German" Regiment. He fought at Sullivan's Island, Brandywine, Germantown, Stony Point, and Yorktown.

By 1784, Muhlenberg had returned to Pennsylvania and was elected to the state's Supreme Executive Council. He served as the state's vice president under Benjamin Franklin. Muhlenberg then sat in Congress for three terms during the 1790s, and was twice a presidential elector. In 1801, he resigned from the United States Senate to accept the appointment as collector of customs in Philadelphia. He died at Gray's Ferry on 1 October 1807.

In 1875, Muhlenberg's descendants commissioned a portrait of their ancestor for the museum in Independence Hall from Gustavus Adolphus Behne (1828–1895), a German artist then working in Pennsylvania. Behne apparently copied John Trumbull's portrayal of Muhlenberg in the 1820 work *The Surrender of Lord Cornwallis at Yorktown* painted for the United States Capitol Rotunda.[1]

❧

Provenance:
Given to the City of Philadelphia by Charles Wetherill Keim on behalf of his stepdaughters Anna Muhlenberg Hiester and Edwardine Lauman Heister, great-granddaughters of the subject, in 1875.

Physical Description:
Oil on canvas. Bust length, head turned three quarters to the subject's left. Dark blue coat with buff facings and gold epaulettes with two silver stars each. White stock and jabot. Powdered hair, gray eyes. Green background. 23½ inches H × 19 11/16 inches W.

[1] Reference to Behne using a Trumbull miniature of this subject is unsubstantiated as no Muhlenberg miniature or sketch by Trumbull is known. Theodore Sizer, *The Works of John Trumbull* (New Haven: Yale University Press, 1950), 42.

THOMAS NELSON JUNIOR (1738–1789)
by William Ludlow Sheppard, after Mason Chamberlain, c. 1876

Catalog Number INDE14107

(SN 13.206)

Nelson was born in Yorktown, Virginia, on 26 December 1738. He later attended London's Hackney School and then Christ's College in Cambridge, England. When he returned to Virginia in 1761, he entered the colony's House of Burgesses and later the royal Executive Council. He was elected to the Continental Congress in 1775, and a year later he carried Virginia's call for American independence to that body in Philadelphia, where he subsequently signed the Declaration of Independence. After a brief retirement in Virginia, he returned to Congress in 1779. He served as his state's governor in 1781, and also led the Virginia militia at the battle of Yorktown. In the last years of the war, he retired to private life in an attempt to settle his personal finances, which had been seriously depleted by his efforts to provision the Revolutionary militia. Nelson died on 4 January 1789.

Just prior to the celebration of the United States Centennial, the City of Philadelphia acquired a portrait of Nelson for its gallery of Declaration signers in Independence Hall. The portrait was painted by Virginia artist William Ludlow Sheppard (1833–1912). Sheppard copied Mason Chamberlain's 1754 portrait of Nelson (now at the Virginia Museum of Fine Arts).

⁂

Provenance:
Given to the City of Philadelphia by the state of Virginia about 1876.[1]

Physical Description:
Oil on canvas. Bust length, torso turned slightly to the subject's right. Dark red coat and waistcoat, white stock. Light brown hair, blue eyes. Dark brown background. 24¼ inches H × 20 3⁄16 inches W.

[1] At one time, the Nelson portrait gift was attributed to the state of Maryland, but no documentation to support this claim has been found. Frank M. Etting's *An Historical Account of the Old State House of Pennsylvania* (Boston: James R. Good and Company, 1876) states that "individuals in … Virginia have generously responded to the personal request made by members of the Committee" for the Restoration of Independence Hall to donate portraits of the Declaration signers (p. 183).

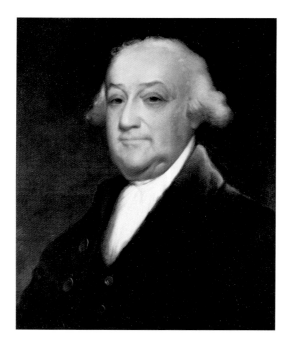

Catalog Number INDE14108
(SN 13.204)

JOHN NIXON (1733–1808)
by Edward Dalton Marchant, after Gilbert Stuart, c. 1878

Nixon was born in Philadelphia in 1733. He inherited his father's shipping business at the age of sixteen. His entry into politics occurred when he served as lieutenant in Philadelphia's Dock Ward Company, a private militia. Later, he supported the city merchants' non-importation agreement signed in protest to the Stamp Act. In 1774, he joined the Committee of Correspondence and the provincial assembly. He was appointed lieutenant colonel of the "Silk Stockings" Battalion in the following year and took a leading position on the Committee of Safety. During the Revolution, he commanded Philadelphia's militia at Fort Island, Amboy, Trenton, and Princeton. On 8 July 1776, he performed the first public reading of the Declaration of Independence in the yard of the Pennsylvania State House.

After several years of experience in financial matters for the state, Nixon helped to organize the Bank of Pennsylvania as a means to finance the Continental army. In 1784, Nixon began his tenure with the Bank of North America. He first served as a director of the institution and then became its president, which he remained until his death. At various points in his life, he served as a city alderman, a manager of the Pennsylvania Hospital, and a trustee of the College of Philadelphia. Nixon died on 31 December 1808.

Nixon's role in the history of the Declaration of Independence placed him in the group of patriots whose portraits the City of Philadelphia acquired for display in Independence Hall. Soon after the city's celebration of the United States Centennial, a portrait of Nixon by Philadelphia artist Edward Dalton Marchant (1806–1887) was added to the museum. Marchant copied Gilbert Stuart's c. 1800 painting (now at the Pennsylvania Academy of the Fine Arts) of Nixon.

—◦◦◦—

Provenance:
Unknown. Acquired by the City of Philadelphia between 1878 and 1882.[1]

Physical Description:
Oil on canvas. Bust length, torso turned slightly to the subject's right. Dark brown coat and waistcoat, white stock and jabot. Powdered gray hair tied in a queue with a black ribbon, brown eyes. Dark reddish-brown background. 23¾ inches H × 20 inches W.

[1] The Nixon portrait is not listed in the 1878 inventory of the Independence Hall collection in the Chew Papers, Independence National Historical Park. The first reference to the painting was made by Frank M. Etting, chairman of the Committee for the Restoration of Independence Hall, to Mrs. Samuel Chew, Committee board member, 5 September 1882. Chew Papers, Independence National Historical Park.

ARTHUR O'CONNOR (1763–1852)
by Rembrandt Peale, from life, 1808

O'Connor was born on 4 July 1762 in Mitchelstown, County Cork, Ireland. He later graduated from Dublin's Trinity College and then joined the Irish bar in 1788. He was a member of the Irish parliament until 1795, when he joined the radical United Irishmen, a group of pro-Catholic politicians who sought to undermine British rule in Ireland. In 1797, as editor of the Irishmen's *The Press*, he was imprisoned on sedition charges. He was acquitted of treason, but remained a prisoner until mid-1803, when he was exiled to France (where he had solicited Napoleon for an invasion of England). There, he served as a general in Napoleon's army and was awarded citizenship in 1818. He published several political treatises before and after his exile, and died in France on 25 April 1852.

Rembrandt Peale (1778–1860) first visited Paris as both a student and a professional portraitist. In 1808, he combined visits to the city's private and public art galleries with painting sessions, during which he created portraits of distinguished French scientists and men of letters for his father's Philadelphia Museum. O'Connor was among the literati of the Napoleonic court. His dramatic history as a revolutionary was well known to French citizenry. Peale's acquaintance with O'Connor's fellow United Irishman, David Bailie Warden (the private secretary to John Armstrong, America's minister to France) may have provided the introduction to O'Connor.[1]

In Peale's portrait of him, O'Connor wears the distinctive uniform of France's Guides, the forerunners of Napoleon's Imperial Guard. The artist's portrayal of this sitter epitomizes the vivid realism that was the style of Jacques-Louis David, with whom Peale studied while in Paris. Details in the sitter's face and the high level of contrast between it and the rest of the portrait are representative of the changes to Peale's work during this period.[2] Early in the twentieth century, this portrait was mistakenly identified as that of Revolutionary War general Charles Lee (1731–1782).[3] No Peale Museum portrait of Lee is known.

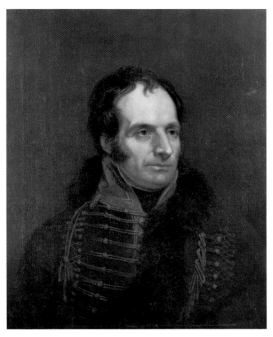

Catalog Number INDE14106
(SN 13.157)

—◦◦◦—

Provenance:
Listed in the 1813 Peale Museum catalog. Purchased by Townsend Ward (librarian of the Historical Society of Pennsylvania) at the 1854 Peale Museum sale. Purchased by the City of Philadelphia from Townsend Ward in 1854.

Physical Description:
Oil on canvas. Bust length, head turned toward sitter's left. Fur-trimmed green cloak with red braid draped over left shoulder. Green uniform coat with red collar and braid. Black stock. Brown hair, blue eyes. Dark brown background. 28⅞ inches H × 23⁷⁄₁₆ inches W.

[1] Rembrandt arranged for the shipment of American geologic specimens to Warden. Rembrandt Peale to Eleanor Peale, 18 August 1808 (Miller, *Selected Papers* 2:2, pages 1118–19, n. 6). Charles Willson Peale, "Daybook 1803–1822," 16 August 1808, pages 23–4. Peale–Sellers Papers, American Philosophical Society.

[2] Lois Marie Fink, "Rembrandt Peale in Paris," *The Pennsylvania Magazine of History and Biography* 110 (January 1986): 75–76.

[3] The city's 1855 and 1915 catalogs list Lee, instead of O'Connor. The 1856 catalog lists both Lee and O'Connor.

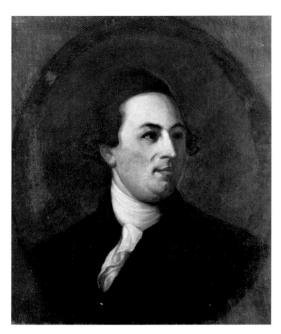

Catalog Number INDE14100

(SN 13.208)

WILLIAM PACA (1740–1799)
by Francis Blackwell Mayer, after Charles Willson Peale, c. 1874

Paca was born in Harford County, Maryland, on 31 October 1740. He graduated from the College of Philadelphia (now the University of Pennsylvania) and then studied law in the Annapolis office of Stephen Bordley and at London's Inner Temple. After his election to Maryland's legislature in 1768, he joined the faction that opposed the royal governor and his implementation of British revenue measures on the colony. In 1774, Paca co-wrote (with Samuel Chase and Thomas Johnson) a popular tract that condemned the poll tax imposed by Parliament for the support of Maryland's Anglican clergy. In that same year, he served on his colony's Committee of Correspondence and in the First Continental Congress. He remained in the Congress through 1779, during which time he signed the Declaration of Independence. A member of the state's Council of Safety, he also participated in the drafting of Maryland's constitution and served in its first state senate. Later, he sat as chief justice of the Maryland General Court and then spent two years as chief justice of the United States Court of Appeals in admiralty and prize cases.

In the closing years of the Revolution, Paca served as governor of Maryland and as vice president of the state's chapter of the Society of the Cincinnati. In 1788, he supported the new federal Constitution at Maryland's ratifying convention. His last public office was that of federal district court judge, which he accepted in 1789 and held until his death on 13 October 1799.

For its contribution to Philadelphia's collection of historical portraits depicting America's founders, Maryland commissioned paintings of three Revolutionary-era statesmen during the preparations for the Centennial celebration. A portrait of William Paca (and those of his colleagues Thomas Stone and Thomas Johnson Junior) were completed in 1874 by Baltimore artist Francis Blackwell Mayer (1827–1899). Mayer's portrait of Paca was based on Charles Willson Peale's 1823 bust length copy (made for the Maryland State House) of his 1772 full length portrait of the sitter (now at the Maryland Historical Society).

❧

Provenance:
Given to the City of Philadelphia by the state of Maryland in 1874.

Physical Description:
Oil on canvas. Bust length, head turned three quarters to the subject's left. Blue coat and waistcoat, White stock and jabot. Brown hair, blue eyes. Dark red background. 24⅛ inches H × 20⅛ inches W.

JOHN PAGE (1743–1808)
by Charles Willson Peale, from life, 1795–1797

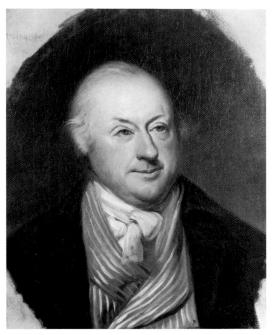

Catalog Number INDE14101

(SN 13.209)

Page was born on 17 April 1743 in Gloucester County, Virginia. He later attended the College of William and Mary, and then entered Virginia's House of Burgesses. He also sat in the colony's executive council. During the Revolution, he took an active role in the transformation of Virginia's government as a member of the state's 1776 constitutional convention and as lieutenant governor under Patrick Henry. Page also served Virginia at the battle of Yorktown. After the war, he sat in his state's assembly and then in Congress from 1789 until 1797. In 1802, he was elected to the first of three successive one-year terms as governor of Virginia. President Thomas Jefferson later appointed him commissioner of loans for the Richmond district, an office Page held until his death on 11 October 1808.

Charles Willson Peale recollected that his museum portrait of Page was "painted with only 2 settings, the 3rd being delayed, I was prevented from the complete finish, but the likeness is good."[1]

Page probably sat for the painting before he left Congress and Philadelphia in 1797 (the portrait is not listed in the 1795 Peale Museum catalog). After Page's death, Peale sent his widow tombstone designs and an eloquent letter of condolence that also serves as the first record of this painting: "Very often looking at the portrait, I venerate the firm and friendly character of my departed friend."[2]

⚬❦⚬

Provenance:
Listed in the 1813 Peale Museum catalog. Purchased by the City of Philadelphia at the 1854 Peale Museum sale.

Physical Description:
Oil on canvas. Bust length, head turned toward sitter's left. Blue coat, brown and white striped waistcoat. White stock. Gray hair, blue eyes. Dark brown background. 22 15/16 inches H × 19 1/8 inches W.

[1] Charles Willson Peale to Rembrandt Peale, 26 September 1819 (Miller, *Selected Papers 3*, page 772). Peale had previously painted a miniature of Page (now privately owned). Sellers, *Portraits and Miniatures*, 155.

[2] Charles Willson Peale to Margaret Page, 4 December 1809 (Miller, *Selected Papers* 2:2, pages 1242–1243).

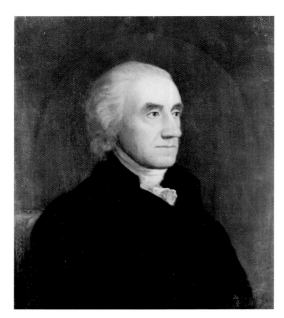

Catalog Number INDE14102

(SN 13.210)

ROBERT TREAT PAINE (1731–1814)
by Richard Morrell Staigg, after Edward Savage, c. 1876

Paine was born in Boston, Massachusetts, on 11 March 1731. He attended the Boston Latin School and then Harvard College. After graduation in 1749, he taught briefly and then studied theology. His only clerical assignment was as chaplain of the 1755 Crown Point expedition during the French and Indian War. He studied law and was admitted to the bar in 1759. His successful legal practice in Taunton, Massachusetts, earned him public notice, and he was selected as associate prosecuting attorney in the "Boston Massacre" trial of 1770. Thereafter, he served in the provincial assembly and entered the First Continental Congress in 1774, where he served, signing the Declaration of Independence, until 1777. Upon leaving Congress, he was elected as the first attorney general of Massachusetts. A year later, he was a member of the legislative committee appointed to draft the new state constitution. In 1780, his interest in science led him to assist in founding the American Academy of the Arts and Sciences. From 1790 to 1804, Paine was a justice in Massachusetts's supreme court. He died in Boston on 11 May 1814.

In 1876, the City of Philadelphia received a portrait of Paine for the museum in Independence Hall. Boston artist Richard Morrell Staigg (1817–1881) may have copied Edward Savage's sketch of Paine, made for the Robert Edge Pine painting *Congress Voting Independence* and later finished by John Coles Junior (now at the Massachusetts Historical Society).[1] Or perhaps Staigg used James Barton Longacre's 1822 engraving of Savage's portrait made for volume two of John Sanderson's *Biography of the Signers to the Declaration of Independence*.

❧

Provenance:
Given to the City of Philadelphia by Charles Jackson Paine and Robert Treat Paine Junior, the subject's grandsons, in 1876.

Physical Description:
Oil on canvas. Bust length, head and torso turned three quarters to the subject's left. Black coat and waistcoat, white stock and jabot. Powdered hair, light brown eyes. Dark-olive background. 24 1/16 inches H × 20 3/16 inches W.

[1] Louisa Dresser, "Edward Savage, 1761–1817," *Art in America* 40 (Autumn 1952): 185–187.

THOMAS PAINE (1737–1809)
attributed to Bass Otis, after Thomas Thompson from the William Sharp
engraving after a painting by George Romney, about 1859

Catalog Number INDE14103
(SN 13.211)

Paine was born in Thetford, England, on 18 January 1737. With a rudimentary education, he worked as a corset maker, sailor, tax collector, teacher, tobacconist, and grocer. A series of confrontations with various employers over his public criticism of working conditions prompted him to leave England in 1774. Bearing letters of introduction from Benjamin Franklin, Paine settled in Philadelphia, where he began a career as a journalist. In early 1776, he published *Common Sense*, his extremely successful pamphlet urging American independence. He continued writing for newspapers, principally a series on wartime government, called *The Crisis*, and he joined the Continental army. In 1771, Congress hired him as a clerk for its committee on foreign affairs, a position he later lost when he published several letters that criticized the French government's method of assisting the American war effort before formal relations were established between the two nations. Toward the end of the war, he raised funds for the American army at home and abroad.

During the next decade, Paine lived in England and France, where he was an early supporter of the French Revolution. In 1791 and 1792, he published *The Rights of Man*, in which he condemned monarchy and praised the republican form of government. As a result, he was tried *in absentia* for treason in London and awarded honorary French citizenship. In the following year, he served in the French legislature before he was briefly imprisoned by the French Jacobin regime as a foreign-born national. After his release, he remained in France and continued writing, most notably his metaphysical treatise *The Age of Reason*. Paine returned to America in 1802, and died in New York City on 8 June 1809.

In 1859, the City of Philadelphia added a portrait of Paine to the museum in Independence Hall. The painting is attributed to Philadelphia artist Bass Otis (1784–1861). Otis's work derives from English artist George Romney's 1792 portrait of the sitter (now unlocated). The Romney work was well known in nineteenth-century America through William Sharp's 1793 British engraving of it. American artists frequently copied Sharp's engraving, as Otis may have done. Or perhaps Otis worked from such a copy (now unlocated) by Thomas Thompson that once belonged to artist Charles Wesley Jarvis.[1] He was the son of painter John Wesley Jarvis, Otis's painting teacher (Otis became Jarvis's student in 1808). The senior Jarvis's own 1805 portrait of Paine is now at the Smithsonian National Gallery of Art (Paine resided in Jarvis's New York City house in 1806 and 1807).[2] Another version of Otis's portrait of Paine is now owned by the Huntington Library.

Provenance:
Given to the City of Philadelphia by
Dr. William Wright and others in 1859.

Physical Description:
Oil on canvas. Bust length, torso turned slightly toward the sitter's right. Brown coat, olive drab waistcoat, white stock and jabot. Graying brown hair, brown eyes. Left background contains a group of leather-bound books on a red tabletop. Dark background. 36¼ inches H × 31⅜ inches W.

[1] A portrait of Paine is in the collections of the Thomas Paine National Historical Association in New Rochelle, New York. This portrait had been attributed alternately to Charles Wesley Jarvis and to George Romney.

[2] *Catalogue of American Portraits in the New-York Historical Society* (New Haven: Yale University Press, 1974) 2, pages 595–596.

Catalog Number INDE12142

CHARLES WILLSON PEALE (1741–1827)
by Charles Willson Peale, self portrait, c. 1795

Peale was born on 15 April 1741 in Queen Anne's County, Maryland. After the death of his father, he was apprenticed to an Annapolis saddler. He attributed his first interest in painting to a time when he saw several landscapes and portraits in the home of a client. Peale thought the paintings were poorly done and tried his own hand at producing something better. He took a few lessons with his neighbor, professional artist John Hesselius, and he visited John Singleton Copley in his Boston studio. Impressed by Peale's amateur ability, a prosperous family friend collected subscriptions from other wealthy Annapolitans and sent the young man to London for further study. Peale spent two years there in the studio of the American expatriate artist Benjamin West. When Peale returned to Annapolis in 1769, he opened his own painting room, where he exhibited his work to prospective clients. He remained there until 1775 when he moved his family to Philadelphia.

During the Revolution and the early years of the American republic, Peale painted over three hundred portraits. Many of these hung in his Philadelphia Museum, first opened in his home at Third and Lombard Streets in 1784. Ten years later, the artist expanded his museum to include natural history specimens and moved the collection to the headquarters of the American Philosophical Society. There, Peale was the first to display birds and mammals in museum cases with painted backgrounds that depicted the creatures' natural habitats. Scientific pursuits, like the discovery of mastodon bones in New York State, and the museum's move to the second floor of the Pennsylvania State House (now called Independence Hall) in 1802 so preoccupied Peale that he stopped painting from 1799 until 1804.

During this time, he continued his efforts to found an art school in Philadelphia, beginning with the short-lived Columbianum and expanding to the Pennsylvania Academy of the Fine Arts. Most of Peale's nine adult children received early and rigorous instruction in the art of drawing; Raphaelle, Rembrandt, Rubens, Titian Ramsay II, and their cousins Sarah Miriam and Anna Claypoole Peale all became professional artists under the senior Peale's tutelage. Peale returned to his easel inspired by the experience his son Rembrandt gained during a sojourn in Paris, where the younger man studied at art academies. Charles Willson Peale continued to paint both private commissions and museum portraits (his last was that of Timothy Matlack, see above) until shortly before his death on 22 February 1827.

Near the end of his life, Charles Willson Peale defined his creative philosophy: "Mediocrity is scarcely admissable [*sic*] in the art of painting. It must be perfect in the representation or it is of no value."[1] With this frame of mind, Peale painted several self-portraits during his long career. Most place him in his professional capacity with the tools of his trade. The rest portray him at close range without props, much like the depictions of famous men that he created for his museum gallery. Peale listed two portraits of himself in the 1795 Philadelphia Museum catalog, but no evidence connecting either of these with the self-portrait in the Independence collection has been found. This self-portrait descended in the family of Peale's son Linnaeus, who was born in 1794, around the time the portrait was probably painted. The portrait exemplifies the changes Peale made in his paint palette during the 1790s. In that decade, he gradually adopted the use of pigments that imparted a silvery tone to his portraits.[2]

·❦·

Provenance:
Descended in the family of Charles Linnaeus Peale. Acquired by Mrs. T. Charlton Henry. Inherited by Julia Biddle Henry. Purchased for Independence National Historical Park by the Friends of Independence Park in 1979.

Physical Description:
Oil on canvas. Bust length, turned toward sitter's right. Greenish gray coat and waistcoat, white stock. White hair, blue eyes. Greenish black background. 25¼ inches H × 21⅜ inches W.

[1] Charles Willson Peale to Rembrandt Peale, 2 January 1819. Peale–Sellers Papers, American Philosophical Society.

[2] John C. Milley, "Mr. Peale's Self Portrait," *Friends of Independence National Historical Park, Independence Gazette* (September 1980), 10. Sellers, *Portraits and Miniatures*, 159–160.

EDMUND PENDLETON (1721–1803)
by William Larned Marcy Pendleton, after William Mercer, c. 1885

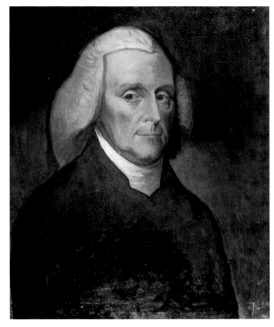

Catalog Number INDE14137
(SN 13.223)

Pendleton was born in Caroline County, Virginia, on 9 September 1721. During his teens, he was apprenticed to the clerk of his county's court, soon becoming clerk to the county's vestry. He also studied law and, after a decade, became a justice of the peace and a member of the colony's House of Burgesses. A leader among Virginia's political conservatives, he served on his colony's Committee of Correspondence and then in the First Continental Congress of 1774. The following year, he presided over his state's Committee of Safety when it served as the temporary executive body of Virginia.

In 1776, he chaired the Virginia convention and wrote the resolutions sent by that body to Congress as a call for independence. He also served on the committee to draft Virginia's first state constitution and to revise its laws. He became the first speaker of the new state legislature and judge of the court of chancery created by the new constitution. From 1779 onward, he presided over the state supreme court of appeals. In 1788, he chaired Virginia's ratifying convention for the new federal Constitution. He supported the Constitution, but disagreed with the policies of President George Washington's administration and refused an appointment to the federal district court. Pendleton died on 26 October 1803.

Near the end of the nineteenth century, the City of Philadelphia acquired a portrait of Pendleton for the museum in Independence Hall. Virginia artist William Larned Marcy Pendleton (born 1865) copied William Mercer's c. 1790 miniature of Pendleton (now at the Virginia Historical Society). The copyist, a great-great-grandnephew of the sitter, also painted a second version of the Pendleton portrait (now hanging in the Virginia state supreme court building).[1]

⁂

Provenance:
Deposited with the City of Philadelphia by Charlotte Pendleton, the subject's great-great-grandniece, in 1898.

Physical Description:
Oil on canvas. Bust length, torso turned slightly to the subject's left. Black coat and waistcoat, white stock. Powdered wig, blue eyes. Brown background. 27 inches H × 22 inches W.

[1] The acquisition of this portrait by the state of Virginia is undocumented. However, the painting's stretchers are stamped with patent information that includes the dates 1883 and 1885.

Catalog Number INDE14136

(SN 13.217)

[1] In the past, the accuracy of the Place portraits of the Penns was challenged. General acceptance of the portraits is now based on the observed physical similarities between the subjects in these portraits and those in other documented portraits of the Penns. "The New Penn Portraits," *Pennsylvania Magazine of History and Biography* 81 (1957): 349–350.

HANNAH CALLOWHILL (MRS. WILLIAM) PENN (1671–1726)
by Henry J. Wright, after Francis Place, 1874

Callowhill was born in Bristol, England, on 11 February 1671. Her parents were prominent members of the city's Society of Friends. As a young woman, she assisted her parents in their mercantile affairs, at which she reportedly displayed considerable aptitude. On 5 March 1696, she married widower William Penn, who had recently received a royal charter for a colony of Friends in North America. In 1699, the Penns crossed the Atlantic to Philadelphia, where their first son was born. They remained there at their estate, "Pennsbury," for two years before political developments in England required William Penn's return to London. The Penns had six more children during the next decade, including a daughter born while her father was briefly imprisoned for debt.

In 1712, her husband suffered an incapacitating stroke and Mrs. Penn assumed the management of his business affairs. Together with James Logan, her husband's secretary, who had remained in Philadelphia, she subsequently oversaw the appointment of Pennsylvania's colonial governor and supervised the sale of colonial lands. She retained her control after her husband's death in 1718 and after a stroke of her own three years later. As acting proprietor, she represented the colony in the settlement of its boundary dispute with Maryland's Lord Baltimore and promoted the recall of Pennsylvania's governor, Sir William Keith, after his disregard for the legal authority of her colonial representatives. Just after the final settlement of her husband's estate, which left the proprietorship of Pennsylvania to her and her children, Mrs. Penn died on 20 December 1726.

In 1874, the City of Philadelphia acquired portraits of Hannah Callowhill Penn and her husband (see below) for the museum in Independence Hall. English artist Henry J. Wright (dates unknown) copied an early eighteenth-century pastel portrait of Mrs. Penn by Francis Place (now owned by the Historical Society of Pennsylvania).[1]

Provenance:
Purchased by the City of Philadelphia through John J. Smith from the artist in 1874.

Physical Description:
Oil on canvas. Bust length, torso turned slightly toward the subject's right. Dark brown hood and dress. Brown hair, gray eyes. Dark green background. Signed along lower left edge: "H. J. Wright Pinxt/Birm. Eng./1875." 30⅛ inches H × 25 inches W.

WILLIAM PENN (1644–1718)
1. by Henry Inman, 1832

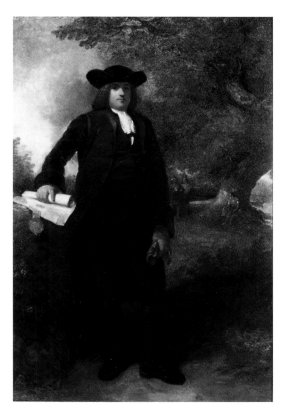

Penn was born on 14 October 1644 in London. He later attended Christ Church College, but his nonconformist religious beliefs led to his expulsion. Afterward, he vacillated between the life of a British aristocrat (military service, law studies, estate management) and that of a devout practitioner of pacifism. He was imprisoned in 1669 for his outspoken defense of individual liberty, and published several religious texts while in prison. After his release, he traveled as a missionary to Holland and Germany for the Society of Friends. He then became involved in the management of the Society's land in New Jersey, writing the colony's charter of liberties in 1677.

Five years later, as payment for his family's assistance to King Charles II, Penn received a large land grant that the king named "Pennsylvania" in honor of his father. Penn's government for the new colony established freedom of worship, protection of individual rights, and representative government as the foundation of his proprietorship. Later, he visited America twice (further democratizing Pennsylvania's government by granting the Charter of 1701, which instituted a unicameral elected legislature). While maintaining his involvement in English political affairs and Quaker missionary work, he continued as proprietor of Pennsylvania until he suffered a stroke in 1712. Penn died on 30 July 1718.

1. In 1826, Philadelphia's Society for the Commemoration of the Landing of William Penn initiated a project for a full-length portrait of the colony's founder, to be displayed in Independence Hall. The Society planned the Penn portrait as a companion for Thomas Sully's portrait of Lafayette (see above) then underway. Although Sully began work on a Penn composition, the commission for the portrait eventually went to New York artist Henry Inman (1801–1846).[1] Inman arrived in Philadelphia in 1831 to join a partnership with the engraver Cephus G. Childs, a member of the Penn Society. By 1832 (the 150th anniversary of Penn's landing in America), Inman's completed portrait of the first proprietor hung in Independence Hall.[2]

In Inman's painting, Penn holds a document and stands before a tree with Native American figures in the background. Inman's composition refers to, but does not highlight, the alleged negotiations for property rights between Penn and the Native American tribes who inhabited the Delaware River basin. Unlike Benjamin West's well-known 1771 painting, *Penn's Treaty with the Indians*, Inman's portrait of Penn focuses specifically on Penn as the founder. During the early nineteenth century, the reality of the treaty signing event was questioned, and Inman chose to de-emphasize it by showing Penn with the proprietary charter instead.

Provenance:
Given to the City of Philadelphia by the Society for the Commemoration of the Landing of William Penn in 1832.

Physical Description:
Oil on canvas. Full length, standing, facing slightly to the subject's left. Brown coat and waistcoat, white stock, brown breeches, gray stockings, black shoes. Black hat. Brown hair, dark eyes. Gloved left hand holds right glove. Right hand holds scroll with red wax seal. Background landscape with "Treaty Elm" and Native Americans in background. 96 inches H × 63¼ inches W.

Catalog Number INDE14117
(SN 13.381)

[1] William H. Gerdts, *The Art of Henry Inman*, Smithsonian National Portrait Gallery exhibit catalog (Washington, D.C.: Smithsonian Institution Press, 1987), 38–39. One of Inman's sketches for the composition is in the Kirby Collection at Lafayette College.

[2] Philadelphia engraver John Sartain produced an engraved version of the portrait in 1832, and it was published by James Earle.

Catalog Number INDE

(SN 13.218)

WILLIAM PENN (1644–1718)
2. by Henry J. Wright, after Francis Place, 1874

2. In 1874, the City of Philadelphia acquired portraits of William Penn and his wife (see above) for the museum in Independence Hall. English artist Henry J. Wright (dates unknown) copied an early eighteenth-century pastel portrait of Penn by Francis Place (now owned by the Historical Society of Pennsylvania).[3]

❧

Provenance:
Purchased by the City of Philadelphia through John J. Smith from the artist in 1874.

Physical Description:
Oil on canvas. Bust length, torso turned slightly toward the subject's right. Brown coat and waistcoat, white stock. Brown hair, brown eyes. Dark green background. Signed along lower left edge: "H. J. Wright Pinxt/ Birm Eng/1875." 30⅛ inches H × 25 inches W.

[3] In the past, the accuracy of the Place portraits of the Penns was challenged. General acceptance of the portraits is now based on the observed physical similarities between the subjects in these portraits and those in other documented portraits of the Penns. "The New Penn Portraits," *Pennsylvania Magazine of History and Biography* 81 (1957): 349–50.

TIMOTHY PICKERING (1745–1829)
by Charles Willson Peale, from life, 1792–1793

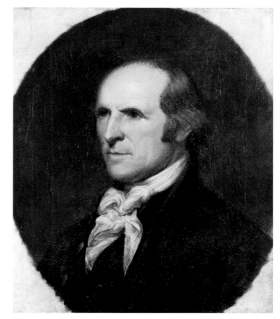

Catalog Number INDE14131

(SN 13.225)

Pickering was born on 17 July 1745 in Salem, Massachusetts. He graduated from Harvard College, and then studied law. He later served as a Salem selectman and a representative to the colonial legislature. During the years immediately preceding the Revolution, he sat on several local committees and wrote many pamphlets and newspaper articles that supported colonial resistance to British rule. In 1775, he published a military drill manual that circulated widely in the Continental Army before the introduction of Baron von Steuben's method. Pickering participated in the New York and New Jersey campaigns of the following winter. In 1780, he accepted an appointment as quartermaster general and retained it until the end of the war.

Pickering later lived in Pennsylvania, moving to the Wyoming Valley frontier, where he founded Luzerne County and represented the new area at Pennsylvania's convention to ratify the federal Constitution and its state constitutional convention. In 1790, President Washington sent Pickering (who opposed the use of force against the Native Americans who populated the frontier) to formalize cordial relations with the Seneca Indian tribe. When he returned from this successful mission, he accepted an appointment as postmaster general. In 1795, he became secretary of war (briefly) and then secretary of state. A strident Federalist and a promoter of New England commerce, he denounced French interests and promoted those of Great Britain. After he repeatedly defied President John Adams's policy of neutrality in foreign affairs, Pickering was removed from office in 1800.

Subsequently, he represented Massachusetts in Congress for fifteen years, alternating for several terms in the House of Representatives and Senate.

Later, Pickering wrote extensively on the people and events of the Revolutionary and republican eras, and planned a biography of Alexander Hamilton. During the 1828 presidential election Pickering endorsed Democrat Andrew Jackson, rather than the conservative John Quincy Adams, as a means of expressing his longstanding contempt for the latter's father. Soon afterward, Pickering died in Salem on 29 January 1829.

Charles Willson Peale probably painted his Museum portrait of Pickering after the sitter moved to Philadelphia as the new postmaster general (an appointment that Peale himself had sought).[1] Possibly, Pickering's enlightened Native American policy inspired Peale (who had both scientific and humanistic interests in tribal cultures) to include this portrait in the museum; the 1795 Peale Museum catalog entry for this painting praises Pickering's work with the Seneca tribes.[2]

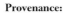

Provenance:
Listed in the 1795 Peale Museum catalog. Purchased by the City of Philadelphia at the 1854 Peale Museum sale.

Physical Description:
Oil on canvas. Bust length, head and torso turned slightly to the sitter's right. Brown coat and waistcoat, white stock and jabot. Graying brown hair, blue eyes. Olive brown background. 22 9/16 inches H × 18 7/8 inches W.

[1] Charles Willson Peale to George Washington, 27 June 1790 (Miller, *Selected Papers* 1, page 589).

[2] Sellers, *Portraits and Miniatures*, 171.

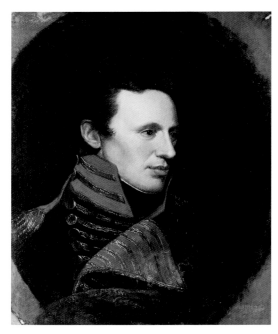

Catalog Number INDE14130

(SN 13.226)

¹ Charles Willson Peale to Rembrandt Peale, 26 June 1808 (Miller, *Selected Papers* 2:2, page 1093).

² Charles Willson Peale to Angelica Kaufmann Peale Robinson, 16 June 1808 (Miller, *Selected Papers* 2:2, page 1087). Rembrandt later copied his father's portrait of Pike, possibly for the Baltimore Peale Museum (it is now owned by the New York State Office of Parks and Recreation).

ZEBULON MONTGOMERY PIKE (1779–1813)
by Charles Willson Peale, from life, c. 1808

Pike was born on 5 January 1779 in Lamberton (Trenton), New Jersey. After attending school in Pennsylvania, he began his military service at the age of fifteen, when he joined his father's company on the frontier. In mid-1805, Pike embarked from St. Louis on an expedition to discover the source of the Mississippi River and to talk with British traders and Native Americans about frontier conditions in the Louisiana Territory. After nine harrowing months, he returned in order to begin a second journey exploring the areas fed by the Arkansas and Red rivers along the Mexican border. Near present day Pueblo, Colorado, he attempted to climb what is now called Pike's Peak, but failed. After convincing the Spanish authorities that his mission was peaceful, he returned to the United States in early 1807.

During his expeditions, Pike accumulated detailed information about Native American cultures and natural phenomena that he described at length in his 1810 memoir, *An Account of Expeditions to the Sources of the Mississippi and through the Western Parts of Louisiana*. His book preceded that of Lewis and Clark's expedition by four years and sold well, including French, Dutch, and German translations. In 1812, he resumed his military service as a deputy quartermaster general and infantry colonel. The following year, he and his troops went to Canada with the American force sent to attack British forts along the Great Lakes. On 27 April 1813 Brigadier General Pike died in a powder magazine explosion during the American assault on Fort York (now Toronto) near Lake Ontario.

From the frontier, Pike once sent two live grizzly bear cubs to President Thomas Jefferson, who gave them to Charles Willson Peale for his Philadelphia Museum. Peale also added a portrait of the bears' captor to his collection in June 1808.¹ This portrait comes from a period of significant stylistic change, one toward greater naturalism, in Peale's work. The senior artist attributed the transformation to lessons learned from his son Rembrandt, newly returned from France. While the method of Rembrandt's instruction is unknown, it apparently emphasized the use of red hues, possibly variations of vermillion paint. In the museum portrait, Pike's skin tones, collar, and coat facings are tinted red, and his chin, lips, cheeks, and eye sockets also reflect that color. In addition, the elder Peale coated the canvas with a red base to warm the overlaying pigments. The artist mentioned this painting to his daughter as proof "that the system of colouring I lear[n]t from your brother Rembrandt is all important, for I never painted with so much ease."²

⤙⥄⤚

Provenance:
Listed in the 1813 Peale Museum catalog. Purchased by the City of Philadelphia at the 1854 Peale Museum sale.

Physical Description:
Oil on paper mounted on canvas. Bust length, head and torso facing slightly toward the sitter's left. Dark blue uniform coat with red facings and collar, silver braid, silver epaulettes. White shirt, black stock. Reddish-brown hair, blue eyes. Dark brown background. 23⅞ inches H × 19⅝ inches W.

THOMAS ANTOINE, CHEVALIER DE MAUDUIT DU PLESSIS
(1752–1791)
by an unidentified artist, probably a copy and after an unknown source,
c. 1850–1900

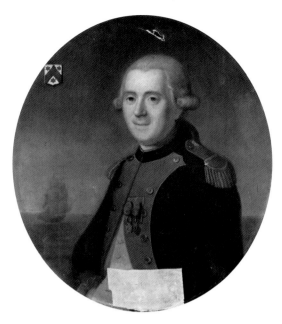

Antoine was born on 12 September 1752 in Hennebon, France. He attended Grenoble's artillery school and then served as a ship's cabin boy in the Mediterranean. In 1777, he joined the American army as a member of Rochambeau's command. A captain of artillery, Antoine fought in the battles of Brandywine and Germantown, became an aide to General Henry Knox, and strengthened the fortifications at Red Bank, New Jersey, before returning to France in late 1778.

After a brief visit to America following the war in 1786, Antoine continued his French army service in Santo Domingo (now Haiti). Within a few years of his arrival, his authority was challenged by the growing radicalism in French politics. In response, Antoine arrested members of the island's revolutionary colonial committee, dissolved its popularly elected assembly, and condemned the emancipation of slaves there. On 4 March 1791 his own regiment rebelled and assassinated him.

In 1905, working on behalf of Philadelphia's effort to build the Revolutionary portrait collection in Independence Hall, local artist Albert Rosenthal purchased a portrait of Antoine in Paris from a Madame de Mauduit du Plessis. Reportedly, the portrait was copied from a pastel by Maurice Quentin de La Tour that was also in Madame de Mauduit's possession (this pastel is now unlocated).

This attribution, however, seems unlikely as La Tour retired from painting in 1773, when Antoine was approximately twenty years old and not yet the decorated officer depicted in this portrait. At present, the basis for this portrait and the artist who copied it are unidentified.

❦

Provenance:
Purchased by the City of Philadelphia through Albert Rosenthal in 1905.

Physical Description:
Oil on canvas. Half length, torso facing slightly to the sitter's right. Blue uniform coat with red facings, silver epaulettes and silver buttons, buff waistcoat, white stock. One gold medal on a red ribbon, one blue medal on a pale blue ribbon. Powdered wig, blue eyes. Family crest of shield with three blue stars on a gold field separated by a blue chevron in upper left. Ship under sail in left midground, blue-gray sky. 28⅝ inches H × 24½ inches W.

Catalog Number INDE
(SN 13.231)

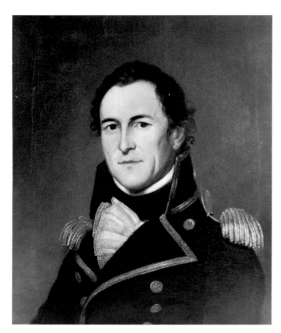

Catalog Number INDE14128

(SN 13.233)

DAVID PORTER (1780–1843)
by Charles Willson Peale, from life, 1818–1819

Porter was born in Boston, Massachusetts, on 1 February 1780. In 1798, he joined the navy as a midshipman and fought aboard the *Constellation* when she captured the *Insurgente* in the most important battle of America's undeclared naval war with France. Later, he commanded vessels in the Mediterranean and was imprisoned in Tripoli for several years. After his release, he was appointed master commandant of the American naval station in New Orleans. In 1811, he sailed the *Essex* to the Pacific, capturing English whaling vessels and protecting American merchant shipping. In early 1813, he lost a fierce naval battle in Chile's Valparaiso harbor and was held captive by the British for a year.

After the war, Porter was appointed commissioner of the Navy Board, but resigned in 1823 in order to accept command of the West India Squadron for suppressing piracy. Recalled two years later for mounting an unauthorized attack on a fort in Puerto Rico, he resigned his naval commission and became commander-in-chief of the Mexican navy. In 1830, he returned to the United States and President Andrew Jackson appointed him consul general in Algiers. Porter's last posting was to Constantinople as United States minister to Turkey. He died there on 3 March 1843.

As one of the navy's highest-ranking officers, Porter earned a place in Charles Willson Peale's Philadelphia Museum. While in Washington in late 1818, the artist arranged portrait sittings with several military figures and politicians. After several aborted attempts, Peale began Porter's portrait in late December. However, the commander proved to be a restless subject, as Peale noted, "He is sildom [*sic*] a minute in the same position, for when any one in the [room] speaks he turns toward them and never thinks that it is necessary to keep himself in the same view to the painter. So that the Painter having formed his design must watch to Sketch the traits as quick as possible."[1] The portrait was finished in January 1819 and added to the museum collection in March.[2]

⁻ᵒ⟨⟨⟩⟩ᵒ⁻

Provenance:
Purchased by the City of Philadelphia at the 1854 Peale Museum sale.

Physical Description:
Oil on canvas. Bust length, torso turned slightly toward the sitter's right. Dark blue uniform coat with gold braid, gold epaulettes. Black stock, white jabot. Dark brown hair, brown eyes. Olive green background. 24½ inches H × 20½ inches W.

[1] Charles Willson Peale, "Diary," 28 December 1818 (Miller, *Selected Papers 3*, pages 644–645). Sellers, *Portraits and Miniatures*, 175.

[2] Charles Willson Peale, "Diary," 29 January 1819 (Miller, *Selected Papers 3*, page 649). Charles Willson Peale, "Memorandum of the Philadelphia Museum, 1803–1842," 97. Peale Papers, Historical Society of Pennsylvania.

COUNT CASIMIR PULASKI (1748–1779)
by Julian Rys, after an unidentified source, c. 1897

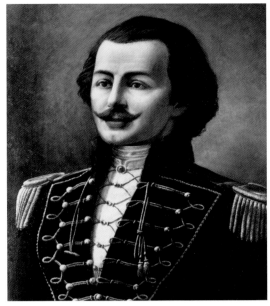

Catalog Number INDE14129

(SN 13.234)

Pulaski was born in Podolia, Poland, on 4 March 1757. He attended the School of the Teatyni Fathers in Warsaw and then served in the guard of Duke Charles of Courland. In 1768, Pulaski rejected his family's aristocratic privilege and joined the rebellion against Poland's Russian-backed king. Despite early military successes, the rebels retreated into exile in Turkey, where Pulaski attempted to convince the Ottoman rulers to declare war on Tsarist Russia. Afterward, fleeing a failed coup, Pulaski arrived in France, where he befriended the American diplomatic party there. In 1777, American minister Silas Deane lent Pulaski the money he needed to sail for America in order to join the Continental army.

General George Washington recommended the newly-arrived Pulaski as commander of all Continental cavalry, and Congress appointed him a brigadier general. He fought at Brandywine and Germantown, and then began the task of retraining the American cavalry. He then resigned his Continental army commission in early 1778 and raised an independent regiment of infantry and cavalry. Sent to protect American supplies at Egg Harbor, New Jersey, Pulaski's Legion was defeated in a surprise attack. Later, the legion guarded the frontier settlement of Minisink on the Delaware River from Native American attacks, but wilderness conditions eliminated the cavalry's effectiveness there. Marching south, Pulaski and his troops joined the American siege of Savannah. During the battle, Pulaski was fatally wounded and he died on 11 October 1779 aboard the brig *Wasp*.

In 1897, the Polish National Alliance commissioned visiting Polish artist Julian Rys (born 1856) for a portrait of Pulaski to hang in Independence Hall. Rys based his work on a now unidentified portrait (possibly an engraving) of Pulaski.

❧

Provenance:
Given to the City of Philadelphia by the Polish National Alliance in 1897.

Physical Description:
Oil on canvas. Bust length, head and torso turned slightly to the subject's right. Dark blue uniform coat with red facings, brown fur collar, gold braid trim, gold epaulettes with red edging. White shirt laced with gold braid and red studs. Brown hair and moustache, brown eyes. Olive brown background.
24 inches H × 20 1/16 inches W.

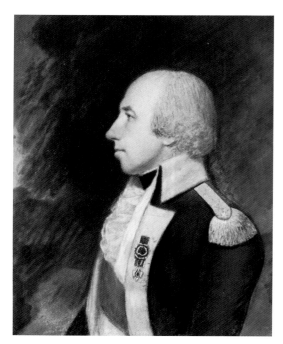

Catalog Number INDE11914
(SN 7.022)

[1] George Washington,
"Opinion of the General
Officers," 9 March 1792
(John C. Fitzpatrick, ed.,
*The Writings of George
Washington* [Washington,
D.C.: U.S. Government
Printing Office, 1939],
31:512).

RUFUS PUTNAM (1737–1824)
by James Sharples Senior, from life, 1796–1797

Putnam was born in Sutton, Massachusetts, on 9 April 1738. He later apprenticed as a millwright, and taught himself basic geography and mathematics. During the French and Indian War, he served with a Connecticut regiment in the Great Lakes region. In 1773, he became the surveyor of East Florida after a trip there to assess veterans' land grants along the Mississippi River. In 1775, he joined one of Massachusetts's first Revolutionary regiments. His fortifications protected Dorchester Heights during the British siege of Boston, and then he supervised the building of defenses around New York City. He refused an appointment as Chief Engineer and took a field command, fighting in the New York campaign that led to the British surrender at Saratoga. He then rebuilt West Point, and fought at Stony Point.

After the Revolution, Putnam returned to survey work in Maine (then part of Massachusetts). He had supported the award of lands in lieu of back pay to soldiers during the war, and was one of the authors of the army's Newburgh Petition to Congress that requested such land disbursements. In 1788, he led a group of Revolutionary veterans to settle Marietta, Ohio, for the Ohio Company. He then became a supreme court judge for the Northwest Territory. Later, he served in General Anthony Wayne's early campaigns against the Ohio Valley Native American tribes. In 1796, President George Washington appointed Putnam as the first surveyor general of the United States, and he served in that capacity until 1803. Putnam died on 4 May 1824.

British pastelist James Sharples Senior (1751–1811) apparently drew Putnam's portrait when both men lived in the federal capital of Philadelphia during 1796 and 1797. The artist depicted his subject in uniform; Putnam wears a green sash to indicate his rank as colonel, his status for most of the Revolution. At the time the portrait was drawn, he apparently regarded this Revolutionary rank as his most significant military service (he had been promoted to brigadier general in late 1783, and had served in this capacity during the Ohio Valley Native American wars). Putnam's reputation was generally overshadowed by those of his contemporaries; as Commander-in-Chief George Washington remarked, he "is but little known out of his own state, and a narrow circle."[1] Perhaps this obscurity explains the omission of Putnam's name from the catalog of portraits that Sharples published in 1802 upon returning to England after his first American painting trip.

Sometime after Sharples completed Putnam's portrait, someone drew and pasted on a brigadier general's one-star epaulette to the sitter's left shoulder. A rendering of the Society of the Cincinnati eagle was added to the portrait in the same way. Possibly, the artist (or a member of his artist family) decided that these changes increased the sitter's public appeal, making the portrait a better attraction to potential clients.

❦

Provenance:
Given by Ellen (Mrs. James) Sharples to Felix Sharples in 1811. Given by Felix Sharples to Levin Yardly Winder in the 1830s. Inherited by Nathaniel James Winder from Levin Yardly Winder. Inherited by Richard Bayly Winder from Nathaniel James Winder in 1844. Purchased by Murray Harrison from Richard Bayly Winder around 1865. Purchased by the City of Philadelphia from Murray Harrison in 1876.

Physical Description:
Pastel on paper. Half length, left profile. Blue uniform coat with buff facings, gold epaulettes. Black stock, white jabot. Green sash across right shoulder and chest. Gold Society of the Cincinnati eagle medal on blue and white ribbon hanging from sitter's left lapel. Gray hair tied in a queue, blue eyes. Variegated brown background breaking into blue in upper left background. 9 inches H × 7 inches W.

DAVID RAMSAY (1749–1815)
by Rembrandt Peale, from life, 1796

Ramsay was born on 2 April 1749 in Lancaster County, Pennsylvania. He later attended the College of New Jersey (now Princeton) and the College of Philadelphia's medical school, training at the Pennsylvania Hospital and in Dr. Thomas Bond's private practice. In 1774, Ramsay opened his own practice in Charleston, South Carolina. During the Revolution, he served as surgeon to that city's battalion of artillery. In 1776, he began his long membership in the state assembly, and two years later joined the state's privy council. He was captured in Charleston's 1780 surrender to the British, exiled to St. Augustine, Florida, and imprisoned for a year. In 1782, he entered Congress for two terms, and later supported the proposed federal Constitution at his state's ratifying convention. He served three terms as president of South Carolina's senate during the 1790s.

Ramsay, the author of several published histories, also helped to found the Medical Society of South Carolina, and attempted to establish educational standards and a professional code of ethics for physicians. In 1802, he opened Charleston's first dispensary for the poor, and he advocated measures to alleviate unsanitary conditions caused by overcrowding and stagnant water in city dwellings. He also strongly urged the compilation of annual statistics on climate, mortality, and disease in the city. Such commitment to public service, ironically, led to Ramsay's death. On one occasion at Charleston's prison, he and another doctor declared a homicidal inmate there insane and recommended his incarceration. Later, the former inmate met Ramsay on the street and fatally shot him. Ramsay died on 8 May 1815.

Ramsay's distinguished status possibly provided entry into South Carolina society for Rembrandt Peale (1778–1860), whose aunt had married Ramsay's elder brother Nathaniel (see below).[1] In 1795, the young Peale brought to Charleston a number of portraits from his family's Philadelphia Museum as an advertisement for that collection and for his own artistic skill.[2] When the artist returned to Philadelphia two years later, his portfolio and fame had greatly expanded, and included this portrait of David Ramsay for the Philadelphia Museum. The Ramsay and other Charleston portraits were Rembrandt's initial foray into his father's, Charles Willson Peale's, established museum format. At the same time, with this portrait, the younger artist was already experimenting with color and the use of contrasting highlights in a way that would soon define the differences between his father's painting style and his own.[3] Rembrandt also painted a full-length replica of Ramsay's museum portrait (now in the Carolina Art Association's Gibbes Art Gallery) for the subject's family.

❧

Provenance:
Listed in the 1813 Peale Museum catalog. Purchased by the City of Philadelphia at the 1854 Peale Museum sale.

Physical Description:
Oil on canvas. Bust length, torso turned slightly to the sitter's left. Dark blue coat, yellow waistcoat, white stock and jabot. Gray hair, brown left eye and blue right eye. Dark maroon background. 23 7/16 inches H × 19 7/16 inches W.

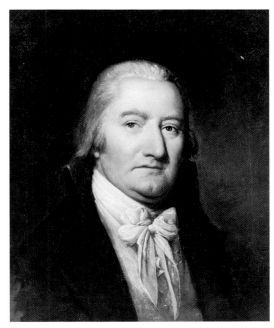

Catalog Number INDE14125
(SN 13.235)

[1] Charles Willson Peale had painted portraits of both Ramsays in the 1770s (both are now privately owned) at the time of Nathaniel's marriage.

[2] *City Gazette and Advertiser*, Charleston, 3 December 1795 (Miller, *Selected Papers* 2:1, pages 131–132).

[3] Carol Eaton Hevner, "The Paintings of Rembrandt Peale: Character and Conventions," in Lillian B. Miller, ed., *In Pursuit of Fame: Rembrandt Peale, 1778–1860*, National Portrait Gallery exhibit catalog (Seattle: University of Washington Press, 1992), 251.

Catalog Number INDE14126

(SN 13.236)

[1] Charles Willson Peale to Richard Key Heath, 21 February 1805 (Miller, *Selected Papers* 2:2, page 813).

[2] Charles Willson Peale had painted Ramsay three times on commission: a 1771 oil portrait and two c. 1793 miniatures (all are now privately owned), one in uniform and the other in civilian dress.

[3] Charles Willson Peale, "Autobiography," 444. Peale–Sellers Papers, American Philosophical Society.

NATHANIEL RAMSAY (1741–1817)
by Rembrandt Peale, probably from life, c. 1797–1808

Ramsay was born on 1 May 1742 in Lancaster County, Pennsylvania. He graduated from the College of New Jersey (now Princeton) and then studied law. Afterward, he opened a legal practice in Cecil County, Maryland. In 1775, Ramsay was elected to the Maryland Convention and to the Continental Congress. After a brief term of service, he accepted a captain's commission and joined the Continental army in mid-1776. Ramsay fought in the battles of Long Island and Monmouth, where he was severely wounded and then captured by the British. After his parole two years later, he resigned his commission and returned to his law practice. After the war, he moved to Baltimore and was re-elected to Congress in 1785, where he served for two years with his younger brother, David (see above). In 1790, President George Washington appointed him United States marshall for Maryland. Four years later, Ramsay became naval officer of the port of Baltimore, a position he held until his death on 24 October 1817.

In 1771, Ramsay married Charles Willson Peale's sister, Margaret Jane, and the two men became lifelong friends. They had many shared interests, and Peale freely attributed the idea of displaying natural history specimens in his Philadelphia portrait gallery to Ramsay.[1] Perhaps to honor Ramsay's contribution, Peale added his brother-in-law's likeness to the museum.[2] The portrait was painted by Peale's son Rembrandt (1778–1860).[3] Since the portrait is not listed in the 1795 Peale Museum catalog, the work apparently dates to sometime after Rembrandt's first painting trip to Charleston and before his first study in Paris.

Provenance:
Listed in the 1813 Peale Museum catalog. Purchased by the City of Philadelphia at the 1854 Peale Museum sale.

Physical Description:
Oil on paper mounted on canvas. Bust length, turned slightly toward the sitter's right. Gray coat and waistcoat, white stock and jabot. Gray hair, blue eyes. Variegated gray background. 23 1/16 inches H × 19 5/8 inches W.

PEYTON RANDOLPH (1721–1775)
by Charles Willson Peale, from life, c. 1782

Catalog Number INDE14124

(SN 13.238)

Randolph was born in 1721 in Williamsburg, Virginia. After graduation from the College of William and Mary, he studied law at London's Middle Temple. He was appointed Virginia's King's attorney in 1748, and he also became a member of the colony's House of Burgesses. He served as both for eighteen years, until he resigned as attorney in order to accept the House speakership. Although he often opposed Virginia's royal governor on issues of taxation, Randolph upheld the principle of loyalty to the British Crown. Similarly, he agreed that the Stamp Act imposed an unfair tax on the American colonies, but he disavowed the Burgesses' radicals (led by Patrick Henry) when they denounced the king in protest of the 1765 Act. This carefully considered moderation increased Randolph's status as a political leader. He chaired Virginia's committee of correspondence and its early revolutionary conventions. At the height of his career, he presided over the First and then the Second Continental Congress until his sudden death from a stroke on 22 October 1775.

Randolph's popularity and the untimeliness of his death prompted a notable display of public mourning for him. A few weeks after Randolph's Philadelphia funeral, Charles Willson Peale began a miniature portrait (now owned by the Carnegie Museum of Art) of the deceased. The source for this posthumous miniature was a full-length portrait (destroyed in the nineteenth century), probably painted by Peale in 1774 for Williamsburg's Masonic Lodge.[1]

The miniature, which remained in Peale's own collection, probably provided the basis for Peale's museum portrait of Randolph. As a former president of Congress, Randolph may have been among the first subjects painted for Peale's Museum, which opened in 1782. His portrait is listed in Peale's advertisement in the 13 October 1784 issue of the *Freeman's Journal and Philadelphia Daily Advertiser*.

Provenance:
Listed in the 1795 Peale Museum catalog. Purchased by the City of Philadelphia at the 1854 Peale Museum sale.

Physical Description:
Oil on canvas. Bust length, facing nearly forward. Umber brown coat and waistcoat, white stock and jabot. Gray wig, brown eyes. Dark brown background. 21 inches H × 17 inches W.

[1] Sellers, *Portraits and Miniatures*, 178.

Catalog Number INDE14127
(SN 13.239)

[1] A replica of Pine's life portrait was begun by Pine and finished by his wife and/or daughters. It is now in the Smithsonian National Portrait Gallery collection.

[2] John Meredith Read Junior to William Thompson Read, 1860 excerpted in Richard S. Rodney to William Jordan (curator of Independence Hall), 11 February 1918. Museum Accession Files, Independence Hall Papers, Independence National Historical Park. Charles Henry Hart, "Thomas Sully's Register of Portraits, 1801–1871," *Pennsylvania Magazine of History and Biography* 33 (1909): 139. Edward Biddle and Mantle Fielding, *The Life and Works of Thomas Sully* (Philadelphia: Wickersham Press, 1921), 257.

GEORGE READ (1733–1798)
by Thomas Sully, after Robert Edge Pine, c. 1860

Read was born on 18 September 1733 near North East in Cecil County, Maryland. Soon afterward, his family moved to New Castle, Delaware and he attended the New London, Pennsylvania academy kept by the Reverend Francis Allison. Later, he studied law in the Philadelphia office of John Moland and then returned to New Castle where he built a prosperous legal practice. In the spring of 1763, Read accepted an appointment as royal attorney general for Pennsylvania's lower counties (now Delaware). He remained in this post for eleven years, despite his active role in protesting British colonial policies like the Stamp Act. In 1765, he won election to the provincial legislature and continued to serve there while he sat in the First and Second Continental Congresses. As a political moderate, he initially opposed American independence. Later, however, he signed the newly adopted Declaration and supported it during Delaware's own constitutional convention of 1776, which he chaired.

At the beginning of the Revolution, Read was elected to the speakership of Delaware's legislative council. He also served one year as the state's chief executive in the fall of 1777. Following a brief retirement from office, he returned to the legislative council in 1782 and also accepted a congressional appointment as a justice in the admiralty court. Later, he attended the Annapolis Convention and supported its call to revise the Articles of Confederation. As the head of Delaware's delegation to the federal Constitutional Convention in 1787, he demanded that the smaller states have a legislative voice equal to that of their larger

and wealthier colleagues. Afterward, he championed the Constitution at Delaware's ratifying convention, the first state body to adopt the new plan. He then served in the United States Senate from 1789 to 1793, when he became chief justice of Delaware. Read died in office on 21 September 1798.

Early in 1860, the City of Philadelphia accepted a portrait of Read for the museum in Independence Hall. Read's family commissioned Philadelphia artist Thomas Sully (1783–1872) for a copy of Robert Edge Pine's c. 1784 portrait of the subject (now in a private collection).[1] According to Sully's painting register, he made a second copy of the Pine portrait in 1860 for the Read family (this second copy is now in a private collection). Although the donor of the Independence portrait reported that he had borrowed the two Pine portraits from Read family members for Sully's work, the artist stated that he had painted the two copies after one (now unlocated) that he had made in 1808.[2]

⁓⁜⁓

Provenance:
Given to the City of Philadelphia by John Meredith Read Senior, the subject's grandson, in 1860.

Physical Description:
Oil on canvas. Bust length, head turned slightly to the subject's right. Dark gray coat and waistcoat, white stock and jabot. Gray hair with black ribbon at nape of neck, brown eyes. Graduated deep-red background. Signed on lining "TS/1860/Copied from a former portrait." 23⅛ inches H × 19⁷⁄₁₆ inches W.

PIERRE FRANÇOIS, COMTE DE RÉAL (1757–1834)
by Charles Willson Peale, from life, probably 1824

Catalog Number INDE14122

(SN 13.240)

Réal was born in Chatou, France, on 28 March 1757. He attended the College of St. Barbe, and began a civil service career in Paris that continued throughout the Jacobin Revolution (including a stint as the public prosecutor of Paris's Revolutionary Tribunal). Becoming more of a political moderate as the Revolution progressed, he was imprisoned in 1794. Within two years came the rise of the moderates and their Directory, and he soon began his association with Napoleon Bonaparte. Réal was appointed to Napoleon's Council of State, where he participated in writing France's new civil code. A member of the Legion of Honor and a minister of police, he was named a count in 1808. After Napoleon's defeat at Waterloo, Réal joined a group of Bonaparte exiles who immigrated to America in 1818. Their first settlements in Alabama failed, and they moved to northern New York where Joseph Bonaparte planned a rescue of his brother from exile on St. Helena. By 1827, Réal had returned to France, retiring to a life of literary pursuits. He died in Paris on 7 May 1834.

Charles Willson Peale probably produced the museum portrait of Réal around 1824, the same time that the artist painted one of Napoleon's brother Joseph, who lived near Philadelphia from 1815 to 1832. Peale had long admired the political principles of the French Revolution, and may have painted Réal (and Joseph Bonaparte) for the museum as representatives of the continuing spirit of liberty.[1]

—◦◦◦◦—

Provenance:
Purchased by "Mr. Barton" at the 1854 Peale Museum sale. Given to the City of Philadelphia by "Mr. Barton" in 1854 or 1855.

Physical Description:
Oil on canvas. Bust length, torso turned toward sitter's left. Black coat, white shirt and jabot. White hair, brown eyes. Dark brown background. 24 inches H × 20 inches W.

[1] Sellers, *Portraits and Miniatures*, 35, 178–179.

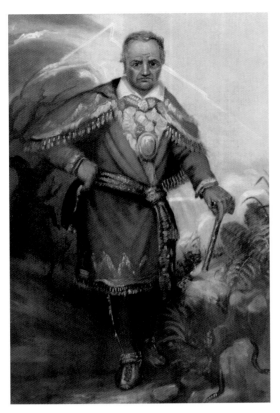

Catalog Number INDE14121

(SN 13.241)

[1] *Catalogue of the National Portraits in Independence Hall* (Philadelphia, 1855), 13. *Catalogue of the National Portraits in Independence Hall* (Philadelphia, 1856), 12.

[2] William T. Alderson, ed., *Mermaids, Mummies and Mastodons: the Emergence of the American Museum* (Washington D.C.: American Association of Museums, 1992), 65.

[3] Jadviga da Costa Nunes, "Red Jacket: The Man and His Portraits," *American Art Journal* 12 (Summer 1980): 12.

RED JACKET/SAGOYEWATHA (about 1758–1830)
by an unidentified artist, after Robert Walter Weir, probably c. 1835

The Seneca chief Sagoyewatha (whose name means "he [who] keeps them awake") of the Wolf clan was born near Geneva, Ontario County, New York, around 1758. He received the Anglicized name Red Jacket during the American Revolution, when the British army rewarded his services with the gift of a scarlet coat. For most of his adult life, he eloquently promoted Native Americans' right to self-determination. He frequently decried the tribes' cooperation with the American government, which other tribal leaders, including Joseph Brant, favored. Despite Sagoyewatha's opposition to formal diplomatic relations, however, he accepted a silver peace medal from President George Washington at the agreement of peace between the Six Nations and the United States in 1792.

In time, Sagoyewatha's protest focused on peaceful resistance to white encroachment on Native American tribal lands. During the War of 1812, he fought with the United States against British settlement near Fort George on the Niagara River. In 1821, his petition to the government of New York State legally established the sanctity of Seneca lands there and mandated the expulsion of Christian missionaries from them. Subsequently, however, his family and many other Senecas converted to Christianity, and he lost his prominence among the tribes. Sagoyewatha died on 20 January 1830.

Purchases made at the 1854 auction of Peale Museum paintings provided the City of Philadelphia with many historical portraits (including one labeled "An Indian Chief") for its museum in Independence Hall. When the City of Philadelphia published its first catalog of the Independence Hall collection, among the portraits listed was one of "The celebrated Indian Chief—Red Jacket." Later erroneously attributed to Charles Willson Peale,[1] this portrait apparently belonged to the Peale family and may have been exhibited in their Philadelphia Museum. Perhaps it was acquired by them after the subject spoke (through a translator) at the Peales' Baltimore Museum in early 1829.[2]

The Independence portrait of Sagoyewatha was copied by an unidentified artist from the 1828 life portrait (now owned by the New-York Historical Society) painted by Robert Walter Weir. In this copy, the artist reversed the orientation of Weir's painting, possibly because the copyist's source was an engraving. M.J. Danforth's engraving of the Weir portrait was the best known of the subject. The Danforth was first published in Benjamin Thatcher's 1832 *Indian Biography* and then in William Stone's 1841 *Life and Times of Red Jacket*.[3]

❦

Provenance:
Purchased by Townsend Ward (librarian of the Historical Society of Pennsylvania) at the 1854 Peale Museum sale. Purchased by the City of Philadelphia from Townsend Ward in 1854.

Physical Description:
Oil on canvas. Full length, facing front. Red jacket and cape with gold tassel fringe. Off-white shirt, patterned neck stock tie. Silver medal around neck, green sash at waist. Green leggings, brown moccasins. Brown hair, brown eyes. Right hand grasping tomahawk; rocks, vegetation, snake in foreground. View of Niagara Falls in right background. Stormy sky. 44⅜ inches H × 29½ inches W.

JOSEPH REED (1741–1785)
by Charles Willson Peale, from life, c. 1783

Catalog Number INDE14118

(SN 13.242)

Reed was born on 27 August 1741 in Trenton, New Jersey. After attending the Academy of Philadelphia, he graduated from the College of New Jersey (now Princeton). He then studied law with Richard Stockton, and spent two years at London's Middle Temple. Reed returned to America in 1765, and started his legal practice in Trenton. There, he was appointed deputy secretary of the colony. Later, he moved to Philadelphia, where he became a member of the city's political committee of correspondence. In 1775, he presided briefly over the provincial congress before he accepted a commission as a lieutenant colonel in Pennsylvania's militia.

In mid-1775, Reed joined the administrative staff of Commander-in-Chief George Washington. Reed also served in the Continental Congress until he joined the Continental army for the Long Island campaign, Brandywine, Germantown, and Monmouth. In 1777, he went back to Congress for a year and was then elected president of Pennsylvania's Supreme Executive Council. After 1781, he returned to his legal practice. He spent 1784 in England with the Reverend John Witherspoon on a fundraising trip for the College of New Jersey. After Reed returned to Philadelphia, he died on 5 March 1785.

Charles Willson Peale admired Reed's commitment to the Revolutionary cause and maintained his respectful regard, even after Reed sustained a vehement attack against his character by his political enemies, who accused him of wartime treason. During the height of this contrived controversy, Peale painted Reed's portrait for the Philadelphia Museum, probably before the sitter left for England in late 1783.[1] The portrait was first listed as "president of Pennsylvania" in the 13 October 1784 issue of the *Freeman's Journal and Philadelphia Daily Advertiser*. For the sitter's family, Peale also painted a posthumous replica (now in a private collection) of the museum portrait, which shows the sitter in civilian clothes.

Provenance:
Listed in the 1795 Peale Museum catalog. Purchased by the City of Philadelphia at the 1854 Peale Museum sale.

Physical Description:
Oil on canvas. Bust length, facing forward. Dark blue uniform coat with red facings edged in silver, two silver epaulettes. Buff waistcoat, white stock and jabot. Powdered hair, blue eyes. Dark brown background. 22 inches H × 19 ½ inches W.

[1] Sellers, *Portraits and Miniatures*, 179.

Catalog Number INDE14119

(SN 13.243)

[1] Sellers, *Portraits and Miniatures*, 182.

[2] Charles Willson Peale to Charles Carroll, 22 August 1779 (Miller, *Selected Papers* 1, page 327).

DAVID RITTENHOUSE (1732–1796)
by Charles Willson Peale, after Charles Willson Peale, c. 1791–1796

Rittenhouse was born on 8 April 1732 near Germantown, Pennsylvania. Though he had little formal schooling, he showed an early talent for things mechanical and mathematical. His scientific self-training began when his uncle, a joiner, gave him some arithmetic and geometry books and a box of carpenter's tools. Around 1750, he opened his own clock-making shop, and ran it successfully on the family farm for over two decades.

The creation of clockworks led Rittenhouse to his lifelong passion for astronomy. In 1767, he began to build an orrery, or mechanical planetarium, to demonstrate the orbits of the planets (excluding Uranus and Pluto, then unknown) at any moment within a ten thousand-year period. He then built the first American telescope in order to observe the 1769 transit of Venus across the sun. Measurements of the time required for this passage were used to calculate the exact distance from the Earth to the sun and then to the other planets. By 1771, almanacs published in Pennsylvania and throughout the Chesapeake region quoted him as the American authority on astronomy.

In 1775, Pennsylvania's Committee of Safety appointed Rittenhouse as its engineer to survey the Delaware River and the New Jersey coast for possible fortification sites, to investigate technical improvements for cannon, and to supervise local saltpeter manufacture. He then assumed Benjamin Franklin's unexpired term in the Pennsylvania Assembly, attended Pennsylvania's constitutional convention, and temporarily presided over the Council of Safety. In 1777, he became the commonwealth's treasurer and a member of the state Board of War. Later, he became sole trustee of Pennsylvania's loan office and vice provost of the new University of Pennsylvania.

An opponent of the federal Constitution when it was first proposed, Rittenhouse nevertheless found a place in the new government. In 1792, President George Washington appointed him director of the new United States Mint. He supervised the Mint's design and construction, and hired the staff to assay and mint coinage until declining health forced him to resign in 1795. The following year, he contracted cholera and died on 26 June 1796. He was buried beneath the floor of his astronomical observatory at Seventh and Mulberry streets.

Charles Willson Peale painted several portraits of Rittenhouse during the two men's acquaintance. These were commissioned by both institutions with which the astronomer was associated (the University of Pennsylvania in 1772, the American Philosophical Society in 1791) and personal acquaintances (a family miniature around 1791, the artist Edward Savage in 1796). Peale also painted a museum portrait that was advertised in the 13 October 1784 issue of the *Freeman's Journal and Philadelphia Daily Advertiser*. This museum portrait (now unlocated), however, was replaced by Peale around 1796 with a second portrait copied in bust-length format from the American Philosophical Society version. Possibly, Peale redid the museum portrait to resemble the popular engraving that Edward Savage produced of the Peale image (copied from the Philosophical Society's version) he owned.[1] Peale had initially planned to produce an engraving of his 1772 portrait of Rittenhouse, but never completed the project.[2]

Provenance:
Listed in the 1813 Peale Museum catalog. Purchased by the City of Philadelphia at the 1854 Peale Museum sale.

Physical Description:
Oil on canvas. Nearly half length, seated, torso turned slightly to the subject's right. Pink-lined blue robe, white waistcoat, white stock and jabot. Gray hair, blue eyes. Top of upholstered chair visible in right midground. Dark brown background. 23⅛ inches H × 19⅛ inches W.

THOMAS ROBINSON (1751–around 1830)
by Charles Willson Peale, from life, 1784

Robinson was born on 30 March 1751 in Naaman's Creek, Delaware. Later, he joined his family's mercantile business. Early in 1776, he joined the Continental army under Anthony Wayne, his youngest sister's legal guardian. He participated in America's invasion of Canada and subsequent retreat to Fort Ticonderoga. He then fought at Germantown and Brandywine, where he was wounded during an advance attack. He returned to the field and, despite a courtmartial for an absence from camp without leave, fought at Yorktown. After the war, he returned to business and farming. Later, he served as a judge in Delaware's Court of Common Pleas. Robinson died around 1830.[1]

Charles Willson Peale's portrait of Robinson shows him uniformed as a colonel (the rank he achieved in late 1783) and wearing his Order of the Cincinnati medal. This painting was not a part of the Peale Museum, but was rather a commission from Robinson.

It differs from the museum's military portraits in size and in its inclusion of several props used to represent the sitter's military authority. As a ranking officer, Robinson carries a decorative sword, his "Orderly Book," and a "Return" order. His double-breasted waistcoat was probably ordered personally by the sitter, as it was not standard issue.

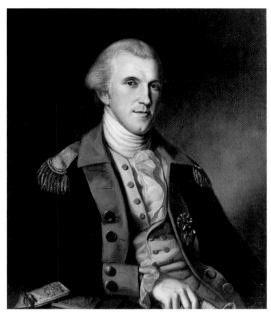

Catalog Number INDE14120

(SN 13.244)

───※───

Provenance:
Given to the City of Philadelphia by Nalbro Frazier Robinson, the sitter's grandson, in 1896.

Physical Description:
Oil on canvas. Half length, seated, torso turned slightly toward the sitter's left. Dark blue uniform coat with red facings, silver epaulettes, off-white waistcoat. White stock and jabot, cuff. Powdered hair, blue eyes. Society of the Cincinnati medal with light blue and white ribbon on left lapel. Right hand holding hilt of silver sword with elbow resting on table on top of two documents. Dark brown background. 30 3/16 inches H × 25 1/8 inches W.

[1] Correspondence between Robinson and his brother-in-law, Judge Richard Peters, exists from 1828. A November 1819 death date on a tombstone in Philadelphia's Christ Church cemetery has been erroneously associated with this Thomas Robinson.

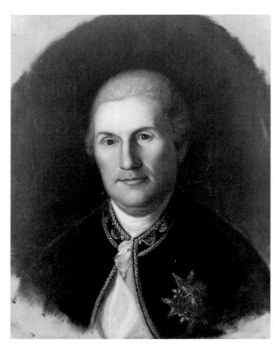

Catalog Number INDE14138

(SN 13.246)

¹ Sellers, *Portraits and Miniatures*, 184–185. *Pennsylvania Packet*, 1 November 1781.

JEAN BAPTISTE DONATIEN DE VIMEUR, COMTE DE ROCHAMBEAU (1725–1807)
by Charles Willson Peale, from life, c. 1782

Rochambeau was born on 1 July 1725 in Vendôme, France. He attended school in Paris and then accepted a calvary commission. He fought in the War of the Austrian Succession and the Seven Years War. In 1761, he was inspector of cavalry and later served as a provincial governor. In 1780, he took command of the large French force sent to aid the Continental army. There, his tactical and administrative knowledge contributed significantly to America's victory at Yorktown in 1781. He returned to France in early 1783 and commanded its northern army in the last years of Louis XVI's reign. Rochambeau retired to his chateau in 1792, but was arrested and imprisoned for six months by Robespierre's revolutionaries. Rochambeau escaped execution and later regained his former status during Napoleon's dictatorship. Rochambeau died on 10 May 1807.

Americans celebrated the victory at Yorktown with displays that exalted its heroic commanders Washington and Rochambeau. Charles Willson Peale decorated the second story of his home with large, painted transparencies that depicted the two men crowned with laurel and surrounded by rays of glory.¹ Around the same time, Peale also painted Rochambeau's portrait for the museum, probably during the latter's visit to Philadelphia in the summer of 1782. In it, Rochambeau wears the elegant dress of a French courtier, which includes the Grand Croix of the Order of St. Louis that he received in 1771 for his distinguished service in the Seven Years War.

The museum portrait was first listed in the 13 October 1784 issue of the *Freeman's Journal and Philadelphia Daily Advertiser.*

Provenance:
Listed in the 1795 Peale Museum catalog. Purchased by the City of Philadelphia at the 1854 Peale Museum sale.

Physical Description:
Oil on canvas. Bust length, facing forward. Dark blue uniform coat with gold braid trim, red waistcoat, white stock and jabot. Pink sash across chest. Gold Maltese cross medal (Grand Croix of the Order of St. Louis). Powdered hair, brown eyes. Dark brown background. 21¾ inches H × 19⅛ inches W.

JOHN RODGERS (1773–1838)
by Charles Willson Peale, from life, 1818–1819

Catalog Number INDE14139

(SN 13.248)

Rodgers was born in 1773 near Havre de Grace, Maryland. After a rudimentary education, he went to sea early, traveling to the West Indies and Europe. He served with the merchant marine and then the United States navy aboard the *Constellation* in the late 1790s. After the naval war with France, he made a commercial voyage to Santo Domingo, where he organized an evacuation of Cap Français during a slave revolt. When the French government arrested him as a participant in that island rebellion, he was imprisoned. When he returned to the United States, he rejoined the navy and sailed to the Mediterranean during the war with the Barbary pirates. There he commanded the blockade of Tripoli and an expedition to Tunis, and directed the 1806 peace negotiations with Morocco.

Rodgers remained in naval service throughout the Jefferson administration's embargo on English trade ships. As commodore of the Navy's northern division, he led the first fleet into the Atlantic against the British in the War of 1812 and later led the naval defense of the Washington capital. In 1815, President James Madison appointed Rodgers to the Board of Navy Commissioners. Six years later he became the navy's ranking officer, and then served as interim naval secretary. After a short tour in the Mediterranean, he retired in 1837. Rodgers died of cholera on 1 August 1838.

Charles Willson Peale conducted two museum portrait sittings with fellow Marylander John Rodgers late in 1818. The artist took pride in this work "done in so short a time [it] astonishes all who see it." The painting, finished in early January, was part of a substantial group added to the museum by the elderly Peale.[1] For this likeness of Rodgers, Peale employed the harmonious, red-toned palette developed by his son Rembrandt. During their sittings, Peale and Rodgers had established a casual friendship based "on the conversations we enjoyed while painting your portrait."[2] Later, the artist asked Rodgers to award his grandson a naval appointment, but the young Peale lacked the necessary job qualifications and the request failed.

Provenance:
Purchased by the City of Philadelphia at the 1854 Peale Museum sale.

Physical Description:
Oil on canvas. Bust length, torso turned slightly toward the sitter's left. Black uniform coat with silver epaulettes having one silver star. White shirt, black stock. Graying brown hair, brown eyes. Olive green background. 24 1/16 inches H × 20 1/16 inches W.

[1] Charles Willson Peale, "Diary," 23 December 1818 and 5 January 1819 (Miller, *Selected Papers 3*, pages 643, 645). Sellers, *Portraits and Miniatures*, 185.

[2] Charles Willson Peale to Rubens Peale, 7 January 1819 (Miller, *Selected Papers* 4, page 679).

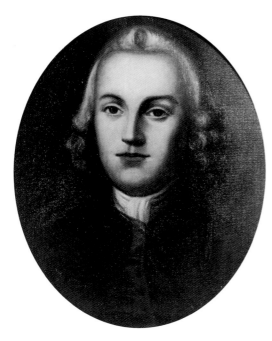

Catalog Number INDE14140

(SN 13.249)

GEORGE ROSS (1730–1779)
by Philip Fisbourne Wharton, after Benjamin West, c. 1873

Ross was born on 10 May 1730 in New Castle, Delaware. He read law in Philadelphia and then moved to Lancaster, where he began his own legal practice. He later became his county's royal prosecutor, and in 1768 took a seat in the colonial assembly. Although at first a political conservative, he later became a member of Pennsylvania's committee of safety and of the First and Second Continental Congresses until late 1775. The following year, he sat as vice president of Pennsylvania's first state constitutional convention. He was reelected to Congress, where he signed the Declaration of Independence, but resigned when illness forced his retirement from public office. With his recovery, he accepted an appointment as judge of the state's admiralty court in early 1779. Ross died in office on 14 July 1779.

In 1873, the City of Philadelphia commissioned local artist Philip Fisbourne Wharton (1841–1880) for a portrait of Ross to hang in Independence Hall. Wharton traveled to Lancaster, where he copied Benjamin West's c. 1760 portrait (now at Franklin and Marshall College) of the subject.[1]

✦

Provenance:
Purchased by the City of Philadelphia from the artist in 1873.

Physical Description:
Oil on canvas. Bust length, facing front. Dark blue coat, brown waistcoat, white stock and jabot. Powdered hair, brown eyes. Dark brown background. 24³⁄₁₆ inches H × 20⅛ inches W.

[1] At the time of Wharton's commission, the West portrait and a copy of it were owned by Ross's descendants. It is unclear which painting Wharton actually copied.

BENJAMIN RUSH (1746–1813)

Rush was born in Byberry Township, Pennsylvania, on 4 January 1746. He attended his uncle's West Nottingham Academy and then graduated from the College of New Jersey (now Princeton) in 1760. For the next six years, he served an apprenticeship with Dr. John Redman of Philadelphia, and then received his medical doctorate from Edinburgh University in 1768. The next year, he opened his own Philadelphia practice and received an appointment as professor of chemistry at the College of Philadelphia. His politics involved Rush in the growing Revolutionary movement (he urged Thomas Paine to publish an attack on monarchical government and suggested the pamphlet's title, *Common Sense*), and he entered Pennsylvania's provincial assembly in 1776. He then served in the Second Continental Congress, signing the Declaration of Independence (along with his father-in-law, Richard Stockton). Early the next year, Congress appointed Rush as surgeon-, and then physician-general, of the army's Middle Department; he served briefly.

Though he remained committed to political causes (he attended Pennsylvania's convention to ratify the new federal Constitution and led the battle for a new state constitution), Rush turned his full attention to public health issues after the war. He joined the staff of the Pennsylvania Hospital, where he advocated humane treatment for the insane. In 1786, he founded the Philadelphia Dispensary, the first free hospital for the poor in America. Three years later, he accepted the College of Philadelphia's chair in the theory and practice of medicine. When the College merged with the University of Pennsylvania in 1791, he became professor of the institutes of medicine and clinical practice.

His greatest medical challenge came soon after with Philadelphia's yellow fever epidemic. The city's mortality rates during the 1790s epidemics were extremely high, and Rush's critics blamed him for contributing to those rates with his radical treatment. Rush defended his fever treatment in the *Account of the Bilious Remitting Yellow Fever ... in the year 1793* and then withdrew from the Philadelphia College of Physicians, which he had earlier helped to organize. Despite this public criticism, he was well respected as a physician and a humanitarian. He helped to found Dickinson College, and was among the charter trustees of Franklin College. He was a founder of the Pennsylvania Society for Promoting the Abolition of Slavery, St. Thomas's African Episcopal Church (the United States' first African American church), and the Philadelphia Bible Society. He published extensively on temperance, veterinary science, mental illness, and public and female education. In 1797, President John Adams appointed him treasurer of the United States Mint. Rush served the Mint until his death from typhus on 19 April 1813.

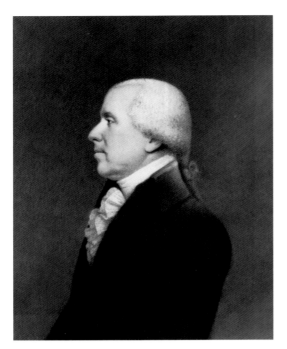

Catalog Number INDE11871

(SN 7.028)

BENJAMIN RUSH (1746–1813)
1. by Ellen Sharples, after James Sharples Senior, 1805

1. Near the end of his family's first visit to the United States, British pastelist James Sharples Senior drew a portrait of Rush, probably in early June 1800 when he spent a day with the doctor.[1] This portrait (now owned by the Bristol Art Gallery in England) later served as a model for Sharples's wife Ellen (1769–1849), an accomplished miniaturist, who began a pastel copy of it in England in June 1805.[2] This pastel has Mrs. Sharples's tightly controlled style of execution, strict attention to detail, and dense quality of the image's background hatching.

❧

Provenance:
Given by Ellen (Mrs. James) Sharples to Felix Sharples in 1811. Given by Felix Sharples to Levin Yardly Winder in the 1830s. Inherited by Nathaniel James Winder from Levin Yardly Winder. Inherited by Richard Bayly Winder from Nathaniel James Winder in 1844. Purchased by Murray Harrison from Richard Bayly Winder around 1865. Purchased by the City of Philadelphia from Murray Harrison in 1876.

Physical Description:
Pastel on paper. Half length, left profile. Gray-black coat and waistcoat, white stock and jabot. Gray hair tied in queue, brown eyes. Gray background. 9 inches H × 7 inches W.

[1] "Commonplace Book of Benjamin Rush 1792–1813," 3 June 1800. George W. Corner, ed., *The Autobiography of Benjamin Rush* (Westport, Conn.: Greenwood Press, 1948), 251. The portrait is listed in Sharples's 1802 catalog as "Dr. Ruth."

[2] "Ellen Sharples Diary, 1803–1836," May–June 1805. Bristol Academy for the Promotion of the Fine Arts, number 200. Microfilm copy in Independence National Historical Park Library, roll number 502. Ellen Sharples's pencil sketch of the Rush portrait is now at the Bristol Art Gallery.

BENJAMIN RUSH (1746–1813)
2. by Charles Willson Peale, after Thomas Sully, 1818

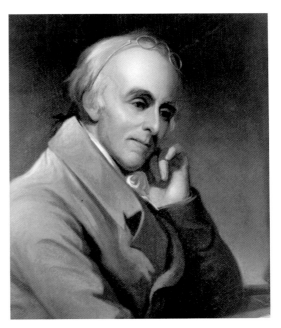

Catalog Number INDE14141

(SN 13.250)

2. Although he had painted a commissioned portrait (now at the Winterthur Museum) of Rush in 1783, Charles Willson Peale did not overcome enough of his disapproval of the doctor's medical theories to include his portrait in the Philadelphia Museum. Peale had previously considered painting a museum portrait of Rush in recognition of his "literary Talents" and because "the appearance of age [was] creeping fast on" the doctor (who was five years younger than the artist) but changed his mind.[3] In late January 1818 Peale recorded that he had finally added a portrait of "Dr. Benjamin Rush (from Sully)" to the museum.[4] Peale copied the subject's head in Thomas Sully's full-length portrait of Rush (now at the Pennsylvania Hospital), which had been commissioned in 1812 by one of Rush's former students.

⁂

Provenance:
Purchased by the City of Philadelphia at the 1854 Peale Museum sale.

Physical Description:
Oil on canvas. Half length, seated with head and torso turned toward subject's left. Tan coat, white stock and cuff, gray hair tied in a queue with a black ribbon, blue eyes, silver spectacles resting on forehead. Left elbow on table with papers, inkwell and quill visible in lower right foreground. Dark brown background. 23⁵⁄₁₆ inches H × 20¼ inches W.

[3] Charles Willson Peale to Rembrandt Peale, 17 November 1809 (Miller, *Selected Papers* 2:2, page 1240). Sellers, *Portraits and Miniatures*, 187.

[4] "Memorandum of the Philadelphia Museum, 1803–4," 91. Peale Papers, Historical Society of Pennsylvania.

WILLIAM RUSH (1756–1833)
attributed to Rembrandt Peale, from life, c. 1810–1813

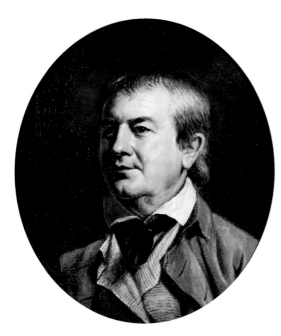

Catalog Number INDE11872
(SN 13.251)

Rush was born in Philadelphia on 4 July 1756. Later, his father apprenticed him to a successful ship carver. After Revolutionary service in Philadelphia's militia, Rush returned to carving. In his work, he developed the distinctive "walking attitude" for ship's figures, in which the subject was posed naturally, as if stepping away from the boat's prow. The demand for figureheads remained high until the 1807 American embargo on English trade led to renewed warfare between the United States and Great Britain and decreased commercial shipping.

An active member of Philadelphia's City Council for more than two decades, Rush participated in several civic improvement projects and other building exercises. He was particularly interested in the development of the city's public water system, and in 1809 supplied his statue of a nymph and bittern for the fountain in front of the Centre Square Water Works. When the expanded waterworks moved to Fairmount in 1828, he created for it two new statues, the *Allegory of the Schuylkill River in Its Improved State (the Schuylkill chained)* and the *Allegory of the Waterworks (the Schuylkill freed)*.

Although Rush executed his large, public works in wood, when carving portrait busts, Rush also worked in plaster and terra cotta. His first bust, carved in 1787 for a Connecticut bookstore, depicted the eighty-year-old Benjamin Franklin. During the early nineteenth century, Rush executed many busts of scientists, artists, politicians, soldiers, explorers, himself, and his own family members.[1]

Although he lacked extensive art training (he had some lessons in modeling from the artist Joseph Wright), Rush devoted much time to art instruction. In 1805, he founded the Pennsylvania Academy of the Fine Arts. The Academy followed the short-lived Columbianum, a group of approximately forty professional artists organized in 1794 that included Charles Willson Peale and Rush. Among the Pennsylvania Academy's courses were those taught with live models, and Rush conducted the Academy's first life class in 1813. He remained a member of the Academy's board until his death on 17 January 1833.

Rush's preeminence in the Philadelphia art community, as well as his professional association with Charles Willson Peale, earned him a place in Peale's Philadelphia Museum. In 1854, Rembrandt Peale identified this painting as his in the Peale Museum sale catalog. During the first decade of the nineteenth century, Peale and his son Rembrandt collaborated on a portrait of Gilbert Stuart and possibly Rembrandt's portrait of William Findley (see above), Albert Gallatin (see above), and Thomas Jefferson.[1] At that time, circumstances occasionally prompted the two artists to share their workload; Rembrandt had developed boils on his eyelid and shoulder, which made painting difficult, and his father was busy with the business of the museum. This cooperation continued when the father and son shared the new coloring technique brought by the latter from France in 1810. Rush's portrait resembles work done by both Peales during this period, and may represent a joint effort between the two artists.

❧

Provenance:
Listed in the 1813 Peale Museum catalog. Purchased at the 1854 Peale Museum sale by Mary Simpson Rush Dunton, the sitter's daughter. Given to the City of Philadelphia by Mary Simpson Rush Dunton in 1854 or 1855.

Physical Description:
Oil on canvas. Bust length, turned slightly to the sitter's right. Tan coat, tan striped waistcoat, white shirt, black stock. Light brown hair, blue eyes. Dark background. 23⅜ inches H × 19¼ inches W.

[1] Linda Bantel et al., *William Rush, American Sculptor*, exhibit catalog (Philadelphia: Pennsylvania Academy of the Fine Arts, 1982), 9–57.

[2] Carol Eaton Hevner, *Rembrandt Peale, 1778–1860: a Life in the Arts*, exhibit catalog (Philadelphia: Historical Society of Pennsylvania, 1985), 42, 97 n. 5. Sellers, *Portraits and Miniatures*, 205.

EDWARD RUTLEDGE (1749–1800)
by Philip Fisbourne Wharton, after James Earl, c. 1873

Rutledge was born in Charleston, South Carolina, on 23 November 1749. Educated by tutors, he later studied law at London's Middle Temple. After being admitted to the English bar, he returned to Charleston. Later, he served in the provincial congress. Widely admired for his successful defense of a printer accused of breach of privilege and contempt before the South Carolina Council, Rutledge was elected to the First and Second Continental Congresses. Initially a supporter of peaceful resolution to the conflict between the colonies and England, he later switched his support to the cause of independence and became the leader of South Carolina's congressional delegation, signing the Declaration of Independence.

In 1779, he served as a captain in the state artillery and was captured during the 1780 siege of Charleston. After his release, he took a seat in the South Carolina legislature (where he remained for nineteen years) and conducted his law practice. Though he believed in states' rights, he supported the new federal Constitution and spoke in its favor at his state's ratifying convention. He later served three times as a presidential elector and two terms in his state's senate. In 1794, he refused an appointment to the United States Supreme Court. Four years later, he became South Carolina's governor. Rutledge died in office on 23 January 1800.

As the Centennial approached, Joshua Francis Fisher (connected by marriage to Edward Rutledge) commissioned a portrait of the governor for the museum in Independence Hall. Philadelphia artist Philip Fisbourne Wharton (1841–1880) copied James Earl's c. 1794 portrait of Rutledge (now privately owned).

❧

Provenance:
Given to the City of Philadelphia by Joshua Francis Fisher, the subject's marital descendant, in 1873.

Physical Description:
Oil on canvas. Bust portrait, torso turned toward subject's left. Reddish brown coat and waistcoat, white stock and jabot. Powdered hair, blue eyes. Dark green background. 24 inches H × 20⅛ inches W.

Catalog Number INDE14142
(SN 13.252)

Catalog Number INDE
(SN 13.258)

PHILIP JOHN SCHUYLER (1733–1804)
by Jacob Hart Lazarus, after John Trumbull, c. 1886

Schuyler was born in Albany, New York, on 11 November 1733. An avid mathematician, he attended school in New Rochelle before entering commerce. In 1755, he accepted a commission in the British army and served throughout the French and Indian War. Afterward, he established himself as a leader among the colony's Dutch aristocracy. He entered the colonial assembly in 1768, and later served briefly in the Second Continental Congress.

In June 1775, Schuyler fortified the American troops at Ticonderoga, Crown Point, and Fort Stanwix before illness necessitated his temporary retirement from active duty. After returning to command of the army's Northern Department, criticism of his actions (in particular, the loss of Ticonderoga to the British) twice resulted in his removal. A court martial acquitted Schuyler in late 1778, but he resigned from service a few months later. Despite his dissatisfaction with military command, he remained involved with the war effort as a member of Congress and of the Board of Indian Affairs.

Following his Revolutionary service, Schuyler served in the New York State Senate for eighteen years and in the United States Senate for its first term. During this time, he expressed great interest in the development of New York's canal system, and sat on the state's Board of Regents when it created Schenectady's Union College. He died on 18 November 1804.

In 1887, to commemorate Schuyler's early role in the Revolution, the City of Philadelphia hung his portrait in Independence Hall. The general's great-grandson commissioned New York artist Jacob Hart Lazarus (1822–1891) to copy John Trumbull's 1792 panel portrait of Schuyler (now owned by the New-York Historical Society).¹

❦

Provenance:
Given to the City of Philadelphia by Philip Schuyler, great-grandson of the subject, in 1887.

Physical Description:
Oil on canvas. Bust length, head turned toward the subject's right. Brown coat and waistcoat, white stock and jabot. Powdered hair, brown eyes. Dark brown background. 24⅛ inches H × 20¾ inches W.

JOHN SAMUEL SHERBURNE (1757–1830)
by James Sharples Senior, from life, 1796–1797

Catalog Number INDE11929
(SN 7.038)

Sherburne was born in Portsmouth, New Hampshire, in 1757. Later, he graduated from Dartmouth, and then from Harvard College where he studied law. He added "John" to his name at this time, probably to distinguish himself from his cousin Samuel. After a brief time in his own law office, John Samuel Sherburne served one year in New Hampshire's Revolutionary militia. During the American retreat from Newport, Rhode Island, in mid-1778, he lost his leg to a British cannonball at Butts (or Quaker) Hill. After his recovery, he returned to his Portsmouth legal practice and also became his county's magistrate. In 1793, he entered Congress, where he served two terms in the House of Representatives. He then spent three years as New Hampshire's United States district attorney. In 1804, President Thomas Jefferson appointed him as a judge of the United States District Court for New Hampshire, where he served until his death on 2 August 1830.

British pastelist James Sharples Senior (1751–1811) apparently painted this portrait of Sherburne when the artist and the Congressman both lived in the federal capital of Philadelphia during 1796 and 1797. Later, Sharples listed "Colonel Sherburn[e], M[ember of] C[ongress]" in the 1802 catalog he published in Bath, England.

Although Sherburne never became a colonel, Sharples may have misunderstood the sitter's former military status (one not associated with the regular army). Sherburne's congressional service, on the other hand, is an obvious matter of public record. In addition, Sharples's sitter closely resembles the man portrayed by Charles Balthasar Julien Fevret de Saint-Mémin in his 1805 engraving called "J: Sam: Sherburn: 1805."[1] Previously, the Independence sitter was identified as Rhode Island's Colonel Henry Sherburne (1747–1824). Colonel Sherburne, however, never served in Congress.

❦

Provenance:
Listed in the 1802 Bath catalog of Sharples's work. Given by Ellen (Mrs. James) Sharples to Felix Sharples in 1811. Given by Felix Sharples to Levin Yardly Winder in the 1830s. Inherited by Nathaniel James Winder from Levin Yardly Winder. Inherited by Richard Bayly Winder from Nathaniel James Winder in 1844. Purchased by Murray Harrison from Richard Bayly Winder around 1865. Purchased by the City of Philadelphia from Murray Harrison in 1876.

Physical Description:
Pastel on paper. Half length, right profile. Gray coat, black-striped white waistcoat, white stock and jabot. Gray wig, brown eyes. Blue-green variegated background. 9 inches H × 7 inches W.

[1] Ellen G. Miles, *Saint Mémin and the Neoclassical Profile Portrait in America*, National Portrait Gallery exhibition catalog (Washington D.C.: Smithsonian Institution Press, 1994), 390.

Catalog Number INDE14147

(SN 13.262)

ROGER SHERMAN (1721–1793)
by Thomas Hicks, after Ralph Earl, c. 1866

Sherman was born in Newton, Massachusetts, on 19 April 1721. He apprenticed with his father as a cobbler and then, largely self-educated, became a surveyor. In New Milford, Connecticut, he served in several local public offices, operated a general store, and published a series of almanacs. In 1754, he joined the Litchfield bar. The following year, he entered the colony's assembly and became a justice of the peace. He gained additional administrative experience during the French and Indian War as commissary for Connecticut's militia. After a move to New Haven and a brief concentration on business affairs, he returned to the colonial legislature in 1764, remaining for twenty years. At the same time, he served as a judge in the colonial superior court and treasurer of Yale College.

Sherman was a member of the First and Second Continental Congresses, and served on the committee that drafted the Declaration of Independence, which he later signed. After the war, he helped to write Connecticut's legal code and served as New Haven's mayor. An advocate of strong central government, he helped to write the Articles of Confederation and later attended the federal Constitutional Convention of 1787. During the convention, he proposed a successful compromise on the issue of representation in Congress that became the dual legislative system used today. He was elected to the House of Representatives in 1789 and to the Senate two years later; he served until his death on 23 July 1793.

Early in 1875, the City of Philadelphia received a portrait of Sherman for Independence Hall. New York artist Thomas Hicks (1823–1890) copied Ralph Earl's 1775–1776 full-length portrait (now at the Yale University Art Gallery) of Sherman. Hicks had produced several copies of the Earl portrait: a bust length signed and dated "1856" (now at the Yale University Art Gallery), a full length signed and dated "[186]6" (now at New York's Oneida Historical Society), and another bust length (at one time in a private New York collection but now unlocated).[1]

❧

Provenance:
Given to the City of Philadelphia by William Maxwell Evarts, grandson of the subject, in 1875.

Physical Description:
Oil on canvas. Bust length, turned slightly to the subject's right. Reddish-brown coat and waistcoat, white stock. Brown hair, blue eyes. Dark brown background. 24 1/16 inches H × 20 1/16 inches W.

[1] These last two copies, plus the Independence portrait, may be those referred to as painted by Hicks in 1866, according to Henry Williard French in his book *Art and Artists in Connecticut* (1879). David Tatham, "Thomas Hicks at Trenton Falls," *American Art Journal* 15 (Autumn 1983): 9.

WILLIAM SHIPPEN JUNIOR (1736–1808)
by James Peale, after Gilbert Stuart, 1811

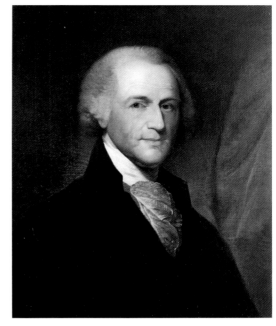

Catalog Number INDE14146

(SN 13.261)

Shippen was born in Philadelphia on 21 October 1736. He attended the West Nottingham Academy and then graduated from the College of New Jersey (now Princeton) in 1754. He then apprenticed with his father, a staff apothecary at the Pennsylvania Hospital, before studying anatomy and obstetrics in London. After his clinical training, he entered the University of Edinburgh, where he received his medical doctorate in 1761. Back in America, he opened an anatomy school and also lectured on anatomy at the Pennsylvania State House (now called Independence Hall) and the Pennsylvania Hospital. Because he demonstrated medical principles through the dissection of cadavers, he incurred harsh and sometimes violent public criticism. In 1765, he attracted further notice when he offered courses in midwifery (traditionally a non-scientific, female practice) and opened a small maternity hospital for poor women in his home.

In 1776, Shippen became administrator of New Jersey's military hospital and then of the military hospitals west of the Hudson River. During that time, he submitted a reorganization plan for the army medical department to Congress. He then received an appointment as director-general of the army's hospitals. He served in this position until early 1780, when he demanded a review of charges of misadministration made against him. Congress declared these charges unfounded but agreed that he had sold hospital supplies for personal profit, and he was discharged. Although he was briefly reinstated, he resigned his position in 1781. In 1787, he helped to found the Philadelphia College of Physicians and later served as its president.

He also joined the staff of the Pennsylvania Hospital and accepted an appointment as professor of anatomy, surgery, and midwifery at the new University of Pennsylvania. In 1798, distraught over the sudden death of his only son, he curtailed his practice and his teaching load. Shippen died on 11 July 1808.

Charles Willson Peale held Shippen in high esteem, and the doctor attended the artist's second wife, Elizabeth DePeyster, in early 1804 when she lost her life during childbirth. For the Philadelphia Museum, James Peale (1749–1831) copied Gilbert Stuart's c. 1798 portrait of Shippen (now privately owned) in 1811.[1] Other Peale copies of the Stuart Shippen portrait are located at the College of Physicians of Philadelphia's Mütter Museum (attributed to Rembrandt Peale) and the University of Pennsylvania Medical School (attributed to Charles Willson Peale).

Provenance:
Listed in the 1813 Peale Museum catalog. Purchased by the City of Philadelphia at the 1854 Peale Museum sale.

Physical Description:
Oil on canvas. Half length, torso turned toward the subject's left. Black coat and waistcoat, white sock and jabot. Powdered wig, blue eyes. Dark red drapery in background. 29 inches H × 23 3/16 inches W.

[1] "Museum Accession Book," 8 December 1811. Peale–Sellers Papers, American Philosophical Society. Rembrandt Peale identified his uncle James as the artist of the Shippen museum portrait in his copy of the 1854 Peale Museum sale catalog. Peale Papers, Historical Society of Pennsylvania.

Catalog Number INDE14145

(SN 13.257)

JOHN ANDREW SHULZE (1775–1852)
possibly by Jacob Eichholtz, from life, before 1823

Shulze was born in Berks County, Pennsylvania, on 9 July 1775. A member of a large family of eminent Lutheran clergymen (which included his uncles, John Peter Gabriel and Gotthilf Henry Ernest Muhlenberg), Shulze studied the classics and theology in Lancaster, York, and New York City. He was ordained in the German Lutheran Church in 1796, and preached in Berks County until rheumatism forced his retirement from the ministry six years later. After several profitable years in business, he entered Pennsylvania's state legislature as a moderate Republican. He served there for several nonconsecutive terms from 1806 until 1823, when he was elected governor. During his two gubernatorial terms, he supported the development of the Susquehanna Canal and headed the movement for more public elementary education in his state. After his retirement from public office, he served as president of Pennsylvania's electoral college. Shulze died in Lancaster on 18 November 1852.

During the early nineteenth century, Charles Willson Peale repeatedly sought financial assistance for his Philadelphia Museum from the state of Pennsylvania. As a gesture of good will toward the state in this regard, the artist amassed a collection of its governors' portraits. Shulze's museum portrait, however, was not claimed by the Peales. Rather, the family attributed it to the Lancaster artist Jacob Eichholtz (1776–1842). It is referred to in the copies of the 1854 Peale Museum sale catalog annotated by Charles Willson Peale's son Rembrandt and granddaughter Mary Jane Peale as "Eicholts."[1]

The Independence portrait, however, differs from the two signed and dated portraits of Shulze (now owned by the Historical Society of Pennsylvania) painted by Jacob Eichholtz in 1823 and 1825.[2] The subject in the Independence portrait is clearly the same person as that in the two documented Eichholtz works; all three share the sitter's combed back hair style, large nose, and full lower lip. But the pose (bust length as opposed to half length) and the style of the Independence portrait seem less sophisticated than those of the other Eichholtz Shulze portraits, and may represent an early work by the artist.

—◦◦◦◦—

Provenance:
Purchased by the City of Philadelphia at the 1854 Peale Museum sale.

Physical Description:
Oil on canvas. Bust length, torso turned to the sitter's left. Dark brown coat, white stock and jabot. Brown hair, brown eyes. Dark background. 24⁵⁄₁₆ inches H × 20⁵⁄₁₆ inches W.

[1] Rembrandt Peale's copy of the 1854 Peale Museum sale catalog is in the Peale–Sellers Papers, American Philosophical Society. Mary Jane Peale's copy of the 1854 Peale Museum sale catalog is in the Independence National Historical Park museum collection.

[2] Rebecca J. Beal, *Jacob Eichholtz, 1776–1842, Portrait Painter of Pennsylvania* (Philadelphia: Historical Society of Pennsylvania, 1969), 220, 321.

WILLIAM SMALLWOOD (1732–1792)
by Charles Willson Peale, from life, 1781–1782

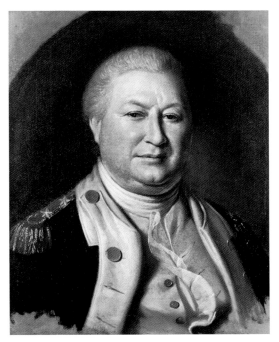

Catalog Number INDE14148
(SN 13.264)

Smallwood was born in Chester County, Maryland, in 1732. He attended school in England and then served in the British army during the French and Indian War. In 1761, he began his political career as a member of the Maryland Assembly. He attended the Maryland Convention in 1775 and advocated armed resistance to the troops posted in America to enforce British tax laws. Early in the Revolution, he was wounded at White Plains and returned home to recuperate. While General Washington camped at Valley Forge, Smallwood rejoined his men at the head of Delaware's Elk River to protect the army's supplies. In 1780, he and his troops formed the reserve at the battle of Camden. After the battle he succeeded to the former command of the fatally wounded Baron de Kalb, but refused to serve under the Prussian Baron von Steuben and so returned to Maryland. He remained there, gathering additional troops and supplies, until the end of the war. His subsequent political career put him in the Maryland governor's office in 1785. He served there for three one-year terms, during which he called the state's federal Constitutional ratifying convention. Smallwood died on 12 February 1792.

Charles Willson Peale painted his museum portrait of Smallwood in the early 1780s. In it, the sitter wears his uniform of major general (the rank he received in recognition for his service at the battle of Camden). Peale considered this portrait "among my best works of that day," and felt nearly forty years later that "The portrait I have of Gen. Smallwood is a faithful and expressive likeness of him."[1] The painting first appears on the 13 October 1784 list published in the *Freeman's Journal and* *Philadelphia Daily Advertiser*. In addition to the museum portrait of Smallwood, Peale repainted his brother James's miniature of the subject (now unlocated) in 1788 and copied the museum portrait for the Maryland State House in Annapolis in 1823. Earlier, Peale's son Rembrandt had copied the museum portrait for use in the Peales' Baltimore Museum (now owned by the Baltimore Museum of Art) c. 1805.

❦

Provenance:
Listed in the 1795 Peale Museum catalog. Purchased by the City of Philadelphia at the 1854 Peale Museum sale.

Physical Description:
Oil on canvas. Bust length, torso turned slightly toward sitter's left. Blue uniform coat with buff facings and gold epaulettes with two silver stars each, buff waistcoat, white stock and jabot. Powdered hair, blue eyes. Dark brown background. 23¹⁵⁄₁₆ inches H × 19¾ inches W.

[1] Charles Willson Peale to Alfred William Grayson, 20 May 1805 (Miller, *Selected Papers* 2:2, page 836). Charles Willson Peale to Nicholas Brewer, 19 September 1823 (Miller, *Selected Papers* 4, page 325).

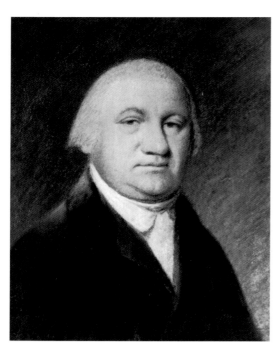

Catalog Number INDE11926

(SN 7.035)

ISAAC SMITH (1736–1807)
attributed to James Sharples Senior, possibly after James Sharples Senior, 1796–1797

Smith was born in Trenton, New Jersey, in 1736. Later, he graduated from the College of New Jersey (now Princeton), and became a tutor there. He then studied medicine at the College of Philadelphia. After a few years as a doctor of physic, he returned to Trenton to practice medicine. Early in 1768, he accepted an appointment as a judge in the Hunterdon County court of common pleas. His professional prominence led to political office as a member of the convention charged with electing New Jersey's delegates to the First Continental Congress and as a member of the colony's Revolutionary committee of correspondence.

When the war began, Smith received a colonel's commission in his state's militia that organized the transport of General George Washington's army across the Delaware River and on to the battle of Trenton. Smith resigned his commission in early 1777, when he was appointed to his state's supreme court, where he remained for twenty-eight years. In 1795, he entered the United States House of Representatives for one term. Afterwards, he served as the founding president of the Trenton Banking Company from 1805 until his death on 29 August 1807.

During his congressional term, Smith sat for a portrait by British pastelist James Sharples Senior (1751–1811). The artist later recorded the image in his 1802 catalog with the entry, "Judge Smith." While the Independence pastel represents the work of a trained painter (especially in the depiction of the sitter's facial features), the details of the sitter's clothing are minimal, suggesting that this might be James Sharples Senior's copy of a life portrait.

Provenance:
Given by Ellen (Mrs. James) Sharples to Felix Sharples in 1811. Given by Felix Sharples to Levin Yardly Winder in the 1830s. Inherited by Nathaniel James Winder from Levin Yardly Winder. Inherited by Richard Bayly Winder from Nathaniel James Winder in 1844. Purchased by Murray Harrison from Richard Bayly Winder around 1865. Purchased by the City of Philadelphia from Murray Harrison in 1876.

Physical Description:
Pastel on paper. Half length, torso turned slightly to sitter's left. Black coat and waistcoat, white shirt. Gray hair, brown eyes. Blue and green variegated background. 9 inches H × 7 inches W.

JONATHAN BAYARD SMITH (1742–1812)
by Rembrandt Peale, from life, 1808

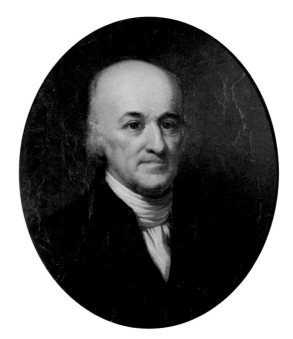

Smith was born in Philadelphia on 21 February 1742. Later, he graduated from the College of New Jersey (now Princeton). He joined his family's successful mercantile business and participated in provincial congresses during the 1770s. A member of his state's Revolutionary council of safety, he presided at the meeting to organize Pennsylvania's defense as the British marched on Philadelphia in 1777. Subsequently, he resigned his new seat in Congress in order to accept a command in the state militia, and fought at Brandywine. In 1778, he returned to Congress and served on Pennsylvania's board of war before he became prothonotary and then justice of his county court of pleas. In 1792, Smith accepted the office of Pennsylvania auditor-general. After 1800, he remained active in state politics and served as a trustee for his alma mater and for the University of Pennsylvania. Smith died on 16 June 1812.

During the Revolution, Charles Willson Peale and Smith shared their political zeal as members of the Whig Society, a group of radical Pennsylvanians who opposed the more conservative elements in state government, especially those who owed their allegiance to the Penn family proprietors. The two men also served together in Philadelphia's militia, the Associators. The artist later added his friend's portrait to his Philadelphia Museum. The portrait itself was painted by Peale's son Rembrandt (1778–1860) before he left Philadelphia on a trip to Paris in April of 1808.[1]

༺⚬⚭⚬༻

Provenance:
Listed in the 1813 Peale Museum catalog. Purchased by the City of Philadelphia at the 1854 Peale Museum sale.

Physical Description:
Oil on paper mounted on canvas. Bust length, torso turned slightly to the sitter's left. Dark brown coat and waistcoat, white stock. Gray hair, brown eyes. Brown background. 24⁵⁄₁₆ inches H × 20⁵⁄₁₆ inches W.

Catalog Number INDE14149

(SN 13.265)

[1] Charles Willson Peale to Rembrandt Peale, 26 June 1808 (Miller, *Selected Papers* 2:2, page 1093).

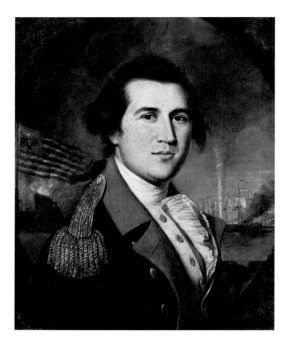

Catalog Number INDE11885
(SN 13.267)

SAMUEL SMITH (1752–1839)
by Charles Willson Peale, from life, c. 1788–1793

Smith was born in Carlisle, Pennsylvania, on 27 July 1752. He attended academies in Maryland and Delaware, and then worked in his father's Baltimore mercantile firm. Afterward, he spent several years in Italy, where he supervised his father's shipping business. At the beginning of the Revolution, Smith organized a volunteer militia and fought at Long Island, in the New Jersey campaign, and at Brandywine. In the fall of 1777, he commanded a small garrison on Mud Island (later Fort Mifflin) in the Delaware River during the British advance on Philadelphia. Although severely injured during a devastating naval bombardment of the fort, he later served at Valley Forge and Monmouth. He resigned from the army in mid-1779, and returned to his business affairs in Baltimore.

In 1790, Smith entered the Maryland legislature; two years later, he received a seat in Congress. He served alternately in the House and Senate for the next forty years. A leader of Maryland's Republicans, he also served briefly in 1801 as President Thomas Jefferson's secretary of the navy. Renewed war with England returned Smith to active duty. As commander of Baltimore's militia, he supervised the city's defenses during the British attack in 1814. When violence in the wake of a bank closure threatened Baltimore twenty years later, he led the militia against rioters. The grateful citizenry elected Smith mayor in 1835, and he served until he died on 22 April 1839.

Charles Willson Peale added Smith's portrait to the museum after the Revolution. The artist depicted the Battle of Mud Island in the right background of his portrait of Smith, an unusual format for a museum portrait. The subject stands before burning ships and the beleaguered fort flying the flag of the Order of the Cincinnati. This flag was not in use in 1777; Smith, president of Baltimore's Cincinnati chapter, asked Peale "to put the order of Cincinati [*sic*] to his Picture" in 1788.[1] This portrait was first listed as part of the museum by an anonymous travel account written for the 4 September 1793 issue of the *National Gazette*.[2]

———⌗———

Provenance:
Listed in the 1795 Peale Museum catalog. Purchased by the City of Philadelphia at the 1854 Peale Museum sale.

Physical Description:
Oil on canvas. Bust length, torso turned toward sitter's left. Dark blue uniform coat with red facings and silver epaulettes, buff waistcoat, white stock and jabot. Brown hair, brown eyes. Left midground contains fort scene with red and white striped flag, soldiers, and cannon. Right midground contains naval battle with three ships, aflame, flying British colors, smoke. 23¼ inches H × 19⅜ inches W.

[1] Charles Willson Peale, "Diary," 31 May and 4 November 1788 (Miller, *Selected Papers* 1, pages 494, 545).

[2] Sellers, *Portraits and Miniatures*, 196.

SIMON SNYDER (1759–1819)
by Charles Willson Peale, from life, 1810

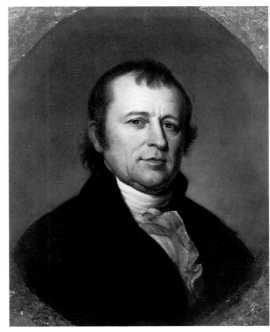

Catalog Number INDE14144

(SN 13.268)

Snyder was born in Lancaster, Pennsylvania, on 5 November 1759. He apprenticed with a tanner in nearby York and attended an evening Quaker school. Later, he opened a store and a mill in Selinsgrove and served as justice of the peace and as a member of his state's 1790 constitutional convention. He then entered the state assembly, where he spent ten years, including three terms as its speaker. Although his first try for Pennsylvania's gubernatorial office resulted in a narrow defeat, Snyder subsequently earned the governor's office in 1808. He remained there for the three-term limit set by state law, during which time he advocated public education, a humane penal code, and limits on governmental powers. Upon leaving the governor's office in 1817, he accepted a seat in the state senate. Snyder died of typhoid fever on 9 November 1819.

Charles Willson Peale's lengthy, but unsuccessful, campaign to acquire public monies for his Philadelphia Museum focused on rallying Pennsylvania's political leaders to his cause. The artist petitioned Governor Snyder several times in hopes of gaining the latter's support for proposed state funding of museum building expenses. As a gesture of good faith in these efforts, Peale added Snyder's image to the collection of Pennsylvania governors' portraits in the museum. The sittings for Snyder's portrait were difficult to arrange (the governor's wife was terminally ill at the time), and Peale went to the capital in Lancaster to take them.[1] According to the artist's accession book, the portrait was added to the museum collection in early 1810.

—❧—

Provenance:
Listed in the 1813 Peale Museum catalog. Purchased by the City of Philadelphia at the 1854 Peale Museum sale.

Physical Description:
Oil on canvas. Bust length, torso turned slightly toward sitter's left. Black coat and waistcoat, white stock and jabot. Brown hair, gray eyes. Brown background. 23 11/16 inches H × 19 13/16 inches W.

[1] Charles Willson Peale to Rubens Peale, 25 February 1810 (Miller, *Selected Papers* 4, page 16). Sellers, *Portraits and Miniatures*, 198.

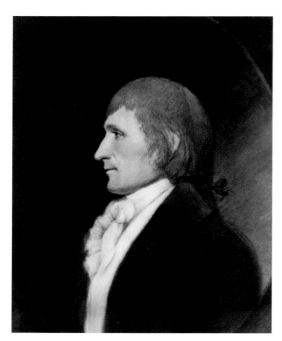

Catalog Number INDE11895

(SN 7.003)

RICHARD DOBBS SPAIGHT (1758–1802)
attributed to Ellen Sharples, after James Sharples Senior, c. 1800–1810

Spaight was born in New Bern, North Carolina, on 25 March 1758. Orphaned at an early age, he went to school in Ireland and later graduated from Scotland's University of Glasgow. After he returned to America, Spaight entered North Carolina's House of Commons in 1779. He served there for eight terms, except when he joined his state's militia at the Battle of Camden and in 1784 when he sat in the Continental Congress. Back in North Carolina, he served a term as speaker of the state legislature. During the 1787 Constitutional Convention, he reversed his usual Antifederalist stance and advocated a strong central government, supporting the Constitution at his state's ratifying convention. As a result, he lost a gubernatorial and then a senatorial race when disgruntled fellow Antifederalists refused to vote for him.

After an extended trip through the West Indies to restore his perpetually poor health, Spaight succeeded to his state's governorship in 1792, and served for three years. Following a term in the United States House of Representatives, he returned to the state legislature in 1801. There, he clashed openly with his successor in Congress, Federalist John Stanly. The two met in a pistol duel, and Spaight was fatally wounded. He died on 6 September 1802.

Around 1800, before returning to England, British pastelist James Sharples Senior visited Philadelphia, where Spaight was concluding his congressional term. The artist painted a portrait of Spaight that he later listed as "Governor Spate, M[ember of] C[ongress]" in an 1802 catalog of his work. The Independence portrait of Spaight is probably a copy painted by Ellen Sharples (1769–1849), the wife of James Sharples Senior, and an accomplished miniaturist. Mrs. Sharples frequently copied her husband's work in a tightly controlled painting style with minutely rendered details (e.g., Spaight's eyelashes). Possibly, the painted oval format of the Independence Spaight portrait is also meant to evoke the appearance of a miniature.

Previously, the identity of this Independence portrait subject was questioned, primarily because no true comparison portrait exists. The only other known portrait of Spaight is part of John Trumbull's 1824 *The Resignation of General Washington*. Trumbull described this posthumous image of Spaight as "ideal" (read: idealized).[1] Presently, the identification of the Independence portrait is based upon a pencil inscription, "Mr. Spaight," on the reverse of the pastel. The inscription was probably added in the mid-nineteenth century when this pastel was part of a large, privately owned collection.

❦

Provenance:
Given by Ellen (Mrs. James) Sharples to Felix Sharples in 1811. Given by Felix Sharples to Levin Yardly Winder in the 1830s. Inherited by Nathaniel James Winder from Levin Yardly Winder. Inherited by Richard Bayly Winder from Nathaniel James Winder in 1844. Purchased by Murray Harrison from Richard Bayly Winder around 1865. Purchased by the City of Philadelphia from Murray Harrison in 1876.

Physical Description:
Pastel on paper. Half length, left profile. Brown coat, white waistcoat, white stock and jabot. Dark gray hair tied in queue at nape of neck, gray eyes. Painted spandrels at four corners suggesting oval format. Graduated gray background. 9 inches H × 7 inches W.

[1] Irma B. Jaffe, *John Trumbull, Patriot-Artist of the American Revolution* (Boston: New York Graphic Society, 1975), 252, 323.

UNIDENTIFIED MAN possibly of the Spaight family
by Charles Balthasar Julien Févret de Saint-Mémin, from life, c. 1798–1800

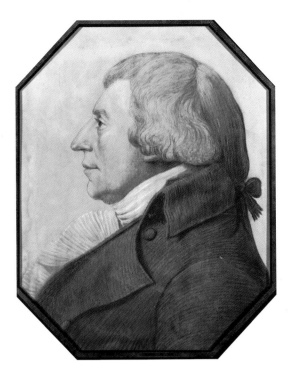

Catalog Number INDE14159

(SN 19.006)

Sometime before 1856, the City of Philadelphia acquired for its museum in Independence Hall a portrait identified as that of "Governor Speight." It was drawn by French artist Charles Balthasar Julien Févret de Saint-Mémin (1770–1852). Saint-Mémin created life size profile portraits on coarse beige paper with a physiognotrace, the machine invented by Gilles–Louis Chrétien around 1787. After tracing a sitter's profile, Saint-Mémin coated the drawing with a pink wash made of white chalk and red lead. He then drew in the sitter's features with black chalk and finished them with white chalk highlights. In addition to his chalk renderings, Saint-Mémin also created reduced size engraved portraits. He offered his customers a basic package: one life size chalk portrait, twelve smaller engravings, and an engraved copperplate. Extra engravings were available at an additional price.[1]

Two engravings identical to Saint-Mémin's chalk portrait of "Governor Speight" are known (National Portrait Gallery and Corcoran Gallery of Art). These engravings, however, both bear the inscription "Wm. Spaight," a name with no known direct connection to that of Richard Dobbs Spaight.[2]

Saint-Mémin worked in Philadelphia when Congressman Richard Dobbs Spaight lived there from late 1798 until the capital moved to the Potomac in mid-1800, but no record of a meeting between the two survives. As a result, the identity of the sitter in this Saint-Mémin portrait remains uncertain.

⁓⊱⊰⁓

Provenance:
Unknown. Acquired by the City of Philadelphia between 1856 and 1858.[3]

Physical Description:
Chalk on paper. Bust length, left profile. High-collared coat and waistcoat, white stock and ruffled jabot. Hair tied in queue. 21½ inches H × 15 inches W.

[1] *Philadelphia Aurora,* 8 January 1799.

[2] A William Spaight died in Craven County, North Carolina (one of the legislative districts represented by Richard Dobbs Spaight) around 1801. It is unknown whether this William Spaight visited either of Saint–Mémin's studios in New York (1796–1798) or Philadelphia (1798–1803). Richard Dobbs Spaight was an only child. Ellen G. Miles, *Saint Mémin and the Neoclassical Profile Portrait in America,* National Portrait Gallery exhibition catalog (Washington D.C.: Smithsonian Institution Press, 1994), 398.

[3] *Catalogue of the National Portraits in Independence Hall* (Philadelphia, 1858), 23.

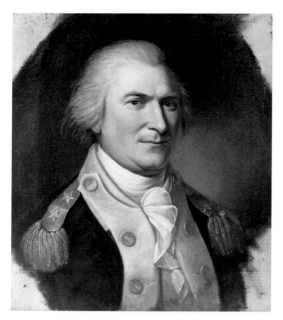

Catalog Number INDE14143

(SN 13.270)

[1] Sellers, *Portraits and Miniatures*, 190.

ARTHUR ST. CLAIR (1736–1818)
by Charles Willson Peale, from life, 1782–1784

St. Clair was born in Caithness County, Scotland, on 23 March 1736. He studied medicine at the University of Edinburgh and served part of an apprenticeship with the renowned anatomist, William Hunter. In 1757, St. Clair changed his career plans and joined the British army, with which he spent five years in Canada during the French and Indian War. He then purchased a substantial estate in western Pennsylvania, where he worked as the agent of the colonial governor. When the Revolution began, St. Clair joined the militia and fought at Trenton and Princeton. Later, his controversial command of Fort Ticonderoga led to public criticism and he received a court-martial. Congress reinstated him within the year, and he later fought at Yorktown.

After the war, St. Clair served two years in Congress, and in 1787 sat as its president. He then became governor of the Northwest Territory. War began there over Native American treaty negotiations, and the Miami chief Little Turtle decimated St. Clair's troops in a 1791 ambush near the Wabash River. Afterwards, St. Clair remained in the governor's office until President Thomas Jefferson removed him for his opposition to Ohio statehood in 1802. He then returned to Pennsylvania and published a defense of his conduct during the failed Northwest Territory campaign. St. Clair died on 31 August 1818.

In 1780, St. Clair commissioned a miniature (now unlocated) of himself from Charles Willson Peale, and the artist painted a duplicate (now owned by the Metropolitan Museum of Art) for his own collection. A few years later, Peale added St. Clair's portrait to the Philadelphia Museum, possibly in honor of his rescue of the Fort Ticonderoga garrison.[1] The museum portrait appears on the list published in the 13 October 1784 issue of the *Freeman's Journal and Philadelphia Daily Advertiser.*

⟶⟨◎⟩⟵

Provenance:
Listed in the 1795 Peale Museum catalog. Purchased by the City of Philadelphia at the 1854 Peale Museum sale.

Physical Description:
Oil on canvas. Bust length, torso turned slightly toward the sitter's left. Dark blue uniform coat with buff facings, gold epaulettes with two silver stars each. White stock and jabot. Powdered hair, blue eyes. Brown background. 22⁵⁄₁₆ inches H × 19⁹⁄₁₆ inches W.

ANNIS BOUDINOT (MRS. RICHARD) STOCKTON (1736–1801)
by James Sharples Senior, from life, 1796–1797

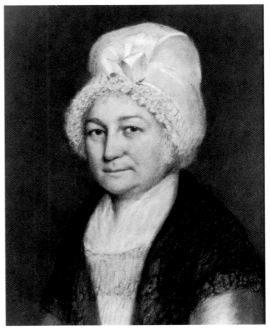

Catalog Number INDE11894

(SN 7.002)

Boudinot was born on 1 July 1736 in Darby, Pennsylvania. Her parents subsequently moved to Philadelphia, where they lived next door to printer Benjamin Franklin. In April of 1758, she married Princeton attorney Richard Stockton (see below) who was her brother Elias's (see above) law instructor. The Stocktons and their six children lived near Princeton in the house that Mrs. Stockton named "Morven," after the home of Fingal (protagonist of a popular fictional account of Scotland's ancient history).

Late in December of 1776, because her husband had committed a traitorous act in signing the Declaration of Independence, Mrs. Stockton and her children fled their home as the British army advanced on Princeton. Subsequently, the British confiscated Morven, destroyed its contents, and captured Richard Stockton. After Stockton spent several months in a New York City prison, he and his family returned to their estate in 1777. During the war, Mrs. Stockton composed a series of poems that celebrated the American cause. Her works commemorated such events as the battlefield deaths of Joseph Warren at Bunker Hill and Richard Montgomery at Quebec; George Washington's victories at Trenton, Princeton, and Yorktown; and her husband's death in early 1781. Twenty years later, Mrs. Stockton died at her daughter's home in Burlington County, New Jersey, on 6 February 1801.

When British pastelist James Sharples Senior (1751–1811) visited the United States at the end of the 1790s, he painted a portrait of Mrs. Stockton along with one of her son Richard, a member of the United States Senate from 1796 to 1799. Possibly, Mrs. Stockton was visiting her son in Philadelphia in late 1796 or 1797 and sat for Sharples. Her portrait was listed in the artist's 1802 catalog as "Mrs. Stockton."

<hr />

Provenance:
Given to the City of Philadelphia by Louis Alexander Biddle, the sitter's great-great-grandson, in 1914.

Physical Description:
Pastel on paper. Half length, torso turned slightly toward the sitter's right. Blue-gray long-sleeved dress with empire waist, white fichu, black lace shawl, white lace cap with white ribbon. Gray hair, brown eyes. Blue background. 9 inches H × 7 inches W.

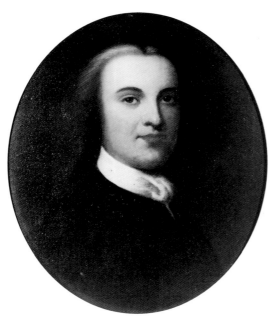

Catalog Number INDE14158

(SN 13.275)

RICHARD STOCKTON (1730–1781)
by George Washington Conarroe,
after a painting attributed to John Wollaston, c. 1876

Stockton was born in Princeton, New Jersey, on 1 October 1730. He attended the West Nottingham Academy and then college in Elizabethtown, New Jersey. Subsequently, he studied law and then opened his own practice in Newark. He was a life-long trustee of Princeton College, and became a member of New Jersey's governor's council in 1767. Later, he served on the colony's supreme court. A political moderate during the 1770's, he supported colonial allegiance to the king but advocated American independence from parliamentary rule. As a member of the Second Continental Congress, he signed the Declaration of Independence and served on a variety of wartime committees. In late 1776, he was captured by the British and briefly imprisoned under harsh conditions. He negotiated his own release with the promise to forego further involvement in the American war effort, and returned to his law practice. Stockton died on 28 February 1781.

The City of Philadelphia added a portrait of Stockton to the museum in Independence Hall as preparation for the Centennial of 1876. Philadelphia artist George W. Conarroe (1803–1882/4) copied a c. 1748 portrait of Stockton now attributed to John Wollaston (owned by the Princeton University Art Museum).[1]

Provenance:
Given to the City of Philadelphia by Mrs. George T. Olmsted, the subject's granddaughter, in 1876.

Physical Description:
Oil on canvas. Bust length, torso turned toward the subject's left. Dark brown waistcoat and coat, white stock. Powdered hair tied in queue, brown eyes. Dark brown background. 24⅛ inches H × 20 inches W.

[1] Family tradition erroneously identified this early portrait of Stockton as the work of John Singleton Copley. Donald Drew Egbert and Diane Martindell Lee, *Princeton Portraits* (Princeton N.J.: Princeton University Press, 1947), 178.

THOMAS STONE (1743–1787)
by Francis Blackwell Mayer,
after John Beale Bordley after Robert Edge Pine, 1874

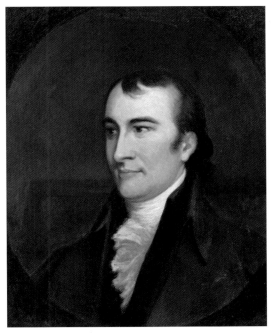

Catalog Number INDE14157

(SN 13.274)

Stone was born during 1743 in Charles County, Maryland. After his early tutoring, he studied law in Annapolis and then opened his own practice in Frederick. He entered the Second Continental Congress in 1775 and later signed the Declaration of Independence. He remained in Congress for three years, during which time he served on the committee that framed the Articles of Confederation, and then in 1783 when he was briefly chairman of Congress. In 1776, he entered his state's senate and served there for the rest of his life. He was elected to the Constitutional Convention in 1787, but declined the seat in order to attend his seriously ill wife. He died a few months after her on 5 October 1787.

In 1874, the City of Philadelphia received from Maryland portraits of the latter's signers of the Declaration for exhibit in Independence Hall. Stone's portrait (along with those of Thomas Johnson and William Paca, see above) was painted by Baltimore artist Francis Blackwell Mayer (1827–1899). In his work, Mayer copied John Beale Bordley's 1834 full-length seated portrait of the subject commissioned for the Maryland State House in Annapolis.

The head in Bordley's portrait was based on one of the two bust portraits of Stone by Robert Edge Pine. Pine's life portrait of Stone (painted in 1785 and now at the Baltimore Museum of Art) and the second portrait (painted by Pine, or a member of his family, and now at the National Portrait Gallery) both belonged to the sitter's family until the twentieth century.[1]

❧

Provenance:
Given to the City of Philadelphia by the state of Maryland in 1874.

Physical Description:
Oil on canvas. Bust portrait, turned toward the subject's right. Brown coat, brown waistcoat, white stock and jabot. Red hair, blue eyes. Red upholstered chair back. Dark green background. 24 5/16 inches H × 20 1/8 inches W.

[1] Robert G. Stewart, *Robert Edge Pine, A British Portrait Painter in America, 1784–1788* (Washington, D.C.: Smithsonian Institution Press, 1979), 87–89.

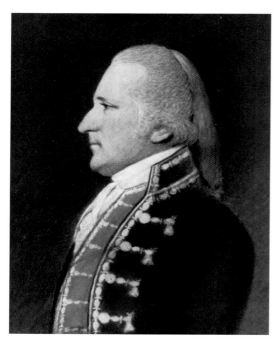

Catalog Number INDE11899

(SN 7.007)

JUAN STOUGHTON (1745–1820)
by James Sharples Senior, from life, c. 1797–1800

Stoughton was born in Spain in 1745. In 1797, he became the country's consul general in New England. As such, he promoted Spanish interests in the southeast, particularly the defense of them from Native American tribes. He returned to Spain in 1815, and died during 1820.

British pastelist James Sharples Senior (1751–1811) and his family visited New England and Philadelphia several times during their first trip to the United States during the 1790s. Stoughton sat for Sharples in either Boston or Philadelphia during this time. In his 1802 catalog of the collection made upon his return to England, the artist listed, "Stou[gh]ton, esq., Spanish Consul." This portrait features one of Sharples's more detailed depictions of a subject's attire; Stoughton's ornamental coat trim is opulently rendered. The sitter's complex wig also received careful attention from the artist.

⁓⊶⊷⁓

Provenance:
Listed in the 1802 Bath catalog of Sharples's work. Given by Ellen (Mrs. James) Sharples to Felix Sharples in 1811. Given by Felix Sharples to Levin Yardly Winder in the 1830s. Inherited by Nathaniel James Winder from Levin Yardly Winder. Inherited by Richard Bayly Winder from Nathaniel James Winder in 1844. Purchased by Murray Harrison from Richard Bayly Winder around 1865. Purchased by the City of Philadelphia from Murray Harrison in 1876.

Physical Description:
Pastel on paper. Half length, left profile. Blue uniform coat with silver braid, red waistcoat with silver braid, white stock and jabot. Gray wig tied in a queue, brown eyes. Variegated blue background. 9 inches H × 7 inches W.

JOHN SULLIVAN (1740–1795)
by Richard Morrell Staigg, after John Trumbull, 1876

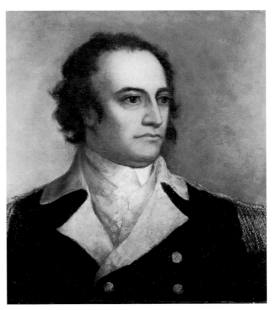

Catalog Number INDE15566
(SN 13.278)

Sullivan was born 17 February 1740 in Somersworth, New Hampshire. He studied law in Portsmouth and accepted an appointment as a major of his colony's militia. In 1774, he served in the First Continental Congress and then led a group of militia against the British garrison at Fort William and Mary in Portsmouth harbor. He returned briefly to Congress the following year before he joined the Continental army for the fortification of Boston. After heading the Northern Army during its retreat from Canada, he was stationed at Long Island, where he was captured by the British in the summer of 1776. Later, he fought at Trenton, Princeton, Brandywine, and Germantown, and led an unsuccessful invasion of Staten Island. Following the winter at Valley Forge, he commanded the Continental forces assembled for the Rhode Island campaign and conducted the siege of Newport. In 1779, he defeated the combined Iroquois and Loyalist forces at Elmira, New York.

In 1780, Sullivan returned to Congress, and the following year he was a member of the New Hampshire constitutional convention. He later served as his state's attorney-general and speaker of its assembly. In 1786, he became governor of New Hampshire and served three non-consecutive terms. He was chairman of the New Hampshire convention to ratify the federal Constitution and served as a United States district judge from 1789 until his death on 23 January 1795.

For its museum in Independence Hall, the City of Philadelphia acquired a portrait of Sullivan by the English-born New England artist Richard Morrell Staigg (1817–1881). Staigg may have based his work on John Trumbull's 1790 miniature (last recorded in 1950 as privately owned) of Sullivan.[1] Alternately, Staigg may have worked from an engraving that reversed Trumbull's other portrait of Sullivan, the one made for his 1786–1828 painting *The Capture of the Hessians at Trenton*. This Trumbull painting shows the subject in uniform but differently posed than Staigg's.

‑◦⟨ཡ⟩◦‑

Provenance:
Given to the City of Philadelphia by Thomas C. Amory, the subject's descendant, in 1876.

Physical Description:
Oil on canvas. Bust length, head turned toward the subject's right. Dark blue uniform coat with buff facings, gold epaulettes, buff waistcoat. White stock and jabot. Brown hair, brown eyes. Light olive-green background. 22½ inches H × 20⅛ inches W.

[1] Theodore Sizer, *The Works of Colonel John Trumbull, Artist of the American Revolution* (New Haven: Yale University Press, 1950), 52–53.

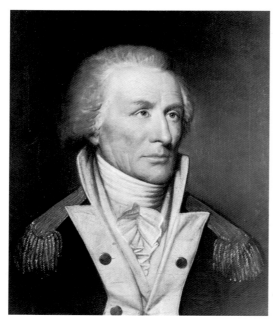

Catalog Number INDE14156

(SN 13.279)

THOMAS SUMTER (1734–1832)
1. by Rembrandt Peale, from life, 1795–1796

Sumter was born in Louisa County, Virginia, in mid-summer (the 14th of either July or August) 1734. With limited schooling, he joined the colonial militia and fought during the French and Indian War. He then visited England as an interpreter for a Cherokee Indian chief, afterward moving to South Carolina. During the early years of the Revolution, he commanded a rifle regiment on the southeastern frontier. When advancing British troops burned his plantation in mid-1780, he left retirement and returned to the war as a guerrilla leader in the Carolinas. For a year, he conducted raids and skirmishes with mixed success against the British. Although he received a congressional commendation for his conduct at the battle of Blackstock's Hill (during which he was badly wounded), he had a reputation for insubordination and was sent away from the battlefront to police the town of Orangeburg. As a result, he resigned from active duty in 1782.

After the war, Sumter entered the South Carolina legislature. He opposed ratification of the new federal Constitution at his state's convention, and supported the Jeffersonians during his congressional career, which began in 1791. He served intermittently in the House and the Senate for nineteen years. During this time, he defended himself against public criticism for his wartime policy of paying his troops with the property of defeated Loyalists. He was the last surviving general of the Revolution (and the man after whom Charleston's Fort Sumter was named). Sumter died on 1 June 1832.

1. Sumter's colorful military career and local renown made him a logical subject for Rembrandt Peale during the artist's visit to Charleston in late 1795 and 1796. Rembrandt (1778–1860) and his younger brother Raphaelle went to Charleston in order to paint portraits of eminent men for their father's Philadelphia Museum.[1] Rembrandt's natural ability as a painter was readily evident in his Charleston portraits; the Sumter work shows considerable attention to the hollows and lines on the sitter's face, and the artist's skillful use of highlights successfully heightens the contrasts in texture between the sitter's hair, flesh, and clothing.[2] Rembrandt painted a copy of the Sumter museum portrait (now owned by South Carolina's Sumter County Historical Society) for the sitter's family around 1798.

Provenance:
Listed in the 1813 Peale Museum catalog. Purchased by the City of Philadelphia at the 1854 Peale Museum sale.

Physical Description:
Oil on canvas. Bust length, head turned slightly toward the sitter's left. Blue uniform coat with buff facings, two gold epaulettes, buff waistcoat. White stock and jabot. Powdered hair, dark blue eyes. Dark red background. 23¼ inches H × 19⅛ inches W.

[1] Rembrandt Peale, "Reminiscences," quoted in C. Edwards Lester, *The Artists of America* (New York: Baker & Scribner, 1846), 204–205.

[2] Carol Eaton Hevner, "The Paintings of Rembrandt Peale: Character and Conventions," in Lillian B. Miller, ed., *In Pursuit of Fame, Rembrandt Peale 1778–1860*, Smithsonian National Portrait Gallery exhibition catalog (Seattle: University of Washington Press, 1992), 250–251.

THOMAS SUMTER (1734–1832)
2. by James Sharples Senior, from life, 1796–1797

2. During late 1796 or 1797, Congressman Sumter sat for British pastelist James Sharples Senior when both were living in the federal capital of Philadelphia.[3] Sharples's 1802 catalog lists "General Sumpter [sic]" with those others portrayed during the artist's first visit to America. The artist vividly captured the sitter's penetrating stare and stern visage through the subtle use of shading around the eyes and mouth.

—⟨⟩—

Provenance:
Listed in the 1802 Bath catalog of Sharples's works. Given by Ellen (Mrs. James) Sharples to Felix Sharples in 1811. Given by Felix Sharples to Levin Yardly Winder in the 1830s. Inherited by Nathaniel James Winder from Levin Yardly Winder. Inherited by Richard Bayly Winder from Nathaniel James Winder in 1844. Purchased by Murray Harrison from Richard Bayly Winder around 1865. Purchased by the City of Philadelphia from Murray Harrison in 1876.

Physical Description:
Pastel on paper. Half length, torso turned toward the sitter's left. Dark blue uniform coat with buff facings, gold epaulette, buff waistcoat, white stock and jabot. Gray wig, gray-blue eyes. Blue variegated background. 9 inches H × 7 inches W.

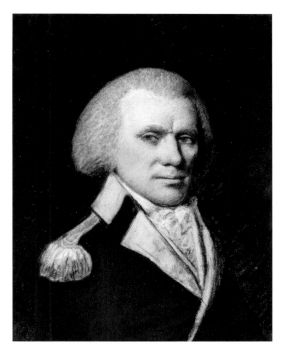

Catalog Number INDE11903
(SN 7.011)

[3] Until the mid-twentieth century, this portrait was incorrectly identified as Georgia's William Few.

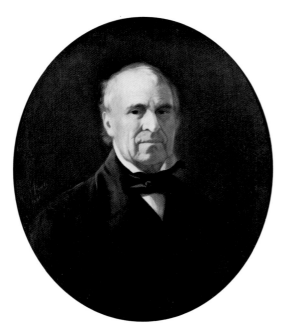

Catalog Number INDE14154

(SN 13.282)

ZACHARY TAYLOR (1784–1850)
by Robert Street, probably after a daguerreotype, c. 1850

Taylor was born on 24 November 1784 at Montebello in Orange County, Virginia. His family moved to the frontier near Louisville (later part of Kentucky) shortly thereafter. In 1808, he began his lifelong military career as a first lieutenant in the Seventh Infantry. During the next six years, he served in the Indiana and Illinois Territories in defense of the frontier. After the War of 1812, he remained in the army with postings in Wisconsin and Louisiana.

In 1832, Taylor received a promotion to colonel and was stationed at Fort Crawford during the Black Hawk Indian War. Later, he served two years as commander of the armed forces in Florida, where he had defeated the Seminole tribes at Lake Okeechobee in 1837 and earned the nickname "Old Rough and Ready." The annexation of Texas in the mid-1840s prompted Taylor's reassignment to the Rio Grande, where he defeated Mexico's forces at Palo Alto, Monterey, and, in 1847, at Buena Vista.

Taylor's popularity as a hero during the Mexican War propelled his political career, and he won the 1848 presidential election as a representative of the moderate Whig party. As president, he opposed the spread of slavery to new states and territories like California and New Mexico. Midway through his presidential term, Taylor died of cholera on 9 July 1850.

In the months following Taylor's death, Philadelphia artist Robert Street (1796–1865) painted several portraits of the president.[1] Street probably based his depiction of Taylor on Matthew Brady's daguerreotype of the president or on Francis D'Avignon's 1849 lithograph of it.[2] The City of Philadelphia's portrait of Taylor was not included in the display of historic portraiture in Independence Hall during the Centennial.[3] Rather, the Taylor portrait may have hung in a municipal office.

—◦⊶⊷◦—

Provenance:
Purchased by the City of Philadelphia from Austin Street, the artist's son, in 1871.

Physical Description:
Oil on canvas. Bust length, torso turned slightly toward the subject's left. Black coat and vest, white shirt, black stock. Graying brown hair, brown eyes. Dark background. Inscribed middle left, "Robt Street/1850." 37¾ inches H × 32¾ inches W.

[1] Other than the Independence example, Street's Taylor portraits are now located at the Union League of Philadelphia (painted in 1850) and the Chicago Historical Society (painted in 1851).

[2] Mathew Brady, *Gallery of Illustrious Americans* (New York, 1850) cited in *National Portrait Gallery Permanent Collection Illustrated Checklist* (Washington, D.C.: Smithsonian Institution Press, 1987), 275.

[3] The 1876, 1878, and 1890 guidebooks to Independence Hall do not mention the Taylor portrait.

JEAN BAPTISTE, CHEVALIER DE TERNANT (1751–1816)
by Charles Willson Peale, from life, c. 1781–1784

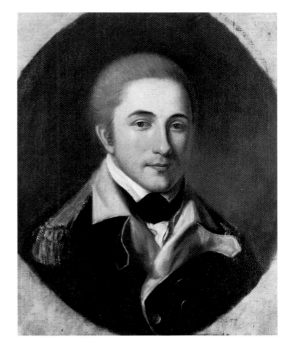

Catalog Number INDE14155

(SN 13.283)

Ternant was born on 12 December 1751 in Damvillers, France. In his youth, he served in the French army engineer corps. Early in 1778, he joined George Washington at Valley Forge as deputy quartermaster on Baron von Steuben's staff. After the battle of Monmouth later that year, Ternant was promoted and sent to the army's Southern Department as a troop inspector. In mid-1780, the British captured him during their successful siege of Charleston. He was paroled shortly thereafter and rejoined the army in early 1782. He then joined Armand's (formerly Pulaski's) Partisan Legion and returned to the South, where he served as a cavalry commander for the remainder of the war.

In 1784, Ternant returned to Europe and commanded a regiment of Dutch cavalry for several years before rejoining the French army in 1788. His knowledge of America led to his 1791 appointment as France's minister to the United States. During his brief tenure, he represented French interests in the ultimately unsuccessful negotiations for a commercial treaty between the two nations. After the destruction of France's monarchy in September of 1793, he was recalled from diplomatic duty. He remained in France until his death at Coudes in April of 1816.

Charles Willson Peale esteemed the men of Europe who supported the American Revolution with their military and diplomatic service. France, in particular, received high praise from the artist. He listed the portraits of eight Frenchmen in the first advertisement for his Philadelphia Museum, published in the 13 October 1784 issue of the *Freeman's Journal and Philadelphia Daily Advertiser*.

Ternant and Lafayette were the youngest of these eight; the former probably posed for Peale during 1781 while the Frenchman served out his parole in Philadelphia.[1] The artist may also have taken the portrait shortly before Ternant left the United States in 1784. In April of that year, the sitter had received a retroactive appointment to colonel, which may explain the unfinished appearance of his epaulettes in the museum portrait. Prior to the promotion, Peale may have been uncertain as to Ternant's ultimate intended rank.

---❦---

Provenance:
Listed in the 1795 Peale Museum catalog. Purchased by the City of Philadelphia at the 1854 Peale Museum sale.

Physical Description:
Oil on canvas. Bust length, facing forward. Blue uniform coat with buff facings, two gold epaulettes. White shirt, black stock. Powdered brown hair, green eyes. Dark brown background. 23 5/16 inches H × 19 5/8 inches W.

[1] Sellers, *Portraits and Miniatures*, 208.

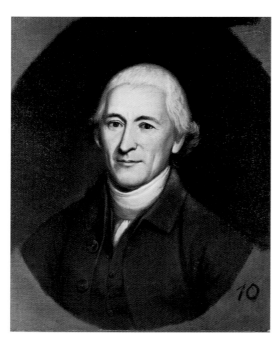

Catalog Number INDE11887

(SN 13.282)

CHARLES THOMSON (1729–1824)
1. by Charles Willson Peale, from life, 1781–1782

Thomson was born on 29 November 1729 in County Derry, Ireland. En route to America, his father died and the ten-year-old Thomson disembarked at New Castle, Delaware, with his five siblings. He then worked for a blacksmith before he enrolled in Dr. Francis Alison's school at New London, Pennsylvania. After several years as a language tutor at the Philadelphia Academy and as the master of a Latin school (now the William Penn Charter School), he became a merchant. As such, he became a leader in Pennsylvania's rejection of the Stamp Act, and served as secretary for his local and regional committees of correspondence. In mid-1774, Pennsylvania conservatives thwarted his election as a delegate to the First Continental Congress, but he subsequently became its secretary and remained in that position for the next fifteen years.

Although the secretary's primary duty was to record congressional proceedings and preserve official documents, Thomson's responsibilities steadily grew to encompass executive functions that later became the prerogatives of the departments of state, war, interior, and the attorney general. From 1785, he acted as the intermediary between Congress and all other bodies; he reviewed every request put to the legislature, recommended a response, and implemented Congress's decision on the matter. He also wrote all of Congress's letters and authenticated the documents with the Great Seal of the United States, the official symbol designed primarily by him.

After his long career at the heart of the governmental bureaucracy, a stunned Thomson learned that no job awaited him under the new Constitution. In 1789, most of his duties were divided among the State Department, the clerk of the House, and the secretary of the Senate. As his last official act, he delivered the news of George Washington's presidential election to Mount Vernon. He then retired to his estate near Philadelphia and composed the first English translation of the Septuagint, a Greek version of the Old Testament. Thomson died on 16 August 1824.

1. Charles Willson Peale chose his fellow radical revolutionary, Thomson, among the first subjects for his Philadelphia Museum. This portrait was first recorded as "secretary of Congress" in the 13 October 1784 issue of the *Freeman's Journal and Philadelphia Daily Advertiser*. In this portrait, the number 10 appears in the lower right corner below the area covered by the frame's spandrel, probably as an indication of its place in the order of items prepared for the museum begun in 1781.

Provenance:
Listed in the 1795 Peale Museum catalog. Purchased by the City of Philadelphia at the 1854 Peale Museum sale.

Physical Description:
Oil on canvas. Bust length, torso turned slightly toward sitter's right. Gray coat and waistcoat, white stock. White hair, blue eyes. Dark olive background. 21 inches H × 16¹⁵⁄₁₆ inches W.

CHARLES THOMSON (1729–1824)
2. by Charles Willson Peale, from life, 1819

2. In 1819, Peale painted a second museum portrait of Thomson while the two men shared their reminiscences of the Revolution.[1] In this portrait, the sitter holds a walking stick that Peale related to two incidents in the former secretary's career in which he came to blows with political enemies.[2] In his detailed study of his ninety-year-old subject, the artist depicted his aged sitter's tautly drawn skin, watery blue eyes, thinning hair, and prominently outlined skull. By including two museum studies of Thomson separated by nearly forty years, Peale may have been celebrating both his scientific interest in human aging and his pride in his own artistic abilities later in life.

Catalog Number INDE14153
(SN 13.285)

⁂

Provenance:
Purchased by the City of Philadelphia at the 1854 Peale Museum sale.

Physical Description:
Oil on canvas. Bust length, seated, head and torso turned toward sitter's right. Brown coat and waistcoat, white stock and jabot, gray hair, blue eyes. Seated in a green upholstered chair ornamented with brass tacks. Right hand holding a gold-topped walking stick. Olive green background. 24⅛ inches H × 20 inches W.

[1] Sellers, *Portraits and Miniatures*, 209.

[2] Charles Willson Peale to Charles Thomson, 18 October 1819 (Miller, *Selected Papers 3*, page 774). In November 1779, Thomson caned a congressional supporter of Arthur Lee, the disgraced commissioner to France. In January 1781, Thomson battled Pennsylvania congressman James Searle over a political disagreement. Kenneth R. Bowling, "Good-by 'Charle': the Lee–Adams Interest and the Political Demise of Charles Thomson, Secretary of Congress, 1774–1785," *Pennsylvania Magazine of History and Biography* 100 (July 1976): 323. Edmund C. Burnett, ed., *Letters of the Members of the Continental Congress* (Washington, D.C.: Carnegie Institution, 1931), 5:10 n.

Catalog Number INDE
(SN 13.286)

MATTHEW TILGHMAN (1718–1790)
by Charles F. Berger, possibly after John Hesselius, 1874

Tilghman was born on 17 February 1718 in Queen Anne County, Maryland. He was adopted by a wealthy cousin, and then began his public career in 1741 as an associate justice in the Talbot County Court. He remained in the court's service for thirty-four years, the last few as chief justice. During this time, he also served in the colonial assembly, where he presided as speaker in 1773 and 1774. Later, he publicly opposed the taxes legislated by the Townshend Acts and chaired the conventions of 1774–1776 that created Maryland's provisional government and its Committees of Safety and Correspondence. He also led his colony's delegations to the First and Second Continental Congresses. There, he supported complete separation from England, although he was absent from Congress when the Declaration of Independence was signed. Earlier, he had returned to Maryland, where he presided over the convention that drafted the state's first constitution and designed its new government. He returned to his state's legislature in late 1776 and served in its senate until 1783. Tilghman died on 4 May 1790.

At the time of the Centennial, the City of Philadelphia included Tilghman's portrait in the Independence Hall museum based upon the subject's leading role in Maryland's adoption of colonial independence. In 1874, the city commissioned Philadelphia artist Charles F. Berger (active 1841–1890s) for a copy of a mid-eighteenth century portrait of Tilghman possibly attributed to John Hesselius (now in a private collection).[1]

❧

Provenance:
Purchased by the City of Philadelphia from the artist in 1874.

Physical Description:
Oil on canvas. Half length, torso turned slightly toward the subject's left. Gray-green coat, black waistcoat, white stock. Gray wig, blue eyes. Dark background. 30½ inches H × 25¼ inches W.

[1] Tilghman is not listed among Hesselius's sitters in Richard K. Dowd's "John Hesselius, Maryland Limner," *Winterthur Portfolio* 5 (1969): 144–150.

GEORGE TURNER (1750–1843)
by an unidentified artist, from life, c. 1835

Catalog Number INDE
(SN 13.292)

Turner was born in England in 1750 and later may have studied law at London's Middle Temple. He immigrated to South Carolina before 1775, when he received a commission in the Continental army. He served throughout the Revolution, including the 1780 seige of Charleston (when he was captured by the British), and was a member of the Society of the Cincinnati. In 1789, President Washington appointed him one of three federal judges sent to govern the Northwest Territory. Turner lived in the Ohio Valley until around 1833, when he retired to Philadelphia. He died on 16 March 1843.

During the Centennial, the City of Philadelphia received a portrait of Turner from his daughter for the museum in Independence Hall. At one time, this portrait was attributed to Philadelphia artist John Neagle (1796–1865).[1] During the 1830s, Neagle did paint portraits of two aged Revolutionary War veterans and became interested in the contemporary political discussion of pensions for such men.[2] And the artist's receipt book lists "Cash from Miss Turner $110" received in mid-1832; $110 was Neagle's price for a kit kat (36 inches high by 28 inches wide) portrait.[3]

Perhaps, the occasion of Turner's portrait was his 1833 move to Philadelphia after nearly thirty-five years on the frontier. At present, the artist of the Independence portrait is unidentified.

⁂

Provenance:
Given to the City of Philadelphia by Mary S. R. Turner, the sitter's daughter, in 1877.

Physical Description:
Oil on canvas. Half length, seated, body turned slightly toward sitter's left. Blue dressing gown(?), white stock. Graying brown wig, blue eyes. Top of red upholstered chair with gold medal (Society of the Cincinnati) on blue and white ribbon draped over chair corner in right midground. 28⅜ inches H × 24¾ inches W.

[1] Charles Coleman Sellers quoted in *Philadelphia Evening Ledger*, 4 August 1932. Clipping in Museum Accession Files, Independence National Historical Park.

[2] Robert W. Torchia, *John Neagle: Philadelphia Portrait Painter*, Historical Society of Pennsylvania exhibition catalog (Philadelphia: Historical Society of Pennsylvania, 1989), 148–151.

[3] "Cashbook," 16 July 1832 and "Blotter," 4 February 1832. John Neagle Collection, Historical Society of Pennsylvania.

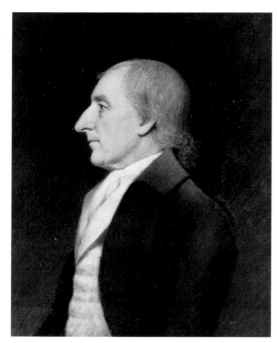

Catalog Number INDE11917

(SN 7.025)

PIETER JOHAN VAN BERCKEL (1725–1800)
by James Sharples Senior, from life, c. 1797–1801

Van Berkel was born in January 1725 in Rotterdam, the Netherlands. He attended school in Utrecht, and served in several administrative governmental positions including mayor of Rotterdam in 1781 and 1782. He was named minister plenipotentiary to the United States in 1783, and served for five years before retiring (his son succeeded him as minister). He then moved to New York, where he developed a mercantile business. Van Berckel died in Newark, New Jersey, on 27 October 1800.

British pastelist James Sharples Senior (1751–1811) and his family moved to New York City in 1797, and the artist probably painted a portrait of Van Berckel around that time. In Sharples's catalog published upon his return to England in 1802, he listed this sitter as "van Berchell, esq., Minister from Holland." Later, Sharples's wife Ellen made a pencil sketch (now owned by the Bristol Art Gallery, England) of the Van Berckel portrait for her own collection.

⁓⊶⧏⊷⁓

Provenance:
Listed in the 1802 Bath catalog of Sharples's works. Given by Ellen (Mrs. James) Sharples to Felix Sharples in 1811. Given by Felix Sharples to Levin Yardly Winder in the 1830s. Inherited by Nathaniel James Winder from Levin Yardly Winder. Inherited by Richard Bayly Winder from Nathaniel James Winder in 1844. Purchased by Murray Harrison from Richard Bayly Winder around 1865. Purchased by the City of Philadelphia from Murray Harrison in 1876.

Physical Description:
Pastel on paper. Half length, left profile. Blue coat, white patterned waistcoat, white stock and jabot. Gray hair, gray eyes. Blue-gray variegated background. 9 inches H × 7 inches W.

PHILIP VAN CORTLANDT (1749–1831)
by James Sharples Senior, from life, c. 1796–1801

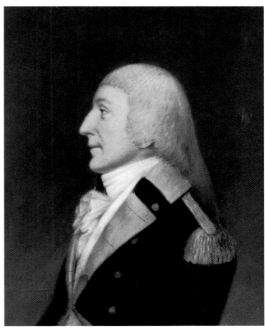

Catalog Number INDE11897
(SN 7.005)

Van Cortlandt was born on 21 August 1749 in New York City. Later, he attended Coldenham Academy and then worked as a surveyor and grist mill manager on his family's extensive landholdings along the Hudson River. In early 1775, he began his public career as a member of New York's Revolutionary provincial convention and its first provincial congress. That same year, he joined the Continental army as a member of General George Washington's staff. Van Cortlandt fought at Saratoga and wintered at Valley Forge, where he supervised the camp during the spring of 1778. He then held various posts in New York, where he accompanied General John Sullivan's campaign against the Iroquois tribes, and fought at Yorktown.

Following the war, Van Cortlandt supported the new federal Constitution at New York's ratifying convention, and served in both houses of the state legislature. In late 1793, he entered the United States House of Representatives, where he remained until 1809. He then retired until 1824, when he accompanied the Marquis de Lafayette on his tour of the United States during the fiftieth anniversary of the Declaration of Independence. Van Cortlandt died on 5 November 1831.

During his first visit to the United States, British pastelist James Sharples Senior (1751–1811) traveled extensively from New England to the mid-Atlantic states. His portrait of Congressman Van Cortlandt may have been painted in 1796 or 1797 while the artist lived in Philadelphia. After this time, Sharples moved to New York City for several years. Van Cortlandt may have visited his studio there during a congressional recess. The portrait is listed in the artist's 1802 catalog as "General Van Courtland."

✦

Provenance:
Listed in the 1802 Bath catalog of Sharples's works. Given by Ellen (Mrs. James) Sharples to Felix Sharples in 1811. Given by Felix Sharples to Levin Yardly Winder in the 1830's. Inherited by Nathaniel James Winder from Levin Yardly Winder. Inherited by Richard Bayly Winder from Nathaniel James Winder in 1844. Purchased by Murray Harrison from Richard Bayly Winder around 1865. Purchased by the City of Philadelphia from Murray Harrison in 1876.

Physical Description:
Pastel on paper. Half length, left profile. Dark blue uniform coat with buff facings, gold epaulette, buff waistcoat. White stock and jabot. Powdered hair tied in a queue, gray eyes. Blue variegated background. 9 inches H × 7 inches W.

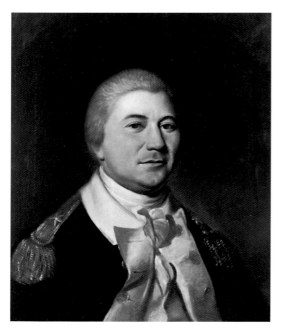

Catalog Number INDE14152

(SN 13.294)

JAMES MITCHELL VARNUM (1748–1789)
by Charles Willson Peale, after Charles Willson Peale, 1804

Varnum was born in Dracut, Massachusetts, on 17 December 1748. He attended Harvard and then Rhode Island College (now Brown University). An honors student, he graduated in 1769 after successfully debating the thesis that America should remain a colonial dependent of England. He taught school for a brief period, studied law with Rhode Island's attorney general, and then opened his own legal office in East Greenwich. In 1774, he helped to organize Rhode Island's Kentish Guards, of which he was commissioned colonel.

After the British marched on Lexington and Concord, Varnum joined the Rhode Island militia and served during the siege of Boston and the battle of Long Island. He later commanded Continental army troops at Forts Mercer and Mifflin, for which he received a commendation. After the winter at Valley Forge, the Monmouth and the Newport campaigns, he became commander of the department of Rhode Island. He remained in this position, despite his resignation from the Continental army in order to revive his law practice, as a major general in the state militia. He was a founding member of the Society of the Cincinnati and its Rhode Island chapter's first vice president.

At the end of the war, Varnum represented Rhode Island in Congress from 1780 to 1782 and again in 1787, when he supported the new federal Constitution. That year, his work as a director of the Ohio Company of Associates earned him an appointment as a federal judge for the Northwest Territory. There, he helped to write the territory's legal code. Varnum died in Marietta, Ohio on 10 January 1789.

Charles Willson Peale painted the museum portrait of Varnum fifteen years after the subject had died. Possibly, Peale used the miniature (now unlocated) that he had painted of the subject at Valley Forge in 1778.[1] In 1804, Peale returned to painting after several years spent away from his easel in order to concentrate on expanding the museum's many collections and moving them to the second floor of the Pennsylvania State House. He noted that "I now paint better portraits than I ever did … all better colouring then my former works, so that the fire of youth is not equal to matured Idea's [*sic*] in the fine arts."[2]

⸻

Provenance:
Listed in the 1813 Peale Museum catalog. Purchased by the City of Philadelphia at the 1854 Peale Museum sale.

Physical Description:
Oil on canvas. Bust length, torso turned slightly toward the subject's left. Dark blue uniform coat with buff facings and gold epaulettes with one star each. Buff waistcoat, white stock and jabot. Powdered hair, blue eyes. Dark brown background. 23⅜ inches H × 19¹¹⁄₁₆ inches W.

[1] Sellers, *Portraits and Miniatures*, 214.

[2] Charles Willson Peale to Mrs. Nathaniel Ramsey, 7 September 1804 (Miller, *Selected Papers* 2:2, page 752).

CONSTANTIN FRANÇOIS CHASSEBŒUF, COMTE DE VOLNEY (1757–1820)
by Charles Willson Peale, after Gilbert Stuart, 1807

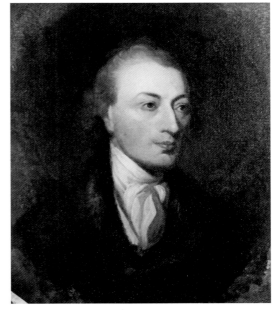

Catalog Number INDE14151

(SN 13.297)

Volney (named Boisgirais at birth by his father, Volney later by his own choosing) was born on 3 February 1757 at Craon in France's Anjou region. From an early age, he was a brilliant student at the academies in Ancenis, Angers, and Paris. His first book, *The Chronology of Herodotus* (1781), established his scholarly career and earned him wide acclaim in the salons of Paris. During the next decade, he visited and wrote about China, Egypt, and Syria. His political career began in 1789, when he represented Anjou in the Estates General. During this time he continued to write on foreign travel (as well as on history and French law), and published his best-known book, *The Ruins of Empire, or Meditations on Revolution* (1791).

A political moderate, he was criticized by the increasingly radical elements of the French assembly and briefly imprisoned by the revolutionary faction in 1793. After his release, he spent a year teaching history in Paris's National Institute. In 1795, he went to the United States for a three-year tour of the new nation. Upon his return to France, he published a study of America's climate and topography. With the rise of Napoleon Bonaparte, whom he had met during a previous visit to Corsica, Volney again achieved political prominence. Although he refused an appointment as France's minister of the interior, he accepted a seat in the Senate and a commander's rank in the Legion of Honor. Named a count in 1808, he began the study of linguistics in his later years. Volney died in Paris on 25 April 1820.

Philadelphia's renowned scientific community welcomed the illustrious Volney into its fold during his investigative tour of the new republic. He was elected to the American Philosophical Society and was an honored guest at Peale's Museum. Impressed by Peale's skill in depicting the range and depth of the natural world, Volney proclaimed the museum "the Temple of God! Here is nothing but Truth and Reason."[1] Peale proudly published Volney's praise and added the Frenchman's portrait to the museum Accession Book on 18 November 1807. For the portrait, Peale copied Gilbert Stuart's 1797 painting (now at the Pennsylvania Academy of the Fine Arts) to the museum collection.

❦

Provenance:
Listed in the 1813 Peale Museum catalog. Purchased by Townsend Ward (librarian of the Historical Society of Pennsylvania) at the 1854 Peale Museum sale. Purchased by the City of Philadelphia from Townsend Ward in 1854.

Physical Description:
Oil on canvas. Bust length, head turned slightly to the subject's left. Brown coat with fur collar, yellow waistcoat. White stock and jabot. Powdered brown hair, brown eyes. Green upholstered chair with brass tacks, green drapery. 23⅝ inches H × 19⅝ inches W.

[1] Charles Willson Peale, "Memorial to the Pennsylvania Legislature," in Dunlap and Claypoole's American Daily Advertiser, 26 December 1795 (Miller, Selected Papers 2:2, page 137).

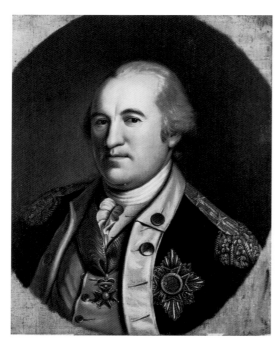

Catalog Number INDE11876

(SN 13.273)

FREDERICK WILLIAM AUGUSTUS, BARON VON STEUBEN (1730–1794)

by Charles Willson Peale, after Charles Willson Peale, 1781–1782

Von Steuben was born in Magdeburg, Germany, on 17 September 1730. He attended Jesuit schools in Breslau, entered the Prussian army's officer corps, serving in the Seven Years' War, and then joined Frederick the Great's military staff. Later, he was appointed chamberlain to the Prussian court of Hohenzollern Hechingen. In 1777, Von Steuben went to Paris in order to meet America's foreign commissioners, Benjamin Franklin and Silas Deane, and offer them his military services. The Continental Congress, much impressed by Von Steuben's title and his refusal to accept any salary while in service, immediately sent him to Washington at Valley Forge.

Although he spoke no English, Von Steuben systematically trained the amateur American troops in military discipline and battle-readiness. This rigorous training of the Continental troops saved them from complete defeat during the battle of Monmouth. In 1779, Von Steuben prepared his *Regulations for the Order and Discipline of the Troops of the United States*, which remained America's official military manual for over three decades.

Later in the war, Von Steuben commanded the army supply center in Virginia and fought at Yorktown. Afterward, Washington employed him in a variety of duties from the creation of a plan to demobilize the wartime army to the acceptance of Britain's surrendered Canadian forts. Von Steuben helped to found the Society of the Cincinnati, and then resigned his American commission in 1784. After the war, the New York legislature granted Von Steuben an estate. He received a small pension from the United States government, but relied on friends like Alexander Hamilton to settle his mounting debts. Von Steuben died on 28 November 1794.

Charles Willson Peale, a frequent visitor to the Continental army's Valley Forge encampment, admired Von Steuben's "skill and persevering industry [which] effected during the continuance of the troops at Vallyforge a most important improvement in all ranks of the army."[1] In late 1779 or early 1780, Von Steuben commissioned Peale to paint his portrait. The artist, stating that the "portrait is now highly approved of, or I am most egregiously flattered,"[2] retained the painting while Von Steuben fulfilled his Virginia command assignment. During this time, Peale copied the portrait for the museum. It appears on the museum's list of paintings in the 13 October 1784 issue of the *Freeman's Journal and Philadelphia Daily Advertiser*.

Peale frequently copied his museum portraits for his sitters, generally keeping the life portrait for himself. Because, however, Von Steuben had commissioned his own portrait, Peale kept the copy as the museum portrait. The life portrait (now at the Pennsylvania Academy of Fine Arts) shows Von Steuben's epaulettes without command stars. The museum portrait, made after Von Steuben received his command appointment in mid-1780, shows epaulettes with two stars each. This change and the exact rendering of the sitter's Order of Fidelity of Baden, illustrate Peale's attention to and familiarity with the details of military decoration.

—◦◦◦◦◦—

Provenance:
Listed in the 1795 Peale Museum catalog. Purchased by the City of Philadelphia at the 1854 Peale Museum sale.

Physical Description:
Oil on canvas. Bust length, torso turned slightly toward the sitter's right. Dark blue uniform coat with buff facings, gold epaulettes with two silver stars each. White stock and jabot. Gold medal (Cross of Fidelity of Baden) suspended from gold ribbon around neck. Gold medal (Star of Fidelity of Baden) pinned to left side of chest. Powdered hair, brown eyes. Dark brown background. 23 inches H × 19⅝ inches W.

[1] Charles Willson Peale, *An Historical Catalogue of Paintings Attached to the Philadelphia Museum* (Philadelphia, 1813).

[2] Sellers, *Portraits and Miniatures*, 200.

JEREMIAH WADSWORTH (1743–1804)
by James Sharples Senior, from life, c. 1795–1801

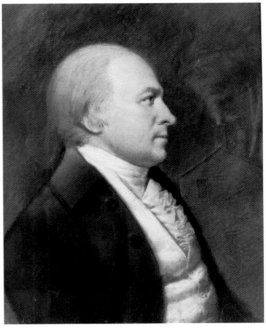

Catalog Number INDE11906

(SN 7.014)

Wadsworth was born on 12 July 1743 in Hartford, Connecticut. He later joined his uncle in a commercial seafaring career. From 1775 through the end of the Revolution, Wadsworth used his mercantile experience in the service of the American Revolution. He was commissary of Connecticut's militia, and then the Continental army's commissary-general, and commissary of the French army in America. After the war, he supported the new federal Constitution at his state's ratifying convention and then entered the United States House of Representatives in 1789. After three terms, he returned to Connecticut and spent six years as a member of the state legislature and of the executive council. In addition to his service in political office, he helped to found the Bank of North America and that of Hartford, and served as a director of the United States Bank and of the Bank of New York. He also founded Connecticut's first insurance partnership. Wadsworth died on 30 April 1804.

On his first visit to the United States from 1795 to 1801, British portraitist James Sharples Senior (1751–1811) worked in New England, New York City, and Philadelphia. Wadsworth sat for the artist at some time during those years, and Sharples's 1802 catalog lists "Colonel Wadsworth." Another version of this pastel, possibly a copy by a Sharples family member, descended in the sitter's family.

In general, Sharples's pastels depict the sitter in a shaded blue-toned background. Occasionally, the artist included loosely painted tree trunks in the background of his portraits. This practice seems to have had a decorative, rather than a symbolic, purpose. The Wadsworth portrait, however, appears to be an exception to this rule. In the pastel's right midground, Sharples placed a one-story frame building with a single window and a smoking central chimney (a second chimney, visible to the right of the first, may be part of an adjacent building). Wadsworth lived his entire life either abroad (at sea, traveling in England and Europe) or in cities (Hartford, Philadelphia). Unless it refers to the sitter's experimental agricultural interests, the significance of the rough-hewn structure in this portrait is unknown.

Provenance:
Listed in the 1802 Bath catalog of Sharples's work. Given by Ellen (Mrs. James) Sharples to Felix Sharples in 1811. Given by Felix Sharples to Levin Yardly Winder in the 1830s. Inherited by Nathaniel James Winder from Levin Yardly Winder. Inherited by Richard Bayly Winder from Nathaniel James Winder in 1844. Purchased by Murray Harrison from Richard Bayly Winder around 1865. Purchased by the City of Philadelphia from Murray Harrison in 1876.

Physical Description:
Pastel on paper. Half length, right profile. Blue coat, white patterned waistcoat, white stock and jabot. Gray hair, gray eyes. Clapboard building with two chimneys in right midground. Blue-gray variegated background. 9 inches H × 7 inches W.

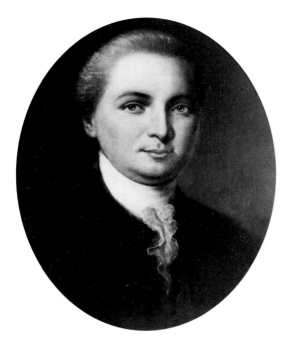

Catalog Number INDE14150

(SN 13.298)

GEORGE WALTON (1741–1804)
by Samuel Bell Waugh, after Charles Willson Peale, c. 1874

Walton was born in 1741 in Prince Edward County, Virginia. Trained as a carpenter, he studied classical subjects and later moved to Savannah, Georgia, where he became a lawyer. Deeply committed to American independence, he served on Georgia's committee of correspondence, presided over its council of safety, and was secretary of its provincial congress. In early 1776, he entered the Continental Congress and later signed the Declaration of Independence. He also negotiated the 1777 treaty between the United States and the Iroquois Six Nations. Later, he accepted a commission in his state's militia and was wounded and captured during the British siege of Savannah. After his release, he served as Georgia's governor in late 1779. Early the next year, he returned to Congress.

After the war, Walton spent six years as chief justice of Georgia. During this time, he also acted as a United States representative to the Cherokee Nation and a trustee of the Richmond Academy and the University of Georgia. He refused an appointment to the 1787 Constitutional Convention, but attended his state ratifying convention the following year. He returned to the governor's office in 1789, and to the judges' bench in 1790. He periodically served in the state's superior court from then on, except for three years in the United States Senate from 1795 to 1799. Walton died on 2 February 1804.

The City of Philadelphia added Walton's portrait to its museum in Independence Hall around the time of the United States Centennial. Philadelphia artist Samuel Bell Waugh (1814–1885) copied Charles Willson Peale's c. 1781 miniature of Walton (now at the Yale University Art Gallery) for the Declaration signers gallery.

❧

Provenance:
Purchased by the City of Philadelphia from the artist in 1874.

Physical Description:
Oil on canvas. Bust length, facing forward. Brown coat and waistcoat, white stock and jabot. Powdered hair, blue eyes. Dark green background. 24 inches H × 20 inches W.

ARTEMAS WARD (1727–1800)
by Charles Willson Peale, from life, c. 1790–1795

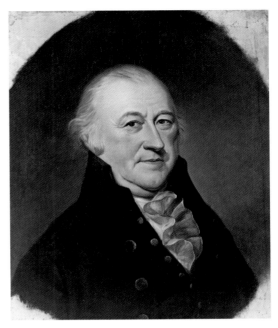

Catalog Number INDE11874

(SN 13.299)

Ward was born on 26 November 1727 in Shrewsbury, Massachusetts. He graduated from Harvard College in 1748, and briefly taught school in nearby Groton. He then returned to his hometown, where he opened a general store, represented Shrewsbury in the colonial legislature, and became chief justice of his county's court of common pleas. During the French and Indian War, he served as a militia colonel but lost his commission when he supported the public boycott of British imports begun in protest of the Townshend Acts. These political beliefs also ended Ward's tenure with the governor's council in 1774, and he joined the pro-resistance provincial congress.

The day after the battle at Lexington, Ward accepted command of all American troops in the Boston area. He received a general's commission and directed the siege of Boston from his Cambridge headquarters. In mid-1775, when George Washington arrived in Boston as commander-in-chief of the Continental forces, Major General Ward became his second in command. Plagued by ill health, Ward resigned the following year although he remained in Boston for several months fortifying the city's defenses. He then returned to politics with service in his state's Executive Council, the Continental Congress, and his state legislature. He entered the United States House of Representatives in 1791 and remained through 1795. Three years later he resigned his common pleas judgeship due to illness. Ward died on 28 October 1800.

Their support for the French Revolution provided common political ground for the Federalist Ward and the Jeffersonian Charles Willson Peale. Peale probably painted Ward's portrait when the latter lived in Philadelphia as a member of Congress. Of his work during this period, Peale later observed: "In those [portraits] painted 5, 6 & 7 Years ago, I discover [*sic*] a poverty in the effect; a minuteness of lines and pains taking" detail.[1] In 1795, the artist's son Raphaelle copied his father's portrait of Ward twice, once for exhibit in Charleston (now located at the Artemas Ward Homestead, Shrewsbury) and once for the sitter's family (now in a private collection).

⁂

Provenance:
Listed in the 1795 Peale Museum catalog. Purchased by the City of Philadelphia at the 1854 Peale Museum sale.

Physical Description:
Oil on canvas. Bust length, turned slightly toward sitter's left. Dark blue coat and waistcoat, white stock and jabot. Gray hair, green eyes. Brown background. 23¼ inches H × 19 3/16 inches W.

[1] Charles Willson Peale to Jonathan Dickinson, 22 March 1799 (Miller, *Selected Papers* 2:1, page 240).

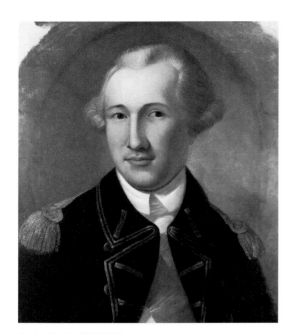

Catalog Number INDE14169

(SN 13.300)

JOSEPH WARREN (1741–1775)
attributed to a member of the Peale family (possibly Charles Peale Polk), after an engraving based on a painting by John Singleton Copley, c. 1795–1810

Warren was born in Roxbury, Massachusetts, on 11 June 1741. He graduated from Harvard College, taught grammar school, and then studied medicine before opening a Boston practice. In the decade preceding the American Revolution, he befriended the popular orator Samuel Adams, and wrote frequently for the *Boston Gazette*. After the Boston Massacre in 1770, he served on the committee appointed to present the city's grievances to the royal governor. He sat on a host of local committees that supported colonial opposition to parliamentary rule, including the Committee of Safety. In 1774, he headed Boston's delegation to the county convention and he wrote the "Suffolk Resolves," a call for Massachusetts's forcible resistance to the Intolerable Acts, which the Continental Congress approved.

During the March 1775 anniversary observance of the Boston Massacre, Warren's dramatic oration at the Old South Church electrified the city and solidified his own commitment to the Revolutionary cause. He closed his medical practice and devoted all his time to organizing armed colonial resistance. In April, he sent Paul Revere and William Dawes on their warning ride to Concord and Lexington, and Warren joined the battle there the following day. During that time, he also served as president pro tempore of the Provincial Congress, and chaired the organizational committee for the Massachusetts militia. In June, he accepted a commission in the militia, insisting upon a field command rather than that of physician general. When the British attacked Charlestown Heights near Boston, Warren rode to Bunker Hill for his assignment. He was sent to Breed's Hill where he died in battle on 17 June 1775.

As one of the first prominent battlefield casualties of the Revolution, Warren was an important subject for inclusion in Peale's Philadelphia Museum. Apparently, however, no portrait of Warren was prepared until after the publication of the museum's first catalog in 1795. By 1810, Philadelphia engraver David Edwin included the museum image in "The American Generals" as "Portraits by Peale."[1] Elements in the museum portrait suggest that it might be the work of Charles Willson Peale's nephew, Charles Peale Polk (1767–1822). After training with his uncle in Philadelphia, Polk moved to Baltimore in 1796. Specifically, the emphasis on highlights in the white of the subject's collar and the shiny braid trim is reminiscent of Polk's work.[2]

The museum Warren portrait was apparently copied from an engraving of John Singleton Copley's 1772–1774 full length portrait of the sitter (now owned by the Museum of Fine Arts Boston). Possible source engravings may have been John Norman's version published in the April 1784 issue of *The Boston Magazine* or Samuel Harris's engraved portrait published in the November 1806 issue of Boston's *The Polyanthos*. Both engravings cropped the Copley image to bust length, but retained the subject's civilian dress. The Peale Museum portrait shows Warren in his militia uniform.

❦

Provenance:
Listed in the 1813 Peale Museum catalog. Purchased by the City of Philadelphia at the 1854 Peale Museum sale.

Physical Description:
Oil on canvas. Bust length, head turned toward subject's right. Dark blue uniform coat with gold braid trim and gold epaulettes, white shirt and stock, red sash across chest. Gray wig, brown eyes. Rose-gray background. 23 inches H × 19¾ inches W.

[1] Mantle Fielding, *Catalogue of the Engraved Work of David Edwin* (Philadelphia, 1905), 2, no. 10. The other portraits were Richard Montgomery, Anthony Wayne, and Nathanael Greene. Brandon Brame Fortune, "Portraits of Virtue and Genius: Pantheons of Worthies and Public Portraiture in the Early American Republic, 1780–1820" (Ph.D. dissertation, University of North Carolina, 1986), figure 23.

[2] Linda Crocker Simmons to Karie Diethorn, 4 January 1993. Museum Accession Files, Independence National Historical Park. Linda Crocker Simmons, *Charles Peale Polk, 1767–1822: a Limner and His Likenesses*, exhibition catalog (Washington, D.C.: Corcoran Gallery of Art, 1981), 9–10.

BUSHROD WASHINGTON (1762–1829)
attributed to Felix Sharples, after James Sharples Senior, 1800

Washington was born on 5 June 1762 in Westmoreland County, Virginia. He studied with a tutor at the nearby estate of Richard Henry Lee, and then entered the College of William and Mary. In 1778, Washington joined the Continental army, serving until the end of the war. Afterward, he studied law in Philadelphia with James Wilson and then returned to Virginia and opened his own law practice in Alexandria. In 1787, he served in the state's House of Delegates and attended its federal Constitution ratifying convention.

In late 1798, Washington joined the United States Supreme Court as an associate justice, taking the seat held by his former law teacher. Washington served on the bench for the next thirty-one years, a time when the Court established its authority as the ultimate arbiter of constitutional interpretation. During these years, he agreed with Chief Justice John Marshall that the Constitution represented the supreme law of the land. Although other interests occasionally occupied Washington (he was the first president of the American Colonization Society and executor of his uncle George's literary and real estate), most of his time was spent on the judicial bench. Washington died in Philadelphia on 26 November 1829.

During his family's first visit to the United States at the end of the 1790s, British pastelist Felix Sharples (born c. 1786) traveled with his father James while the latter painted pastel portraits of society. The Sharples family left America in 1801, but Felix returned to America in 1806, accompanied by his half brother James. The two young men settled in different areas, Felix in Virginia and James in Albany, where they established independent careers as painters. After their father's death in 1811 during a second visit to the United States, James returned to England with his mother and sister while Felix remained behind. During the next

twenty years, Felix traveled extensively in southeastern and central Virginia as a professional artist. The last recorded reference to him is in 1830, and his death date is unknown.[1]

Although he undoubtedly studied with his father, Felix never attained the level of painterly skill that the elder Sharples reached. Felix's documented sitters are drawn in a very linear manner, and their facial features lack definition, giving them a rather amorphous appearance. Such work characterizes the Independence portrait of Bushrod Washington.[2] In addition to the unsophisticated drawing technique used in the work, the artist of this pastel traced part of the image in pencil prior to applying the pigment, a practice not associated with James Sharples Senior. A series of pencil lines is clearly visible in the sitter's hairline and around his eyes.[3] This pastel is probably a copy of the life portrait painted in 1799 or 1800 by the senior Sharples and listed in his 1802 catalog as that of "Judge Washington." This life portrait is now unlocated, but an 1803 pencil copy of it drawn by Ellen Sharples is in the collection of the City Art Gallery in Bristol, England. This pastel was part of a collection given to Felix by his stepmother after his father's death with the hope that it would help the younger artist attract potential clients.

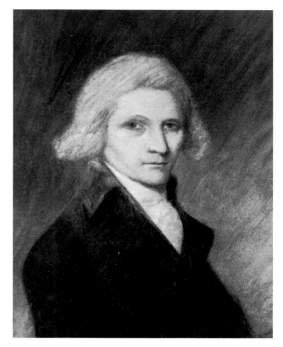

Catalog Number INDE11907
(SN 7.015)

[1] Alice E.A. Hunt, "Notes on Felix Thomas Sharples," *Virginia Magazine of History and Biography* 59 (April 1951): 215–218.

[2] John C. Milley, "Thoughts on the Attribution of Sharples's Pastels," University of Pennsylvania Hospital Antiques Show, 1975, p. 62.

[3] These tracings may represent an aspect of Felix's career as a drawing instructor. (Knox, *The Sharples*, 48).

⤎⊙⊙⤏

Provenance:
Listed in the 1802 Bath catalog of Sharples's work. Given by Ellen (Mrs. James) Sharples to Felix Sharples in 1811. Given by Felix Sharples to Levin Yardly Winder in the 1830s. Inherited by Nathaniel James Winder from Levin Yardly Winder. Inherited by Richard Bayly Winder from Nathaniel James Winder in 1844. Purchased by Murray Harrison from Richard Bayly Winder around 1865. Purchased by the City of Philadelphia from Murray Harrison in 1875.

Physical Description:
Pastel on paper. Half length, torso turned toward the subject's left. Black coat and waistcoat. White stock and jabot. Gray wig, brown eyes. Blue-green variegated background. 9 inches H × 7 inches W.

GEORGE WASHINGTON (1732–1799)

Washington was born in Westmoreland County, Virginia, on 22 February 1732. After his father died, Washington was raised by relatives, including his older brother Lawrence, the owner of Mt. Vernon. Early experience as a surveyor gave the younger Washington his first job, which was followed by important military experience in the French and Indian War, including the ill-fated Braddock campaign against Fort Duquesne. From 1755 through 1758, Washington commanded Virginia's entire frontier force and eventually saw the ouster of the French from the region. He began his legislative service in 1759 and added to it work as justice of the peace in the following year. By 1774 with the dissolution of the House of Burgesses and his election to the First Continental Congress, he was a cautious but committed supporter of colonial protests against British commercial restrictions. His military background was well respected, and he was appointed militia commander for several Virginia counties.

By July 1775, Washington's solid military and administrative reputation led Congress to appoint him commander-in-chief of the entire American army. Thereafter, from the siege of Bunker Hill to the British surrender at Yorktown, Washington faced inadequate funding, inexperienced men and officers, lackluster congressional support, and challenges to his military authority.

With America's triumph and the end of the war in 1783, he had mastered these challenges and welcomed the return to private life. Preoccupied with the management of Mt. Vernon, he initially resisted but later agreed to attend the federal convention in 1787 as its presiding officer. Widespread confidence in his authority and judgment then led to his election as the first president of the United States in 1789.

During his two presidential administrations, Washington balanced domestic and foreign issues by maintaining the same studied and practical decision-making process he had used during his wartime experience. He created a cabinet of diverse advisors, like Thomas Jefferson and Alexander Hamilton, often diametrically opposed to one another in policy. Through them, Washington sought to put the new government on a solid economic and political footing by focusing it on its own welfare and away from foreign conflicts. Nevertheless, public resistance to national excise taxes (like Pennsylvania's frontier Whiskey Rebellion), unresolved territorial issues in the West, and free navigation of the Atlantic challenged his presidency. These issues, and Washington's response to them, defined his presidential legacy.

In his last retirement, Washington returned to his first love, the agricultural pursuits of a country gentleman. He continued to contribute to educational efforts, like the future Washington and Lee University, and family concerns. A severe chest cold, complicated by a heavy-handed medical response, led to the president's death on 14 December 1799.

GEORGE WASHINGTON (1732–1799)
1. by Robert Edge Pine, possibly from life, 1785–1787

1. In the spring of 1785, British-
born artist Robert Edge Pine
(1742–1788) visited Mt. Vernon for
nearly a month in order to paint a
portrait of Washington for public
display and sale. Francis Hopkinson,
who provided Pine with a letter of
introduction to Washington, assured
the general that "I know you have
already suffered much persecution
under the painter's pencil, and
verily believe you would rather
fight a battle, on a just occasion,
than sit for a Picture," but appealed
to his tolerant nature for the sake
of the artist's good intentions.[1] Pine
left Mt. Vernon with the portrait
unfinished, completing it in
Philadelphia in early 1787. Three
versions of Pine's Washington
portrait are known to exist (in the
collections of Independence National
Historical Park, the Smithsonian's
National Portrait Gallery, and the
Wallace Collection of the Gulf
States Paper Corporation in
Tuscaloosa, Alabama). The three
have slight differences in the
subject's face and the props used,
but it is unclear which is the life
portrait.

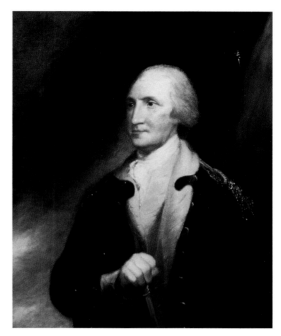

Catalog Number INDE14170
(SN 13.301)

‒∙⟨◦⟩∙‒

Provenance:
Given to the City of Philadelphia by
Benjamin Moran (former United States
minister to Portugal) in 1886.[2]

Physical Description:
Oil on canvas. Half length, standing with
head and torso turned slightly toward the
subject's right. Blue uniform coat with buff
facings and gold epaulettes, buff waistcoat.
White stock and jabot. Powdered hair tied in
a queue with a black ribbon, blue eyes. Gloved
right hand holds the gold-tipped head of a
walking stick. A banner or tent with the tip of
a spontoon visible in right background.
Brown and gray background. 36⁵⁄₁₆ inches H
× 29³⁄₁₆ inches W.

[1] Robert G. Stewart, *Robert
Edge Pine, a British Portrait
Painter in America,
1784–1788*, National Portrait
Gallery exhibition catalog
(Washington, D.C.:
Smithsonian Institution
Press, 1979), 92.

[2] Moran's estate reported that
he received the Pine portrait
from a George Washington
Phillips, purportedly
Washington's godson, who
received the portrait from
the president. Phillips is
currently unidentified.

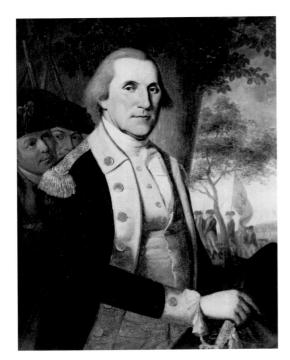

Catalog Number INDE14171

(SN 13.302)

GEORGE WASHINGTON (1732–1799)
2. by James Peale, after Charles Willson Peale, c. 1787–1790

2. Charles Willson Peale's 1787 museum portrait of Washington (now owned by the Pennsylvania Academy of the Fine Arts) provided the artist's younger brother James (1749–1831) with a source for his own c. 1790 portrait of the general at the battle of Yorktown. James Peale borrowed other elements from his brother's work for this painting: the background landscape is possibly from Charles Willson Peale's 1784 full length portrait of Washington (now owned by the Fogg Museum of Art). Perhaps in reference to the two brothers' joint Revolutionary experience, James included them in the painting directly behind Washington.[3] Several of James's copies of the museum Washington portrait with varying backgrounds exist (along with others by the Peales' nephew, Charles Peale Polk) in public and private collections.[4]

❦

Provenance:
Possibly purchased by John Dunlap from the Peale family at an unknown date. Purchased by John Binns from John Dunlap c. 1810. Purchased by the City of Philadelphia from John Binns in 1849.

Physical Description:
Oil on canvas. Three-quarter length, standing with body turned toward the subject's left. Blue uniform coat with buff facings, gold epaulettes with three stars each. Buff waistcoat. White stock, jabot and cuff. Powdered hair, blue eyes. Right hand holding gold sword hilt, glove, black tricorner hat. Two uniformed and armed men (James and Charles Willson Peale) standing behind subject's right shoulder under tree. Column of uniformed soldiers, one carrying the French flag, in the right midground. 36½ inches H × 27 ¹³/₁₆ inches W.

[3] The Peales were identified in this painting by John C. Milley, chief of museum operations at Independence National Historical Park, in 1981.

[4] Ten James Peale copies are recorded in John Hill Morgan and Mantle Fielding, *The Life Portraits of Washington and Their Replicas* (Philadelphia, 1931), 125–129.

GEORGE WASHINGTON (1732–1799)

3. attributed to Ellen Sharples, after James Sharples Senior, c. 1796–1810

3. In 1797, British pastelist James Sharples Senior painted the last life portrait of Washington during the president's final months in Philadelphia before returning to Mt. Vernon. The artist listed it as "General Washington" in the 1802 catalog of his American works. Approximately thirty versions of this portrait are known with variations in the pose and attire.[5] Most show Washington in left profile wearing civilian dress (including the copies in the Philipse Manor Hall State Historic Site, the Smithsonian's National Portrait Gallery, and the Independence collection), but he was also depicted in right profile (Mt. Vernon) and in three-quarter pose wearing his uniform (Bristol Art Gallery in England).

Although the James Sharples life portrait of Washington is currently unlocated, the Independence portrait is a copy by Sharples's wife Ellen (1769–1849). Compared to the versions attributed to James (e.g., the National Portrait Gallery and Philipse Manor Hall portraits), the Independence portrait appears more tightly drawn as reflects Mrs. Sharples's training as a miniaturist. In addition, details in the Independence subject's attire (specifically the jabot that is lacking in detail and the hair ribbon, which is an unvaried string, rather than a broad textured ribbon) are not typical of James Sharples Senior's skilled work.

—◦❀◦—

Provenance:
Given by Ellen (Mrs. James) Sharples to Felix Sharples in 1811. Given by Felix Sharples to Levin Yardly Winder in the 1830s. Inherited by Nathaniel James Winder from Levin Yardly Winder. Inherited by Richard Bayly Winder from Nathaniel James Winder in 1844. Purchased by Murray Harrison from Richard Bayly Winder around 1865. Purchased by the City of Philadelphia from Murray Harrison in 1874.

Physical Description:
Pastel on paper. Half length, left profile. Black coat and waistcoat, white stock and jabot. Powdered hair tied in a queue with a gray ribbon, blue eyes. Blue-green variegated background. 9 inches H × 7 inches W.

Catalog Number INDE11919
(SN 7.027)

[5] Ellen G. Miles, *George and Martha Washington, Portraits from the Presidential Years*, Smithsonian National Portrait Gallery exhibition catalog (Charlottesville: University of Virginia Press, 1999), 48–50.

GEORGE WASHINGTON (1732–1799)
4. by Rembrandt Peale, after Rembrandt Peale, 1848

Catalog Number INDE11867

(SN 13.303)

4. Having painted his first portrait of Washington in 1795, Rembrandt Peale (1778–1860) subsequently envisioned an epic equestrian portrait of Washington for permanent public display in the Capitol. Rembrandt intended the equestrian portrait to represent the ideal Washington, a man of noble deeds and selfless public service.[6] In 1824 the artist began work on this monumental canvas, entitled *George Washington Before Yorktown* (and featuring Lafayette, Rochambeau, Knox, and Hamilton) which he intended for purchase by Congress but which remained in Rembrandt's studio until privately sold. This painting (a version is at the Corcoran Gallery of Art) and Rembrandt's bust-length portrait of Washington in black robes, entitled *Patriae Pater*, were both placed within painted stone portals, ostensibly to facilitate their use in a print medium.[7]

From the mid-1820s until the end of his life, Rembrandt painted numerous copies of the *Patriae Pater* and an abbreviated version of the *Yorktown*. The latter was painted in 1848 and purchased by the City of Philadelphia at the urging of the Pennsylvania Academy of the Fine Arts in a gesture honoring Peale, a member of the Academy.[8]

❧

Provenance:
Purchased by the City of Philadelphia at the 1862 Rembrandt Peale estate sale.

Physical Description:
Oil on canvas, full length equestrian with head turned toward the subject's right. Dark blue uniform coat with buff facings, gold epaulettes. Buff waistcoat and breeches. White stock and jabot. Black riding boots. Black tricorner hat held in right hand, gun holster on hip. White horse with dark mane, tan saddle and gold-edged red saddle blanket. Background of foliage and sky. 73 inches H × 54⅝ inches W.

[6] Lillian B. Miller, *In Pursuit of Fame: Rembrandt Peale, 1778–1860*, Smithsonian National Portrait Gallery exhibition catalog (Seattle: University of Washington Press, 1992), 147.

[7] Carol Hevner, *Rembrandt Peale, 1778–1860: a Life in the Arts*, exhibition catalog (Philadelphia: Historical Society of Pennsylvania, 1985), 86.

[8] Ibid., 104, n. 9.

MARTHA DANDRIDGE CUSTIS (MRS. GEORGE) WASHINGTON
(1731–1802)
by Charles Willson Peale, from life, 1795

Catalog Number INDE14172
(SN 13.304)

Dandridge was born on 2 June 1731 in New Kent County, Virginia. Although her father was a merchant of moderate wealth, Dandridge's 1749 marriage to Daniel Parke Custis elevated her to the landed aristocracy. Mrs. Custis had four children, only two of whom survived infancy, before her husband died in 1757. During her subsequent widowhood, Custis met Colonel George Washington, whom she married on 6 January 1759. At that time, her new husband was already a public figure through his service to the British army during the French and Indian War, and Mrs. Washington began her long career as the gracious hostess of his Virginia estate, Mt. Vernon.

During her husband's tenure as commander of America's Continental army from 1775 until 1783, Mrs. Washington managed his plantation and properties. Frequently she joined her husband at his winter headquarters, first in Cambridge, and later at Morristown, Valley Forge, and Newburgh. After the war she and Washington lived at Mt. Vernon and, although they had no children of their own, reared two of her grandchildren from her first marriage.

Early in 1789, Mrs. Washington went to New York City as the wife of the first president of the United States. There, and later in Phila-delphia, Mrs. Washington managed the presidential household. She established its formal entertaining schedule, which included semi-weekly levees, a state dinner every Thursday, and her own Friday evening receptions. In her role as the president's lady, she stylishly maintained his official residences, dressed with restrained elegance, and kept a strict schedule of social calling. After her husband's retirement in 1797, she returned with him to Mt. Vernon, where he died in late 1799. She remained there with her family until her death on 22 May 1802.

In the fall of 1795, Charles Willson Peale arranged a series of sittings with President and Mrs. Washington for a pair of portraits to hang in the Philadelphia Museum. Many years later Peale's son Rembrandt recounted that, just before these sittings, his father met Mrs. Washington in the street, and was struck by her con-tented air and healthy appearance. Rembrandt recalled that, when his father reported this observation to the president and requested a portrait sitting from Mrs. Washington, the president agreed.[1] The museum portrait is the last painted of "the amiable consort of the President" by the senior Peale.[2] Previously, he had produced three miniatures (1772 owned by the Yale University Art Gallery, 1776 and 1791 unlocated) and two three-quarter lengths (1776 and 1786 unlocated).[3] Some years later, Rembrandt Peale copied his father's museum portrait of Mrs. Washington, probably for his own museum, which opened in Baltimore in 1814 (this copy is now at the Virginia Historical Society).[4]

❦

Provenance:
Listed in the 1795 Peale Museum catalog. Purchased by Lewis H. Newbold at the 1854 Peale Museum sale. Purchased by the City of Philadelphia from Lewis H. Newbold in 1854.

Physical Description:
Oil on canvas. Half length, seated with torso turned slightly toward the sitter's left. Pale pink dress with white fichu, black lace shawl. White lace cap with silver ribbons, gold hoop earrings. White hair, gray eyes. Red upholstered chair back with ornamental brass tacks. Dark brown background. 28⅝ inches H × 23⁵⁄₁₆ inches W.

[1] Sellers, *Portraits and Miniatures*, 243.

[2] Charles Willson Peale, *Catalogue of the Philadelphia Museum* (1795).

[3] Sellers, *Portraits and Miniatures*, 241–243.

[4] In the 1850s, Rembrandt painted several additional copies of Mrs. Washington's museum portrait. Among the surviving are those in the collections of the New-York Historical Society, the Historical Society of Pennsyl-vania, the Smithsonian's National Portrait Gallery, the Metropolitan Museum of Art, the University of Michigan Museum of Art, the United States Department of State, the Union League of Philadelphia, and several private owners. These 1850s copies show the subject within a painted stone porthole, and were intended as companion portraits to identically formatted portraits of the president.

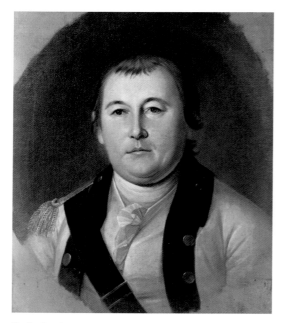

Catalog Number INDE14173

(SN 13.305)

WILLIAM AUGUSTINE WASHINGTON (1752–1810)
by Charles Willson Peale, from life, 1781–1782

Washington was born on 28 February 1752 in Stafford County, Virginia. His parents intended him to join the ministry and sent him to study with a theologian. However, in early 1776 he accepted a captain's commission in the Continental army commanded by his cousin, George Washington, and then fought at Long Island, Trenton (where he was wounded), and Princeton. In 1780, he transferred to the army's Southern Division and fought in a series of skirmishes around Charleston. The following year, he led his cavalry to victory in close combat with British regulars at Cowpens. His success there, in particular his hand-to-hand saber battle with the British commander Tarleton, earned Washington a congressional medal. He then joined the American forces in North Carolina for battles at Guilford Courthouse, Hobkirk's Hill, and Eutaw Springs, where he was wounded and captured. He remained a paroled prisoner-of-war in Charleston until the city's evacuation by the British at the end of 1782.

After the war, Washington stayed in Charleston, where he served in the state legislature. He later refused a gubernatorial nomination, but in 1798 returned to public service as a brigadier general for service in America's undeclared naval war with France. Washington died on 6 March 1810.

Charles Willson Peale probably painted the museum portrait of Washington sometime in 1781, after the victory at Cowpens, when the sitter came to Philadelphia to accept his congressional honor, and before his capture at Eutaw Springs. In the painting, Washington wears his white linen field uniform with only a captain's single epaulette. Apparently, the lieutenant colonel never added the second epaulette he had earned to his field uniform.[1] The portrait is first recorded in the 13 October 1784 issue of the *Freeman's Journal and Philadelphia Daily Advertiser*. In the early 1790s, Rembrandt Peale copied his father's Washington portrait for use in advertising his own painterly skill during a 1795–1796 patronage trip to Charleston. This copy (now at the Maryland Historical Society) was later displayed in the Baltimore Peale Museum.

Provenance:
Listed in the 1795 Peale Museum catalog. Purchased by Townsend Ward (librarian of the Historical Society of Pennsylvania) at the 1854 Peale Museum sale. Purchased by the City of Philadelphia from Townsend Ward in 1854.

Physical Description:
Oil on canvas. Bust length, facing front. White coat with blue facings, one gold epaulette on right shoulder. White waistcoat. Black sword belt over right shoulder. White stock and jabot. Brown hair, brown eyes. Variegated brown background. 23⅝ inches H × 19⅝ inches W.

[1] Sellers, *Portraits and Miniatures*, 244.

ANTHONY WAYNE (1745–1796)
by James Sharples Senior, from life, 1796

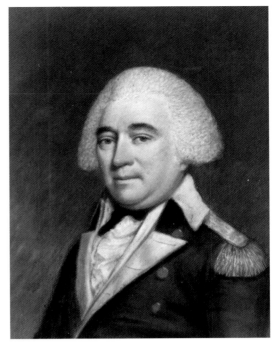

Catalog Number INDE11922
(SN 7.031)

Wayne was born in Chester County, Pennsylvania, on 1 January 1745. He attended his uncle's private academy in Philadelphia, and then spent a year as a surveyor in Nova Scotia and worked in his father's tannery. In 1775, he served in the provincial assembly. The following year, he and his troops joined the American army's unsuccessful invasion of Canada, during which he commanded the distressed forces at Fort Ticonderoga. Later, he commanded the Pennsylvania line at Brandywine, Paoli, and Germantown. After winter quarters at Valley Forge, he led the American attack at the battle of Monmouth. On the Hudson River, he captured the British garrison at Stony Point, for which Congress awarded him a medal. Victories at West Point and Green Spring, Virginia, increased his popular reputation as a bold commander. After the British surrendered at Yorktown, he went further south and severed the British alliance with Native American tribes in Georgia. He then negotiated peace treaties with both the Creek and the Cherokee, for which Georgia rewarded him with the gift of a large rice plantation.

After the war, Wayne returned to Pennsylvania. He served in the state legislature for a year, and later supported the new federal Constitution at Pennsylvania's ratifying convention. In 1791, he spent one year in Congress as a representative of Georgia, but lost his seat during a debate over his residency qualifications. President George Washington then placed him in command of the army opposing Native American tribes in the Ohio Valley. In 1794, he defeated Little Turtle's Miami forces at Fallen Timbers near present day Toledo. On a return trip to Pennsylvania from a military post in Detroit, Wayne died on 15 December 1796.

British pastelist James Sharples Senior (1751–1811) probably painted his portrait of Wayne in June of 1796 before the commander left Philadelphia for his post in Detroit. Sharples later listed "General Waine" among his sitters in a catalog published upon the artist's return to England. At one time, this portrait was misidentified as that of James Wilkinson. Recent scholarship compared this pastel with other life portraits of Wayne and Wilkinson, and corrected the identification.[1]

❧⟐❧

Provenance:
Listed in the 1802 Bath catalog of Sharples's work. Given by Ellen (Mrs. James) Sharples to Felix Sharples in 1811. Given by Felix Sharples to Levin Yardly Winder in the 1830s. Inherited by Nathaniel James Winder from Levin Yardly Winder. Inherited by Richard Bayly Winder from Nathaniel James Winder in 1844. Purchased by Murray Harrison from Richard Bayly Winder around 1865. Purchased by the City of Philadelphia from Murray Harrison in 1875.

Physical Description:
Pastel on paper. Half length, torso turned slightly toward sitter's right. Dark blue uniform coat with buff facings, gold epaulette. Black stock, white jabot. Gray wig, brown eyes. Blue-green variegated background. 9 inches H × 7 inches W.

[1] David Meschutt, "Portraits of Anthony Wayne: Reidentifications and Reattributions," *American Art Journal* 15 (Spring 1983): 37–38. Sharples's portrait of Wilkinson is in the collections of the Massachusetts Historical Society.

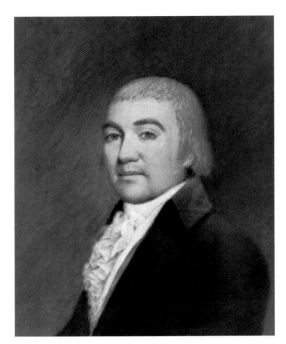

Catalog Number INDE11934

(SN 7.043)

NOAH WEBSTER (1758–1843)
by James Sharples Senior, from life, c. 1795–1801

Webster was born in West Hartford, Connecticut, on 16 October 1758. He later graduated from Yale and worked as a teacher and clerk in Connecticut and New York. Then he studied the law, but practiced only briefly during the early 1790s. His initial work in American linguistics began when he wrote his first spelling book while teaching school in New York. This speller (published in 1783) with its associated grammar (1784) and reader (1785) constituted Webster's *Grammatical Institute of the English Language*, which sold rapidly and well in its many editions. Early in the books' publication history, the author added the word "American" to their titles as their contents reflected the particulars of the new nation's common speech and vocabulary.

An advocate of linguistic nationalism, Webster also supported the drive for a strong federal government under the new Constitution. He published several pro-Federalist political pamphlets and newspaper articles in Connecticut and New York, and traveled throughout the United States to establish his books' copyright claims (which he obtained in 1786). In 1793 he created two Federalist newspapers, New York City's *American Minerva* and its *Herald* (a daily and a weekly, respectively). He remained the papers' publisher for the next decade, while he continued his grammar series and also wrote on epidemic diseases, climatology, agriculture, and banking.

In 1803, Webster retired from publishing and returned to Connecticut, where he remained active in local politics and began his study of lexicography. Three years later, he published a preliminary *Compendious Dictionary of the English Language*, the foundation of his mammoth subsequent work. Completed in 1825 and published three years later, his two-volume *American Dictionary* recorded tens of thousands of words, many for the first time. In this work, he took a new approach to the study of English: he documented both formal vocabulary and those words common to everyday American speech. After the *Dictionary*'s publication, he regularly produced revisions of it in order to improve its accuracy and to incorporate additional words. A lifelong educator (he was a founder of Amherst College), he also published a new version of the English Bible. Webster died in New Haven on 28 May 1843.

During his years in New York City, Webster befriended a variety of literary and scientific men in pursuit of his varied personal interests. Among these were many members of the "Friendly Club," a social group that included artist William Dunlap, poet Charles Brockden Brown (see above), jurists James Kent (see above) and William Johnson, physician Elihu Hubbard Smith, and several others. The British pastelist James Sharples Senior (1751–1811) was also an acquaintance of the Friendly Club and completed portraits of many of its members during the late 1790s. Webster (unlike the members of the Friendly Club) was not mentioned in Sharples's 1802 catalog, but the artist's portrait of the newspaper publisher probably dates from this period when the Friendly Club members' portraits were painted. Most certainly, Webster met Sharples through their common acquaintances in the Friendly Club.[1] There is another version of the Sharples Webster portrait (possibly a copy by a Sharples family member) at the Metropolitan Museum of Art.

Provenance:
Given by Ellen (Mrs. James) Sharples to Felix Sharples in 1811. Given by Felix Sharples to Levin Yardly Winder in the 1830s. Inherited by Nathaniel James Winder from Levin Yardly Winder. Inherited by Richard Bayly Winder from Nathaniel James Winder in 1844. Purchased by Murray Harrison from Richard Bayly Winder around 1865. Purchased by the City of Philadelphia from Murray Harrison in 1875.

Physical Description:
Pastel on paper. Half length, torso turned toward the sitter's right. Black coat, white waistcoat. White stock and jabot. Gray hair, brown eyes. Blue-green variegated background. 9 inches H × 7 inches W.

THOMAS WEST, LORD DE LA WARR (1577–1618)
by Margaret Thomas, after Wybrandt De Geest, c. 1882

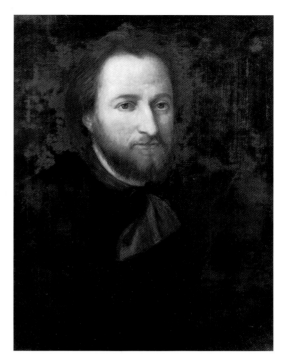

Catalog Number INDE
(SN 13.309)

West was born on 9 July 1577 in England. He briefly attended Queen's College, Oxford and traveled on the Continent. After his return to England, he sat in Parliament and then completed military service in the Netherlands. In 1602, he succeeded his father as Lord de la Warr and became a member of the Queen's Privy Council. In the council, he was a strong advocate for England's colonization of America. He supported the founding of the Virginia Company in 1606, and subsequently became one of its council members. The company elected him Virginia's lord governor and captain general in 1610, and he sailed to America to assume his office. Although he remained in Virginia for less than a year due to poor health, De la Warr succeeded in reestablishing the Jamestown settlement, which had nearly failed for lack of food and leadership. He returned to England in early 1611, but retained his governor-generalship and his intense interest in the Virginia colony. Lord de la Warr died on 7 June 1618 while en route to Jamestown for a second time.

In 1881 Britain's minister to the United States, Leonard S. Sackville-West, toured Independence Hall during a visit to Philadelphia. Upon his return to England, he commissioned a copy of his ancestor's portrait for Philadelphia's gallery of famous colonial persons. The then Earl De la Warr, Sackville-West's brother, owned Wybrandt De Geest's original portrait of Thomas West, which London artist Margaret Thomas (dates unknown) copied for Independence Hall in 1882.

❧⊙⊙❧

Provenance:
Given to the City of Philadelphia by the subject's descendants in 1883.

Physical Description:
Oil on canvas. Bust length, turned slightly to the subject's left. Blue cape, brown stock. Brown hair and beard, brown eyes. Brown background. 23 inches H × 18 inches W.

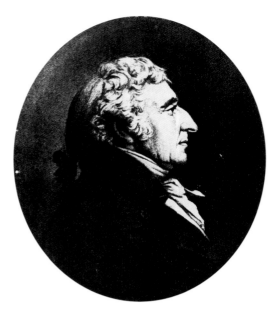

Catalog Number INDE
(SN 13.312)

JOSEPH WHIPPLE (1738–1816)
by Stephen James Ferris, after
Charles Balthazar Julien Févret de Saint-Mémin, 1876

Whipple was born on 14 February 1738 in Kittery, Massachusetts (now Maine). He received a local education, and later joined his elder brother William in a Portsmouth, New Hampshire, shipping company. In 1773, the younger Whipple founded the town of Dartmouth (now Jefferson), New Hampshire. During the American Revolution, he served New Hampshire briefly as a militia colonel and in the provincial legislature. In 1789, President George Washington appointed him the United States collector of customs for Portsmouth. Whipple's Antifederalist sympathies cost him the position during the Adams administration, but he regained it in 1801 under President Thomas Jefferson. Whipple died in Portsmouth on 26 February 1816.

During Philadelphia's celebration of the United States Centennial in 1876, the city attempted to create a portrait gallery of signers of the Declaration of Independence.

The city commissioned local artist Stephen James Ferris (1835–1915) to create a portrait of New Hampshire signer William Whipple for Independence Hall.[1] The artist mistakenly copied an 1805 engraving of the signer's younger brother, Joseph, by French artist Charles Balthazar Julien Févret de Saint-Mémin (example owned by the Smithsonian's National Portrait Gallery).

❦

Provenance:
Purchased by the City of Philadelphia from the artist in 1876.

Physical Description:
Oil on canvas. Bust length, right profile. Grisaille (gray tones reminiscent of engraving). 24 inches H × 20 inches W.

[1] The only extant portrait of William Whipple, Declaration signer (died 1785) is that by John Trumbull in his *Declaration of Independence* and his *Surrender of General Cornwallis at Yorktown* (both owned by the Yale University Art Gallery).

THOMAS HARRISON WHITE (1779–1859)
by Benjamin Trott, from a miniature by Benjamin Trott, c. 1800–1820

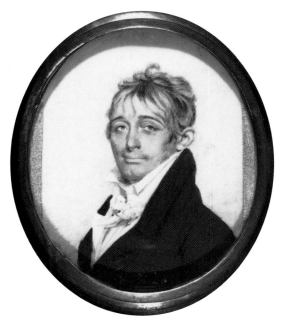

Catalog Number INDE13721

White (he later added his mother's maiden name, Harrison, to distinguish himself from a contemporary of the same name) was born on 12 November 1779 in Philadelphia. His father, Bishop William White (see below), sent him to the University of Pennsylvania and then placed him with the shipping firm of Thomas Willing and Robert Morris (see above), where the young White worked as a supercargo, sailing to Europe and China. After the firm's financial demise in 1798–1799, White started his own business as a wine merchant in Philadelphia. He remained active in the commercial community until about 1840, and was treasurer of the Ridge Turnpike Company. He also served many years as a vestryman for the city's Christ Church, and participated in its philanthropic organizations. White died on 15 October 1859.

During his long commercial career, White's economic and social associations provided him with connections to the city's artistic community, in particular with local miniaturist Benjamin Trott (around 1770–1843).[1] Mr. and Mrs. White probably posed for Trott just after their wedding in October of 1804. Trott's miniature of Maria Key Heath (Mrs. Thomas Harrison) White is now known only through a photograph, but two versions of her husband's miniature portrait survive (one is owned by Independence, the other by the Historical Society of Pennsylvania). The Independence miniature is apparently a replica of the one at the Historical Society.[2] The replica at Independence also includes an underdrawing (INDE14175) of the sitter that was once adhered face up to the back of the painted ivory. This underdrawing, unique in Trott's work, may have been used by the artist as a guide in composing the replica or as a means of enhancing the painted miniature.[3]

❧

Provenance:
Given to Independence National Historical Park by Mrs. James Alan Montgomery Junior, the sitter's great-great-granddaughter by marriage, in 1986.

Physical Description:
Watercolor on ivory. Bust length miniature, torso turned three quarters to the subject's right. Black coat, white shirt and stock. Brown hair, gray-blue eyes. Blue background. Signed on paper backing "pinxit B. Trott," and inscribed in a different hand "Thomas H. White/about 1804?" 3⅜ inches H × 2⅞ inches W.

[1] Anne A. Verplanck, "Benjamin Trott: Miniature Painter" (M.A. thesis, College of William and Mary, 1990), chapter 3. Ibid., 57–62.

[2] The HSP miniature is labeled "Original" on the paper backing behind the ivory.

[3] Verplanck, 28.

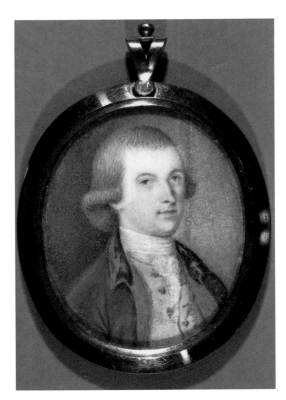

Catalog Number INDE13720

[1] Peale painted his first
American miniatures after his
June 1769 return to Annapolis
from London, where he
had spent nearly two years
studying in Benjamin West's
studio. It is unknown which
professional miniaturists
instructed Peale during his
London stay; West himself
did not paint miniatures
(Miller, *Selected Papers* 1,
pages 48–50, n. 1–8). After
October 1786, when he
turned the miniature business
over to his younger brother
James, Charles Willson Peale
painted few miniatures (Ibid
1, page 458, n. 3).

WILLIAM WHITE (1748–1836)
1. attributed to Charles Willson Peale, miniature from life, 1769–1770

White was born in Philadelphia, on 4 April 1748. Later, he graduated from the College of Philadelphia (now the University of Pennsylvania) and then completed divinity studies in London, where he was ordained a priest of the Church of England in the spring of 1772. With his return to America, he was appointed assistant minister to Philadelphia's Christ Church, where he became rector in 1779. During the American Revolution, he served as chaplain to the Continental Congress.

In 1786, White was elected bishop of the first Pennsylvania diocese of Pennsylvania's Protestant Episcopal church. He led his diocese's effort to join with those in the other states as one church, and had drafted the constitution under which this new American Episcopal church formed itself. Among his many contributions to this organizational plan was the concept of shared governance of the church by the clergy and the laity. In 1787, he returned to London, where he was consecrated as the first bishop of the American Protestant Episcopal church. Ten years later, he succeeded Samuel Seabury as the presiding Episcopal bishop in America. At this time, White also served as chaplain of the United States Senate.

White's pastoral duties (which included Philadelphia's St. James's and St. Peter's churches, in addition to Christ Church) involved him in a wide range of philanthropic and educational activities. He was active in Philadelphia's charitable organizations, the governance of the University of Pennsylvania (he was awarded the university's first doctor of divinity degree in 1782), the Episcopal Academy, and the formation of Sunday schools. He founded the Bible Society of Philadelphia and co-authored a popular American revision of the Church of England's Book of Common Prayer. He was long an officer of the American Philosophical Society, and he published a number of theological treatises and histories of the American church. White died in Philadelphia on 17 July 1836.

1. Before sailing to London in the fall of 1770 for his ordination, White sat for a miniature made for his family. In this portrait, the young divinity student appears in his street clothes, not admitted to religious orders. At a later date (probably after the sitter's death) the year "1772" (which marked White's acceptance into the ministry) was engraved on the miniature's locket. This miniature has traditionally been regarded as Charles Willson Peale's work, albeit one of the artist's earliest examples.[1] Though he lived in Annapolis at this time, Peale visited Philadelphia regularly, specifically in late 1769 and in the summer of 1770, when he may have painted his miniature of White.

⁕⟨∘⟩⁕

Provenance:
Given to Independence National Historical Park by Mrs. James Alan Montgomery Junior, the subject's great-great-great-granddaughter by marriage, in 1986.

Physical Description:
Watercolor on ivory, half-length miniature, head and torso turned toward the sitter's left. Blue coat, yellow waistcoat, white stock and jabot. Brown hair, dark eyes. Blue background. Engraved on locket reverse: "William White/(Bishop White)/C.W.Peale/1772." 1½ inches H × 1¼ inches W.

WILLIAM WHITE (1748–1836)
2. by Charles Willson Peale, from life, 1788

2. Peale's museum portrait of White was painted in 1788. By this time, the two men were well acquainted through their membership in the American Philosophical Society and the artist's regular attendance at Christ Church during the war years. The newly consecrated bishop's distinguished reputation of service to the city and the country placed him in the company of Peale's other Revolutionary portrait subjects in the Philadelphia Museum.[2]

─◦◦◦◦─

Provenance:
Listed in the 1795 Peale Museum catalog. Purchased by the City of Philadelphia at the 1854 Peale Museum sale.

Physical Description:
Oil on canvas. Bust length, torso turned toward the sitter's right. White clerical collar and bands, black stole, white surplice. Powdered hair, blue eyes. Green background. 22¾ inches H × 18¾ inches W.

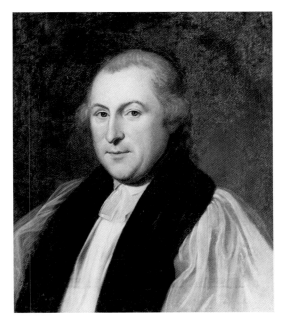

Catalog Number INDE14163
(SN 13.311)

[2] The Reverend Manasseh Cutler recorded in his diary a 1787 visit to Peale's Museum where he saw "a number of ye. Most distinguished Clergymen in ye. Midle[*sic*] & southern States, who had, in some way or other, been active in ye. Revolution" (Miller, *Selected Papers* 1, pages 484, 486).

Catalog Numbers (A) INDE1363 (B) INDE8425 (C) INDE8426

WILLIAM WHITE (1748–1836)
3. by William Russell Birch, three identical miniatures after the John Sartain engraving of a painting by Thomas Sully, c. 1830–1834

3. Bishop White's popularity made him a frequent subject for artists; during his long life, he posed for seven different painters. Among these was Thomas Sully, who painted six portraits of him. Sully's last life portrait of the bishop, a bust finished in early 1828, was later copied (now unlocated) by the artist for the Philadelphia engraver John Sartain. In 1830 or 1831, Sartain published his engraving of Sully's White portrait.

Sartain's engraving of White provided British-born enamelist William Russell Birch (1755–1834) with the source for his miniature of the bishop. As he had with a least one other sitter, Birch produced several examples of the White miniature.[3] In addition to the three versions at Independence, Birch miniatures of White survive at the Historical Society of Pennsylvania, the Rosenbach Library and Museum, the Philadelphia Museum of Art, the Smithsonian's National Portrait Gallery, the Metropolitan Museum of Art, the Norton Gallery in Louisiana, and the Carnegie Museum of Art, and in several private collections. These miniatures vary slightly from one another in size, shape, and coloration; most were fashioned as brooches.

❧

Provenance:
Given to Independence National Historical Park by (A) Mrs. J. Bennett Hill and Mrs. Ledlie Irwin Laughlin in memory of their grandfather Bishop Mark Anthony DeWolf Howe in 1959. (B & C) James Alan Montgomery Senior, the subject's great-great-grandson, through Christ Church in 1967.

Physical Description:
Enamel on copper. Bust length, head turned toward subject's right. White clerical collar and bands, black stole, white surplice. White hair, dark eyes. Dark background. Set into a gold brooch. (A) Painted on reverse in yellow enamel: "White." (A) 1¼ inches H × 1 inch W. (B) & (C) 1 inch H × ⅞ inches W.

[3] An example of Birch's Daniel Webster (Richard and Gloria Manney collection) is marked "11" on the reverse; one of the artist's White examples (Historical Society of Pennsylvania) is marked "16" on the back. Possibly, Birch produced these series miniatures on subscription.

JAMES WILKINSON (1757–1825)
by Charles Willson Peale, from life, 1796–1797

Catalog Number INDE14166

(SN 13.318)

Wilkinson was born in Benedict, Maryland, in 1757. He later studied medicine at the University of Pennsylvania and then returned to Maryland, where he opened a medical practice. During the Revolution, he served as aide-de-camp to General Horatio Gates and carried the news of America's victory at Saratoga to Congress. At the time, Wilkinson's indiscreet criticism of General Washington's authority forced his reassignment to administrative duty as clothier general, in which post he served until 1781. Three years later, he moved to the Virginia frontier, where he promoted the territory's reorganization as the new state of Kentucky. At that time, he secretly advised the Spanish government on American plans for western development, receiving a sizable annual pension and favored trading status for his cooperation.

In 1791, Wilkinson returned to military duty during the Ohio River Territory Indian campaigns, in which he succeeded General Anthony Wayne. As military governor of the southwest territory, Wilkinson participated in the 1803 transfer of the Louisiana Purchase from France to the United States. Briefly serving as governor of the vast new territory, he was publicly criticized for his heavy-handed administration and reassigned to frontier military duty. Public concerns about his abuse of authority increased when Wilkinson's participation in former vice president Aaron Burr's scheme to establish an independent western nation was revealed. Although Wilkinson narrowly escaped indictment during Burr's treason trial, the general was twice investigated by Congress. Following an unsuccessful courtmartial, he returned to his military command in New Orleans.

With the outbreak of renewed war between America and England in 1812, Wilkinson was posted to Canada. His major offensive against the British in Montreal failed, and he was discharged from active service. Wilkinson died in Mexico on 28 December 1825.

In late 1796 or early 1797, Charles Willson Peale painted Wilkinson's portrait for the Philadelphia Museum. The subject had come to Philadelphia in order to testify before Congress about his unofficial trade relations with Native Americans in the Ohio Territory. While Wilkinson was there, he succeeded his territorial commander, Anthony Wayne, who had suddenly died en route to his post. Wilkinson's new assignment, initially a popular one, probably influenced Peale's consideration of him as an appropriate subject for the museum.[1]

Provenance:
Listed in the 1813 Peale Museum catalog.
Purchased by the City of Philadelphia at the 1854 Peale Museum sale.

Physical Description:
Oil on canvas. Bust length, head turned toward sitter's right. Dark blue uniform coat with buff facings, gold epaulettes with one star showing on each. Buff waistcoat, black stock and white jabot. Powdered hair, blue eyes. Dark brown background. 23⅛ inches H × 19⁷⁄₁₆ inches W.

[1] Sellers, *Portraits and Miniatures*, 248.

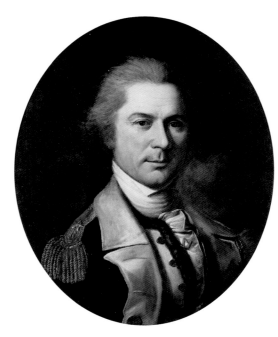

Catalog Number INDE14164
(SN 13.315)

¹ Charles Willson Peale,
"Diary," 4 November 1788
(Miller, *Selected Papers* 1,
page 545).

² Of the forty-four portraits on
the 1784 list for the museum,
twenty-two are in military
uniform. Of these, only four
(Ternant, Lafayette, Cambray
Digny, and Henry Lee) wear
black stocks.

³ The miniature and the
Rembrandt Peale and Sarah
Miriam Peale copies are all
owned by the Maryland
Historical Society.

OTHO HOLLAND WILLIAMS (1749–1794)
by Charles Willson Peale, after Charles Willson Peale, 1782–1784

Williams was born in Prince Georges County, Maryland, in March of 1749. In his youth, he worked for, and then became, his county's clerk. After a brief period as a merchant in Baltimore, he joined the Frederick City rifle corps in mid-1775. At the start of the Revolution, he served during the siege of Boston. In late 1776, he was wounded and captured at Ft. Washington, New York. There, the British suspected him of espionage and imprisoned him for over a year in New York City. After his exchange, he fought at Monmouth and then joined the Continental army's southern campaign, about which he later wrote in his detailed *Narrative of the Campaign of 1780*. He fought at Camden, King's Mountain, Guilford Court House, Hobkirk Hill, and Eutaw Springs, serving until the war's end.

Elected naval officer of Baltimore in late 1783, Williams later became customs collector for the port. He declined a recommission as the army's second-in-command in 1792 on the basis of ill health. The search for relief from earlier war injuries then took him to Barbados. After his return to the United States, Williams died on 15 July 1794.

Charles Willson Peale's museum portrait of Williams appeared on the list published in the 13 October 1784 issue of the *Freeman's Journal and Philadelphia Daily Advertiser*. Apparently, the museum portrait is a copy of a similar portrait (destroyed in 1977) painted for the sitter's family. The museum replica lacks both the life portrait's background material (a classical temple labeled "MARS," which represents the sitter's military prowess) and its inclusion of a Society of the Cincinnati eagle medal, which Peale recorded that he had added

to "Genl. William's picture" in late 1788.¹ In addition, the artist changed the color of Williams's stock from black (in the life portrait) to white (in the replica).²

There are many Peale-related images of Williams, and all combine various elements of the life and museum portraits. Both Charles Willson Peale's 1780s miniature of Williams and Rembrandt Peale's 1796 copy of the Williams museum portrait made for the young artist's patronage trip to Charleston, depict the sitter without a Cincinnati medal and wearing a white stock. Sarah Miriam Peale, Rembrandt's cousin, included these aspects in her c. 1830 copy of the Williams life portrait (with its classical temple).³ James Barton Longacre copied most of the museum portrait's elements for his engraved portrait of Williams published in *The National Portrait Gallery of Distinguished Americans* (1834–1839). In the engraving, Williams wears a white stock and a Cincinnati medal (Longacre also altered the trim on Williams's waistcoat to brocade and buttoned his collar).

❦

Provenance:
Listed in the 1795 Peale Museum catalog. Purchased by the City of Philadelphia at the 1854 Peale Museum sale.

Physical Description:
Oil on canvas. Bust length, torso turned slightly toward the subject's left. Dark blue uniform coat with buff facings, gold epaulettes with one star. Buff waistcoat with fur trim, white stock and jabot. Masonic pin on jabot. Powdered brown hair tied in a queue with a black ribbon, brown eyes. Brown background. 23 1⁄16 inches H × 19 1⁄2 inches W.

WILLIAM WILLIAMS (1731–1811)
by James J. Sawyer, after John Trumbull, 1873

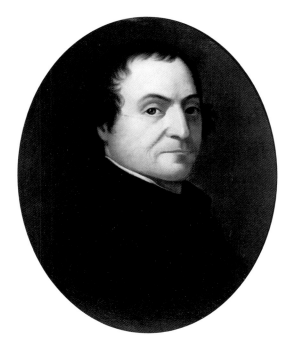

Catalog Number INDE14165
(SN 13.316)

Williams was born on 8 April 1731 in Lebanon, Connecticut. After he graduated from Harvard, he studied theology with his father, a Congregational minister. Despite this training, the younger Williams chose a business career, following his brief service in the colonial militia at the beginning of the French and Indian War. From that time on, he served in many public offices: town selectman and clerk; state assemblyman, clerk, and house speaker; and governor's council member.

During the Revolution, Williams contributed substantial sums to the Connecticut militia and defended the American cause in the local press. He had represented his colony at various provincial assemblies prior to the war's outbreak, and later served in the Continental Congress, where he signed the Declaration of Independence. In 1788, he attended Connecticut's federal Constitutional ratifying convention as a supporter of the proposed federal plan. Throughout these later years, he presided over his county and district probate courts. Williams died on 2 August 1811.

For its Centennial gallery of Declaration signers in Independence Hall, the City of Philadelphia commissioned Connecticut artist James J. Sawyer (1813–1888) for a portrait of Williams. Sawyer copied the 1778 bust portrait of Williams (now privately owned) by John Trumbull.[1] The only other portrait of Williams, Trumbull's painting of him in *The Declaration of Independence*, exists in several versions. Trumbull's original *Declaration* depicts Williams as a man older than the man in Sawyer's portrait, having gray hair and posed fully facing the viewer. Trumbull's 1818 Capitol Rotunda and 1832 (now at the Wadsworth Athenaeum) versions show a younger Williams with dark hair and in the frontal pose used in the original *Declaration*.

❧

Provenance:
Purchased by the City of Philadelphia from the artist in 1873.

Physical Description:
Oil on canvas. Bust length, torso turned toward subject's left. Black coat, white shirt. Black hair, brown eyes. Dark background. 23 inches H × 20 inches W.

[1] Theodore Sizer, *The Works of Colonel John Trumbull, Artist of the American Revolution* (New Haven: Yale University Press, 1950), 67.

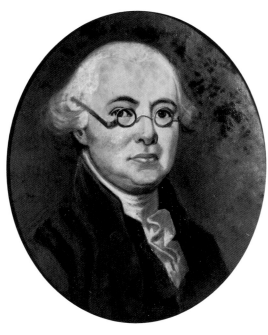

Catalog Number INDE
(SN 13.313)

JAMES WILSON (1742–1798)
by Philip Fisbourne Wharton, after the James Barton Longacre engraving from a painting by Jean Pierre Henri Elouis, 1873

Wilson was born on 14 September 1742 in Carskerdo, Scotland. The son of a farmer, he later attended the University of St. Andrews. In 1765, he immigrated to America, taking the position of Latin tutor at the College of Philadelphia. Meanwhile, he read law under Pennsylvania governor John Dickinson. Wilson then opened a law practice, first in Reading and later in Carlisle. He later became the chair of his town's Committee of Correspondence and then attended the provincial conference. During this time, he published his widely read political opinion that the colonies were independent, although joined together under the same sovereign. In 1776, he was elected to the Second Continental Congress and signed the Declaration of Independence. Shortly thereafter, his vehement opposition to Pennsylvania's new constitution cost him his seat in Congress and prompted an inflamed mob to attack his house. After the Revolution, he built a thriving law practice in Philadelphia and engaged in large land purchase ventures. An advocate of the Bank of North America, he became its legal advisor. In later years, he was an occasional member of Congress.

In 1787, at the federal Constitutional Convention, Wilson served on the committee of detail that prepared the draft of the new plan. Though a Federalist who strongly opposed equal representation for states in the Senate, he favored popular election for the president and Congress. Later, he led the effort to ratify the Constitution in Pennsylvania. He also ensured that his state's new constitution was similar to the federal Constitution, and was appointed to the United States Supreme Court in 1789.

During the 1790s, Wilson entered numerous speculative financial dealings, and failed to pay the interest on the loans. Eventually, he was jailed for debt while riding the North Carolina court circuit. Freed but bankrupt, Wilson died on 21 August 1798.

As a signer of both the Declaration and the Constitution, Wilson was an important subject for Philadelphia's Independence Hall museum. At the time of the Centennial, the City of Philadelphia commissioned local artist Philip Fisbourne Wharton (1841–1880), who based his portrait of Wilson on James Barton Longacre's c. 1825 engraving for John Sanderson's *Biography of the Signers of the Declaration of Independence*. Longacre had copied Jean Pierre Henri Elouis's c. 1792 miniature watercolor of Wilson (now at the National Museum of American Art).

❧⊷⊶❧

Provenance:
Purchased by the City of Philadelphia from the artist in 1873.

Physical Description:
Oil on canvas. Bust portrait, torso turned toward subject's left. Blue coat and waistcoat. White stock and jabot. White wig, blue eyes, gold spectacles. Dark blue background. 23⅞ inches H × 20 inches W.

JOHN WITHERSPOON (1723–1794)
by Charles Willson Peale, after Charles Willson Peale, 1783–1784

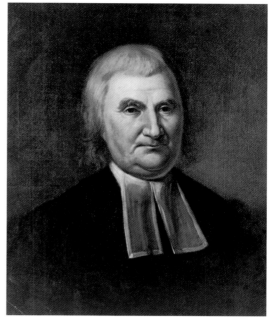

Catalog Number INDE14167
(SN 13.321)

Witherspoon was born in Haddingtonshire, Scotland, on 5 February 1723. He later received a master of arts and then a divinity degree from the University of Edinburgh. In 1757, he became the pastor of the Presbyterian congregation in Paisley, Scotland. He remained there until 1768, when he became the president of the College of New Jersey (now Princeton), a position he held until his death. Well known for his strict orthodoxy in church matters, he also had a reputation for his dedication to public service. At the College of New Jersey, he expanded the curriculum to include philosophy, French, history, and oratory, skills he deemed necessary for the students' moral education and developing sense of civic responsibility.

When the Revolution began, Witherspoon participated in local committees of correspondence and provincial conferences. In the summer of 1776, he took his seat in the Second Continental Congress, where he spoke in favor of independence and signed the Declaration. Subsequently, his sermons and pamphlets extolling the virtue of liberty reached a wide audience in America and England. He remained in Congress, where he served on more than one hundred committees, until 1782. His colleagues valued his practical opinion, and he actively participated in debates on the Articles of Confederation, the organization of the new American government, and the terms of peace with England.

After the war, Witherspoon served several terms in his state's legislature. In 1787, he attended New Jersey's convention to ratify the new federal Constitution. At the same time, he planned the organization of America's Presbyterian Church into a national body. Witherspoon died on 15 November 1794.

Witherspoon's influential congressional career and his role as a respected Revolutionary spokesman made him a candidate for Peale's Museum. The museum portrait was first listed in the 13 October 1784 issue of the *Freeman's Journal and Philadelphia Daily Advertiser*. At this time, Peale was working on a private commission from Witherspoon; early in 1783, he sent a note to Witherspoon requesting an unspecified payment that may represent payment for a painting (possibly the half length portrait given to Princeton University by the sitter's descendants).[1] The museum portrait is probably a replica of this commissioned painting. In the 1790s, Peale's son Rembrandt copied the Witherspoon portrait for the subject's family (the portrait is now at the Smithsonian's National Portrait Gallery).

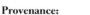

Provenance:
Listed in the 1813 Peale Museum catalog.[2]
Purchased by the City of Philadelphia at the 1854 Peale Museum sale.

Physical Description:
Oil on canvas. Bust length, facing forward. Black robe, white clerical bands. White hair, blue eyes. Dark brown background.
22½ inches H × 19 inches W.

[1] Miller, *Selected Papers* 1, page 422, n. 4. Sellers, *Portraits and Miniatures*, 253. In 1787, Peale apparently painted a third portrait of Witherspoon (now unlocated).

[2] The Witherspoon portrait does not appear in the 1795 Peale Museum catalog.

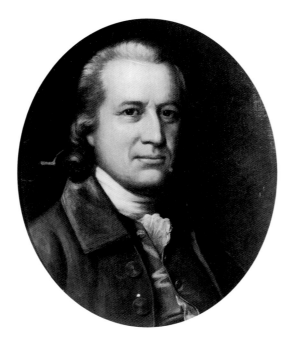

Catalog Number INDE14161

(SN 13.322)

OLIVER WOLCOTT (1726–1797)
by James Read Lambdin, after Ralph Earl, 1873

Wolcott was born in Windsor, Connecticut, on 20 November 1726. As a young man, he led his class at Yale College and served as a captain in the colonial militia during its 1747 expedition against French Canada. Trained as a physician by his uncle, Wolcott instead became sheriff of Litchfield in 1751. He retained that office for two decades while he acted as a deputy in the legislature. In the early 1770s, he sat on the judge's bench for the county and probate courts. Throughout the American Revolution (except for 1779), he served in the Continental Congress and the Connecticut militia. A signer of the Declaration of Independence, he also commanded his state's coastal and western frontier defenses against the British. In 1784, he directed peace treaty negotiations between the United States and the Six Iroquois Nations at Fort Stanwix. After the war, he supported the federal Constitution at his state's ratifying convention in 1787; there he also accepted election as Connecticut's lieutenant governor. Nine years later he succeeded to the governor's office, where he remained until his death on 1 December 1797.

A late signer of the Declaration of Independence (illness had interrupted his congressional attendance for several months during the fall of 1776), Wolcott was included in the City of Philadelphia's Centennial collection of portraits in Independence Hall.

In 1873, the city commissioned local artist James Read Lambdin (1807–1889), who copied either Ralph Earl's 1784 portrait of Wolcott, which hung in the Connecticut State House (now at the State Library), or Joseph Steward's 1796 copy of Earl's painting (now at the Connecticut Historical Society) for the subject's family.

⚬✦⚬

Provenance:
Purchased by the City of Philadelphia from the artist in 1873.

Physical Description:
Oil on canvas. Bust length, torso turned toward subject's left. Gray-green coat and waistcoat. White stock and jabot. Gray hair, blue-gray eyes. Brown background. Inscribed in lower left, "Oliver Wolcott/after Earle/ W.S."[1] 24 inches H × 20⅛ inches W.

[1] "W.S." may refer to William S. Stokley, mayor of Philadelphia from 1871 to 1881, who oversaw the Centennial restoration of Independence Hall.

GEORGE WYTHE (1726–1806)
by John Ferguson Weir, after John Trumbull, 1876

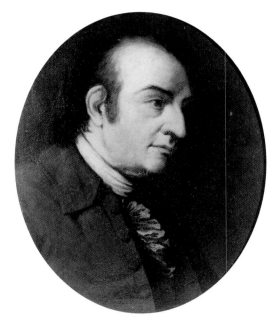

Catalog Number INDE14162
(SN 13.323)

Wythe was born near Hampton, Virginia, in 1726. Later Virginia's leading classical scholar, he received his early education from his mother. In time, he read law and was admitted to the Virginia bar in 1746. His political career began in 1754, when he served for a few months as Virginia's acting attorney general. The following year he entered the House of Burgesses, where he served intermittently for the next two decades and eventually as its clerk. There he opposed the Stamp Act in a series of resolutions drafted for, but rejected as too strident by, the Burgesses.

Elected to the Continental Congress in 1775, Wythe was an early advocate of independence and signed the Declaration. Afterward, he returned to Virginia, where he served with Thomas Jefferson and Edmund Pendleton as an author of the state's new legal code finished in 1779. Wythe was also a member of Virginia's House of Delegates, one of the first judges in the state's high court of chancery, and America's first professor of law at the College of William and Mary. A strong supporter of federalism, he briefly attended the Federal Convention in 1787 and later led the movement for the adoption of the Constitution by his state as president of Virginia's ratifying convention. In 1790, he resigned his professorship at William and Mary and moved to Richmond, where he presided over its chancery court district. There, he also served as an ex officio member of the state supreme court of appeals.

Ironically Wythe, who had devoted his whole life to justice, came to a death unavenged by the law. He was poisoned by his disgruntled grandnephew, George Sweeney. Successful prosecution of the case depended upon the testimony of a black servant, a circumstance prohibited by the very Virginia laws Wythe revised. Although Sweeney escaped legal punishment, his great uncle lived long enough to disinherit him. Wythe died on 8 June 1806.

During the nation's Centennial, the city commissioned New England artist John Ferguson Weir (1841–1926) to paint a portrait of Wythe for the museum in Independence Hall. Weir based his portrait on that of Wythe painted by John Trumbull for *The Declaration of Independence* (now at the Yale University Art Gallery). For *The Declaration*, Trumbull frequently worked from life sketches of his sitters done at an earlier date; the artist's 1791 sketch of Wythe is now unlocated.[1]

Provenance:
Purchased by the City of Philadelphia from the artist in 1876.

Physical Description:
Oil on canvas. Bust length, head and torso turned almost to right profile. Reddish brown coat and waistcoat. White stock and jabot. Brown hair, brown eyes. Dark brown background. 23 inches H × 20 inches W.

[1] Irma B. Jaffe, *Trumbull: The Declaration of Independence* (New York: Viking Press, 1976), 81.

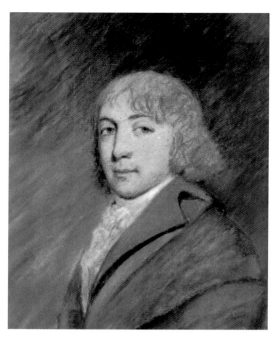

Catalog Number INDE 11927

(SN 7.036)

CARLOS MARIA MARTINEZ, MARQUES DE CASA D'YRUJO
(1763–1824)

attributed to a member of the Sharples family,
after James Sharples Senior, c. 1796–1810

D'Yrujo was born in Cartagena, Spain, on 4 December 1763. Later, he was educated at the University of Salamanca. His diplomatic career began in 1786 when he became a secretary to the Spanish embassy in London. Within three years, he had served briefly in the Netherlands before returning to the Foreign Office in Madrid in 1789. In 1793, he went back to London until his appointment as Spain's minister plenipotentiary to the United States in 1795.

D'Yrujo's nine years in America were volatile ones as Spain attempted to benefit from the shifting loyalties between America, France, and England. From his arrival in the United States in 1796, D'Yrujo was an outspoken critic of Jay's Treaty, claiming that it contradicted the terms of the 1795 Treaty of San Lorenzo negotiated by Charles Cotesworth Pinckney. In 1797 and 1798, D'Yrujo was involved in a libel suit between his father-in-law, Pennsylvania Chief Justice Thomas McKean, and the editor of *Porcupine's Gazette*, William Cobbett. Eventually, d'Yrujo's public disdain for American diplomatic policy reached an unacceptable level when his condemnation of the Louisiana Purchase led President Thomas Jefferson to demand his recall by the Spanish government in 1807. D'Yrujo then returned briefly to Spain before his next assignment as minister to Brazil in 1810. He died in 1824.

During his family's first visit to the United States, British pastelist James Sharples Senior painted a portrait of d'Yrujo, probably when both men lived in the American capital of Philadelphia. After returning to England, Sharples listed the sitter as "Chevalier de Yrugo, Spanish Minister" in the artist's 1802 catalog of pastel portraits. Later, a member of Sharples's family copied the life portrait (now unlocated). The copy shows a capable artist's work, but it lacks the skillful modeling and attention to detail produced by James Sharples Senior in his portrait work.

Provenance:
Given by Ellen (Mrs. James) Sharples to Felix Sharples in 1811. Given by Felix Sharples to Levin Yardly Winder in the 1830s. Inherited by Nathaniel James Winder from Levin Yardly Winder. Inherited by Richard Bayly Winder from Nathaniel James Winder in 1844. Purchased by Murray Harrison from Richard Bayly Winder around 1865. Purchased by the City of Philadelphia from Murray Harrison in 1876.

Physical Description:
Pastel on paper. Bust length, torso turned toward the subject's right. Red cloak with brown trim, tan coat and waistcoat. White stock and jabot. Brown hair, brown eyes. Blue variegated background. 9 inches H × 7 inches W.

UNIDENTIFIED MAN formerly called "James Lawrence"
by Gilbert Stuart, from life, c. 1825–1828

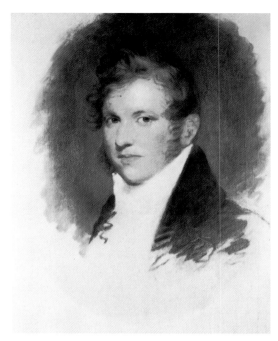

Catalog Number INDE12319

Despite some similarities between this painting and Gilbert Stuart's well-documented 1812 portrait of Captain James Lawrence (now in the museum of the United States Naval Academy), a comparison between the two reveals their important differences.[1] In the Independence portrait, the sitter's pose, Byronic hairstyle, and facial features approximate those of the Naval Academy portrait. However, the former depicts a man in his twenties dressed in civilian clothes, while the latter shows the thirty-one-year-old Lawrence in full uniform. Lawrence joined the navy at age sixteen and served until his death sixteen years later. During these years (1797–1813), he would not have posed out of uniform for a portrait.

The timing of Lawrence's naval career strongly suggests that the sitter in the Independence portrait is not the captain. The portrait's form, too, dissociates it from Lawrence. In the Independence painting, Stuart carefully portrayed the sitter's head, but only sketched his shoulders and the background. Stuart frequently produced such works in the last years before his death in 1828.[2]

Since Lawrence died more than a decade before that time, he could not have been the subject of such a late work by Stuart.

⁓꧁꧂⁓

Provenance:
Given to the Washington Association of New Jersey by Mrs. Mary Blanchley Knight in 1915. Given to Morristown National Historical Park by the Washington Association in 1938. Given to Independence National Historical Park by Morristown National Historical Park in 1981.

Physical Description:
Oil on canvas. Bust length, torso turned slightly toward the sitter's right. Dark green coat, white stock. Golden red hair, green eyes. Dark green background. 24 inches H × 20 inches W.

[1] Lawrence Park listed both the Independence and Naval Academy portraits as James Lawrence. Lawrence Park, *Gilbert Stuart: an Illustrated Descriptive List of His Works* (New York: William Edwin Rutledge, 1926), 3, pp. 466–467. David Meschutt, formerly curator of paintings at the West Point Museum, first questioned the identification of the Independence portrait as Lawrence. David Meschutt to Robert L. Giannini, III, 15 March 1982. Museum Accession Files, Independence National Historical Park.

[2] Edgar P. Richardson, *Gilbert Stuart, Portraitist of the Young Republic*, Smithsonian exhibition catalog (Washington, D.C.: National Gallery of Art, 1967), 55.

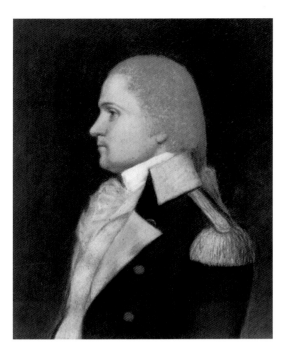

Catalog Number INDE11918

(SN 7.026)

UNIDENTIFIED MAN formerly called "William Loughton Smith"
attributed to a member of the Sharples family (possibly Ellen), c. 1795–1810

This sitter does not resemble documented portraits of William Loughton Smith (1758–1812) by John Trumbull, Archibald Robertson, or Gilbert Stuart. Furthermore, Smith never served in the American army either during or after the Revolution. The tightly executed painting style in this portrait suggests the work of British pastelist Ellen Sharples (1769–1849).

—⁓◦⊙◦⁓—

Provenance:
Given by Ellen (Mrs. James) Sharples to Felix Sharples in 1811. Given by Felix Sharples to Levin Yardly Winder in the 1830s. Inherited by Nathaniel James Winder from Levin Yardly Winder. Inherited by Richard Bayly Winder from Nathaniel James Winder in 1844. Purchased by Murray Harrison from Richard Bayly Winder around 1865. Purchased by the City of Philadelphia from Murray Harrison in 1876.

Physical Description:
Pastel on paper. Bust length, left profile. Blue uniform coat with white facings and silver epaulettes. White waistcoat. Powdered hair tied in queue, brown eyes. Dark gray background. 9 inches H × 7 inches W.

UNIDENTIFIED WOMAN formerly called "Dolley Madison"
attributed to a member of the Sharples family (possibly James Senior), from life?, c. 1795–1810

This sitter does not resemble the documented portrait of Dolley Madison (1768–1849) by Sharples in the Independence collection (see above). The expert facial modeling and the sure hand in depicting the sitter's costume details (e.g. the lace shawl and cape) suggest the work of British pastelist James Sharples Senior (1751–1811).

———⟨⟩———

Provenance:
Given by Ellen (Mrs. James) Sharples to Felix Sharples in 1811. Given by Felix Sharples to Levin Yardly Winder in the 1830s. Inherited by Nathaniel James Winder from Levin Yardly Winder. Inherited by Richard Bayly Winder from Nathaniel James Winder in 1844. Purchased by Murray Harrison from Richard Bayly Winder around 1865. Purchased by the City of Philadelphia from Murray Harrison in 1875.

Physical Description:
Pastel on paper. Bust length, torso turned slightly toward sitter's left. White empire-style dress, black lace shawl. White hair, brown eyes. White lace cap with black bow. Black ribbon necklace. Blue-gray variegated background. 9 inches H × 7 inches W.

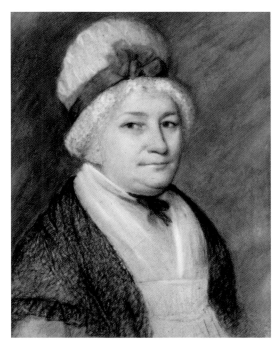

Catalog Number INDE11936
(SN 7.045)

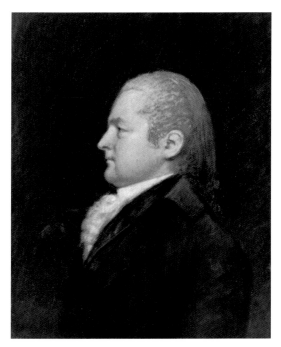

Catalog Number INDE11928

(SN 7.037)

UNIDENTIFIED MAN formerly called "John Adams"
*attributed to a member of the Sharples family (possibly Ellen),
after James Sharples Senior, c. 1795–1810*

This sitter does not resemble the one in the documented British artist Ellen Sharples's copy (now at the Bristol Museum of Art in England) of James Sharples Senior's life portrait of John Adams (1735–1826) recorded as "John Adams, esq" in Sharples's 1802 catalog. The Independence work is stylistically similar to Ellen Sharples's (1769–1849) other attributed pastels, especially in the minuteness of this subject's eyebrows and lips.

⁕

Provenance:
Given by Ellen (Mrs. James) Sharples to Felix Sharples in 1811. Given by Felix Sharples to Levin Yardly Winder in the 1830s. Inherited by Nathaniel James Winder from Levin Yardly Winder. Inherited by Richard Bayly Winder from Nathaniel James Winder in 1844. Purchased by Murray Harrison from Richard Bayly Winder around 1865. Purchased by the City of Philadelphia from Murray Harrison in 1874.

Physical Description:
Pastel on paper. Bust length, left profile. Dark gray coat and waistcoat. White stock and jabot. Powdered hair tied in queue, brown eyes. Dark blue background. 9 inches H × 7 inches W.

UNIDENTIFIED MAN formerly called "Charles Cotesworth Pinckney"
attributed to a member of the Sharples family,
after James Sharples Senior, c. 1795–1810

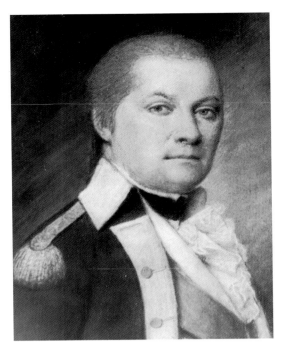

Catalog Number INDE11909

(SN 7.017)

This sitter does not resemble those in the documented portraits of Charles Cotesworth Pinckney (1746–1825) by Henry Benbridge, John Trumbull, and Ralph Earl. James Sharples Senior's 1802 catalog lists "General Pinkney, late Ambassador to France." The Independence portrait appears to be a copy of a different life portrait.

⎯✿⎯

Provenance:
Given by Ellen (Mrs. James) Sharples to Felix Sharples in 1811. Given by Felix Sharples to Levin Yardly Winder in the 1830s. Inherited by Nathaniel James Winder from Levin Yardly Winder. Inherited by Richard Bayly Winder from Nathaniel James Winder in 1844. Purchased by Murray Harrison from Richard Bayly Winder around 1865. Purchased by the City of Philadelphia from Murray Harrison in 1876.

Physical Description:
Pastel on paper. Half length, torso turned toward subject's left. Blue uniform with buff facings, gold epaulette. Buff waistcoat. Black stock and white jabot. Powdered hair tied in queue, brown-gray eyes. Light blue shoulder sash. Variegated gold, blue, and gray background. 9 inches H × 7 inches W.

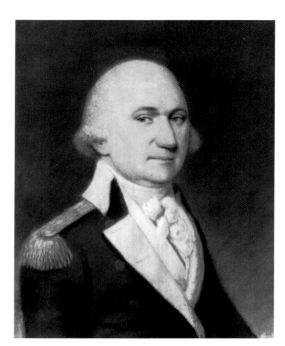

Catalog Number INDE11912

(SN 7.020)

UNIDENTIFIED MAN formerly called "Samuel Smith"
attributed to a member of the Sharples family
(possibly James Sharples Senior), c. 1795–1810

This sitter does not resemble the documented portraits of Samuel Smith (1752–1839) by Gilbert Stuart and Rembrandt Peale. James Sharples Senior's 1802 catalog lists "General Smith, M[ember of] C[ongress]." The Independence pastel appears to be a different life portrait.

⟶⟨⟨⟩⟩⟵

Provenance:
Given by Ellen (Mrs. James) Sharples to Felix Sharples in 1811. Given by Felix Sharples to Levin Yardly Winder in the 1830s. Inherited by Nathaniel James Winder from Levin Yardly Winder. Inherited by Richard Bayly Winder from Nathaniel James Winder in 1844. Purchased by Murray Harrison from Richard Bayly Winder around 1865. Purchased by the City of Philadelphia from Murray Harrison in 1876.

Physical Description:
Pastel on paper. Half length, torso turned toward subject's left. Blue uniform with buff facings, gold epaulette. Buff waistcoat. White stock and white jabot. Wig tied in queue, blue eyes. Variegated gray background.
9 inches H × 7 inches W.

UNIDENTIFIED MAN formerly called "Admiral Sir William Penn"
by Charles Willson Peale, after an earlier portrait by an unknown artist, 1810

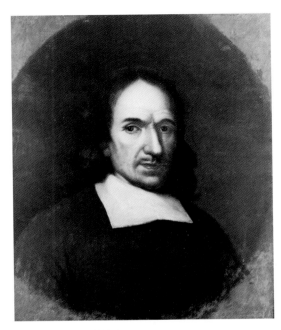

Catalog Number INDE15213

(SN 13.215)

In 1810, Peale copied a portrait for his Philadelphia Museum purportedly of Sir William Penn (1621–1670), the father of Pennsylvania's founder. However, this portrait does not resemble documented likenesses of the elder Penn.[1] Benjamin Franklin had borrowed the portrait during a mid-eighteenth century visit to Scotland and never returned it. At the time of Peale's copy, the borrowed portrait (now unlocated) was owned by a Franklin descendant.

—⟨⟩—

Provenance:
Listed in the 1813 Peale Museum catalog. Purchased by the City of Philadelphia at the 1854 Peale Museum sale.

Physical Description:
Oil on paper mounted on canvas. Bust length, torso turned slightly toward subject's left. Reddish brown coat, white collar. Dark brown hair and moustache, brown eyes. Dark olive background. 22⅞ inches H × 17⅝ inches W.

[1] Sellers, *Portraits and Miniatures*, 169–70.

General Index

Subject Index

Artist Index

Source Index